D1574049

J. M. W. TURNER • A LIFE IN ART • I

YOUNG MR TURNER

THE FIRST FORTY YEARS • 1775–1815

ERIC SHANES

PUBLISHED FOR THE PAUL MELLON CENTRE FOR STUDIES IN BRITISH ART BY
YALE UNIVERSITY PRESS • NEW HAVEN AND LONDON

Copyright © 2016 by Eric Shanes

All rights reserved.
This book may not be reproduced, in whole or in part,
in any form (beyond that copying permitted by
Sections 107 and 108 of the U.S. Copyright Law
and except by reviewers for the public press),
without written permission from the publishers.

Designed by Emily Lees
Printed in China

Library of Congress Cataloging-in-Publication Data

Shanes, Eric, author.
Young Mr Turner : the first forty years, 1775–1815 / Eric Shanes.
pages cm
Includes bibliographical references and index.
ISBN 978–0–300–14065–1 (cl : alk. paper)
1. Turner, J. M. W. (Joseph Mallord William), 1775–1851. 2. Painters – Great Britain – Biography.
I. Title.
ND497.T8S525 2016
759.2 – dc23
2015019937

A catalogue record for this book is available from the British Library

Half-title page: *Self-Portrait*, 1791, National Portrait Gallery, London (see fig. 47).
Frontispiece: *Cadair Idris, Afterglow*, c.1799, National Gallery of Scotland, Edinburgh (detail of fig. 233).
Facing page: *Kidwelly Castle, South Wales*, summer 1835, Harris Art Gallery, Preston (detail of fig. 135).
Image on p. vi: *Radley Hall, Oxfordshire from the south-east*, 1789, Tate Britain, London (detail of fig. 31).

For Jacky, again and for ever

Contents

Prologue		xi
Abbreviations		xiii
1	Antecedents and Early Years ♦ 1775 to 1788	1
2	London Again ♦ Autumn 1788 to Autumn 1789	15
3	In Sir Joshua's House ♦ 1789 to 1792	31
4	Six Advantages and a Demand ♦ 1792 to 1793	49
5	The Only Turner Prize ♦ 1793	71
6	A Mere Six to Eight Tones by Candlelight ♦ 1793 to 1794 and beyond	81
7	Coming of Age ♦ 1795 to 1796	105
8	Grandeur ♦ 1796 to 1798	131
9	The Sister Arts ♦ 1798	151
10	Vindication ♦ November 1798 to November 1799	163
11	The Dark Side ♦ 1799 to 1800	185
12	Tragedy and Triumph ♦ December 1800 to April 1801	201
13	Gaining the Summit ♦ April 1801 to February 1802	213
14	High Places and High Art ♦ February to October 1802	223

15	Dispute and Disillusion ♦ November 1802 to July 1803	239
16	Another Great Room ♦ Spring 1803 to Spring 1804	249
17	Arcadia-upon-Thames ♦ June 1804 to December 1805	259
18	Staying Away ♦ December 1805 to December 1806	277
19	Another Grand Title ♦ November 1806 to December 1807	291
20	Higher Education ♦ January to September 1808	307
21	'The First Landscape Painter in Europe', 'the First Marine Painter in the World' ♦ September 1808 to June 1809	321
22	Six Houses, Three Castles and a High Street ♦ June to December 1809	337
23	A Year's Grace ♦ 1810	353
24	Just Six Weeks ♦ January and February 1811	371
25	A New Epoch ♦ February to November 1811	389
26	'This Prospero of the Graphic Art' ♦ November 1811 to May 1812	401
27	A Man of Property ♦ June 1812 to May 1813	415
28	An English Eden ♦ May to December 1813	425
29	'The Eye Wanders Entranced' ♦ January to November 1814	435
30	The Tremendous Range of his Accomplishments ♦ November 1814 to May 1815	447

Appendix: Chronology of Turner's government stock transactions	459
Notes	466
Bibliography	510
Acknowledgements	518
Index	522
Photograph credits	537

To be an artist...involves the whole of your being – it's not just a skill, or something you like to do, but an obsession with a strong element of fantasy, an attempt to turn away from pain.

Tom Kempinski, 1980

I can scarcely reconcile my mind to the idea that [Turner] painted those grand pictures. The exterior so belies its inhabitant the soul.

Thomas Cole, 1829

The great contrast of the man and his works presents one of those anomalies of character that puzzles...His very person and face were the antagonists of the ideality of his works.

William Havell, 1851

No one would believe, upon seeing my likeness, that I painted those pictures.

J. M. W. Turner, before 1805

Prologue

Wednesday 10 February 1802 was the tenth day of the ninth year in the latest of a long series of wars between Britain and France. With a ceasefire in place since the previous October, negotiations to end the hostilities between plenipotentiaries of the contending powers continued in Amiens in northern France. That morning the Paris newspapers stated that the Batavian Republic of the Netherlands had reached a settlement with the deposed and exiled ruler of Holland over the future of his remaining property in the lowlands. At St James's Palace in London that afternoon, King George III held a magnificent levee, during which he met with all the foreign ambassadors to his court, and did so in the presence of the Lord Chancellor, the Chancellor of the Exchequer, other top officers of state and a great many aristocrats. That Wednesday also saw the election of a new Speaker of the House of Commons who would hold the post until 1817. Later in the day, at the Theatre Royal, Covent Garden, the second performance took place of *The Cabinet*, a comic opera written by five minor composers working collaboratively. Perhaps the *Morning Post* of 10 February best identified the reason for the ultimate demise of the piece when it declared in a review of its premiere: 'Nothing in the form of a drama ever afforded less food for the mind.'

At seven o'clock that cold winter evening, no fewer than thirty-five of the surviving thirty-seven Royal Academicians convened in General Assembly before a roaring fire in their official meeting room on the first floor of the Royal Academy of Arts in Somerset House, the Strand, London. Their principal goal was to vote in three more of their number. The leading candidate in the first election was J. M. W. Turner. Following the normal procedure, two ballots were held. In the initial poll, twenty-one of the Academicians voted for Turner and thirteen for his nearest rival. In the follow-up ballot, one of the voters changed sides, which still left Turner with six more votes than his opponent. Accordingly, he was elected. At 26 he was the youngest artist to have been elevated to such a rank in the thirty-four years of the institution's existence. But since the spring of the previous year, when he had exhibited a large seascape that had taken the world by storm, his election had been a foregone conclusion.

This book tells the story of what led to that triumph, as well as to the showing in 1815 of the picture that Turner himself considered to be his 'chef d'oeuvre'. By digging far more deeply into the evidence than any previous biography, huge amounts of new information have been forthcoming and a great many errors have been corrected. Everywhere the author has attempted to communicate Turner's extraordinary intellectual range and complexity, which have often been masked by his verbal and written inarticulacy. To that end, and where space permits, priority has been given to his writings in the form of his letters, his lecture manuscripts, his book annotations, and the records and observations he jotted down in his sketchbooks, for naturally they all supply direct conduits to his mind. And equally close attention has been paid to his images, for a number of them contain biographical dimensions, while a great many more attest to the outstanding fertility of his thinking.

This book, which is itself vast in scale, condenses a biography more than twice its length that is to appear electronically. The length

of both publications has been necessitated by the sheer complexity of Turner's life, thought and art, which have never previously been explored to anything like the same extent in relationship to one another. The book is aimed at both the general reader and the scholar, the electronic version at specialists and laypersons interested in an even more thorough account of the subject. Both publications are serviced by the illustrations appearing in these pages.

Down the years there has been no shortage of Turner biographies, for apart from dozens of potted lives and general surveys, there have been six originally researched accounts of the artist's life. These were by Walter Thornbury (1862, revised 1877); Bernard Falk (1938); Alexander J. Finberg (1939, revised 1961); Jack Lindsay (1966); James Hamilton (1997); and Anthony Bailey (1997). Each possesses strengths, Finberg and Lindsay especially; and each contains weaknesses, in Thornbury's case some insuperable ones. Yet all of these works share two interrelated failings: they are virtually unillustrated and – because they therefore lack almost any user-friendly means of exploring the artist's images – they are forced to dwell mostly on Turner the man, even though Turner the man is always less than half the story. Divorced from his painting, Turner's life is rather thin stuff for a biographer. But no biography should ever limit itself to the actions and personal relationships of its subject; it should help us enter that person's mind, to find out exactly what made or makes them tick. To delve very far inside Turner's mind we need to get inside his art, for that is almost completely where he kept it. By means of copious illustrations and the detailed analysis of many of his images, it is hoped that a great deal of that reach will be attained here.

Unless otherwise stated, all of the illustrations in this book are of works by Turner, and all watercolours are on paper. The artist's original titles have been used throughout, even where the spellings of names and words in those titles may differ from modern ones or from spellings of the same words in different Turner titles. Similarly, virtually all quotations, Turner's original spellings and the spellings of his day are given without the tedious addition of *sic* in square brackets. Instead, that term is only used occasionally to prevent ambiguities from arising. Short references to literature within the main text and the endnotes allude to full citations in the Bibliography (which doubles as a glossary of abbreviations). In all cases, artists are accorded the Royal Academy status they enjoyed at the moment under discussion (for example, Thomas Lawrence is entitled an Associate Royal Academician between 1791 and 1794, a Royal Academician between 1794 and 1820, and the President of the Royal Academy thereafter). Where no dates are provided for persons mentioned in the text, this is either because their dates are unknown or because they are too renowned to require dating. Throughout the book a precise distinction is maintained between the words 'sketches' and 'studies'. Sketches are works from which no subsequent images emanated, while studies are works from which further images were developed.

Height precedes width in all pictorial dimensions. Due to the discovery of Turner's principal bank records from the age of nineteen onwards, the imperial currency that was familiar to him has not been decimalised in these pages. For those not ancient enough to remember imperial, there were 4 farthings to a penny; 2 halfpennies to a penny; 12 pennies to a shilling; 240 pence or 20 shillings to a pound; and 21 shillings to a guinea. Until decimalisation was introduced in 1971, the written abbreviation for amounts of sterling currency was '£-s-d'. For example, 15 pounds, 17 shillings and 6 pence would have been represented as £15-17s-6d. And because Turner would only have known imperial measurements, these are also employed throughout. This is especially important with regard to pictorial dimensions, for like many of his contemporaries Turner often trimmed his works to the quarter, half or three-quarter divisions of inches, or created them to those divides. When metric replaces imperial, such purposeful markers disappear. For the sake of consistency, dimensions are therefore also given below in miles, yards, feet and inches (with the exception of illustration captions, where sizes are provided in both imperial and metric forms). In an early draft of this work the author did place metric equivalents in parentheses after all the imperial sizes throughout the main text, but this made for very pedantic interruptions that constantly impeded the flow of the narrative. For those readers wishing to ascertain metric equivalents, there are many imperial-to-metric tables and conversion engines freely available on the World Wide Web.

It is impossible to calculate what the pound sterling of Turner's lifetime would be worth today, as huge alterations in economic and cultural values render comparisons invalid. This is especially the case where works of art are concerned, for the outstanding amounts that Turner received for his works and those attained by more acclaimed artists in the vastly inflated art market of today are simply not comparable. Nor can middle-class income or cost of living comparisons be of much assistance either. For these reasons the author will only refer occasionally to the £26 per annum earned by a common labourer in Turner's lifetime, in order to provide an elementary yardstick with which to judge the painter's yearly income in relation to basic incomes of the day.

The author owes an incalculable debt to a huge number of Turner scholars, both past and present. Naturally their help is implicitly cited in the notes to this work, just as their direct aid is specified in the acknowledgements section at the end of both the book and the electronic version of the text. However, he would also like to thank all those scholars collectively here, for without their enormous, unstinting, generous and invaluable efforts, this biography could never have appeared in any form whatsoever.

Abbreviations

B.J. The catalogue raisonné of Turner's oil paintings by Martin Butlin and Evelyn Joll, *The Paintings of J. M. W. Turner*, London and New Haven, revised edition, 1984.

B.L. British Library Manuscripts Division.

L.V. The numbers assigned to the paintings of Claude le Lorrain as drawn in the same artist's *Liber Veritatis* (British Museum, London), and as listed in Marcel Röthlisberger, *Claude Lorrain: The Paintings*, London, 1961.

R. Prints listed in the two-volume catalogue of the engravings after Turner written by W. G. Rawlinson, *The Engraved Work of J. M. W. Turner, R.A.*, London, 1908 and 1913.

R.A. The Royal Academy.

PRA President of the Royal Academy.

RA Royal Academician.

ARA Associate Royal Academician.

T.B. The Turner Bequest holding of the painter's output in the collection of Tate Britain, London.

W. The listing of Turner's finished watercolours by Andrew Wilton in *The Life and Work of J. M. W. Turner*, London and Fribourg, 1979.

George Dance the younger RA, *Portrait of Joseph Mallord William Turner*, dated 'Augst. 4th/1792', pencil and watercolour on laid paper, oval, 8½ × 6½ (21.5 × 16.5), private collection.

I

Antecedents and Early Years

1775 to 1788

He lived to paint. Nothing else mattered. For over sixty years he rose at dawn and painted with enormous energy until sunset. Everything was sacrificed to painting, sometimes brutally so. When he became a member of an institution that was largely dedictated to the art of painting, he obsessed about the well-being of that body to the same degree. Things were only of any importance if they assisted his painting. Even his favourite pastime served that end, inasmuch as he often used fishing to intensify his understanding of water, and therefore to improve his painting. Money served painting, human relationships and sex too. For Turner, life was wholly subordinate to art. We need to be aware of this from the very beginning. In what follows it is useless looking for much of a life beyond painting, for it barely existed.

Joseph Mallord William Turner was born on 23 April 1775, or so he claimed with respect to the day of the month and the month itself.[1] He was christened on Sunday 14 May 1775 in St Paul's Church, Covent Garden, London. Perhaps the delay of three weeks between birth and christening was caused by a combination of post-natal difficulties, cold weather, the mental imbalance of his mother and the distraction of his father.

Turner hailed from relatively prosperous forbears on both his paternal and maternal sides. His father, William (fig. 1), was a wig-maker, wig-dresser and barber. He had been born the third of seven children and the second of five sons on 29 June 1745 in the small farming and cloth-making town of South Molton, Devonshire.[2] Of moderate height, he possessed good health, a lean muscular build, a parrot nose, a projecting chin, small blue eyes, a broad Devonian accent that could be mistaken for 'a peculiar transatlantic twang',[3] and a smiling disposition that must have gone down well with his customers. It is likely that he had taken up wig-making and hair-dressing while in his mid-teens and still living in South Molton.

Turner's maternal forbears can be traced back to the late sixteenth century and were active in the London meat trade, where they greatly prospered, possibly by initially specialising in the breeding of ducks for human consumption.[4] One of them, Joseph Mallard (1671–1741), altered the spelling of his surname to Mallord. With its phonetic proximity to a haughtily pronounced 'my lord', this must have sounded somewhat more classy and less avian than Mallard. By the time of his demise Joseph Mallord owned properties to the east of London and out in Essex. These included four houses in Wapping, one of which would eventually be inherited by J. M. W. Turner.[5]

Joseph Mallord's wife, Sarah, née Marshall, was the granddaughter of a Nottingham tailor. She was probably born in 1670 and died in 1747. Joseph and Sarah Mallord had four children, of whom the third, also named Sarah, was the painter's maternal grandmother. She was born in 1701 and died in 1758. In 1733 she married a salesman of sheep and cattle, William Marshall (1703–1761), who also resided in the parish of St Mary's, Islington. According to Turner family

Left 1 Charles Turner ARA, *Portrait of William Turner*, c.1820, chalk on paper, 15½ × 12½ (39.4 × 31.8), private collection.

Above 2 Artist and date unknown, *Portrait of Sarah Mallord Marshall?*, watercolour and gouache on ivory, oval, 3⅛ × 2½ (8 × 6.2), private collection.

tradition, the heirloom reproduced here is a portrait of her in old age (fig. 2).

William and Sarah Marshall had four children, of whom the second was Mary, the painter's mother.[6] She was born in November 1735. A possible portrait of her appears here (fig. 3). The final child was Joseph Mallord William Marshall, who was born in 1740 and who would die in 1820. He became a butcher and meat wholesaler out in Middlesex, to the west of London. Quite clearly Mary Marshall adored her baby brother, which is why she conferred all his forenames upon her son.[7]

William Turner had moved to London by late July 1773, for on 27 August of that year he applied to the Surrogate Registrar of the Diocese of London at Lambeth Palace for a licence to marry Mary Marshall. Nothing is known of when, where or how the couple met, or how long their courtship had lasted. In order for the wedding to be permitted in the church of St Paul's, Covent Garden (and without any proclamation of banns), William Turner had to testify that he had been living in the parish for at least the 'space of four weeks last past'.[8] The ceremony took place on 29 August 1773. Neither the groom nor his bride married young, for he was 28 and she was 37. She pretended to be four years younger, for a bride of 37 would have been considered ancient at the time.

When Turner was born, his parents were living at 21 Maiden Lane, Covent Garden, which was then a cul-de-sac.[9] Their place of business and residence formed half of a building that had been divided only a short time before.[10] Each half basically consisted of a moderately large cellar room, a very lofty room on the ground floor, and a suite of rooms on the top floor. Because William Turner's shop took up his entire ground floor, he used the cellar for living and cooking, and the top floor for sleeping.[11]

It is likely that the dividing walls between 20 and 21 Maiden Lane were very thin, as were the original walls within both buildings. As a consequence, noise constantly arose from a drinking emporium, the 'Cider Cellar', next door. This was one of the worst

3 Artist and date unknown, *Portrait of Mary Marshall Turner?*, watercolour and gouache on ivory, oval, 3 × 2½ (7.5 × 6.2), private collection.

4 Artist unknown, *26 Maiden Lane, Covent Garden, and Hand-court*, engraving appearing opposite page 2 of Walter Thornbury, *The Life of J. M. W. Turner*, vol. 1, London, 1862. The chimney on the adjacent building does not appear on other, contemporaneous depictions of 26 Maiden Lane.

hell-holes in Covent Garden, staying open virtually all night for boozing, the singing of bawdy ballads and the recitation of lewd verses. Fights were frequent, and the occasional murder took place. For the truly desperate the services of the oldest, most diseased and cheapest prostitutes could be procured there after all the thousands of their sisters in the locality had gone off to rest their aching parts.[12] The sounds of carousing (or worse) must have blasted through the walls of the Turner dwelling every night, especially after the 'Cider Cellar' had transformed itself into a 'midnight concert room'. Sleep cannot have come easily anywhere in 21 Maiden Lane, especially with a babe in arms. And frequently the noise must have continued well into daylight hours, which surely alienated William Turner's clientele.

Probably that is why on Lady Day, 25 March 1776, and thus less than a year after the birth of J. M. W. Turner, the perruquier and barber moved his family diagonally across the way to 26 Maiden Lane (fig. 4).[13] In addition to being far quieter, all of the front rooms of 26 Maiden Lane could receive sunlight until the late afternoon during the summer, for the building stood on the northern side of the street. The new dwelling probably consisted of eight or more rooms.[14] Entrance to it was gained by way of two side-doors located in a gated and partially covered passageway immediately to the east of the shop. In time these two doorways – both of which are visible in fig. 4 – would permit Turner to have twin addresses, one of which would be used for professional purposes. Eventually he would have three working areas in 26 Maiden Lane: his top-floor bedroom, a sitting-room behind the wig emporium and barber's shop, and the cellar that was primarily used as the family kitchen and everyday living space. Possibly the building had no chimneys and its heating was effected by stoves that vented their fumes at its rear. If that was the case, then perhaps the only parts of it that were heated were the cellar and ground-floor shop. The inefficient venting of fumes from the cellar could have led to quite a fug developing, possibly with detrimental effects upon the very young Turner's breathing. And as

we shall see, that condition might equally or alternatively have been caused by an atmospheric disaster that would occur in 1783.

At some point, probably in 1787 or the following year, the shop window would be transformed into a 'gallery' employed to display the young Turner's watercolours and drawings. Until then it was filled with barber's blocks. These simplified wooden busts coloured with oil paint by an itinerant painter supported sample wigs and the wigs that were on sale. When the wigs were sold their blocks probably accompanied them after they had been recoloured with simple flesh tones and had rudimentary portraits of the purchasers of the wigs painted upon them. Possibly such simplification would one day affect Turner's art, for large numbers of the people he would paint would have their physiognomies represented in hugely simplified ways.

In all likelihood the shop-window blocks were brilliantly coloured with rich yellows, pinks, reds, purples, blues and greens in order to grab the attention of passers-by and equally to suggest the colours of the clothes, decorations and other accoutrements that might be complemented by a wig. And because the shop window blocks were brightly painted, there is a good chance that the interior of the shop itself was also painted in the same rich colours that proved highly fashionable during the Georgian era. Naturally, if Turner was surrounded with brilliant colours in this way when young, then his amenability to intense hues later in life might well have been influenced by them. They would have introduced something unusually vibrant into his early life.

Due to the proximity of 26 Maiden Lane to the various buildings used by the Royal Academy not far away, a number of William Turner's clients were artists, art dealers and minor art collectors. The shop provided a fairly engaging and mentally invigorating environment, and it surely made the barber a reasonable living, although he only charged a penny for a shave, which was hardly the path to riches. For that reason, William Turner was very focused upon money, as he made apparent on one occasion by pursuing a customer down Maiden Lane demanding 'a halfpenny for soap'.[15] Turner himself would tell his old friends that 'Dad never praised me for anything but saving a halfpenny!'[16] Clearly, care over money had been impressed on him from the start.

Mary Ann Turner

At some point around the beginning of September 1778, William and Mary Turner presented their three-and-a-half-year-old son with a sister. On 6 September of that year she was baptised Mary Ann Turner at St Paul's, Covent Garden. Sadly she would only live for the next four years and eleven months, for on 8 August 1783 she would be buried in the churchyard of St Paul's, Covent Garden.[17] Both the date and cause of her death are unknown. However, her demise could have been precipitated by the 'killer cloud' of poisonous gas that had rapidly moved across Britain in late June 1783, just over six weeks before she was interred. This resulted from a huge volcanic eruption at Laki in Iceland on 8 June 1783 that eventually killed upwards of 100,000 people across Britain in what was the worst natural disaster ever recorded in our island history. Perhaps the intense heat that summer had led Mary Ann and her brother to play in the street on the morning of Sunday 22 June when the sulphur dioxide mist created by the eruption crossed London, to overtake them with its fumes.[18] As we shall soon discover, by 1785 Turner would almost certainly suffer from a respiratory problem, and it appears very possible that it might have derived from the deadly cloud of two years earlier. Because of the Laki eruption, the following winter was exceedingly prolonged and cold, and that too might have impaired the boy's breathing in the prevailing atmospheric conditions.

Like many volcanic disturbances, the Laki eruption could have created vivid sunsets for years afterwards. If that was the case, then perhaps they became linked with death in Turner's mind. Although he is renowned as a painter of sunsets, there are few brilliantly red sunsets in his art, and most of those are linked to death and destruction. Maybe the Turnerian association between blood red skies and death began in 1783. And who is to say that the shipwrecks, drownings, plagues, infernos, avalanches and other catastrophes he would one day depict did not ultimately have their origins in the death of a beloved sister that simultaneously toppled his mother over the edge of insanity?

At the time of Mary Ann Turner's burial, her brother was 8 years and 4 months of age, while Mary Marshall Turner was in her mid-forties. Sadly we know virtually nothing about her. Thornbury tells us that her aspect was 'masculine, not to say fierce', that she had been 'a person of ungovernable temper', that she had 'led her husband a sad life' and that towards 'the end of her days she became insane, and was in confinement'.[19] On one occasion Turner's father would tell a visiting cousin from Devon that Mary Turner had been 'out of her mind'.[20] Fierceness, an 'ungovernable temper', mental illness requiring confinement and an absence of lucidity might suggest a number of psychiatric conditions, but without further evidence it is pointless to speculate about any of them. Yet two things do stand out about the relationship of Turner to his mother.

The first is his desire to disassociate himself from her completely after 1799, when he and his father would surreptitiously place her in care and apparently take no further interest in her. From that rupture, plus Mary Marshall Turner's attested fierceness and rage, we might just catch a glimpse not simply of psychological ferocity but even of physical violence having once entered into the relationship between mother and son (as well as between wife and husband). If

such brutality did exist, then perhaps it began with the loss of Turner's sister. That catastrophe might well have tipped Mary Marshall Turner into insanity, in the process abruptly forcing a rapid withdrawal of the love she had formerly bestowed upon her husband and son. Such a sudden reversal of feelings, and its consequent destruction of trust in the child, could well explain Turner's unloving and calculating later treatment of his mother, his apparent inability to place sufficient trust in any woman to form a loving relationship, a sexual fear that apparently led to voyeurism or the treatment of women simply as objects to be looked at but not touched, and his hiding behind barriers of secrecy throughout his life. Moreover, if love and trust had suddenly been terminated and both physical and mental violence did enter the relationship between mother and son, then it could easily have led the young Turner to begin creating pictorial worlds in which to find psychological security.

The other noticeable fact about Turner and his mother is her virtual absence from his life as recorded by others. Many of the young painter's admirers visited Maiden Lane or used his father's shop without apparently ever setting eyes on her. Perennially she would be conspicuous by her absence. But where was she? Was she always conveniently out, or was she simply taken for granted and therefore effectively rendered invisible like so many women of her day? Or might she have been locked away like Mrs Rochester? Was she even in Maiden Lane for much of the time after 1785? Could she have been placed by then in the care of her Brentford sister-in-law's relatives in Sunningwell, Oxfordshire, a village situated about four miles south of Oxford, with William Turner too exhausted to cope with his son and thus packing him off to stay with J. M. W. Marshall in New Brentford? That would certainly explain why Turner visited Sunningwell so many times during his youth, for his Brentford uncle would not retire to the completely out-of-the-way Oxfordshire village until some time between June 1802 and April 1803.[21] As a consequence, Turner's many youthful visits to Sunningwell could not have been undertaken to see him, as has been claimed by all previous biographers of the artist.

In any event, if intense grief unhinged Mary Turner and her mental instability grew over the eighteen or so months after August 1783 to produce unbearable or violent scenes at home,[22] then such difficulties might explain what happened to her son at the end of that period. Yet there may have been an alternative or additional reason behind the next major event in his life.

In 1785 Turner was sent to stay with his aunt Ann (1729–1798) and her husband, the butcher and meat wholesaler J. M. W. Marshall, at New Brentford in Middlesex, on the river Thames about eight miles to the west of Covent Garden.[23] Their business and home stood on the north side of the marketplace, just behind the town hall, with the river Brent to its rear. From there he attended a free school run by John White (b.1745?) in which only the three Rs and Scripture were taught to fifty boys and ten girls.[24]

Thornbury stated that Turner had been sent to Brentford in 'consequence of a fit of illness (want of air – chief disease in London!)'.[25] It could be that the boy suffered from mild corrosion of the lungs caused by the sulphur dioxide cloud of 1783 that may have killed his sister. But even if that was not the case, Maiden Lane would have been a difficult place in which to find clean air. For that reason an alternative condition that might have afflicted Turner was tuberculosis. It seems very likely that the person who provided Thornbury with knowledge of 'want of air' was the Revd Henry Scott Trimmer (1778–1859), who had been a fellow pupil at John White's day school, as had his elder brother John (1775–1791). Henry Scott Trimmer certainly knew a thing or two about 'want of air', for as a child he had contracted tuberculosis (or consumption, as it was then known). If Turner was not tubercular, nonetheless he might have contracted a bad cough that was misdiagnosed as being symptomatic of that disease, which is why William Turner moved him to an airier location than Maiden Lane. His fears are entirely understandable if Turner's sister had coughed herself to death, either from sulphur dioxide inhalation or from consumption.

The young Turner was profoundly impressed by both the picturesque architecture that Brentford still retained by 1785 and by the idyllic surroundings of the town. To a boy coming from the crowded vistas, filthy streets and stinking courts of Covent Garden, it must have seemed as though he had arrived in paradise when, from his base in New Brentford, he explored the banks of the Thames downriver to Kew and Putney, and upriver to Eton and Windsor. In time he would become the supreme painter of English idealised landscapes, and the groundwork for that mastery was definitely laid during the early years spent in New Brentford. And many of Turner's Thames forays must have doubled as angling expeditions with his schoolmates, for it was undoubtedly at New Brentford that he first developed his lifelong passion for fishing.

It was also at New Brentford that he manifested the earliest inklings of his visual sensibility, drawing birds, flowers and trees from his schoolroom windows, as well as cockerels and hens on walls as he dawdled his way to school and back.[26] And it is probable that an image that made a seminal contribution to his life and future artistic development was very closely scrutinised by him in Brentford in 1786.

Long after that time Turner would tell Henry Scott Trimmer's eldest son, Henry Syer Trimmer (1806–1876), that a 1724 mezzotint reproduction in green ink (fig. 5) of the oil painting *Shipping in a Storm* by Willem van de Velde the younger (1633–1707) had 'made me a painter.'[27] As we shall discover shortly, the boy had certainly acquired watercolour paints and brushes by 1787, so it is extremely likely that he was impressed by *Shipping in a Storm* at the age of just

Left 5 Elisha Kirkall after Willem van de Velde the younger, *Shipping in a Storm*, 1724, coloured mezzotint, 17 × 12¼ (43.2 × 31.2), British Museum, London.

Above 6 Artist unknown but print possibly coloured by J. M. W. Turner around 1787, *Rochester Castle in Kent*, plate size 4¾ × 6⅔ (12.2 × 17.5), London Borough of Hounslow Libraries.

The light area of sky on the extreme right particularly suggests that it may have been Turner who tinted this image.

ten or eleven in the previous year, and that he had already set his mind on being a painter by then. And perhaps his ambition was reinforced by widely circulated reports of the sinking of the *Halsewell* East Indiaman with over 160 fatalities in January of that year. This catastrophe was to Georgian Britain what the loss of the *Titanic* in 1912 would be for the twentieth century, namely a momentous tragedy that doubled as a moral lesson regarding the hubris and fragility of human life. In 1818 Turner would depict the 1786 disaster, and probably he did so because it had been the very first nautical calamity to have entered his consciousness.[28]

Boswell's 'England and Wales'

Turner's uncle was friendly with a Brentford distillery foreman, John Lees (1755–1825), who was the proud owner of a large leatherbound tome, Henry Boswell's *Picturesque Views of the Antiquities of England and Wales*.[29] Over time, Lees had 381 of its 489 engraved views of historic buildings and landscapes tinted by a number of colourists (fig. 6). One of them was Turner, who coloured 'about seventy' of them for a fee of tuppence per plate.[30] Because of its 25 November 1786 publication date, he had to have undertaken the work after that point in time, and thus between the ages of 11 and 13. Unfortunately, there is no way of knowing which seventy images Turner coloured, or exactly when he did so. This is because John Lees understandably had no idea that the youngster who periodically or eventually stood before him requesting payment would one day become an important artist, and so he kept no record of Turner's labours.

In order to obtain the commission, Turner must have shown the distillery foreman evidence of his abilities as a colourist. Although any such works with which he proved himself have long been lost to us, they must have been reasonably impressive for Lees to have entrusted his cherished prints to someone so young. Naturally, the very scale of Turner's commitment to this project by 1787 or 1788 makes it clear that he owned a set of watercolours and brushes by that time. Perhaps William Turner already believed in his son's abilities and had purchased such materials for him, or else the boy had himself worked to acquire the basic tools of what would soon become his trade. But in either case, such an acquisition of watercolours and brushes indicates a very early desire to be a painter,

thereby equally strengthening the belief that the van de Velde print had given him that impetus in 1786.

The large amount of work involved in tinting around seventy images at tuppence a time would have earned Turner about eleven shillings and sixpence in all. As this was slightly more than an ordinary workman would earn in a full working week, it must have seemed like a fortune to a schoolboy. The commitment to such labour on the part of a lad of around 12 also makes it evident that he already aspired to be a painter by that age. And this is proven even more strongly by the plate boundaries. These involved tinting up to sharply defined margins and not beyond them, thereby avoiding ragged edges. Most of the tinted edges on the majority of the plates are absolutely straight.

Such attentive colouring necessarily tested patience and presented a technical challenge, especially for a relatively inexperienced boy drawing a brush along those many boundaries that curve steeply inwards towards the gutter of the book, which is a little under three inches thick. Moreover, in order to avoid blotting colours or offsetting them onto opposite pages, the young Turner would necessarily have been forced to wait for them to dry before moving from one page to the next. The enforced inactivity must have dragged out the time spent colouring the book. Such waiting around might well have suited any older, more prosperous and leisured amateur who also tinted the tome, but it would not have suited the young Turner at all.

This is because he was being paid a piecework rate, for which rapid working would have resulted in more plates being coloured, and therefore the earning of more of those vital tuppences. Possibly it was memories of such an imposed and necessarily frustrating inaction that compelled Turner subsequently to think hard about how to solve such a problem. Admittedly, during any of the waiting periods he could have read Boswell's texts. In addition to serving as a valuable means of improving reading and comprehension skills, these would have constituted an exceedingly helpful primer in British history. Here might very well have resided the basis of Turner's extensive knowledge of the many castles and other subjects he would one day depict. Of equal relevance to the future is the fact that around 1825, when he was 50, he would confer the very similar title of 'Picturesque Views in England and Wales' upon a major project in which he was involved. This title surely derived from Boswell's *Picturesque Views of the Antiquities of England and Wales*. Over time, Turner would represent no fewer than 110 of the places depicted in the Boswell set, and 58 of them would appear in his 'England and Wales' series. For many such images he would choose exactly the same viewpoints he might well have first encountered in the Boswell tome.

Wide vistas tinted in the Boswell book in 1787 appear to have inspired Turner to create a view of Oxford in watercolour during that same year (fig. 7). Its inscription makes it look like one of the inscribed plates in the Boswell work. A view of Clifton, a country house at Nuneham Courtenay, near Abingdon, which is also signed and dated to 1787 (fig. 8), may well have derived from a print.[31]

Turner might have first visited Oxfordshire in 1785, when he was 10. In Sunningwell, his mother could have been cared for by Mary (1733–1826) and Sarah Haines (1738–1822), the younger sisters of Ann Marshall. If Turner was taken to see his mother there as early as 1785, then that would explain the existence of a pen and ink sketch of St Leonard's Church, Sunningwell (fig. 9). This was quite clearly made by a young boy, for it bears all the characteristics of child art, being not nearly as sophisticated – if such a term is appropriate – as the 1787 view of Nuneham Courtenay.[32]

A further drawing made in 1787 (fig. 10) is a copy of an engraved view of Folly Bridge and Bacon's tower, Oxford, by Michael Angelo Rooker ARA (1746–1801) that had adorned the annual Almanack or calendar of the Oxford university year in 1780.[33] In terms of sophistication, the copy only marks a slight advance over the Nuneham Courtenay depiction, and it provides a clear notion of Turner's limitations in his thirteenth year. Again everything is slightly askew: the perspectives are imperfect, the spatiality is not fully grasped and the figures are drawn in a childish way, with no attempt having been made to replicate the formal and tonal complexity of Rooker's sky.

Turner's first viewing of an oil painting may have derived from his friendship with Henry Scott Trimmer. The latter's mother, Sarah Trimmer (1741–1810), had inherited a number of works by Thomas Gainsborough (1727–1788) from her father, the architect and painter Joshua Kirby (1716–1774). She hung them in her Brentford home where Turner undoubtedly saw them when visiting his school friends.[34] Her collection included 100 Gainsborough drawings and 8 Gainsborough landscapes in oil, one of which had been rescued by Kirby after Gainsborough had attempted to destroy it (fig. 11).[35]

When Turner lived in New Brentford it was the most fiercely pro-democratic town in Britain, simply because it was where voters from all over Middlesex – which included a major part of London – congregated every four or so years to return two county Members of Parliament.[36] J. M. W. Marshall is known to have participated in those elections in 1768 and 1784, and probably he did so in 1769, 1774 and 1780 as well.[37] In each poll he voted either for the staunch defender of British liberty, John Wilkes (1725–1797), or for a candidate who substituted for Wilkes when he was banned from standing because of his radical advocacy of constitutional government, the widening of the suffrage, and religious equality. In pursuit of these causes he was a determined opponent of George III and his ministers.

Naturally, J. M. W. Marshall could easily have communicated his libertarian sympathies to his nephew. In any event, the boy could not have missed seeing evidence of the demands for liberty, for Wilkes's name and the number '45' – to denote the 45th issue of

7 *A View of the CITY of OXFORD*, here dated 1787, watercolour on paper, 12 × 18¼ (30.4 × 46.3), Turner Bequest III-B, Tate Britain, London.

Wilkes's *North Briton* newspaper series of attacks on arbitrary government – were painted or scrawled across a vast multitude of flat surfaces throughout New Brentford.[38] Turner wrote '45' on the back of a very early drawing, and the number may well have alluded to 'Wilkes and Liberty'.[39] Much later he would repeatedly deal with the theme of liberty and with battles for political freedom, not least of all in Britain. Perhaps he did so because of his early experiences in New Brentford.

Sea Air

By the summer of 1788 the 13-year-old had been moved to Margate, Kent, a small town near the mouth of the River Thames about 65 miles east of London that was mainly reliant upon therapeutic sea-bathing, tourism and fishing.[40] There he attended a school run by a Methodist preacher, Thomas Coleman.[41] In the late 1770s Coleman had been hounded out of the nearby villages of St Nicholas at Wade and Burchington on religious grounds and for proselytising far too insistently.[42] His Margate school was located at the corner of Love Lane and Puddle Dock, and it contained a large schoolroom that could accommodate a substantial number of pupils.[43] High school numbers in the eighteenth century implies teaching by rote, which is never a particularly efficient means of imparting knowledge, so probably Turner only advanced his command of the three Rs a little further at Coleman's school. However, it does seem likely that the teacher was as fiercely evangelical in the educational sphere as he was in the religious one. If that was the case, then he may well have stimulated Turner's imagination by recounting tales from the Bible in ways that would have

8 *Clifton, Nuneham Courtenay, near Abingdon*, signed and dated 1787, watercolour on paper, 11¾ × 16¾ (29.8 × 42.5), Turner Bequest I-B, Tate Britain, London.

9 *St Leonard's Church, Sunningwell, Oxfordshire*, here dated to around 1785, pen and ink on paper, 6⅛ × 15¾ (15.5 × 40), Turner Bequest III-3(a), Tate Britain, London.

10 J. M. W. Turner after M. A. Rooker, *Folly Bridge and Bacon's Tower, Oxford*, signed and dated 1787, watercolour on paper, 12⅛ × 17 (30.7 × 43.1), Turner Bequest I-A, Tate Britain, London.

11 Thomas Gainsborough RA, *Open Landscape with Wood-Gatherer, Peasant Woman with her Baby on a Donkey, and Peasants seated round a Cooking Pot on a Fire*, c.1753–4, oil on canvas, 19 × 24½ (48.3 × 62.2), Tate Britain, London.

This canvas was slashed by Gainsborough, who gave it to Joshua Kirby, who had it repaired. It was inherited by the Revd Henry Scott Trimmer, and sold at his sale in 1860. Possibly it was the first landscape by an acknowledged British master ever seen by Turner.

12 *St John's Church, Margate*, here dated 1788, pen, ink and watercolour on paper, 12⅛ × 17⅛ (30.8 × 43.5), private collection.

appeared vivid to children. Here could have resided the familiarity with the Good Book that the future painter would later demonstrate in a fair number of his works, as well as the imaginative thrall it would hold for him.

Turner does not appear to have been moved to Margate for educational reasons. In 1788 John Trimmer had contracted tuberculosis and possibly been sent to Margate to recuperate. For the same reason he was certainly in the Kent town by May 1791, and he would remain in a rented house there with his own nurse while attending a sanatorium until the following August, when he would die of the disease in the Margate clinic.[44] Moreover, in 1792 Henry Scott Trimmer would also contract the illness and still be laid low with it by March 1793, although he would gradually recover thereafter. And as if this were not enough, in 1795 their older sister, Elizabeth Trimmer (1769–1816), would equally become consumptive.[45] That three children living under a single roof in Brentford all developed or would contract tuberculosis makes it clear that the largely airborne disease was rife in the Middlesex town.[46] Given Turner's friendship with Henry Scott Trimmer and, presumably, with his exact contemporary and classmate John Trimmer as well,[47] then perhaps he caught the disease too.

As we have seen, a bronchial condition had possibly led William Turner to move his son to Brentford in 1785. Yet perhaps it was exacerbated in the Middlesex town by mild tuberculosis. If that danger had suddenly become clear to Turner's father in 1788, then that would explain why the boy was shifted to a place thought to

13 *A street in Margate, looking down to the harbour*, here dated 1788, pen, ink and watercolour on paper, 10⅗ × 16 (27 × 40.7), private collection.

help combat the disease, rather than for educational reasons. Any schooling he received in Margate was simply a bonus.

Pictorially and stylistically, watercolours created in Margate represent a marked advance upon drawings that Turner had made in 1787 (figs 8 and 10). Now there is a marked sense of spatiality, combined with a more confident representation of architecture. In *St John's Church, Margate* (fig. 12), the handling of perspective is reasonably adept, and the distribution of light within the shadowed side of the church is exceptional for one so young – not for nothing would Turner, in his role as Royal Academy Professor of Perspective, one day talk happily about reflections, including reflected light within areas of shadow. In *A street in Margate, looking down to the harbour* (fig. 13), the perspective is slightly less certain but in a *Distant View of Minster, Isle of Thanet, Kent* (fig. 14) Turner embarked upon a ceaseless dialogue with his artistic predecessors, for the pictorial composition and detailing make it apparent that he had been looking recently at Gainsborough. On the right of a view of Minster Church (fig. 15) we can determine that he had already grasped the principle of using trees as framing devices.

In all likelihood, Turner resided with the Trimmers in Margate.[48] His first stay there undoubtedly laid the foundations for his lifelong love of the place. Such a regard is unsurprising, for the town and the cliffs to the east of it then afforded one of the finest nautical grandstands in the world. On his way to and from school, after school, at weekends, and on high days and holidays, the lad must have gazed with wonder upon a sun rising and setting over a Thames

14 *Distant View of Minster, Isle of Thanet, Kent*, here dated 1788, pen, ink and watercolour on paper, 10⅖ × 14⅘ (27.6 × 37.8), private collection.

estuary that was enormously and endlessly busy with vessels passing across it. Immediately to the east of the town, Margate Roads would frequently have been filled with vessels at anchor, while just a little further to the east a multitude of craft would have been making their way into or out of the North Sea and around the North Foreland into the English Channel. The majority of vessels criss-crossing the Thames estuary were sailing in and out of London, already the largest seaport on the planet by far. The river mouth would also have been teeming with fishing boats serving the culinary needs of London and the Home Counties. About twenty miles to the west of Margate, in the centre of the Thames estuary, lay the major fleet anchorage of the Nore. Large men-of-war were constantly sailing to and from there. And further warships and smaller vessels were making eventually for Chatham, one of the three leading military bases and shipbuilding centres in Britain.

It was surely at Margate that Turner first witnessed storms at sea, and the sun rising and setting through sea mists or 'vapour'. His sense of the mystery engendered by such veilings may initially have arisen at Margate too. Here, in addition, he must have gained his first awareness of the vast scale of men-of-war and of scarcely less grand merchantmen gliding majestically, often with their sails fully set. He would have seen numerous hoys or sloop-rigged coastal and river boats arriving at Margate or setting forth to convey passengers to London in just a few hours, thereby saving an overnight journey by land (indeed, Turner may have first travelled to Margate on just such a boat).[49] Margate harbour pulsed with activity as it serviced

15 *Minster Church, Isle of Thanet, Kent*, here dated 1788, pen, ink and watercolour on paper, 12 × 16⁷⁄₁₀ (30.5 × 42.6), private collection.

fishermen and tourists, while most mornings its adjacent beaches would have been crowded with bathing machines and with fishermen cleaning and selling their catch. The local pier, which was then a wooden structure, would stay with Turner for many years, eventually finding its way into very Dutch-looking images long before the artist could ever possibly visit Holland. Out at sea, buoys bobbed about heavily with vessels rounding them, a sight that might also have been stored away for life.

The romantic in Turner could easily have been aroused by the sight of large ships sailing off to the four points of the compass, thereby engendering thoughts of limitless horizons. Fishermen trawling the night waters by lanternlight, moonlight or both would hardly have seemed any less romantic. And naturally the schoolboy might easily have begged rides on local vessels or gone out with the Margate fishermen as they plied their trade. If Turner did view all these sights and enjoy such experiences at Margate in 1788–9, as appears likely, then it is no wonder he would often return to the town, for it had strongly helped to form him.

2

London Again

Autumn 1788 to Autumn 1789

Turner returned to London from Margate in the autumn of 1788, and was enrolled at a leading boys' school, the Soho Academy, at 8 Soho Square.[1] The subjects taught there included Greek, Latin, French, English, accountancy and drawing, although the last cannot have been of any value, for it simply involved the depiction of 'flowers and other objects' in the necessarily simplified and flattened style of embroidered images.[2] Probably Turner only attended the institution between the autumn of 1788 and the spring of 1789, for he was already determined to apply for art school. At most he had received five years' worth of conventional education, which was more than enough for a boy of humble origins in the 1780s.

In order to help support himself, the school dropout not only created his own landscapes but also made free transcriptions and straight copies of watercolours, of other drawings and of prints. Being cheap, they were all readily saleable at prices from one to three shillings. Probably his father had been displaying such works in his shop window, in the shop itself and around the entrance to his cellar kitchen for some time by early 1789. And William Turner could prove equally active on his son's behalf by taking his son along when visiting his private bewigged and tonsorial clients who possessed artistic interests. On one occasion the boy was left to his own devices and drew a complex, emblazoned coat of arms that was hanging on the wall. The client responded so enthusiastically to the work that the elder Turner's opinion that his son was going to be a painter was confirmed.[3]

John Raphael Smith

Soon another way of making money opened up. At 31 King Street, Covent Garden – and therefore just two streets to the north-west of Maiden Lane across Covent Garden piazza – stood a print shop run by John Raphael Smith (1752–1812). As a top mezzotint engraver, Smith had reproduced works by Sir Joshua Reynolds PRA (1723–1792), Benjamin West RA (1738–1820), James Barry RA (1741–1806), Richard Cosway RA (1740–1821) and Joseph Wright of Derby ARA (1734–1797), among many others.[4] That Reynolds had permitted him to reproduce no fewer than forty of his paintings by 1789 particularly indicates Smith's talents as an engraver, for naturally the illustrious first President of the Royal Academy could take his pick of such craftsmen. And Smith not only engraved images by painters who elevated the tone of art; he also reproduced the work of painters who did quite the opposite. One of them was his great friend, George Morland (1763–1804), who churned out portraits, interior and exterior genre scenes, landscapes often filled with highly characterful specimens of humanity, and animal pictures.

Then, as now, it was much easier to sell coloured images than monochrome ones, a fact recognised by most printsellers. As a consequence, Smith employed struggling young artists and other needy individuals to lay down delicate washes of transparent watercolour

Detail of fig. 23.

16 *Self-Portrait*, here dated to early 1789, oil on canvas, 20½ × 16½ (52 × 42), Indianapolis Museum of Art.

over the black and white engraved reproductions he made or handled. Naturally, a modicum of nerve and complete steadiness of hand proved integral to the process, lest the prints be spoiled.

One of Smith's employees between 1789 and 1792 was the young Turner, for whom such tasks held no terrors because of his considerable experience in colouring the engravings in Boswell's *England and Wales*. Turner and his fellow colourists were undoubtedly paid piecework rates. In Turner's case, the tinting process was greatly speeded by the fact that the images sold by Smith were engraved on separate sheets rather than being bound together, as in the Boswell tome. As a result, no waiting around for pigments to dry proved necessary, for several prints could be tinted very rapidly in succession by deploying a single colour across the relevant parts of those sheets before mixing the next hue to be employed in other locations within all the prints. Here was a technique that Turner would very soon be applying to his own creations, if he had not done so already. Shortly we shall discover where such ingenious economy of means would lead.

It was while working for Smith that Turner became friendly with another immensely talented young watercolourist, Thomas Girtin, who had also been born in 1775. The second son of a Southwark brush-maker, in the summer of 1789 Girtin would become apprenticed for seven years to the watercolourist Edward Dayes (1763–1804). However, before he took up that commitment he worked briefly for J. R. Smith. His friendship with Turner extended beyond the confines of Smith's shop, for the two of them painted together on the Thames. They may also have gone out fishing with Smith, who frequently took his apprentices and assistants on piscatorial expeditions.

The First Painting Lessons

During the winter of 1788–9 Turner began receiving some important technical instruction in oil painting. These lessons were furnished by the itinerant painter who coloured his father's barber's blocks, and they taught him 'to place a small piece of carmine in the centre of a cheek, and to lose it by degrees'.[5] The oil painting in which Turner attained this end was a self-portrait (fig. 16).[6] The itinerant's help goes a long way towards explaining why the work looks technically advanced for a 13-year-old, while the youth's inexperience as a portraitist explains why the person depicted does not much resemble the Turner we know from other portraits (and why the picture has therefore always puzzled students of his art).

Turner also carried over the gentle modulation of 'carmine in the centre of a cheek' into a contemporaneous watercolour (fig. 17). Here a kneeling girl proffers a spoon containing milk to a sick cat that is being cuddled by a young woman with very rosy – and therefore healthy – cheeks. She is surely the mother of the girl whose face remains hidden, and of the boy with equally rosy cheeks who is breaking up wood to feed the fire. Psychologically and biographically the image is extremely revealing, for its idealisation of a humble but apparently happy home containing a good-looking mother and her male and female offspring surely expressed Turner's yearning for a close and loving relationship with an attractive and doting mother, of the kind he had probably not known for a long time – if he had ever done so – and with a sister he might only have remembered with great sadness.

In 1798 or thereabouts, Turner would make an extremely large and detailed pencil line drawing of the service mounted in St Paul's Cathedral on St George's Day, 23 April 1789, to celebrate the recovery of King George III from a bout of apparent insanity that had lasted from the summer of 1788 until February 1789 (fig. 18). All but

17 *The Sick Cat: A Cottage Interior*, here dated to 1789, watercolour on paper, 9½ × 12⅝ (24.1 × 32), Turner Bequest XVII-L, Tate Britain, London.

one of the many people on view would be drawn with two dots for the eyes, a single dot for the nose, and another dot for the mouth. The exception is a young lad at the bottom-right who was drawn carefully in profile using a far more traditional and detailed method of representation (fig. 19). His long hair is gathered in a queue at the nape of the neck, and he greatly resembles the very young Turner as he is known to have looked from a self-portrait made in 1791 that will be discussed shortly (see fig. 47). Possibly Turner had put himself into the 1798 St Paul's Cathedral drawing because he had actually been present in that building on the very day he had celebrated his fourteenth birthday but had then lacked the ability to draw what was in front of him.

Because Turner received his 'first lessons in painting' at around the time he began working for J. R. Smith, he may also have made copies of oil paintings by George Morland in oils for the engraver and printseller.[7] Smith certainly had a financial interest in stimulating the production of Morland copies, for works by that painter were enormously popular and it was therefore easy to market copies at lower prices than originals, let alone palm off copies as originals. A link with Morland at this time would go a long way towards explaining why Turner's depiction of the sick cat is so Morlandesque, as is its subject.

Before long, Turner also devised a further way of making money, and of boosting his development in the process. This grew out of

19 *St Paul's with the King &c. &c. after his recovery 23 April* (detail of fig. 18).

his habit of spending hours lying on his back looking at the sky, and then of going home and painting what he had seen in watercolour. Subsequently he would sell these drawings to a stall in Soho, receiving 3s-6d for the large ones and 1s-6d for the small ones. As he would later boast, 'There's many a young lady has got MY sky to her drawing'.[8] The fact that he simply looked at the skies and then went *home* to paint them indicates how the reliance upon observation and memory proved vital to him from the start.

Turner also supplied landscape surroundings for architect's elevations of their proposed or completed buildings. One of those architects who avidly bought the young Turner's skies and landscape surrounds was William Porden (c.1755–1822). Apparently he offered to take on the lad as an apprentice architect without the payment of any premium because he was so delighted with Turner's skies and landscape backgrounds. However, his invitation was refused because the boy was entirely focused upon becoming a painter. When Turner would eventually terminate his professional relationship with Porden, he would furnish him with many drawings of skies for later use.

Turner also worked for Thomas Hardwick (1752–1829), an architect from Brentford and close friend of the Trimmers. It appears likely that during the spring or summer of 1789 Turner worked in Hardwick's office for several weeks, supplying skies and landscape surrounds for elevation drawings; indeed, he probably went on spasmodically servicing Hardwick's needs in this respect for some years to come. As well as being reasonably well paid for doing so, in the process he must have picked up a great deal of useful knowledge regarding the classical architectural orders and the basics of architectural form.

Hardwick made his appreciation of the lad's talent especially clear by commissioning him to make two watercolours of his latest project. This was the new church of St Mary the Virgin at Wanstead, northeast of London, built to replace the old one, which was falling down. In 1789 Turner elaborated a finished watercolour of the dilapidated building before it was demolished (fig. 20), and in the following year he complemented it with a representation of its successor. These works have long disappeared, but Thornbury, who saw the second of them, mentioned the side wall of the new church as being 'cleverly and truthfully illumined by a white reflection from the ground',[9] thereby again revealing that even at a very early age the painter was hugely alert to reflectivity.

By mid-1789 Turner had made up his mind to apply for entry to what was virtually the only full-time art training institution in Britain, the Royal Academy Schools. J. R. Smith and Thomas Hardwick supported his decision, as did others. Understandably, Smith knew many artists who had studied there, while Hardwick was a Schools graduate who may have been the first person to recommend that Turner apply for free training by the Royal Academy.

20 *St Mary the Virgin at Wanstead* (*Wanstead Old Church*), 1789, watercolour on paper, 11¾ × 43 (29.8 × 41.2), location unknown. Not in Wilton.

Facing page 18 *St Paul's with the King &c. &c. after his recovery 23 April*, c.1798, pencil on paper, 29½ × 24¾ (74.9 × 62.8), Turner Bequest XLIV-V, Tate Britain, London.

Application for entry to the Schools was a relatively complex and prolonged affair. Initially, Turner would have to make a drawing of a plaster cast of a classical sculpture, and do so away from the Royal Academy. If that effort subsequently satisfied the Keeper of the organisation, then upon the latter's recommendation to the Royal Academy Council or committee delegated to run the day-to-day affairs of the institution, the applicant would be allowed to spend a probationary term in the lower of the two Royal Academy Schools, the Academy of the Antique. Here he would have to make a drawing from a classical cast, and a further drawing of an anatomical cast placed next to a skeleton. This second work would have to be over twenty-four inches in height, and it would have to list all the bones, muscles, tendons and other parts of the body. Finally, both of these drawings would have to be approved by both the Keeper and by a Visitor or drawing instructor in the Academy of the Antique before being placed before the Council. If the assent of that committee was forthcoming, then a 'Letter of Admission as a Student in the Royal Academy' would finally be issued.

Turner's First Drawing-Master

The artist who helped Turner on a one-to-one basis with the essential task of learning to draw from a classical cast had to have been the history painter Mauritius Lowe (1746–1793).[10] Although Lowe had won the very first Gold Medal for Historical Painting awarded by the Royal Academy back in 1769, subsequently he had been an utter failure. By 1789 he was mired in poverty and squalor, with a large family to support. It is easy to perceive why William Turner employed him: the teaching of drawing from antique casts was right up Lowe's street, for the portrayal of the figure was central to his art. As a classicising artist he probably also enjoyed access to classical statues in the British Museum and elsewhere, while perhaps some beaten-up garden statues knocked around in his studio. And given his straightened circumstances he would have been very cheap, which undoubtedly would have appealed to Turner's father. Lowe was therefore taken on to teach the prodigy.

This period of tuition might have begun in late July 1789 when Turner had a couple of months free before needing to submit a suitable drawing to the Royal Academy on 29 September, the day the Academy of the Antique reopened after the summer vacation. During that period he elaborated a drawing of a Greek statue. The drawing is said to have been 'a foot long' and was shaded by means of stippling or the accumulation of a multitude of tiny dots and dashes.[11] Stipple engraving being one of the reproductive techniques most favoured by J. R. Smith, any use of stippling by Turner would undoubtedly have derived from the influence of his part-time employer.

Unwittingly, Lowe may also have imparted something else of long-term importance to Turner. If the lad called upon the poor man in his workplace – which seems likely – then he entered a space that was described by one visitor as a 'repository of all the nastiness and stench and filth' imaginable.[12] Such a visit or visits could easily have planted the very first seeds of the compassion for impoverished artists that would later cause Turner to direct significant amounts of energy towards helping far lesser talents than himself. Certainly he would never encounter a more poverty-stricken or depressing painter than Lowe.

'My Real Master'

By the summer of 1789 Turner was beginning to be seriously held back as a landscape and architectural draughtsman by his lack of perspectival skills. To help solve that problem, the services were enlisted of Thomas Malton the younger (c.1751–1804, fig. 21), an artist who specialised in depicting buildings in perfect perspective and whose rather stiff and prosaic but highly detailed designs were mainstays of the topographical engraving industry.

Probably Turner studied with Malton for two-and-a-half years, from about June 1789 until late 1791.[13] Such a long study period would have been necessitated by the complexities of the science, particularly under the tutelage of a stickler for accuracy like Malton. Yet it was vital to get things right, for after all, depictions of landscapes and buildings would have been fatally flawed if they were riddled with perspectival errors. But two-and-a-half years is not such a long period of study if, say, the tutorials took place on a weekly rather than a daily basis, let alone at even greater intervals. Necessarily, quite a number of the more complex perspective diagrams the pupil needed to make would have taken a long time to produce. Equally, it is possible that Turner was required to complete 'homework' by following up a good number of his perspective lessons with the drawing of actual buildings or sections of them, thereby putting theory into practice. This too could have taken a relatively long time, given the need to get all the perspectives correct. And then there is the fact that relatively long periods between lessons might well have been caused by Turner's many commitments during the June 1789 to December 1791 period.

Later in life Turner would state that 'my real master, you know, was Tom Malton of Long Acre.'[14] Clearly, he held his teacher in such high regard because the latter had helped him solve the only pictorial problem he had ever faced as a landscape painter, and equally because Malton had stressed the need to balance theory with the evidence of the eye, or even to accord precedence to the latter.

Such a prioritisation emerges from a passage in one of Turner's perspective lectures given in 1811 and repeated many times subse-

21 William Whiston Barney after Gabriel Stuart, *Portrait of Thomas Malton*, mezzotint, 1806, British Museum, London.

quently, in which he would recall being told by Malton that when the latter had once been drawing the west towers of Westminster Abbey, he had first represented all the vertical lines of those structures in parallel fashion, not realising that when lines rise spatially they converge, just like non-vertical lines when they recede perspectivally towards a horizon. Malton only overcame this difficulty by rejecting preconceived ideas and trusting to the truth of his perceptions. As Turner commented, Malton 'exulted in recommending whatever he saw in nature [as] Incontravertible'.

Malton's drawing of the façade of Westminster Abbey may well have been made prior to 1789. It therefore appears unlikely that he and Turner were together when the teacher learned his vital lesson. Yet because it was just as important to Malton to teach perspective by means of observation and drawing as it was to impart its theory, both he and his pupil did go out drawing together.

The evidence for this assertion resides in three images. The first of them is the watercolour of Old Palace Yard (fig. 22) that Malton made for mezzotint engraving in his 'Picturesque Tour through the Cities of London and Westminster' print series, where it would appear in 1793. Here we look in evening light towards Henry VII's Chapel at the eastern end of Westminster Abbey. In viewpoint the image is extremely similar to a depiction of much of the same scene at an identical time of day by Turner (fig. 23). Quite evidently, the teacher had stationed his pupil on the street corner he represented on the extreme right of his own image, both to keep an eye on the youth and to make it easier to compare notes on their treatments of essentially the same view. And further support for the claim that Malton could place Turner within his line of sight was provided by the teacher in another of his 'Picturesque Tour' images.

This is his depiction of the view along Whitehall towards Charing Cross, with Melbourne House on the left (fig. 24). Like the Westminster Abbey view, the original drawing may have been made years before it appeared as a print, and thus it could well have been created in the summer of 1789. At the lower-left of both drawing and engraving (fig. 25), a long-haired youth lies on the pavement in order to draw with a quill pen upon a large roll of paper resting on some boxes. He looks very like Turner, who wore his hair long during this early period of his life, as we shall again discover (having seen it once already in the early 1789 self-portrait, fig. 16).[15] And clearly Malton went to some trouble to stress the young man's nose. Given that such a proboscis was a pronounced feature of Turner's physiognomy, plus the fact that the person depicted is an unusually absorbed, dedicated and confident draughtsman, there can surely be no doubt that this is Turner in the first of many images of him at work that would be made surreptitiously over the course of his long career. Malton must have placed the youth just before him so as to be on hand if advice or technical help were required and, finding the need to introduce a figure at the lower-left of his own composition, he then depicted him there. Probably Turner was so engrossed in his work that he kept rather still, thus making it easy for Malton to represent him. It takes a great deal of self-absorption, concentration and self-confidence to draw while reclining on a pavement in front of strangers, but if it is Turner we see, then quite evidently at 14 he already possessed those traits in abundance.

It has long been recognised that one of the creative techniques Turner derived from Malton's teaching was the use of extremely low viewpoints. In Malton's image we see a boy drawing in just such a position. And if it is Turner who is represented, then doubtless Malton had instructed him to lie on the ground when drawing, for by placing himself there tall buildings and other structures would necessarily have towered over him. Such a technique would serve Turner well during the opening years of his career, for it would greatly aid his ambition to make buildings appear even grander than they could ever look in reality. Moreover, the procedure was extremely practical, for if you can lie on the ground and simply prop a piece of paper on a makeshift support, then there is no need to

Facing page top 22 Thomas Malton the younger, *Old Palace Yard, Westminster, looking towards Henry VII's Chapel, Westminster Abbey*, c.1790, watercolour on paper, 13 × 19 (32.9 × 48.1), British Museum, London.

Facing page bottom 23 *Westminster Abbey with Henry VII's Chapel*, c.1790, pen, ink and watercolour over pencil on paper, 12³⁄₁₆ × 17¾ (30.9 × 45), private collection. Not in Wilton.

Above 24 Thomas Malton the younger, *Melbourne House looking along Whitehall*, c.1789, watercolour on paper, 8½ × 12 (21.6 × 30.50), private collection.

Right 25 Thomas Malton the younger, *Melbourne House looking along Whitehall*, detail of the aquatint engraving, published 1797, National Art Library, Victoria and Albert Museum, London.

26 *St George's Church, Wrotham*, here dated to 1789, watercolour on paper, size and location unknown. Not in Wilton.

carry around a heavy drawing board when sketching. As we shall discover, the placing of paper upon improvised supports such as work boxes or portfolios would also stand Turner in good stead.

Turner's representation of Westminster Abbey with Henry VII's Chapel in evening light (see fig. 23) was drawn in ink and watercolour over pencil. As a result, a quill pen would necessarily have been employed for the work, for metal pen nibs would not appear on the market until about forty years later. Clearly a quill pen was part of Turner's toolbox when he studied under Malton. And a quill pen is precisely what is being used by the reclining youth in Malton's view along Whitehall, just up the road from Westminster Abbey. If it is Turner we see there, then his 'real master' did not invent that detail. But in either event, Turner's view of Westminster Abbey furnishes evidence of his enormous self-confidence when young, for drawing with pen and ink leaves virtually no room for error.

Because the Westminster Abbey with Henry VII's Chapel drawing was never completed, we can perceive that although the perspectives within its left half are fairly free of faults, often they are extremely incorrect across parts of both the Palace of Westminster on the right and the Ship pub that stands before it. These defects make it apparent that Malton's teaching of perspective had not yet been fully assimilated when Turner elaborated the work, and that it must therefore date from not long after the beginning of their relationship. It is thus extremely likely that the drawing was created in the summer of 1789, a season borne out by the foliage represented. The people at the lower-right already enjoy something of the characterfulness of Turner's later figures.

The Revd Robert Nixon (1759–1837) was the curate of All Saints' Church in Foots Cray, near Sidcup in Kent. As an amateur watercolourist who would exhibit at the Royal Academy after 1790, he was an admirer of the young Turner's talent, which he may initially have come across in the Maiden Lane barber's shop. The lad appears to have visited Foots Cray this summer, and from there ventured on to Margate. As a result of this trip, some important finished watercolours of Kent subjects were created in 1789. One was a view of St George's Church, Wrotham (fig. 26) in which the influence of Malton upon Turner's command of perspective can be discerned in the depiction of the church tower, although the perspectives of the house immediately before it are rather out of kilter, and especially the window above its doorway. Another such work is a representation of East Malling Abbey, Kent (fig. 27). Here the tonal attention that the 14-year-old accorded to the many bricks and slabs of masonry spread across the foreground is particularly noteworthy. In total, eight tones of four colours were used throughout the drawing. The hues employed for the abbey are particularly delicate. Clearly, Turner had seen brilliant light being reflected off the building's façade, and his depiction of it prefigures the dazzle that makes large numbers of his later works appear almost blinding. Once again, Turner's ends can be detected in his beginnings, for almost at the very outset of his career he already possessed a vision of things shining.

The *Distant View of Oxford from the Abingdon Road* (fig. 28) may have emanated from a visit to see Mary Turner in Sunningwell in the late spring or early summer of 1789. Here the faraway buildings are perspectively convincing and they sit well amid their surroundings. In a distant view of Oxford from the south (fig. 29) a stand of trees almost fills the foreground, while shallow diagonals that meet just beyond and to the left of the wood lead the eye into the distance. An approaching shepherd and his flock animate the scene while simultaneously imparting a necessary sense of scale. And possibly a

27 *East Malling Abbey, Kent*, here dated to 1789, watercolour on paper, 8½ × 10¼ (21.5 × 26), private collection. Not in Wilton.

return trip to Sunningwell in October 1789 may have led to a number of complex watercolours, including two views of Radley Hall (figs 30 and 31). In both works the emphatically perspectival representation of the architecture remains weak. Much later we shall again encounter paired depictions of the same place from opposed viewpoints, as here. For future reference it is worth noting that all the window panes in both drawings of Radley Hall were simply painted black. And because the cathedral tower and spire, and the wall, fencing and road in a depiction of Christ Church, Oxford, from Merton Fields (fig. 32), do not quite cohere perspectively, it seems likely that this was another of the works created before the teaching of Malton became fully effective. The pictorial border with its somewhat self-conscious identificatory title surely harkens back to the borders and titles that Turner had encountered in Boswell's *England and Wales* prints.

In and around London Turner also gained the material from which to develop watercolours in 1789. In a view of *Lambeth Palace* (fig. 33) we can determine the degree to which he laboured hard over his perspective exercises under Malton and made fairly rapid

Facing page top 28 *Distant View of Oxford from the Abingdon Road*, signed and dated 1789, watercolour on paper, 9¾ × 17 (24.7 × 43.1), Turner Bequest III-A, Tate Britain, London.

Facing page bottom 29 *Distant View of Oxford from the south*, here dated to 1789, pencil, pen, ink and watercolour on paper, 7⅗ × 9⅕ (19.5 × 25), private collection. Not in Wilton.

This page top 30 *Radley Hall, Oxfordshire from the north-west*, 1789, watercolour on paper, 13½ × 17½ (34.2 × 44.4), Turner Bequest, III-C, Tate Britain, London.

This page bottom 31 *Radley Hall, Oxfordshire from the south-east*, signed, 1789, watercolour on paper, 11¾ × 17¼ (29.8 × 43.8), Turner Bequest II-D, Tate Britain, London.

32 *Christ Church, Oxford, from Merton Fields*, here dated to 1789, pen, ink and watercolour on paper, 10⁷⁄₁₀ × 13 (27.2 × 33.2), Turner Bequest VIII-A, Tate Britain, London.

progress. The drawing directly prefigures the first work that Turner would exhibit at the Royal Academy, a 1790 representation of the same building from exactly the same viewpoint (see fig. 40). In both images the buildings to the right of centre demonstrate a markedly Maltonian perspective.

The principal subject of *All Saints' Church, Isleworth* (fig. 34) was also treated in a strict, Maltonian perspective, as was its river wall. With the latter structure we once again encounter Turner's genius peeping forth, for instead of carrying the wall completely over to the right as he had done in the original pencil study from which he developed the image,[16] he made the sweeping sails of a Thames barge cut completely across it, thereby offsetting any symmetry in the image. The diagonal lines of the spars that support the sails parallel and amplify the smaller diagonals of the topsails and rigging of the lesser barges. As a consequence, they strongly reinforce the pictorial architecture. This small tour de force by a boy of 14 presents us with a vivid foretaste of things to come from one of the finest masters of pictorial composition in all painting. Despite its architectural subject, the work is Turner's earliest surviving nautical image.

The Final Hurdle

In addition to being able to draw a plaster cast adequately, Turner had another requirement to fulfil before he could enter the Royal Academy Schools: according to the regulations, he needed to obtain a 'testimony of his moral character from an Academician or other person of respectability'. Reading between the lines, the 'other person of respectability' was not expected to be any ordinary respectable person but an artist of some repute. However, this rule presented a problem. William Turner's clientele included several artists and architects but none of them were Academicians or outstanding figures in the visual arts. So who could be approached?

Fortunately the Revd Nixon was able to overcome this difficulty. He was friendly with the Royal Academician John Francis Rigaud (1742–1810), and so he took Turner to see him. Rigaud was impressed by such natural talent. And with his endorsement, Turner finally possessed all he needed.[17] Consequently, at the beginning of the Royal Academy winter term, on 29 September 1789 or very shortly afterwards, the extremely focused youth placed before the Keeper of the Royal Academy, Agostino Carlini RA (1718?–1790), the plaster cast drawing he had made under the supervision of Mauritius Lowe that summer. Carlini's assent and that of the Council being forthcoming, Turner was admitted as a probationary student to the Academy of the Antique, in order to make the two further drawings that proved vital if he was to enter the Schools.

If Thornbury can be believed, the classical cast that Turner then drew derived from a Greek statue.[18] Around the same time he also elaborated his necessary drawing of an anatomical figure placed next to a skeleton. Probably it took another couple of months to complete the two additional works. And towards the end of the autumn term the Keeper and the then-current Academy of the Antique Visitor – who providentially happened to be J. F. Rigaud – approved Turner's drawings. Accordingly, on 11 December 1789, these works were among the submissions by six candidate students that were placed by Carlini before the Council, which was presided over by Sir Joshua Reynolds in his capacity as PRA. Collective approval being forthcoming, Turner was officially authorised to enter the institution as a regular student. The fourteen-and-a-half-year-old had thus achieved the first part of his grand strategy, for he had not simply chosen an art school; probably because of information gained from artists among his father's clientele, he was aware that he had obtained entry to what could prove to be a lifelong career path.

33 *Lambeth Palace*, 1789, watercolour on paper, size and location unknown. Not in Wilton.

34 *All Saints' Church, Isleworth*, 1789, watercolour on paper, size and location unknown. Not in Wilton.

3

In Sir Joshua's House

1789 to 1792

In Turner's era the Royal Academy of Arts in London stood at the very heart of British culture in a way that no organisation dedicated to creativity within the visual arts could ever match today. If you succeeded within it you could flourish on the national stage by gaining state honours, important patronage and press coverage. Artists therefore had every incentive to gravitate towards the body. And it certainly proved central to the life and art of J. M. W. Turner, for it helped train him, defined his aesthetic goals, furnished his most stimulating intellectual environment, functioned as his premier exhibiting and teaching space, determined the scale of many of his most important oil paintings and afforded him a platform on which to speak. In the process it elevated his social status, gradually softened his cockney accent and rough edges, provided him with a substitute home life and, not least of all, helped make him exceedingly wealthy.

The Royal Academy had come into existence in 1768 with two related goals in mind: to mount an annual exhibition of contemporary art and to train new generations of fine artists and architects. Until 1816 its Schools would only offer tuition in drawing from sculptures and plaster casts in its Academy of the Antique (fig. 35), and then, when a sufficient level of proficiency had been attained, from the life in its Academy of Living Models. Turner would therefore be forced to learn his craft as a painter beyond the institution, although undoubtedly he and his fellow students often gleaned painting tips from the Schools Visitors. The ultimate ambition of most of the non-architectural students was to forge a reputation in the Royal Academy Exhibitions, which had been mounted every spring since 1769 (fig. 36).

When the 14-year-old entered the Schools in 1789 the statutory period of study was six years, a span that would be increased to seven years in 1792. If Turner had strictly limited himself to the latter period, then he would have completed his formal studies by December 1796; in fact he would go on working sporadically in the life room for three years after that. Initially he drew periodically in the Academy of the Antique from either the end of 1789 or the beginning of 1790 until the end of 1793. His final attendances there would overlap with time spent in the Academy of Living Models from June 1792 until October 1799 (and therefore only a couple of weeks before he would be elected an Associate Royal Academician in November 1799).

What did Turner draw in the Academy of the Antique? Among the many casts on display were the *Dying Gaul*, which he would draw several times; the *Meleager*, which he would draw full-length with its dog and boar around 1790 and without its animals around 1792; the *Standing Discobolus*, which would be drawn by him both in its entirety and in part around 1791; the *Belvedere Antinoüs*, which he would draw around 1792 (fig. 37); the *Borghese Gladiator* or 'Fighting Gladiator', which he would draw in outline around 1790, as a modelled full-length around 1791 and on a large scale around 1792;

Detail of fig. 45.

Facing page top 35 E. F. Burney, *The Antique School at Somerset House*, c.1780, pen, ink and watercolour on paper, 13¼ × 19 (33.5 × 48.5), Royal Academy of Arts, London.

Facing page bottom 36 Pierre Antoine Martini after Johann Heinrich Ramberg, *The Exhibition of the Royal Academy, 1787*, hand-coloured engraving and etching, British Museum, London.

Above left 37 The *'Belvedere Antinoüs'*, c.1791, black and white chalk on brown paper, 15½ × 8¼ (39.3 × 20.9), Turner Bequest V-L, Tate Britain, London.

Above right 38 The *'Apollo Belvedere'*, c.1790, chalk on grey paper, 18½ × 11¾ (46.9 × 26), Turner Bequest V-C, Tate Britain, London.

and the *Apollo Belvedere*. He would make two drawings of this around 1790, a full-length version at that time (fig. 38), and a very fine study of the upper torso and head around 1793 (fig. 39). The *Venus de' Medici* would be drawn by him twice, initially around 1791 and then perhaps again during the following year, while the *Bacchus* of 1511–18 by Jacopo Sansovino (1486–1570) would also be drawn by him around 1790 and possibly once more in the following year.

Given Turner's aspirations to be a landscape and marine painter, it is perhaps understandable that relatively few of the dozens of drawings he must have made in both of the Royal Academy Schools have survived. He probably destroyed large numbers of them because he regarded them simply as a means to an end, rather than as ends

39 *Torso and Head of the 'Apollo Belvedere'*, c.1793, chalk and stump on brown paper, 16½ × 10¼ (41.9 × 26), Turner Bequest V-D, Tate Britain, London.

The 1790 Royal Academy Exhibition
TUESDAY 27 APRIL TO THURSDAY 8 JULY

The Royal Academy of Arts in London formed the principal exhibition space for Turner throughout his lifetime. That is why his entries to its annual shows will be accorded great prominence in these pages.

The only work Turner had accepted in 1790 – and quite possibly his only submission that year – was *View of the Archbishop's Palace, Lambeth* (fig. 40). It was hung within the ground-floor Exhibition Room of Sculptures and Drawings, which at other times served as the Academy of Living Models. In many ways it improved upon the representation of the same subject made not long before (see fig. 33), for now the area depicted is like a stage set that has been filled with actors. Both designs demonstrate Turner's desire to show off his perspectival skills, for because the buildings represented were not aligned at right angles to one another, their perspectives were unusually difficult. And in the second version the artist also demonstrated how much his figures owed to Malton. This is especially true of the dandy and his young lady who immediately engage our attention due to their proximity. Stylistically, the couple are extremely similar to the fashionable types who are often to be seen admiring their architectural surroundings in Malton's images. Yet in many respects Turner went far beyond his teacher. Thus he cleverly aligned a good number of his figures – who quite naturally differ in height – along an axis that pulls the eye towards Westminster Bridge in the far distance on the left. He also subtly reinforced that line by means of the evening shadows that fall diagonally across the scene from the left. Turner was surely upstaging his teacher by means of a parade of people in perfect perspective, for Malton's figures may occasionally project a little animation but usually they are distributed far more randomly and to much weaker pictorial effect.

Turner's 1790 Royal Academy exhibit received no mention in the press. However, its qualities might have sparked the architect-turned-portraitist, George Dance the younger RA (1741–1825), to elaborate a small representation of the 15-year-old at this time (fig. 41).[1] If that was the case, then clearly Dance possessed the ability to recognise exceptional talent.

in themselves. Drawing from both casts and live models deepens the comprehension of form, quickens the relationship between eye and hand, and helps find inventive ways of representing things. Turner can have had little or no use for the end products – it was what had passed through them into his mind and hand that counted. However, some of the surviving drawings are very accomplished, even if difficulties with proportion are occasionally evident, especially in the feet (see figs 112 and 113).

Learning from Reynolds

On 10 December 1790 Sir Joshua Reynolds (fig. 42) celebrated the twenty-second birthday of the Royal Academy by delivering his fifteenth and final discourse to a large assembly of Academicians, Associates, Schools students and members of the public gathered in the Great Room on the top floor of Somerset House, the largest and most prestigious space within the Royal Academy (which

doubled as its Lecture Room). His talk was on Michelangelo (1475–1564), and there is strong evidence to suggest that Turner was present to hear it.[2] It marked not only the aesthetic and educational climax of the 1790 academic year within the institution but also the intellectual highpoint of his entire career as a student.

Turner's admiration for Reynolds would increase in time but it already existed when he was a student, as he would one day make evident by asserting that studies under the master had constituted 'the Halcyon perhaps of my days'.[3] He could have read the previous

Above 40 *View of the Archbishop's Palace, Lambeth*, R.A. 1790 (644), watercolour on paper, 10⅓ × 14⅖ (26.3 × 37.8), Indianapolis Museum of Art.

Right 41 George Dance the younger RA, *Portrait of Joseph Mallord William Turner as a Boy*, 1790?, date, medium, size and location unknown.

42 George Clint after Sir Joshua Reynolds, *Self-portrait of Sir Joshua Reynolds*, mezzotint, 1800–30, British Museum, London.

fourteen talks prior to 10 December 1790.[4] As the Royal Academy took it for granted that aspiring artists would learn their craft beyond its walls, so it expected that the theories promulgated within them would be explored by the Schools students as a matter of course. From the start Turner therefore had to educate himself in the historical and aesthetic dimensions of his art as fully as he did its craft. A central aid to doing so was a reading of Reynolds's *Discourses*, for the talks had been elaborated for that very purpose – indeed, in printed form they collectively constituted the official Royal Academy educational, art-historical and theoretical handbook.

The reason to believe that Turner read the *Discourses* very early in the 1790s is that his works began to reflect what they had to say from that time onwards. Throughout his talks Reynolds promulgated a group of interrelated ideas concerning the visual arts, at the core of which lay the notion of ideal beauty. In the lecture that appears to have been attended by Turner, Reynolds termed this beauty 'the greater truth', by which he meant an ultimately Platonic concept of beauty that exists far above everyday reality. Reynolds saw it as the duty of the artist to somehow imagine such a beauty and express it by means of what he termed the 'great style', which he regarded as being exemplified by those many works by Michelangelo, Raphael (1483–1520), Parmigianino (1503–1540) and other artists who had imbued their offerings with a sense of grandeur. Throughout the *Discourses* Reynolds promulgated the notion of grandeur, and in this respect Turner soon began to follow him pictorially, as can be witnessed in his tendency from the early 1790s onwards to aggrandise scale by means of exaggerations of size, perspectival distortion and the frequent adoptions of low viewpoints he had anyway been encouraged to use by Thomas Malton. Over time, Reynolds's idealism would have a profound effect upon him in many other ways too, as will gradually emerge in these pages. By the end of his life he would have fulfilled almost all of Reynolds's ambitions for painting as an idealising art, albeit in ways that the great pedagogue could never have imagined.

The 1791 Royal Academy Exhibition
FRIDAY 29 APRIL TO SATURDAY 11 JUNE

The Academy of the Antique reconvened after the Christmas break on 6 January 1791. The surviving attendance records suggest that Turner was highly studious throughout that winter. And during that time he also created two watercolours for London's premier art display. Like his submission the previous year, they were both hung in the ground-floor Exhibition Room of Sculptures and Drawings. One of them was a view of a house near Uxbridge, and the other is reproduced here.

Judging by the convincing perspectives of *King John's Palace, Eltham* (fig. 43), the studies with Malton were really paying off by now. In early morning light the Great Hall towers over us, and its sense of verticality is heightened by a perspectival illusion, wherein a large tree that is actually quite a few feet lower than the building appears to be higher. In overall terms the image projects grandeur, and it was probably the very first of Turner's works to do so. Clearly he had taken on board Reynolds's pronouncements on the subject the previous December.

Two outstanding watercolours suggest that Turner may have visited east Kent in 1791; if so, he probably did so in June. Initially *Dent de Lion, Margate* (fig. 44) may have been drawn on the spot and coloured later, either in Margate or London. Once more we witness the young artist's growing understanding of perspective, for the many horizontal courses and other lines of the fifteenth-century gatehouse and the adjacent barns run downwards into the distance in perfect recession. Still in evidence are the extremely convoluted tree forms that are such

43 *King John's Palace, Eltham*, R.A. 1791 (494), watercolour on paper, 14 × 10½ (35.6 × 26.7), private collection.

44 *Dent de Lion, Margate*, here dated to 1791, pen, ink and watercolour on paper, 10¹⁄₁₀ × 16⅗ (25.7 × 34.6), Yale Center for British Art, Paul Mellon Collection.

a pronounced feature of images created between mid-1789 and mid-1792. The horse and rider establish a sense of scale, while the dogs that will become a marked feature of many drawings made in the 1791–3 period subtly animate the scene. And *The Dover Mail* (fig. 45) may also have been initially drawn in east Kent in the midsummer of 1791 and coloured later. Although the work was reattributed to Girtin in 2008, there were no solid grounds for doing so, and there are many reasons for continuing to believe it is by Turner, particularly the over-riding human dimension to the image.[5] Such an emphasis upon people is not to be encountered anywhere in Girtin's art. On the other hand, even by 1789 it had already entered Turner's art in *The Sick Cat: A Cottage Interior* (see fig. 17).

The rumbustiousness of the sailors and the placing of amusing figures within a fairly elaborate topographical setting in *The Dover Mail* is reminiscent of Thomas Rowlandson (1756–1827). By 1791 a strong indirect link existed between Turner and Rowlandson. This was Thomas Malton, who by the time of his death in 1804 would have collected 140 Rowlandson drawings and prints, as well as a book of the satirist's etchings.[6] Moreover, in 1791 – and thus at the very time Turner was deeply immersed in his perspective studies

45 *The Dover Mail*, c.1791, watercolour with pen, brown ink and rubbing out on paper, 14¾ × 19¼ (37.5 × 49), private collection. Not in Wilton.

with him – Malton was hard at work as an aquatint engraver reproducing several Rowlandson designs. If Turner had viewed those drawings and prints as well as a number of other Rowlandsons when studying with Malton, then it is wholly unsurprising that the satirist's influence should have made itself felt in *The Dover Mail*.

It is very likely that Turner worked intermittently in the Academy of the Antique over the spring and summer of 1791, supplementing those studies with further drawing under Malton's guidance, and with the usual copying, transcription and tinting work. And during that summer he also probably produced another oil painting, *Watermill and Stream* (fig. 46), the tree-forms of which are stylistically typical of 1791. Although it is not a particularly inventive work, it does contain some fine passages, especially the upper clouds, with their subtle sunset colours. During this period the lad could prove quite artful when encountering difficulties, as can be detected on the left where he placed a grey cloud behind the tree in order to save having to gradate the blue of the sky between its branches.

46 *Watermill and Stream*, here dated to 1791, oil on paper, 9¾ × 11¹³⁄₁₆ (24.7 × 29.7), Turner Bequest XXXIII-a, Tate Britain, London.

47 Leicester Fields

During the spring to summer months of 1791 Turner explored a completely different type of imagery as well, for he was able to work in a disused gallery that formed part of Sir Joshua Reynolds's residence and studio complex at 47 Leicester Fields. This was one of a row of late seventeenth-century houses that stood on the western side of what would be renamed Leicester Square in 1874.

Sir Joshua had long made a habit of opening his studios to the Schools students early in the morning and offering critiques of their works before commencing work for the day. But he can hardly have done so when Turner worked on his premises, for on 13 July 1789 he had been forced to abandon painting almost completely due to the onset of an ocular condition that led him to lose the sight of his left eye less than ten weeks later. As a result, he quit his studio for the rest of 1789 and only occasionally pottered about there in 1790 and 1791 before dying early in 1792. Reynolds was too depressed in 1790 to have been able to cope with students, and the need to leave his house and studio complex largely unheated and unlit during the winter of 1790–91 obviates the possibility that it could have been opened to outsiders during that period either. That is why we can safely deduce that Turner worked there during the spring to summer months of 1791. One day he would attest that he had copied 'many of [Reynolds's] pictures when he was a student'.[7]

That places him in the Royal Academy Schools at the time, and thereby explains how and why he obtained entry to Reynolds's studio. But if Reynolds was ever around when Turner visited, he could only have given the youth general encouragement.

There are no known early Turner copies of Reynolds's portraits. It is anyway impossible that in 1791 the art student could have copied Reynolds's full-length or half-length portraits size-for-size, for he lacked the technical skills to do so. Such paintings would also have required substantial wherewithal, for canvas, stretchers and paints were expensive. The copies to which Turner referred must therefore have been small oils or, more likely, drawings on paper made in pencil, ink or watercolour. Probably all of Turner's copies were eventually destroyed by the artist himself, for there can never have been any commercial demand for them even if he had been willing to part with them, which is highly unlikely.

Bristol and the Avon Gorge, 1791

At the beginning of September, when the antique academy broke for vacation, Turner travelled down to Bristol, probably stopping off en route at Malmesbury in Wiltshire to sketch its ruined abbey, and in Bath to draw its abbey church. His host in Bristol was John Narraway (1744–1822), who was involved in the glove-making, skinning, leather, sheepskin and animal-extracts trades in the city. Narraway and William Turner were old friends from their early days in north Devon. At least eleven Turner works would be acquired by Narraway in a relatively short period during the early 1790s. Foremost among them was the 1790 *View of the Archbishop's Palace, Lambeth* (see fig. 40). Probably Turner gave it to Narraway at the behest of his father.

The Narraways treated Turner as a member of the family. However, according to John Narraway's niece, Ann Dart, the visitor was antisocial, uncommunicative and difficult to understand when he did speak; probably his cockney accent did not help. Although constantly good humoured, he was only really interested in drawing.[8] Often this preoccupation took him out sketching prior to breakfast and after dinner, or even prevented him from returning for meals at all. The further claim by Ann Dart that Turner had 'no faculty for friendship' would one day be disproven by Narraway's daughter, for the painter would give or lend her money.[9] But although Narraway 'thought Turner somewhat mean and ungrateful', that was hardly a valid complaint if he did receive the *Archbishop's Palace, Lambeth* for nothing. Moreover, Ann Dart contradicted herself in this respect as well, for she stated that Turner 'would do anything my uncle or cousins would ask him in the way of taking sketches in the neighbourhood', and that 'he gave us many of these drawings which we have since given

40

a cave with just such an unusual sight and youths clambering up the gorge demonstrates (fig. 48).

Further pictorial growth resulted from the 1791 trip. In *Hot Wells, from St. Vincent's Rock, Bristol* (fig. 49) sailors tie up a beached vessel. A pipe-smoking seaman points towards the distance, as if to draw attention to the breeze, which has completely filled out the sails of a boat in midstream. Sharply outlined and highly curved tree-forms augment our sense of space and scale, while subtly investing the scene with energy.

Turner sits on the ground drawing in *Stoke House, Bristol* (fig. 50). He is accompanied by John Narraway's son. The nearest of the two onlookers is reputedly the son of the baronet who then owned the property. Clearly, Turner was intent upon showing off his increased command of perspective here, for the building is accurate in recessional terms, even if its upper reaches are greatly increased in angularity. Such distorted perspectives make it tower over us, as can be seen especially clearly in the nearest chimney stack.

In *Bath Abbey from the north-east* (fig. 51) Turner failed to make the sedan chair and its carriers the correct size, for like the dog they are too large in relation to the walking couple. Moreover, the triangular bay windows beyond the sedan chair do not cast convincing shadows, and consequently they seem spatially incorrect. Across the abbey, however, almost all of the perspectival lines are convincing,

47 *Self-Portrait*, 1791, watercolour on paper, 3¾ × 2¾ (9.5 × 7), National Portrait Gallery, London.

48 *The Mouth of the Avon, near Bristol, seen from cliffs below Clifton*, 1791, pencil and watercolour heightened with white on paper, 8⅝ × 11¼ (22 × 28.5), Bristol Museum and Art Gallery. Not in Wilton.

away'. And prompted by his host, Turner also made him a miniature self-portrait (fig. 47), although initially he harboured reservations about doing so, declaring that 'it is no use taking such a little figure as mine, it will do my drawings an injury, people will say such a little fellow as this can never draw'.[10] Even at the age of 16, Turner was well aware of the gap that existed between his outer guise and his inner powers. That dichotomy would grow, and eventually become the overriding mystery of his life for many of his admirers.

Turner loved the Avon Gorge, which then lay beyond the boundaries of Bristol. Such an attraction is unsurprising, for it brought together charcterful buildings, seagoing shipping on a working river, and natural scenery of a scale, rockiness and romantic semi-wildness he had never before encountered. His clamberings all over the defile led the Narraways to dub him 'The Prince of the Rocks'.[11] Moreover, the gorge frequently presented the spectacle of ship's masts and sails appearing from behind the hillsides far below. Turner would always be highly receptive to unfamiliar views of things and that responsiveness was already alive in him in 1791, as a view from inside

49 *Hot Wells, from St Vincent's Rock, Bristol*, 1791, pen, ink and watercolour on paper, 14⅛ × 16⅛ (35.9 × 41), Bristol Museum and Art Gallery.

50 *Stoke House, Bristol*, signed, 1791, watercolour on paper, 11⅗ × 16¼ (29.9 × 41.2), private collection.

51 *Bath Abbey from the north-east*, 1791, watercolour on paper, 12 × 10 (30.4 × 25.4), Turner Bequest VII-F, Tate Britain, London.

52 *Bristol Cathedral from the north-west*, 1791, watercolour on paper, 13⅜ × 12¼ ins (34 × 31.2), Turner Bequest VII-A, Tate Britain, London.

53 *Malmesbury Abbey*, 1791, pen, ink and watercolour on paper, 7½ × 10⅓ ins (19.1 × 26.2), Bacon Collection.

even if the diagonals towards the top of the tower slant in an increasingly exaggerated way as the eye ascends. Obviously they do so in order to make the building rise up dramatically. Once again Turner was aiming to project a sense of grandeur.

The top of the tower in *Bristol Cathedral from the north-west* (fig. 52) is impossibly slanted, for if its upper lines are carried downwards to intersect with the other perspectival lines below, all of them would meet far above our eye level, in contravention to correct perspective. And in *Malmesbury Abbey* (fig. 53) the foreground tree acts as a highly effective framing device that invests the image with enormous dynamism by means of its swirling rhythms and exaggerated branchings. No less fine is the tonal gradation from foreground to background. All of the dark tones were placed across the foreground, the mid-tones in the centre-distance, and the delicate tones in the background. As a consequence, the landscape enjoys a marked sense of spatial recession, with the distant abbey looking very ethereal in the evening light. From the outset of his career, Turner possessed the ability to create both energy in his foregrounds and airiness in his backgrounds.

Turner kept himself fairly occupied in the Academy of the Antique throughout the autumn. And not long into the New Year an unusual disaster presented him with an exciting challenge, for on the night of Saturday 14 January 1792 the Pantheon Opera House in Oxford Street burned down, having been torched by arsonists.[12] Turner visited the ruins the very next morning and on a subsequent day in order to draw them; from one of those studies[13] he elaborated a complex watercolour showing the ruins immediately after the fire (see fig. 56).

On 23 February 1792 Sir Joshua Reynolds died. Given Turner's known regard for the late President, it hardly seems likely that he did not pay his respects when the coffin rested in state within Somerset House on the night of Friday 2 March. The funeral in St Paul's Cathedral the next day was a huge affair, and it must have brought home to Turner the national honour that could accrue to a great painter and teacher, thereby arousing or renewing his ambition to be both. Little could he have suspected that some fifty-nine years later he would be buried virtually next to Sir Joshua in the crypt of the same cathedral.

It was perhaps during the late winter of 1792 that Turner became acquainted with John Soane (1753–1837, fig. 54). The architect had himself studied in the Royal Academy Schools, from which he had graduated as a Gold Medallist in 1776. A 29 March 1792 reference in one of Soane's notebooks to 'Turner/Portland draw[in]g' might refer to a work by the budding painter.[14] Soane derived from very humble origins, for his father had been a bricklayer, and he was therefore well able to understand any social unease felt within the frequently snobbish and stuffy atmosphere of the Royal Academy.

54 George Dance, *Portrait of John Soane*, 1795, pencil on paper, 14⅛ × 12¼ (36 × 31), Sir John Soane's Museum, London.

If he did take Turner under his wing, he would probably have boosted the painter's self-confidence. With his innate responsiveness to architecture, Turner would undoubtedly have been drawn to him.

The 1792 Royal Academy Exhibition
FRIDAY 27 APRIL TO SATURDAY 9 JUNE

This year there was a major innovation, for the first-floor Library and the adjacent Academy of the Antique – under the name of the 'Antique Room' – had been converted into display areas for the duration, thereby significantly boosting the overall amount of hanging space. Both of Turner's submissions were placed in the second of these. It is a mark of the degree to which appreciation of his talents was growing that they were hung in a room that necessarily attracted much public attention.

In *Malmsbury Abbey* (fig. 55) Turner made the ruin loom over us by extending its highest reaches beyond the boundaries of the image. The vegetation springing from those remains imparts a marked sense of neglect. And by including pigs, a man carrying their swill and an overturned wheelbarrow, Turner the 17-year-old moralist pointed up the coarse modern usage of a structure that had once been sanctified and sublime.

The architectural influence of Malton is particularly apparent in *The Pantheon, the morning after the fire* (fig. 56); for the buildings recede in perfect perspective. Far beyond Malton's observational skills, however, are the wall stainings, the surface irregularity of those walls and the way that light is unevenly reflected within the areas of shadow. The low January temperature is made clear by the numerous icicles formed from water sprayed throughout the night. No less minutely observed are the firemen emptying their buckets, the army officer with his two fashionable companions discussing the fire, and the distinctly unstylish onlookers. Among the last are several children, one of whom pulls up his jacket because of the cold. The icy, blue-grey colour of the ruined building advances the sense of cold, and that frostiness is further intensified by the contrasting warm colours of the surrounding brickwork, as well as by the still warmer pinks and reds created by the sunlight. The overall emphasis upon the staffage further demonstrates Turner's resolve to bring humanity to the forefront of his art.

A drawing by Thomas Sandby RA (1721–1798) affords us an idea of how the Antique Room display was arranged in 1792 (fig. 57). Turner's Malmesbury watercolour is visible in the third vertical row of images from the leftmost end of the screen on the right. The name 'W Turner' is scrawled across it and it hung immediately under the line, a divide that ran around each of the rooms within the Royal Academy at the height of the tops of the doorways, in order to impose visual cohesion on all the exhibits.[15] The Pantheon watercolour is apparent on the extreme right in the penultimate position at the bottom of the same screen, again with Turner's name written across it. Perhaps because the many figures in *The Pantheon, the morning after the fire* are stylistically unconventional or the Academicians who hung the show regarded them as inept, it was almost placed on the floor. Maybe that is why it never sold and remains in the Turner Bequest. However, the members of the hanging committee clearly did think highly of the young artist's other 1792 submission, for they placed it in an extremely well-lit location just a little above eye level. Their positivity is unsurprising, for although it is not widely known today, undoubtedly *Malmsbury Abbey* was the first work to establish that Turner was an extraordinary new talent within the Royal Academy, and thus within British art more generally.

Facing page 55 *Malmsbury Abbey*, signed, R.A. 1792 (436), watercolour on paper, 21½ × 15¼ (54.6 × 38.7), Norwich Castle Museum and Art Gallery.

Right 56 *The Pantheon, the morning after the fire*, R.A. 1792 (472), watercolour on paper, 15½ × 20¼ (39.5 × 51.5), Turner Bequest IX-A, Tate Britain, London.

Below 57 Thomas Sandby RA, *The Antique Room Display in the 1792 Royal Academy Exhibition*, 1792, pencil on tracing paper, laid down, 9⅘ × 17½ (25 × 44.4), Royal Academy of Arts, London.

4

Six Advantages and a Demand

1792 to 1793

The Thomas Sandby drawing of the 1792 Antique Room hang also affords us evidence concerning Turner's creative development. This is because it reveals that just one horizontal row down and one vertical row across from the *Malmsbury Abbey* hung a watercolour that exercised a seminal influence upon Turner as a tonalist, and therefore ultimately as a colourist. This was *Battle Abbey-gate, Sussex*, by Michael Angelo Rooker ARA (fig. 58).

Rooker made a speciality of painting bricks or slabs of masonry in a variety of colours and a multitude of tones from light to dark, as *Battle Abbey-gate* amply demonstrates. Thus there are no fewer than eighteen separate yellow-grey and red-grey tones discernible within the sunlit area of the façade alone. To add to this profusion, Rooker also depicted the shadows cast on the building by some trees, thereby introducing seven additional dark tones (three of which were also used to add deeper shadings to various points within the sunlit area). In the foreground are three tones of green, one of which does double duty by complementing a darker tone used in the distance on the left. In areas of the sky and the abbey façade the pale yellowish tint with which the entire sheet had been underpainted was permitted to show through, while other parts of the sky were overpainted with two blues and three greys. For the figures and dogs, ten tones of four colours were used, with six of the tones also serving elsewhere. In sum, Rooker here elaborated five colour scales composed of no fewer than forty-four tones. Such immensely varied and subtle tonal scales were a far cry from the tonal simplicities – if not even the tonal crudities – used by many of Rooker's contemporaries, Malton included.

Tint by Tint by Tint: The Scale Practice

As we have seen, by 1792 Turner had for some years been deploying wide ranges of tone in his watercolours. Yet even in the 1792 *Malmsbury Abbey* he had deployed a mere fifteen tones. Accordingly, he now set to work to obtain the kind of immensely delicate and controlled nuances he had observed in *Battle Abbey-gate*. Because copying was not permitted within the Royal Academy exhibitions, he was forced to look hard at the Rooker, and then rush back to Maiden Lane to set down his gleanings on paper. Initially the results took the form of two watercolour transcriptions of areas of the Rooker created while memories of it remained fresh (figs 59 and 60). In one of them Turner not only emulated something of Rooker's tonal variety but did so with a section of the left-hand gate tower and adjacent wall that the older painter had overlaid with the shadows of trees. And simultaneously or soon afterwards, he also made a watercolour of part of St Mary's Church, Petworth, in which he explored the subtle tonal differences between the building's roof-tiles and areas of masonry (fig. 61).[1] Yet far from this drawing and

Detail of fig. 74.

58 Michael Angelo Rooker ARA, *Battle Abbey-gate, Sussex*, signed and dated 1792, R.A. 1792 (438), watercolour on paper, 16½ × 23½ (41.9 × 59.7), Royal Academy of Arts, London.

the Battle Abbey pair marking the end of Turner's exploration of the tonal implications of Rooker's *Battle Abbey-gate*, he would go on to investigate something of far greater importance he had recognised in the work. Very soon this would revolutionise the way he created watercolours.

The method of tonal gradation employed by Rooker in *Battle Abbey-gate* was known as the 'scale practice' because it necessitated working down the tonal scale from light to dark. By definition, a scale is a progression of upward or downward steps divided by regular intervals. However, in watercolour a scale progression must necessarily move from light to dark because of the inherent transparency of the medium. This makes it virtually impossible to put a light mark over a darker one and expect it to remain visible. Yet in order to understand the scale practice and how it revolutionised Turner's approach to watercolour, we initially need to place the process within a wider creative framework.

Watercolour painters enjoy two very different ways of organising their palettes so as to attain the tonal control they might require. On the one hand, they can prepare in advance all the various scales of colour they intend to use, deploying across a necessarily large

palette the exact number of tints from light to dark they subsequently want to transfer to their support. We can term this approach the 'tonal variety' method, for having a large number of colours and their tints already prepared on the palette would facilitate abrupt tonal changes from moment to moment – you see any colour or tone you require, you pick up a brush, and you can immediately transfer the pigment to the support. Yet this approach creates handling problems. If each of, say, fifteen tones in a trio of colours from light to dark – such as the blue, pale ochre and yellow ochre deployed by Turner in his *Malmsbury Abbey* drawing (see fig. 55) – has a paint-

Above left 59 *An octagonal turret and battlemented wall: study of part of the gateway of Battle Abbey after M. A. Rooker*, 1792, watercolour on paper, 6¾ × 5¾ (17.2 × 14.6), Turner Bequest XVII-R, Tate Britain, London.

Above right 60 *Foliage and an octagonal turret with part of a battlemented wall: study of Battle Abbey after M. A. Rooker*, 1792, watercolour on paper, 6¾ × 5¾ (17.2 × 14.6), Turner Bequest XVII-Q, Tate Britain, London.

Right 61 *Petworth Church from the north-west*, 1792, watercolour on paper, 10¾ × 8½ (27.2 × 21.4), Turner Bequest XXIII-E, Tate Britain, London.

brush solely dedicated to it, then the user of those implements might well face the major difficulty of holding and/or differentiating so many tools at once. Moreover, the constant changeovers of brush would slow activity enormously, no matter how deftly they were handled.

Naturally, just one or two brushes could be used for all fifteen tones, and they could continually be rinsed in a cleanser before changing from one – possibly very different – tint to the next. Yet unless great care is exercised, this approach could easily create problems, for the cleaning would have to be especially thorough lest differently toned mixtures adversely affect one another. (Naturally, such contamination would prove very unfortunate if the artist were attempting to establish finely gradated tonal relationships.) Equally, it would be just as vital to prevent the cleanser – which would necessarily become increasingly discoloured in the cleaning process – from dirtying the tint to be used subsequently, although the employment of several receptacles for that liquid would obviate this problem.

Given the brush-control and brush-cleaning problems inherent to this 'tonal variety' method, we can perceive that if Rooker had employed no more than, say, three brushes for the forty-four tones of five basic colours used in *Battle Abbey-gate* and done so by working consecutively from, say, the top of the sheet to its foot, then he would continually have had to change, wipe or wash off his brushes every time he wanted to transfer a tonally different tint from his palette to the paper. Such a constant varying of tones is perfectly feasible, but it would take for ever because of all the brush cleaning or brush changing involved.

The alternative, much simpler and far faster procedure is to use the 'scale-practice' or evolutionary method of colouring and tinting. Here an artist simply mixes a very light tone of a *single* colour on the palette and then, during the working process, he or she gradually darkens it 'down' the tonal scale from light to dark. Only one brush is needed at any one time. A lump of darkly toned colour or black pigment can be placed at the edge of the palette and a tiny amount of that pigment can be introduced – possibly by means of the very tip of the brush – to the existing pool of colour, thereby fractionally darkening it from stage to stage down the tonal scale (while also perhaps slightly altering its colour in the process). This is a far simpler procedure than constantly lifting a large number of possibly very different tones from the palette with a multiplicity of brushes, and it means that precise tonal control can be constantly and evenly maintained, with the most minute tonal differentiations being achieved.

To illustrate this entire process, it should be imagined that upon beginning a drawing very pale overall washes are applied, perhaps using delicate tones of the two or three colours that will dominate the palette. For example, an extremely light blue could be used for the sky, a very delicate ochre for the central massing of the forms, and the palest of yellow-ochres for a few smaller areas. Upon drying, applications of a single, slightly darker tone of each of these colours are added in turn to a number of *different* small areas across the sheet. Subsequently, each pool of colour on the palette can be slightly darkened by the use of just one brush and the procedure repeated, with yet another darkening of tone supplying further areas of the patchwork. By degrees the image comes together, rather as a jigsaw is pieced together, with the darkest tones finally adding the greatest depth to the image.

This is the scale practice and it enjoys six advantages, although it does exert a single, crucial demand. The first benefit is that an artist can create a vast number of tones by employing just a few brushes that rarely have to be cleaned during the working process. Naturally, this greatly facilitates rapid working. The second advantage is that only a simply organised, normal-sized and highly manageable palette is required. It is therefore very easy to take in at a glance what is distributed across it, for very few pools of pigment reside upon it at any one time. It is also very easy to move it around the studio. This flexibility leads to the third and fourth interrelated advantages: a simply organised palette facilitates a fast speed of working and a high volume of production. Thus, while one watercolour is drying, some of the pigment of a given tone that remains on the palette can be applied at various locations within a number of further sheets of paper or other form of support. These watercolours can be worked upon in succession, before an eventual return to the by-now-dry initial image and a new mixing of a very slightly darker colour to continue the tonal evolution of that work and its successors.

By employing this method, there is never any need to wait for paint to dry; instead, it is possible to work extremely rapidly on what would today be termed a production line, with many drawings being gradually advanced towards completion around the studio. A minor artist who would later watch Turner at work would testify that he made watercolours in this sequential way,[2] and that the scale practice lay at the core of his approach, for it enabled him 'to paint at a prodigiously rapid rate' with never a moment or drop of watercolour going to waste.[3]

The fifth blessing of the scale practice devolves from the fact that because a painter is necessarily applying tonal washes or touches of watercolour to *different* parts of a given drawing, it lessens the danger of adjacent areas of wet pigment diffusing into one another. Naturally, such diffusions would prove particularly unfortunate if, say, large numbers of masonry slabs with only thin demarcations to denote intervening layers of mortar are being elaborated. The relevance of this observation will become apparent before long.

The sixth advantage of the scale practice derives from its all-over, fragmentary development of an image. By dint of the fact that the

most distant parts of a landscape or seascape are necessarily rendered in the lightest tones first, and parts of the foreground are put in using the darkest tones towards the end of the working process, the entire composition – rather than simply parts of it – simultaneously advances spatially from its light background to its darker foreground as the painter works from light to dark, thereby making it far easier to judge the overall tonal effect and sense of depth engendered. As the interrelationship between tonal subtlety and spatiality grew in importance for Turner, this advantage would prove increasingly vital.

Finally, in the necessarily fragmented pictorial approach inherent to the scale practice resides the huge demand the procedure imposes: from the very beginning the artist has to possess a strong mental image of what the final drawing should look like, so as to be able to place all the individual tones in exactly the right places. It is like carrying an imaginary, completed jigsaw around in your head from beginning to end while you are actually in the process of gradually fitting it all together piece by piece. Fortunately, Turner was endowed with a powerful ability to form mental images, which is why he never felt taxed by constructing drawings out of tonal washes or touches of colour that were often widely spaced apart across the support. We shall see what he began to achieve by means of the scale practice very soon. And eventually he would carry over the technique to his oils.

The Academy of Living Models

At 4 p.m. on Monday 25 June 1792, Turner was finally admitted to the life school of the Royal Academy. This comprised a large ground-floor room whose shutters were usually kept closed, mainly so that candlelight could create chiaroscuro or a sharp division between areas of light and darkness that served to bring out the subtleties of the human form (moreover, the closure of the shutters prevented prying eyes in the Strand from gazing in upon the models). As in the Academy of the Antique upstairs, the atmosphere must have been very smoky and hot, especially on those many cool or cold days throughout the year when there was a need to heat the models. These took up their poses for two hours at a stretch, although they could grab brief rest periods when necessary. The male models had to be physically strong because they were often required to strike the demanding poses encountered in Old Master paintings and ancient sculptures. Slings hanging from the ceiling helped them achieve this by providing support for their arms when raised.

Turner signed in to the life classes just forty-four times between his initial attendance and the end of 1792, as well as sporadically in the Academy of the Antique for some time to come. Unfortunately, very few of his life drawings have survived, and only one of them could possibly date from 1792 (fig. 62). It is a rather clumsy affair,

62 *Male nude seated cross-legged on rocks, with his chin in his hand*, c.1792, black, white and red chalk on light buff paper, 20½ × 16 (52 × 40.6), Turner Bequest XVIII-J, Tate Britain, London.

for the left half of the upper torso is disproportionate, having been carried over much too far to the left. Yet the modelling of the forms is vivacious and it brings to mind the technique of stipple engraving, in which we similarly encounter lines of dots defining the form. As we have seen, in 1789 Turner had apparently used a stipple technique when making his first application drawing for entry to the Schools. Clearly, the approach still proved useful. Perhaps the strongest feature of the 1792 work is the head, for it is psychologically well characterised – the man stares out at us with a palpable sense of anxiety.

Wales, 1792

At some point before the fourth week of June 1792, Turner undertook a major excursion from London. First he revisited Bath and Bristol, where he again stayed with the Narraways. Then he crossed

63 *Llanthony Abbey, Monmouthshire*, 1792, watercolour over pencil, strengthened with pen and ink on paper, 8⅜ × 10⅝ (21.4 × 27), Indianapolis Museum of Art.

the Severn estuary to Wales, to stroll up the valley of the river Wye to Tintern Abbey, where he made a few drawings before continuing on to Monmouth. Next came Abergavenny on the river Usk, which was followed as far as Crickhowell. By now, Turner was getting into the very wild country of the Black Mountains. Following primitive roads and shepherds' trails through or across these hills, he made his way north-eastwards to the ruined Llanthony Abbey, the dereliction of which was intensified by its extreme isolation. He then continued onwards to Hereford where he rejoined the Wye valley before moving westwards to his ultimate destinations, the Mynach Falls and the Devil's Bridge, about ten miles east of Aberystwyth in west Wales. He probably stayed a night or two in Aberystwyth. If he had walked the entire distance from his entry point in Wales to Aberystwyth – as seems likely – then he would have covered about 120 miles on foot. Because he was a sturdy walker who was reputedly capable of tramping twenty to twenty-five miles a day,[4] he could have encompassed that distance in as little as six days.

Returning to Hereford, perhaps by stagecoach, Turner must have subsequently taken another such vehicle, or succession of them, down to Oxford. There he made a number of pencil drawings. From Oxford he could easily have visited Sunningwell to see his mother if she was there. He then returned to London where we can firmly locate him on 4 August 1792, for on that day he again sat for George Dance, who helpfully dated his work (see p. xiv above).

Turner's first Welsh tour therefore probably lasted about three weeks. It is very possible that he suffered from poor weather in the country, for the summer of 1792 appears to have been very wet all over Britain. Only a few pencil drawings, one or two watercolour studies, and a small number of finished watercolours emanated from the tour. They include a memorable depiction of Llanthony Abbey (fig. 63), in which the strong wind blowing across the scene is made apparent by the trees in mid-distance, by the shepherd clamping his hat to his head on the far bank of the river, and by the distant pall of smoke emanating from a cottage. On the right, the stricken shapes of a fallen tree make evident the damage that has already been wrought by the elements.

During the late summer of 1792 Turner also visited Canterbury in Kent. Although we possess no documentary record of this trip nor any sketches arising from it, it had to have taken place because Turner would display a richly detailed Canterbury subject at the Royal Academy in April 1793 (see fig. 88). He must therefore have obtained the visual data from which to develop that work not long before. A number of finished but unexhibited watercolours of Canterbury subjects that were undoubtedly begun in the late summer of 1792 and possibly completed early in 1793 also support this contention, as will now be ascertained.

The Scale Practice Sets of 1792–3

As stated above, the scale practice transfer of the gradually darkening tones of various colours meant that it was both logical and economical to work upon several sheets of paper distributed around a workplace, rather than simply labour upon one watercolour at a time. Turner therefore needed to test such a process. After returning from his travels in 1792, he did just that by creating a set of drawings ('Set A', figs 64–73), with a second set following a few months later and into 1793 ('Set B', figs 74–80). It must be stressed that he was not making thematically related images in either set; he simply needed to see how well the scale practice would service his creative requirements. Within each set, similarities of drawing style, size of sheet, paper type and colours and tones suffice to link all the works. Unfortunately, watercolours in both sets (figs 66 and 71) have suffered from indigo fading over time.

In Set B there is a greater refinement to the drawing, a more sophisticated and complex response to architecture, a more purposeful staffage and, naturally, a finer control of tone.

Scale Practice Set A

64 *Christ Church Gate, Canterbury*, 1792, watercolour on paper, 8⅜ × 10⅝ (21.2 × 26.9), Turner Bequest XVII-A, Tate Britain, London.

This acted as the study for a watercolour made in 1793–4, W.54, Yale Center for British Art, Paul Mellon Collection.

65 *West Gate, Canterbury*, 1792, watercolour on paper, 8⅔ × 10¾ (21.2 × 27.3), Turner Bequest XV-E, Tate Britain, London.

Scale Practice Set A

66 *Christ Church Gate, Canterbury*, 1792, watercolour on paper, 10¼ × 10½ (26 × 26.6), Fitzwilliam Museum, Cambridge.

This was the study for the *Christ Church Gate, Canterbury* exhibited in the 1794 Royal Academy Exhibition.[5] Here Turner made the building about as twice as large as it would have been in relation to the man, horse and cart passing through the gateway itself. As we have seen, this tendency to enlarge things had already emerged in his work, and it had surely done so in response to Reynolds's injunctions regarding the need for grandeur.

Scale Practice Set A

67 *Landscape composition with a ruined castle on a cliff*, 1792, watercolour on paper, 8½ × 10¾ (21.5 × 27.3), Turner Bequest XXIII-Q, Tate Britain, London.

68 *Rochester Castle from the River Medway*, 1792, pencil and watercolour on paper, 8⅜ × 10⅝ (21.2 × 26.9), Turner Bequest XV-D, Tate Britain, London.

Scale Practice Set A

69 *St Mary's from Oriel Lane, Oxford*, 1792, watercolour on paper, 8½ × 10¾ (21.5 × 27.3), Turner Bequest XIV-C, Tate Britain, London. And see also fig. 101.

Scale Practice Set A

70 *Gate of St Augustine's monastery, Canterbury*, 1792, watercolour on paper, 8⅜ × 10⅝ (21.2 × 26.9), Yale Center for British Art, Paul Mellon Collection.

This was the study for fig. 88. Here, and possibly for the first time, Turner gave rein to a predilection that would eventually find its outlet in a great many of his works: visual punning, or playing upon the similarities of things. A piece of timber with three branches leans against the low wall in front of the gateway. Immediately beyond the wall may be seen the crossbars of what is possibly a washing-line post. The eye connects these two discrete objects to create a larger overall form reminiscent of a crucifix. Naturally, such a cross is highly appropriate to a Canterbury view, for it not only denotes the Christian links of the ruined gateway but reminds us that the city lay at the end of a major pilgrimage route.

Such a visual pun is unsurprising, for associative devices were very common on the walls of the Royal Academy and elsewhere. Indeed, they had been recommended by Sir Joshua Reynolds in his seventh discourse as a way of moving painting closer to poetry, where 'figurative and metaphorical expressions' abound.[6] Turner's pictorial pun suggests that he was already beginning to take Reynolds's ideas about the relationship of painting and poetry seriously. It also tells us a lot about his imaginative powers at a relatively early age, as well as about his sly sense of humour.

Scale Practice Set A

Left 71 *Malmesbury Abbey*, 1792, watercolour on paper, 9½ × 8 (24.1 × 20.3), Smith College Museum of Art, Northampton, Mass.
This was the study for another view of the same subject now in a private collection, W.36.

Right 72 *Tom Tower, Christ Church, Oxford*, 1792, watercolour on paper, 12½ × 9½ (31.5 × 24), private collection.
This was the study for fig. 74.

Facing page 73 *The Founder's Tower, Magdalen College, Oxford*, 1792, watercolour on paper, 10½ × 8⅛ (26.6 × 20.6), present location unknown.
Not in Wilton.
This was the study for fig. 97.

Scale Practice Set A

Scale Practice Set B

Facing page 74 *Tom Tower, Christ Church, Oxford*, 1792–3, watercolour on paper, 10¾ × 8½ (27.3 × 21.5), Turner Bequest XIV-B, Tate Britain, London.

This second view of Christ Church is imbued with a greater tonal richness than its predecessor (fig. 72), especially across the building on the right where remarkable care and patience was clearly exercised to build up the pattern of differently toned masonry slabs while retaining all the thin, linear pointings between them. Overall, the drawing is made up of eighteen separate tones that constitute the three colour scales forming the sky, the college tower, and the foreground buildings and people. Eighteen tones are still far short of the forty-four tones Rooker had achieved in his 1792 *Battle Abbey* depiction, and not much of an advance over the fifteen tones used for the *Malmsbury Abbey* (fig. 55). However, the shifts are now far more subtle than they were in both the earlier depiction of Christ Church and the Malmesbury drawing. This is particularly apparent in the tones employed to represent Tom Tower, for because they all exist within an extremely narrow range from light to dark, it looks immensely ethereal in the afternoon sunlight.

Top 75 *River landscape with distant mountains*, 1792–3, watercolour on paper, 8⅜ × 10⅝ (21.2 × 26.9), Turner Bequest XXIII-N, Tate Britain, London.

Originally the artist placed a gesticulating man just below the centre of this river scene but because he must have somewhat disturbed the peacefulness of the landscape, he was partially rubbed out and not replaced.

Bottom 76 *The Vale of Bath from Kingsdown Hill*, 1792–3, watercolour on paper, 6⅞ × 10¼ (17.4 × 26.3), Bacon Collection.

Here the immensely delicate tones with which the distant city is represented in the afternoon sunlight are especially noteworthy. In their subtlety, they prefigure the immensely subtle tones that are commonly to be encountered in Turner's late representations of Venice.

Scale Practice Set B

77 *Sailors getting pigs on board in a gale*, 1792–3, watercolour on paper, 8½ × 11 (21.5 × 27.9), Turner Bequest XXIII-T, Tate Britain, London.

Clearly, Malton's love of Rowlandson affected Turner's imagery here. This work will also be discussed below.

78 *A bay on a rocky coast with a man running*, 1792–3, watercolour on paper, 8⅜ × 10⅝ (21.2 × 26.9), Turner Bequest XXIII-V, Tate Britain, London.

Here the figure introduces a note of urgency.

Scale Practice Set B

79 *A rocky shore, with men attempting to rescue a storm-tossed boat*, 1792–3, watercolour on paper, 6¼ × 9⅛ (15.8 × 23.1), Turner Bequest XXIII-R, Tate Britain, London.

80 *A shipwreck on a rocky coastline, with a ruined castle*, 1792–3, watercolour on paper, 6⅝ × 9¼ (16.8 × 23.4), Whitworth Art Gallery, University of Manchester. Not in Wilton.

This work will also receive discussion below.

The French Master

The scale practice sets of watercolours created between the late summer of 1792 and the spring of 1793 make it clear that the 17-year-old Turner was already intensely methodical and patient, for only someone of an acutely meticulous and unhurried cast of mind could have differentiated the tonal intervals they contain. And these watercolours equally demonstrate that Turner could tackle a diverse spread of imagery. Such a trait, along with much else, may have reflected the influence of an extremely wide-ranging painter with whom he was coming into close contact at this time.

Philippe Jacques de Loutherbourg (1740–1812, fig. 81) hailed from Alsace, France, and he had settled in London in 1771. He was elected a Royal Academician ten years later. A small but informative scrap recorded by Thornbury links him to Turner: 'It is said that Mrs Loutherbourg grew very jealous of Turner's frequent visits to her husband, and that at last suspecting the young painter was obtaining all her husband's secrets from him, on his next visit she shut the door in his face and roughly refused him admittance.'[7] Because this information appears in Thornbury's biography immediately prior to a section dealing with Turner's life as a near neighbour to de Loutherbourg in Hammersmith between 1806 and 1811, it has always been assumed that if the 'frequent visits' and their unfortunate aftermath took place at all, then they must have done so during that period. Yet Turner was hardly a 'young painter' between 1806 and 1811, especially in an era of much shorter longevity than our own. But around 1792–3 he was still very young, and someone whose style demonstrated the marked influence of de Loutherbourg at that time. Nor between 1806 and 1811 had Turner any need of de Loutherbourg's 'secrets', let alone 'all' of them. However, when he was 17-years of age things were very different, for that was exactly when he had been most in need of the older painter's expertise and, indeed, precisely when his images strongly suggest he received it. And that de Loutherbourg's guidance was considerable, and that it was spread over a matter of months, can be gleaned from Thornbury's mention of 'frequent' visits and the fact that Mrs de Loutherbourg 'at last' suspected the young painter, for the latter term necessarily implies that a succession of visits had preceded it. But whatever prompted a series of visits to de Loutherbourg's studio, they surely did take place between the autumn of 1792 and the spring of the following year.

This belief equally derives from the fact that marine watercolours in the two scale practice sets of 1792–3 demonstrate the marked influence of the French-born painter. Thus the *Landscape composition with a ruined castle on a cliff* in the first scale practice set (see fig. 67), and *A rocky shore* in the second group (see fig. 79), seem like amalgams of features apparent in two works by de Loutherbourg, namely his *A storm, and passage boat running ashore* of 1791 (fig. 82), and his *Storm and shipwreck, with banditti and figures* of 1792–3 (fig. 83). Admittedly, the second of these pictures may still have been in progress by 1792 but of course if Turner did visit the Hammersmith studio at that time, then he could have seen it as it neared completion. Not only do the principal compositional lines in his two watercolours run from lower-left to upper-right – just as they do in both of the de Loutherbourg paintings – but in all four works the major vessels are positioned in identical locations at the lower-centre, with people placed at the lower-right. Additionally, the castle in Turner's *Landscape composition with a ruined castle on a cliff* resembles the one in de Loutherbourg's *A storm, and passage boat running ashore*, while the gigantic boulders dominating *A rocky shore* clearly derive from the similarly placed rocks in the *Storm and shipwreck, with banditti and figures*.

Two more works further help pinpoint the exact period during which Turner and de Loutherbourg frequently came together in Hammersmith. Perhaps the French-born artist's most celebrated landscape is one of the defining images of the Industrial Revolution,

81 Philippe Jacques de Loutherbourg, *Self-portrait*, 1805–10, oil on canvas, 50 × 40 (127 × 101.6), National Portrait Gallery, London.

his *Coalbrookdale by Night* (fig. 84). This painting must have been developed from sketches made during one or other of de Loutherbourg's only visits to the industrial Midlands, in 1778 and 1783, and it would be exhibited at the Royal Academy in 1801. However, it may well have been finished – or at least taken to an advanced stage of completion – by late 1792 or early 1793, for at that time Turner undoubtedly saw it in the Hammersmith Terrace studio. We can be certain of this because, as Ian Warrell was the first to notice, on the skyline of *A shipwreck on a rocky coastline, with a ruined castle* (see fig. 80) Turner made a group of buildings almost exactly replicate the gathering of buildings in the de Loutherbourg oil, while on stylistic grounds the watercolour itself can only have been made during the 1792–3 period.[8]

As several of the watercolours belonging to the scale practice sets and many other contemporaneous drawings indicate, in 1792–3 de Loutherbourg also influenced the way that Turner depicted flora. This is especially clear in a generalised scene that the 17-year-old created in the latter half of 1792 or shortly after, the *Landscape with a Man watering his Horse* (fig. 85). By this date he had tamed his previous approach to trees, which was to twist their limbs into fantastic and highly expressive shapes. Instead, he now began to make them look far more subtly rhythmic and naturalistic. The drawing of the leaves and their gathering into bunches especially reflects the influence of de Loutherbourg, who often also gave his leaves very serrated edges and frequently depicted them as light-on-dark forms (although on occasion he alternatively silhouetted them against light backgrounds).[9] Such jagged edging and silhouetting of arboreal forms wholly belongs to the 1792–3 period in Turner's output.

Because de Loutherbourg was not a watercolourist, any technical 'secrets' he may have imparted cannot have involved that medium. Turner must therefore have sought his insights into how to use oil paint in landscape and marine pictures. And that is surely what finally proved to be too much for Mrs de Loutherbourg, for there are necessarily many more 'secrets' involved in oil painting than there are in watercolour, due to its greater chemical complexity. As

Top 82 Philippe Jacques de Loutherbourg, *A storm, and passage boat running ashore*, signed and dated 1791, R.A. 1792 (13), oil on canvas, 42½ × 63 (106.7 × 160), Victoria Art Gallery, Bath.

Middle 83 Philippe Jacques de Loutherbourg, *Storm and shipwreck, with banditti and figures*, signed and dated 1793, oil on canvas, 43½ × 63 (110.5 × 160), Southampton City Art Gallery.

Bottom 84 Philippe Jacques de Loutherbourg, *Coalbrookdale by Night*, signed and dated 1801, R.A. 1801 (54), oil on canvas, 26¾ × 42 (68 × 106.7), The Science Museum, London.

85 *Landscape with a man watering his horse*, c.1792–3, pencil and watercolour on paper, 5⅞ × 7¾ (15 × 19.7), private collection, Australia. Not in Wilton.

a result, answers to its manifold problems can easily turn into 'secrets' within the highly competitive art world. Probably Mrs de Loutherbourg eventually grasped the scale of Turner's talent and feared for her husband's career if he imparted 'secrets' to someone who, once armed with them, might eventually outshine him (as would indeed prove to be the case). That would explain why she abruptly excluded the young man from her husband's studio, and why it then took Turner three more years to master oil paint sufficiently to exhibit on the walls of the Royal Academy a marine subject made with that medium.

When Mrs de Loutherbourg shut the door in Turner's face, he must have been nonplussed, for not only had a vital supplement to his artistic training been rudely cut off but his distrust of women was probably reinforced. He may even have been prompted to feel contempt for any women who meddled in the affairs of men, and been led to conclude that painters with serious ambitions – or at least male artists with such aims – should always steer well clear of marriage.

Another pictorial vista was also furthered for Turner by de Loutherbourg. This devolved from the way that the Academician could adapt the style of his figures to the types of images in which he placed them. Thus in his religious, historical and military subjects, de Loutherbourg usually represented people in a straightforward and anatomically skilful manner, as befitted the seriousness of those images. But in some of his landscapes he could create moral contrasts between the beauty of nature and human imperfection by making his figures verge on caricature, or even cross that boundary.

One of the principal influences upon de Loutherbourg in this respect was the Flemish painter David Teniers the younger (1610–1690). In *Sailors getting pigs on board in a gale* (see fig. 77) of the second 1792–3 scale practice set, Turner assimilated the influence of Teniers, possibly through having seen how the Flemish artist had influenced a number of early works by de Loutherbourg. At the stern of the nearest boat, a man with hunched shoulders and a flat, red Lowlands cap pulls on an oar. Clearly he derived from Teniers, for the Flemish painter had frequently depicted both landsmen and seamen wearing flat, red Lowlands caps that are either aligned with their hunched shoulders or slightly overlap them, and who are often viewed from behind. Similar figures derived from Teniers would make their way into a number of Turner's landscapes and seascapes from 1801 onwards, especially in the guise of red-capped helmsmen viewed from the rear and who hunch their shoulders as they control their fishing boats and other sailing vessels. A little later Turner would paint a dentist's surgery and several rural interiors very much in the style of Teniers, with Teniers-like figures in evidence.

Teniers was immensely popular in eighteenth- and early nineteenth-century Britain because his village fairs, tavern interiors, military guard-rooms, dental surgeries and the like are usually filled with an earthy, vulgar and lowborn humanity that is observed with great wit and insight. Clearly this was what attracted Turner to his works. Due to the latter's lowly class origins, he wanted to find a way of stating his awareness that most people in his day were uneducated, underfed and unwashed. The most direct way of attaining that end was to make his figures seem as imperfect as possible by giving them satirical, doll-like facial features and misshapen bodies. By matching the physically unrefined to the psychologically raw, such an approach effects an exact congruence between outer guise and inner reality. In such metaphors for the true nature of the common people around him resides the supreme linkage of form and dramatic content in Turner's art, and one that states something about our species that necessarily approaches the universal. In *Sailors getting pigs on board in a gale*, Turner took a big step in that direction, albeit a satirical one.

It has long been recognised that in *Sailors getting pigs on board in a gale*, Turner came equally close to Rowlandson, both stylistically and in terms of subject matter. Rowlandson himself had long admired the work of de Loutherbourg. As a consequence, in 1776 he had made a version of the French artist's *A winter morning, with a party skating* when the latter picture had hung in the Royal Academy as one of a pair of complementary images.[10] As we have seen, there is a very strong possibility that Turner first became aware of Rowlandson's images through Thomas Malton and consequently made *The Dover Mail* in 1791 when under the influence of the satirist

86 *Study for Don Quixote and the enchanted barque*, c.1792–3, pen and grey wash over pencil on paper, 6⅝ × 9 (16.8 × 23), private collection.

and caricaturist. If Rowlandson did influence Turner at that time, then it is wholly unsurprising that the young artist proved equally receptive to the caricatural element in de Loutherbourg's work.

Sailors getting pigs on board in a gale was not the only pictorial satire that Turner created during the 1792–3 period. Possibly at the instigation of de Loutherbourg, he began *Don Quixote and the enchanted barque* (fig. 86). Within his overall shape, Turner created a fine sense of compositional cohesion by fashioning a triangular underpinning in the centre. The tonalities of the masonry slabs forming the lower part of the nearest wall of the mill are very carefully differentiated, and they point to the 1792–3 dating of the image, as do the de Loutherbourg-like serrated edges of the foliage to the left.

Around 1792–3 Turner was also inspired to make some sketches of various characters in *The Grave* by the Scots poet Robert Blair (1699–1746).[11] This poem moralises on the fate that awaits us all, be we artists, warriors, doctors, rich men or fools. The figures Turner chose to draw were a grieving, prostrate widow from early on in the poem, as well as a sottish gravedigger from towards its end. Like the Cervantes illustration, the sketches inspired by *The Grave* establish firmly, and for the first time, that the young man was beginning to take literature and poetry very seriously. After 1798 he would quote passages from a number of poems in connection with his images, and it is wholly unsurprising that he would do so, for by then poetry had long helped form his social, moral and creative view of the world.

5

The Only Turner Prize

1793

On the evening of Monday 18 February 1793, Turner was present in the Lecture Room of Somerset House when the Royal Academy Professor of Painting, James Barry, gave the last of his annual series of six talks. In the course of it Barry lamented that Schools students had recently taken short-cuts while attempting to win 'the glorious prize' of art. 'Go home from the academy,' he proclaimed, 'light your lamps, and exercise yourselves in the creative part of your art, with Homer, with Livy, and all the great characters, ancient and modern, for your companions and counsellors.' The phrase 'light your lamps' as an injunction to hard work stirred Turner deeply, for as he would tell a friend in 1817, 'Barry's words are always ringing in my ears'.[1] Certainly he embraced Barry's recommendation that great poets, historians and 'characters, ancient and modern' be his constant 'companions and counsellors', as the Cervantes and Blair illustrations had already demonstrated and as he would show countless times more.

It seems likely that Turner had attended all the preceding lectures in Barry's series, or heard them in previous years, for they constituted a fairly systematic history of the art of painting. Given Barry's identification with history painting – the category of subject matter that covered history, mythology, poetry, literature and religion – his lectures leaned heavily towards humanism, a generalised view of nature, and high seriousness in art. Pictorially the contentious Irishman never exercised any sway over Turner, but his high regard for the Great Style, in which elevated subjects were invested with heroic grandeur, undoubtedly appealed to a young artist who had begun aggrandising the scale of things not long before. Over time, Turner would effect a triumphant fusion between history painting and his own branches of art, and Barry was one of the many artists who led him to do so.

The Society of Arts

Either on the same day that Barry gave his sixth talk or the next one, Turner entered a competition 'For the best Drawing of a Landscape after nature' that was promoted by the Society of Arts. This organisation had been founded in 1754 to foster innovation in all cultural and industrial spheres. Almost from the start it had begun awarding prizes or 'premiums' in a great many fields, including the 'Polite Arts' of 'History Painting', 'Historical Drawing', and 'Drawings of Machine' or technical drawing. By Turner's day the awards in the fine arts categories took the form of small, imitation artist's palettes or 'pallats'. Turner's submission was a view of 'Lodge Farm, near Hambleton, Surrey'.[2]

The verdicts were revealed on Wednesday 27 March 1793. He had won. However, that was not the end of the matter. In order 'to encourage real merit', and to prove that the winning submission had

Detail of fig. 88.

87 Obverse and reverse of the 'Greater Silver Pallet' awarded to Turner by the Society of Arts in 1793. Image reproduced from the *Connoisseur*, February 1923, page 79.

not been made by someone else, Turner then had to elaborate a further drawing under the keen eyes of the judges. The encouragement of 'real merit' was deemed vital, for the term signified the crucial difference between making 'a Landscape after nature' directly from a subject and creating one within a studio or similar space from sketches and memory. Naturally, it was essential to be able to do both, but the latter skill was especially prized, quite simply because it was held to be more imaginatively and intellectually taxing.

As a consequence, on Wednesday 17 April 1793 Turner created his second work in front of the judges. Like its predecessor, it probably represented a farm scene. Again he was victorious. Indeed, the judges were so impressed by his offering that they had his silver medal set in a gold rim (fig. 87), which indicates that he had particularly distinguished himself. He was handed his medal by the 11th Duke of Norfolk (1746–1815) on 28 May 1793 in the Great Room of the Society of Arts building in John Adam Street, just off the Strand. It seems safe to assume that his father was in the audience and beamed with pleasure at his son's achievement, even if it did mean quitting the shop for part of the day. The medal remained in Turner's possession throughout his lifetime, after which it was stolen from his studio. It has now in a private collection in Canada.[3] The prizewinning watercolours have long since disappeared.

Given that the Society of Arts competition conferred no pecuniary advantage, why did Turner enter it?

The Royal Academy provides the answer. During most years it awarded gold medals to Schools students for prowess in oil painting, sculpture and architecture. Additionally, silver medals could be conferred for figure and architectural drawings made in the Schools. By 1793 Turner did not yet possess a strong enough technique to win a prize for oil painting, and of course he had no way of knowing when he would be good enough to compete for one. And by 1793 he must already have concluded that he was never going to win any kind of prize for life drawing. It must therefore have caused him intense irritation that the Royal Academy conferred no medal for landscape drawing. Yet that type of prize *was* granted by another prestigious cultural organisation just down the road from Somerset House – indeed, it was the only such award to be conferred anywhere. Naturally, it was well within his grasp. Possession of it might bring no financial reward, but it would certainly assuage his chagrin at being excluded from the Schools competitions. So he entered the contest and won the prize. With his Greater Silver Pallet he was able to stand alongside the Schools medal winners with pride, if not even with a hint of disdain, for he knew how far he already outstripped most of them in talent. Possession of it cannot have done him any harm within the more general realm of the Royal Academy either, quite simply because almost everyone in the higher reaches of the institution paid extremely keen attention to honours of all kinds. Such an awareness came with the territory.

The 1793 Royal Academy Exhibition
FRIDAY 26 APRIL TO SATURDAY 8 JUNE

Turner had three watercolours on display this year. Two were views near Bristol that are now both unidentifiable and untraced. One was shown in the Ante-Room to the Great Room – or 'Anti-Room' as it was always called and will be termed hereafter – on the top floor of Somerset House, while the other two were placed in the Library on the first floor. Fortunately, the exhibit we can identify was arguably the most advanced British watercolour yet created by anyone.

Gate of St Augustine's monastery, Canterbury (fig. 88) was extremely cutting edge because of one overriding factor: it is made up of no fewer than sixty-one tones of yellow, yellow ochre, red, blue, green, and various brown-greys and blue-greys.[4] Obviously, Turner put an extraordinary effort into creating so many tonal variants of upwards of ten colours, and it is easy to see why he did so: he wanted to outdo Rooker's *Battle Abbey-gate* of 1792 (see fig. 58), with its forty-four tones of five colours. It is a mark of the young man's intense creative focus, ambitiousness and sense of challenge that he had attained that ambition in just a year.

As in the Rooker, evening light falls from the left. Such a distribution is also evident in a good number of other representations of building façades that Turner created during this period, and for the same, Rooker-inspired reason. Clearly, the 1793 design was devel-

88 *Gate of St Augustine's monastery, Canterbury*, R.A. 1793 (316), watercolour on paper, 13½ × 19⅜ (34.3 × 49.3), Yale Center for British Art, Paul Mellon Collection.

oped from the very much cruder representation of the same subject that is to be found in the first scale practice set of watercolours made in 1792 (see fig. 70), with the Bell Harry tower of Canterbury Cathedral appearing in the distance on the right of both images. The exhibited watercolour enjoys a far firmer quality of draughtsmanship than its study, along with a much greater certainty regarding the architecture, a more pronounced spatial separation, a far subtler modulation of tone into the distance, and a more firmly structured composition. The foliage on the left and at the centre is drawn in the manner of de Loutherbourg, and it indubitably fixes the creation of the work as having taken place during the first part of 1793.

By the time the 1793 Royal Academy Exhibition opened, Turner was finding it rather demeaning that visitors to his studio had to access it via a hairdressing salon. This was understandable, given the 18-year-old's independence of mind and wish to appear fully adult. Entry by way of a separate doorway would make him look the complete professional. Accordingly, this year he stopped giving his address in the exhibition catalogue as '26 Maiden Lane, Covent Garden' and instead listed it as 'Hand-court, Maiden-lane, Covent-garden'. By this means he distinguished between entrance to his studio being through the first door on the left as one entered Hand-court – which necessitated passing through the shop – and

89 Studio of Rembrandt van Rijn, *The Holy Family at Night* (*The Cradle*), 1642–8, oil on panel, 23⅝ × 30⅜ (60 × 77), Rijksmuseum, Amsterdam.

90 Rembrandt van Rijn, *The Mill*, 1645–8, oil on canvas, 34½ × 41½ (87.5 × 101.5), National Gallery of Art, Washington, DC.

the second door which may well have been marked 'Private',[5] and thus been identifiable by visitors as belonging to the young artist.

In Pall Mall between April and June 1793, a London art dealer mounted an exhibition of 147 Dutch, Flemish and German pictures that had formerly belonged to Louis Philippe Joseph, the Duc d'Orléans (1747–1793). They included two paintings that strongly impacted upon Turner at this time, or would do so later. One was *The Holy Family at Night* (*the Cradle*). This shows Jesus in a crib (fig. 89) and although in 1793 it was regarded as being by Rembrandt van Rijn (1606–1669), it is now thought to have been painted by one of his pupils. The other work, *The Mill* (fig. 90), is indubitably by Rembrandt. Although Turner would enjoy the opportunity of seeing it again in 1806, it affected him deeply in 1793. The combination of a solitary building set against what Turner believed to be a dawn sky, and located upon a dark hillside that rises above an open stretch of water, would be replicated by him in several depictions of castles in similar landscape relationships and light conditions he would create during the late 1790s.[6]

Before the War

Turner may well have remained in touch with Mauritius Lowe after 1789 and remembered his first teacher's keen interest in pictorial allegory. At any rate, in 1793 he made an ambitious allegorical statement of his own, in the form of a very large watercolour (figs 91 and 92). Here he removed Windsor Castle from its normal setting in Berkshire and placed it upon an incline that looks very like part of the Avon Gorge near Bristol. The result may seem topographically bizarre, but in this very peculiarity resides a vital clue that we are not looking at a straightforward landscape depiction.

In fact, the watercolour is a systematically ordered allegory of peace and harmonious social relations, with Windsor Castle standing for the political and social power of the British monarchy, and all of the other elements of the image falling into place behind it as *signifiers*, rather than merely acting as topographical contributions. Thus in front of Windsor Castle rises a sunlit spire. Necessarily this betokens the spiritual realm, as represented by the Church of England. The presence of a town or city is strongly implied by the location of this structure, for such a conurbation could well begin with the buildings situated on the brow of the hill in front of it, and continue over that crest to stand under the protection of the church supporting the spire. Much nearer to hand, a large factory and its ancillary buildings collectively signify industry.[7] There can be no doubt that we are looking at a factory, for the roof with its long sets of skylights makes that evident. By 1793 the similar forms of Richard Arkwright's three cotton mills of 1771–83 in Cromford,

Derbyshire, had set the pattern for mills and factories throughout Britain,[8] and they would continue to do so thereafter. Moreover, that we are looking at a factory receives support from the fact that the building is placed near a river that could have supplied it with the energy it required.

The quay in front of the factory points to the most efficient way of taking heavy goods to market in a pre-railway Britain that possessed few surfaced roads, and in which canals and rivers instead served as major industrial and commercial arteries. Naturally, the moored vessels represent the transportation on such waterways. Beyond the boats are cultivated fields, with smoke issuing from a

Above 91 *Britain at Peace* (formerly known as 'Imaginary Landscape with Windsor Castle', and as 'Imaginary Landscape ?on the River Teifi'), here dated to 1793, pencil and watercolour with gouache on paper, 18 × 29⅛ (46 × 74), Turner Bequest XXXIII-H, Tate Britain, London.

Right 92 *Britain at Peace* (detail).

93 *Arch of the old abbey, Evesham*, signed and dated 1793, blue and grey washes, watercolour and black ink over pencil on paper, 8½ × 11 (21.1 × 27.9), Museum of Art, Rhode Island School of Design, Providence.

94 *Arch of the old abbey, Evesham*, 1793, watercolour over pencil on paper, 8½ × 10⅞ (21.2 × 27.6), private collection.

building that might well be a farmhouse. The smoke indicates that peaceful life is being enjoyed there. To right and left of the fields, and across the entire foreground, are areas of wilderness. All the regions of tamed nature have obviously been wrested from former stretches of that wasteland. In the foreground a road and a pack mule serve as additional reminders of commerce. It can be noted that the sky is very peaceful, with no storm clouds that might associatively denote stress and conflict anywhere in sight.

The image therefore contains representative examples of almost all the leading aspects of British life. Only one important sector of society is unrepresented, namely the military. This could easily have been signified by the introduction of a few soldiers or sailors into the landscape. Their absence makes it evident that we are perceiving a peaceful scene and that, taken as a whole, we are witnessing a systematic analysis of British society immediately prior to the outbreak of war early in 1793. To effect this symbolic depiction of peace and socio-economic order, Turner necessarily resorted to a synthesising approach to landscape, for there was no other way of bringing together all of the associative signifiers he needed. Such synthesis in landscape painting had been approved by Sir Joshua Reynolds in his fourth discourse as the way to overcome the 'accidents of nature',[9] or the arbitrariness of reality and experience. Turner's image is not topographically cavalier, for topographical veracity played no part in it. Instead, the young painter wanted to remind his fellow countrymen of what had been lost when Britain went to war with France. He was looking back nostalgically at a nation at peace and, by implication, expressing the hope that peace would soon return. That is why it is wholly appropriate to rename this watercolour *Britain at Peace*, for such a title enacts a far more accurate description of its contents than the wholly inauthentic, inadequate, uncertain and misleading name of 'Imaginary Landscape ?on the River Teifi' under which it labours at present.

Given the scale and complexity of the image, Turner must have worked on it over a period of several months; indeed, it was clearly his most ambitious work to date. That he put so much effort into it was only fitting, given its thematic range. It is not known why he failed to display it, for its size and detail strongly suggest it was made with exhibition in mind. Perhaps the realisation that such a wistful view of Britain at peace might be interpreted as anti-patriotic when the nation was at war prevented its display. But *Britain at Peace* of 1793 was Turner's first generalised landscape in the grand manner (albeit only in watercolour); his first associative landscape of any consequence; his first extended allegory; and, by dint of the fact that it alludes to both the recent past and the desired future of his native land, his first large-scale historical composition. As such, it undoubtedly forms one of the key works in his *oeuvre*.

95 *Hereford Cathedral*, 1793, watercolour on paper, 12⅛ × 16½ (30.9 × 41.9), Hereford Museum and Gallery.

In the summer of 1793 Turner revisited Oxford. If his mother was in Sunningwell, then perhaps he went to see her. Subsequently he moved on to Hereford as part of a tour that also took in Worcester, Great Malvern, Ledbury, Tewkesbury, Evesham and the Wye valley. He was back in London by 6 August 1793, when he signed into the Academy of Living Models. Watercolours emanating from the 1793 tour of south Wales, Herefordshire and Worcestershire include two views of the archway of the old abbey in Evesham (figs 93 and 94). In both may be witnessed the optical glare that Turner would often create later in life. This was achieved by gradually lightening the shadowed tones as they near the bases of the arches and, in one of the works, by severely restricting the tones used for the sunlit tower to a very narrow range from light to dark. The tonal delicacy of that tower is further intensified by the dark accents provided by some wheeling birds, which are a fairly rare sight in Turner's output anyway.

Arguably the finest watercolour to emanate from the 1793 visit to Hereford is a view of its cathedral (fig. 95). Here one of the houses on the right was drawn in a perspectivally incorrect manner. However, the differentiation of light and dark is faultless, with everything rooted spatially by means of the most meticulous tonal gradation. Because of the play of light within the many shadowed areas, the entire scene is subtly energised.

Turner and the Picturesque

The 1793 Hereford watercolour arguably constitutes the most impressive city view that Turner had created to date. In it he purposefully contrasted the splendid cathedral with the many dilapidated but highly characterful buildings that surrounded it. During the 1790s his alertness to quaint architectural structures would intensify, moving him to depict other ramshackle dwellings standing near to venerable buildings, as well as ecclesiastical and secular piles shattered at the behest of monarchs, parliaments or by civil war, houses visibly falling apart, decrepit ancient cottages, immensely quirky inns and pubs, old-fashioned market squares, rickety bridges supporting human habitations, cracked watermills, abandoned churches employed as agricultural sheds, pig pens and chicken runs, and neglected medieval halls used for storing animal fodder, farming implements and the like. Because of such subjects, Turner has often been linked to the then fashionable cult of the picturesque, with its taste for highly characterful buildings and ruins. But did the theory of the picturesque prompt these responses, or was Turner motivated by some greater actuality that underlay that body of ideas?

The connection of Turner with the picturesque is particularly understandable around 1793, for promulgation of the theory of the picturesque was then at its height. In the previous year the Revd William Gilpin (1724–1804) had provided an aesthetic framework for the picturesque with a book of essays theorising picturesque beauty, travel and sketching practice. In the following year another theorist, Uvedale Price (1747–1829), would publish his *Essay on the Picturesque* in which he attempted to place the picturesque on the same aesthetic level as the sublime and the beautiful. In 1794, too, the connoisseur, writer on aesthetics and collector Richard Payne Knight (1750–1824) would publish a didactic poem, *The Landscape*, that would offer an alternative explanation as to what constitutes the picturesque, as well as explore further ramifications of the concept, especially its inherent associationism.

These and several other such analysts were all principally catering to the new middle classes that the Industrial Revolution was bringing into existence. Until the eighteenth century, the aesthetics of landscape were largely taken for granted by most people in Britain (if they were ever accorded any consideration at all). However, when industrialisation began to give rise to the middle classes while simultaneously creating far greater geographical mobility, the resulting tourists – who included many an amateur painter among them – were frequently unable to come to terms with the landscapes at which they gazed. They needed educating in what to look for and how to go about it. Gilpin proved especially good at providing just what was needed, as was demonstrated by the huge success of his many books on particularly attractive parts of Britain.

Because nature in the raw often proved too much for the new middle-class tourists, theorists of the picturesque such as Gilpin, Price and Payne Knight frequently mediated that realm by means of art. For example, Gilpin was especially fond of vistas that might remind the viewer of landscape depictions by Claude Gellée, le Lorrain (c.1604–1682). No less attractive were wild scenes that provoked memories of works by Salvator Rosa (1615–1673), or impressive landscapes that brought to mind the pictures of Nicolas Poussin (1594–1665). And given the attraction to the rough, the ragged, the rugged and the timeworn that stood at the very heart of the picturesque, it was equally understandable that for some commentators and painters – notably Price and Gainsborough respectively – a strong vein of the picturesque was seen to run through Lowlands art, with its manifold depictions of unkempt villages and weather-beaten cottages, characterful windmills, blasted heaths, rutted tracks, gnarled or pollarded trees and the like. As we have seen, Gainsborough's Lowlands-influenced landscapes had already impressed Turner well before 1793. In that attraction lay the seeds of the latter's affinity with Lowlands art more generally, especially Dutch landscape painting.

It appears highly probable that before Turner embarked on his visit to Tintern in 1792 – and possibly again the following year – he read or looked into a book on Wye valley scenery that Gilpin had published in 1782, if only to glean tips on especially picturesque places to see. Another book by Gilpin, on scenery in the Midlands, the North of England, and the mountains and lakes of Cumberland and Westmoreland, was certainly known to Turner by 1789 or thereabouts, for he copied two aquatints in it.[10] However, there is no indication in his writings or recorded sayings that he ever read any of the other books, essays and poems on the picturesque by Gilpin, Price and Payne Knight.[11] When he occasionally employed the word 'picturesque', he would do so simply to denote the broken and the rough (as opposed to the ordered and the smooth), those qualities within a given landscape that would prove most amenable to pictorialisation.

Such related meanings overlapped with further definitions advanced by theorists of the picturesque, for whom the term could also signify the fashioning of vistas, gardens, follies and the like, in order to invest them with 'that peculiar kind of beauty which is agreeable in a picture' (to quote Gilpin).[12] Naturally, the various theories of the picturesque must have been discussed by the Academicians and students who surrounded Turner within the Royal Academy and its Schools during the early 1790s. Yet it does not seem likely he depicted a great many landscapes and architectural subjects that look picturesque because he was induced to do so by student discussions and the rest, let alone by the literature on the picturesque. After all, he was surely the one artist in Britain during the period in which the theory of the picturesque flourished who required the least prompting as to what would look 'agreeable in a picture'. So

what explanation can we find for the frequency with which Turner represented subjects that seem so picturesque?

One answer could reside in the fact that tumbledown, shattered and shaky subjects always make it easy to create interesting images, for their forms are imbued with character. Turner became a master of such picturesqueness. But another and far deeper answer as to why he so frequently addressed the picturesque resides in his cultural surround.

By the 1790s vast changes were afoot throughout an increasingly industrialised Britain. The transformations caused by the increasing migration of people away from the countryside to towns and cities, by the consequent growth of those areas of population, and by the encroachment, density and ugliness of such environments were becoming ever more apparent. By 1793 Turner was undoubtedly aware of this impingement, for his *Shipwreck on a rocky coastline, with a ruined castle* of 1792–3 (see fig. 80) proves that he knew de Loutherbourg's *Coalbrookdale by Night* (see fig. 84), and anyone who has ever set eyes on that painting could hardly remain unaware of the cost of 'progress'. Turner himself would always harbour mixed feelings of excitement and uncertainty about the Industrial Revolution, and he would vividly express that ambivalence in his most popular work, *The Fighting 'Temeraire'* of 1839.

Throughout British society, the insecurity engendered by industrial change frequently gave rise to a profound identification with the self-confidence of preceding eras, and especially with the deep sense of spiritual and psychological conviction that had brought about the emergence of the Gothic style in architecture during the late Middle Ages. Such an identification explains why large numbers of artists and architects of Turner's day would not only connect with the Gothic style but even revive it. As we have already seen, and will do so again many times, Turner greatly admired the complexities and beauties of English Romanesque, Gothic and late medieval architecture, whether it remained intact or lay in ruins. Moreover, during the 1790s he was particularly responsive to highly characterful secular architecture dating from the centuries that followed the Gothic epoch. Such involvements were as important to him as they were to many of his leading contemporaries such as Dayes, Rooker and Girtin. All of them were somehow aware of the fact that an older and enormously cherished Britain was already beginning to slip from view as the country transformed itself into the world's first industrialised society. By depicting so many of its most picturesque buildings, and especially those teetering on the edge of collapse, Turner and his contemporaries were capturing some of the last surviving glimpses of that earlier era before it disappeared for ever. Here, surely, lay the ultimate reason why so many artists became so interested in picturesque subjects and why Turner in particular would always retain that regard. The decayed and the antiquated, the seedy and the crumbling, the neglected and the ruined, all profoundly appealed to him because they either possessed a history or had suffered from its effects, and because history itself is a very sharp reminder of the transience of existence. Turner would later become arguably the finest of British history painters, and that power grew directly from a recognition of the effects of history upon architecture that had first emerged during the 1790s. In Turner and the picturesque we are actually witnessing a crucial aspect of the artist in germination, namely his response to modernity, change and the loss of the past. Such concerns would never leave him. Instead, they would always fuel his intense romanticism and sense of artistic purpose.

6

A Mere Six to Eight Tones by Candlelight

1793 to 1794 and beyond

The speed of Turner's development during this period can be seen especially clearly if we compare *Tintern Abbey, West Front* of 1792 (fig. 96) with *The Founder's Tower, Magdalene College* of about a year later (figs 97 and 98). In the latter drawing the command of tonality and draughtsmanship are far more assured. The somewhat jagged, de Loutherbourg-influenced approach to foliage encountered from late 1792 onwards is evident on the right, while the very low viewpoint adds to the grandeur of the Founder's Tower. And in the gardener's scythe may again be encountered the painter's propensity for pictorial rhyming, to be seen in the way that the quarter circle formed by the blade of the scythe is amplified by the semicircle formed by the top of the nearby entranceway. It subtly strengthens the relationship between man and building.

An unfinished design of this period, *St Mary's Church and the Radcliffe Camera from Oriel Lane* (fig. 101), points to the future. It was developed from a drawing in the first scale practice set (see fig. 69). Perhaps it was abandoned because the delicate tones used to underpaint the building on the left communicate a dazzling sense of light that the artist felt it necessary to preserve. By not much later a brilliance of light brought about by such a narrow tonal range or even through the reservation of the paper – that is, the preservation of the inherent whiteness of the sheet – would become fairly common.

In the late summer of 1793 Turner was invited to make an oil painting of Rochester castle and its environs, and to do so before the subject itself. The invitation was extended by the Revd James Douglas (1753–1819), the Chaplain in Ordinary to the Prince of Wales and an antiquarian and amateur geologist with a distinguished publishing record.[1] Although he lived in Rochester, he had first come across the young artist when visiting the barber's shop in Maiden Lane.[2] He put Turner up in Rochester for the duration, and also supplied the canvas on which to paint the work. The resulting picture disappeared long ago, but it was described as being 'a view of Rochester Castle, with fishermen drawing their boats ashore in a gale of wind'. According to the same observer, it was well drawn, stylistically influenced by de Loutherbourg and carefully elaborated with semi-opaque paint used so thinly – like watercolour in fact – that the pigments had run down the canvas.[3]

Once he had completed the oil, Turner went on to tour Kent in the company of an engraver, Edward Bell (fl. 1793–1840?), visiting Canterbury, Margate, the North Foreland and probably Ramsgate, Broadstairs and Deal. In Dover, he made a number of detailed pencil drawings, to one of which he added watercolour to its sky in order to depict a storm approaching from offshore. It furnishes our earliest Turnerian glimpse of the immense power of the sea (fig. 99). Subsequently, Turner went on to Little Hawkwell, near Tonbridge, where his mother's older sister resided with her son, his first cousin William Harpur (1767–1810). A particular object of Turner's attention on this trip were picturesque watermills, including Pembury Mill, a working

Detail of fig. 103.

96 *Tintern Abbey, West Front*, 1792, watercolour on paper, 16½ × 12½ (41.9 × 31.6), Henderson Bequest, British Museum, London.

97 *The Founder's Tower, Magdalene College*, 1793, watercolour on paper, 14 × 10⅜ (35.7 × 26.3), Salting Bequest, British Museum, London.

98 *The Founder's Tower, Magdalene College* (detail).

99 *Storm off Dover*, 1793, pencil and watercolour on paper, 10 × 14¼ (25.4 × 36.1), Turner Bequest XVI-G, Tate Britain, London.

100 *Interior of King John's Palace, Eltham*, 1793, watercolour on paper, 13 × 10⅝ (33.2 × 27), Yale Center for British Art, Paul Mellon Collection.

concern with which Harpur was probably involved by 1793 and a building in which he would live slightly later.[4] Back in London, Turner and Bell often went sketching on the Thames. One day their boat got stranded in thick mud because they were so busy drawing they failed to notice that the tide was going out. Only with great difficulty did they manage to refloat the vessel.[5] Turner elaborated a sunset view in oils from a sketch he had made on the boat, but sadly it has long since disappeared.

In the autumn of 1793 Turner began a large number of watercolours from sketches and studies made in Kent not long before. One of them was *Interior of King John's Palace, Eltham* (fig. 100). Turner may have revisited the building on his way to Rochester a few weeks earlier. The structure was in use as a barn at the time. In the watercolour he represented its hammerbeam roof in perfect perspective and with a complete understanding of its architectural complexity. To capture the strength of brilliant sunlight as it enters a dark space, he greatly narrowed the tonal range of everything at the lower-centre and lower-right. By the barn door he rubbed the surface of the paper to the point of granulation, thereby evoking the dustiness of the ground. Already, at the age of just 18, he was employing unconventional means to push painting to the limits of the visual.

Facing page 101 *St Mary's Church and the Radcliffe Camera from Oriel Lane*, 1793, pencil and watercolour on paper, 20¾ × 15 (52.8 × 38.2), Turner Bequest XXVII-X, Tate Britain, London.

102 *Rochester*, 1793, pencil and watercolour on paper, 8½ × 11 (21.6 × 28.1), Sterling and Francine Clark Art Institute, Williamstown, Mass., Gift of the Manton Art Foundation.

Having recently received a commission to make watercolours for line-engraved reproduction in a serial publication, the *Copper-Plate Magazine*, Turner had also made a distant pencil study of Rochester during this stay there. From it, he probably elaborated a view of the city in the immediate aftermath of the Kent tour (fig. 102). The vista is partially blocked by three boats, while a fourth vessel passes downstream beyond them. Such partial obstruction of a view would become a common feature of Turner's art, and it may well have made its initial outing in this watercolour. It is easy to see why he created such blockages: he not only wanted us to look at his images, but also to have to work hard at doing so. No less recurrent would be his tendency to place ships or boats in jumbled groupings, even though he could easily have separated and distributed them across a wide arena. Before he was even 19 he had discovered another of the pictorial tricks he would play for the rest of his life. And there can be no doubt why he liked such jumbles: they enabled him to create varied shapes. These satisfied a longing for complex forms that was lodged deep within his psyche.

A third fine work to grow out of the autumn 1793 Kent tour was *The West Gate, Canterbury, Kent* (fig. 103). Here we encounter the painter's fondness for circular structures, as well as his predilection

Facing page 103 *The West Gate, Canterbury, Kent*, 1793, pencil and watercolour on paper, 11 × 8 (27.9 × 20.2), National Gallery of Ireland, Dublin.

for juxtaposing the sturdy and the flimsy, to be seen in the tower and lean-to before it. As in the earlier depiction of Hereford (see fig. 95), the surface of a body of water is divided into a number of wide, parallel and highly reflective ripples. Such an approach is also evident in a number of other drawings made during the 1793–4 period.

Naturally, as Turner was now elaborating watercolours composed of a great many tones, and as he was undoubtedly working upon them in large batches, each work was being created over a longer period, although the time that was being individually expended on them was probably shorter than ever. Such industriousness surely explains why we virtually lose sight of him between 8 October 1793 and the end of April 1794, when he again exhibited at Somerset House. Yet thankfully there now exists a new way in which we can catch sight of him, and not only at this point in his life but during the rest of it.

Securing the Money

On Tuesday 4 March 1794, and again on the following Friday, 7 March, Turner acquired Bank of England Consolidated £3% Annuities, in two tranches of £100 each.[6] And when he would subsequently receive payment for many of his works, he would also often use the money to purchase this type of stock, as well as Reduced £3% Annuities and Navy £5% Annuities. Thereafter, when cash was required, he would simply sell stock to obtain the scrip and loose change from the various stockbrokers he employed to acquire stocks on his behalf through the Bank of England. Although this was not Turner's only bank – for the monies accruing from the sales of a number of major paintings did not get converted into government stock, particularly during the 1800 to 1803 period – nevertheless it was clearly a principal bank of choice, if not even the main one. Probably this was because he did not trust any of the hundreds of private banks that then operated throughout Britain. Such distrust would prove wise, for many times in the years to come a sizeable number of these institutions – including some major London ones – would fail, ruining their account holders in the process. Turner would remain untouched.

Because the Bank of England maintained a meticulous record of its stock transactions by means of double-entry bookkeeping in huge ledgers,[7] from 4 March 1794 onwards we therefore possess a highly detailed record of many of Turner's banking operations throughout the rest of his life. Equally, from the compilation of a running total from this data, we can fix his nominal financial status at any given moment after 1794. And as a great many of his Bank of England ledger entries are linked to the sales of his works, we simultaneously possess an indirect record of those sales. Just as evident are some of Turner's major expenditures. Of course, government stocks fluctuate in value daily, and an attempt to chart those changes in relation to Turner's holdings remains beyond the scope of this work. Similarly, we cannot determine any dividends he received from his Bank of England investments, quite simply because the ledgers used to record those amounts have not survived. But we can ascertain his apparent holdings, as will be set out below and in the Appendix to this book.

John Soane was the likeliest person to have advised Turner to invest in Bank of England stock. After all, as an architect he was used to handling money, and since 1788 he had been the official architect to the Bank of England. In that position he had been responsible in 1791–2 for the design and construction of the Stock Office, the very department through which the painter invested.

One of the two £100 amounts that Turner invested in 1794 could easily have derived from the sales of watercolours by that year. The other £100 might have emanated from payment for the 1793 Rochester oil painting. That is very probably the kind of sum that a canvas by Turner would have cost by that date. Moreover, it is not far from the amount that he must have received from the sale of the very first oil painting he would ever publicly exhibit, which transaction would take place a couple of years later. In an era in which ordinary working men often earned just £26 per annum for a six-day week with no job security, no annual holidays, no medical insurance or state health provision, no unemployment benefit and little or no chance of saving anything, £200 was not a bad sum for a youth of 18 who had raised himself from humble beginnings. Investing £200 in low-yield, long-term government stock was a safe and steady way of increasing capital. In the main, such security was what Turner would always seek for his money. Where finance was concerned, he was averse to taking risks.

The 1794 Royal Academy Exhibition
FRIDAY 25 APRIL TO SATURDAY 14 JUNE

This year Turner displayed five watercolours of ruins, landscapes and buildings in Cardiganshire, Worcestershire and Kent. They were all hung in the converted Academy of the Antique on the first floor. Two of them are reproduced here.

In *Porch of Great Malvern Abbey, Worcestershire* (fig. 104) the subtle glow of the porch was created by the architectural details having been drawn over the underlying washes in extremely light tones. As in the work discussed next, the windows are now reflective instead of appearing simply as blank, dark apertures. At long last, Turner had grasped how light operates upon glass.

Immense poetic licence was used in *St Anselm's chapel, with part of Thomas-à-Becket's crown, Canterbury Cathedral* (fig. 105), for the

104 *Porch of Great Malvern Abbey, Worcestershire*, R.A. 1794 (336), pencil, watercolour and gouache on paper, 12⅝ × 16⅞ (32.1 × 42.9), Whitworth Art Gallery, University of Manchester.

section of building represented was doubled in height and halved in width. In order to boost its scale even further, the relative size of the staffage was reduced. An extremely low viewpoint also makes the building tower over us, and that effect is heightened by the upright format which reinforces the many verticals in the image. The two Rowlandson-like figures look very clumsy and characterful, and by means of them Turner contrasted profoundly sophisticated architecture with raw humanity. By dint of this contrast we are encountering yet another of his moral landscapes.

Turner gained his first newspaper reviews this year. On 13 May the *St James's Chronicle* praised the placing and precision of his outlines and his colouring abilities, while the *Morning Post* of 24 May declared that three of his watercolours were among the best works in the exhibition.

The Midlands and North Wales, 1794

Most of July and possibly part of August this year was spent in the Midlands. Turner travelled up to Northampton, from where he progressed mainly by foot to Warwick, Birmingham, Lichfield, Wolverhampton, Bridgnorth, Shrewsbury, Chirk, Llangollen, Wrexham, Chester, the Wirral, Buxton, Matlock, Derby, Nottingham, Newark-on-Trent, Lincoln, Peterborough, Ely, Cambridge and Waltham Cross. Not far from Nottingham he visited relatives on his mother's side who lived at Shelford Manor House, near Radcliffe on Trent. As they were his only relations to live in a grand house, it seems natural he should have wanted to meet them. More than forty years later a third cousin who remembered this visit would return the courtesy in London, to Turner's extreme consternation (which would quickly subside).

Turner was greatly inspired by the cathedrals at Lichfield, Lincoln, Peterborough and Ely, just as he was by ruined monastic buildings at Buildwas, Valle Crucis and Crowland (or Croyland). Old shops in Chester and Lincoln intrigued him too. Castles in Warwick and Newark-on-Trent would respectively receive heroic and elegiac treatment (see fig. 106 for a representation of the former building). The bridges in Shrewsbury carrying the main roads between England and Wales stimulated him sufficiently to make watercolours of them in due course; one of them appears here (see fig. 128). Small images of subjects drawn on this tour would be reproduced in the *Copper Plate Magazine* before 1794 had ended, and others – especially Midlands cathedral views – would appear in that publication in subsequent years.[8] For decades to come Turner would continue to depict places from sketches and studies made on the trip. Some particularly fine examples created in or around 1794 are *Warwick Castle and Bridge* (fig. 106); *King's College Chapel, Cambridge* (fig. 107); and *Llangollen, North Wales* (fig. 108).

The last of these drawings may have been the very first work in which Turner represented truly grand hill scenery he had actually observed (as opposed to vistas simply imagined or copied). We look south-westwards across the Vale of Llangollen at around midday, with Llangollen church and bridge highlighted in the centre, and the bulk of Moel-y-Geraint or Barber's Hill beyond. The composition is dominated by that hill and by further heights that rise to the distant skyline in fold upon fold upon fold. Quite evidently, Turner found psychological liberation and spiritual exaltation in heights such as these. And by placing Llangollen so near the foot of the image, he appears to be stating that amid such scenery, the creations of man seem puny.

Facing page 105 *St Anselm's chapel, with part of Thomas-à-Becket's crown, Canterbury Cathedral*, R.A. 1794 (408), pencil and watercolour on paper, 20⅜ × 14¾ (51.7 × 37.4), Whitworth Art Gallery, University of Manchester.

106 *Warwick Castle and Bridge*, 1794, watercolour and pencil with gum on paper, 16¾ × 20¾ (42.5 × 52.7), Whitworth Art Gallery, University of Manchester.

107 *King's College Chapel, Cambridge*, c.1794, watercolour on paper, 13 × 9 (32.9 × 22.9), King's College, Cambridge.

108 *Llangollen, North Wales*, c.1794, watercolour over pencil on paper, 8 × 10⅜ (20.2 × 26.3), Whitworth Art Gallery, University of Manchester.

In *Ely Minster: Transept and Choir* (fig. 109) – which was elaborated within the building itself – Turner captured the immense spatiality of the cathedral and suggested something of its underlying structural dynamics. Throughout the drawing, the firmness of the linework is astounding, especially the freehand depiction of the curved ribbing of the vaults. This pencil study would form the basis of two outstanding watercolours (see figs 155 and 165), the first of which would be exhibited at the Royal Academy in 1796.

Back in London, Turner set to work making watercolours for copying by engravers. One of them was a depiction of All Saints' Church, Northampton (fig. 110), although its reproduction would never be published. Thirty-six years later the artist would elaborate a watercolour of essentially the same view and reintroduce the stagecoach that had distantly appeared in the first scene. Some things lodged hard and fast in his memory. And he also laboured over more ambitious images. One of them (fig. 111) is a signed and dated variant

109 *Ely Minster: transept and choir*, 1794, pencil on paper, 26¼ × 20½ (66.6 × 52), Turner Bequest XXII-P, Tate Britain, London.

110 *Northampton*, 1794, pencil and watercolour on paper, 2¾ × 4½ (7 × 11), Northampton Museum & Art Gallery.

111 *Malmesbury Abbey*, signed and dated 1794, watercolour on paper, 13¾ × 10 (35 × 25.4), private collection.

of the view of Malmesbury Abbey exhibited at the Royal Academy two years earlier (see fig. 55). Understandably, the new version enjoys a greater tonal range than its predecessor, as well as a tauter compositional structure. It also demonstrates Turner's ability to connect representations made years apart, for whereas in the 1792 version a farm worker carries a pail of pigswill towards us, in the 1794 version the pigs have been fed and a yoke-bearing rustic moves off with his milk churns away from us.

Turner still occasionally looked in on the Academy of Living Models, but perhaps lax supervision and overgrown schoolboy behaviour in both the plaster and life schools put him off attending more frequently.[9] One work that may date from 1794 is a chalk drawing of a seated male nude in a landscape setting (fig. 112). The modelling

112 *Academy study of a seated male nude with a staff, and with his right arm on his head, in a landscape*, c.1794, chalk on paper, 18¼ × 11⅞ (46.3 × 30), Turner Bequest XVIII-C, Tate Britain, London.

113 *Academy study of a standing male nude, with right arm raised, seen from behind*, c.1796, chalk and watercolour on paper, 20¾ × 13¾ (52.7 × 35), Turner Bequest XVIII-G, Tate Britain, London.

and proportioning of the figure are adroit, but by placing the head and torso near the top-centre of the piece of paper when commencing work, Turner made a commonly encountered blunder: he had a large empty area to fill on one side of the sheet but ran out of space on the other, which is why a foot was cut off. (If the head and shoulders had been placed far over to the left, the appendage would never have suffered that fate.)

After 11 March 1794 we lose sight of Turner in the Schools until December 1795, for the attendance books for most of 1795 are lost to us. In 1796 he would register three times in January, once in February, once in March and twice more prior to mid-August. A forceful depiction of a well-built man seen from the rear might date from 1796 (fig. 113). The perspective, modelling, comprehension of the musculature and sense of animation are all skilful, and they completely belie the notion that Turner did not understand the human frame.

Officially, Turner should have finished his seven-year period of Schools study in December 1796, but as he had flourished as a professional artist since well before that time, obviously none of the Visitors gave any thought to the rules. After August 1796 Turner did not sign in again except on three occasions in 1799. Clearly, he looked in on the life class simply as the mood took him, and he would go on doing so for the rest of his life. Always he would feel

he had something to learn from the human body, from the act of looking, and from thinking about how to translate his perceptions into inventive marks on a flat surface.

On Certain Winter Evenings

During the winter of 1794–5 a part-time occupation began to give Turner a small but regular amount of pocket money, plus something delicious to eat. The labour in question was provided by a Fellow of the Royal College of Physicians and the Chief Physician to both the Bridewell Prison and the Bethlehem mental hospital, Dr Thomas Monro (1759–1833, fig. 114). He also ran private asylums in Hackney and Clerkenwell. Like earlier members of his family, he specialised in psychiatry, or what passed for that science in the eighteenth century, which by modern standards was not much. And Dr Monro was also an enthusiastic amateur artist and art collector; indeed, if it had not been for the untimely death of his older brother (in whose stead he took up medicine), he might well have become a professional painter. In the event, he only created charcoal, chalk and wash drawings in the style of Gainsborough, the care of whose mentally ill daughter had been assumed by his physician father in 1771. Monro inherited that responsibility, having become friendly with the portrait and landscape painter down the years. Occasionally he even accompanied him on sketching expeditions.

By the time of his death, Monro's art collection would comprise upwards of 5,500 works. These included oil paintings and drawings ascribed to Titian (*c*.1488/90–1576), Jan Van Goyen (1596–1656), Claude, Rembrandt, Adriaen van Ostade (1610–1685), Rosa, Van de Velde the younger, Antoine Watteau (1684–1721) and Antonio Canaletto (1697–1768). The modern British works in the collection would include Gainsborough's lightbox for viewing hand-painted colour transparencies, as well as oils and drawings by Gainsborough, Richard Wilson RA (1714–1782), de Loutherbourg, Thomas Hearne (1744–1817), Paul Sandby RA (1725–1809), Rooker, John Robert Cozens (1752–1797), Francis Wheatley (1747–1801), Dayes, Girtin, his own drawing master John Laporte (1761–1839), and Turner. It appears likely that Monro had first met the latter when he had acquired 'country sketches' from the Maiden Lane shop window around 1792. In the years that followed, Turner had made watercolours of properties in Finchley and Monken Hadley, Hertfordshire, that were owned by Dr Monro's brothers, as well as a view of the physician's private asylum in Hackney. One of the Turners owned by Dr Monro was the Canterbury Cathedral view exhibited at the Royal Academy in 1794, another the *Llangollen, North Wales* that was probably made later that year.

In March 1794 Dr Monro had moved to 8 Adelphi Terrace, amid an elegant row of houses high above the Thames about a quarter of a mile south of the Strand, to the south-east of Maiden Lane. In his new abode, which afforded breathtaking views across London, Kent and Surrey, Dr Monro hung works by artists ranging from Gainsborough and Laporte to Turner and Girtin, with about 120 watercolours and other drawings adorning his drawing room, and 90 more of them filling his dining room. The walls can scarcely have been visible for works of art.

114 John Henderson, *Portrait of Dr Thomas Monro*, *c*.1795, pen and grey ink on paper, 6⅞ × 5 (17.5 × 12.9), British Museum, London.

As Dr Monro appears to have done when residing previously at 53 Bedford Square, Bloomsbury, he invited up-and-coming artists to visit Adelphi Terrace and copy works in the family collection. They were paid a small sum for doing so, and their drawings were retained by the physician, which is why he would eventually own thousands of them. By December 1794 the Adelphi Terrace house was described by the Royal Academician and diarist Joseph Farington (1747–1821) as being 'like an Academy in an evening' with 'young men employed in tracing outlines'.[10] The drawings they traced (and tinted) were

115 Charles Turner after John Hoppner, *John Hoppner*, mezzotint, 1805, National Portrait Gallery, London.

supplied by some of Dr Monro's friends, including his favourite watercolourist, Thomas Hearne. Others were by the amateur artist, collector and connoisseur John Henderson (1764–1843), who lived along the way at 4 Adelphi Terrace. Among the 'young men' who worked in 8 Adelphi Terrace or would do so down the years were John Varley (1778–1842), his brother Cornelius (1781–1873), John Sell Cotman (1782–1842), Peter De Wint (1784–1849) and Anthony Copley Fielding (1787–1855). Some of the older artists who dropped in on Dr Monro from time to time probably included Michael Angelo Rooker, Edward Dayes and John Hoppner RA (1759–1810, fig. 115). And also employed there 'on certain evenings' or 'stated evenings' during the winters of 1794–5, 1795–6 and 1796–7 were Turner and Girtin, who in mid-November 1798 would tell Farington that 'They went at 6 and staid till Ten. Girtin drew in outlines and Turner washed in the effects. They were chiefly employed in copying the outlines or unfinished drawings of Cozens &c &c of which Copies they made finished drawings.'[11]

The five-day sale at Christie's that would follow Dr Monro's demise in 1833 would contain no fewer than 769 drawings ascribed to Turner. When we take into account the extremely limited nature of what the painter created in the works he is known to have made for Dr Monro, as we shall do shortly, then it becomes clear that it was perfectly feasible for him to have made four drawings an hour, or sixteen watercolours per evening over an average of sixteen evenings per winter between 1794 and 1796–7, thereby creating such a large body of work.

Like everyone else, Turner and Girtin were paid two shillings and sixpence per evening for working at 8 Adelphi Terrace.[12] A variety of food was on offer, including oysters, which was perhaps Turner's favourite delicacy. The two young artists worked at double-sided drawing desks that had been constructed to Dr Monro's specification. As a portrait possibly made by the physician demonstrates (fig. 116), the right-handed Turner would dress up for the occasion, as befits a visitor to a smart house, and with his long hair tied neatly in a queue, probably by his father. A large pot of water was fixed to the front of the desk exactly where it was most needed, with two small receptacles that probably contained cakes of watercolour resting above it. Placed within the water-pot was possibly a small sponge. Such a tool would have proven highly useful for damping paper and removing wet paint. And although we only see a double candleholder at the far end of the desk, probably it was balanced by another one at the near end.

The double candleholder is undoubtedly the most revealing clue to what actually transpired at 8 Adelphi Terrace, for even if it was matched by a second such support, it proves that on Turner's side of the desk he had to work principally by the light of just two candles. Naturally, the flame of one or two candles servicing the other side of the desk would have slightly boosted the light level, and perhaps further candles and candelabra located around the room would have provided even more illumination. Yet necessarily the overall light level would have been poor. The relevance of this will soon become apparent.

From what Farington tells us and as other evidence reveals, Girtin would either trace or copy the outlines of images made by a number of artists who included Cozens, Hearne and Henderson, and then pass his outline drawing to Turner for washing with tints of blue-grey or other colours. But what could Turner have added by way of colours, especially given the meagre light under which he laboured and his abhorrence of working by artificial light?

The answer to this question stares out at us from the great many drawings that Turner coloured for Dr Monro, for the vast majority

Facing page 116 Artist unknown but possibly Dr Thomas Monro, *J. M. W. Turner at a drawing table*, c.1795, pencil on off-white laid paper, 7⅛ × 6¼ (18.1 × 15.9), Indianapolis Museum of Art.

117 Thomas Girtin and J. M. W. Turner, *Entrance to Nemi*, c.1794–7, pencil and watercolour wash on paper, 7¼ × 10³⁄₁₆ (18.4 × 26), Turner Bequest CCCLXXIII-37, Tate Britain, London.

118 Thomas Girtin and J. M. W. Turner, *Castle on Promontory*, c.1794–7, pencil and watercolour wash on paper, 6¹³⁄₁₆ × 9¾ (17.1 × 24.7), Turner Bequest CCCLXXIII-54, Tate Britain, London.

of them are tinted with just six tones of two or three colours (figs 117–20). Occasionally a seventh or eighth tone augments the sense of depth. Yet as we have seen, even by 1793, with the *Gate of St Augustine's monastery, Canterbury* exhibited at the Royal Academy that year (see fig. 88), Turner could produce images made up of more than sixty tones. Obviously, for half-a-crown and possibly his favourite dish he was only prepared to provide Dr Monro with about a tenth of what he could produce at home by daylight, not least of all because he was being expected to part with the results for ever. If he was feeling generous, especially creative or unusually inspired he might throw in an extra tone or two, but in the main he limited himself to just six. Because Dr Monro had purchased the *St Anselm's chapel, with part of Thomas-à-Becket's crown, Canterbury Cathedral* exhibited at the Royal Academy in the spring of 1794 (see fig. 105), with its forty-eight tones of white, blue, ochre, green, green-grey, yellow-grey, red-grey and blue-grey, by the following winter he cannot have remained unaware of the tonal richness that Turner was capable of producing. However, he could hardly have remonstrated with the young man for not providing him with such tonal abundance when he was only paying him a mere two shillings and sixpence to acquire large batches of watercolours, oysters or no oysters.

And this brings us to the ultimate question: why did Turner work for Dr Monro at all, given the mediocre light and appalling pay?

There is an overriding answer here too: although the copying and transcription of many types of images undoubtedly went on at 8 Adelphi Terrace, Dr Monro's 'Academy' was the nearest to a school

119 Thomas Girtin and J. M. W. Turner, *Near the Pantin Bruck, in the Canton of Glarus*, c.1794–7, pencil and watercolour wash on paper, 9½ × 7¼ (24.1 × 18.4), Turner Bequest CCCLXXIV-8, Tate Britain, London.

120 Thomas Girtin and J. M. W. Turner, *A timber-framed house, with a hillside beyond*, c.1794–6, pencil and watercolour on paper, 7½ × 9⅝ (19.4 × 24.7), Turner Bequest CCCLXXV-31, Tate Britain, London.

for the advancement of landscape painting that had ever yet arisen in Britain. Unfortunately, this ad hoc school had come into existence just a little too late for Turner's own training, but nonetheless he gave it his backing. That is why he worked for the physician virtually for nothing. And the use of the word 'Academy' in Farington's 1794 diary entry provides us with some further answers to the question of why Turner laboured at 8 Adelphi Terrace on those winter evenings between 1794 and 1796–7.

It is very evident that Dr Monro had two related reasons for particularly inviting young artists to attend his soirées: they could educate themselves through copying and the like, and they could acquire a little money in the process. In microcosm his 'Academy' paralleled the Royal Academy of Arts just up the road, with its twin aims of educating the young and helping artists by promoting the sale of their works. Dr Monro was never rich enough to pay realistic sums to those frequenting his 'Academy', as was clearly understood by all concerned, Turner included. That is why everyone in attendance was offered a flat rate of just two shillings and sixpence, plus their dinner. You either took it or you stayed away. If you took it, the benefits were tangible: an extremely handsome, welcoming and warm environment on what were often very cold winter evenings; plenty of cultured and convivial company; an abundance of intelli-

gent conversation within a community of artists; a number of beneficial educative tasks; free access to a fine private collection of works of art in a Britain that was completely devoid of public galleries, with good things to copy if required; and the advice and often helpful criticism of one's artistic peers. And during the course of each evening a little financial and culinary recompense was probably washed down with something alcoholic and tasty. That was not at all a meagre tradeoff.

Of all these further compensations, the 'community of artists' would undoubtedly have most appealed to Turner. This is because, having been denied any real family life by his sister's demise and his mother's mental illness, he quickly became the kind of person who adored joining clubs. Of course he was loved by his father, and treasured him in return. Equally, he would form several close friendships, his attachment to Girtin being possibly the first and most profound of them. Moreover, some of his other friends would belong to loving families that would fully extend their welcome to him. Yet none of this would ever suffice. Throughout his adult life, Turner required the camaraderie, pride in belonging to a professional élite, and the focused loyalty and mutual support afforded by clubs. (Moreover, one can quit a club at any time, which is not quite the case with marriage or a family.)

That is why Turner would eventually belong to four clubs: the Royal Academy of Arts which, for most painters and sculptors, was the most élite club in Britain, if not the world; the Royal Academy Club, a club within a club that met regularly for tavern feasts between November and June every year, and at picnics during the summer months; the Athenaeum Club in Pall Mall; and the very first club it was ever possible for him to join, the membership of which was made up of a shifting group of artists who convened on certain winter evenings at 8 Adelphi Terrace, just south of the Strand. Turner was like a fish out of water in polite society, and he would always remain so, as we might expect of a psychologically bruised and unpolished wig-maker and barber's son from an unfashionable part of town. Yet within his peer groups he felt very much at home. When the time came he would be intensely proud of being a Royal Academician, and he must have been no less proud of being a member of Dr Monro's little band of brothers. When Turner's father complained indignantly of '<u>Him</u> making drawings for Dr Monro for half-a-crown', he had truly grabbed the wrong end of the maulstick.[13]

At Dr Monro's house, therefore, Girtin drew outlines of images by other artists for Turner to amplify in monochrome or a very limited range of colours. Somewhat less frequently, Girtin also traced those outlines. Occasionally he expressed the desire to work in watercolour as well, for simply drawing or tracing outlines did not afford him 'the same chance of learning to paint' that Turner enjoyed.[14] He must have been permitted to do so. Yet in the main, the roles of the two young artists were clearly defined, and they can only have remained that way because, while Dr Monro fully recognised Girtin's drawing skills, he also knew that Turner was by far the more advanced tonalist. The latter was therefore capable of providing much more inventive colourings, even if they were necessarily limited in tonal increments.

As Turner and Girtin told Farington, they frequently copied drawings by J. R. Cozens. Early in 1794 the latter had suffered a complete mental breakdown and been taken into the care of Dr Monro. As a result, the physician had obtained temporary custody of seven of his sketchbooks. It was from these that Turner and Girtin mainly worked, as well as from watercolours purchased by Monro at the sale of Cozens's studio effects mounted in July 1794. Moreover, the doctor probably borrowed drawings from other admirers of Cozens as well. Judging by their responses, Girtin and Turner were greatly impressed by the compositional inventiveness and sense of grandeur to be found in the watercolours of Cozens, although Turner probably did not think much of the older artist's ability to gradate tones, for he had rarely created more than seven or eight tonal variants of three or four colours. But at his best, Cozens deeply impressed Turner (fig. 121).

Turner and Girtin also put a fair amount of effort at 8 Adelphi Terrace into copying watercolours by the latter's teacher, Edward Dayes, as well as drawings by Paul Sandby and by Thomas Hearne, one of whose mill scenes Turner had possibly been requested to copy several times by Dr Monro.[15] In 1794 Turner's way of drawing trees began to alter yet again, this time under the influence of Hearne. Now the leafage and boughs are invested with a greater sweep and rhythmic flow, as can be seen particularly clearly in a signed and dated 1794 view of Christ Church cathedral in Oxford (fig. 122). And Turner probably also looked carefully at the Gainsborough lightbox or 'showbox' owned by Dr Monro, with its transparencies painted in oils on glass to effect a brilliant luminosity of colour.

It may have been in response to this lightbox that Turner produced a watercolour of a cottage whose occupant stands outside smoking his pipe with a lantern at his feet.[16] On the reverse of the sheet Turner darkened the paper everywhere except where the lantern, cottage windows and sunset sky appear on the obverse, so that when the drawing is placed before a very bright light, those passages glow vividly. This is but one of a number of experiments in reinforced colour and light transmission that Turner undertook in watercolour between 1794 and 1798,[17] and it is difficult to imagine that such explorations were not aided – or even caused – by seeing the Gainsborough lightbox and transparencies at 8 Adelphi Terrace.

121 J. M. W. Turner probably after J. R. Cozens, *The Falls of the Anio at Tivoli near Rome*, c.1794, watercolour on paper, 19¼ × 12¾ (49 × 32.5), Victoria and Albert Museum, London.

The mistiness in the centre, caused by the nearby fall of water, is an especially fine touch, necessarily based as it was on the close observation of waterfalls elsewhere. The softness of the mist is augmented by the firmer tones used to depict the town above.

Not only did Girtin and Turner copy, trace and elaborate images by John Henderson at 8 Adelphi Terrace, but their images were copied by that near neighbour as well. Apparently, Girtin had worked for Henderson either in 1793 or prior to that date.[18] The wealthy amateur (fig. 123) was an enthusiastic draughtsman, if a somewhat mechanical and uninspired one. In addition to lending his own drawings to Dr Monro for use by others, Henderson also lent drawings by Canaletto. Indeed, it may have been his works by the Italian master (rather than those owned by his neighbour) that exercised a strong effect upon Girtin. The linear style that the latter had rapidly evolved in 1793 in response to Canaletto's manner of drawing had soon rubbed off on Turner, many of whose pencil outlines around 1793 were often similarly invested with Canaletto-like dashes and squiggles, to terminate very frequently in heavy dots as increased pressure was applied to the graphite. However, Turner did not copy the drawings by Canaletto owned by Henderson but preferred copying contemporary works owned by him, and most 'particularly the drawings of antiquities &c. by Thomas Hearne, of which Mr Henderson had a fine collection'.[19] Henderson would eventually own eleven watercolours by Turner, although he would sell off seven of them in 1802.[20]

Henderson was also a painter in watercolours. There are at least four Henderson copies of watercolours by Turner, one of which is sufficiently adept to have been mistaken for a Turner for many years.[21] Additionally, a watercolour by Henderson might have been partially worked upon by Turner. In a sequence of Dover views, the pictorial relationship between the two men becomes far too tangled to be dealt with here.[22] Moreover, the problem of who painted what is compounded by the fact that there are quite a few similar-looking drawings of Dover made by Dayes and Girtin. Sadly, the confusion between all the Turner, Girtin, Dayes and Henderson drawings of Dover has led to the baby being thrown out with the bathwater, for the works in the group that are unmistakably and wholly by Turner have not been included in the standard listing of all his watercolours. As a consequence, they are virtually unknown. But one of the best of them is seen here (fig. 124). It enjoys enormous compositional strength and tonal lucidity.

The Ultimate Benefits

Either at Dr Monro's house or in his own residence, Henderson got Turner and Girtin to trace and/or copy his own pencil outline drawings and then elaborate them in watercolour. But for the very same reason that the lad from Maiden Lane refused to labour for Dr Monro in Full, Glorious Turnercolour, he declined to do so for Henderson as well. Instead, he simply worked up his drawings in around six tones of blue-grey. In Turner's labours for Henderson, as

122 *Christ Church, Oxford*, signed and dated 1794, pencil and watercolour on paper, 15½ × 12⅝ (39.5 × 32), Fitzwilliam Museum, Cambridge.

123 Artist unknown but possibly Dr Thomas Monro, *John Henderson*, c.1795, grey ink on white laid paper, 3⅜ × 4¹³⁄₁₆ (95 × 122), Indianapolis Museum of Art.

in his work for Dr Monro, tonality reigned supreme. And this leads us directly to the fact that he obtained three further advantages from toiling for these men (but especially from working for Dr Monro).

Because painting at night by artificial light in 8 Adelphi Terrace rendered it impossible for Turner ever to create watercolours using the dozens of tones he would normally have developed in such works by daylight, he was forced to select the most crucial tones of all those available to him. The perpetual search for exactly the right tones at Dr Monro's house over three winters can only have boosted his sureness of eye, mind and touch. That was equally the case with the tonal harmonisations of blue-grey created for John Henderson.

Then there was the geographical enquiry that the pencil outlines engendered. Whenever Turner received from Girtin a bare pencil outline drawing of some distant place he had never visited (as was almost always the case in Adelphi Terrace), he was forced to ascertain at the outset the directionality of the view he had been given: was he looking east, west, north or south? This was extremely important, for without such elementary information, geographically correct light effects could not be introduced (it might easily have provoked the scorn of someone knowledgeable about a place if the light source had been situated in an impossible geographical location).[23] Later in life Turner would elaborate a great many depictions of landscapes he had not yet visited or never would behold – in Italy, Greece, the Holy Land, Egypt and India, for example – and almost always he would get the direction of the light correct. That accuracy must have grown out of working for Messrs Monro and Henderson, and from having to ascertain vital directions in the process.

Finally, and perhaps most crucially of all, Turner was forced to use his memory and imagination when working for Dr Monro and his friend. After all, Girtin only ever handed him bare outlines; he then had to impart all the light, shade, architectural substance, foliage and further details to those drawings. Naturally, this process required a great deal of imagination or remembrance of effects viewed elsewhere. Even by 1794 Turner was well on his way to becoming one of the most imaginative painters ever, with both memory and imagination forming the basis of his art. In his own practice beyond the walls of Adelphi Terrace he would often gaze long and hard at a landscape while being forced to imagine how it could look in weather and light conditions other than those appearing before him. No less frequently, and also following the teaching of Reynolds, he would take 'bits' of a place memorised or drawn here, meld them to stretches of a landscape viewed there, introduce effects of light and weather witnessed elsewhere, and mix in human incidents

124 *Dover*, signed and dated 1794, pencil and watercolour on paper, 9½ × 7½ (24.2 × 19), private collection. Not in Wilton.

observed in entirely unrelated locations (and possibly seen quite a lot earlier). This, again, was how one overcame the arbitrariness of experience that Reynolds had disparaged in his fourth discourse. The fact that for some years during the 1790s Turner was forced to put a good deal of pictorial flesh upon bare bones at 8 Adelphi Terrace can only have considerably furthered this side of his art. For that reason, and for all the foregoing ones, the hours spent diligently washing drawings, pocketing half-crowns and swallowing oysters in Dr Monro's house were never time wasted.

7

Coming of Age

1795 to 1796

During these years Turner and Girtin often compared notes. Constantly one of them pulled ahead of the other, and was then overtaken again as they played creative leapfrog. In 1795 Girtin showed Turner *St Paul's Cathedral from St Martin's-le-Grand, London* (fig. 125), in which the space is well defined and the street pulses with life and energy. Although Turner had long been capable of making a comparably elaborate and dynamic street scene – as his Pantheon watercolour of three years earlier demonstrates (see fig. 56) – he nonetheless encouraged his friend to think he had taken the lead by stating: 'Girtin, no man living could do this but you.'[1] In the process he demonstrated the supportive side of his nature rather than told the complete truth. This was because Girtin had depicted all the windows along St Martin's-le-Grand in dark, flat tones. In this respect he still had to catch up with Turner. Not long afterwards, Girtin's watercolour would spur his rival to make another dynamic street scene of his own (see fig. 152).

Around this time the reflectivity of glass caused a confrontation between Turner and an architect named Dobson who had commissioned him to colour a perspective drawing of a mansion. When Turner came to depict the windows, he represented the sky reflecting off the glass. The architect was discountenanced by this approach and insisted that the panes be painted a uniform grey. 'It will spoil my drawing,' said the artist. 'Rather that than my work,' answered the architect: 'I must have it done as I wish.'[2] Turner doggedly obeyed but never laboured for Dobson again. All previous writers on the painter have dated this skirmish to around 1789, but as Turner only noticed the reflectivity of glass in 1794, it must have occurred in that year or just a little later.

Given this mid-1790s work for an architect, and the fact that Turner would still be labouring for such professionals not long before the end of the decade, it appears likely he had continued to assist architects ever since 1789 or 1790, when he had quit the employ of William Porden and Thomas Hardwick. Such labours would necessarily have continued to strengthen his understanding of buildings, of the relationship of man-made structures to natural ones, of perspective and of the properties of colour, light and shade in relation to architecture. He probably thought 'what could be better practice?',[3] just as he had done when supplying skies to architects and amateur artists during the early 1790s.

The teaching of amateurs was another way of putting bread on the table. That Turner was teaching by 1794 is proven by the note 'Major Frazer. April 6. I Hour & Half. 8 Lessons' in a sketchbook used that year.[4] There is also a strong probability that John Henderson received paid tuition in 1794 or by not much later. The artist never obtained more than seven shillings and sixpence an hour for individual tuition, and usually it was just five shillings. He was described by one of his pupils as 'eccentric, but kind and amusing'.[5] Yet his innate reserve, verbal inarticulacy, inability to flatter and

Detail of fig. 156.

125 Thomas Girtin, *St Paul's Cathedral from St Martin's-le-Grand, London*, c.1795, pencil, watercolour, pen and ink on paper, 19¼ × 14⅞ (48.8 × 37.8), Metropolitan Museum of Art, New York.

inherent impatience worked against him being a good teacher of amateurs, as did his belief that 'those who could not obtain a hint would not understand a volume of advice'.[6] Almost certainly this opinion derived from his studies with Malton, whose teaching method 'was divested as much as [possible?] of prolixity and much improved the [matter?] by useful abbreviation', according to Turner himself in one of the perspective lectures he would first deliver in 1811.[7] His fondness for 'useful abbreviation' explains why he frequently hinted at things, rather than explained them to pupils, to admirers struggling to understand his images and to fellow painters attempting to improve their works. Clearly, he thought that the mind needs to make its own connections, rather than have everything spelled out for it. If not, explanation might well lead to a long-term failure in understanding, for it can prevent us from having to work things out for ourselves. Where art is concerned there can be no such short-cuts. Rather than being curmudgeonly, Turner was only forcing others to stretch their deductive and reasoning powers, just as he had been similarly compelled.

While Turner laboured for Dr Monro 'on certain evenings' in the winter of 1794–5, he also worked by day on impressive watercolours of his own. One of them depicts the ruins of Valle Crucis Abbey in Denbighshire, Wales, with the remains of the slightly older castle of Dinas Brân in the distance above (fig. 126). Here again Turner emphasised the degradation of what had once been a noble religious building, as a girl feeding pigs in the foreground makes clear. Such was the long-term historical and moral outcome of the Reformation. The watercolour was developed from a study made on the 1794 Midlands tour, when Turner had visited Valle Crucis from nearby Llangollen.[8] It is one of the earliest works in which he took full advantage of a basic trait of watercolour, namely its resolubility.

When oil paint dries, it does so for ever, and there is no way of revitalising it; it simply hardens. However, when watercolour dries it can always be reactivated with water. That is why it is possible to immerse entire drawings or areas of them in water to remove most or some of their pigment, while leaving behind subtle stains and traces of colour that can be worked over when dry. A related technique is to employ a soft, damp cloth or – even better – a sponge to remove precise or general areas of colour, while imparting texture by means of rubbing and/or dabbing. And Turner also employed stale breadcrumbs to add texture by acting as mini-blotters, soaking up the wet pigment in tiny areas and adding textural variety in the process. All these ways of removing pigment have traditionally been lumped together under the rubrics of 'washing' or 'washing-out', and Turner used them endlessly.

In the Valle Crucis image, he both washed off colour from the sunlit upper section of the landscape and rubbed over that area with dry breadcrumbs, just as he had done to impart an initial, similarly grainy texture to the section of the sheet that would subsequently be overpainted with the abbey façade. In time, the removal of watercolour pigment through washing and sponging would become vital to Turner, and he would frequently use breadcrumbs to add texture. It seems possible that he first explored such techniques in this very work, which may be why he never parted with it.

The 1795 Royal Academy Exhibition
FRIDAY 1 MAY TO SATURDAY 13 JUNE

This year Turner displayed eight watercolours of landscapes and buildings in Wales and the Midlands. One work was hung in the Antique Academy (as the Academy of the Antique was now known during exhibition times) and the other seven in the adjacent Council

126 *The Ruins of Valle Crucis Abbey, with Dinas Brân in the Distance*, c.1794–5, pencil and watercolour on paper, 18⅛ × 14¾ (46 × 37.5), Turner Bequest XXVIII-R, Tate Britain, London.

127 *Cathedral Church at Lincoln*, R.A. 1795 (621), pencil and watercolour on paper, 17¾ × 13¾ (45 × 35), British Museum, London.

128 *Welsh Bridge, Shrewsbury*, signed and dated 1794, R.A. 1795 (593), pencil and watercolour on paper, 8¾ × 10¾ (22.4 × 27.4), Whitworth Art Gallery, University of Manchester.

129 *The Two Eldest Daughters of W. F. Wells playing in an interior*, c.1795, pencil, pen, brown ink and watercolour on paper, 7 × 9 (17.5 × 22.5), private collection. Not in Wilton.

and General Assembly Room. Among the latter group were the two drawings reproduced here.

In *Welsh Bridge, Shrewsbury* (fig. 128), we see a new bridge being built across the river Severn through an arch of the rickety, cracked and crumbling medieval bridge it would soon replace. As always, Turner was intensely aware of progress and the price paid for it. And *Cathedral Church at Lincoln* (fig. 127) was lent to the show by John Henderson. Lincoln Cathedral soars above its picturesque surroundings as people wind down their activities for the night.

Two Young Ladies

Around this time, Turner made a watercolour (fig. 129) of the two eldest daughters of his friend, the artist William Frederick Wells (1764–1836, fig. 130). He and Wells had been close since 1792, when they had both been students together at the Royal Academy Schools. Wells exhibited at the Royal Academy for the very first time this year, and perhaps he was encouraged to do so by Turner. The house in which his two daughters are playing was located at 34 Mount Street, Mayfair, to which address Wells had moved his family earlier in 1795. Clarissa Anne Wells (1786–1873) – known as Clara – is kneeling, while Mary Anne Wells (1788–1861) reclines beside her.

130 H. P. Briggs, *Portrait of William Frederick Wells*, c.1814, oil on canvas, size unknown, private collection.

Clara Wells tells us that Turner loved her father 'with a son's affection' and regarded him as 'an able counsellor in difficulties'.[9] In time Turner would also become 'as an elder brother' to her. She recalled him visiting 34 Mount Street three or four evenings a week during unspecified winters when young, sitting by the fireside and joining her father in drawing or sketching by lamplight while her mother practised her needlework and she herself read aloud from some worthy or entertaining tome. Clearly, Turner completely relaxed in such company, which had decidedly not been the case with the Narraways in Bristol. Perhaps this was due to the fact that Wells expected nothing of him by way of painting, unlike John Narraway, and that 34 Mount Street was always available as 'a haven of rest from many domestic trials too sacred to touch upon'. This observation by Clara Wells perhaps points towards Turner's mother being in Maiden Lane after 1795.

The drawing of the two children at play is only a minor work of art, but it does tell us a good deal about Turner's approach to his fellow human beings. In anatomical terms the depiction of the girls is good, especially that of the reclining Mary Anne, with her tipped toes. Physiognomically, however, both girls look like dolls, with their faces indicated by means of the characteristic Turnerian dots and dashes. Clearly, the painter did not attempt to capture true likenesses. Given such simplified representations, it would be easy to imagine that he suffered from some psychological block that prevented him from seeing people as they really are. But what such an argument would obscure is Turner's clear desire to express what he felt about people by effecting a complete congruence between their outer guise and their inner character, something he had already attained in many works by 1795. When he represented the two Wells children, what could have been more fitting than to draw their faces in a wholly childlike way?

Wales, 1795

We do not know exactly when Turner embarked upon his third foray into Wales, but it is likely to have been sometime in June. Initially he travelled the 130 miles from London to Wells in Somerset. From there he walked the Mendip Hills to Bristol where he possibly stayed with the Narraways. Subsequently he crossed the Severn estuary and then made his way over a number of days via Newport, Cardiff, Llandaff, Ewenny, Bridgend, Margam, Briton Ferry, Neath, the falls at Aberdulais, and Melincourt, to Swansea. Subsequently he slowly moved westwards to Kidwelly, Carmarthen, Laugharne, Tenby, Carew, Pembroke, Haverfordwest and St David's. From there he returned to Carmarthen, from where he walked eastwards up the valley of the river Tywi to Dynavor, Llandeilo and Llandovery. After passing on foot through Brecon, Abergavenny and Hereford – where he surely stayed once again – he took the main road northwards to Leominster. However, before reaching that town he turned off to Hampton Court, a crenellated country mansion on the river Lugg in Herefordshire owned by the 5th Viscount Malden (1757–1839), who in 1799 would become the 5th Earl of Essex.

In all probability, Viscount Malden had seen Turner's watercolours in the Royal Academy Exhibition this year and invited him to visit his borders retreat in order to draw it. The painter stayed at Hampton Court for several days, probably being waited upon hand and foot by liveried servants for the first time ever. Such treatment might well have struck him as an apt reward for all his artistic dedication and hard work. Yet although rich food, good drink, a luxurious bed and assorted laundry services would have proven very agreeable and useful (especially after some of the 'hospitality' he had recently endured in the Welsh backwoods), he must still have been up with the lark every morning to roam the vast estate in search of new sights, not the least of which were provided by the shallow but powerful waterfalls on the Lugg. And by the mid-morning of each day he might have sufficiently slackened off work to have undertaken some fishing. This was an activity he took just as seriously as painting, quite simply because it had already made a vital contribution to his art and would always do so, due to the amounts of time it afforded for intense looking at the movement and reflectivity of water, at skies and at much else besides.

By the time Turner departed Hampton Court, Viscount Malden had commissioned five watercolours of his house and its environs. After returning to Hereford, Turner travelled to Ross-on-Wye, before following the course of the Wye down to Goodrich Castle and Monmouth. From there he returned to London via a country house in Wiltshire we shall come to shortly.

Pencil sketches and watercolours of an extraordinary quality appear in both the sketchbooks that Turner took on this tour,[10] as well as on a number of loose sheets. Among them are depictions of cathedrals (including those at Llandaff, St David's, Gloucester and Hereford); castles (at Kidwelly, Llanstephan, Laugharne, Carew and Goodrich, among others); industrial kilns (one of which was at Llanstephan); no fewer than nine watermills (at Aberdulais, Llandowro and various unidentified locations); gated bridges (such as those in Hereford and Monmouth); shops (at Ross especially); and ruins everywhere. The glory and loss of the past was always with him, as was the transience of the present.

The 20-year-old was so pleased with one watercolour in his large sketchbook that he detached and mounted it (fig. 131). With this work we can determine that he no longer indulged in romantic fantasies concerning the appearance of large rocks, as he had done in various de Loutherbourg-influenced watercolours made in 1792–3

131 *St David's Head from Porthsallie Bay*, 1795, pencil and watercolour on paper, laid down on a washline mount by the artist, 7⅛ × 10½ (20.1 × 26.8), fol. 29 of the *South Wales* sketchbook, Turner Bequest XXVI, Tate Britain, London.

(see figs 78–80). Instead, he had depicted a vast outcrop in terms of its true size and geological make-up. He had also imparted a convincing surge and swell to the sea. It is not surprising that he especially valued this watercolour, for it marked a bold step forward in his development as a marine painter. Now the empty rhetoric of the Sublime had vanished, to be replaced by a true sense of immensity and a strong suggestion of breeziness. We can almost sniff the salt air.

Economy, Anatomy and the Ideal

In creative terms, Turner was becoming hugely economical by 1795, especially in the detailed pencil outline drawings made in his sketchbooks and upon loose sheets. This can be seen especially clearly if we compare a pencil study elaborated in the larger of the two sketchbooks taken to Wales in 1795 (fig. 132), with the watercolour developed from it and exhibited at the Royal Academy in 1796 (fig. 133). In the study Turner fully depicted the sculptural niche near the top of the bell tower but wholly defined only one of the columns on the level beneath it. Obviously such minimal information was all that was required, for he could replicate the further columns from his summary indication. On the next level down, less than half a window arch, a few capitals and some columnar embellishments stand for all their companions. The principal doorway was also indicated merely in part. From this slight visual data, Turner would be able to work up the finished watercolour. There all the colours, light effects and figures would be supplied entirely from memory and imagination. The final drawing will receive further mention below.

By 1795 the economy brought to the Llandaff pencil study had become almost the norm in Turner's representation of architectural subjects or fragments of them. Such simplicity of means, concentration upon essentials and intense discipline may well have been prompted in part by the training in anatomy that the Royal Academy afforded to all the Schools students in Turner's day.[11] At the time, the Professor of Anatomy was Dr John Sheldon FRS (1752–1808), who had been appointed in 1783. Despite suffering from bipolar disorder, Sheldon travelled up to London every December from his home in Exeter in order to deliver his talks, mainly because they afforded him virtually his only relief from his illness. Turner could have attended Sheldon's anatomy lectures in December 1790 and thereafter. Given that in 1809 he would certainly be present at anatomy lectures delivered by Sheldon's successor, it seems likely that he heard the anatomy lectures in the 1790s too. They could have led to serious thought being given to the relationship of skeletal to fully fleshed form, and therefore to the relationship of economical sketches – the bare bones of a subject – to fleshed-out landscapes and seascapes. As we have seen, bare bones and raw muscles had undoubtedly played a part in Turner's earliest art education, with the making of a probationary cast drawing that included a skeleton in 1789. And between that year and 1791 he had copied an *écorché* or figure with the skin removed, as depicted by the Lowlands physician and early modern anatomist Andreas Vesalius (1514–1564).[12]

An equally likely determinant of Turner's analytical and objective approach to drawing was his response to the 'accidents of nature'. By 1795 Turner had thoroughly adopted the synthesising approach with which this limitation could be overcome. While he respected a great many of the places he depicted in general terms, he also allowed himself the utmost latitude to move things around and introduce pictorial elements from elsewhere. Scale could also be enhanced or diminished, light and shade could be altered, and weather effects, people, buildings, animals, trees, rivers, seas, rocks, mountain ranges and man-made objects could all be introduced or modified to typify, energise or expand a scene. In Turner's analytical and objective sketchbook and non-sketchbook outline drawings we see him creating the necessarily bare frameworks for such conquests of the transient.

Another fine example of this process can be encountered within the larger of the two leatherbound volumes taken to Wales in 1795.

132 *The west front of Llandaff Cathedral*, 1795, pencil on paper, 10⅜ × 8 (26.3 × 20.3), fol. 4 of the *South Wales* sketchbook, Turner Bequest XXVI, Tate Britain, London.

133 *Landaff Cathedral, South Wales*, R.A. 1796 (701), graphite and watercolour on paper, 14 × 10 (35.6 × 25.5), Turner Bequest XXVIII-A, Tate Britain, London.

Here a study (fig. 134) would serve as the basis of a watercolour (fig. 135) about forty years later. When elaborating the 1835 work Turner would add figures and animals, while simultaneously carrying over the cattle standing in mid-river he had untypically included in the original outline drawing. It can be observed that in 1795 he made those creatures smaller than they would have been in relation to the castle in reality, in order to enhance the scale of the building by contrast. He would transfer those diminished animals to the 1835 watercolour for the selfsame reason.

Stourhead

On his way back to London from Wales in 1795, Turner visited Stourhead, the Wiltshire country seat of an important new patron, Sir Richard Colt Hoare (1758–1838, fig. 136).[13] This baronet and widower hailed from a leading banking family, but he had been compelled to give up banking upon inheriting Stourhead in 1785, to his enormous relief. This was because his true interests were antiquarianism and landscape gardening.

134 *Kidwelly Castle*, 1795, pencil on paper, 10⅜ × 8 (26.3 × 20.3), fol. 16 of the *South Wales* sketchbook, Turner Bequest XXVI, Tate Britain, London.

135 *Kidwelly Castle, South Wales*, summer 1835, watercolour on paper, 11½ × 17½ (29 × 44), Harris Museum and Art Gallery, Preston.

136 Samuel Woodforde, *Sir Richard Colt Hoare aged 37 and his son aged 11*, 1795, oil on canvas, 100 × 66 (254 × 167.64), National Trust, Stourhead.

It appears likely that Colt Hoare had first encountered Turner's work in the 1795 Royal Academy Exhibition. He could then have visited Turner's studio and acquired a sizable view of Ely Cathedral (see fig. 155) that had just been completed or was still being developed from the large pencil drawing of that subject made in 1794 (see fig. 109). Although we possess no documentary evidence of Colt Hoare's ownership of this watercolour, he has been traditionally linked with it, and if he did purchase it, then its submission to the 1796 Royal Academy Exhibition was made with his blessing. Moreover, he has also been linked to a view of the exterior of the same cathedral that would be exhibited at the Royal Academy in 1797 (see fig. 165), and he may even have commissioned that work, as well as permitted it to be displayed.

In any event, in the spring of 1795 Colt Hoare invited Turner to stay at Stourhead later in the year. It was this invitation that caused the painter to visit the property on his way back from Wales. With its garden, lake, imitation Pantheon, Temple of Apollo and bridge inspired by Andrea Palladio (1508–1580), Stourhead calls forth strong associations of the landscapes of Claude le Lorrain and Nicolas Poussin, thereby evoking a more perfect reality. At this juncture in Turner's development he was only beginning to grasp such idealism, for he was largely unfamiliar with paintings by these two Frenchmen, not having enjoyed the chance to see many of them. Probably that is why it would be some years before he would pictorially respond to the garden, which is arguably the greatest glory of Stourhead.

Among the works hanging in the house were thirteen landscape watercolours by the Swiss artist Louis Ducros (1748–1810). Although they possess many virtues, by the time Turner set eyes on them he had progressed far beyond Ducros, so it is likely he did not rate them very highly. Certainly he is never known to have mentioned them. Far more to his taste were Colt Hoare's many etchings by Giovanni Battista Piranesi (1720–1778), the influence of which would soon make itself felt in his art and remain there for many years. Probably he also scrutinised *A Barn with a Still Life of Kitchen Utensils and a Sleeping Cook* by David Teniers and Herman Saftleven (1609–1685), which still hangs in the house. Of equal interest may have been a fine group of drawings by Canaletto that Colt Hoare had acquired in Italy during his youth. Yet without doubt the work that most profoundly impressed Turner at Stourhead in 1795 was a small panel painting by Rembrandt.

This was the *Holy Family Resting on the Flight into Egypt* of 1647 (fig. 137). At some point between 1808 and 1811 Turner would write of it that 'in no picture have I seen that freshness, that negative quality of shade and colour, that aerial perspective enwrapt in gloom, never attempted but by the daring hand of Rembrandt in his Holy Family Reposing, a small picture at Stourhead...Rembrandt has introduced two lights, one of the fire and the other from a window, to contrast the grey glimmering dawn from gloom'.[14] By the time Turner drafted this passage, it was at least ten years since he had last seen the work back in 1798, so obviously it had affected him deeply. And why he had been so impressed in 1795 by Rembrandt's only extant nocturnal landscape in oils remains just as evident.

As we have observed, until then Turner's principal concern regarding colour was its tonality or degree of intensity from light to dark. However, as the result of looking carefully at the Stourhead Rembrandt, he would now start to pay far more attention to colour temperature, or the warmth and coolness of colours. Nor was he impervious to the energisation of darkness in the *Holy Family Resting on the Flight into Egypt*, for although Rembrandt's image is predominantly black or dark grey, its 'gloom' is never inert, heavy or empty; for Turner, the Dutch master had invested it with airiness and vitality (or 'freshness', as he put it). Both the single point of light in a distant

137 Rembrandt van Rijn, *The Holy Family Resting on the Flight into Egypt*, signed and dated 1647, oil on panel, 13⅞ × 18¾ (34 × 48), National Gallery of Ireland, Dublin.

window, and the lighter area of sky near the moon, prevent any monotony from arising. And Turner was equally alert to Rembrandt's pushing of light and dark to extremes. Nor would he ever lose his love of another contrast present in the Dutch night-piece: activity versus stillness.

And there was more, for Turner was undoubtedly receptive to Rembrandt's associative use of objects, such as the tree under which the refugees shelter. So firmly does this cover the Holy Family we can be in no doubt that it stands for divine protection. Moreover, Turner also perceived in the Rembrandt a highly useful form of visual dynamic, namely vertical alignment, as witnessed in the straight tree-trunk that thrusts the eye upwards to the tiny sliver of moon peeking through the clouds. Not long after 1795 Turner would begin to use trees associatively, just as he would start to align objects vertically, both to make us connect those pictorial components and tauten his images structurally. And Rembrandt's small landscape must have very rapidly strengthened Turner's belief that colour derives from light while its tonalities are degrees of darkness (for after all, he had been effecting tonal changes by gradually darkening his palette for some years by now). Similarly, he recognised that Rembrandt had

used light and darkness in a symbolic way that enjoyed a long Christian history, to denote the opposition of good and evil respectively. Perhaps in the Stourhead Rembrandt, he even interpreted the dark cloud at the top-right as denoting the evil forces from which the Holy Family was making its escape. But certainly he too would juxtapose light and dark to engender associations in many of his own later historical or biblical subjects, just as he would use storm-clouds and other pictorial components with which to do so.

At some point during this stay, Turner showed Colt Hoare the sketchbook drawings he had recently made at Hampton Court, Herefordshire. The baronet thereupon ordered two watercolours of the house. One of them was a depiction of it as seen from the north-west, the other as viewed from the south-east. Probably Colt Hoare wanted the views to adorn a very rare book he prized in his library, *An Account of the Manor of Marden in Herefordshire* of 1722 and 1727 by the 1st Earl of Coningsby (1656–1729), who had resided at Hampton Court.[15] And because Colt Hoare had recently become aware of Turner's prowess, he also commissioned a set of ten watercolours of Salisbury Cathedral, as well as ten more watercolours of views in and around Salisbury.[16]

Back in London, Turner set to work elaborating watercolours from material gathered on the Welsh trip. A little later he visited Oxford for a day or two in order to make studies for four watercolours of Christ Church ordered by a student at that college. This was Viscount Stormont (1777–1840), who would become the 3rd Earl of Mansfield in 1796. At some point this summer, Turner may also have gone out on a short sketching expedition in Windsor Great Park with Tom Girtin, for they both made views of Windsor Castle from very similar viewpoints to the south-east of the great pile. A watercolour of Swansea that can only have derived from the recent Welsh tour must have been completed by mid-July 1795, for on the first day of September an engraved reproduction of it appeared in the *Pocket Magazine*, and it must have taken at least a month to create that print. Maybe Turner had elaborated the original watercolour in Wales itself.

The *Pocket Magazine* was a monthly partwork that went through various guises between 1794 and 1796, and Turner produced sixteen small watercolours for them. Virtually all of the drawings have disappeared, but in one of them, *Elgin Cathedral, Morayshire*, he exercised poetic licence to an unusually imaginative degree. In the original sketch of the building by an antiquary and amateur artist he had been supplied to work from, 'the windows of the nave were closed or built up, but in the drawing Turner made, he left them open. On being spoken about this a few years since he said, "They ought to have been open; how much better it is to see the light of day in God's house than darkness!"'[17] The open windows are also visible in

138 J. Walker after J. M. W. Turner, *Elgin Cathedral, Morayshire*, engraving, 1797, image size 4⅜ × 6½ (11.1 × 16.5), British Museum, London.

the print made from Turner's drawing (fig. 138). The story indicates his awareness, even at a relatively early age, of the need to match light to the underlying content of an image in dramatic terms. Such appropriateness would play an important role in his art, as will be seen in due course.

The Isle of Wight, 1795

Probably in August but certainly in harvest time, Turner undertook a tour of the Isle of Wight. He did so at the behest of the engraver John Landseer (1769–1852), who wanted to produce a set of prints under the title of 'Views in the Isle of Wight'.

Turner first made for Winchester (fig. 139), and then for Salisbury to gain material for the Colt Hoare commissions. Subsequently, he visited Romsey, Southampton and Netley Abbey before crossing to the Isle of Wight. Among other places, over a number of days he visited Newport, Carisbrooke Castle (fig. 140), Godshill, Appuldurcombe Park, Ventnor, Niton, Chale, Mottestone, and the south-western range of cliffs running up to Freshwater Bay. Finally, he arrived at the Needles, the group of jagged rocks at the western tip of the island. Possibly he went out to sea with fishermen in order to view these rocks from offshore, as well as the island from the south. Back on land, and turning north-eastwards, he made his way around Alum Bay (fig. 141), Totland Bay and Colwell Bay to Yarmouth or Freshwater. He then explored the eastern half of the island, visiting Shanklin, Brading, Bembridge and Ryde, from where he

probably caught a boat across to Portsmouth to view the wartime naval activity. Such a journey would have taken him through a Spithead that was crowded with vast men-of-war, which would have thrilled him. From Portsmouth he could easily have returned to London by stagecoach. By the time he arrived back in Maiden Lane, the sketchbook that had accompanied him contained forty-five drawings, quite a few of which were fully or partially coloured.

Once home, Turner worked up scenes in Wales, Kent and Herefordshire, as well as some Isle of Wight views. By now he must have been using quite a few of the rooms above his father's shop as studios, and they would all have been awash with paper. Outstanding drawings of the 1795–6 period include *Aberdulais Mill* (fig. 142), which is arguably the most dynamic of Turner's mill scenes of this period; *Llanstephan Castle by moonlight, with a kiln in the foreground* (fig. 143), in which part of the sky later became discoloured, but the contrast between the heat of the fire and the coolness of the moon has survived sufficiently to make the impact of the Stourhead Rembrandt very evident; *A lime kiln by moonlight* (fig. 144), in which the influence of the Stourhead Rembrandt is also discernible; and *Cowes Castle, Isle of Wight* (fig. 145). In *Rochester* (fig. 146), we can possibly detect for the first time in Turner's work something of the spatial expansiveness of Claude le Lorrain, as well as the renewed use of one of the French painter's favourite devices for augmenting that spatiality, a *repoussoir* or placing of trees to one side of a foreground in order to establish scale and distance (for it will be recalled that back in 1788 Turner had placed a tree to one side of his view of Minster Church, see fig. 15). Although it appears unlikely he had seen many paintings by Claude by 1795, he had probably viewed

Above left 139 *Winchester Cathedral from the Avenue*, 1795, pencil with washes of India ink and sepia on paper, 10⅜ × 8 (26.3 × 20.3), fol. 11 of the *Isle of Wight* sketchbook, Turner Bequest XXIV, Tate Britain, London.

Above 140 *View of Carisbrooke Castle, from Clatterford: Carisbrooke Church to the left*, 1795, pencil and watercolour on paper, 10⅜ × 7¾ (26.3 × 19.7), fol. 25 of the *Isle of Wight* sketchbook, Turner Bequest XXIV, Tate Britain, London.

Below 141 *Alum Bay, Isle of Wight*, 1795, pencil and watercolour on paper, 10⅜ × 7¾ (26.3 × 19.7), fol. 41 of the *Isle of Wight* sketchbook, Turner Bequest XXIV, Tate Britain, London.

Above 142 *Aberdulais Mill*, c.1796, watercolour on paper, 14 × 19¾ (35.6 × 50.2), National Library of Wales, Aberystwyth.

Facing page top left 143 *Llanstephan Castle by moonlight, with a kiln in the foreground*, 1795–6, pencil and watercolour on paper, 8⅜ × 11 (21.3 × 28), Turner Bequest XXVIII-D, Tate Britain, London.

Facing page top right 144 *A lime kiln by moonlight*, here re-dated to c.1795, watercolour on paper, 6½ × 9½ (16.5 × 24), Herbert Art Gallery and Museum, Coventry.

Facing page bottom 145 *Cowes Castle, Isle of Wight*, 1795–6, watercolour on paper, 12 × 17 (30.4 × 43), Turner Bequest XXVII-F, Tate Britain, London.

In addition to this view made for the 'Isle of Wight' scheme, Turner represented Shanklin, Chale Farm, Orchard Bay, Freshwater Bay, Alum Bay and the Needles as seen from Alum Bay. John Landseer advanced this image and the Shanklin subject to an open-etching state, and fully engraved the next four subjects, but then a quarrel arose and the project was terminated. We know nothing about the dispute and most of the watercolours disappeared long ago. None of the prints were issued in Turner's lifetime.

engraved reproductions of such pictures. Additionally, he must have seen images by Richard Wilson that drew heavily upon the French artist's work.

In *London from Lambeth, with Westminster Bridge* (fig. 147) a large Union flag hangs limply upon a Thames barge. In doing so it indirectly points towards the very building in Westminster within which the affairs of the Union were largely decided. Of course, Turner's main concern in this image was the breadth and attractiveness of the vista in evening light, but evidently he thought it no less beneficial to extend that scope. Once again we witness him exploring the association of images and ideas, and doing so here with a subtle wit, given the wilting of the flag. And *The Cascades, Hampton Court, Herefordshire* (fig. 148) was one of the watercolours made for Viscount Malden. By means of its diagonals, it subtly and ingeniously reinforces our sense of water falling to the right.

At Christie's on 15 November 1795, Turner purchased three groups of works by Charles Reuben Ryley (1752–1798), who had been a pupil of the historical painter John Hamilton Mortimer (1740–1779). Some of this material still remains together in a private collection and – by very dint of the fact that Turner bought it – he obviously found much to admire in it, not least in the twenty-two historical sketches that constituted one of the groups. He knew that he wanted to be a painter of historical landscapes, and possibly he thought the Ryleys would help him gain that end, if only for Mortimer's input. Moreover, an additional attraction must have been the influence of Salvator Rosa upon both Mortimer and Ryley. As we shall determine presently, Rosa's influence would become very apparent in several oil paintings Turner would make around 1800, and that sway was surely affected by the Ryleys he acquired in 1795. Perhaps it was even sparked off by them.

In December 1795 Turner made the acquaintance of Charles Turner (1774–1857), to whom he was unrelated.[18] The latter was then a student at the Royal Academy Schools, and he would go on to enjoy a successful career as an engraver, not least of images by

149 Formerly attributed to Charles Turner, inscribed twice '*A Sweet Temper*', c.1796, pencil on paper, 7¼ × 4½ (18.3 × 11.6), British Museum, London.

Facing page top left 146 *Rochester*, signed and dated 1795, watercolour on paper, 9 × 12 (22.8 × 30.3), Manchester Art Gallery.

Facing page top right 147 *London from Lambeth, with Westminster Bridge*, c.1795–6, pencil and watercolour on paper, 12½ × 17¾ (31.8 × 45.1), private collection, courtesy of Andrew Clayton-Payne.

Facing page bottom 148 *The Cascades, Hampton Court, Herefordshire*, signed and dated 1795, watercolour on paper, 12⅜ × 16⅜ (31.4 × 41.5), Victoria and Albert Museum, London.

J. M. W. Turner. It may have been at some early point in their relationship, and possibly in Dr Monro's residence in Adelphi Terrace, that an amusingly titled portrait of J. M. W. Turner was elaborated, perhaps by Charles Turner himself (fig. 149). It was twice inscribed 'A Sweet Temper', obviously because its subject looked so glum. The work is no masterpiece, but around the eyes it does hint at someone who had witnessed suffering.

If Turner really was born on St George's Day, then on Saturday 23 April 1796 he reached his majority. He probably spent the day working. At twenty-one he was ostensibly a timid, deferential fellow.

Yet appearances were deceptive, for his character had been steeled by family traumas and by the conviction that he possessed enormous gifts and even greater potential. He would be ruthless in unlocking that power, not least of all through the acquisition of money, which would entirely free him from the vagaries of taste. He may still have worried about his comparatively small stature, but any such uncertainty was diminishing as his work increasingly received acclaim. Behind his defences lay an unusually sensitive mind that was exceptionally enquiring and deep. His memory was outstanding, and he already used it to store endless data. This could range from, say, the florid body language of a military sightseer (as in fig. 56), to the way that light falls across the most humdrum of surfaces (as in fig. 128). Even though his verbal capacity was extremely limited, he was strongly drawn to it in others, and especially in poets. In their work he understandably gravitated towards landscape imagery, especially when it summons forth a cosmic sense of scale, as do the verses of John Milton (1608–1674), James Thomson (1700–1748) and Mark Akenside (1721–1770). He especially prized one of the greatest imaginative assets of poetry, namely its capacity for metaphor. Such an ability to enrich things by connecting disparate objects and phenomena was something he himself possessed to an inordinate degree, which is why visual metaphors and other associative devices were already creeping into his works and why they would regularly find a home there throughout his life.

And Turner not only possessed genius – he also possessed the rare capacity to manage that gift. That is why he had obtained the most out of his makeshift education, both within the Schools and beyond them. Naturally he was alert to the politics of the Royal Academy, for he was determined to become one of its members. He may even have already harboured a secret ambition to become a president of the institution, like Sir Joshua Reynolds. Membership of the Royal Academy was an arduous process, but fortunately Turner already possessed the talent, patience and diplomacy to attain that end. In pursuit of it he forced himself to appear humble and reserved throughout the 1790s, never vaunting himself except through the images he submitted for display in Somerset House. Those works explain why the Royal Academicians had begun to take him extremely seriously by the middle of the decade, as they would now demonstrate.

Facing page 150 *Close Gate, Salisbury*, R.A. 1796 (369), pencil and watercolour on paper, 20 × 15 (50.8 × 38.1), Newnham College, Cambridge.

We view the scene shortly after dawn. The delicacy of tone across both the cathedral spire and the right side of the gatehouse is particularly remarkable. Turner has made the gateway about twice as wide as it is in reality. And see fig. 313 for essentially the same view towards sunset.

The 1796 Royal Academy Exhibition
FRIDAY 22 APRIL TO SATURDAY 11 JUNE

This year Turner had no fewer than ten watercolours and an oil painting on display, showing scenes in London, Salisbury, Wolverhampton, Llandeilo, the Isle of Wight, Llandaff, Waltham in Essex and Bath. The acceptance of so many submissions by a non-Academician demonstrates the degree to which the magnitude of his talent was receiving recognition by now.

Among his exhibits were two watercolours placed in the Antique Academy. *Close Gate, Salisbury* (fig. 150) was the first of two treatments of this subject (for the second, see fig. 313). In *St Erasmus and Bishop Islip's Chapel, Westminster Abbey* (fig. 151) the number of tones seems limitless. On the floor of the abbey the young artist demonstrated his certainty as to where his genius was taking him by signing the work 'WILLIAM TURNER NATUS 1775', as though those words had been cut into a slab above his grave. (One day he would be laid to rest under a very similar stone, albeit in a different cathedral.) In smaller letters above the main inscription he also wrote 'natus William TURNER S of A', the last two upper-case letters alluding to the only artistic honour he had yet received. Naturally, the principal inscription confirms his year of birth.

A further eight watercolours were displayed in the Council Room, of which five are reproduced here. *Landaff Cathedral, South Wales* (see fig. 133) is yet another of Turner's moral landscapes, for it shows children making music and dancing upon gravestones while adults look on pensively. Well might they do so, for they are far closer to their demise than the youngsters. Here Turner was firmly connecting with a moral tradition that was best exemplified in poetry by Gray's *Elegy* and Blair's *The Grave*, works with which he was familiar.

In Turner's day, as now, it would have been distinctly odd to have seen children at play in a graveyard or inside a cathedral, yet he depicted them indulging in such behaviour a number of times. This leads one to suspect that he was thinking associatively when doing so, and that he particularly wanted us to remember Christ's injunction: 'Suffer little children to come unto me and forbid them not: for of such is the Kingdom of God' (Luke 18:16). Certainly Turner knew his Bible, probably from having had it drummed into him in Brentford and within the religious forcing house that had doubled as his school in Margate. Given such likely assimilations in his childhood, there cannot have been anything more natural than to take Jesus at His word both within and around the buildings that were expressly dedicated to His worship, and thus populate them with children at play. 'Forbid them not' indeed. And here too may reside an indirect autobiographical dimension, for if Turner held that the innocence of childhood is a holy state, then he may equally have felt that his own childhood innocence had been violated by the furies

152 *Woolverhampton, Staffordshire*, R.A. 1796 (651), watercolour on paper, 12½ × 16½ (31.8 × 41.9), Wolverhampton Art Gallery.

of his mother. That could be why he reasserted its importance in this watercolour and similar views of religious buildings, as will be seen.

In *Woolverhampton, Staffordshire* (fig. 152), Turner responded to the street scene by Tom Girtin that had so impressed him a year or so earlier. As detailed analysis demonstrates, he possessed an extremely thorough knowledge of the annual fair in the Midlands town.[19] And *Internal of a cottage, a study at Ely* (fig. 153) was heavily influenced by Teniers (fig. 154). The hour-glass before the old lady empties as she contemplates her time running out. Turner the moralist was emerging more firmly than ever, albeit with increasing subtlety.

If Colt Hoare owned *Trancept and Choir of Ely Minster* (fig. 155), then he necessarily lent it to the exhibition. Although it is rather yellow today and some of its colours have faded, other watercolours of the same year can help us imagine how much fresher and bolder in tone it must have looked originally. Yet despite its defects, the

Facing page 151 *St Erasmus and Bishop Islip's Chapel, Westminster Abbey*, R.A. 1796 (395), pencil and watercolour on paper, 21½ × 15⅝ (54.6 × 39.8), British Museum, London.

distorting the aerial perspective, so that as the eye ascends, the upper reaches of the structure appear at increasingly acute angles. As we have seen, ever since studying with Malton between 1789 and 1791, Turner had been distorting the higher parts of buildings in this way, and by 1796 the resulting augmentation could project an immense spatiality, as here. By now, however, it was effected with subtlety, which had not been the case at the beginning.

With his strong architectural instincts and love of metaphor, Turner was profoundly drawn towards major ecclesiastical buildings such as the great English cathedrals because they were intended to impart spiritual meaning and act as simulacra of the divine realm. Even by this stage of his life he probably did not believe in the Jehovah of the Judeo-Christian tradition. However, like many a non-believer, he did feel the intense spirituality that great Christian architecture can communicate. The part of him that would soon respond fervently to artistic idealism began by reacting to Christian architectural metaphors for the heavenly kingdom.

For that reason Ely, like many another English cathedral, was not simply a building to be drawn well or better than others had depicted it. Instead, it answered a core need in Turner, as did many of its medieval counterparts elsewhere. From such majestic buildings, and especially their interiors, he gained a sense of vast scale that he rapidly pushed into every aspect of his art. In the cathedrals that scale was spiritual rather than merely physical and materialistic: to find and express their spirituality, the builders of the great cathedrals had manipulated space in a dynamic way, as Turner was beginning to understand. Moreover, medieval stained glass – or what had survived of it in Britain – created a radiance and a colour that were deemed to express the light of God. For Turner, too, light would come to possess a divine aspect, with its major source on Earth probably being held by him to constitute the godhead itself. The basis of that belief surely resided in his early experience of light and colour as filtered through glass within buildings that, in Britain at least, have never been surpassed in their majesty. And the suggestion of organic growth and flowering in the structuring and weight-bearing distribution of high ecclesiastical buildings similarly impressed Turner and began to receive expression in his art. All in all, the great English cathedrals made an incalculable contribution to the development of key areas of his sensibility, even though they have never received any recognition in the literature on him.

In *West front of Bath Abbey* (fig. 156) Turner created an exquisitely delicate and radiant glow across the façade, the better to draw attention to the two ladders bearing ascending and descending angels that form an unusually imaginative part of the architecture. Beneath the base of the nearest of these embellishments two porters stand on either side of a sedan chair used to convey individuals who are somewhat less sprightly than angels, with one of the men invitingly

153 *Internal of a cottage, a study at Ely*, R.A. 1796 (686), watercolour on paper, 7¾ × 10⅝ (19.8 × 27.1), Turner Bequest XXIX-X, Tate Britain, London.

grasp of architectural form and tension, the play of light and shade, the mastery of composition and the consummate draughtsmanship all remain apparent. Turner made the interior appear larger than it is in reality by diminishing the size of the figures and by subtly

154 David Teniers the younger, *A barn interior with a maid preparing vegetables*, signed and dated 1643, oil on oak panel, 13¼ × 19⅞ (33.7 × 50.5), private collection.

holding open its door. He and his companion may have a long wait for custom, as the only other occupants of the entire churchyard and its surroundings are five unaccompanied females. Because no respectable woman in Turner's era would ever have strolled alone in a city towards nightfall, we can safely assume they are prostitutes touting for business. A beautiful building dedicated to the highest moral purpose is therefore seen beyond people of low morals, or no morals at all. Late eighteenth-century Bath was a city of medicinal waters, money, fashion and high society, but equally it possessed a seamy side due to the wealth and sexual exploration it attracted, as Turner was undoubtedly aware and subtly expressed here (and maybe he had even been solicited on this very spot). On the artistic side it is worth noting that the elongation of the women is equally to be encountered in the figures appearing in an important view of Tintern Abbey (fig. 157) that may even have been made in the same work session.

Finally, with *Fishermen at sea* (fig. 158), Turner had again only made it to the 'Anti-Room' to the Great Room on the top floor of Somerset House. There his very first oil painting ever to go on show in the Royal Academy 'would have borne a brighter situation', according to the *London Packet* of 23 April-11 June. In his *Critical Guide* to the 1796 exhibition, the pseudonymous critic 'Anthony Pasquin' singled out the painting for its pictorial organisation, which he rated as 'one of the greatest proofs of an original mind'.[20] An anonymous *Companion* to the display further praised the work for its 'natural and masterly' colouring, and for the way its indistinct figures matched the 'obscure perception of the objects, dimly seen through the gloom of night, partially illumined'. The picture demonstrates the marked influence of de Loutherbourg, especially in the shaping of the clouds. Although Turner was now banned from Hammersmith Terrace, there was nothing to stop the older painter from occasionally dropping in on him at Maiden Lane, especially as it was just up the road from Somerset House. But clearly Turner did receive advice from de Loutherbourg when labouring over *Fisherman at sea*, for stylistically and technically it owes more to the French-born artist than do any of his other oils. Perhaps it was even a push from de Loutherbourg that had finally led Turner to attempt an ambitious exhibition piece in oils.

Turner is supposed to have sold *Fishermen at sea* for a mere £10, but the amount does not seem credible.[21] Either 100 or 150 guineas would have been a far more believable price for the work (for pres-

Top 155 *Trancept and Choir of Ely Minster*, R.A. 1796 (711), pencil and watercolour on paper, 26 × 20 (66 × 50.8), Corsham Court Collection.

Bottom 156 *West front of Bath Abbey*, R.A. 1796 (715), watercolour on paper, 9¼ × 11 (23.5 × 28), Victoria Art Gallery, Bath.

157 *The transept of Tintern Abbey*, 1795, watercolour on paper, 13½ × 10 (34.5 × 25.4), British Museum, London.

158 *Fishermen at sea*, R.A. 1796 (305), oil on canvas, 36 × 48 (91.5 × 122.4), Tate Britain, London.

tige, accepted practice and self-esteem dictated that Turner would only have accepted payment in guineas.) Far higher amounts received during this period probably account for the sale.[22]

The subject may have derived from viewing the western end and the southern coast of the Isle of Wight from offshore. If that was the case, then the canvas had been created in just seven months. The influence of the Stourhead Rembrandt (see fig. 137) is very apparent in the colour temperature of the painting, with its cool moonlight contrasting with the warm lamplight cast by fishermen working the waters of Alum and Freshwater Bays. Rembrandt was undoubtedly one of the major influences upon the young Turner, although his sway has not been widely recognised simply because it was a creative input rather than a stylistic one. In *Fisherman at sea* Turner emulated the chiaroscuro of Rembrandt and attempted to invest it with the same 'freshness' or vitality that had so impressed him in the Dutch painter's *Holy Family Resting on the Flight into Egypt* at Stourhead. From the moment that Turner had first set eyes on that work, he had been changed, and huge benefits would emanate from his altered awareness, especially over the next few years. *Fishermen at sea* was merely the first great outcome of that transformation.

8

Grandeur

1796 to 1798

In the spring of 1796 Turner began renting additional space in the lane at the end of Hand-court. There he supposedly found life 'quieter, more secret, and freer from interruption from visitors coming to the shop'.[1] The rooms he took reputedly had two front windows but remained 'rather dark'.[2] A possible reason for the move is clear: it is likely that the 36 × 48 inch *Fishermen at sea* was painted in the top-floor bedroom cum studio at 26 Maiden Lane. As a consequence, getting it down the stairs could have necessitated the complete removal of the canvas from its stretching frame and restretching it on the ground floor of the building, or even within Somerset House. That would have proved an irksome business, for a perfect restretch of any picture can never be guaranteed. If Turner was contemplating the creation of further canvases on the same scale by 1796, as seems likely, then obtaining a new, ground-level studio may have been partially undertaken with the prevention of restretching problems in mind.

It was probably also by the spring of 1796 that Turner purchased Robert Anderson's thirteen-volume compendium entitled *A Complete Edition of the Poets of Great Britain*, issued in 1795 and hereafter known simply as Anderson's *Complete Poets*. The forty poets represented within its covers ranged from Geoffrey Chaucer (c.1343–1400) to Oliver Goldsmith (1730–1774), and many of their works would inspire images or imagery by Turner.

During the late spring or early summer of 1796 Turner visited Viscount Malden at his family residence and principal home, Cassiobury Park, near Watford in Hertfordshire. He did so in order to hand over the five views of Hampton Court, Herefordshire, that had been commissioned the previous summer.[3] The stay must have been enjoyable, for the house contained pictures by Sir Anthony van Dyck (1599–1641), Canaletto, Reynolds, Gainsborough and Morland, among other celebrated artists. Turner also made a number of watercolours of Cassiobury house, as well as studies of beech trees in its park (fig. 159).

159 *Beech Trees at Cassiobury Park, Hertfordshire*, 1796, pencil and grey wash on paper, 9¼ × 14¾ (23.5 × 37.4), private collection.

Detail of fig. 162.

160 *Brighton from the west*, 1796, pencil and watercolour on paper, 15¼ × 20⅛ (38.7 × 51.1), The Timothy Clode Collection. Not in Wilton.

Apart from the Cassiobury visit, the summer of 1796 constitutes one of the most mysterious periods in Turner's life. Thornbury filled it with a love affair in Margate that supposedly 'affected [the painter's] mind for ever'.[4] However, we need waste no space on the tale here, for it contains many flaws, and in any case it far too strongly resembles Victorian melodrama to be credible.[5] Yet the summer of 1796 is curious, for Turner undertook no major tour and only occasionally appears to have used a single sketchbook. Although it has been argued that he was seriously ill this year, there is no evidence of that either.[6]

One possibility is that he simply went on holiday to Margate, Brighton and Chichester, for after all he had been working extremely hard. Alternatively, he may have enjoyed a break in order to take stock of where he was going artistically. And then there was his growing involvement with poetry, as manifested in the acquisition of Anderson's *Complete Poets*. Perhaps he spent the summer reading

and musing on history, mythology and new ways of investing landscape and marine painting with 'poetic' meaning. Yet there could have been a further reason for his limited output this summer.

As we have seen, in the spring of 1796 Turner had exhibited his first major seascape in oils, and undoubtedly he wanted to excel as a marine painter. However, in order to do so he needed to intensify his insight into the nature of nautical behaviour and ship-handling. Because Britain had been at war since 1793, no military or large merchant vessel would ever have given space to a 'landlubber' who wanted to learn the ropes, for events were too pressing to be wasted on such elementary training. But small fishing vessels were a different matter. Perhaps Turner spent several weeks at Brighton this summer working in a lowly paid or unpaid capacity upon a fishing boat. Heavy manual labour by day and night could easily have exhausted someone unused to a life spent at sea, and consequently robbed him of the energy to pick up his brushes very often. Only on Sundays might he possibly have known a day's rest. Admittedly, this is completely speculative but Turner did acquire a great deal of knowledge about nautical behaviour and he had to have gained it from somewhere.

Yet even if Turner was ill that summer, he certainly produced some good works at the time. Quite a few of the drawings and watercolours contained in a sketchbook in use then are anything but 'slight and timid', as has been claimed.[7] At least four of them were studies for an extremely fine watercolour of the view looking eastwards from Hove towards Brighton (fig. 160). That Turner was systematic enough to make preliminary studies for a finished watercolour somewhat undermines the claim that he was suffering from weakness of mind in the summer of 1796. And no less pictorially strong is an unfinished watercolour of the same date showing the view looking eastwards from Brighton towards Rottingdean (fig. 161). At least nine more watercolours of boats and light effects were created at Brighton during this year, and all of them are of a relatively high standard.[8] The claim that Turner was visually feeble in the summer of 1796 simply does not pass muster.

If Turner was not highly productive that summer, he certainly made up for it during the following autumn and winter with the creation of many new oils and watercolours. One of the most impressive of the latter is a variant version (fig. 162) of the large view of the interior of Ely Cathedral that had been exhibited at the Royal Academy the previous spring (see fig. 155).[9] The new work was commissioned by the Bishop of Ely, Dr James Yorke (1730–1808), obviously because he had been greatly impressed by the earlier watercolour. In that previous version, late afternoon sunlight falls from the left, whereas in the new design morning sunlight descends from the right. As in the earlier image, the figures within the crossing and up in the lantern help establish the immense scale of the building. An understanding of the underlying dynamics of architecture is

161 *Brighthelmstone*, 1796, watercolour on paper, 16¼ × 21½ (41.3 × 54.6), Victoria and Albert Museum, London.

again apparent, as is a sense of radiant light, with the distant reaches of the chancel almost receding to infinity in their luminosity. By now Turner's ability to create the most extraordinary delicacies of tone was paying glorious dividends.

The 1797 Royal Academy Exhibition
FRIDAY 28 APRIL TO SATURDAY 17 JUNE

Turner had six works on show this year, two of them oils. The watercolours all hung in the Council Room.

It has long been recognised that *Trancept of Ewenny Priory, Glamorganshire* (fig. 163) was heavily influenced by the Rembrandt night scene and various Piranesi prints that Turner had viewed at Stourhead in 1795. The impact of Piranesi is evident in the architectural massing and light coming from opposite directions, while the input of Rembrandt is apparent in the juxtaposed extremes of light and dark, as well as in the cool and warm colour oppositions on the left and right respectively. Part of the grandeur of the image emanates from the liberties Turner took with scale, for he greatly enlarged both the presbytery beyond the screen on the left, and the south transept to the right of centre beyond the crossing. And Turner the moralist was also at work here, for by making pigs, poultry and farm implements so prominent, he stressed the low use to which the priory had fallen because of the Reformation.

163 *Trancept of Ewenny Priory, Glamorganshire*, R.A. 1797 (427), watercolour on paper, 15¾ × 22 (40 × 55.9), National Museum of Wales, Cardiff.

In the centre, the tomb-effigy of Sir Paganus de Turbeville of Coity (*fl.*1070) that Turner had drawn in pencil at Ewenny Priory in 1795 has been rotated through 180 degrees,[10] quite evidently to project the complete turnabout of the building's fortunes effected by the Reformation, as well as the reversed hopes of the ancient knight that he might rest in eternal peace (for now he is surrounded by farmyard noises). The *Trancept of Ewenny Priory* is yet another work in which we can discern Turner's increasing involvement with the moral, associative and historical ramifications of a theory connecting painting and poetry that was widely disseminated in his era. We shall explore that body of ideas shortly.

Turner placed one of the most conspicuously inventive allusions in his entire output within *Choir of Salisbury Cathedral* (fig. 164). Here we look eastwards across the cathedral Choir towards the Trinity Chapel, where a stained glass triptych of the Resurrection based upon a design by Sir Joshua Reynolds is so brilliantly lit that we might be excused for thinking the sun is shining through it.[11] However, the mid-afternoon sunlight falling from the right demonstrates that the sun must be high in the sky to the south, and that the triptych could therefore not be illuminated in that way. The intensity of its colour is greatly heightened by the almost mono-

Facing page 162 *Interior of Ely Cathedral, looking towards the north transept and chancel*, 1796–7, watercolour on paper, 24¾ × 19¼ (62.9 × 48.9), Aberdeen Art Gallery & Museum.

This work has often been confused with the *Ely Cathedral, South Trancept* exhibited at the Royal Academy in 1797.

165 Possibly the *Ely Cathedral, South Trancept* exhibited at the Royal Academy in 1797 (464), pencil and watercolour on paper, 13 × 19½ (24 × 33), private collection.

chromatic, subdued hues present everywhere else in the image, including those of further stained glass windows that in reality may well have matched the triptych in their intensity of colouring.

Clearly we are beholding the radiance of the risen Christ in this drawing. Naturally, the trope generates further associations, for of course to believers the Christian Church ultimately arose from the Resurrection of Jesus Christ.[12] Additionally, Turner was necessarily paying Reynolds a huge compliment by suggesting that the latter's powers of representation had been so great that he had been able to depict both Christ *and* the light He generated. Although Turner had hinted at God's light in the Elgin Cathedral view of 1795 (see fig. 138), in *Choir of Salisbury Cathedral* he depicted the shining of divine light itself, and did so for the very first time. Moreover, his representation of the Reynolds triptych proves that he had perceived a connection between stained glass, art, earthly light and divine light.

Possibly the work exhibited at the Royal Academy in 1797 under the title of *Ely Cathedral, South Trancept* was an image that includes two south transepts (fig. 165), with the one specified by the title of the exhibit dominating its entire right half, while the south-west transept juts out from the distant west tower on the left. But in this watercolour Turner undoubtedly indulged his penchant for associa-

Facing page 164 *Choir of Salisbury Cathedral*, signed and dated 1797, R.A. 1797 (450), watercolour on paper, 25½ × 20 (64.8 × 50.8), Salisbury Museum.

166 *North Porch of Salisbury Cathedral*, R.A. 1797, watercolour on paper, 19⅝ × 25⅝ (50 × 65), Salisbury Museum.

tionism once again, for as in his Llandaff Cathedral depiction (see fig. 133), clearly he included children at play because Christ had held little ones to be particularly blessed instruments of God, while play is what usually makes them happy.

On the left of *North Porch of Salisbury Cathedral* (fig. 166) workmen labour on the east side of the porch, possibly as part of the restoration work undertaken around the mid-1790s by the architect James Wyatt RA (1746–1813). If Wyatt was not already known to Turner by the spring of 1797, he soon would be. With great elan, some tree shadows are distributed across the near-side of the porch, and possibly Turner put them there with Michael Angelo Rooker in mind. Within the porch two beggars ply their trade, while some well-off persons enter or approach the doorway. Nearby, a woman holds a baby, obviously to introduce associations of traditional representations of the Virgin and Child. The other people are no less appropriate to a depiction of a Christian building. Further away, figures crowd the greensward in front of the cathedral as they watch a passing show.

167 Giovanni Vendramini after Sir William Beechey, *Sir Peter Francis Bourgeois*, stipple engraving, 1811, National Portrait Gallery, London.

168 *Moonlight, a study at Millbank*, R.A. 1797 (136), oil on panel, 12⅜ × 15⅞ (31.5 × 40.5), Tate Britain, London.

With both of his 1797 exhibited oil paintings, Turner had at last made it into the Great Room, at least to start with. But just prior to the Royal Academy dinner, when the hanging of the entire show had been completed and the first edition of the catalogue had already been printed, Turner was forced to swap one of his entries with a portrait by Sir Francis Bourgeois RA (1756–1811, fig. 167) that had been placed in the Anti-Room.[13] This left a small oil entitled *Moonlight, a study at Millbank* (fig. 168) as his sole representative within the Great Room. The work owes much to the Rembrandt night scene at Stourhead. Now pushed into the Anti-Room was *Fishermen coming ashore at sun set, previous to a gale*, which is also known as *The Mildmay Sea-Piece* after its first owner, Sir Henry St John-Mildmay (1746–1808), who may have commissioned it. Sadly, it disappeared long ago,[14] and it is therefore represented here by its mezzotint reproduction (fig. 169). This would be drawn and etched by Turner in 1812 as Plate 40 of his set of prints entitled *Liber Studiorum*, to which we will come below.[15]

The critics were kind about Turner's exhibits, with the 20–23 May edition of the *St James's Chronicle* not only citing *Trancept of Ewenny Priory* as being 'in point of colour and effect ... one of the grandest Drawings' ever seen in Somerset House, but stating that it was 'equal to the best Picture of REMBRANDT'. Furthermore, the same critic recognised Turner's metaphor in *Choir of Salisbury Cathedral*, for after praising the work's 'numerous beauties' he declared: 'The light and

169 *The Mildmay Sea-Piece*, mezzotint engraving drawn and etched by J. M. W. Turner as Plate 40 of *Liber Studiorum* (after the *Fishermen coming ashore at sun set, previous to a gale* exhibited at the R.A. in 1797), the first state of which bears the inscription 'Picture in the possession of Sir John Mildmay Bart ... 3 Feet by 4 Feet', 1812, image size 7⅛ × 10⅜ (18 × 26.3), British Museum, London.

170 *Colebrook Dale*, c.1797, oil on panel, 11⅜ × 15⅞ (29 × 40.3), Yale Center for British Art, Paul Mellon Collection.

colour through the painted window are charmingly described; and the effect is true sublimity and grandeur.' He would hardly have used the last two terms with respect to such a comparatively small detail had he not perceived the significance of the light shining through the Resurrection triptych. And 'Anthony Pasquin' in the *Morning Post* of 5 May (and again in the critical guide to the exhibition that appeared just a little later) commended *Fishermen coming ashore at sun set* for its originality and 'undeniable proof of the possession of genius and judgement'. The *Times* critic of 3 May 1797 declared of the same work that he had 'never beheld a picture of the kind possessing more imagination, or exciting more awe and sympathy in the spectator'.

When Turner had painted *Moonlight, a study at Millbank* (see fig. 168) on panel, it appears likely that he had simultaneously been working upon another night-piece on wood that is virtually equal to it in size. This is *Colebrook Dale* (fig. 170), which also owes a great deal to Rembrandt's *Holy Family Resting on the Flight into Egypt* (see fig. 137). Here the overriding gloom is invested with a wondrous sense of 'freshness', for there are no dead areas of darkness anywhere in sight. The slopes of the bank on the left, the water and leaves across the foreground, the landscape stretching off to the right, the slightly illumined trees in the centre-distance, and the night sky are all clearly defined, no matter how shadowy they might be. Perhaps more than any other work Turner had created to date, this modest and somewhat overlooked little oil demonstrates just how controlled his tonal skills had become by 1797. It is one thing to deploy a very wide range of tones but quite another to obtain so much variety within the narrow tonal spectrum required by a night scene. Rembrandt would surely have approved.

The North of England, 1797

This spring Turner gained two important new patrons: Edward Lascelles junior (1764–1814, fig. 171), of Harewood House in Yorkshire; and the 1st Baron Yarborough (1749–1823) of Brocklesby Park in Lincolnshire. Lascelles hailed from a family whose wealth was rooted in sugar, and therefore in slavery. A watercolourist himself, he collected such drawings and had possibly taken lessons in watercolour from Dr Monro. At this time he paid Turner three guineas for the *St Erasmus and Bishop Islip's Chapel, Westminster Abbey* (see fig. 151) that had not sold at the Royal Academy in 1796. Turner probably

171 John Hoppner, *Portrait of Edward Lascelles, junior*, 1797, oil on canvas, 36 × 27⅜ (89.8 × 69.6), Harewood House.

172 Sir Joshua Reynolds, *The Hon. Charles Anderson Pelham, afterwards 1st Baron Yarborough*, 1766, oil on canvas, 55½ × 27 (141 × 68.5), private collection.

let it go at that extremely low price because it was now old stock and equally because he wanted to tempt Lascelles into spending a lot more money on further watercolours.

Both Lascelles and Lord Yarborough (fig. 172) invited Turner to visit their country seats this summer. In Lord Yarborough's town house in Arlington Street, Mayfair, Turner looked carefully at what was arguably the finest painting owned by the aristocrat, namely the *Landscape with a Rural Dance* of about 1637 by Claude le Lorrain (fig. 173). Not only would its golden light, misty distance, and animated and colourful figures long remain in his memory, but in 1819 he would introduce into his largest painting to date a detail that undoubtedly derived from a similar form in the Claude.

Turner may have embarked upon the tour that was partially prompted by these two prospective patrons at the end of June 1797.[16] By daily progressions and overnight stops he travelled from London via Derby, Sheffield, Doncaster, Leeds, Ripon and Durham to Ber-wick-upon-Tweed, which formed the most northerly point on his tour. By the time he arrived there he had probably spent up to two weeks on the road. After visiting four ruined Borders abbeys, at Kelso, Melrose, Dryburgh and Jedburgh, he moved down to Keswick in Cumberland. This acted as his base for explorations of the Lake District, which was mostly wet, windy and grey. Finally, he gradually moved down to York before arriving at Harewood House. On his way north he had passed very near to that mansion, but only now, when the junior Edward Lascelles had at last arrived for the summer, could he stay there.

Turner probably spent a week enjoying the luxuries of Harewood and he drew the house from a variety of angles. Edward Lascelles's father had no great proclivity for buying pictures, but he was so taken with Turner's talents that he commissioned two identically sized canvases to fill spaces created by the removal of a pair of false doors in the saloon of Harewood House. Both paintings were to depict Plomp-

173 Claude le Lorrain, *Landscape with a Rural Dance*, c.1637, oil on canvas, 28 × 39½ (71 × 100.5), private collection.

ton Rocks, a nearby pleasure garden and artificial lake that the older Lascelles owned. Turner was to receive fifteen guineas for each work.

After this idyllic interlude – which was probably made even more pleasurable by its prospect of financial reward – Turner moved down to Brocklesby Park in Lincolnshire, where he probably stayed a night or two. There he would have seen fine pictures by Aelbert Cuyp (1620–1691), Poussin, Claude-Joseph Vernet (1714–1789) and Rosa, as well as discussed with Lord Yarborough the possibility of making watercolours of the mausoleum housing the remains of the late Lady Yarborough that James Wyatt had recently designed and built there. From Brocklesby, Turner gradually returned to London via Louth (fig. 174) and other Lincolnshire and East Midlands towns. He reached home by mid-August, having been away for about six weeks, and having returned with several orders for watercolours, some for subsequent engraving.

All but one of Turner's ten exhibits at the 1798 Royal Academy Exhibition would depict buildings, ruins and scenery he had encountered on the 1797 North of England tour. Additionally, during 1797–8 the painter would make many outstanding depictions of North of England subjects that he would never show publicly. Quite a few of them demonstrate his astonishing technical control and expansion of artistic boundaries.

Thus, in a highly spontaneous and expressive watercolour of a cannon foundry possibly located at Burcroft, near Conisbrough in Yorkshire (fig. 175), immense heat is communicated by the simplest of means: in order to depict the white glow of the molten metal,

174 *Louth, Lincolnshire: St James's Church and Upgate from the junction with Mercer Row*, 1797, pencil on paper, 8¼ × 10⅝ (21 × 27.2), fol. 80 of the *North of England* sketchbook, Turner Bequest XXXIV, Tate Britain, London.

175 *A Cannon Foundry*, 1797, pencil and watercolour on paper, 9¾ × 13½ (24.7 × 34.7), Turner Bequest XXIII-B, Tate Britain, London.

In *The Interior of Durham Cathedral, looking east along the south isle* (fig. 176) all the pigment used to depict the upper part of the building on the left was blotted, dabbed and sponged, and the paper surface rubbed away, to create the brightest area of light in the entire image. Although the many rays of light falling across the space are enormously subtle, above the crossing the nearly total obliteration of form makes that light seem almost blinding.

Turner could also obtain the utmost advantage from poor-quality paper, as can be seen in *Dunstanborough Castle from the South* (fig. 178). Here just four tones of grey were employed. Turner's draughtsmanship was so assured we could almost be looking at a brush drawing by a Chinese master. The paper he used possesses a weak internal structure, for it was very cheap, being made for wrapping parcels. If it was rubbed when wet, it would simply have disintegrated. However, Turner took advantage of its propensity to suck in water, and thus to dry watercolour pigment very rapidly. Consequently, he must have brushed in his four tones in no more than a few minutes.

The art collector and connoisseur William Lock (1732–1810) cultivated ferns. That is why in September 1797 he invited Turner to visit or revisit his home, Norbury Park, near Mickleham in Surrey, and to make a watercolour showing the resplendent colours of his fern-house.[17] The resulting drawing would be exhibited at the Royal Academy next spring. It is likely that Turner had been introduced to Lock by Thomas Lawrence RA (1769–1830, fig. 177), for the latter

177 Frederick Christian Lewis senior, *Portrait of Sir Thomas Lawrence*, stipple engraving, 1831, National Portrait Gallery, London.

176 *The Interior of Durham Cathedral, looking east along the south isle*, c.1797, watercolour on paper, 29⅞ × 22⅞ (75.8 × 58), Turner Bequest XXXVI-G, Tate Britain, London.

the paper was simply left blank. Instead, the metal is made to seem molten by means of the carefully graded tones that surround it. For the water flowing off the water-wheel in the distance on the left, the surface of the paper was simply scratched away to reveal its underlying white strata, one of the first times Turner ever did this. He could easily afford to take such risks, for the rag-made papers he almost always employed were much stronger than the wood-pulp or cellulose watercolour papers of today. If the surface was scratched, it simply lifted or crumbled (whereas if a modern watercolour paper is scratched, it usually rips). This is because the internal fibres of rag-made paper are closely knit together, and consequently are very strong. Turner was well aware of this strength and would always rely upon it to work in his favour (which it did).

178 *Dunstanborough Castle from the south*, 1797, pencil, white chalk and watercolour wash on parcel wrapping paper, around 10⅜ × 13 (26.3 × 33), Turner Bequest XXXVI-S, Tate Britain, London.

had painted the collector's portrait in 1790 (Museum of Fine Arts, Boston, Mass.), as well as several members of his family thereafter. The friendship between Turner and Lawrence had certainly begun by 1797, and it arose from their mutual admiration for each other's work, as well as from the fact that they both derived from humble beginnings (Lawrence's father had been an exciseman turned innkeeper). Moreover, the two artists held the Royal Academy in the highest esteem.

At Norbury Park, Turner doubtless looked carefully at Lock's art collection, which included a great many drawings by Richard Wilson.

Now or slightly later he made views of Mickleham and Box Hill,[18] as well as watercolours and wash drawings of beeches and other types of trees, a number of which were arrayed in their richest autumnal hues (figs 179 and 181). In the depictions of beeches a new sense of rhythm and energy is present, with something of the inner life of the forms receiving expression. The fruits of Turner's arboreal labours can equally be witnessed in a fine drawing of Leatherhead, less than two miles from Lock's house (fig. 180). Here the artist gave us a wider variety of trees, with one of them looking particularly autumnal in colour.

179 *Beech Trees at Norbury Park, Surrey*, September 1797, pencil and watercolour on paper, 17⅜ × 17 (44.1 × 43.3), National Gallery of Ireland, Dublin.

180 *Leatherhead, Surrey, from across the River Mole*, 1797, pencil and watercolour on paper, 9¾ × 13¾ (24.5 × 35), private collection. Not in Wilton.

On 21 November 1797 Edward Lascelles junior paid Turner twenty guineas for two moderately distant depictions of Harewood House, one as viewed from the north-east and the other from the south-west. The painter must have set to work upon these watercolours fairly soon after returning from the North of England.[19] Ten guineas for each work represented a gratifying advance on the three guineas Lascelles had paid for the Westminster Abbey drawing earlier that year, and such sums fully justified the painter's gamble. Turner went on to make four more watercolours of Harewood House for Lascelles, as well as two depictions of the nearby Harewood Castle. On 15 March 1798 Lascelles would pay him fifty guineas for five of those drawings.[20]

Two of the Harewood watercolours are particularly outstanding. In *Harewood House from the north east* (fig. 182) we gaze at the mansion past estate workers who have felled a large tree and dug out its roots. As timber production always flourished on the Yorkshire estate, Turner was both stating an economic truth of place and underlining the human effort that went into maintaining the Lascelles family in style.[21] In *Harewood House from the south east* (fig. 183), Turner made little more than a small area of hillside on the right catch the final rays of evening sunlight. He thereby subtly augmented the grandeur of the house, for within the distant parts of the landscape, only that building is also picked out by the sun. The spatiality of the scene demonstrates the degree to which beauty and immensity were becoming inextricably linked in Turner's art by 1798.

It may have been during this autumn that Turner badly disappointed a Mr Blake who had commissioned a watercolour view of Norham Castle in Northumberland for eight guineas (possibly this was the William Blake of Newhouse and/or of Portland Place who had been one of his recent pupils). When shown the resulting work, Blake was delighted but his pleasure was short-lived, for by that time someone else had offered twelve guineas for the drawing, as he was now informed. On principle the indignant Mr Blake declined to match that price, and so failed to obtain the work.[22] Not for the last time, Turner's conditioning to obtain every penny for his creations had worked against his reputation, but he need not have been so heedless as to what anyone might have thought, for the Bank of England records show that by the end of 1797 he had £810-11s-11d invested in stock.[23] This represented a marked advance on the £352-1s-2d he had possessed in the Bank of England by the end of the previous year.

The painter's ability to stand at an easel and paint in oils was greatly impaired in February and March of 1798 when he tripped on a rough pavement and badly hurt his knee.[24] Fortunately, this would not have greatly hampered work on watercolours, which could be

181 *Beech Trees at Norbury Park, Surrey,* autumn 1797, pencil and watercolour on paper, 11¼ × 13¼ (28.5 × 33.5), private collection. Not in Wilton.

made sitting down. And following his submission of ten works to the 1798 Royal Academy Exhibition around the beginning of April, he took advantage of the fine weather to undertake a short sketching expedition in Kent. After visiting Margate and Canterbury, he ended up in Foots Cray on Saturday 14 April. There he stayed with the Revd Robert Nixon, another guest of whom was Stephen Francis Rigaud (1777–1861), the painter son of his first Royal Academy sponsor, J. F. Rigaud. The next morning he caused some consternation by declining to attend church and labouring over a watercolour instead.[25] And on the Monday the three men strolled to West Malling and Maidstone, where they based themselves and where they spent the following two days exploring and sketching the town and its environs.

That Monday the weather was extremely fine, but Turner again caused eyebrows to shoot up when the party stopped at an inn for lunch and he declined to share in any wine by saying, 'No, I can't

182 *Harewood House from the north east*, 1797, watercolour on paper, 19½ × 25⅜ (49.5 × 64.5), Harewood House.

stand that.'²⁶ It could be that he refused to drink because he could not cope with the effects of alcohol when working, especially on a hot day. If this was his reason, then it merely attests to his professionalism. Yet Rigaud took the denial to signify tight-fistedness, adducing that the love of money was already Turner's 'ruling passion', as he commented further. In this instance such perceived parsimony was thought to be particularly deplorable because Turner was the most prosperous person present, and he had suffered no qualms about drinking his host's wine back at Foots Cray. However, it must be remembered that Rigaud wrote this after Turner's death. By that time the latter's supposed miserliness had long been the subject of public debate, so it seems very possible that the intervening years had coloured Rigaud's memory.

When Turner had worked on his Exhibition entries during February and March 1798, he had undoubtedly been aware of an important change that had recently been effected in Somerset House. For a number of years, dissatisfaction with the communicative limitations of the Royal Academy catalogues had been growing. Now a number of Academicians had concluded that the adding of quotations from

183 *Harewood House from the south east*, late 1797 or early 1798, watercolour on paper, 18⅝ × 25⅜ (47.4 × 64.5), Harewood House.

literature and poetry to the titles of works in the catalogues should be formally allowed, or even encouraged. Accordingly, at the 20 January 1798 meeting of the Council, the following change in the rules of the Royal Academy was enacted: 'Resolved, That every Artist may give in writing such description of his Performance, as he thinks proper for insertion in the catalogue; but it is expected that such descriptions should be confined to as few Words, as are absolutely necessary.'[27]

This ruling may look innocuous and it would never limit verbosity, but it would alter the course of British art for long afterwards, and usually for the worse. A literary tendency had now been granted its head, and frequently it would strangle the art. Yet in Turner's case the change would prove entirely beneficial, for it would never lead to any diminution of his visual sensibility. Instead, it would permit a heightening of that faculty, while simultaneously opening up new horizons for his imagination. And it would also prompt a far greater realisation of the aesthetic goals handed down by Sir Joshua Reynolds. This is because the equation of painting and poetry was no empty task for this gifted young man. On the contrary, by 1798 it had already begun to stand at the very heart of his project.

9

The Sister Arts

1798

By Turner's day it was widely accepted that painting and poetry were 'Sister Arts' and that, like the most seriously minded poets and dramatists, visual artists should principally focus their attention upon the underlying motivations and moral dilemmas of humanity. Simultaneously, correspondences needed to be found to the epic scale, mellifluity of discourse, appropriateness of language, measure and imagery, and associative and metaphorical invention that are present in the most exalted poetry and poetic drama.[1]

Because man was considered to be the paragon of animals, a hierarchy of artistic values devolved from this outlook, which can usefully be termed the theory of poetic painting. At the top of the scale was history painting, or the treatment of historical, allegorical, mythological, religious, literary and poetic subject matter. Beneath that was portraiture, which, instead of treating humanity in the broadest and most universal terms, merely depicts individuals. Next was genre painting or the representation of 'low' humanity, in the form of socially unsophisticated people and their rudimentary cultural mores. Then came landscape painting, with its unfortunate but necessary reliance upon the 'accidents of nature', or the arbitrariness of experience: if a landscapist goes out painting when the weather and light are poor, for instance, then if veracity be respected, those conditions would have to be depicted. And finally there were the other varieties of subject matter such as animals, flowers and still lifes that make little or no demand upon the intellect, both in the artist who creates them and in the viewer who appreciates them.

By 1798 Turner subscribed to the theory of poetic painting almost completely. Thus, most of his images already contained a human dimension, no matter how tiny his figures might be pictorially. Equally, by then he had become a moral landscape painter, for already he had frequently touched upon the brevity of human life, the transience of our achievements, the spiritual purity of children, and the reversals of history due to politics and religion. Moreover, by 1798 he had often heeded Reynolds's admonition that artists should not concern themselves with petty experience but instead investigate the broader constants of human life, just as they are explored in the most serious kinds of poetry and poetic drama. In pursuit of this ambition, Turner had begun capturing the underlying psychological, physical, economic and social truths of our existence. And because the species to which we belong forms part of the natural world, he had expressed something of the inner processes of nature beyond man, as well as of the physical laws of the structures we have created. One day he would characterise such traits as 'the qualities and causes of things'.[2]

Initially, Turner had expressed 'the qualities and causes of things' in his representations of architecture. Something of this is apparent in the 1794 exhibited view of Canterbury Cathedral (see fig. 105),

Detail of fig. 186.

with its grasp of the complex dynamics of the building. By not much later that understanding had developed greatly, as may be seen in the 1797 *Trancept of Ewenny Priory* (see fig. 163). Here the spans of the presbytery and transept are seen to push against one another so markedly that they suggest the internal physical tensions that hold them up. In time, Turner would go on to capture the 'qualities and causes' of geological, hydrodynamic, meteorological and arboreal forms.

By 1798 Turner had already imbued a number of works with associative meanings, similar to those commonly encountered in poetry. Visual allusions, or subtle references to broader underlying meanings, could even be strung together to create complex allegories, as in the *Britain at Peace* of 1793 (see figs 91 and 92). Additionally, Turner had created visual puns or plays upon the similarities of things, as well as similes or direct comparisons of form. In all of these ways he followed recommendations put forward by Sir Joshua Reynolds in his *Discourses*.

Then there was the landscape counterpart to the appropriateness of gesture, body language and dress encountered in both history painting and in the dramatic side of poetics. This was known as 'decorum' in the aesthetic literature known to Turner, and many of his favourite landscape painters – particularly Claude, Poussin, Rosa and Wilson – had often observed it by matching the seasons, times of day, light and weather-effects to their subjects. Thus, sunrises could correspond to the rise of city-states or to embarkations upon long sea voyages; sunsets could parallel the decline of city-states, enhance the return from overseas voyages, or complement episodes of imminent death and destruction; and storms could accompany scenes of human conflict.

Reynolds's advocacy of the grandeur attained by Michelangelo, as stated in the final discourse that was almost certainly overheard by Turner in 1790, reinforced the young artist's desire to attain a concomitant grandeur in his images. A direct way of achieving such majesty was through amplifying the scale of our surroundings, as we have seen in many of his works. Moreover, by enhancing scale he was also able to meet the moral demands of the theory of poetic painting, for it allowed him to stress all the 'littleness of man', as he would one day put it.[3]

Yet Turner did not accept every aspect of the theory of poetic painting. At the core of this nexus of ideas lay the metaphysical notion of ideal beauty, which he did embrace. But Reynolds and his aesthetic predecessors had argued that artists should conceptualise perfect or ideal *human* forms existing on a metaphysical plane beyond our ken, and give them shape here on earth. Turner largely rejected this. That is why beautified, muscular specimens similar to the *Apollo Belvedere* and the figures of Michelangelo, as recommended by Reynolds, play virtually no part in his work. Turner was simply not interested in populating his scenes with perfect physical types of the kind frequently depicted by idealising artists of the past. Instead, through his conscious identification between 1789 and 1793 with the figures of Morland, Rowlandson, Teniers the younger and de Loutherbourg (when in satirical mode), he began formulating a very different kind of human representation, and one that was decidedly 'low' in character. And character is very much the key here.

The reason that Turner identified with 'low' humanity is clear: he wanted to attain a greater universality than could ever be achieved by the perfect-looking figuration demanded by the theory of poetic painting. Such uncouth universality was not difficult to encounter in the real world. As anyone who hailed from the Covent Garden area was particularly well equipped to recognise, most people were made ugly by their constant struggle for existence. That is unsurprising, for in the main they led impoverished, brutalised, uneducated, exploited and anonymous lives. If Turner had followed Reynolds as far as our species was concerned, he would have compromised the truthfulness of what he was saying, for most people looked nothing like the superhuman creatures created by idealising artists such as Phidias (*c*.490–430 BCE), Praxiteles (*fl*. 370–330 BCE) and Michelangelo (and in the age of obesity in which we now live, they do so even less). Instead, Turner gave us a misshapen prototypical humanity. In the process he attained an extremely original form of decorum, for he created a congruence between our imperfect outer guises and the spiritual, psychological and moral imperfections of humanity.

For ideal beauty in Turner's work we therefore cannot look to man; we have to look instead to the natural world beyond our species, in all its beauty, immensity, power and majesty, and with its wealth of inner processes, the 'qualities and causes of things'. Only in his representations of that external realm would he create ideal forms that he had perhaps first conceptualised as existing metaphysically beyond human sight. Humanity acts as a foil to that beauty, as well as its moral antithesis, for by creating an imperfect figuration Turner would simultaneously service the central moral statement of his art – namely, the contrast that exists between the imperfection and cosmic powerlessness of humanity, and the beauty and infinite power of the world that surrounds us. By making his figures appear misshapen and even doll-like, he was able to stress our relative physical weakness and childlike vulnerability within a universe that frequently threatens our survival and is always indifferent to our fate. We might think we lord it over creation, but Turner begged to differ. As we have seen, from 1792–3 onwards – if not even earlier – he had already begun to express that outlook by means of his highly characteristical and 'deformed' figures, to use Platonic terminology.

On Sunday 22 April, Turner went into Somerset House. As a consequence, Joseph Farington (fig. 184) met him for the very first time and found him to be 'modest & sensible'.[4] To seem that way could

have been a calculated effect on Turner's part, for he must have been aware that a mediocre landscape painter like Farington might well have felt threatened by his talents. Clearly, he wanted the highly influential Academician on his side, and to obtain that end he went out of his way to appear polite and level-headed. A major advantage of having been immersed in the Royal Academy since an early age was that tuition in the art of the courtier had always formed an implicit part of his training. Unlike some of his contemporaries, Turner had accepted such schooling with alacrity, for he fully grasped the vital importance of acquiring useful connections in Georgian Britain.

The 1798 Royal Academy Exhibition
FRIDAY 20 APRIL TO SATURDAY 16 JUNE

This year four of Turner's ten submissions were oils and all but one of the works on display show scenes in the North of England. Of them, two hung in the Great Room, so at long last the young artist was reasonably well represented in the most prestigious public exhibition space in Britain.

The strength of Turner's identification with the theory of poetic painting by 1798 is strikingly demonstrated by the fact that in this, the very first year in which the Royal Academy officially permitted the quotation of verse in its exhibition catalogues, the titles of five of his exhibits were accompanied by poetry in the catalogue. Admittedly, five was no great number within the universal scheme of things, but nonetheless half his entries were enhanced, and by more than double the number of quotations used by anyone else.[5] Moreover, in aggregate Turner quoted twenty-six lines of verse, whereas his nearest rival only quoted twenty of them.

The title of *Morning amongst the Coniston Fells, Cumberland* (fig. 185) was accompanied by lines from Milton's *Paradise Lost*:

 -------Ye mists and exhalations that now rise
 From hill or streaming lake, dusky or grey,
 Till the sun paints your fleecy skirts with gold,
 In honour to the world's great Author, rise.[6]

An area of brilliant sunshine containing mists rising up the slopes of Coniston Old Man is clearly separated from the part of the

Top 184 George Dance RA, *Portrait of Joseph Farington*, signed and dated 5 May 1793, pencil, black and pink chalk, blue wash and black wash on paper, 9⅝ × 7½ (24.5 × 19.1), Royal Academy of Arts, London.

Bottom 185 *Morning amongst the Coniston Fells, Cumberland*, R.A. 1798 (196), oil on canvas, 48⅜ × 35⁵⁄₁₆ (123 × 89.7), Tate Britain, London.

landscape still awaiting the sun. The lower sector afforded the artist many opportunities to invest darkness with the 'freshness' he had greatly admired in the Stourhead Rembrandt. By means of the link to Milton, associations of divine sublimity, movement and the passage of time are introduced that would otherwise have remained beyond the reach of painting. The use of a sun as painter metaphor seems worthy of note.

Turner had five watercolours on display in the Council Room, of which three are particularly notable. In *Refectory of Kirkstall Abbey*,

Left 186 *Refectory of Kirkstall Abbey, Yorkshire*, R.A. 1798 (346), watercolour on paper, 17⅝ × 25⅝ (44.8 × 65.1), Sir John Soane's Museum, London.

Below 187 *Norham Castle on the Tweed, Summer's morn*, R.A. 1798 (353), watercolour on paper, 20 × 29 (50.9 × 73.5), private collection.

188 *The dormitory and transcept of Fountain's Abbey. – Evening*, R.A. 1798 (435), watercolour on paper, 18 × 24 (45.6 × 61), York Art Gallery.

Yorkshire (fig. 186) Turner showed off his mastery of architecture, his responsiveness to light within a deeply shadowed environment, and his outstanding tonal control. The work vividly communicates the poignancy of a once-great building now being used merely to house cattle.[7]

The title of *Norham Castle on the Tweed, Summer's morn* (fig. 187) was followed in the catalogue by lines drawn from 'Summer' in Thomson's *The Seasons*:

> ---- But yonder comes the powerful King of Day,
> Rejoicing in the East: the lessening cloud,
> The kindling azure, and the mountain's brow
> Illumin'd ---- his near approach betoken glad.[8]

Clearly, the pall of bluish smoke that gradually rises along the Tweed valley was introduced to reinforce the suggestion of 'kindling azure' in the sky, but Turner left the 'King of Day' to labour on his own behalf, for to paint such a monarch would have been far too literal and baroque.

The 1–3 May edition of the *St James's Chronicle* praised the drawing for having 'the force and harmony of oil painting' and thought it 'the best Landscape in the present Exhibition', while the *Whitehall Evening Post* for 31 May–2 June was equally positive, stating that it was a work 'upon which we could rivet our eyes for hours, and not experience satiety'.

The title of *The dormitory and transcept of Fountain's Abbey. – Evening* (fig. 188) was accompanied by five lines drawn from 'Summer'

189 *Buttermere Lake, with part of Cromackwater, Cumberland, a shower*, R.A. 1798 (527), oil on canvas, 36⅛ × 48 (91.5 × 122), Tate Britain, London.

in Thompson's *The Seasons*.[9] They tell of the coming of evening and the lengthening of shadows as they slowly circle 'to close the face of things'.[10] Here Turner used verse to introduce an awareness of time and movement that painting cannot suggest without verbal assistance. The profoundly deep tones deployed in this drawing, especially as set off by its gilded frame, must have made it look far more like an oil painting than a watercolour.

The oil painting *Buttermere Lake, with part of Cromackwater, Cumberland, a shower* (fig. 189) was placed in the Antique Academy. Its title was accompanied in the catalogue by seven lines or parts thereof taken from an eighteen-line passage in the 'Spring' section of Thomson's *The Seasons*.[11] These tell of an evening sun bursting forth from behind clouds to illumine damp mountains and cause a yellow mist and a richly hued, 'grand ethereal' rainbow to move across the landscape. Again, a necessarily static image is imaginatively animated by verse. The profoundly dark tonality of the picture, with its brightest point of light being placed at the very centre, brings Rembrandt to mind.

In addition to the above works, Turner had helped complete another watercolour hanging in the 1798 Exhibition, although the catalogue listed it as being wholly by James Wyatt RA. This was *North-West view of a building now erecting at Font-hill, in Wiltshire, the seat of William Beckford, Esq. in the style of a Gothic abbey* (fig. 190). Either the architect or one of his studio draughtsmen had first outlined the building, and then Turner had coloured it before adding the surroundings and sky. The fact that he laboured for Wyatt as late as 1798 suggests he had continued to work for architects at intervals throughout the entire decade.[12]

Soon after the 1798 Exhibition had ended and all the works been taken down, Turner added his name to a list that went up in the Great Room. It invited artists to put themselves forward for election as an Associate Royal Academician. In doing so, Turner ignored the rule that nobody under the age of 24 need apply. He must have known that in 1791 Thomas Lawrence had been elected an Associate at the age of 23, and so he cannot have been unduly worried about the limitation. Clearly he hoped that genius would help him surmount it, just as it had done for his friend.

190 J. M. W. Turner and James Wyatt RA, *North-West view of a building now erecting at Fonthill, in Wiltshire, the seat of William Beckford, Esq. in the style of a Gothic abbey*, R.A. 1798 (955), watercolour on paper, 26⅜ × 39¾ (67 × 101), Yale Center for British Art, Paul Mellon Collection.

Searching for Wilson

By the late spring of 1798 an enthusiasm for the works of Richard Wilson that had been aroused in Turner almost three years earlier was beginning to intensify. Fine paintings and works on paper by that artist were owned by Sir Richard Colt Hoare (fig. 191), Henry Scott Trimmer (fig. 192), William Lock (fig. 193) – who would eventually possess around 230 Wilson drawings – Dr Monro and Joseph Farington, while other owners of Wilsons who would be known to Turner (but perhaps were familiar to him already) included the distiller William Leader (1767–1828) and the baronet, connoisseur and amateur painter, Sir George Beaumont (1753–1827).[13]

Although Turner would later come to detest the latter, by 1798 relations between the two men probably remained civilised enough to permit a viewing of Beaumont's version of Wilson's *The Destruction of the Children of Niobe* (destroyed). Turner would refer to this work in his 'Backgrounds' lecture given at the Royal Academy in and after 1811.[14]

Turner copied a number of Wilsons into a sketchbook,[15] and in addition to seeing, copying and even acquiring original paintings by the Welsh artist, there were many drawings he could easily have scrutinised. This was especially the case where the William Lock collection at Norbury Park was concerned. Moreover, engraved reproductions of images by Wilson could equally have acted upon him. Some of these prints reproduced history paintings, such as *Celadon and Amelia*, *The Destruction of the Children of Niobe*, *Apollo and the Seasons*, and *Cicero and his Friends at his Villa at Arpinum*, while others transcribed purely topographical scenes, such as views of Cilgerran Castle, Caernarfon Castle, Cadair Idris, Mount Snowdon, and Pembroke Castle and town, all subjects that Turner would himself tackle one day. From Wilson he gained a further inkling of how to link landscape painting and history painting, and thus how to raise his preferred genre in both status and quality. Moreover, Wilson had effected a marriage between British and Italian landscape, in order to make some stretch of native scenery partake of the greater serenity or grandeur of classical ground. This, too, influenced Turner. And it was Wilson more than any other British painter who had been profoundly influenced by the idealism, imagery, spatiality, colouring and tonal gradation of Claude le Lorrain, as well as by the pictorial coherence of Nicolas Poussin. By acting for

Above left 191 Richard Wilson RA, *The Lake of Nemi, or Speculum Dianae*, c.1758, oil on canvas, 29¾ × 38¼ (75.6 × 97.2), The Trustees of Jane, Lucy and Charles Hoare, Stourhead, Wiltshire, National Trust.

Above 192 Richard Wilson RA, *Temple of the Sibyl and Campagna at Tivoli*, c.1765–70, oil on canvas, 39½ × 49½ (100.3 × 125.7), Tate Britain, London.

Below 193 William Woollett and John Browne after Richard Wilson, *Celadon and Amelia*, engraving, 1766, 17½ × 21½ (44.6 × 54.8), British Museum, London.

Turner as the vital stepping-stone to both Claude and Poussin between 1798 and 1800, Wilson helped him become a painter of ideal landscapes.

Wales, 1798

Turner worked on in his Covent Garden studios throughout the late spring and summer of 1798. At the beginning of August he quit the city for Elcot Park, near Newbury,[16] and Salisbury. Subsequently passing across the Fonthill estate to sketch the tower rising there,[17] at Stourhead he refreshed his memory of the Rembrandt nightpiece, looked anew at the three Wilsons hanging in the house, and discussed the possibility of elaborating further watercolours for Colt Hoare. He also talked to his patron about developing an oil painting of Lake Avernus in Italy from a drawing of that body of water that the baronet had made in 1786 (fig. 194). To further this end, he created a free transcription in pencil (fig. 195) of the Colt Hoare drawing, from which to work back in London.

Turner then moved on to Lacock, Malmesbury and Bristol, where he once again lodged with the Narraways, this time for a fortnight.[18] When he finally set off from there, he would be mounted upon a pony lent him by John Narraway. Perhaps that loan took a little time to organise or Turner needed to be taught how to ride, or both. In any event, during this stay the painter made a few drawings around Bristol[19] and it was almost certainly during this sojourn that he perhaps spent a day or two visiting Dunster Castle in Somerset as the guest of its owner, John Fownes Luttrell MP (1752–1816), who had commissioned three watercolours of his residence. He required prints to be made of them, probably to give to friends. The resulting engravings would appear in May 1800 and constitute the first reproductions of Turner watercolours to appear without any connection to a print scheme. One of them contains a surreptitious portrait of Turner that was possibly smuggled into the image by the engraver.[20]

On this visit to Bristol, Ann Dart was also staying with the Narraways. As a consequence, we can ascertain exactly what she made of Turner herself, rather than what she had gleaned from the Narraways in testimony upon which we have already drawn. She found the painter to be

> a plain uninteresting youth both in manners and appearance ... very careless and slovenly in his dress, not particular what was the colour of his coat or clothes, and ... anything but a nice looking young man ... He would talk of nothing but his drawings, and of the places to which he should go for his sketching. He seemed an uneducated youth, desirous of nothing but improvement in his art. He was very difficult to understand, he would talk so little.[21]

She also recorded that he was 'sedate and steady', happy to stay at home and think (rather than read or draw when in the company of

194 Sir Richard Colt Hoare, Bt, *The Lake of Avernus, a finished version of a sketch made in Italy*, 1786, ink and wash on paper, 14¾ × 21 (37.4 × 53.3), National Trust, Stourhead.

195 *Copy of a View of Lake Avernus in Italy by Sir Richard Colt Hoare, Bt.*, 1798, pencil on paper, 14¾ × 21 (37.4 × 53.3), Turner Bequest LI-N, Tate Britain, London.

others), and that he was not particularly polite at table but was content to be waited upon, 'caring little for anyone but himself'. Yet clearly the Narraways bored him witless, unlike the Wells family in London. Perhaps he only stayed with them at the behest of his father. Turner needed to be fired up intellectually and emotionally, and when that combustion did not occur, dullness, apathy and an egocentric disdain for others could result. Ann Dart may have regarded him as utterly deficient in social skills, but had she been able to discuss artistic matters with him or ascertain what was passing through his mind as he sat 'quietly thinking', she might have discovered a very different side to his character. As things stood, he was far beyond her ken. Turner did, however, take something of her away with him, for in a pocketbook he used for hasty sketches and jottings, he noted down her herbal remedy for cuts and abrasions.[22]

Turner must have consulted John Narraway as to whether it was feasible to visit both Wales and the West Country from Bristol. In the end, he opted to visit the former, leaving the latter to be explored at a later date. Many years later he would explain that on this trip he had been 'in search of Richard Wilson's birthplace'.[23] Perhaps he meant the phrase to be taken metaphorically as well as literally, hoping to find in Wales the beauty, wildness and immensity that had once inspired the Welsh painter.

As well as the pony, John Narraway lent Turner a saddle, bridle and cloak.[24] By 1798 Turner had probably familiarised himself with the most thorough guidebook to north Wales that was then available.[25] This was *A Tour In Wales* by Thomas Pennant (1726–1798), which had first been published in 1773, and it explored the language, religion, history, antiquities, economic activities and geology of the country. It even devoted space to the 'fish of the rivers', which might well have caught Turner's eye.

From Bristol the painter crossed the Severn and then moved slowly up the Wye valley, via Tintern Abbey, to Monmouth, Raglan, Usk, Abergavenny, Crickhowell, Brecon and possibly Hay-on-Wye. Back in Brecon he then progressed south, down the valley of the river Taff, to Morlais and Merthyr Tydfil from where it was easy to access Pontypridd, Caerphilly and Cardiff.

Now he was back on familiar ground. He made his way to St Fagan's, Wenvoe, St Donat's, Ewenny Priory, Swansea, Carreg Cennen, Llandeilo and Llandovery. He was drawing castle ruins all the way. By returning to Llandeilo he was able to reach Carmarthen, and thence Newcastle Emlyn and Cardigan, which provided the perfect base from which to draw Cilgerran Castle and its environs. By this time he was most definitely following in Richard Wilson's footsteps.

From Cardigan, Turner went to stay at Hafod, a large mansion situated about twelve miles south-east of Aberystwyth.[26] Next it was up to Aberystwyth itself in order to reach Machynlleth, from where he then travelled a couple of miles inland to visit Richard Wilson's

196 *'Pool on the Summit of Cader Idris'*, 1798, watercolour on paper, 13 × 9 (33 × 22.8), fol. 70 of the *Hereford Court* sketchbook, Turner Bequest XXXVIII, Tate Britain, London.

birthplace in the tiny hamlet of Penegoes. Subsequently he followed the coast road around to Dolgellau, where he based himself in order to explore some of the valleys leading up to the dominant height of the area, Cadair Idris. One day he climbed that mountain, and made a watercolour of the Llyn-y-Cau pool near its summit. It quickly became sullied by raindrops when laid out to dry (fig. 196).

At Dolgellau Turner appears to have loaded his animal onto a boat which carried them downriver to Barmouth, and thence up the coast to Harlech.[27] After drawing there he moved on to Ffestiniog, around to Porthmadog and Criccieth, and ultimately into Snowdonia. Here he encountered mixed weather that produced some striking light effects. Typically, he explored the area by methodically travelling along the three major valleys that bisect it.

First he rode his pony slowly from Bedgellert to the Llanberis Pass, from where he and the animal ambled north-westwards via Dolbadarn Castle to Caernarfon. Then it was up the coast to cross the Menai Strait to Beaumaris in Anglesey; Turner wanted to see both Beaumaris Castle and the fine view it affords of Snowdonia. Returning to the mainland, he proceeded south-eastwards down to Capel Curig via Llyn Ogwen and the Swallow Falls. From nearby Betws-y-Coed he roamed northwards up the Conwy valley to Conwy itself. Next he travelled eastwards, taking in Rhuddlan Castle and traversing the north coast of Wales to the Dee estuary, where Flint Castle particularly attracted him. From there he returned to St Asaph, to pick up the main road leading southwards to Llangollen. Subsequently he made his way to Welshpool, from where he took

a short stroll to Powis Castle. Next he followed the main road down to Ludlow, and from there he visited Hereford, stopping off at Hampton Court en route to pay his respects to Viscount Malden. He came away from the house with an order for another view of it.[28] From Hereford he moved on to Oxford. The fate of the pony is unknown.[29]

The Oxford Almanacks

Turner had to visit Oxford on his way back from Wales because he had received a commission to make two images for the publishing arm of Oxford University, the Clarendon Press. Every year since 1674 this company had published the *Oxford Almanack*, a single-sheet calendar bearing an engraved image above a listing of university events and ecclesiastical affairs (it will be remembered that Rooker's 1780 *Oxford Almanack* view of Folly Bridge and Bacon's Tower had been copied by Turner in 1787, see fig. 10). It appears likely that he had obtained the 1798 commission through the Dean of Christ Church, Cyril Jackson (1746–1819), who served as one of the Delegates or governors of the Clarendon Press.[30] In addition to making watercolours for engraving of Christ Church as seen from the south across the meadows, and of the chapel and hall of Oriel College as viewed from its adjacent quadrangle, around this time Turner also elaborated an experimental watercolour of the interior of Christ Church Cathedral and two similarly adventurous drawings of the interior of New College Chapel. One of the latter was partially worked up in watercolour in order to round out more fully Sir Joshua Reynolds's west window representation of the Nativity.[31] Perhaps Turner was thinking of making a finished watercolour that would transmit the same kind of metaphorical religious light that blazes in his view of the Choir of Salisbury Cathedral of 1797 (see fig. 164), with its Resurrection window after a design by Reynolds.

Turner may well have chosen the Christ Church and Oriel College subjects because the first of these institutions was associated with Cyril Jackson and the second with Dr Thomas Monro. He was to be paid ten guineas for each of his designs, but would only receive the money in 1799 after the two images had been engraved.[32] Yet although the sums were relatively inconsequential, almost two thousand copies of the *Oxford Almanack* would be sent to graduates of the university, who naturally included some of the most influential movers and shakers in the land. Before long the commission would therefore garner the artist 'priceless publicity'.[33] Because he was so inventive, it would also lead to orders for further *Oxford Almanack* designs.

Turner returned to London in mid-September laden with material. He had been away some seven weeks, about three of them in Wales. One of the five sketchbooks he brought back contains drawings that were made with history paintings in mind.[34] They include a representation of David holding up the head of Goliath (fig. 197), in which the tiredness of the figure is apparent; and several sketches of the Carthaginian general Hannibal Barca (248–182 BCE) attaining his first sight of Italy in 218 BCE, the inspiration for which undoubtedly derived from a painting of the same subject by J. R. Cozens.[35] Elsewhere, in the *Swans* sketchbook,[36] may be found the earliest surviving examples of Turner's versification in his sketchbooks. A moderately long poem telling of the tribulations of a seaman's life was perhaps composed in Bristol, while a rhythmically gawky catch or glee was composed on the subject of the mythological nymph Echo. In 1804 Turner would exhibit a picture of Narcissus and Echo at the Royal Academy, and perhaps its origins resided in these lyrics. But drawings in the *Swans* sketchbook demonstrate that when Turner was on tour in 1798, his mind often explored the scenery in terms of an historic subject matter towards which the landscapes he captured on paper could be orientated. That process that would soon quicken because of his growing identification with the notion of poetic painting.

About three weeks after visiting Farington on 26 September,[37] Turner again quit the capital, this time for Brocklesby Hall in Lincolnshire. He did so because Lord Yarborough had finally decided to commission three watercolours of the mausoleum designed by James Wyatt that held the remains of the aristocrat's late wife. Probably the trip lasted about a week. And following Turner's return, on 24 October, he once more called upon Farington, this time to tell him of the Brocklesby visit.[38] The discussion then moved on to the younger painter's current situation. He told the Academician that by continuing to reside in Maiden Lane he helped his parents, presumably by assisting his father in looking after his mother, as well as bringing in a lot of extra money. However, he thought that moving to more salubrious quarters would benefit him professionally. He said that he had more commissions at present than he could possibly execute and that his income outweighed his expenditure. Farington advised him to stay in Maiden Lane until he had saved a few hundred pounds, whereupon he could move to quarters that would be more fitting to his artistic station. Clearly, Turner had not disclosed the four figure sum he already possessed in the funds, so he probably nodded sagely at the financial advice he was given so loftily.

Later that day Farington visited Turner in Hand-court. He found the apartments there 'small & ill-calculated for a painter'. Turner showed him three sketchbooks 'filled with studies from nature', a number of which had been coloured on the spot.[39] Turner averred that these drawings were the ones that proved most useful to his needs. He then invited Farington to choose one of the subjects from those drawings, so that he could elaborate a painting or watercolour

197 *Academy study of a kneeling male nude, posed as David holding a sword and gigantic decapitated head*, 1798, pencil on paper, 5¼ × 3⅞ (13.3 × 9.8), fols. 24v and 25 of the *Dinevor Castle* sketchbook, Turner Bequest XL, Tate Britain, London.

of it for the Academician. Farington declared that he was unfit for such an honour, but when pressed he promised to look through the sketchbooks again and accept Turner's offer. He was told that John Hoppner had already done the same, and chosen a view of Durham for his gift.[40] And Hoppner had also told Turner that his pictures tended too much to '*the brown*', obviously because the colouring of his oils had hitherto been principally orientated towards the chiaroscuro of Rembrandt. Turner told Farington that, as a result, he was paying more attention to the true colours of nature. But painting for him would always necessitate finding a perfect balance between artifice and reality. In fact, it would be a fairly long time before he would attempt to capture the true hues of things, and even then he would still subject them to the overriding demands of art, like many a painter before him. But after the autumn of 1798 he would slowly become less reliant upon chiaroscuro in his oils, and more orientated towards capturing an overall brightness of light. In this respect Hoppner would make a small but significant contribution to his development.

Turner had not offered to make oils or watercolours for Farington and Hoppner without wanting something in return. He was engaging in art politics, for on 5 November the General Assembly of the Royal Academy would be electing two Associate Royal Academicians. By offering works to Farington and Hoppner – and probably to other Academicians as well – Turner was enlisting their support for his candidacy as an ARA. He was not blind to the positivity towards his art that had been growing within Somerset House for quite some time. Now the moment had finally arrived to put that approval to the test.

10

Vindication

November 1798 to November 1799

In order to become a Royal Academician, one first had to be elected an Associate. Membership of the Royal Academy granted entry to an exalted elite; it raised one's social standing; it almost conferred the right to have one's works automatically displayed in the annual exhibitions; it helped an artist command higher prices; and, not least of all, it secured greater control over one's pictorial, intellectual, economic and social destinies. But Turner faced stiff competition in the 5 November 1798 election, for there were no fewer than twenty-seven candidates for the two Associate vacancies. Among them were Thomas Malton, William Porden and Thomas Hardwick.

Understandably, Turner was 'anxious' on the morning prior to the poll; he badly wanted to win.[1] However, the portrait painter Martin Archer Shee (1769–1850) led the field by a long way and was duly elected. In the second election the sculptor Charles Rossi (1762–1839) obtained Associate status. But although Turner only gained three votes in the first poll and twelve in the second, he was the principal runner-up. As such, he was sure to be elected the next time round. Rather than affording him anticipatory pleasure, however, such knowledge would lead to renewed anxiety, lest the internal politics of the Royal Academy deny him his reward.

On the day after the vote, Turner called on Farington to acknowledge 'his obligation to the members of the Academy for the support He had [received] and said He had no title to so much favor'.[2] In all probability he thought he had every entitlement to that backing but it was far safer to be deferential, lest anyone think him cocky. That he expressed his thanks to the Academicians by way of Farington makes it evident that he was well aware of the latter's reputation as 'Warwick, the King Maker' (as he had been called in 1796).[3] Deference to Farington came easily, for although Turner already possessed an admirable father, he also needed an Academy father-figure, at least temporarily. Perhaps because Farington had no offspring, he took to the part readily. Turner chose well, for Farington knew all about the workings of Somerset House, as well as the art world in general. Over the next few years, he would give Turner much wise counsel.

Turner, Farington and Hoppner met socially on 12 and 28 November 1798.[4] Girtin was also present at the first of these gatherings, and it was at this dinner that he and his friend told Farington of their working at Dr Monro's on winter evenings over a three-year period some time before. On the second occasion Turner informed Farington of his determination 'not to give any more lessons in drawing. He has only had five shillings a lesson.'[5] And something he would say to the same listener on 22 October 1799 would supply a vital clue as to his motive for no longer teaching amateurs: 'His last [teaching] practice was to make a drawing in the presence of his pupil and leave it for him to imitate.'[6] Showing how a drawing is made hardly confers the same ability (and especially at the speed at which Turner worked), while leaving pupils to copy without any

Detail of fig. 226.

198 *Caernarfon Castle, sunset*, 1798, watercolour and gouache on blue paper tinted with a reddish wash, 8½ × 5½ (21.4 × 14), fol. 39 *verso* of the *Academical* sketchbook, Turner Bequest XLIII, Tate Britain, London.

further intervention is not a very smart method of teaching, for they are likely to conclude rather quickly that they could gain just as much from copying without having to pay for the privilege. Moreover, by 'lessons in drawing' Turner undoubtedly meant lessons in landscape drawing in watercolour. But as Turner's own watercolours had become very technically advanced by now, they must have been difficult to copy. And an assertion by Thornbury ties in with Turner's statements to Farington: 'Turner did not abandon teaching, but teaching... abandoned Turner. He was too rough and odd for fashionable people. He was not going to let out guinea secrets for five shillings; so he let his pupils paint on as they liked.'[7] Letting pupils 'paint on as they liked' was not the way to retain them, especially if they had your own increasingly inventive watercolours sitting before them but were not taught in any great detail – if at all – how to emulate them technically.

Turner was therefore deserted by his pupils, who did him a favour as a consequence. The lessons may have supplied them with little for five shillings, but they provided a far worse return per man-hour for a tutor who was increasingly obtaining large sums for his paintings and watercolours. Consequently, Turner virtually gave up the teaching of amateurs. In future, only his friends would receive his guidance, and even then they would not get it very often, although probably it would be obtained for nothing.

Turner continued with his own education, however, for a number of fine drawings of both male and female nudes in the *Academical* sketchbook indicate that he intermittently visited the life room in Somerset House during the winter of 1798–9. The leatherbound volume also contains several rough watercolours of Caernarfon Castle, which would facilitate the creation of a finished watercolour of the same subject that would be displayed in the 1799 Royal Academy Exhibition (see fig. 209). One of these studies enjoys an almost jewel-like intensity of colour (fig. 198). It was probably during this winter, too, that Turner created the view of Durham he had promised Hoppner. However, Farington could still not make up his mind over the subject of the watercolour Turner had offered to elaborate for him, and consequently he called around at Maiden Lane or Hand-court to take another look at the young man's sketchbooks. It was a fruitless expedition, for he remained unable to decide.

A Cause for Tears

Judging by the finished watercolour of Caernarfon Castle that would be exhibited in the 1799 Royal Academy Exhibition in the spring, it was probably not long before its creation that Turner was profoundly affected by a painting by Claude le Lorrain that was owned by John Julius Angerstein (c.1732–1823, fig. 199). This highly successful marine insurer was one of the founders of the modern Lloyd's exchange. In that role he indirectly benefited greatly from the West Indies slave trade, for slave cargoes were often heavily insured.

Angerstein was an avid collector with a formidable eye. His discernment is made clear by the fact that shortly after his death the best paintings in his holding, including works by Raphael, Titian, Sir Peter Paul Rubens (1577–1640), Diego Velázquez (1599–1660), Rembrandt, Claude and Poussin, would be purchased by the nation to help form the nucleus of the National Gallery collection.

Turner may have first met Angerstein at Norbury Park through William Lock, whose second daughter was engaged to the insurer's son (they would marry in September 1799). In the autumn or winter of 1798–9 Turner visited Angerstein either in his London town house at 102 Pall Mall or at his country residence, Woodlands, in Greenwich.[8] There an incident took place that would be recorded fifty-eight or more years later by Turner's friend, the military artist George Jones RA (1786–1869), who had probably received the story from Angerstein himself: 'When Turner was very young he went to see Angerstein's pictures. Angerstein came into the room while the young painter was looking at the Sea Port by Claude, and spoke to him. Turner was awkward, agitated, and burst into tears. Mr Angerstein enquired the cause and pressed for an answer, when Turner said passionately, "Because I shall never be able to paint any thing like that picture."'[9] The work that so moved him was the *Seaport with the Embarkation of St Ursula* (fig. 200), which the collector had bought in 1791 or during the following year.[10] That the young painter

Left 199 Edward Scriven after Sir Thomas Lawrence PRA, *Portrait of John Julius Angerstein*, stipple and line engraving, c.1815, British Museum, London.

Right 200 Claude le Lorrain, *Seaport with the Embarkation of St Ursula*, 1641, oil on canvas, 44½ × 58⅝ (113 × 149), National Gallery, London.

quickly came to regard the Claude as an inspiration rather than a deterrent probably explains why he appears to have undertaken a close examination of the major part of the French artist's output soon afterwards.

He must have done so through the engraved reproduction of a book of Claude drawings – the so-called *Liber Veritatis*, or 'Book of Truth' – that a London engraver, Richard Earlom (1742–1822), had produced in 1777. Earlom had copied Claude's inventive pen, ink and brush drawings using etched lines and mezzotinted tones, with sepia-coloured ink roughly approximating the hues originally employed by Claude. The resulting prints are somewhat crude, although for Turner they must have been much better than nothing. Judging by the strong Claudian strain that would begin to appear in his art in the spring of 1799, the Claude-Earlom *Liber Veritatis* certainly helped him understand the French master's imagery and associative techniques.

It would have taken an ordinary workman a little under forty years to earn the £1,050 that the 23-year-old Turner possessed in Bank of England stock by the end of 1798.[11] But the painter did not rest on his laurels. Instead, he worked hard throughout this period preparing works for the next premier showcase display at Somerset House. And it was probably at this time that he also began – but never finished – some moderately large watercolours of the lake and garden at Stourhead, as well as possibly a painting for Colt Hoare he did complete.

In *Cross at Stourton, Wiltshire* (fig. 201) Turner paid more attention to the medieval cross in the foreground than he did to the imitation Pantheon in the background. Clearly, he was not particularly interested in associations of the classical world that had been created fairly recently in the depths of Wiltshire. In *Sunrise at Stourhead, Wiltshire* (fig. 203) we look towards the village of Stourton at dawn. Turner rubbed the paper mercilessly in an attempt to capture the brilliance of the sun burning off the early morning haze. The sunrise is so blinding that it prefigures similar light effects in the artist's late work. And *Aeneas and the Sibyl, Lake Avernus* (fig. 202) was Turner's first ever ideal, classical and Italian landscape in oils. It was developed from the pencil outline transcription he had recently made of Colt Hoare's 1786 depiction of Lake Avernus in Italy (see figs 195 and 194 respectively). Perhaps the patron had commissioned this oil to hang alongside a Richard Wilson view of Lake Nemi with Diana

165

201 *Cross at Stourton, Wiltshire*, c.1798, watercolour on paper, 15¾ × 21½ (40 × 54.6), Turner Bequest XLIV-e, Tate Britain, London.

202 *Aeneas and the Sibyl, Lake Avernus*, c.1798, oil on canvas, 30⅛ × 38¾ (76.5 × 98.5), Tate Britain, London.

and Callisto he had inherited, but then found it looked weak by comparison and so ultimately rejected it. That rejection may have led, in turn, to Turner only completing eight of the ten large Salisbury Cathedral views commissioned by Colt Hoare.

To the left of centre the Cumaean Sibyl stands before Aeneas, who has just asked to visit his deceased father in Hades. The priestess has given her assent and proffers the golden bough he will need to take with him if he is to return to the land of the living. A frequent modulation of surface touch assimilated from Wilson imbues the painting with an appropriate sense of life and energy.

By the spring of 1799 the 7th Earl of Elgin (1766–1841) faced a problem. Having recently been appointed the British ambassador to the Ottoman court at Constantinople, this diplomat and soldier was looking for someone to make accurate drawings of the many antiquities distributed around Athens, which then formed part of the Turkish empire. His plan was to have those images engraved, and the resulting prints disseminated throughout Britain, thereby hopefully raising the artistic standards of the nation. Unfortunately, however, he was entirely unrealistic about what such an employee would cost. He proposed to pay £30 per annum, for which he also wanted to keep all the drawings. Additional duties would include 'decorating fire-skreens, work-tables and other such elegancies'.[12] Because of the low sum on offer, Lord Elgin was turned down by an architect and four painters, one of whom was Girtin.[13]

He also offered the job to Turner, who was amenable to taking on the task but only for either £400 or £800, depending on whether you believe Farington or Lord Elgin.[14] Although it might be thought that either of these high demands was intended to express Turner's derision at the invitation, this seems improbable, given that a few years later he would be extremely appreciative of Lord Elgin's work in Greece. Instead, it is much more likely he had calculated the job would involve him making forty or eighty drawings (the latter number being the more probable of the two). As in normal circumstances Turner might have obtained ten guineas each for the types of accurate drawings required, to ask for either £400 or £800 was therefore only requesting conservative payment, given the extra duties involved. But understandably the aristocrat declined his offer and the negotiations ended.[15]

The 1799 Royal Academy Exhibition
FRIDAY 26 APRIL TO SATURDAY 15 JUNE

This year Turner had eleven oils and watercolours on display. One of his submissions showed a castle in the North of England, two represented Salisbury Cathedral, and four more were of Welsh subjects. And Turner also exhibited a poetic landscape, a contemporary battle scene and a generalised marine view. Once more he headed the field where quotations linked to titles in the catalogue were concerned, with lines of poetry attached to five of his submissions.[16]

203 *Sunrise at Stourhead, Wiltshire*, c.1798, watercolour on paper, 17½ × 23½ (44.4 × 59.6), Turner Bequest XLIV-g, Tate Britain, London.

His determination to break the existing bounds of poetic painting could not have been clearer.

Two of the oils hung in the Great Room. The title of *Harlech Castle, from Twgwyn ferry, summer's evening twilight* (fig. 204) was accompanied in the catalogue by verses drawn from Milton's *Paradise Lost* that tell of the coming of sunset, the emergence of the 'starry host' and the rising of the moon. The timescale of the evening scene is therefore extended by the poetry. To the right of centre may be seen a typically Turnerian visual clutter, in the form of vessels jumbled in front of a building. In the *Sun* newspaper of 13 May Turner was praised for combining 'the style of Claude and of our excellent Wilson' in this painting but also advised against getting into 'a habit of *indistinctness*'. Thankfully, he would ignore that advice, for 'indistinctness' would eventually become one of the great strengths of his art.

In the Anti-Room hung *Kilgarren castle on the Twyvey, hazy sunrise, previous to a sultry day* (fig. 205). The large 'X' that pinions the centre of the composition reflects Turner's newfound determination to structure his images more forcefully. The paint surface was frequently

Above 204 *Harlech Castle, from Twgwyn ferry, summer's evening twilight*, R.A. 1799 (192), oil on canvas, 34¼ × 47 (87 × 119.5), Yale Center for British Art, Paul Mellon Collection.

Above right 205 *Kilgarren castle on the Twyvey, hazy sunrise, previous to a sultry day*, R.A. 1799 (305), oil on canvas, 36 × 48 (92 × 122), National Trust (on loan to Wordsworth House, Cockermouth).

Below 206 *Abergavenny bridge, Monmouthshire, clearing up after a showery day*, R.A. 1799 (326), watercolour on paper, 20 × 28¼ (50.9 × 71.8), private collection.

worked in the manner of Richard Wilson, whose pictures often contain a similar 'flutter and flickering', as was observed at the time.[17] Consequently, everything is imbued with a restless energy.

Turner's next seven exhibits were all watercolours placed in the first-floor Council Room. One of them was *Abergavenny bridge, Monmouthshire, clearing up after a showery day* (fig. 206), in which cattle enter the river Usk towards sunset. The pictorial sweep of this watercolour demonstrates that by 1799 Turner had nothing more to learn from Girtin about breadth in the depiction of landscape.

Colt Hoare lent *Inside of the chapter-house of Salisbury Cathedral* (fig. 207).[18] Here we look eastwards in late morning light through the entrance to the meeting place, which acts as a highly effective framing device. As in a number of Turner's other depictions of religious buildings and ruins, boys play on sanctified ground to remind us of Christ's statement concerning childhood and the Kingdom of God. By making two of them sit, and through only populating the scene with diminutive figures anyway, the grandeur of the space is greatly enhanced.

We view part of the same building on a lovely summer's evening in *West front of Salisbury Cathedral* (fig. 208), which was also lent by Colt Hoare. Here three clerics and an elegantly dressed female member of the congregation enter the cathedral while still more playing children call forth appropriate associations of innocence in

Facing page 207 *Inside of the chapter-house of Salisbury Cathedral*, R.A. 1799 (327), pencil and watercolour on paper, 26 × 20 (66 × 50.8), Victoria and Albert Museum, London.

208 *West front of Salisbury Cathedral*, R.A. 1799 (335), watercolour on paper, 19 × 26 (48.5 × 66), Harris Museum and Art Gallery, Preston, Lancs.

the divine realm. By keeping the cathedral's tower and spire beyond the right-hand edge of the image, and by omitting its entire roof, Turner prevented the façade from being dwarfed by those structures, and thus magnified its overall scale.

The title of *Caernarvon Castle* (fig. 209) was accompanied in the Royal Academy catalogue by verses aimed at enhancing our awareness of the passage of time. They were taken from *Amyntor and Theodora* of 1748 by David Mallet (c.1705–1765).[19] This was the watercolour with which Turner responded to the Claude seaport scene he had viewed at Angerstein's house in London or Greenwich not long before, as well as perhaps to further seaport scenes in the Claude-Earlom *Liber Veritatis*. It was virtually the first image created since the time of Claude in which the sun shines directly at us and reflects upon water (for most artists since the late seventeenth century had artfully hidden it behind buildings, rocks or clouds).[20] As such, it stands at the head of a new line in Turner's art.

When the sun is looked at directly in reality, all the tones surrounding it are forced into a very narrow range from light to dark. Few artists realised this in the age before photography. The watercolour therefore demonstrates Turner's extraordinary observational acuity, for even its darkest hues are quite light; by restricting the tones in such a manner, the sense of dazzle is greatly enhanced. And

209 *Caernarvon Castle*, R.A. 1799 (340), watercolour on paper, 22½ × 32½ (57 × 82.5), private collection.

Turner's assimilation of Wilson's 'flutter and flickering' really paid off here, for by permitting many tiny areas of the yellow-ochre and light grey underpaint to show through the darker yellow-grey overpaint that makes up the shadowed areas of the castle, he subtly imbued the building with luminosity and energy. He had progressed a long way from the dull flatness of Malton's walls. The figures add scale to the proceedings, while their limited numbers further the sense of Caernarfon Castle having been abandoned.

Clearly Angerstein saw the connection between this watercolour and his seaport scene by Claude, for Farington reported on 27 May that the collector 'is to give [Turner] 40 guineas for his drawing of Caernarvon Castle. The price fixed by Mr A., & was much greater than Turner wd. have asked.'[21] That Angerstein offered so much demonstrates his delight in the image, his generosity and his desire to encourage young talent. The critic writing in *Lloyd's Evening Post* for 10–13 May also derived great pleasure from what he called a 'most exquisite Drawing', declaring it was impossible to do it justice, for it was 'to be classed with the very best that the Art has produced'. He went on to state that 'Mr Turner possesses a true poetical spirit, and can give to the ordinary scenes of Nature an air of grandeur and beauty that makes its way immediately to the imagination of the spectator...This is a drawing that Claude might have been

proud to own'. Given that just a few months earlier Turner had felt he would never be able to match Claude, such positivity must have given him satisfaction.[22]

In the exhibition catalogue, verses assembled from various passages in the 'Summer' section of Thomson's *The Seasons* were used beneath the title of *Warkworth Castle, Northumberland – thunder storm approaching at sun-set* (fig. 210). They enhance the temporal range of the image, induce an awareness of meteorological change, communicate the sense of threat posed by the approaching storm, and link human destiny to the violent discharge of that phenomenon. Without verbal assistance, all these dimensions would normally reside well beyond the scope of painting.

The Altieri Claudes

Given the recent awakening of Turner's interest in Claude by the Angerstein seaport scene, and probably by the Claude-Earlom *Liber Veritatis* as well, it was extremely serendipitous that two of the French artist's largest and loveliest canvases should have appeared on the London art market in the spring of 1799. They were *Landscape with the Father of Psyche sacrificing at the Milesian Temple of Apollo* of 1663 (fig. 211); and its pendant *Landscape with the Landing of Aeneas in Latium* of 1675 (fig. 212). Both paintings had originally been commissioned by members of the Altieri family in Rome, and they had recently been brought to England where they were acquired for 7,000 guineas by the enormously wealthy sugar magnate, slave owner,

Above 210 *Warkworth Castle, Northumberland – thunder storm approaching at sun-set*, R.A. 1799 (434), watercolour on paper, 20½ × 29½ (52.1 × 74.9), Victoria and Albert Museum, London.

Below 211 Claude le Lorrain, *Landscape with the Father of Psyche sacrificing at the Milesian Temple of Apollo*, 1663, oil on canvas, 68½ × 86⅝ (174 × 220), National Trust, Anglesey Abbey, Lode.

Below right 212 Claude le Lorrain, *Landscape with the Landing of Aeneas in Latium*, 1675, oil on canvas, 68⅞ × 88⅓ (175 × 224), National Trust, Anglesey Abbey, Lode.

Above 213 John Hoppner RA, *William Beckford*, c.1800, oil on canvas, 48⅞ × 39 (124 × 99), Salford Museum and Art Gallery, Salford.

Above right 214 *Study of the composition of Claude's* Landscape with the Landing of Aeneas in Latium, c.1799, ink, pencil and watercolour on paper, 8½ × 5½ (21.5 × 13.8), fol.122 of the *Studies for Pictures* sketchbook, Turner Bequest LXIX, Tate Britain, London.

novelist, travel writer, collector, occasional Member of Parliament and bisexual social pariah, William Beckford (1760–1844, fig. 213). He immediately put them on public display in his London town house at 2 Grosvenor Square.

It was to that address that the leading *cognoscenti* flocked on Wednesday 8 May 1799 to see the paintings. Among them were many Academicians, Associates and other artists, including Turner. He was overwhelmed by one of them, telling Farington that 'He was both pleased and unhappy while He viewed it, – it seemed to be beyond the power of imitation.'[23] Probably the picture that affected him was the *Father of Psyche*, although there is no way of knowing for sure, especially as he made a partial record of the *Landing of Aeneas* in a sketchbook (fig. 214), and probably did so from memory, which would explain why his version contains no figures. But ultimately both paintings must have impressed him. This was because, as with the Angerstein seaport scene, he was equally receptive to Claude's sense of beauty and to the technical challenges the French master posed.

On the following day Turner looked at the paintings again, as did many others. Within Farington's hearing, various aspects of them were discussed, including their fidelity to nature, their pictorial vivacity, their compositional inventiveness, their depictions of the human figure, their colourings and their execution over dark grounds. Yet the paintings had their detractors as well. That evening the painter

Left 215 John Jackson after Mary Smirke, *Portrait of Robert Smirke RA*, engraving, 1814, National Portrait Gallery, London.

Robert Smirke RA (1753–1845, fig. 215) visited Farington's house to talk about them.[24] Among other things, he thought it absurd that in the *Father of Psyche* Claude had represented an ancient sacrifice 'in a *ruined* temple', while in the *Landing of Aeneas* the French painter had mixed a 'modern Italian building, with circumstances which represented ancient times'. For Smirke, Claude 'wanted sense', while Richard Wilson was 'much his superior in conception, and exhibits more sense, by preserving propriety'. Because Smirke and Turner were becoming quite friendly at this time, identical sentiments might well have been expressed to the younger artist earlier that day if he found himself standing next to Smirke in front of the pictures. Turner had already demonstrated a responsiveness to decorum in his own works, and if Smirke did express his reservations to him, they can only have underlined the need for such appropriateness or 'propriety'.

On 27 May 1799 Turner called on Farington, who assured him he would be elected an Associate if he put himself forward at the next opportunity.[25] Turner then told him he had received an invitation to stay at William Beckford's country seat in Wiltshire. Evidently he was somewhat mystified by this invitation, for the collector had not specified what he wanted him to do there. However, as he anyway needed to visit the nearby city of Salisbury in connection with the ongoing Colt Hoare commissions, such a trip would be easy.

Because of his forthcoming second attempt to gain the Associate status he so badly wanted, Turner was networking heavily. Thus he attended the king's birthday dinner on 4 June.[26] The very fact that he was invited demonstrates the regard in which he was held, and it augured favourably for his chances of gaining Royal Academy membership. Yet just as he had become nervous prior to his previous attempt to attain Associate status, now his anxiety started up again, probably because he wanted to be an 'insider' just a little too strongly.

When Turner once more called on Farington on the morning of Saturday 6 July, he was again assured that his Associateship was certain. By now he was seriously thinking of moving out of Maiden Lane and Hand-court. The money he had received for *Caernarvon Castle* and the fact that 'He had 60 drawings now bespoke by different persons' (as he would also tell Farington that morning) afforded him the financial confidence to do so.[27] The Academician advised him not to buy a house but to rent lodgings, advice he would adopt.

In Turner's studio two days later, Robert Smirke chose a view of Derwentwater in the Lake District as the subject of the watercolour to be elaborated for Farington because the latter had remained unable to make up his mind.[28] At the same time Smirke requested that a view of Richmond in Yorkshire be made for himself.[29] He must have been promised a free work in exchange for having pledged to vote for Turner in the next Associate election to take place, for in the previous such ballot he had polled for Turner's opponent, Rossi.

On Sunday 21 July Turner took advantage of the fine weather to stroll down to Fulham where John Hoppner and his wife had hosted a lunch party for Henry Fuseli RA (1741–1825), Farington, Sawrey Gilpin RA (1733–1807), John Opie RA (1761–1807) and his wife. Turner joined the company for tea. Subsequently, Farington recorded being supposedly told by the latecomer that 'He has no systematic process for making Drawings, – He avoids any particular mode that He may not fall into manner. By washing and occasionally rubbing out, He at last expresses in some degree the idea in his mind.'[30] Certainly Turner did not have a fixed, step-by-step process for making his watercolours. Yet the penultimate sentence of Farington's account makes no sense whatsoever, for 'washing' and 'rubbing out' are wholly *subtractive* processes, whereby colours already present upon a piece of paper are removed. Such removal can take place by submerging the entire sheet or part of it in water, by dabbing off pigment with a damp sponge or brush, or by rubbing it off, and perhaps taking the top surface of the paper with it. However, the complete removal of pigment from a sheet of paper could never have been the method by which Turner had ever 'at last' expressed to some degree an idea held in his mind, given that his finished drawings of this period are always firmly pigmented affairs (albeit with occasional small internal areas of the paint having been removed by means of washing and rubbing). Quite evidently, Farington had failed to remember a good deal of what Turner had told him about his watercolour technique, possibly because he had imbibed quite a lot of wine over lunch.

A similar failure would occur after Turner had paid a visit to Farington's home in Upper Charlotte Street on Sunday 16 November 1799: '[Turner] reprobated the mechanically systematic process of drawing practiced by [John 'Warwick'] Smith & from him so generally diffused. He thinks it can produce nothing but manner and sameness . . . Turner has no settled process but drives the colours abt. till He has expressed the idea in his mind.'[31] The first two sentences of this passage are unquestionably accurate, for Turner would have necessarily rejected a 'mechanically systematic' or highly formulaic approach to the creation of watercolours. After all, he was a profoundly inspirational artist who firmly believed that constant inventiveness was intrinsic to his chosen discipline. Not for him the 'manner and sameness' of John 'Warwick' Smith (1749–1831) and others like him who were often beholden to doing things the same way every time, no matter what excitements their subjects afforded, or pictorial and technical challenges they posed. For Smith, just as for other artists and drawing teachers who were overly given to a 'mechanically systematic process of drawing', playing safe was everything. But Farington again omitted vital information here, for his final sentence makes no mention of the tonal scale practice that unquestionably formed a highly 'settled process' within Turner's technical armory.

Unwittingly, Turner could have been responsible for that omission. Without doubt he did drive his colours about, exactly as Farington related. However, he only did so when working on the *primary* stages of finished watercolours, or while making rough preparatory studies for those images, or when simply testing out an idea on paper without taking an image any further. By 1799 the scale practice had mainly become the vital *secondary* process in his watercolour art, with underpaintings that had recently been pushed around but which still needed a great deal of tonal reinforcement duly receiving it through the addition of a multitude of brushstrokes or washes (and, naturally, colours could also be modified or removed at any time by means of wetting, dabbing or rubbing). It may be that Turner did not mention the scale practice to Farington because he was only talking about the primary level of his drawings – the stage he would later describe as its 'beginning'.[32] Alternatively, he could have described his entire procedure for making watercolours but his auditor failed to take it all on board, just as he had done on the previous occasion they had discussed Turner's watercolour method. Yet in either case the 21 July and 16 November passages in Farington's diary fail to present us with the complete story.[33] Unfortunately, both of them have been treated as gospel by generations of commentators on Turner, but they really do need to be approached with great caution, for even gospels can lead us astray.

Fonthill House and Abbey

Around 21 August Turner quit London for William Beckford's country seat, Fonthill House, not far from Salisbury (fig. 216). He would spend the next three weeks there, returning home on 10 September or thereabouts. Also visiting the residence during this period were Benjamin West PRA, William Hamilton RA (1751–1801) and Henry Tresham RA (1756–1814). When Turner arrived at Fonthill, he received a commission from Beckford to develop a watercolour of Fonthill House as viewed from across its adjacent lake, an image that was quickly elaborated and soon engraved.[34] And Beckford also requested that Turner make him a set of five large watercolours of Fonthill Abbey, the new abode he had commissioned James Wyatt to design and construct for him on high ground about half a mile to the south-west. Additionally, he ordered a large depiction in oils of the fifth plague of Egypt. However, he was only prepared to agree on the prices of all these works when he had viewed the finished products. Turner had no choice but to consent to such unusual terms.

Obviously he suffered no problems accepting money that was deeply tainted with blood from a slave owner like Beckford. This was because Jamaica, the West Indies, the Middle Passage and Africa all seemed very remote, if they impinged on his consciousness at all.

216 *Fonthill House*, 1799, pencil on paper, 13 × 18⅝ (33 × 47.3), fol. 25 of the *Fonthill* sketchbook, Turner Bequest XLVII, Tate Britain, London.

His first allegiance was to his own survival. If incredibly rich men whose fortunes wholly or partially derived from slavery, such as the Lascelles (father and son), John Julius Angerstein and William Beckford, required his services, he was hardly in a position to refuse. For the time being, at least, he set aside his moral scruples, if he possessed any, which must be doubted. The economics of art and social morality were separate entities for Turner, at least when young. Thirteen or so years later his attitude would begin to change.

By 1799 Turner could never have stayed in a more sumptuously appointed residence than Fonthill House, for it was filled to the rafters with all manner of fine things. Not for nothing was it called 'Fonthill Splendens'.[35] But Beckford found the place too foggy and damp. That is why he had ordered the building of Fonthill Abbey. It was because of work on the latter structure that Wyatt descended on Fonthill during Turner's stay there.[36] His assistance was constantly required because as the abbey materialised, Beckford's intense romanticism, his immense illusions of grandeur, his response to the social rejection his sexuality had caused, and his passing infatuation with the Gothic led him to elaborate the building on an increasingly fantastic scale. In particular, its octagonal main tower constantly grew taller, in a seeming attempt to storm the heavens.

Although Fonthill Abbey was still under construction in August 1799, with scaffolding erected and builders clambering all over the place, Turner created some fine closeup drawings of the shell. With his acute responsiveness to Gothic architecture and lack of any great enthusiasm for its inauthentic modern counterparts, he probably did

not think much of Beckford's project. Still, he threw himself into his task. To that end he roamed the estate and its environs, creating pencil studies of the abbey from different points of the compass (fig. 217 is an example). Subsequently he went on to elaborate watercolour sketches such as the works reproduced here (figs 218 and 219). For future reference it is worth noting that they have fully retained their freshness of colouring.

Left 217 *Fonthill Abbey from the south-west: study for 'Morning'*, 1799, pencil on paper, 13⅛ × 17 (33.5 × 43.3), fol. 25 (?) of the *Fonthill* sketchbook, Turner Bequest XLVII, Tate Britain, London. This was the study for fig. 237.

Below 218 *Distant View of Fonthill Abbey from the East, with Bitham Lake and the River Nadder*, 1799, watercolour on paper, 13⅛ × 17 (33.5 × 43.3), fol. 46 of the *Fonthill* sketchbook, Turner Bequest XLVII, Tate Britain, London.

219 *A wooden shelter on the Fonthill estate, with a flock of sheep and shepherd; the unfinished tower of Fonthill Abbey seen on the horizon*, 1799, watercolour on paper, 13⅛ × 18½ (33.3 × 46.8), fol. 47 of the *Fonthill* sketchbook, Turner Bequest XLVII, Tate Britain, London.

By Wednesday 11 September Turner was back in London. That same day he called upon Farington to ascertain the situation regarding the forthcoming election of an Associate Royal Academician.[37] Due to a mix-up caused by the inexperience of Thomas Lawrence in chairing the previous evening's General Assembly meeting in the absence of West, only a single Associate could be elected in 1799. Yet despite this limitation, Farington once again reassured Turner that he was certain to be elected because he had done so well at the previous Associate election.

Subsequently, Turner informed Farington that he had been engaged to visit Lancashire to make drawings of the remains of Whalley Abbey for a new antiquarian project, a history of the village of Whalley that had originally grown up around the Cistercian foundation in the Ribble Valley, about four miles north-west of Burnley. For the proposed *History of Whalley* he had been commissioned to make ten watercolours at ten guineas each. The author of the history was to be the Revd Thomas Dunham Whitaker (1759–1821, fig. 220), a Church of England minister, antiquarian and mag-

istrate. The venture was underwritten by the leading British collector of classical antiquities, Charles Townley (1737–1805), of Towneley Hall, near Burnley in Lancashire.[38] Other supporters included Thomas Lister Parker (1779–1858), of Browsholme Hall, near Clitheroe, which is also in the same county.

Lancashire and North Wales, 1799

By Sunday 15 September Turner was in Manchester,[39] in order to visit Worsley Old Hall, just six miles from the city centre. The house was owned by the 3rd Duke of Bridgewater (1736–1803, fig. 221), who had spent the best part of his life at the forefront of British canal building. Reputedly his annual income was £107,000, which would translate to many millions today, if not even to billions.

Turner waited upon the industrialist in order to discuss a possible commission. It appears likely that the nobleman had attended the Royal Academy Exhibition that spring and, having been impressed by Turner's works, had asked around, only to learn that the young artist entertained great ambitions as a marine painter. What the duke therefore now requested was a companion picture to his van de Velde *Ships in a Stormy Sea* (see fig. 250), which then hung at Worsley Old Hall and which would continue to do so until 1801.[40] Turner was very amenable to a commission that would enable him to pit himself against one of the leading marine painters of all time, and the very artist who had sparked off his interest in marine painting in the first place. By way of payment he requested 250 guineas. The Duke of Bridgewater appears to have asked for time to think about that demand.

Turner next went to stay with Thomas Dunham Whitaker at Holme in Cliviger, near Burnley. From there he ventured forth to draw the ruins of Whalley Abbey, the village of Whalley, Towneley Hall, Gawthorpe Hall, Mitton, Stonyhurst College, Browsholme Hall, Whitewell and Clitheroe. Over the next couple of years he would develop his ten watercolours from that material. Most of the pencil drawings made on the trip are very low-keyed, but occasionally Turner responded passionately to what he had seen, as in a sketch of a blasted oak (fig. 224). Unfortunately, none of the *History of Whalley* watercolours are particularly ground-breaking, probably because Turner felt there was hardly any point in making extraordinary images if the engraver responsible for reproducing them, James Basire junior (1769–1822), would not be able to do them much justice. At this time there were no landscape engravers comparable in skill to portrait engravers. One day Turner would change all that.

The depiction of Gawthorpe Hall, Padiham, just outside Burnley, was responsible for bringing the relationship between Turner and Charles Townley to an abrupt close. This is because the latter had

220 William Holl senior after James Northcote, *Portrait of Thomas Dunham Whitaker*, stipple engraving, 1816, 14⅞ × 10⅞ (37.8 × 27.7), National Portrait Gallery, London.

221 Peter Rouw, *Francis Egerton, the 3rd Duke of Bridgewater*, 1803, wax medallion, 2¾ × 2½ (7 × 6.4), National Portrait Gallery, London.

222 *Stonyhurst College*, c.1800, watercolour on paper, 8¼ × 12 (21 × 30.5), private collection.

223 James Basire after J. M. W. Turner, *Stonyhurst*, engraving, 1801, 6⅞ × 10⅛ (17.4 × 25.7), British Museum, London.

come across 'an old and very bad painting' of Gawthorpe and requested that, instead of making his own view of the building, Turner should copy the oil. He refused to do so. Although at first Townley caved in, he quickly regained his determination, with the result that there never would be a Turner watercolour of Gawthorpe Hall. Instead, Basire copied the old painting, with dire results indeed.

Townley preferred the 'old and bad painting' of Gawthorpe Hall because it showed the Elizabethan mansion as it had appeared in the seventeenth century. And that explains why the image of Stonyhurst College that Turner would make in 1800 (fig. 222) would be significantly altered when engraved (fig. 223). In his watercolour he would include the baroque pinnacles, cupolas and bronze eagles that had been placed upon the building's gatehouse in 1712. However, Basire would completely remove those upper structures, obviously because Townley had ordered him to make the gatehouse look pretty much as it had done when it had been built in 1595. Clearly the backer did not want all of the *History of Whalley* images to show buildings as they appeared contemporaneously – there needed to be a historical spread in an antiquarian work on places that had existed for centuries. Such an attitude is understandable in someone so bound up with history, but the gross pictorial interference it engendered would not endear Townley to the painter.

As the dedication below the Stonyhurst engraving would make evident, the print would be paid for by its dedicatee, Thomas Weld (1750–1810). A devout Roman Catholic, in 1794 Weld had given Stonyhurst Hall to the Society of Jesus for educational purposes. Because Townley hailed from one of the oldest Roman Catholic families in Britain, it is extremely likely that he would be the person responsible for involving Weld in the project. And there can be no doubt that Turner learned of the Roman Catholic connections of Stonyhurst College, for they were mentioned by Whitaker in his text. This was undoubtedly discussed with the painter, or shown to him in draft form at an early stage in the proceedings, in order to

224 *A blasted oak tree near a cottage in a wood*, 1799, pencil on paper, 13 × 19 (33 × 22.8), fol. 48 of the *Lancashire and North Wales* sketchbook, Turner Bequest XLV, Tate Britain, London.

help him choose the subjects he would be illustrating. In his text, Whitaker specified that Stonyhurst College was 'a large catholic seminary', while in a lengthy footnote he expressed the hope that the Jesuits who had fled from persecution on the Continent and created the Lancashire seminary would respect the established religion of Great Britain. He then went on to state that both Catholics and Protestants 'hold the fundamentals of Christianity in common – as both theirs and ours are true churches, claiming their respective rights in succession from the apostles'.[41]

Such tolerance was extremely rare in a Britain in which even the mildest suggestion that Roman Catholics might enjoy the same religious and political rights as Protestants was enough to set vast numbers of the latter foaming at the mouth. Coming from a Church of England minister, it was quite extraordinary, and clearly it taught Turner a lesson that would stay with him forever. Whitaker's equation of the two major branches of British Christianity perhaps explains why Turner's Stonyhurst watercolour would show two swans in front of the twin pinnacles of the gatehouse. These birds confront one another in an unusually formal way and, by dint of that opposition, they could well have been intended to allude to the customary opposition of the principal forms of Christianity within Great Britain.[42] Turner would certainly express himself associatively in another of the *History of Whalley* depictions of a Christian structure he would make around 1800. This is a view of the ruined cloisters of Whalley Abbey (untraced) that is solely populated by children at play. By now the inclusion of such holy innocents in a Turner depiction of a Christian surround should require no explanation.

From Lancashire, Turner moved on to north Wales where he made drawings of a house near Bangor owned by an older brother of James Wyatt and designed by another of the latter's brothers, as well as related buildings.[43] Turner then travelled to Bedgellert via Penygroes and the Glaslyn estuary near Traeth Mawr, and up through the Llanberis Pass to Dolbadarn Castle. Everywhere the majesty and beauty of the mountains thrilled him, and both in Wales and upon his return to London he expressed that excitement with a renewed sense of energy (figs 225–9). He then moved down to Capel Curig and Betws-y-Coed before travelling up the Vale of Conwy via Llanrwst to Conwy. From there he moved by stages to Rhuddlan, Denbigh, Llangollen and Wynnstay. This last was the country seat of the Member

Above left 225 *Traeth Mawr, with Y Cnicht and Moelwyn Mawr*, 1799, pencil and watercolour on paper, 21⅜ × 30 (54. × 76.4), Turner Bequest LX(a)-F, Tate Britain, London.

Above 226 *Nant Peris, looking towards Snowdon*, 1799, pencil and watercolour on paper, 21¾ × 30⅜ (55.3 × 77.2), Turner Bequest LX(a)-A, Tate Britain, London.

Facing page top 227 *View across Llyn Padarn towards Snowdon*, 1799, watercolour on paper, 21⅜ × 30⅛ (54.7 × 76.5), Turner Bequest LXX-d, Tate Britain, London.

Facing page bottom left 228 *Dolbadarn Castle and the Llanberis Pass*, 1799, pencil and watercolour on paper, 26⅝ × 38¼ (67.7 × 97.2), Turner Bequest LXX-O, Tate Britain, London.

Facing page bottom right 229 *Dolbadarn Castle from above the Llanberis Pass*, 1799, pencil and watercolour on paper, 21⅞ × 29⅞ (55.5 × 75.8), Turner Bequest LXX-Z, Tate Britain, London.

230 *A Beech Wood*, October 1799, oil on paper, 6½ × 9½ (16.5 × 24.1), Harvard Art Museums/Fogg Museum, Cambridge, Mass.

of Parliament for Merionethshire, Sir Watkin Williams-Wynn (1772–1840), who was reputedly the wealthiest landowner in Wales and who already possessed an early Turner view of Tintern Abbey.[44] The painter spent a night or two as his guest. While doing so he made a sketchbook drawing of Nicolas Poussin's *Landscape with a Man Killed by a Snake* of 1648 (National Gallery, London).[45] It is the earliest surviving manifestation of his admiration for the French master.

Approaching the Summit

By Monday 14 October 1799 Turner had returned to London.[46] On the 22nd he visited Farington to ask if he should take lodgings in George Street, Hanover Square, Mayfair.[47] He was advised that it was 'a very good situation', as indeed it would have been. It was on this occasion that Turner told Farington about his low earnings from teaching, as related above, as well as his final, hands-off approach to that task.

On 30 October Turner called upon Farington to inform him he had just returned from Kent where he had been painting beech trees.[48] Three oil paintings have come down to us from this trip, one of which is reproduced here (fig. 230). A good deal of walking and looking at nature, plus the technical problems of employing oil paint to depict spatially complex forms like trees, were probably just what Turner had needed to distract him from the anxieties of waiting for the forthcoming election. The paintings themselves enjoy immense vitality, a significant part of which clearly derived from their having been worked on with enormous rapidity.

By the time Turner visited Farington on 30 October, his worries had returned in force. This was because he had discovered that Paul

Sandby and other Academicians intended to vote for Colt Hoare's protégé, the painter Samuel Woodforde (1763–1817). Farington assured him he still had nothing to fear. Turner then updated him on his search for a new home and studio. At last he had found what he was looking for, at least where the workplace was concerned. His new studio would be in Harley Street, although Turner kept to himself the fact that he had selected it from a number of available properties because it possessed an extraordinary asset for a painter in watercolours, as we shall discover shortly. It would keep him rooted to this corner of the world for the rest of his life. The rent was 'abt. 50 or £55 a year' – very typically Farington could not remember the correct sum by the time he came to write up his diary – but in either case it was well within Turner's means. Farington approved of the move, for Harley Street being 'very respectable & central enough', it fully met the two criteria that were perhaps most essential to the showing of works to prospective clients at a studio address.

On the afternoon of Monday 4 November, Turner again called on Farington, this time to tell him that an attempt would be made to add more Associates to the one scheduled to be elected by the General Assembly that evening. And so it transpired, with an argument over the number finally resulting in a walkout by those who wanted more, for they were outvoted.[49]

The candidate list comprised sixteen painters, including Edward Dayes and Thomas Malton, and three architects. The first ballot fell upon just six candidates. The matter was decided quickly. In the initial poll eighteen votes were cast. Turner received ten of them, his nearest rival three. The follow-up ballot produced the same numbers. Accordingly, the President declared 'Willm Turner to be duly Elected an Associate of the Royal Academy'.[50] The meeting then adjourned, whereupon Farington, Smirke, Thomas Daniell (1749–1840), Hamilton, Lawrence, Sawrey Gilpin and Hoppner all hurried off to Maiden Lane to congratulate Turner on his win. Given the latter's anxieties, it is easy to imagine him waiting near the threshold of the barber's shop or just behind his Hand-court studio entrance for the first sign of his friends, and his big grin when it emerged that all his fears had proven groundless. Of course, he did not know that Hoppner and Gilpin had been among the Academicians who had walked out, and consequently had not voted. Probably Farington was sufficiently diplomatic not to tell him. But in any event, both the supporters and the abstainers supped with Turner and 'staid till past one'.[51] It must have been a jolly affair, with William Turner joining in as well. Of the many hundreds of artists in Britain, his 24-year-old son had been voted an Associate Royal Academician! What a vindication.

11

The Dark Side

1799 to 1800

Turner's election as an ARA on 4 November 1799 acted as the catalyst for his long-desired move away from Maiden Lane and Handcourt. In the days following his triumph he transferred his principal living quarters to 75 Norton Street, Marylebone,[1] and his painting activities to the ground and first-floors of 64 Harley Street, Marylebone, about a third of a mile to the south-west of Norton Street.

64 Harley Street

Unfortunately we know nothing of the Norton Street house, although it was probably quite large. On the other hand, we are unusually well informed about the Harley Street house. This is because in 1803 Turner would somehow obtain a March 1801 lease for the property that also contains a Schedule or highly detailed listing of every one of its rooms, windows, fixtures and fittings, as well as precise descriptions of its outbuilding and garden.[2] We also possess a plan of the entire 64 Harley Street site that probably dates from 1813 (fig. 231).[3]

Located at the intersection with Queen Anne Street West, number 64 stood on the west side of Harley Street and was probably the oldest surviving building in that thoroughfare.[4] Crucially, it possessed a 'Spring Well' in its backyard. In a London that enjoyed virtually no pressurised mains water supply, such a feature was no small advantage for a watercolourist. The house had four floors, plus a basement. Up to second-floor level the interior was covered in oak panelling, and was therefore rather dark. The ground floor contained two large front rooms, which Turner would use as his watercolour studios, obviously because of their proximity to the well. In all likelihood a rear parlour would be employed until 1803 for the storage of works on paper, after which time it would revert to its original function. On the first-floor front were the two largest and highest rooms in the house, which Turner would use as his oil painting studios. Each of them was about 16½ feet in width by 10 feet in depth, so they were not large by the standards of artists' studios today. A back room probably served as a storeroom for canvases.

Three floor-to-ceiling windows illuminated each of these studios. As with the watercolour studios beneath, morning sunlight would have streamed in. For many years to come, Turner would make his studios in rooms that faced east, north-east or south-east, due to his propensity to work very early in the day, and his consequent need for bright light at such times. This habit had formed in Maiden Lane, where his top-floor bedroom/studio had faced south-east.

The second floor comprised two front rooms of the same floor dimensions as the ones beneath. However, they had much lower ceilings, having originally been intended for use as bedrooms. A back bedroom was located on the south side of the stairwell. Finally, on the top floor were three 'garretts' designed for use by servants.

Detail of fig. 239.

231 *The Portland Estate Plan of 64 Harley Street, St Marylebone, c.1813*, watercolour on paper, page size 8⅞ × 7⅝ (22.6 × 19.3), Howard de Walden Estate, London.

A backyard immediately behind the house ran across virtually the full width of the property. At its northern end, just beyond the 'Spring Well', it terminated in a lockable gate affording access to Queen Anne Street West. At its southern end stood a privy. The 'Out Building' beyond the yard possessed two floors, the lower one of which had probably served initially as a bagnio or bath house, with the room above it perhaps having been originally subdivided to provide its changing rooms and/or extra bedrooms for the prostitutes who had serviced it. Later the lower floor had become a warehouse. By 1799 it had probably been disused for some time. By the 1770s the upper space had been turned into a schoolroom, for William F. Wells had studied there during that decade.[5] By 1801 that place of learning was entitled the Cavendish Academy. To the west of the warehouse-schoolroom was a garden enclosed by a brick wall on three sides. A fence containing a gate divided the garden up the middle, with its northern half possessing a doorway onto the street.

Turner's landlord was Robert Harper, who almost certainly ran the Cavendish Academy. Harper got the landlord of 65 Harley Street, Revd Hardcastle, to act as his rent collector, which initially led Turner to believe that the clergyman was his landlord.[6]

Turner had completed his twin moves before Sunday 16 November 1799 – and thus just under a fortnight after his elevation in status to ARA – for on that day he called on Farington to notify him of his change of studio.[7] Prior to quitting Maiden Lane and Handcourt he had compiled an inventory of every article of clothing he owned, probably in order to forestall thefts by the removal men.[8] The inventory contains fifty-nine items, including ten waistcoats, five of them coloured. Obviously Turner needed to cut a dash when finding himself in smart surroundings, and fancy waistcoats helped attain that end, especially when on tour and staying in grand houses.

When Turner called on Farington on Sunday 16 November, he also talked again about his primary approach to making watercolours, as discussed above. But unfortunately 64 Harley Street contained a potentially serious drawback, as Turner had only discovered belatedly and now informed his mentor.

For five or six hours in the middle of each day the marine painter John Thomas Serres (1759–1825) was to have the use of the two front bedrooms on the second floor immediately above his oil painting studios. Probably Serres intended to use them for painting and display purposes, the cultivation of potential clients, and entertainment. Since September 1799 he had been conducting a hydrographic survey on board a Royal Navy blockade ship off the coast of Brittany.[9] It is likely he had negotiated the use of the upstairs rooms just before his departure. Understandably, Turner feared that following the marine artist's planned return in December, the part-time occupancy would 'subject him to interruption'. Yet even before that date there existed the very real danger of intrusion by Serres's wife, Olivia, who lived with their two daughters in the very next street.

Olivia Wilmot Serres (1772–1834) was also a painter, and one not without talent. Mainly she painted landscapes in the style of Richard Wilson. However, she was also mentally unbalanced. A spendthrift and forger of cheques in her husband's name, she would bankrupt Serres in 1800. Moreover, she was highly promiscuous, as several illegitimate children would attest after her legal separation from her husband in 1803. Sadly, she would abandon them all. Eventually she would call herself 'Princess Olive of Cumberland' because of her claim to be the illegitimate daughter of a brother of King George III. That claim might have been justified but it would hardly meet with royal approval, let alone any social acceptance.

Given that rumours concerning Olivia Serres might well have been circulating by 1799, Turner was highly alarmed by the potential presence of both her and her husband in 64 Harley Street. As he

would be using four rooms as studios, he needed the absolute freedom to roam freely among them, creating at will. For that reason all their doors had to remain open, or at least unlocked. But with Olivia Serres at large, the locking of doors would prove essential. Yet to have to search constantly for keys, let alone unlock doors with wet paint on the hands, would prove an intolerable impediment to full creative flow. Moreover, to have a mentally ill person go on the rampage near a place of work would indeed cause 'interruption', perhaps in more ways than one. And when J. T. Serres returned from abroad, violent altercations might easily break out just above Turner's head. Such clashes would not only disturb his concentration but also remind him of painful scenes witnessed earlier in life. He therefore had just cause for concern.

Descent into Hell

Turner was not the only person to move out of Maiden Lane in November 1799; his mother was moved out as well. Through intermediaries and by a process of fraud too lengthy to be described here, on 29 November 1799 Mary Turner was committed to St Luke's Hospital for Lunatics in Old Street, London.[10] The two intermediaries who obtained her that place appear to have been professional colleagues or friends of William Turner, whose name would never appear on any of the documents relating to the asylum committal.[11] In order to gain Mary Turner a year's free admittance to St Luke's, undertakings were given that she was curable, that she had not been ill for more than a year at the time of application, and that she was impoverished. The first of these claims was probably untrue, the others completely so.

It is easy to see why William Turner used intermediaries, and was a party to fraud. He was not protecting himself or trying to save money. Instead, he was shielding a son who lived in abject terror of being professionally compromised by public knowledge of his mentally ill mother. After all, if the numerous satirical printmakers and journalists, or the many jealous and hostile artists, connoisseurs and critics had found out about Mary Turner's condition, they might have made much of it, especially in those decidedly uncompassionate and intolerant times. Yet such was the secrecy maintained by both father and son that even Farington, who was always alert for the very tiniest morsels of tittle-tattle, never got wind of Mary Turner's condition. As for the good lady herself – well, she had entered hell as far as any effective treatment of her mental condition was concerned.[12]

After 1797, St Luke's contained around 300 inmates, of whom about 180 were deemed curable, although how much of an improvement could be effected in the space of a single year is highly questionable. It was a gloomy place, with long corridors linking the cells, and with no views from within the cells themselves through the high, mesh-covered windows. The hospital was completely unheated, so it must have been freezing when Mary Turner entered it in late November 1799. Nor were there any hot baths. Instead, a deep 'bath of surprise' contained icy water into which patients were occasionally flung bodily as a form of primitive shock therapy. Mary Turner would have slept upon a pile of straw on a wooden bedstead and, if she was violent, she would have been chained to the wall in a damp basement cell. If she was especially noisy she would have been kept in even more isolation. Only basic food was served: a little meat once in a while, lots of bread, and some butter and cheese, while for drink there was merely small beer and water. No vegetables, tea, coffee, milk or sugar were ever given to the patients.

The physician in charge was Dr Samuel Foart Simmons (1750–1813). By 1799 he had acted in that capacity for the past eighteen years, and he would go on doing so until 1811; in 1803 and 1811 he would also wait upon the intermittently disturbed King George III. Simmons can rarely have looked in on Mary Turner and he must have relied upon the female Keeper to maintain an eye on her. As both this lady and her husband, the male Keeper, firmly believed that the fear of punishment was a better cure for mental illness than medication, it is very likely that Mary Turner had the chains applied often, for as we have seen, she was reputed to be 'fierce' and 'a person of ungovernable temper'. In any case the only available medicines were primitive antispasmodics, emetics and purgatives. If Mary Turner soiled herself, she would have been kept naked or semi-naked in her cell while her clothes were being cleaned. As it is rather difficult for someone held in chains to maintain any degree of personal hygiene, perhaps she frequently found herself in that degrading and squalid state.

Day after day, week after week, month after month, she and her fellow patients sat around indoors or, if they were not regarded as potentially violent, were allowed to wander aimlessly around the walled gardens that were reserved for persons of either sex, with no treatment whatsoever. The noise throughout the hospital was 'almost deafening'. Hell must have looked, sounded and smelt a lot like St Luke's, even if it would have been somewhat warmer in winter. Moreover, because psychiatric patients can easily exacerbate the mental disturbance of others, Mary Turner's instability could easily have been undermined even further by her incarceration. If that was the case, then she would not have been the only member of the Turner family to have been locked into a vicious circle.

It is always claimed by writers on Turner that he remained utterly indifferent to the fate of his mother. However, if that had been the case, he would surely have been able to speak of her with some degree of heartlessness, if not even equanimity. Instead, he would never speak of her and would always deeply resent any allusion to her.[13] He would

even become enraged at innocuous enquiries regarding her side of the family.[14] Such violent anger, and its close proximity to the surface, surely indicates that he felt profoundly guilty about dumping his mother in a 'lunatic' asylum, and that he had consequently locked himself into an endless cycle of silence and guilt. He must have been determined to bear such stress in the cause of his art, which included his professional advancement and financial success. In the more understanding and compassionate era in which we arguably now live, it would be easy to regard Turner as callous. However, we must never forget that in his day mental illness was considered to be deeply shameful. That is why an overwhelming sense of shame could easily have played a major part in Turner's relationship with his mother. Shame certainly provides an additional reason why he surrounded her with so much secrecy. And if he had been profoundly hurt by her when young, both mentally and physically, and he had also been forced to watch helplessly as she caused immense suffering to the father he deeply loved, then perhaps we can also begin to understand why he turned his back on her so resolutely in 1799 and thereafter.

Sarah

Mary Turner's incarceration was not the only secret in Turner's life around this time, for when he transferred his living quarters from Maiden Lane to 75 Norton Street in November 1799, he also began cohabiting with a widow who was at least five years his senior, and maybe eight years older then himself.

Of Lincolnshire stock, in 1788 Sarah Goose (1761/7 to 1861) had married a fellow Roman Catholic, the musician John Danby (1756–1798).[15] Eventually they had six or seven children, of whom four daughters survived by 1799. John Danby had been an organist who had worked for a number of years at the chapel of the Spanish Embassy in Manchester Square, London, and in that capacity he had composed several masses and a number of motets. However, he was far better known as a composer of secular music, especially glees and catches, of which no fewer than ninety-two by him were published. Three books of them appeared during his lifetime, and a fourth was brought out by his widow shortly after his death. That had occurred on 16 May 1798, probably from paralysis brought on by severe rheumatoid arthritis. His last child had been born in January 1799, and thus eight months after his demise.

Turner would never have considered marrying Sarah Danby, or anyone else for that matter, for as he would later declare, 'I hate married men; they never make any sacrifice to the Arts, but are always thinking of their duty to their wives and families, or some rubbish of that sort.'[16] Given such misogamy, he must therefore have stipulated that marriage was impossible and perhaps, with even more selfishness, that Sarah must never become pregnant. To prevent that happening, the couple could have used primitive condoms, sponges, folk preventatives and the like. But if Turner did say no to children, that would certainly explain why he would never have much to do with the two daughters Sarah would bear him. He felt betrayed, and unfairly blamed them (and of course, if Sarah the Roman Catholic refused to use any form of birth control, then this can only have exacerbated Turner's resentment).

Unfortunately, we do not possess a single communication between Turner and Mrs Danby. Amid the great many lines of romantic verse that Turner scribbled in his sketchbooks on the subject of desirable women, there is no mention of a Sarah. Nor can we even form an idea of her looks, for none of the women in their thirties whom Turner depicted in underpaintings and pencil sketches are identifiable.

Yet despite this paucity of information about Sarah Danby, we can deduce a few things about her that might have proved attractive to Turner. Thus her marriage to a professional musician suggests that she may have been receptive to art and beauty. Indeed, she could well have been a woman of some refinement, for reputedly the composer had been very opposed to coarseness.[17] Given her marriage to a musician and her publication of some of his works, it appears likely she could read music, at least to the relatively simple level of glees and catches. As the mother of six or seven children, she undoubtedly possessed considerable sexual experience. Turner must have found her unusually attractive physically, for he appears to have possessed a fairly low sex drive. And while it would be unsafe to assume he was drawn to an older woman because he sought a substitute for his mother, of course that may have been a possibility. As for what Sarah might have seen in him: well, he was a rising star in the art world; he was not physically unattractive; by November 1799 he could already have been tolerant of Roman Catholics in a Britain in which such acceptance was far from universal; and, of course, he possessed money, although it is highly unlikely he told her too much about that. Yet Sarah had an income of her own. This might easily have been a major reason Turner consented to live with her, if not even his principal motive for doing so.

Sarah Danby's wherewithal stemmed from her late husband, John. In 1787 he had begun paying ten shillings a year into a pension scheme run by a benevolent association, the Royal Society of Musicians. By the time of his demise he had paid a total of six pounds and ten shillings into his protection plan. It was unquestionably the wisest investment of his life, for following his death the charity then paid his widow a pension for the next sixty-three years, as well as monies for their daughters. The amounts were hardly negligible: Sarah herself received £31-10s per annum for life, while for her four

girls she received an annual total of £36 until they reached the age of five, after which the payments went up for each of them until they reached fourteen in turn. For a number of years, therefore, she received the grand sum of £81-18s a year, or more than three times the annual income of a common workman. Moreover, not only did the Royal Society of Musicians keep Sarah Danby's daughters fed, clothed and housed, but it also paid for their schooling and for at least three of them to be subsequently trained as schoolteachers. And such was the generosity of the charity that when those young women did finally qualify as teachers, it even paid them a bonus of £5 each for having graduated.

Because Sarah was in receipt of this pension, Turner did not have to pay for her upkeep and for that of her offspring. Undoubtedly that proved hugely attractive to him. And yet she ran a huge risk by living with him, due to a clause in her entitlement. This was that it would be entirely and perpetually forfeited if she ever engaged in 'an illicit intercourse' or relationship outside of marriage (whereas if she did remarry, her pension would have only been suspended for the duration of that alliance).

Providentially, the Royal Society of Musicians has retained a number of its claimants' receipt books, within which its beneficiaries (or their representatives) signed for their monthly allowances. As Jean Golt discovered in 1987, the books that record the payments to Sarah Danby between 1810 and 1838 are among them. They demonstrate that she signed for her pension payments many times, and that, on her behalf, so did her niece 'Hanah' – whom we shall encounter in due course – her daughters by John Danby, her other relatives and her friends.[18] And also to be found in a claimants' receipt book in November 1810, in December 1811, and in January, February, March, May and June 1812 is the signature of Turner's father. It is difficult to imagine how he got away with it unless he passed himself off as Sarah's father, uncle or landlord. The first two were perfectly feasible for, after all, he was between sixteen and twenty-two years older than her, depending on when she was born.

If Sarah had told nobody of the charity's 'illicit intercourse' ban, then she could hardly have expected them to keep her relationship with the painter a secret when signing for her pension, let alone requested that they not inadvertently blurt out that she had borne Turner a child between 1800 and 1801, and another one in 1811 or early in 1812. Yet if she did warn everyone to keep quiet and provided them with her reasons for doing so, then she ran an even greater risk, for the higher the number of participants in any offence, the greater the chances of detection. In both the swindle that William Turner and his son perpetrated upon St Luke's Hospital (and again in their defrauding of another hospital we shall come to shortly), only two co-conspirators were involved, and they served to distance the instigators of the crime from their actions. The same could hardly be said of William Turner and many others entering the offices of the Royal Society of Musicians in order to participate in a massive fraud that would last for well over half a century.

Sarah must have initially informed Turner of the 'illicit intercourse' ban simply because the pension was her only source of income. He cannot have been too happy about indirectly benefiting from the swindle because the embarrassment and shame that would have been heaped upon him if he had been detected in such cheating would have been terrible to behold, especially as word of his participation would surely have reached the newspapers, the satirical printmakers and, not least of all, the many gossips within the Royal Academy of Arts and its cultural surroundings.[19] Sarah Danby may have had a fair amount of money to lose from living with Turner, but he would have put his entire reputation on the line by being party to the financial deception of a highly admired charity that enjoyed sovereign status. Yet the pension did mean that Sarah could remain financially independent of him. That must be why he agreed to run the risk. Money could easily cloud his judgement, and it would do so increasingly over time.

Sarah's pension therefore enabled her to hold on to Turner. That is why she ran the risk. And to minimise that danger, the two of them must have agreed she would remain entirely out of the limelight. That would have suited him just fine, for limelights can cost a great deal of money. He was not willing to bestow a single penny upon her. That is why he gave her nothing except, possibly, free board and lodging. Clearly, there were some things that Turner was prepared to pay for generously, such as the finest canvases, papers, pigments and brushes, and others he was not. A common-law wife, her children and even his own daughters by her resided at the very bottom of his list of priorities. While we can certainly pass a harsh moral judgement upon him for his huge neglect of Sarah over time, simultaneously we must understand her financial independence and the crucial artistic fact that in Turner's mind he was married already. Nor would he show much interest in their girls either, for the offspring he considered his most unique contribution to the world usually entered it within frames.

Among the many outstanding works that were probably in progress during the extremely busy autumn and winter of 1799–1800 were an oil painting of Dolbadarn Castle in north Wales, some of the studies for which are in pastel (for an example, see fig. 232); and a depiction of Cadair Idris in the afterglow of sunset, with the full moon rising beyond it (fig. 233). Here a number of small, localised passages of mist appear throughout the vista. They subtly enhance our understanding of the lie of the land and add luminosity to the scene. Before long, such passages would become one of Turner's most subtle ways of enlivening a landscape.

232 *Study for Dolbadern Castle, North Wales*, 1799, pastel on paper, 8½ × 5½ (21.5 × 13.9), fol. 112 of the *Studies for Pictures* sketchbook, Turner Bequest LXIX, Tate Britain, London.

After finally receiving the order for a large marine painting to complement the Duke of Bridgewater's van de Velde, and probably obtaining it at the nobleman's London residence, Cleveland House, Turner may have gone home and stretched up its bare canvas that very evening.[20] There could well be some truth in the claim that at dawn the next day he began the work by blocking in its general areas of 'dead colour' or underpaint by using rabbit-skin glue mixed with black, grey, white and dark brown pigments. As the glue dried, it would have both tautened the canvas and bound the pigments. Perhaps in advance of receiving the order, Turner had made his preparatory drawings for the image, as well as a small study in oils, so keen was he to embark upon it.[21] Equally, it is possible that he would have produced the final picture even in the eventuality of the commission *not* being forthcoming, so powerfully had the van de Velde impacted upon his imagination. If this was the case, then maybe he began the work without waiting for the order.

On 31 December Turner received his Associate Royal Academician's Diploma. In all likelihood he did so wearing one of his fancy waistcoats, a pair of his nattiest breeches, and his most stylish shoes and stockings, with his locks having been groomed by his own personal and very personable hairdresser. And on 31 March 1800 he posed yet again for a profile portrait by George Dance (fig. 234). His long hair indicates he did not make any show of holding the 'democratic' sympathies that King George III abhorred. This was unlike Robert Smirke, his son Robert junior (1780–1867) and Tom Girtin (fig. 235), who all wore their hair cropped in the style of Roman republican portrait busts in order to identify openly with French republicanism.[22] But Turner had more subtle ways of expressing his responses to the contemporary state of liberty, or the lack of it, as he would be making clear on the walls of Somerset House this very year.

The 1800 Royal Academy Exhibition
FRIDAY 25 APRIL TO SATURDAY 14 JUNE

Turner had submitted two Welsh scenes, a biblical landscape and the five commissioned watercolours of Fonthill Abbey developed over the winter. Two of the Fonthill drawings were displayed in the first-floor Council Room and the others in the adjacent Antique Academy. In each of them, the tower of Fonthill Abbey was depicted not as the scaffolded shell of middling height that Turner had actually seen in August 1799, but as the immense structure it was intended to become. Obviously such projection had been facilitated by access to Wyatt's architectural plans. Although the blue-greys in all five drawings have faded and the works have yellowed, watercolour sketches of the subject such as *View looking towards the village of Fonthill Bishop* (fig. 236) and other works we have noted (see figs 218 and 219) have fully retained their hues. They furnish an idea of what the final drawings such as the south-west view (fig. 237) and the south view (fig. 238) originally looked like in colour and tone.

Although the titles of the Welsh and biblical subjects were accompanied in the catalogue by quotations, this year Turner was no longer in the vanguard where the number of such enhancements was con-

233 *Cadair Idris, Afterglow*, c.1799, watercolour on paper, 20¾ × 29¾ (52.7 × 75.6), National Gallery of Scotland, Edinburgh, Mrs Peggy Parker Gift 1991.

cerned. Obviously he felt he had made his point with regard to poetic painting. Now it was up to others to spread the word, and they were beginning to do so, literally.[23] Two of the three Turners whose titles were accompanied by quotations were oil paintings, and they both hung in the Great Room.

The first of them was *Dolbadern Castle, North Wales* (fig. 239). Here Turner addressed the curbing of individual liberty. In the foreground, a kneeling man with a halter around his neck and his wrists bound behind him is being guarded by two soldiers, while another figure points to the castle above them. The bound man is either being threatened with imprisonment or is on his way to captivity in the castle. From verses in the catalogue that may have been composed by Turner himself, we are able to infer that the prisoner, 'hopeless OWEN', is Owain Goch (Owain ap Gruffudd, d.1282), who was incarcerated by his brother in Dolbadarn Castle between 1255 and 1277, when he was freed by King Edward I of England (1239–1307). By depicting Owen in a semi-naked state, and by placing him within such an utterly treeless, bleak and forbidding landscape, Turner rendered him helpless and hopeless indeed. And by highlighting him, and by situating Dolbadarn Castle immediately in front of a halo of bright light, the eye is pulled from the prisoner to the tower, while by locating that building within an extremely confining space

234 George Dance RA, *J. M. W. Turner ARA*, signed and dated 31 March 1800, R.A. 1800 (263), black chalk touched with white and pink on paper, 10 × 7⅝ (25.5 × 19.5), Royal Academy of Arts, London.

235 George Dance RA, *Thomas Girtin*, signed and dated 28 August 1798, pencil on paper, 10 × 7½ (25.3 × 19.2), British Museum, London.

formed by the adjacent mountains, an appropriate sense of entrapment is projected.

Of course, during the period between late November 1799 and April 1800 in which Turner was bringing *Dolbadern Castle, North Wales* to completion, someone profoundly close to him also lay helpless, hopeless and trapped within a predominantly dark, bleak and intensely confining space. It is impossible to determine whether Turner was aware of the connection with his mother when he painted this picture, and was thus externalising his feelings in an attempt to deal with them, or whether his subconscious compelled him to paint the picture because he had suppressed all conscious thought of her. Given that he would always remain silent about her, that he would never tolerate enquiries about her, that he probably harboured deep feelings of shame concerning her illness, and that he may well have suffered from feelings of intense guilt over her abandonment, the latter option is very possible. On the other hand, perhaps Turner and his father lived in hope that Mary Turner would one day be cured of her insanity and, like Owain ap Gruffudd, finally return to the world. If Turner did think that, then he could well have been consciously drawing a parallel between the Welshman and his mother. But of one thing we can be certain: it was no coincidence he produced a painting dealing with the incarceration of one family member by another, and that he did so at the precise moment the person who had brought him into the world was being locked away by members of her own family.

236 *View looking towards the village of Fonthill Bishop and the unfinished tower of Fonthill Abbey from the north-east*, 1799, watercolour on paper, 13 × 18½ (33.2 × 46.9), fol. 11 of the *Fonthill* sketchbook, Turner Bequest XLVII, Turner Bequest, Tate Britain.

Dolbadern Castle, North Wales continued Turner's creative engagement with Rembrandt's *The Mill* (see fig. 90), with its solitary building set against a bright sky and located upon a dark hillside falling to an open stretch of water. Equally, the prevailing darkness filled with subtle gleams of light that spatially define the terrain and impart dynamism to the scene links to the Stourhead Rembrandt (see fig. 137). Ultimately, the style and grouping of the figures owes much to Salvator Rosa.[24] Yet these inputs only serve to fortify the possible statement about the condition of Mary Turner's psyche and the narrow confinement of her person. If such a parallel was intended, then maybe the painting was created to assuage a profound sense of guilt. And if that was the case, then in purely autobiographical terms *Dolbadern Castle, North Wales* is Turner's most deeply personal utterance. Before long he would give it away, perhaps because he found it impossible to live with.

It will be remembered that William Beckford had commissioned *The Fifth Plague of Egypt* (fig. 240). Once he saw it hanging in the Great Room, he agreed to pay 150 guineas for it.[25] Such an acquisition was profoundly ironical, for he probably owned almost as many slaves as the Pharaoh who had kept the ancient Israelites in bondage.

237 *South-west view of a Gothic Abbey (Morning), now building at Fonthill, the seat of W. Beckford, Esq.*, R.A. 1800 (341), watercolour on paper, 27¼ × 40½ (69.3 × 102.9), Art Gallery of Ontario, Toronto.

238 *South view of the Gothic Abbey (evening) now building at Fonthill, the seat of W. Beckford, Esq., R.A.*, 1800 (566), watercolour on paper, 27¾ × 41 (70.5 × 104.4), Montreal Museum of Fine Arts.

Facing page 239 *Dolbadern Castle, North Wales*, R.A. 1800 (200), oil on canvas, 47 × 35½ (119.5 × 90.2), Royal Academy of Arts, London.

240 *The Fifth Plague of Egypt*, R.A. 1800 (206), oil on canvas, 49 × 72 (124 × 183), The Indianapolis Museum of Art.

In all likelihood the parallel never occurred to him, any more than it did to Turner; instead, they probably both regarded the enslavement that had provoked the biblical plagues of Egypt as being echoed by recent French expansionism.

In *The Fifth Plague of Egypt*, dead horses in the foreground make evident the murrain or infectious disease affecting animals that constitutes the fifth curse upon the Egyptians. By giving us Aaron crouching behind Moses on the right to gather up soot that the latter will soon throw into the air to warn of the fine dust that will subsequently fall upon Egypt, thereby causing its men and beasts to erupt in boils, Turner simultaneously alluded to the sixth plague. Finally, he brought into the picture the seventh plague, of hail and fire, an assimilation he specified by citing verses from the Book of Exodus in the catalogue. When it came to divine visitations, Turner was nothing if not comprehensive.[26]

The painting earned huge plaudits. Thus the *Sun* for 3 May mentioned Turner's genius in the work, while the *St James's Chronicle* for 29 April–1 May declared it to be in 'the grandest and most sublime stile of composition, of any production since the time of *Wilson*. The whole of the conception is that of a great mind.' For the *General Evening Post* of 26–29 April the canvas was 'a most striking work' that gave Turner 'a new character in his profession' and was 'without a rival in the rooms'. The *London Packet* of 25–28 April enthused that it was 'indisputably the best landscape in the Exhibition'.

Turner's remaining exhibit was another watercolour, *Caernarvon Castle, North Wales* (fig. 241), and it joined the Fonthill views in the Council Room. Its title was accompanied in the catalogue by verses also possibly by Turner. They tell of the supposedly last surviving Welsh bard singing his song of sorrows to the few remaining survi-

241 *Caernarvon Castle, North Wales*, R.A. 1800 (351), watercolour on paper, 26⅛ × 39⅛ (66.3 × 99.4), Turner Bequest LXX-M, Tate Britain, London.

vors of Anglesey, the island visible to the left of the distant castle that had been begun by King Edward I of England in 1283 to subjugate the Welsh. Turner derived the subject from Thomas Gray's *The Bard* of 1757. The watercolour continued a succession of pictorial responses to that poem by Paul Sandby, Thomas Jones (1742–1803), de Loutherbourg and Richard Westall (1765–1836).[27]

Although Turner had previously exhibited a seaport scene in which he had drawn stylistically upon Claude le Lorrain (see fig. 209), until he displayed *Caernarvon Castle, North Wales* he had not yet shown a landscape made under the influence of the French painter.[28] The input of Claude can be detected in the organisation of space and in the use of a fairly dark tree as a *repoussoir* to intensify the sense of light and space beyond. Yet the watercolour also demonstrates the degree to which Turner had become aware of the associationism employed by Claude, most probably through images he had closely scrutinised in the engraved version of the *Liber Veritatis*.

In many of his historical subjects, Claude had depicted a time of day that fully accords with the dramatic events being enacted. In *Caernarvon Castle, North Wales* Turner did so too, for the evening light associatively matches the decline of Welsh freedom that is implied in the verse accompaniment to its title. Claude also employed tree-forms associatively many times, and the tree on the left both amplifies the threatening gesture of the bard beneath it, and formally echoes the uppermost curve of his harp. Because Gray had employed trees in his poem to amplify the threats uttered by the bard,[29] Turner was necessarily effecting an equivalence between painting and poetry here.

242 William Daniell after George Dance, *Portrait of Benjamin West*, soft-ground etching, 1809, British Museum, London.

In both *The Fifth Plague of Egypt* and *Caernarvon Castle, North Wales*, Turner addressed constraints to national liberty or inroads upon it. As such, the two works complement *Dolbadern Castle, North Wales*, which deals with the threat to individual liberty. Yet despite the fact that *Dolbadern Castle, North Wales* and *Caernarvon Castle, North Wales* were created in different media and were displayed in different spaces within Somerset House in 1800, they are related, for the invasion of Wales by Edward I that would eventually free Owain ap Gruffudd would simultaneously condemn the last of the Welsh bards to his doom (or at least it would do so according to Thomas Gray). This would not be the last time that Turner would comment upon the ironies of history. But it is unsurprising that he gave thought to the subject of liberty in 1800, for by that date it was widely under pressure both at home and abroad. We have already alluded to French political and military expansionism on the Continent, but in Great Britain the war with France and the political fallout from the French Revolution had resulted in the suspension of *Habeas Corpus*, the enactment of laws to ban radical political activity, the proscription of societies demanding the reform of an extremely unrepresentative parliamentary system, the prohibition of trades unions and the official sanctioning of summary trials.

Turner might well have remembered his uncle's identification with the demands for liberty made by John Wilkes down in Brentford. Certainly he could have been roused to deal with the loss of liberty by his great friend Tom Girtin, who held extremely radical political views. Equally, he might have been encouraged to treat of liberty by William Beckford who, despite his self-serving hostility to the freedoms of black people, was very mindful of British liberties, an awareness he had inherited from his father. And the Royal Academy certainly encouraged Turner's awareness of liberty and its constraints.

This is because by 1800 a number of Academicians and Associates had become alarmed by the recent suppression of civil liberties in Britain or had directly suffered from curbs placed upon their freedoms. By that date Turner was on good terms with a number of them. They included John Hoppner, Robert Smirke, Thomas Stothard RA (1755–1834), Martin Archer Shee, Henry Fuseli and Thomas Banks. And although John Opie was apolitical, his wife Amelia Alderson (1769–1853) held very radical political views indeed. Even the PRA, Benjamin West (fig. 242), was suspected of holding 'democratic' opinions, mainly due to the fact that he was American. In recent memory James Barry had been expelled from the Royal Academy, ostensibly for insulting his peers but really for promulgating republican views. Moreover, as we shall discover when we reach 1803, the Royal Academy was divided into pro-democratic and anti-democratic factions, and by 1800 the split between them was already beginning to widen. Turner had friends in both camps but he would side with the 'democrats' in many Royal Academy elections. It is therefore entirely unsurprising that a painter who originated from near the bottom of the social scale and who harboured aspirations to be taken seriously would have wanted to address the loss of liberty in 1800.

The artist did not undertake a major tour this year, perhaps because his new set of studios made him want to take full advantage of the extra space, long summer days and strong light in London. As 75 Norton Street and 64 Harley Street were only about five minutes apart, he could easily be at his easel soon after dawn. In the 1801, 1802 and 1803 Royal Academy catalogues he would give '75 Nortonstreet, Portland-road' as his address. Perhaps he furnished that information after losing business through prospective patrons turning up at his studio but not knowing where to find him out-of-hours.

Turner painted his second and final self-portrait in oils at some point between 1800 and 1802 (fig. 243). It owes much to Rembrandt, even if it does not bear qualitative comparison with portraits by that master. It is also possible to detect the influence of Hoppner,[30] who may have advised on the drawing of the head, for the creation of

243 *Self-Portrait*, c.1800, oil on canvas, 29¼ × 23 (74.5 × 58.5), Tate Britain, London.

any portrait entails certain rules of cranial perspective and the symmetric alignment of facial parts, all of which Turner got exactly right for once. As to why such a work was created by a painter who thought himself to be physically 'insignificant': well, perhaps it was an attempt to convince himself to the contrary, while equally constituting a technical exercise (and a further reason for making it will be advanced in due course). In any event, the person who looks out at us seems fully assured, which was decidedly the case where his art was concerned. Yet there is also a certain sadness around the eyes, a worn look that suggests the person depicted had known suffering, which was indeed the case. How deeply he had been hurt we shall never know, but such pain may have enjoyed a positive side, for over time it could have sparked many an escape into realms of light and colour that had never yet been captured in paint.

Probably in September or early October, Turner conveyed the Beckford oil painting and the five Fonthill Abbey watercolours to Fonthill House. It was during this visit that the collector agreed to pay him thirty-five guineas for each of the watercolours. Apparently Turner only stayed a night or two.[31] He could hardly have been ignorant of the fact that the abbey tower had fallen down just a couple of months earlier. Given that in 1797 part of it had been laid low by a spring gale, it was therefore now being built for the third time. That would surely have amused him. After all, he was thoroughly acquainted with the cathedrals at Canterbury, Durham, Salisbury, Peterborough, Lincoln, Ely, Winchester and Wells, in addition to Westminster Abbey and King's College Chapel. He was therefore highly aware that genuine Gothic buildings had often taken hundreds of years to build and been created to last.[32] That may have been William Beckford's intention with his Wiltshire folly, but because he cut corners on materials, no sooner had his tower gone halfway up than it had collapsed, and not just once but twice. If any building ever sent a message to Turner about transience and the vanity of human aspirations, it was Fonthill Abbey. He must have headed back to London with a fat cheque in his pocket and a wry smile on his lips. Never again would he paint a new building that had vanished so soon after his depictions of it had dried. Admittedly, the pile was now arising yet again, and this time it would finally reach its full height. However, it would only dominate its surroundings for another twenty-five or so years, after which it would crash back to earth and then remain there for ever.

12

Tragedy and Triumph
December 1800 to April 1801

When Mary Turner's year at St Luke's came to an end on 5 December 1800, she was transferred to the Bethlem Hospital, which was more commonly known as 'Bedlam' because it was such a hellhole for the mentally ill.[1] Situated near Finsbury Circus at Moorfields, it was in very poor condition due to weak foundations, an over-heavy roof and cracked walls. Little light and fresh air entered because of the close proximity of surrounding buildings. Again intermediaries fraudulently obtained free treatment for Turner's mother.[2] One of them was her brother-in-law, Joshua Turner (1757–1816), who was a Customs Clerk in the London Excise Office.

For the unfortunate Mary Turner, conditions in the Bethlem were no less atrocious than they had been in St Luke's. Once more she found herself in a freezing building in one of the coldest parts of the year (it being common for patients to lose their fingers and toes to frostbite during winters spent in the Bethlem). Many of the patients were chained in their cells for months on end, or shackled in the internal yards or 'airing courts'. One unfortunate was even permanently housed in a metal cage. If the inmates had nobody to send them clothes, they simply went naked. Only a few had blankets; most slept under straw. As had been the case at St Luke's, patients suffering all kinds of psychiatric conditions were thrown together, usually and very predictably with deleterious effects upon those who were only moderately ill. Because there were just four keepers to supervise the 120 or so patients, violence was endemic. As at St Luke's, there were few medications, but anyone who refused them could have their jaws prised open with a specially designed metal key that was just one of the many pacifying devices used frequently in the Bethlem. And as at St Luke's, the noise and hubbub were 'almost deafening'.[3]

The supposedly resident apothecary of the Bethlem only put his head inside the building for about half an hour a day, and even then he frequently disappeared for days at a time. Still less in evidence was the Chief Physician, a certain Dr Thomas Monro, who had a penchant for collecting English watercolours and who on certain winter evenings employed up-and-coming artists to advance their skills at little cost to himself. Monro may have been the son and grandson of two chief physicians at the Bethlem, but he was not particularly interested in the mentally ill. Given that he would prove helpful over the care of Mary Turner some thirteen months later, he must have known of the poor woman's presence in the Bethlem. However, it must be doubted that he ever accorded her preferential treatment, for that could well have imperilled the Turner family secret if tongues wagged.

This need for secrecy also makes it extremely improbable that Mary Turner was ever visited in the Bethlem Hospital by her husband and son. Yet we cannot know how hard or for how long they had tried to deal with the poor woman before finally turning their backs on her. Given such a lack of information, it is dangerous

Detail of fig. 245.

244 *Ludlow Castle, Shropshire*, c.1800, watercolour on paper, 20⅞ × 30⅛ (53 × 76.5), private collection.

to be too judgemental about their apparent heartlessness. Perhaps they had tried their best to help her down the years and simply been worn to a frazzle in the process.

Among the many watercolours and oils that may have been created in the latter half of 1800 and the winter of 1801 were views of Ludlow Castle in Shropshire (fig. 244) and of Conwy Castle in north Wales (fig. 245). And it was probably around this time that Turner made four watercolours of the Seringapatam fortress in India and its seizure from Tipoo Sultan on 4 May 1799 during the fourth Mysore War. They were probably based upon sketches created on the spot by the military artist Thomas Sydenham (1780–1816).[4] Unfortunately, they lack pictorial inspiration, possibly because the material that Turner worked from was uninspiring or the person who had commissioned them made it clear that imaginative treatment was not required. However, the battle scene among them may well have stimulated Turner's interest in military affairs, with important results for a large depiction of an army he was creating at the time.

Early in 1801 Turner took an interest in music, albeit halfheartedly. Inside the front cover of a sketchbook he set out the clefs for the soprano, mezzo-soprano, alto, tenor and bass parts.[5] He also named the space notes of the treble staff, followed by the divisions

245 *Conway Castle, North Wales*, c.1800, watercolour on paper, 21 × 30 (53.4 × 76.3), J. Paul Getty Museum.

of time, namely semibreve, minim, crotchet, quaver, semiquaver and demi-semiquaver. Furthermore, he set out the ascending scale from E, followed by the symbols that denote the sharp, flat and natural pitches. It may have been the case that he had attended musical soirées organised in Norton Street by Sarah Danby and was inspired by the proceedings. There were plenty of people in the circles in which he moved who possessed a good working knowledge of music, so if Mrs Danby could not help him understand the basic mechanics of what he was hearing, there were many others who could have done so. Setting out some basics was the first step to understanding them. However, that Turner ever made that move must be doubted, for he had his hands brimming over with one major art form already.

At some point in 1801 Sarah may have invited her niece Hannah Danby (c.1785–1853) to join the Norton Street household, probably as a domestic servant. In March 1801 Turner attended at least three of Fuseli's lectures as the Royal Academy Professor of Painting.[6] And by 1 April he was discussing his possible involvement in yet another print project, *Britannia Depicta*, to which he would contribute seven watercolours.[7] In order to gain the necessary topographical material he appears to have undertaken a short tour in the spring of 1801, visiting Eton, Newbury, Abingdon and High Wycombe in particular.

246 *London: Autumnal morning*, R.A. 1801 (329), watercolour on paper, 23¾ × 39 (60.3 × 99.1), private collection.

He would also stop off at Chester that summer for the same reason. Possibly he made all of the watercolours in the latter part of the year. Although he worried for a time that the engraver who was behind the scheme would empower John 'Warwick' Smith to choose his subjects for him, he made a stand against that possibility and his fears were not realised. Two of the prints would be published in 1803, another three in 1805, and the final two in 1810.

The 1801 Royal Academy Exhibition
FRIDAY 24 APRIL TO SATURDAY 13 JUNE

This year Turner attended the Royal Academy dinner, perhaps the first time he did so. He had six contributions hanging in Somerset House, of which two were oils. The watercolours were all placed in the Council Room. They included *London: Autumnal morning* (fig. 246), in which we look from Battersea Rise towards Westminster Abbey and St Paul's Cathedral in the distance. The scene depicted looks more like the Roman campagna than a vista in Surrey. With this drawing, Turner took another large step towards realising his ambition to create ideal landscapes.

Turner had two watercolours of subjects in south Wales on display, of which one was *Pembroke castle, South Wales: thunder storm approaching* (fig. 247). A previously overlooked review in *The London Packet* for 6–8 May 1801 stated that within the drawing 'The coming on of the tempest is perfectly expressed, as is the bustle of the fishermen in getting their nets, &c together. The anchors, and other marine articles scattered on the beach, are touched with wonderful force and effect.' The mention of 'nets' proves that the Pembroke Castle watercolour exhibited in 1801 was a work now in Toronto, and not one in a private collection (see fig. 335), as has previously been maintained.[8] This is because only a tiny area of netting is visible in the latter drawing, which therefore dates from 1806 for reasons that will become evident. And the fishermen working on the beach make

247 *Pembroke castle, South Wales: thunder storm approaching*, R.A. 1801 (343), watercolour and gouache over pencil on paper, 26½ × 39⅞ (67.3 × 101.1), University of Toronto Art Collection.

it plain that the storm is still approaching, for they have yet to take shelter from any rain. A flag on a distant boat points towards the approaching storm-clouds, but winds can blow in opposite directions at different altitudes, as Turner may have observed in Pembroke in 1795.[9] The flattening of cloud-forms on the right demonstrates the marked influence of Nicolas Poussin, to whose art Turner was becoming increasingly receptive by 1801.

Chapter-house, Salisbury (fig. 248) relates directly to the *Inside of the chapter-house of Salisbury Cathedral* that had been exhibited at the Royal Academy in 1799 (see fig. 207), for it reverses the viewpoint of that drawing so that instead of looking towards the chapter-house doorway from the outside, we are doing so from the inside. Turner had created opposed views like this years before, in his depictions of Radley Hall (see figs 30 and 31). The drawing makes particularly apparent the artist's understanding of the organic nature of Gothic architecture. Again boys play within a sacred space to remind us of Christ's statement concerning childhood and the kingdom of God. By being kept so near to the ground, they help maximise the grandeur of their surroundings.

Upstairs in the Anti-Room hung the oil painting, *The army of the Medes destroyed in the desert by a whirlwind – foretold by Jeremiah, chap. XV ver. 32, and 33* (untraced).[10] The relevant text tells of disaster going from nation to nation, and of a great whirlwind rising up from the furthest parts of the earth, with the unlamented slain being strewn across the land. Given that by the spring of 1801 Napoleon was raising the whirlwind of destruction across Europe and elsewhere

249 Possible study for *The army of the Medes*, c.1800, black and red chalk on paper, 5¼ × 7¾ (13.3 × 19.6), fols. 60v and 61 of the *Dinevor* sketchbook, Turner Bequest XL, Tate Britain, London.

— and had recently done so to little avail in the wastes of Egypt as well — it appears likely that Turner intended his desert storm to allude to that state of affairs. If that was indeed the case, then he had created a subtly patriotic image, just as he would do with his other oil painting exhibited in 1801, as will be seen.

Fortunately, Turner appears to have made a number of preparatory studies for the vanished whirlwind painting, one of which is shown here (fig. 249). We can therefore form some idea of what it might have looked like. Turner had undoubtedly depicted his whirlwind very boldly, for the *Star* of 8 May commented wittily: 'To save trouble the painter seems to have buried his whole army in the sands of the Desert with a single flourish of his brush.'[11]

Facing page 248 *Chapter-house, Salisbury*, R.A. 1801 (415), watercolour on paper, 25⅕ × 20 (64 × 51), Whitworth Art Gallery, University of Manchester.

Finally, Turner exhibited what was undoubtedly the most decisive picture of his entire career, for it would gain him Royal Academician status at the next possible opportunity. *Dutch boats in a gale: fishermen endeavouring to put their fish on board* (fig. 251) was the canvas that had been commissioned by the Duke of Bridgewater in 1799 to hang alongside his van de Velde the younger (fig. 250). Such was its impact that even while the Royal Academy show was still being hung, word spread that Turner had sent in something tremendous. That is why it appears to have been placed upon the line directly opposite the doorway to the Great Room, one of the most prized positions in Somerset House. At that height it would have been visible from virtually everywhere in the room and it would certainly have been the very first picture visitors saw upon entering the space.

The advantageous placing of *Dutch boats in a gale* in the Great Room contributed to its popularity, making it 'a peculiar favourite of the spectators'.[12] Clearly, Turner had kept the van de Velde in the forefront of his mind when creating it, for the mainsail upon his

250 Willem van de Velde the younger, *Ships in a Stormy Sea*, c.1672, oil on canvas, 52 × 75½ (132.2 × 191.9), Toledo Museum of Art, Toledo, Ohio.

principal fishing boat is tilted at a precisely judged, contrary angle to the mainsail and supporting sprit or diagonal spar upon the principal vessel in the Dutch painting. By this means a very close visual bond was created between the two pictures. They must have looked stunning when they were subsequently hung together in the Duke of Bridgewater's London residence and elsewhere.[13]

Not only was *Dutch boats in a gale* Turner's finest seascape to date; it was also the most impressive oil painting he had yet produced, both in scale and in handling. With it he had transformed the entire genre of marine painting and, within that branch of the art, pulled far ahead of the Dutch tradition that went back to both of the van de Veldes, and to Ludolf Backhuizen (1630–1708), Jacob van Ruisdael

(c.1629–1682) and Rembrandt. Simultaneously, because of the way he had depicted the figures who man the boats in the forefront of the image, he had linked the painting to the Flemish 'low-life' tradition represented by David Teniers the younger. As we have seen, Turner had first identified with the rude qualities of Teniers's figures by 1793 (see fig. 77), but now he drew far more heavily upon their coarse frames in order to suggest the extremely raw character of Dutch seadogs. It should especially be noted that a Teniers-like figure with hunched shoulders and a red, flat Lowlands cap is visible at the tiller of the nearest vessel.

The Dutch dimension to the work was recognised by Benjamin West, who said of the painting that 'it is what Rembrant [sic] thought

251 *Dutch boats in a gale: fishermen endeavouring to put their fish on board*, also known as 'The Bridgewater Seapiece', R.A. 1801 (157), oil on canvas, 64 × 87½ (162.5 × 222), private collection.

of but could not do'.[14] He was alluding to the Dutch master's *Christ in the Storm on the Sea of Galilee* of 1633 (fig. 252), which hung at the time in a private collection not far from Harley Street.[15] It was no mean feat for a painter still in his mid-twenties to have been put up against Rembrandt and adjudged to be the winner. And Fuseli also spoke of Turner's picture 'in the highest manner', for he regarded it as the finest work in the Exhibition.[16] He, too, connected it with Rembrandt, probably again because of the 1633 seascape. Unusually, he considered Turner's figures to be 'very clever'. That was quite a compliment coming from someone who possessed a considerable talent for figure painting himself. What he had surely understood was Turner's communication of the inner character of his fishermen by means of the figure-style with which they are depicted, for they are not well drawn in conventional terms.

Yet there is also an allegorical level to *Dutch boats in a gale*, stemming from the fact that Great Britain and Holland were at war when the canvas was painted and exhibited. Fundamentally, the conflict had come about because the Dutch nation was divided between the Orangists, or supporters of the Stadtholder, William V, the Prince of Orange-Nassau (1748–1806), and the Dutch Patriots who demanded more democratic governance and were generally pro-French. During the late eighteenth century the opposition of

252 Rembrandt van Rijn, *Christ in the Storm on the Sea of Galilee*, 1633, oil on canvas, 63 × 50⅞ (160 × 128), Isabella Stewart Gardner Museum, Boston, Mass., from where stolen in 1990.

these parties had led to huge strife, with the Patriots eventually gaining the upper hand due to French support. In 1795 this had brought about the creation of the Batavian Republic, from which the Stadtholder had taken refuge in London and immediately gained the backing of the British government. As a consequence, Great Britain had declared war upon Holland.

The major marine engagement of the conflict so far had been a notable British victory over the Netherlands, the Battle of Camperdown. This had taken place on 11 October 1797 just a few miles off the Dutch coast at Kamperduin, near Alkmaar. At the time, a strong westerly wind had been blowing towards the land. The British victory had been principally effected by the commander of the North Sea fleet of the Royal Navy, Admiral Adam Duncan (1731–1804), putting his column of ships between the Dutch and their coastal shallows, which would have afforded them protection. Such a dangerous ploy was strictly against British naval regulations, which is probably why it took the Dutch by surprise, thereby hastening their defeat.

Due to the war, the coast of Holland had been continuously blockaded by the Royal Navy, with all Dutch vessels – including relatively small fishing boats – only venturing a little way out to sea from the safety of their home ports, lest they be seized as prizes. For that reason, and because the picture title tells us we are looking at *Dutch* boats in the painting, the distant sunlit shoreline on the right must represent the coast of Holland (and not, say, the English coast). As the most populated part of the Dutch coast almost entirely faces west to north-west, we must consequently be viewing that piece of land from a south-westerly direction in afternoon light. On such a bearing we can equally deduce from the flags flown by all the vessels that a westerly wind is blowing, with the dark storm-clouds therefore approaching from the general direction of Great Britain. Naturally, this westerly wind acts as a reminder of the British naval victory off Kamperduin back in 1797, and possibly of enmity to come.

Because the wind is blowing towards the land, the area of visible terrain constitutes a lee shore. These were the bane of seafarers in the age of sail, for unless firm nautical control was exercised, it was very easy to be blown onto lee shores by strong winds and be wrecked in the process. Other than by making out to sea, virtually the only way of obviating that risk was to turn into the wind, drop anchor, pray your anchor did not drag, and ride out the storm. Prudently, the captains of the three large Dutch vessels in the distance on the right have opted to take that course of action.[17] (The fact that they have scarcely ventured from their home ports might also allude to the British naval blockade of Holland.) Yet the Dutch fishing boats in the forefront of the image are blithely disregarding the danger they face from being blown onto the shore by the approaching storm.

And this brings us to a very odd occurrence that Turner placed immediately before our gaze. The crew of the nearby large vessel with the billowing mainsail is taking on board the catches of smaller boats, for subsequent landing ashore. One of these subsidiary craft is the small fishing smack in the forefront of the image (fig. 253). The helmsman of this boat is apparently so preoccupied with the actions of his fellow crew members in sorting their catch into baskets that he has failed to notice that his vessel is about to pass immediately under the bow of the approaching mother ship. That is why he still points his tiller straight ahead, rather than move it hard to left or right in order to turn his boat one way or the other, thereby hopefully avoiding collision. But due to his carelessness, within the next few seconds the bow of the mother ship will undoubtedly smash down on his vessel and probably sink it.[18]

No competent helmsman would ever have willingly endangered his craft like this, but poor seamanship cannot have comprised the entirety of Turner's message, for he would hardly have expended so much energy upon making such a comparatively small point. Instead,

253 *Dutch boats in a gale* (detail of fig. 251).

he must have intended the imminent collision to refer to some larger clash. Within the context of the strife that was contemporaneously embroiling the Dutch, it is easy to grasp his larger meaning: the impending collision signified the political and military collisions that had involved conflicting parties in Holland during the period leading up to 1801 and that doubtless would continue to do so for many years to come, for no end to the war was in sight. Moreover, the related moral that it is easy to lose sight of larger matters is of equal historical relevance, for the British thought that the Dutch had shortsightedly taken the wrong side in the war with the French. And both of these meanings are strengthened by the storm approaching from the west, and thus from the direction of Great Britain, for Turner surely intended the approaching gale to remind the world that at the Battle of Camperdown the Batavian Republic had already suffered from winds blowing from the direction of his native land, and that it would continue to be threatened by the storms of war inflicted on it from those shores. In the context of an exhibition that would undoubtedly be visited by many army and naval officers, let alone other British patriots, it does not seem at all surprising that Turner invested an image treating of Dutch marine affairs with patriotic undertones. *Dutch boats in a gale* constituted yet another mark of his determination to imbue his art with the seriousness and allusive richness that was more usually encountered in both history painting and epic poetry.

When Turner attended the Royal Academy dinner on Saturday 25 April 1801, he probably not only belatedly celebrated his twenty-sixth birthday a couple of days earlier; he also experienced what would prove to be the most significant triumph of his career.[19] After all, seated as he was not far from what was undoubtedly his most impressive work to date, he was now perceived in a completely new light. Here was someone who was much more than just an unusually talented watercolourist and occasional creator of fine oil paintings: *Dutch boats in a gale* had changed everything.

Among those present that evening were some of the top people in the land, including the Prime Minister and the Speaker of the House of Commons. But a further exalted guest was of huge relevance to *Dutch boats in a gale*, for he was none other than His Serene Highness the Stadtholder, William V, the Prince of Orange-Nassau.[20] If Turner was introduced to that luminary — which seems likely, given that his painting of a Dutch subject was generally held to be the picture of the year — he could never have mustered the words needed to explain to the prince the underlying significance of his picture, even if he had wanted to or was given the time to do so, both of which possibilities seem extremely unlikely. Perhaps the prince worked things out for himself, given his experience of stormy Dutch affairs and the fact that prior to being forced to flee from Holland he had owned a valuable collection of paintings. It does appear likely, however, that he commended Turner on his canvas, for never before had an English artist produced anything on a Dutch subject to approach it, let alone rival it.

And there were other worthies present that evening who surely expressed their admiration to Turner as well. They included his established patrons, Lord Yarborough and the 5th Earl of Essex, as well as his future patrons, the 3rd Earl of Egremont and Sir John Fleming Leicester. So if the young painter permitted himself a little exaltation that evening, who can blame him? For some years now he had been steadily building his reputation within the leading art institution in Britain. Finally, by working on a large scale and stretching himself fully, he had attained a status never before enjoyed by a British marine painter. Soon that regard would equally extend to his landscape paintings (if it did not do so already for his many admirers). As a consequence, the world now lay at his feet, with the future beckoning more brightly than ever.

13

Gaining the Summit

April 1801 to February 1802

Michael Angelo Rooker had died on 3 March 1801 and on 30 April, just six days after the 1801 Royal Academy dinner, Turner attended the second day of his posthumous studio sale. He purchased a number of items, including a drawing of Newport Castle that is imbued with a wide tonal range and much sparkle (fig. 254).[1] By now, the Delegates of the Clarendon Press had received so much favourable comment concerning Turner's 1799 and 1801 contributions to the *Oxford Almanacks* that they took the unprecedented step of deciding to use an interior view for the 1802 calendar. The necessary watercolour of the eastern end of Merton College Chapel was already in their possession.[2] It too dated from 1798. As usual, Turner was paid ten guineas for his design, rather than the five guineas given to other contributors. Clearly, the Delegates rated him twice as good as his rivals, which was undeniable.

After the Royal Academy Exhibition ended, Turner sent *Dutch boats in a gale* to Cleveland House where the Duke of Bridgewater would be hanging it alongside his van de Velde seapiece, which had been brought down to London for the purpose. But when Turner delivered his canvas he not only sought the 250 guineas he was owed; he also asked for a further twenty guineas for its frame. The duke refused to pay. Turner applied several times more but always without success.[3] After the death of the nobleman on 8 March 1803 his heir would not pay for the frame either. Turner was therefore in a no-win situation: for seeking reimbursement he was accused of 'narrowness of mind',[4] and by not doing so he lost out financially. Such can be the difficulties that artists face when dealing with the super-rich. Because of this impasse, Turner would always in future make sure he obtained a purchaser's advance consent to pay extra for frames.

The North of England and Scotland, 1801

On 10 June, Turner told Farington he felt 'weak and languid'.[5] For that reason, by the third week in June he had decided to take a holiday, followed by a sketching tour of the Scottish Highlands. These plans had come into focus by Friday 19 June, with departure scheduled for the very next day. Turner planned to spend three months on the road, and for part of that time he would be accompanied by 'a Mr Smith of Gower-Street', who was almost certainly a fellow angler.[6] Before leaving, Turner complained to Farington of 'imbecility', on which account Farington advised to him to postpone his trip for a day or two.[7] In all probability he was suffering from mental exhaustion and overwork caused by painting non-stop for months. In any event, he seems to have quit London on Saturday 20 June 1801, as planned.

Turner and his companion travelled north by stagecoach to Helmsley in north Yorkshire via Chesterfield and York. They then gradually moved on to Scarborough, Whitby, Durham, Newcastle,

Detail of fig. 257.

254 Michael Angelo Rooker ARA, *Part of the castle at Newport on Usk, Monmouthshire*, date unknown, pen with brown and grey ink and watercolour over pencil, 7½ × 10¾ (19 × 27.5), National Gallery of Scotland, Edinburgh.

This drawing was purchased by Turner at the Rooker sale on 30 April 1801.

Morpeth, Weldon Bridge, Alnwick, Berwick-upon-Tweed, North Berwick, Haddington and Dalkeith. Finally, they arrived in Edinburgh. Among the places Turner drew en route were Robin Hood's Bay, near Whitby; Norham Castle, near Cornhill; and Tantallon Castle, near North Berwick. Yet between leaving Helmsley and arriving in Edinburgh – a distance of about 200 miles, given the slightly roundabout route taken by the two men – they usually covered distances of less than ten miles a day. Because the painter did not make many drawings during this period, the only explanation for such relatively short progressions and for so little to show for them by way of sketches must be that he had taken the holiday of which he had spoken to Farington, and that he had consequently devoted a good deal of time to fishing.

Turner arrived in Edinburgh on Saturday 11 July, or exactly three weeks after leaving London. He appears to have spent a week in the Scottish capital, roaming all over it, drawing as he went. Understandably, the castle frequently acted as a focal point. He left Edinburgh on Saturday 18 July[8] and then moved by daily progressions via Queensferry, Linlithgow, Cumbernauld, Glasgow and Dumbarton to Luss on Loch Lomond, where he entered the Highlands proper. He walked the entire length of Loch Lomond, drawing it from the west, the north-west, the north and the north-east, where he reached Inversnaid. Subsequently, he ambled onwards to Inverary, Kilchurn Castle on Loch Awe, Dalmally, Kenmore, Loch Tummel (see fig. 264), Killiecrankie (see fig. 265) and Blair Atholl, the most northerly place on the tour. From there he moved down to Dunkeld, Stirling, Hamilton, Lanark and Moffat. On Tuesday 5 August – and thus nineteen days after setting out from Edinburgh – he arrived in Gretna Green, on the border between Scotland and England just north of Carlisle. This means that on a number of days he must have travelled more than twenty-five miles, which strongly suggests he had now toured alone.

A fine variety of works emerged from the tour. They include two particularly vivacious depictions of Edinburgh. Thus, a view across the city from above Duddingston (fig. 255) conveys the showery weather encountered there. The lightening of tone just below St Giles's Cathedral, at the point where the lines of two hills converge to form a shallow 'V', creates a passage of mist that not only conveys the fresh atmospherics of a downpour but also clarifies the physical relationships of the landscape.

In *Edinburgh from the East, with St Mary's Loch in the Foreground and Calton Hill to the Right* (fig. 256) just six tones of two colours were employed. The resistance of the paper to water was turned to advantage, for the broken washes add vivacity to the image.

In addition to such works, Turner made sixty drawings on large sheets of paper stained with ink and tobacco-water (for examples, see figs 257–9 and 264–5). Known as the 'Scottish Pencils' because they were mostly drawn in black lead pencil, they were occasionally heightened with black crayon and white chalk, and with a white gouache preparation of Turner's own devising. From the type of detail many of them contain, it is apparent they were elaborated in front of their subjects, although the long summer evenings doubtless afforded Turner numerous opportunities to complete them back in his lodgings or in the open air nearby. All of them are limited to six tones or less, plus the ink and tobacco-water base tone. The drawings were a farewell to the restrictive tonal ranges of Turner's youth, being a final, largescale demonstration of what could be done with such limitations. And often they are magnificent examples of draughtsmanship that fully bear comparison with the landscape drawings of Richard Wilson, which might have influenced them and which they slightly resemble stylistically.

Facing page top 255 *Edinburgh, from above Duddingston*, 1801, watercolour on paper, 10⅛ × 16¼ (25.8 × 41.1), National Gallery of Ireland, Dublin.

Facing page bottom 256 *Edinburgh from the East, with St Mary's Loch in the Foreground and Calton Hill to the Right*, 1801, watercolour on paper, 5 × 7¾ (12.7 × 19.7), fol. 10 of the *Edinburgh* sketchbook, Turner Bequest LV, Tate Britain, London.

Left top 257 *Loch Lomond from near Inveruglas, with Ben Lomond in the Distance*, 1801, pencil and gouache on paper, 14½ × 19 (36.8 × 48.4), Turner Bequest LVIII-14, Tate Britain, London.

Left middle 258 *The promontory of Rubha Mor on Loch Lomond*, 1801, chalk, graphite and watercolour on hand-coloured paper, 11⅝ × 16⅞ (29.7 × 42.9), Turner Bequest LVIII-47, Tate Britain, London.

This 'Scottish Pencils' drawing would serve as the basis of an oil painting treating of a subject taken from *The Poems of Ossian* by James Macpherson (1736–1796) that Turner would exhibit at the Royal Academy in 1802. His backpack might be the large object resting on the beach.

Left bottom 259 *Loch Lomond from near Tarbet*, 1801, chalk, pencil and watercolour on paper, 11⅝ × 17 (29.7 × 43.3), Turner Bequest LVIII-46, Tate Britain, London.

This 'Scottish Pencils' drawing would form the basis of the *Loch Lomond* watercolour, reproduced on the facing page, which was one of three designs created to adorn a book on Highland scenery.

A number of the 'Scottish Pencils' would serve as the basis of finished watercolours, such as a view of Loch Lomond from near Tarbet that would be elaborated around 1804 (fig. 261).[9] But Turner did not necessarily wait for years to respond to beauties he perceived in the Highlands. Thus a depiction of Loch Long in evening light might well have been made on the spot (fig. 260). And some weather effects were so spectacular that they, too, soon demanded commitment to paper. For example, a 'Scottish Pencils' view of Kilchurn Castle with Loch Awe and Ben Cruachan beyond (fig. 262) formed

260 *Loch Long, evening*, 1801, watercolour on paper, 13⅞ × 19⅜ (35.1 × 49.1), Turner Bequest LX-G, Tate Britain, London.

261 *Loch Lomond from near Tarbet*, c.1804, signed 'J. M. W. Turner RA' at lower-right, pen and watercolour on paper, 7¾ × 11¼ (19.7 × 28.5), private collection.

the basis of a watercolour showing a spectacular storm passing across the mountain and its adjacent heights. (As this work was last seen publicly in 1904, it is represented here by the engraving made of it in 1847, fig. 263.)[10] And Turner also responded to Highlands scenery in oils, although he must have done so back in London (fig. 266).

From Gretna Green, Turner travelled by stages to Chester where he fished the Dee, possibly for a fortnight, and obtained material for two more *Britannia Depicta* designs.[11] It is likely that the weather and food there were better than they had been in Scotland. Probably by the end of August he was back in London, where he set to work on paintings and watercolours elaborated from the Scottish material.

In February 1802 he would tell Farington that he had found Scotland more picturesque than Wales, for he considered 'The lines of the Mountains [to be] finer, and the rocks of larger masses'.[12]

At some point between 29 August 1800 and 29 August 1801 a daughter was born to Turner and Sarah Danby.[13] She was given the name Evelina after the heroine of the hugely popular novel of that title by Fanny Burney (1752–1840), which had first been published in 1778. If she was born in August 1801, then it would have been entirely in character for Turner to have absented himself in Scotland during the final stages of the pregnancy. He would not have wanted to be weighed down with such matters and may have reasoned that

Above 262 *Kilchurn Castle, with the river Orchy; Loch Awe and Ben Cruachan beyond*, 1801, pencil and gouache on paper, 13⅜ × 18⅞ (34 × 48), Turner Bequest LVIII-16, Tate Britain, London.

Left 263 William Miller after J. M. W. Turner, *Kilchurn Castle, Loch Awe*, engraving, 1847 (R. 664), 13⅛ × 20⅛ (33.3 × 51.1), Tate Britain, London.

Facing page top left 264 *Loch Tummel looking east towards Ben y Vrackie and Ben Uan*, 1801, pencil and gouache on paper, 13⅜ × 18⅞ (34 × 48), Turner Bequest LVIII-32, Tate Britain, London.

Facing page top right 265 *?Killiecrankie*, 1801, pencil and gouache on paper, 13¼ × 19⅛ (33.8 × 48.6), Turner Bequest LVIII-36, Tate Britain, London.

Facing page bottom 266 *Tummel Bridge, Perthshire*, 1801, oil on canvas, 11 × 18¼ (28 × 46.5), Yale Center for British Art, Paul Mellon Collection.

267 *?Ash Grove, William Well's Cottage in Knockholt, Kent*, c.1801, watercolour on paper, 7⅝ × 11 (19.4 × 27.9), Turner Bequest XXXIII-G, Tate Britain, London.

Sarah already had four daughters to assist her, let alone a niece, friends and, quite possibly, his own father. In an age in which men almost invariably took no hand in bringing their offspring into the world, a lack of involvement on his part might have seemed normal, even if it could well appear to our eyes as being sexist, thoughtless and uncaring, which it probably was.

In October 1801 Turner probably went to stay in the little farming community of Knockholt in Kent where his friend, W. F. Wells, had recently acquired a property, Ash Grove.[14] This might be the house depicted by Turner in a watercolour created at around this time (fig. 267).[15] Clara Wells would later state that Turner 'always spent a part of the autumn at our cottage',[16] and she recalled incidents that may have occurred during this period, including going out sketching with Turner, watching him climb a tree to obtain a better view, handing up his colours for him to make a sketch, and seeing him play uproariously with her little sisters and brothers. As she observed, 'Of all the light-hearted, merry creatures I ever knew, Turner was the most so; and the laughter and fun that abounded when he was an inmate in our cottage was inconceivable, particularly with the juvenile members of the family'.[17] Clearly, Turner let his guard down fully at Knockholt because he was in the company of people he could trust. Children made no demands on him, and therefore they would always touch him to the core, perhaps because his own childhood had been so difficult. And as his playfulness makes clear, not very far behind his normally defensive and reserved façade the child lived on, just as it does in many of us.

Turner wrote to Colt Hoare from Norton Street on 21 November 1801, in his earliest surviving letter.[18] In addition to presenting his bill for seven of the commissioned Salisbury watercolours, he asked Sir Richard if he could 'show him a small piece of Scilica [i.e. silica] to make use of in the Trancept'. Silica being a fundamental constituent of glass, by 'Scilica' Turner possibly meant a fragment of the white glass that had recently been removed from Salisbury Cathedral while it was being rebuilt by James Wyatt. Perhaps Colt Hoare had retrieved some of it from the detritus that was being carted away. If this was what Turner meant, then maybe he wanted to experiment with that 'Scilica' by mixing it in with the gouache paint he would be using to depict the windows in a view looking towards the building's north transept that he was either planning to elaborate, or was even making at the time.[19] Instead of painstakingly depicting the leading used to hold each individual pane of glass in place, as he had done in all his other cathedral interiors that included windows, in this work he instead represented the serried ranks of panes by means of lines of tiny blobs of off-white paint that may even contain ground-down particles of silica bound up in them. Perhaps Turner wanted the glass he represented to sparkle, and to do so by means of actual pieces of glass retrieved from Salisbury Cathedral itself. Certainly it would have been entirely in keeping with his experimental nature to have attempted this, and it is difficult to imagine why he requested a small piece of silica 'to make use of in the Trancept' if this was not his intention.

On 26 December 1801 Mary Turner was discharged from the Bethlem Hospital. However, this was merely a formality, for she remained in confinement. Exactly a week later, her name was entered in the hospital's 'Incurable Admission Book'.[20] The previous intermediaries again petitioned the hospital for her care, stood surety for her good conduct, and agreed to take full responsibility for her welfare should she be discharged. Now that she had deteriorated from being a 'curable' patient to an 'incurable' one, they had to post a bond of two hundred pounds, or double what had formerly been pledged. They also had to begin handing over two shillings and sixpence a week for her upkeep, a 50 per cent reduction on the normal charge. Dr Monro must have had a say in both her continuing incarceration and the lowering of her fees, which was undoubtedly represented to the hospital's governing body as a necessary act of charity because she was so deeply impoverished. Strictly speaking, this was true. Yet as her son was well on his way to becoming wealthy, it was nonetheless a lie. The weekly money must have been channelled through the intermediaries or taken around to the hospital by messenger every Saturday, the day set for payment. This is because it is impossible to imagine that the two Turner men ever visited the hospital treasurer themselves. Maintaining secrecy was their prime concern.

Election

The deaths of three Academicians having occurred in 1801, polls for their replacements were scheduled to take place in February 1802. All nineteen Associates were eligible candidates. By now, the Royal Academy was well on its way to dividing into two factions, one of which was highly reactionary in its politics, the other progressive. Both parties put up candidates, with the reactionaries particularly supporting the architect Joseph Bonomi (1739–1808), who had failed to be elevated back in 1790. Due to his conservative views, they thought he might vote with them if elected. On the other hand, because Turner did not share their thinking, they opposed him. He was backed by the progressives, who had also agreed to support John Soane and Charles Rossi, and to do so in that order, for it ranged the three men in magnitude of talent and therefore in chances of success.

Turner was unaware of this scheming, for because he was only an Associate he was not party to the backroom politicking within Somerset House. That is why, in his ignorance, he canvassed for support. And that is why there was such a high turnout on Wednesday 10 February, as related in the Prologue. The progressives and several floating voters polled in favour of Turner, the reactionaries for Bonomi. In the two subsequent elections, both Soane and Rossi were also elected. The progressives had therefore achieved the double feat of trouncing the opposition and of elevating two of the greatest talents ever to stand for election as Royal Academicians. As in 1799, when he had been elected an ARA, Turner was surely elated at his success, although on this occasion he hosted no celebratory supper. Smirke, Edmund Garvey RA (1740–1813) and Daniell simply called on him with the good news before going on to late-night drinks with Farington.[21] The lack of festivity was appropriate, for Turner's election as a Royal Academician had really taken place in the Great Room the previous spring, when *Dutch boats in a gale* had caused a sensation. But as the result of both that impact and the recent political manoeuvring, Turner had finally arrived at the summit of his profession, exactly where he had always wanted to be. Little did he know how much contentiousness he would encounter there before too long.

14

High Places and High Art
February to October 1802

Britain and France had fought each other to a standstill. On 1 October 1801 a temporary ceasefire was agreed and formal peace negotiations began. By the time Turner was elected an Academician on 10 February 1802, he could begin to hope that he might soon be able to visit continental Europe, and thus explore more breathtaking landscapes than any he had previously encountered. On 25 March the war would end with the signing of the Treaty of Amiens.

It was the custom for new Academicians to call upon their supporters in a recent poll, in order to thank them for their backing. Thomas Stothard pressed Turner to do this but he refused, stating: 'If they had not been satisfied with [my] pictures, they would not have elected [me]. Why, then, should [I] thank them? Why thank a man for doing a simple duty?'[1] Before his election Turner had gone out of his way to appear modest and deferential. Now he had attained his goal, he threw off that guise. He was justified in doing so, for his talent was huge and his pictures had undeniably served to elect him. Moreover, he must have been mindful of the time it would take to call upon all twenty Academicians who had finally voted for him. He preferred to spend that time painting. So instead he wrote a letter to the Royal Academy Council, thanking his new peers by way of that body. And two days after his election, he attended a Royal Academy Club dinner.[2] Out of the ten Academicians present who had participated in the poll, Farington gauged that all but one had voted for him,[3] so he must have received some hearty congratulations and taken the opportunity to thank at least some of them.

Farington caught sight of Turner's oil painting palette when he visited 64 Harley Street on 27 February.[4] It contained white, yellow ochre, vermilion red, Venetian red, raw and burnt sienna, umber, Prussian blue, ultramarine blue and blue-black. During this phase of his career Turner did not employ bright yellow in his oils, which is probably why yellow ochre sufficed for that band of the spectrum. The four earth colours – Venetian red, raw sienna, burnt sienna and umber – had been the stock-in-trade of painting for centuries, and they were especially useful for the 'dead colour' stage of underpainting. Prussian blue is a very acidic blue, useful for painting skies (and Turner is also known to have used the paler variety of that colour known as Antwerp blue). Ultramarine blue is a uniquely harmonious blue, but until the 1820s – when the chemical substitute, French ultramarine blue, would come on the market – it could only be obtained by grinding down the semi-precious stone lapis lazuli, which is why it proved hugely expensive. However, as Turner's use of the only slightly less costly vermilion red demonstrates, he did not flinch at spending comparatively large sums on paint. The knowledge that he could recoup such outgoings through the sale of oils and watercolours helped somewhat. Finally, certain blue-blacks can produce far darker tones than lamp or ivory black, which is surely why Turner employed them.

Detail of fig. 291.

268 *Fishermen upon a lee-shore, in squally weather*, R.A. 1802 (110), oil on canvas, 36 × 48 (91.4 × 122), Southampton City Art Gallery.

In his new guise as Royal Academician, Turner would attend his first General Assembly meeting on 14 April. However, in order to receive the Diploma signed by the monarch that would officially denote his elevation in status, he was first required to gift to the Academy a work he held to be representative of his talents as a painter. Yet instead of submitting a single offering, he sent in two of them 'at different times', along with a letter inviting the Council to choose between them.[5] One of them was the *Dolbadern Castle, North Wales* exhibited in 1800 (see fig. 239). It was unanimously accepted at a 2 March Council meeting. Perhaps Turner selected it as his Diploma work because he was aware that behind the 'hopeless OWEN' of the picture lay his mother, and that the canvas therefore signified something of the price he had paid to become a Royal Academician. Unfortunately, the other submission cannot be identified as its title was not recorded in the minutes. Possibly it was the self-portrait painted recently (see fig. 243). After all, who at the time would have purchased a Turner self-portrait? It would have been unsaleable. On the other hand, it would have constituted an excellent

way of representing oneself at the Royal Academy, if a somewhat uncharacteristic one.

Ever since the hair powder tax had been introduced by a Tory administration in May 1795, William Turner had seen his previously lucrative wig trade steeply decline. No amount of shampoos, shaves and haircuts fully compensated for that loss. So when Turner had moved out of Maiden Lane in mid-November 1799, and his mother had been taken from there not long afterwards, they had perhaps been following a plan to close the shop within the next two or three years, with the father going to live with the son and to work for him thereafter. Such a strategy made sense, for by now the painter was bringing in far more money than his father had ever earned from his wig-making and tonsorial labours. That is why at some point not long before 25 March 1802, William Turner finally quit Maiden Lane, in favour of living with his son in Norton Street and helping him out in Harley Street.[6]

On the evening of Wednesday 14 April 1802, Turner, who may well have been dressed very smartly, attended his first General Assembly meeting. Along with the other newcomers Soane and Rossi, he publicly subscribed to the 'Obligation' incumbent upon all RAs to respect the rules of the institution, and consequently received his Diploma signed by King George III. The President, Benjamin West, then declared them 'to all effects – Academicians of the Royal Academy'.[7] This was another proud moment in Turner's life, but one that unfortunately his father could not share, for only Academicians were permitted to attend General Assembly meetings.

The 1802 Royal Academy Exhibition
FRIDAY 30 APRIL TO SATURDAY 12 JUNE

This year Turner had eight works on display, including two seascapes, a biblical scene and a historical landscape. He had been working hard since returning from Scotland, for half his exhibits depicted landscapes north of the border. One of them, *Ben Lomond Mountains, Scotland: The Traveller – Vide Ossian's War of Caros* (Fitzwilliam Museum, Cambridge) partly drew upon poetry for its inspiration.

Fishermen upon a lee-shore, in squally weather (fig. 268) hung in the Great Room. Clearly it grew out of the pictorial relationship between the Duke of Bridgewater's van de Velde (see fig. 250) and *Dutch boats in a gale* (see fig. 251), for whereas opposed diagonals create a strong connection between those two pictures by means of masts leaning respectively to the left and right within each of them, here Turner moved those contrasting but connective slants into a single image. The bright crimson of a fisherman's jacket must have leapt across the entire room to grab the viewer and obviate any danger that the picture might look somewhat monochromatic.

269 *The tenth plague of Egypt*, R.A. 1802 (153), oil on canvas, 56½ × 93 (142 × 236), Turner Bequest, Tate Britain, London.

The painting makes the danger inherent to lee shores very explicit. Turner the moralist shows us a fisherman attempting to stave off disaster with a boathook. Given that such an implement could never prove adequate to the task, the detail points up the delusions and physical limitations of mankind. Additionally, the upturned craft is about to be thrown upon an anchor on the left. Undoubtedly it will be smashed in the process. Therein lies a bitter irony, for it is the very want of an anchor that has led the vessel to its destruction in the first place.

The *Monthly Mirror* for June 1802 called the work 'A masterly performance', although some newspapers criticised Turner for a lack of precision and detail. Thus the *Star* of 6 May termed the work 'a very admirable sketch' but not a 'good finished picture'. Obviously the fact that representational looseness helps lend a sense of movement and physical power to the scene eluded the critic entirely.

Also exhibited in the Great Room was *The tenth plague of Egypt* (fig. 269). Its title was accompanied in the catalogue by verses taken from the Book of Exodus concerning the smiting of the firstborn at midnight, and the discovery that 'there was not a house where there was not one dead' the next morning. The artist might have reached into his memory to paint this picture, for of course his own home had once witnessed the loss of a child, albeit not its firstborn. In conformity with the subject, intense darkness extends the mood of merciless annihilation.

Robert Smirke was 'surprised' by *The tenth plague of Egypt*, thinking it 'an extraordinary production'.[8] In the main, the critics were of like mind, the *Star* of 5 May calling it a work 'of the highest

Above 270 Ships bearing up for anchorage, R.A. 1802 (227), oil on canvas, 47 × 71 (119.5 × 180.3), Tate Britain and the National Trust, Petworth House, Sussex.

Below 271 The fall of the Clyde, Lanarkshire: Noon. – Vide Akenside's Hymn to the Naiads, R.A. 1802 (366), watercolour on paper, 29⅜ × 41⅝ (74.5 × 105.8), Walker Art Gallery, Liverpool.

Below right 272 Jason, R.A. 1802 (519), oil on canvas, 35½ × 47⅛ (90 × 119.5), Tate Britain, London.

order' and the *St James's Chronicle* for 18–20 May praising it as 'the first Picture in the present Exhibition'.

Ships bearing up for anchorage (fig. 270) hung in the Anti-Room. Near its centre several vessels turn into the wind to drop anchor. By massing them together, Turner was able to create the type of complex nautical jumble he particularly relished. It may be that he had intended the stormy sky, tumbling sea, nautical dynamism and swirling confusion to act as an analogue for the war that had still been in progress when the picture was painted. The *Daily Advertiser* for 5 May called the canvas 'forcible and judicious . . . well drawn and admirably coloured'.[9]

Turner had three watercolours on display in the Council Room. One of them was *The fall of the Clyde, Lanarkshire: Noon. – Vide Akenside's Hymn to the Naiads* (fig. 271). The directing of the viewer's attention to Akenside's poem of 1746 makes it apparent that the naked bathers are not everyday inhabitants of Lanarkshire. Instead, they are mythological and symbolic creatures invested with the powers of nature. By contributing to the fullness of navigable rivers, they lead to the rise of maritime power and commerce. The lyricism of the scene surely survives the fact that the image now tilts towards the yellow and red bands of the spectrum, due to the employment of indigo and the consequent fading of its blue-greys.

In *Jason* (fig. 272), which was hung in the Antique Academy, the protagonist is seeking to kill the ever-watchful serpent that guards the golden fleece. By only showing us part of that creature, Turner was able to suggest its immensity within a comparatively small space. The many shattered trees project a sense of violence, an association that is furthered by the vivid red of the discarded cloak, with its hints of blood. Turner took the subject from Book IV of the *Argo-*

nautics of Apollonius Rhodius (3rd–2nd century BCE), translation of which was available to him in the thirteenth volume of Anderson's *Complete Poets*. The marked resemblance of the image to Salvator Rosa's *Landscape with St Anthony and St Paul* of the 1650s or 1660s (fig. 273) strongly suggests he had seen the latter work, which then hung at Woburn Abbey in Bedfordshire.

France, French Savoy, Piedmont and Switzerland 1802

During the month that followed the closure of the Royal Academy Exhibition, a plan to travel abroad came into focus. Turner would be visiting Paris on a subsidised study trip. The French capital was chosen because a great many works of art that previously could only be seen across Europe had recently been brought together there. But Turner had also set his sights higher. Having exhausted the Welsh mountains by 1800 and having had his appetite for elevated places more recently intensified by the heights of Scotland, he now wanted to visit some uplands that would dwarf those peaks entirely.[10]

Initially, Lord Yarborough was asked to help Turner tour France, French Savoy, Piedmont and Switzerland, but he would only pay for the Paris trip, and even then he was only prepared to assist the artist by possibly persuading two of his friends, Sir John Boyd (1750–1815) and the 3rd Earl of Darlington (1766–1842), to do so as well. He was successful. In all, perhaps thirty guineas was raised, which would have purchased a fairly luxurious two-week stay in Paris, *champagne et huîtres* included. But doubtless Turner put much of that grant – or even all of it – towards his planned tour of the alps. And during the process of raising the money, the name of somebody else who also fancied a visit to the Continent arose, probably through Lord Darlington.

This was Newbey Lowson (1773–1853, fig. 274), a country squire with hunting, antiquarian, topographical and artistic interests who hailed from Witton-le-Wear, County Durham, just six or so miles from Lord Darlington's residence, Raby Castle, in the same county.[11] The fact that Turner would make no notes in his sketchbooks of places to visit on this tour, or list there any expenses or foreign-language phrases of the type he would usually jot down during his later tours abroad, suggests that Lowson advised him on where to go, controlled their finances, and did all the talking in French, which

Top 273 Salvator Rosa, *Landscape with St Anthony and St Paul*, 1650s or 1660s, oil on canvas, 26½ × 19½ (67.3 × 49.5), National Gallery of Scotland, Edinburgh.

Bottom 274 Joseph Bouet, *Portrait of Newbey Lowson*, Durham University Library.

Turner lacked (indeed, it may have been the painter's fears of going abroad without possessing a foreign language that had first created his link-up with Lowson). Naturally, the sharing of expenses was welcome to both parties.

Yet Turner did not let Lowson become his travelling companion without setting a condition, or possibly two of them.[12] The first was that the artistically minded country squire would never sketch any view that Turner himself chose to draw. The reasoning behind this was that the painter wanted to protect his intense mental concentration, which might well have been shattered if someone ventured to speak while sketching alongside him. Equally, he did not want to have to be polite about the sketches of an amateur. Moreover, we are also told that 'Turner did not show his companion a single sketch' made on the trip. This may have followed upon another condition, namely that Lowson would not ask to see his sketches. The motive behind such a demand was that Turner did not want any comments to be based *solely* upon being able to see what he had committed to paper. This was because he was always taking in far more of what he saw than his sketches could actually denote.

Turner and Lowson left for the Continent on Thursday 15 July 1802. Perhaps they sailed directly from London to Calais. The Channel crossing was fairly rough. When they arrived off the French port, it was to find that the tide was not in their favour and that the harbour bar had not yet cleared, thus keeping them out to sea. Rather than be tossed around idly, Turner and his companion transferred to a small boat which was 'Nearly swampt' when gaining the shore.[13] Turner also drew 'Our Situation at Calais Bar' (fig. 275).

The two men probably arrived in the French capital on Sunday 18 July and remained there for a week. It is not known where they stayed. The painter spent time in the Louvre and acquired sketchbooks and fine paper.[14] He and Lowson purchased a cabriolet or two-wheeled light carriage drawn by a pair of hired horses, as well as hired a Swiss servant to drive them to Switzerland and act as their

Top 275 'Our Situation at Calais Bar', inscription by Turner on fol. 70 of the *Calais Pier* sketchbook, 1802, black and white chalk on grey paper, 17⅛ × 10¾ (43.5 × 27.3), Turner Bequest LXXXI, Tate Britain, London.

Middle 276 *The Isère Valley from above La Frette*, 1802, watercolour on paper, 12⅜ × 18⅝ (31.4 × 47.3), fol. 26 of the *St Gothard and Mont Blanc* sketchbook, Turner Bequest LXXV, Tate Britain, London.

Bottom 277 *The Post-House, Voreppe, with the Grande Aiguille beyond*, 1802, pencil, black chalk and gouache on brownish paper, 8⅝ × 10 (21.9 × 25.3), Turner Bequest LXXIV-22, Tate Britain, London.

The cabriolet used by Turner and Lowson is discernible outside the inn.

guide.[15] They probably quit Paris on Monday 26 July, bound for Lyons, Grenoble, the Grande Chartreuse and Geneva, where they are likely to have arrived two weeks later. En route, Turner had drawn his first sight of the Alps in all their glory (fig. 276), as well as the cabriolet itself (fig. 277). After possibly four nights in Geneva, the travellers then moved on to Bonneville and Chamonix, in the latter of which towns they may have spent up to seven nights. For years to come, Turner would build upon sketches and studies created during these halcyon days in and around around Chamonix. One such work was a view across the Mer de Glace (fig. 278), another a view of Mont Blanc as seen from the Montanvert mountain in the valley of Chamonix. (fig. 279).

On 19 August or thereabouts, Turner and Lowson temporarily parted company with their coachman and vehicle, arranging to meet up in Martigny ten days later, probably on 28 August.[16] With a guide, they then traversed the western edge of the Mont Blanc massif by foot. In the village of Les Contamines-Montjoie at dawn on the second day, the painter was rewarded with the sight of a vivid beam of sunlight momentarily flashing across the cloudy sky from behind the mountain range (fig. 280). Gradually the men moved up to the Col de la Seigne pass, at more than 8,200 feet probably the highest elevation the painter would ever reach. It afforded them a staggering view to the south-east that in 1812 would unsurprisingly make its way into a painting of Hannibal and his army crossing the alps (see fig. 418). Finally they descended to Courmayeur, on the far, Piedmontese side of the massif, from where they gradually walked down to Aosta. This served as a base for pos-

Top 278 Drawing labelled by Turner: 'Mer de Glace, le Cabin de Blair, Aigule du Rouge', 1802, pencil, black chalk, watercolour and gouache on paper prepared with a grey wash, 12⅜ × 18¼ (31.4 × 46.8), Turner Bequest LXXV-22, Tate Britain, London.

The 'cabin' was an alpine refuge built in 1779 by an English resident in Geneva, Charles Blair. And see fig. 382, which was based upon this story.

Middle 279 Drawing labelled by Turner: 'Chamoni Mt Blanc', 1802, pencil, black chalk, watercolour and gouache on paper prepared with a grey wash, 12½ × 18¾ (32 × 47.5), Turner Bequest LXXV-15, Tate Britain, London.

The lower peaks of the Mt Blanc massif are visible above the trees growing on the slopes of the Montanvert mountain in the valley of Chamonix.

Bottom 280 Drawing labelled by Turner: 'Contamine – avec Mt Blanc', 1802, pencil, black chalk, watercolour and gouache on paper prepared with a grey wash, 12½ × 18¾ (32 × 47.5), Turner Bequest LXXV-24, Tate Britain, London.

281 *Aosta with Mt Emilius in the distance*, 1802, pencil, black chalk, watercolour and gouache on paper prepared with a grey wash, 8⅓ × 11 (21.1 × 28.1), formerly a sheet in the *Grenoble* sketchbook, Turner Bequest LXXIV-11, Tate Britain, London.

282 *A couple in bed*, 1802, watercolour on paper, 6¼ × 7¾ (15.8 × 19.6), fol. 1 of the *Swiss Figures* sketchbook, Turner Bequest LXXVIII, Tate Britain, London.

sibly three nights (fig. 281). The travellers then trudged northwards to the top of the Great St Bernard Pass, a gradual climb of almost 6,200 feet spread over twenty-five miles that probably took two days. Subsequently it was downhill all the way to Martigny where they met up with their coachman. From there they moved on by gradual progressions to Chillon, Vevey, Lausanne, Avenches and Berne where Turner had to acquire three new sketchbooks, for he was running short of paper. He may have drawn a couple in bed together when in Berne (fig. 282).

From there the travellers continued over the following days to Thun, Unterseen, Lauterbrunnen (with its renowned Staubbach waterfall), Grindelwald, Meiringen, the great fall of the Reichenbach, Brienz and Lucerne. They then took a small boat to the south-east corner of Lake Lucerne at Flüelen. Next, Turner and Lowson walked by way of Altdorf southwards down the valley of the river Reuss towards the St Gotthard Pass. Eventually they reached the narrow and precipitous gorge crossed by the Devil's Bridge, which was so named because of the dangers of the surrounding mountains. Following their return to Flüelen, Turner and Lowson progressed over the next week to Zurich, Baden, Schaffhausen, Laufenburg, Bad Sackingen, Rheinfelden and Basle. Probably it then took them five days to return to Paris via Strasbourg, Nancy and Ligny-en-Barrois. They appear to have arrived back in the French capital on Monday

Possibly Turner created this artfully structured composition in Berne. It might depict two Swiss honeymooners, with what appears to be the limp penis of the newly-wed husband being disinterestedly held by his forlorn-looking bride, in a comment upon the disillusion that many couples encountered on their wedding nights in an age in which premarital sex was largely unknown, and when it was usually too late to undo the marriage knot once it had been tied. Alternatively, Turner could have been representing two unhappy-looking women in a statement about the alienation, hopelessness and loneliness generated by prostitution (for the gender of the furthermost figure is not entirely clear). That would not have been beyond his remit as a moralising artist either. However, the figures are not drawn with quite enough detail for us to be absolutely certain of anything.

28 September. If that was the case, then they are likely to have been on the road for a day over nine weeks since leaving Paris.

By the time Turner and Lowson returned to the metropolis, Farington had arrived there too. When he visited the Louvre on the afternoon of 30 September he encountered Turner in one of the galleries. On that occasion and in the course of further meetings he was informed of various details of the tour. Thus the weather in the alps had been good, although Turner had also seen some 'very fine Thunder Storms among the Mountains'.[17] Possibly because of the recent hostilities, Switzerland had been in a very troubled state, but fortunately the populace remained 'well inclined to the English'. Turner had suffered 'much fatigue from walking' and had 'often

experienced bad living and lodgings'. On the whole, he thought the vast, fragmented rocks and precipices of Switzerland to be 'very romantic, and strikingly grand'. With regard to the shapes they made, he found them to be 'rather broken', even if they contained some 'very *fine parts*'. Clearly, as in Wales and Scotland, he partially judged mountains by their ability to provide him with sweeping lines.

Once back in the French capital, Turner and Lowson paid off the servant and sold the cabriolet. It seems likely that the country squire then returned home. By now Turner had no shortage of other possible companions, for thousands more Britons had flooded into the city since he had left it. They included West, Fuseli, the sculptor John Flaxman RA (1755–1856), Opie, Daniell, Smirke, Hoppner and Shee, all of whom were intent upon seeing what was undoubtedly the most breathtaking collection of ancient and Old Master art that had ever been assembled under one roof, or ever will be for that matter.

The One-Stop Grand Tour

It was the greatest show on earth. As the result of seizures by post-revolutionary French governments from royal, aristocratic and ecclesiastical collections, and appropriations since 1794 by French armies during their campaigns across Europe, by September 1800 the so-called Musée Central des Arts that was housed in the Louvre palace in Paris was in possession of 1,500 classical sculptures and other antiquities, 1,390 foreign Old Master paintings, 279 French Old Master pictures, more than 1000 modern French paintings, 20,000 drawings, 30,000 engravings and 4000 engraving plates, and all at a time in which there was not a single public art gallery anywhere in Britain, let alone a national collection.[18] That is why, if one were truly serious about painting and sculpture, Paris was the place to be in the summer of 1802.

The major displays in the Louvre were contained in the Salon Carré and the Grande Galerie, the latter of which was then 440 yards in length (fig. 283).[19] Among the spoils of war on show were two works that were generally considered to be the supreme masterpieces of western painting, namely Raphael's *Transfiguration of Christ* of 1518–20 (fig. 284), which had been taken from the Vatican and which would be returned there in 1815; and Titian's *Death of St Peter Martyr* of 1526–30, which had been appropriated from the church of SS

Top 283 Hubert Robert, *The Grand Gallery of the Louvre after the reopening in 1801*, c.1802, oil on canvas, 13⅜ × 17¾ (34 × 45), Musée du Louvre, Paris.

Bottom 284 Raphael, *The Transfiguration of Christ*, 1518–20, oil on canvas, 159½ × 109½ (405 × 278), Pinacoteca Vaticana, Rome.

285 Martino Rota after Titian, *The Death of St Peter Martyr*, engraving, 1560–1580, British Museum, London.

Giovanni e Paolo in Venice. In 1815 it too would be restored to its rightful owners, only to be destroyed by fire in 1867 (which is why it is represented here by an engraving by Martino Rota, fig. 285).

Arguably the finest sculptures on view were 146 leading pieces from the ancient world. Exhibited in a magnificent suite of seven interconnecting rooms on the ground floor, the *Apollo Belvedere* formed the climax of a display that included the *Laocoön* and the *Belvedere Torso*. All three works had been looted from the Vatican and would eventually be returned there. The *Dying Gaul*, the *Belvedere Antinoüs* and a Roman *Sarcophagus of the Muses* that dates from about 150 CE had been taken from the Museo Pio-Clementino in Rome, to which holding the first two pieces would later be restored. As Turner had drawn most or all of these works in plaster-cast form in the Schools, it is likely he looked closely at the originals.

It may have been a condition of Turner's grant that when he returned to England he should be able to show evidence of his studies in Paris to his three sponsors. If that was the case, then he was happy to oblige, in the form of the *Studies in the Louvre* sketchbook. Here he responded to upwards of thirty-seven works by more than sixteen artists, as well as analysed the distribution of hues in nine pictures by some of those painters and others.

The artist to whom he paid the most attention was Poussin, fifteen of whose paintings were explored or briefly mentioned in the sketchbook. Additionally, Turner scrutinised five paintings wholly or partially by Titian; four works by Lorenzo Lotto (c.1480–1556); three pictures by Rubens; two paintings by Raphael, one of them in the form of a colour-structure analysis of *The Transfiguration of Christ*; two pictures by Domenichino (1581–1641); three works by Il Guercino (1591–1666), one of which Turner mistook for a Domenichino; two paintings by Pier Francesco Mola (1612–1666); two seascapes by Jacob van Ruisdael; and single pictures by Antonio da Correggio (1489–1534), Sir Anthony van Dyck, Rembrandt and Charles Le Brun (1619–1690). Furthermore, he also copied two paintings by a follower or followers of Rembrandt; a picture derived from an image by Jan Lievens (1607–1674); and a drawing by Francesco Primaticcio (1504–1570).

The latter work was probably seen in the Galerie d'Apollon, a room off the Salon Carré that contained no fewer than 1,797 drawings (they included Raphael's vast cartoon for his *School of Athens* fresco in the Vatican, a work now in the Ambrosiana Gallery in Milan). For some unknown reason, Turner only saw two of the fifteen or so paintings by Claude that were owned by the Louvre (and even then he took both of them to be works by Herman van Swanevelt, 1603–1655).[20] Perhaps the other Claudes had been rendered rather difficult to see by the uneven lighting in the Grande Galerie. Alternatively, because the hang was in a state of flux when Turner was there – partly to accommodate the annual showing of contemporary French paintings in the Salon Carré – it could well have been the case that very few pictures by Claude were on display.

Compositionally, Turner found Titian's *St Peter Martyr* (fig. 285) to be 'beyond all system' or pictorial formulas – he would always distrust shortcuts.[21] He also admired its 'simplicity of ... parts', by which he probably meant the clear separation of figures, angels, trees and other forms that helped each of them project with the utmost power. Equally, he enthused about the contribution made by colour and form to Titian's *Entombment of Christ* (fig. 286), in which the richly hued garments of the figures invest the image with great colouristic range without making the dead figure look pallid or leaden by comparison. The *Woman with a Mirror* (fig. 288) he called 'A wonderful specimen of [Titian's] abilities as to natural color for the Bosom of his Mistress is a piece of Nature in her happiest moments'. Because of their wealth of colour, he copied both the entombment scene and the female

286 Titian, *The Entombment of Christ*, c.1516, oil on canvas, 58¼ × 84⅝ (148 × 215), Musée du Louvre, Paris.

287 Copy of Titian's *The Entombment of Christ*, 1802, watercolour, 5¹⁄₁₆ × 4⅜ (12.8 × 11.1), fol. 32 of the *Studies in the Louvre* sketchbook, Turner Bequest LXXII, Tate Britain, London.

288 Titian, *Woman with a Mirror*, c.1515, oil on canvas, 36⅝ × 30 (93 × 76), Musée du Louvre, Paris.

289 Copy of Titian's *Woman with a Mirror*, 1802, watercolour, 5 1/16 × 4⅜ (12.8 × 11.1), fol. 25 of the *Studies in the Louvre* sketchbook, Turner Bequest LXXII, Tate Britain, London.

portrait in watercolour (figs 287 and 289 respectively), rather than simply drew them in monochrome. Titian's mastery of body language he deemed to be vital in externalising feelings and states of mind. Thus he found the figures surrounding Christ in the *Entombment* to be highly successful in making their responses to death apparent. He also relished the way that the twisted legs of Jesus in the *Christ Crowned with Thorns* of c.1542 (fig. 290) communicate 'excessive pain and exertion' in their own right.[22] He copied this too (fig. 291).

Perhaps the most valuable aspect of Turner's thinking in the *Studies in the Louvre* sketchbook concerns a type of colour that has been completely misunderstood until now. When he analysed history paintings that hung in the Grande Galerie, he often employed the term 'Historical colouring'.[23] This denoted the arrangement of all the colours in a given history picture so as to make them serve the subject in a wholly appropriate way. For Turner 'Historical colouring' effected an associative matching of colour to content. Essentially, it was a form of decorum.

He clarified exactly what he meant by 'Historical colouring' in his discussion of *The Raising of Lazarus* of around 1619 by Guercino (fig. 292). This he found to be 'a charming specimen of Guerchino's Historical mode of treatment [for] the color so unites with the subject as to impress it forcibly'.[24] Because Lazarus is the dominant figure in the image and, in his semi-nude state, he projects more colour and bright tone than anyone else, he looks to be full of life.[25] As can be imagined, such an emphasis is extremely apt in a resurrection scene. Turner stated that Guercino's 'mode of treatment ... may surely be deem'd Historical colouring [and it can only] be applied where nature is not violated.' Always he held it important that associative effects should not look unnatural. He further observed that Guercino's associative use of colour and its tonalities demands 'sympathetical ideas' to be understood, which cannot be gainsaid.

Elsewhere, in his discussion of Titian's *St Peter Martyr*, Turner also touched upon 'historical colour', although he thought that the success of that painting derived not from any associative use of

Left 290 Titian, *Christ Crowned with Thorns*, c.1542, oil on panel, 119¼ × 70⅞ (303 × 180), Musée du Louvre, Paris.

Above 291 Copy of Titian's *Christ Crowned with Thorns*, 1802, watercolour, 5 1/16 × 4⅜ (12.8 × 11.1), fol. 52 of the *Studies in the Louvre* sketchbook, Turner Bequest LXXII, Tate Britain, London.

Below 292 Guercino, *The Raising of Lazarus*, c.1619, oil on canvas, 79⅛ × 91¾ (201 × 233), Musée du Louvre, Paris.

colour but from its representation of figures, angels, trees and other forms.[26] Yet he certainly did deem 'Historical colouring' to be integral to the success of Poussin's *The Israelites Gathering Manna* of 1639 (fig. 293). This he judged to be 'the grandest system of light and shadow in the [Louvre] collection', which was no small compliment.[27] Here he found that 'figures of equall power occupy the sides and are color'd alike. They carry severally their satellites of colour into the very centre of the picture where Moses unites to them by being in Blue and red. This strikes me to be the soul of the subject as it creates a harmonious confusion.'

293　Nicolas Poussin, *The Israelites Gathering Manna*, 1639, oil on canvas, 57⅞ × 78¾ (147 × 200), Musée du Louvre, Paris.

294　Nicolas Poussin, *Winter (The Deluge)*, 1660–64, oil on canvas, 46½ × 63 (118 × 160), Musée du Louvre, Paris.

Why 'the soul of the subject'? Well, simply because Turner had concluded that the chaos of colours distributed throughout the image reflects the subject but is finally unified by the colours of the garments worn by the protagonist at its centre. By being made to do so, they relate to Poussin's biblical source, namely chapter 16 of the book of Exodus. This tells of Moses gradually overcoming and reconciling the confusions of the children of Israel with regard to the gathering, keeping and consumption of the manna. For Turner, an underlying central meaning was fully capable of being furthered associatively by means of colour.

An awareness of 'Historical colouring' also made its way into Turner's written response to Poussin's *Winter (The Deluge)* of 1660–64 (fig. 294).[28] He was unhappy with many aspects of this painting, especially its 'defective' compositional structure, for it is far too orderly and placid to accord with a world being overtaken by a maelstrom. Moreover, the waterfall is tranquil, as are the attitudes of the figures, both physically and psychologically. Thus, a woman unconcernedly hands up a child to a helper, while a man floats by with a small piece of board as though no 'current or effluvium' were propelling him to destruction. Equally 'ill judged' is the boat, for 'the figures are placed at the wrong end [of it] to give the idea of falling'. The sun did not impress either, for its size, colour and tonal weakness struck Turner as being more reminiscent of the moon. However, he entertained no reservations regarding the 'dark color' or dingy overall tonality of the work, for he found that it 'impresses the subject more than the incidents'.

295　Marguerite Gérard, *The Reader*, date unknown, oil on canvas, 25⅝ × 21¼ (64.8 × 53.8), Fitzwilliam Museum, Cambridge.

The head of the woman on the left may have been painted by Fragonard.

We can obtain a further idea of what he meant by this from a lecture he would give at the Royal Academy in 1811 and thereafter. Speaking of the *Deluge*, he would explain: 'For its colour it is admirable. It is singularly impressive, awfully appropriate, justly fitted to every imaginative conjecture of such an event.'[29] It is clear why he thought the colour 'awfully appropriate' and 'justly fitted', for with its general air of tonal dullness and colouristic muddiness, Poussin's painting projects a world that will soon be wholly inundated, and covered with 'the residue of earthy matter' in the process. Here may be perceived the extent to which Turner could discern the broadest ramifications of 'Historical colour', or colour that associatively matches the subject. Because by 1811 he had not seen Poussin's painting since 1802, the comments he would make at that time must have drawn upon opinions formed in Paris.

Even before Turner analysed the works of Titian, Guercino, Poussin and others with regard to their 'Historical colouring' in 1802, that associative concept had entered his own work. Thus, if we return to the very Poussinesque *The tenth plague of Egypt* (see fig. 269) exhibited at the Royal Academy earlier that year, we can see that its intense gloom and muted colours were not prompted by any desire to create some deliciously terror-laden darkness, of the kind inherent to the theory of the Sublime as expounded by Edmund Burke, as has frequently been asserted. Rather, the darkness and sombre colouring matches the central mood of grief inherent to the subject. The restrained colours were entirely associative or 'poetical' inputs. Clearly, the concept of 'Historical colouring' had been present in Turner's mind before he visited Paris in 1802; the time spent in the Louvre and the resulting sketchbook notes on what he viewed there merely articulated an aspect of his thinking about history painting that was already well developed by that date.

Perhaps another associative awareness arose in Turner's mind in the Louvre in 1802, however. The recent discovery of a colour-coded analysis of Raphael's *Transfiguration* in the *Studies in the Louvre* sketchbook[30] strongly suggests that the artist simultaneously analysed the underlying linear structure of Raphael's painting when undertaking that examination. We are led to this conclusion by the fact that his 1802 viewing of the picture was the only one he would experience before creating a drawing of the underlying compositional structure of its upper part some years later (see fig. 400). An integral component of that underpinning is a triangle pointing up to Christ that can only signify the Holy Trinity. It is very likely that Turner had grasped that pictorial framework and its meaning in Paris in 1802.

Turner also saw some contemporary works in Paris. By far the most important of these was the portrait of Napoleon on horseback crossing the St Bernard Pass prior to the Battle of Marengo in 1800 by Jacques-Louis David (1748–1825), which now hangs in the Palace of Versailles. Turner vividly remembered this image, for he would allude to it in a tiny watercolour of Marengo he would make about twenty-five years later.[31] He and David met, but naturally they could not converse because of the language barrier, although the odd remark or two may have been translated for them by fellow visitors to David's studio. The other contemporary work known to have impressed Turner was *The Return of Marcus Sextus* by Pierre-Narcisse Guérin (1774–1833), for this was the only modern painting he drew in the *Studies in the Louvre* sketchbook. It now hangs in the Louvre.

Upon visiting the Salon Carré to see the annual exhibition of contemporary French art that had just gone on display there, Turner remarked that he thought the show 'very low, – all made *up of Art*' (by which he probably meant that the works it contained were self-consciously 'artistic' rather than being rooted in any experience of the real world).[32] He did, however, find the paintings of Marguerite Gérard (1761–1837) 'very ingenious'. Turner might well have admired her pictures for their extremely fine finish and high level of craftsmanship (fig. 295), as well as for their debt to seventeenth-century Dutch art, especially the paintings of Gerard ter Borch (1617–1681) and Gabriël Metsu (1629–1667).

With Farington's departure for home on Friday 8 October, Turner probably quit Paris that weekend as well; after all, by now he had been away for a comparatively long time. Judging by his expenditures, the trip had cost him about £82 inclusive of the return travel to Paris, and after the cabriolet had been sold back for maybe just over half its purchase price.[33] At that time it would have taken an ordinary workman more than three years to have earned £82, but of course Turner had travelled in some style. One can perceive the usefulness of the 30 guineas he had perhaps received from his sponsors. That money would have brought the call on his finances down to £50-10s, which was not bad, given that he had been away for about three months and seen an enormous amount, both of the world and of great art.

Turner was certainly back in London by 20 October, for he attended a General Assembly meeting that evening. His time abroad had been enormously fruitful. Many of the works seen in the Louvre would lodge in his mind to the end of his days. Today, foreign study is routine, but in the early nineteenth century it was rare. The wealthy, and artists supported by men of substance, often embarked upon the Grand Tour but they did not always take the adventure very seriously. In Paris the Grand Tour had fortuitously come to Turner, and he had taken it very seriously indeed. By closely scrutinising many of the western world's leading works of art, he had enormously boosted his visual acuity and cultural awareness. And no less importantly, by exploring alpine scenery in France, Savoy, Piedmont and Switzerland that would remain with him for ever, he had furthered his art immeasurably.

15

Dispute and Disillusion

November 1802 to July 1803

Tom Girtin died in his studio above a framemaker's shop in the Strand on 9 November, probably of a heart attack brought on by tuberculosis and/or severe asthma. Turner attended his funeral at St Paul's, Covent Garden, on 17 November. The death must have hit him hard, for Girtin had undoubtedly been his closest friend and creative soulmate. Both had been pioneers of a new formal dynamism, a greater spatial breadth and a more intense expressivity in watercolour painting. Now Turner stood alone.

He would never forget Girtin. It is likely he contributed towards a headstone that stood in St Paul's churchyard for many years.[1] During the 1820s he would move some of Girtin's images into a more public domain, and as late as 1846 he would draw upon Girtin's pictorial example. According to Thornbury, Turner said 'if Tom Girtin had lived I should have starved'.[2] If he did say that, it was merely a compliment, for it could never have been true. However, Turner's assertion that 'We were friends to the last' was undoubtedly correct,[3] for professional rivalry, 'foolish friends and small malignant enemies' had never driven them apart.[4]

The Troubles Begin

In order to involve new Royal Academicians in the running of the Royal Academy from the outset, it is ordained that they have to serve on the Council in the year following their election. That is why Turner attended his first-ever Council meeting on the evening of Saturday 29 January 1803. Due to the fact that the Royal Academy had begun to split into two factions by that date, he could never have joined it at a worse moment in its history.[5] At the heart of the conflict resided the thorny problem of democracy.

Because King George III always took the keenest interest in the running of 'his' Academy, he therefore harboured profound anxieties about whether it was becoming deeply infected with the 'democratic' spirit that was spreading throughout Britain in the wake of the American and French revolutions. That is why he was deeply unhappy with Royal Academy power being shared by all forty of the Academicians in the form of their General Assembly. Instead, he wanted that control to be almost wholly vested in the eight-man Council, half of whom were automatically retired from office annually. To his absolutist way of thinking, such change prevented dangerous cabals from forming. Having just eight artists in charge (plus the President and the Treasurer) was far better than letting forty Academicians run the institution, for it would always be much easier to bring the smaller numbers under control.

Several Academicians shared the views of the king. Their group was known as the 'rebel' or 'Court party', and it comprised John Singleton Copley (1737–1815, fig. 296), Sir Francis Bourgeois, James Wyatt, J. F. Rigaud, Sir William Beechey (1753–1839) and the Royal Academy Treasurer, the architect John Yenn (1750–1821). The more

Detail of fig. 298.

296 William Daniell after George Dance, *Portrait of John Singleton Copley*, between 1804 and 1814, graphite and red chalk on beige paper, Yale Center for British Art, New Haven, Gift of Jules D. Prown, M.A.H. 1971.

numerous members of the 'Academical' or 'prevailing party', led by West and Farington, were far from disloyal, but they did want their institution to be wholly free of royal interference, with the ultimate say over its affairs being invested in the General Assembly. If such decision-making was perceived to be 'democratic', then so be it. As we shall see, Turner sided with the 'Academical' party not because he was anti-monarchist or particularly pro-democratic, but because he believed fervently in the right of artists to be fully in control of their own destinies and not to be ruled by non-artists, even if one of them did wear a crown.

Unfortunately, a financial investigation that had been instigated by the General Assembly on 15 January 1803 blew up in the Royal Academy's face when the next Council meeting took place on the evening of 4 March, with Copley, Bourgeois and Wyatt insisting that the Council possessed the 'entire direction of management of all the Business of the Society'. Absolutists to a man, they were then joined by Yenn to quit the room, in the process rendering the meeting inquorate and thus at an end. With this, all the tensions that had been building for some years between the Court party and the Academical party finally came to a head. A committee drawn from members of the General Assembly had been waiting around to deliver a report on Royal Academy finances all evening, but although it was finally admitted into the Council Room to be apprised of the situation, all it could do was appeal to West. At the committee's behest, he scheduled an extraordinary meeting of the General Assembly on the following Saturday evening.

At that 12 March meeting, the report on finances was read out. In essence it declared the supremacy of the General Assembly over the Council and its right to vet the finances. The four Court party Council members were also officially censured for their 'presumption', their 'disrespect', for having forfeited the confidence of the Royal Academy, and for having acted against its true interests. But although the rebels were summoned to answer for their misdeeds, there was no prospect of them doing so, for they knew full well they enjoyed the support of the monarch. And if anything, George III had become even more suspicious of 'democrats' within the Royal Academy after Britain had made its peace with France in 1802 than he had been before the cessation of hostilities.

He was particularly prejudiced against those members who had recently been to Paris, for he considered them to be highly 'democratical'. In this respect, West and Smirke especially aroused his suspicions. West was distrusted for having supposedly been a friend of Tom Paine, for having exhibited works in Paris in 1802, and for being known to admire Napoleon. Smirke was distrusted for also having visited the French capital, and for supposedly having said in 1793, when Marie-Antoinette was executed, that 'the Guillotine might well be employed upon some more crowned Heads'.[6] And to add to the king's anxieties, on 8 March 1803 – and thus exactly four days after matters had finally come to the boil within the Royal Academy Council – he had been forced by Napoleon's opportunism to mobilise the army and the navy, thereby putting the nation back onto a war footing. Early March 1803 was therefore an extremely ill-judged time for many Academicians to plead for governance of a more democratic kind.

Soon another problem arose, this time in Council on 26 March. Copley requested permission to send in a vast portrait of the Knatchbull family after the submission dates for the annual Exhibition would close on 7 April. Most Academicians had always taken an extremely dim view of late submissions because of the hanging difficulties they could engender and the sense of unfairness they aroused in artists who had taken the trouble to meet the deadlines. Accordingly, Copley's request was denied. Although in West's absence due to illness, Copley would manoeuvre Turner into chairing a 4 April

Council meeting in order to exploit his inexperience, and be duly rewarded by being granted permission to submit his picture late, in the end his victory would avail him nothing. This is because it would arouse such widespread hostility that he would be forced to back down and send in his painting by the final submission date.

Copley soon exacted his revenge, however, when he noticed on 5 April that West had submitted a painting entitled *Hagar and Ishmael* that puzzlingly bore two dates: 1776 and 1803. A few seconds' research in the Library revealed that the picture in question had been exhibited in the earlier year. As it was strictly against Royal Academy regulations to exhibit works twice, Copley gleefully brought up the subject when he chaired the Council meeting on 8 April (for West remained ill). There being no disregard for the rules even by the President, Copley demanded that West withdraw his painting. His ultimatum caused consternation amongst the other Council members and the meeting broke up as a result. Because of confusion caused by this hurried adjournment, no letter was sent to West asking that he withdraw his painting. Consequently, it took until 14 April for him to learn of the *Hagar and Ishmael* problem from the newspapers, to which the matter had been leaked by a member of the Council. He was able to defend himself by arguing that he had simply forgotten the previous showing, that he had completely repainted the picture since 1776, and that if he had intended to deceive, he would hardly have left the earlier date upon the painting. That final defence was inarguable, even if his other justifications remained open to debate.

The matter was further explored in Council on 15, 17, 18 and 21 April, with Turner present at all four meetings. At the last of them, the Royal Academy finally terminated its embarrassment by deciding that West's painting could not be received, a proposal made by Bourgeois and seconded by Turner. Ironically, by that time Copley had been plunged into embarrassment himself, for the newspapers found his Knatchbull family portrait risible, and their criticisms led Sir Edward Knatchbull (1781–1849) to demand the withdrawal of the work.[7] His wish had to be met. The time and effort that the Royal Academy Exhibition Committee of Arrangement or hanging committee then had to expend on filling the large gaps created by the removals of both *Hagar and Ishmael* and *The Knatchbull Family* can be imagined. Fortunately, the catalogue had not yet been printed.

The repercussions caused by the *Hagar and Ishmael* press leak would last for months. Today, such unauthorised disclosures are taken pretty much for granted, but in 1803 they were rare. West was livid, as were many other members of the Royal Academy, for the leak had undermined the dignity of the presidency and of the institution more generally. The President further attempted to justify himself to the General Assembly at meetings convened on 25, 26 and 27 April, in Turner's presence. Finally, on the last of these occasions, the General Assembly unanimously declared itself satisfied that the newspaper charges laid against West had been baseless, and that he had behaved honestly if somewhat carelessly. Even if he had lost the battle over *Hagar and Ishmael*, he had at least salvaged his honour. But sadly the war would continue for some time to come.

Originally, Turner had not been scheduled to serve on the Committee of Arrangement in 1803. However, on 26 March Copley had moved in Council that Turner should take the place of the Keeper, who was indisposed. The measure was unanimously approved on 4 April, and it determined Turner's fate for the three weeks after 8 April, the time it took to hang the Exhibition.

The 1803 Royal Academy Exhibition
FRIDAY 29 APRIL TO SATURDAY 11 JUNE

On Saturday 30 April Turner attended the Royal Academy dinner that preceded the public opening of the show. There he was seated next to, or near, Sir Henry St John-Mildmay, Henry Tresham, Lord Yarborough, Lord Egremont and, a little over twenty feet away, Vice-Admiral Lord Nelson (1758–1805).[8] Already the author of many victories, most notably the Battle of the Nile in 1798, his greatest moment of glory was yet to come. Although Turner would have had difficulty in seeing him across the mêlée – for the vice-admiral sat with his back to him – nonetheless he would have enjoyed many opportunities to study the great man's bearing and features both before and after the dinner.

This year Turner had five oils and two watercolours on display. All but one of them – a biblical subject – were of scenes in France. Three of the canvases and both drawings are reproduced below.

The festival upon the opening of the vintage of Mâcon (fig. 297) hung in the Great Room to constitute Turner's first great homage in oils to Claude le Lorrain.[9] The artist had sketched the vista he depicted on his way down to Lyons, obviously because it reminded him of Claude.[10] Upon returning from France, he had begun the picture by separately mixing black, brown and white pigments in water-based glue-size solutions before applying them to a completely unprimed length of canvas that had been tautened over a wooden straining stretcher.[11] As the glue-size dried, it both sealed and tightened the support. Because at least two litres of size would have been needed to cover such a large canvas, the work had to have been initially painted while lying on the floor, for otherwise the very runny pigment-size would simply have streamed downwards.[12] Long before Jackson Pollock opened up the floor as an arena for painting, Turner was there first.

Lloyd's Evening Post for 29 April–2 May stated that for 'depth, beauty, and clearness' *Mâcon* was the best of Turner's exhibits this

297 *The festival upon the opening of the vintage of Mâcon*, R.A. 1803 (110), oil on canvas, 57½ × 93½ (146 × 237.5), Sheffield City Art Galleries and Museums.

year, while the *British Press* of 6 May declared that it was 'without comparison' and added that Turner had 'even surpassed [Claude] in the richness and forms of some parts of his picture'. The same critic also commended the figures, considering them to be 'drawn and grouped in a style far superior to any of this artist's former productions'. He did, however, find the sky unnaturally blue. The *Star* for 10 May criticised Turner's foreground as being insufficiently detailed, for everything seemed too sketchy.

Sir John Fleming Leicester (1762–1827), of Tabley House in Cheshire, offered Turner 250 guineas for the work. Probably he knew that the 3rd Duke of Bridgewater had paid just such a sum two years earlier for *Dutch boats in a gale* and therefore thought his offer would prove acceptable. But Turner demanded 300 guineas and he knew his market, for he would soon obtain that amount.

Calais Pier, with French poissards preparing for sea; an English packet arriving (fig. 298) may have hung upon the line almost opposite the doorway into the Great Room, where the Bridgewater seapiece had been placed two years earlier.[13] As the *Star* for 5 May observed, the painting was 'much noticed by the visitors to the Academy'. Turner might well have hoped – or even seen – that Lord Nelson was among them. And given that *Calais Pier* was by far and away the finest marine painting hanging in Somerset House in 1803, perhaps he was even introduced to the great naval hero at the dinner.

To the left of centre in *Calais Pier* the English cross-channel packet-boat enters harbour, with bedraggled passengers crowding its deck and the Union flag flying from the peak of the gaff or spar that supports its mainsail. In front of that vessel, the helmsman of a fairly large French fishing boat or 'poissard' is pushing his tiller hard to port in order to avoid collision, even though he should have ensured that his way was clear before casting off from the pier.[14] By this means Turner commented wittily, if somewhat jingoistically, upon the poor seamanship of the French. Moreover, many of the figures on the pier also pander to anti-French sentiment, for they are somewhat caricatural, especially the fisherman and fishwife fighting over a bottle that presumably contains alcohol. Clearly these people belong to a tradition in British art typified by *O, the Roast*

298 *Calais Pier, with French poissards preparing for sea; an English packet arriving*, R.A. 1803 (146), oil on canvas, 67¾ × 94½ (172 × 240), National Gallery, London.

Beef of Old England (The Gate of Calais) of 1748 (Tate Britain, London) by William Hogarth (1697–1764). Turner surely knew this image either in painted or engraved form (or both). It is worth noting that the helmsman of the large fishing vessel was painted very much in the style of Teniers, complete with flat, red Lowlands cap.

We have no way of ascertaining whether the English and French vessels will collide, but as there was much talk in Britain of the imminent resumption of hostilities with France during the period in which this picture was being painted, the dangerously close proximity of the ships seems significant. The strength of the prevailing wind and the direction it takes are denoted by a number of flags, sails and vessels being heeled over by it throughout the picture. In combination with the black clouds entering from the left, these details indicate that a storm is rapidly approaching from the west, to darken the sky completely before very long. Given this storm and the almost inevitable disappearance of the only remaining patch of blue sky, the possible collision between British and French vessels immediately beneath that final area of peace anywhere in the image could easily have been intended to allude to a coming military 'collision' between Britain and France. And if such an allusion was

299 *Holy family*, R.A. 1803 (156), oil on canvas, 40¼ × 55¾ (102 × 141.5) Tate Britain, London.

intended, then events would show it to have been justified, for just sixteen days after this work first went on public display at the Royal Academy on 2 May 1803, hostilities between Britain and France resumed. Turner appears to have hinted at the approaching conflict presciently, ingeniously and subtly.

With his extensive knowledge of poetry, the painter was undoubtedly aware that a great many poets had used storms to denote war metaphorically, and consequently he drew upon such usage in *Calais Pier*. The rather flat shapes of the clouds demonstrate the continuing stylistic influence of Poussin. However, they were not admired by the critic of the *True Briton* for 3 May, for he likened them to 'a heap of *marble mountains*' that seemed 'quite out of harmony with the objects below'. Similarly, the reviewer for the *British Press* of 6 May called them 'too material and opake; they have all the body and consistence of terrestrial objects, more than fleeting vapours of insubstantial air'. It is quite possible that this criticism got through to Turner, for he would gradually invest his clouds with a greater sense of insubstantiality. And although to our eyes the sea might well appear to be imbued with a profound sense of ebb and flow, and a huge amount of energy, it was also attacked by the critics. Thus the reviewer for the *True Briton* called it '*soap-suds, chalk, smoke*, and many other things'. As we shall discover, he was not the only person to disparage this aspect of the painting. But although the heir to the 3rd Duke of Bridgewater, the 2nd Marquess of Stafford (1758–1833), would enquire into the price of the picture, he was not prepared to pay the 350 guineas that Turner probably demanded.[15]

Also hanging in the Great Room was *Holy family* (fig. 299). Originally Turner had sketched out this image as an upright composition that he modelled closely upon the layout of Titian's *St Peter Martyr* (see fig. 285). Perhaps he altered the format because he preferred to emulate Titian's *Holy Family and Shepherd* of around 1510 (National Gallery, London), which he had probably seen in January 1801 when it was sold as part of the W. Y. Ottley collection.

Because of its figures, the critics disliked *Holy family*. Thus the *St James's Chronicle* of 10–12 May stated that the subject was 'wholly unsuited' to Turner's talents, while the *Morning Herald* of 2 May declared that the work was 'very deficient', and that 'A genius so well calculated to add lustre to his own department, should for the future, avoid these eccentricities'. *The Times* of 2 May asserted: 'The grouping is destitute of that consummate judgement which a first artist should possess.'

Turner's last two exhibits in 1803 were watercolours displayed in the Council Room. The first of them was *St Huges denouncing vengeance on the shepherd of Cormayer, in the valley of d'Aoust* (fig. 300). Here a monk – whom we may safely take to be the saint of the title – approaches a cowering shepherd. The road pulls the eye into the distance, while the monk also does so by means of his pictorial location and raised arms. Although the saint of the title has been linked to the founder of the Chartreuse monastery, St Hugh of Châteauneuf (1052–1132), it has never been possible to associate him with the Aosta valley, let alone with any vengeful denunciations of a shepherd from Courmayeur.[16] Nor could he be St Hugh of Lincoln (*c.*1135/40–1200), with whom there existed a William Beckford connection, inasmuch as the latter had inherited the ruins of Witham Priory in Somerset, a foundation linked to the English saint.[17] Perhaps Beckford had picked up some tale connected with this St Hugh – who had trained in the Chartreuse monastery – and eventually passed it on to Turner. But both hypotheses fall down on the fact that the monk in Turner's watercolour is dressed in the brown sackcloth of the Franciscans rather than the white garb of the Carthusians, to which order both of the saintly Hughs had belonged. The subject of the work must therefore remain an enigma.

The 'Arveron' mentioned in the title of *Glacier, and Source of the Arveron, going up to the Mer de Glace* (fig. 301) is the Arveiron, a tributary to the river Arve in the Chamonix valley. Sadly, the drawing has lost all its blue-greys, due to the use of indigo. However, by 1803 a new mastery of pictorial structure was entering Turner's art and that remains fully evident. A large 'V'-shape is formed by the white, upper edge of the Glacier du Bois slanting down from the left, and by the shadow cast by the Montanvert mountain slanting down from the right. This convergence is reinforced by a 'V'-shaped cleft in the rocks below them. The declivity leads the eye to a rock pool that reinforces our awareness of the ice that is turning to water beyond

300 *St Huges denouncing vengeance on the shepherd of Cormayer, in the valley of d'Aoust*, R.A. 1803 (384), watercolour on paper, 26½ × 39¾ (67.3 × 101), Sir John Soane's Museum, London.

301 *Glacier, and Source of the Arveron, going up to the Mer de Glace*, R.A. 1803 (396), watercolour on paper, 11 × 15½ (27.8 × 39.5), National Museum of Wales, Cardiff.

it. On the left a youth throws rocks at an adder reclining on a boulder at the centre, quite evidently to remind us of the danger inherent to wild places.[18]

Although West admired Turner for his cleverness in *Calais Pier* and Fuseli did so for his 'power of mind' in both that painting and the *Mâcon*, the latter also felt that the foregrounds of both works were 'too little attended to' and 'undefined'.[19] Subsequently, Fuseli found Turner's pictures to have 'flashes of excellence in them, but they are not uniform. There is a want of precission in his foregrounds'.[20] Sir George Beaumont shared that view, telling Farington: 'Turner finishes his distances & middle distances upon a scale that requires *universal precission* throughout his pictures, – but his foregrounds are comparatively *blots*, and faces of figures witht. a feature being expressed.' He also thought that the water in *Calais Pier* looked 'like the veins on a marble Slab'.[21] Farington himself regarded Turner's pictures as being 'crude', 'ill-regulated' and 'unequal', while the person who had painted them was 'presumptuous' although, he conceded, 'confident' and 'with talent'.[22] Hoppner asserted that Turner painted in a 'presumptive' and 'careless' manner, by which he meant that representationalism was taken for granted and that 'so much was left to be *imagined that it was like looking into a Coal fire, or upon an Old wall, where from many varying undefined forms the fancy was to be employed in conceiving things*'.[23]

Yet Turner also had his admirers. Thus, Thomas Lawrence stated that 'in Turner's pictures there are his usual faults, but greater beauties'.[24] And John Opie hugely admired the *Mâcon*, calling it perhaps the finest work in the Great Room because it was the one in which its creator had 'obtained most of what He aimed at'.[25] Moreover, when John Constable (1776–1837) sought out the views of Thomas Phillips (1770–1845), Henry Thomson ARA (1773–1843) and William Owen (1769–1825), he was told that 'Turner's pictures [are] of a very superior order, – & [that these artists] do not allow them to be in any [way] extreme'.[26]

A Growing Unease

On 3 May, and thus the day after the 1803 Exhibition had opened to the public, the General Assembly convened to discuss the newspaper leak regarding West's *Hagar and Ishmael*. Eventually it was decided that the members of Council should 'exonerate themselves' by signing a 'Declaration' stating they had not been responsible for such an 'improper communication'. Such a document was duly drawn up and Turner, among others, signed it. But Ozias Humphry (1742–1810), for one, objected violently to being forced to do so. As he was 'a gentleman of the old school' (fig. 302),[27] he felt it was quite enough for Academicians simply to give their word that they

302 William Daniell after George Dance, *Ozias Humphry* [in 1793], 1806, soft-ground etching, British Museum, London.

were innocent. If that was deemed insufficient, then they could sign some vaguely worded formulation regarding their blamelessness. And employing a phrase taken from the third of the 'Three Letters Upon the Use of Irish Coal' of 1729 by Jonathan Swift (1667–1745), he then complained that they were instead being treated more like 'Coal porters' than gentlemen of liberal arts and education by having to sign a document that was too 'closely worded' as to innocence or guilt. He found such a lack of trust intolerable.

Perhaps Humphry stated these objections to Turner when they met in Somerset House on 9 May, and the ill-educated younger painter with the cockney accent – who is hardly likely to have recognised a somewhat obscure passage in Swift – pulled up his elder over the snobbery he thought to be implicit in the cavil about 'Coal porters'. But that he did remonstrate with his fellow Academician is suggested by Humphry's complaint less than a week later regarding Turner's 'arrogant manners...more like those of *a groom* than anything else: no respect to persons and circumstances'.[28] Clearly, upon attaining full Academician status, Turner had at last

been able to drop the extreme deference, if not even servility, he had been feigning for years. And this also explains why John Hoppner had recently complained 'with great disgust' of Turner being 'presumptive & arrogant' (while simultaneously protesting that his paintings left so much to the imagination it was like looking at 'a Coal fire, or upon an Old wall').[29]

The power struggle within the Royal Academy continued throughout May.[30] Turner necessarily witnessed it at close hand by dint of his membership of the Council. Eventually, matters reached a climax at a meeting of the General Assembly on 30 May when it was resolved that Copley, Bourgeois, Wyatt, Yenn and Soane – who had swapped sides to become one of the 'rebels' – should immediately be suspended as members of the Council.[31] This motion was adopted unanimously, which meant that Turner, Rossi and Humphry had voted against their fellow Council members. They could not have made their stance regarding Royal Academy power more clear.

On 3 June the General Assembly elected an eleven-man subcommittee 'to consider the conduct of the Council & to recommend such measures to the General Assembly as the occasion should require'.[32] Turner and Rossi only received single votes in the poll for membership of this body, so perhaps they voted for each other, or even for themselves. However, it is highly revealing that they were prepared to stand for a General Assembly subcommittee that would investigate a Council on which they themselves sat. By doing so, they again clearly signalled their progressive thinking that the larger body took precedence over the smaller one.

On 21 July the General Assembly subcommittee recommended that Copley, Bourgeois, Wyatt, Yenn and Soane be removed from the Council and replaced. It also asserted that the General Assembly enjoyed authority over declarations that might be made against it by *'any power whatever.'*[33] These and further suggestions were adopted unanimously by the Academicians attending a specially convened meeting of the General Assembly on 29 July (from which, however, Turner was absent).[34]

Now it was up to West to put the recommendations before the king. He would do so at Windsor on 7 August but would have to wait until 13 November to receive a response. We shall deal with that decision below. But in mid-June an alarming rumour began to circulate, and here we finally get to the rub where Turner was concerned. It was claimed that because of all the troubles in Somerset House, 'The King was going to new Organize the Academy, and to appoint a New President.'[35] In all likelihood this falsehood was circulated by the 'rebels' because the uncertainty it generated greatly served their interests. However, the rumour, or one just like it, clearly led Turner to ask himself a couple of uneasy questions. If a restructured Royal Academy were to be formed by the king, how could he be certain of a place in it, especially with Copley or one of his friends in charge? After all, he himself had been one of the Academicians who had visited Paris in 1802; he was fairly friendly with Robert Smirke, possibly the most politically radical of all the RAs (as George III was well aware); he had voted consistently against the Court party members in both Council and General Assembly; he had been extremely close to the openly 'democratical' Tom Girtin; and – although it was unlikely that many people realised this – he had made statements about liberty and its curtailment in works exhibited in 1800.

Moreover, what if George III said 'a plague on both your houses' and withdrew his official sanction from the Royal Academy altogether? A plain 'Academy of Arts' would be a very hollow-sounding institution indeed, especially as an ex-Royal Academy of Arts would undoubtedly be forced to vacate Somerset House by a government that was always extremely hungry for office space.

For years Turner had striven to become a member of the Royal Academy. Now the institution looked at though it might soon fall apart. Faced with that threat, the painter obviously concluded that he had better speed up the creation of an alternative way of getting his goods to market. That is why, during the latter half of 1803, he finally put into action a plan he had been formulating all year. This was to create a 'Turner Gallery' at 64 Harley Street. After all, Reynolds, Gainsborough, West and Copley had each created galleries within their homes or next to them, so why not him too?[36] There he would be able to display his works without having to worry about councils, assemblies and committees tearing each other to pieces and alienating the monarch in the process. And there, too, he would be able to get over the disillusion he was beginning to feel about a Royal Academy that far too frequently resembled the warring world beyond Somerset House, instead of the peaceful and harmonious artistic summit it was surely intended to be.

16

Another Great Room

Spring 1803 to Spring 1804

In April 1803 Turner probably set eyes for the very first time upon two paintings by Claude, *Landscape with the Marriage of Isaac and Rebekah* and *Seaport with the Embarkation of the Queen of Sheba* (figs 303 and 304), both of 1648. They had come onto the art market and Angerstein bought them for £8,000. The seaport scene might well have stirred Turner deeply, for it is arguably an even finer work than the harbour view by Claude that had so moved him to tears at one of Angerstein's mansions during the autumn or winter of 1798 (see fig. 200).

On 12 May 1803, Farington recorded: 'A Clergyman has complained of T[urner] neglecting an Uncle, a Butcher, who once *supported him* for 3 years. He has become Academical. He does not look towards him.'[1] The notion that Turner had become 'Academical' – by which his uncle and the unknown clergyman presumably meant some kind of Somerset House snob – is not supported by Farington's diary, for as we have seen, Turner most certainly did not put on airs and graces with his fellow Academicians (or with almost anyone else for that matter). If anything, he was currently coming across as somewhat ill-mannered and 'common' – rather like a groom in fact. But, of course, Farington and the clergyman knew nothing of the condition and whereabouts of Turner's mother, and in all probability nor did J. M. W. Marshall. And Turner was not about to tell him either, lest the dark family secret be revealed. That is surely why he put up a barrier of pretended snobbery between himself and his uncle, and why he never looked 'towards' the retired butcher and meat wholesaler – he had a terror of the truth being wormed out of him and his mother being located, especially now that people were beginning to think his images looked as formless as 'Coal fires' and 'Old walls'. It is easy to imagine the ridicule that might have ensued if it became known that Turner had a mentally ill mother, let alone where and how she was being incarcerated by means of subterfuge and lies.

This year Turner did not tour, although probably in late July he visited Oxford. The Clarendon Press had been so delighted with the positive response to his *Almanack* designs that it now commissioned him to make seven more drawings at ten guineas each.[2] An image for the 1804 *Almanack* would be among them. In one fell swoop, the Delegates of the Clarendon Press had solved the problem of illustrating their university calendars for some years to come (or so they thought where one of them was concerned).

Turner's stay in Oxford may have lasted up to ten days.[3] Such a sojourn was required in order to meet with the Delegates and to draw six university buildings, as well as to make a general view of the city. Back in London, watercolours were swiftly worked up of Worcester, Brasenose and Exeter Colleges, the Hall of Christ Church, a view of Oxford from 'Heddington Hill', and Christ Church Cathedral with part of Corpus Christi. The reproductions of them would appear annually between 1804 and 1811. Only in 1810 would a commissioned design not be used. This was because the depiction of the

Detail of fig. 307.

303 Claude le Lorrain, *Landscape with the Marriage of Isaac and Rebekah*, 1648, oil on canvas, 58¾ × 77½ (149 × 197), National Gallery, London.

In April 1803 Turner probably saw this Claude and the following one either in the showrooms of the Erard Harp Manufactory in Great Marlborough Street, Soho, or a little later in John Julius Angerstein's town house at 102 Pall Mall.

304 Claude le Lorrain, *Seaport with the Embarkation of the Queen of Sheba*, 1648, oil on canvas, 58½ × 76¼ (148.5 × 76¼), National Gallery, London.

south-west corner of Balliol College quadrangle would so unsettle the Master of Balliol that it would be replaced with a representation of the same subject by a minor artist.[4]

In a number of the drawings, including the portrayal of Worcester College (fig. 305), Turner juxtaposed boys at play and men at work. Given that universities usually bridge the playful world of childhood and the intense labours of adulthood, such figures seem like natural associative adjuncts. Clearly, that is why boys at play and men at work would become a fairly fixed Turnerian association of Oxford in due course, as would the fact that the workmen almost invariably labour in the construction industry. The connection between youth and the building of knowledge at Oxford follows on logically from that.

On 22 August Turner visited the Truchsessian Gallery, New Road, Marylebone, where a special viewing of a collection of Old Master paintings had been arranged for the Royal Academicians and their associates.[5] The gallery was the creation of Joseph, Count Truchsess (*fl. c.*1800–10), who had spent upwards of £3,000 upon its construction. Both Farington and Lawrence thought little of its contents, and possibly Turner shared their view. However, he may have been impressed by the top-lighting of the gallery and remembered it when creating his own display space a little later.

In October Turner may have paid his annual visit to Ash Grove, William Wells's cottage in Knockholt, Kent. And on Thursday 10 November he attended a Royal Academy Club dinner, during which West received his first presentiment of how the outcome of the war within Somerset House had finally been decided.[6] For members of the Academical party that judgement became painfully clear three days later when King George III announced in writing that the status quo the Royal Academy had enjoyed before 4 March must be fully restored. To that end he reaffirmed the positions of Copley, Bourgeois, Wyatt, Yenn and Soane on the Council and ordered that resolutions removing them be expunged from the minutes. The Council was thus left enjoying complete power over the affairs of the Royal Academy, just as the 'rebels' had always demanded. It was wholly unsurprising that Copley and his friends had been able to so influence the king's thinking, for they had found it very easy to reinforce his belief that the 'Academy was filled with *Anarchists*' and 'democrats'.[7] For the General Assembly the war had been a complete waste of time and energy, as wars often are, but at least it had been fought over a vital democratic principle. And historically, at least, time would be on its side.

The General Assembly convened on 21 November to learn the bitter news officially. Turner was present, as were twenty-nine other Academicians and their President. The king's paper was read out twice by the Academy Secretary, John Inigo Richards (1731–1810). Copley, Bourgeois, Yenn and Soane were all in the company and

305 *A View of Worcester College &c.*, signed, 1803, watercolour over pencil on paper, 12⅝ × 17½ (32 × 44.3), Ashmolean Museum, University of Oxford.

they must have exulted, even if they did not sing and dance. There was nothing to be done by the General Assembly except submit a humble address of thanks to the monarch for his 'gracious attention'. Typically, even this move led to a squabble over whether the official gratitude should be extended by the Council or by a committee expressly formed by the General Assembly to convey that thanks. The latter course of action was adopted. By this time Turner had begun to take a very dim view of committees,[8] and the creation of yet another one must have reinforced his contempt.

The king having restored Copley, Bourgeois, Wyatt, Yenn and Soane to the Council, that body could again convene at long last. This it did on the evening of Saturday 26 November, with Turner present. The meeting quickly turned into yet another battle, this time over orders given by the monarch to expunge all record of the condemnation of Copley, Bourgeois, Wyatt, Yenn and Soane from the General Assembly minutes. It transpired that the Academy Secretary had done this while obliterating motions advanced by members of the Court party in the Council minutes as well. Eventually it was decided to seek clarification from the king over exactly which minutes he had wanted obliterated.

Turner was given a sick headache by all this. Just when he might have hoped that peace and good fellowship would return to Somerset House, war had broken out yet again. And more contention followed in the General Assembly meeting held on 1 December, when in Turner's presence Copley, Bourgeois, Rigaud, Wyatt, Yenn and Soane all walked out.

On Sunday 4 December, West and Richards attended upon the king at Windsor in order to seek his clarification regarding the

minutes. It emerged that the sovereign had not wanted the Council minutes to be effaced, and he said that he would have a new paper drawn up to make his exact intentions clear. This was done, and on the following Thursday, the Academy Secretary received those orders. They instructed that all the motions censuring members of the Council in the General Assembly minutes be expunged, while the Court party motions in the Council minutes that had been obliterated should be restored. The king concluded by 'recommending harmony in the Academy'.

His rulings literally worked to that end, for when they were read out twice to the General Assembly convened for the Annual General Meeting of the Royal Academy on Saturday 10 December 1803, in the presence of Turner and twenty-two other Academicians plus the President, they were received with the most easily attainable form of close harmony, namely utter silence. Subsequently the Academicians were reminded that their four peers who would rotate onto the 1804 Council to replace Copley, Humphry, Wyatt and Yenn would be Dance, Farington, de Loutherbourg and Smirke. Turner, for one, must have breathed a sigh of relief, for like Farington and others, he may have feared that the king would retain the existing members of Council rather than permit them to be automatically replaced. However, that would not be a problem, for the monarch was a stickler for procedure and he was not about to start breaking the rules.

But this sorry Royal Academy saga had still not ended. On 15 December poor Turner had to attend yet another Council meeting that went up in flames. Also present were West, Rossi, Copley, Bourgeois and Soane. This time the cause of the strife was the doctoring of the Council minutes, which had taken place prior to the king's final wishes being clarified. The proceedings ended in acrimony.

Turner took part in further contention when the General Assembly met on Christmas Eve for the annual Schools prize-giving. At the outset of proceedings, Soane declared that Yenn joined with him in finding it extremely unfair that this year it had been decided to award no prize for architectural drawing. After some debate, the Academicians agreed to troop upstairs to the Great Room and peruse the architectural drawings once again, with a view to taking a poll as to whether they should award a prize after all. When they did finally vote, Soane, Copley, Bourgeois and three other supporters of the Court faction opted to make an award, and the nine members of the Academical group (including Turner) voting against doing so. But during this process Bourgeois was overheard to remark that when architectural drawings and sculptures were being assessed for prizes, he always let the opinions of architects and sculptors dictate his judgements. Turner quipped it was a shame he did not adopt the same approach when the judging of figure drawings took place. Bourgeois being principally a painter of figures, he understandably took offence and called Turner 'a little Reptile', to which the latter replied that his fellow Academician was 'a Great Reptile with ill manners'.[9] It can hardly be coincidental that Turner would feature a large reptile rather prominently in a work entitled *The goddess of Discord choosing the apple of contention in the garden of the Hesperides* that he would possibly begin over the coming New Year period and exhibit in 1806 (see fig. 333).[10] In his confrontation with Bourgeois we possess concrete evidence of him giving a mediocrity short shrift (for which he was doubtless regarded as being 'presumptive & arrogant').

Turner's Second Gallery

By March 1801 the lease on 64 Harley Street had thrice been reassigned fairly quickly, first by the schoolmaster Robert Harper to a Mr Warriner; then by the latter to a Mr John Pratt; and subsequently by Pratt to Thomas Webb, another schoolmaster who probably paid £300. The annual rateable value remained £70 throughout. And prior to 14 January 1803, Webb offered to reassign the remaining fifteen-year lease to Turner for £325. The deal failed to go through, probably because Turner was in search of something that Webb could not supply. As a consequence, on 28 March 1803 Webb put the lease up for auction.[11] It was acquired for £350 by Charles Elliott (1751–1832), a committed Christian idealist, property magnate and the Royal Cabinet-Maker and Upholsterer to both King George III and the Duke of York (1763–1827). He had also worked for the Prince of Wales.[12] But Elliott did not hang on to the lease for long, for on 10 June 1803 he reassigned it to Turner for £450.[13]

There can only be one reason that Turner paid £450 for the lease in June 1803 when he could have obtained it for £325 just six months earlier: in exchange for the higher sum, Elliott had agreed to convert an existing space on the Harley Street site into the gallery that Turner required. With his widespread property interests and cabinet-making expertise, Elliott enjoyed close contacts with jobbing builders and carpenters who could carry out the work. This explains why – if Turner bid at all – he failed to outbid Elliott at the 28 March auction, when he could possibly have obtained the lease for, say, £360. The £125 difference between the £325 wanted by Webb and the £450 paid to Elliott was not negligible, for it would have taken an ordinary workman almost five years to earn that sum.

On 22 March 1804 Farington would observe that Turner was furnishing 'a Gallery 60 feet long in His own House'.[14] He had received this information from the animal painter and engraver James Ward (1769–1859), who had been given it by Bourgeois. Yet on 19 April 1804 the diarist would also note that he had supposedly been

told by Turner that at 64 Harley Street the latter had 'opened a Gallery of pictures 70 feet long & 20 wide'.[15] Which measurements were correct?

In fact, we possess irrefutable evidence that both were hopelessly wrong. This is because Turner's Gallery was undoubtedly the outbuilding that ran parallel with the rear of 64 Harley Street, with a narrow yard separating the two. Far from being 60 or 70 feet in length, internally it was just 35 feet long by 10 feet wide. Added together, two 35-foot walls provided 70 feet of semi-continuous horizontal hanging space, while two 10-foot lengths supplied 20 feet of semi-continuous horizontal hanging space.[16] These are unquestionably the 70 feet by 20 feet figures that Turner imparted to Farington on 19 April. As was sadly all too often the case where the painter-diarist was concerned, he had just not listened or remembered carefully enough (and the alternative 60-foot length recorded on 22 March might easily been caused by an error in transmission as the correct data was passed from Bourgeois via Ward to him). Compared with most modern art galleries, a space 35 feet long by just 10 feet wide would seem more like a corridor than an art gallery. However, perhaps Turner sought a miniscule version of the Grande Galerie in the Louvre. Certainly his very large paintings would have seemed overwhelming in scale within such a narrow confine.

For the first few years at least, visitors to Turner's Gallery passed through the 64 Harley Street house, across its back yard via the rear door of the house, and then through a doorway into the former ground-floor warehouse and up a new stairwell let into the gallery floor. This approach provided the most direct means of access to the gallery without sacrificing an inch of precious wall space. The lower-level former warehouse was also converted into a gallery, although it probably only possessed a single (new) window at its southern end and was therefore not well lit.

The main gallery did not need to be especially high, for Turner did not plan to hang any full-length portraits within it. Because it could possess no side windows due to the need to maximise wall-hanging space, it had to have been top-lit and was almost certainly illuminated by a glazed lantern inserted into the existing roof of the old schoolroom. Naturally, the cabinet-making expertise that Charles Elliott could draw upon would have significantly contributed to the creation of such a structure. As the Great Room at Somerset House admitted light through a lantern set in its ceiling, a fine example of how best to light a gallery space was therefore readily available to Turner. He would also have remembered Reynolds's studio cum gallery complex, which was top-lit; the Truchsessian Gallery, with its roof lanterns; and possibly Copley's gallery in George Street, with its skylight. We know for certain that top-lighting was the method Turner would later use for the gallery he would construct at 47 Queen Anne Street West, and clearly he would do so because he had employed it upstairs in the 64 Harley Street outbuilding in 1803–4 as well.

The gallery must have been heated by a Portland stone fireplace that had been retained from the former schoolroom. It seems likely that this was located midway along the west wall. Medium-sized oils, as well as watercolours and engravings, were probably hung above it. We do know that Turner included such works in his shows, so the location of the fireplace might explain why he did so – he made a virtue out of a necessity.

On 19 November 1803 Turner sold £150-worth of Consols £3%, while on 21 February, 6 March and 8 September 1804 he respectively sold two tranches of £100-worth and a further £50-worth of the same stock.[17] There can be no doubt that the £400 went towards paying Elliott, and therefore also towards the building costs of the new gallery. Turner and his father might well have helped with the construction work. As anyone who has ever built or altered a property can testify, there are constant calls upon one's time by the builders, so probably Turner's freedom to paint over the winter of 1803–4 was severely attenuated if he did lend a hand, as seems likely.

Fortunately, with the automatic rotation of Copley, Wyatt and Yenn from the 1804 Council, tempers subsided in Somerset House. After 3 January 1804, Turner's attendance at Council meetings remained fairly committed until the end of April. And as we have noted, on 22 March Farington picked up from Bourgeois by way of Ward his first inkling of the big new development in Turner's life. He also recorded the claim that, instead of exhibiting at the Royal Academy in 1804, Turner intended 'to make an Exhibition and to receive money' from the sale of work in his gallery. Bourgeois was wrong about the artist not showing in Somerset House, but the fact that Turner was 'painting pictures' for the gallery – as Farington also noted on 22 March – indicates that work on the conversion was nearing completion by that date. It must therefore have commenced by the autumn of 1803 at the latest. And that it had been completed by 29 March 1804 is proven by the books of the Sun Fire Insurance Company, which record on that date that Turner took out annual cover for £300 'On his Picture Room behind his Dwelling House', plus £1,000-worth of cover for the paintings hanging on its walls.[18]

J. T. Serres had moved out of 64 Harley Street by October 1802.[19] That had freed Turner to take over the lease to the entire property on 10 June 1803. He must have made the house his principal residence by mid-March 1804, for by living right next door to his new gallery, he was able to keep a close eye on things and possibly lend a hand as construction work neared its end.

On 1 April 1804, Farington attended a dinner given by Sir George Beaumont, during which Turner's art was discussed.[20] The baronet criticised West for having been over-enthusiastic about

Dutch boats in a gale (see fig. 251). Although the PRA had remarked that Turner's sea made the water in the linked van de Velde seascape look as brittle as bottle glass, Sir George thought that the Dutch painter's sea made Turner's water 'appear like pease soup'.[21] Another guest, the portraitist and miniaturist Henry Edridge (1769–1821), also stuck his table-knife into Turner by passing on Thomas Hearne's criticism that the sea in the 1803 *Calais Pier* looked like batter. And both the baronet and Edridge agreed that Turner had 'never painted a good sky'. On the other hand, by 6 April Robert Smirke had enjoyed the opportunity of looking carefully at Sir George's submissions to the 1804 Exhibition. He was thoroughly unimpressed, telling Farington 'they were very well for an Amateur, – but His moonlight He sd. was *trash*. – and the others rubbish when compared with what pictures should be.'[22] Sir George had asked for such criticism, especially if Smirke had learned of the baronet's opinion of Turner's work from Farington, which seems likely, given the latter's propensity for gossip.

Turner's mother passed away in the Bethlem Hospital on Sunday 15 April 1804.[23] Apparently she was not mourned by her husband and son, for they had maintained their distance to the bitter end. It may even have been a day or two before they received news of her decease, for of course that information had to be filtered through the men who fronted for them. There is no record of any interment or formal funeral, so in all likelihood Mary Marshall Turner was accorded a pauper's grave, with nobody in attendance save the gravedigger and perhaps a lowly divine employed by the hospital to utter a few words as she was laid to rest.

If Turner had been a loving son to his mother, the news of her passing would have come at a very bad time, for just that week he embarked upon a momentous step that had cost him a great deal of time and money, and he had to keep his eye on the ball. Moreover, he was also attempting to complete works for the approaching Royal Academy Exhibition. But as it was, his stride probably remained unbroken by his mother's demise. The love between them had died long ago, in painful psychological and physical circumstances we cannot surmise, let alone profitably imagine.

The 1804 Turner Gallery Exhibition
?MONDAY 16 APRIL TO SATURDAY 30 JUNE

Probably Turner opened his gallery on the day after his mother's death. If that was the case, then he had anticipated the public opening of the Royal Academy Exhibition by exactly two weeks. Such anticipation appears to have been his practice for some years to come.

Given that a visitor to the gallery on 9 May would liken it to a '*Green Stall*' (as will be seen), perhaps its walls were covered with a dark green fabric. Some of the most recent pictures on display included the *Tenth plague of Egypt* of 1802 (see fig. 269); *Calais Pier* of 1803 (see fig. 298); and the *Holy family* of the same year (see fig. 299). For a stylistic reason to be discussed, it seems likely that also on show was a painting that has always been thought to date from later, the large *Fall of the Rhine at Schaffhausen* (see fig. 334), which would be exhibited at the Royal Academy in 1806. For the same reason, another painting on display may have been *Fishing boats entering Calais harbour* (Frick Collection, New York). There can be no doubt that *The festival upon the opening of the vintage of Mâcon* of 1803 (see fig. 297) was on view, for around this time Lord Yarborough obtained it, almost certainly for the 300 guineas the artist had originally sought for it. As John Opie would rightly comment to Henry Thomson, he 'did not see why Turner should not ask such prices as no other persons could paint such pictures'.[24]

A Yorkshire landowner, Walter Fawkes, may have visited the Turner Gallery inaugural exhibition and commissioned three large watercolours of alpine scenery. Two of them (figs 306 and 307) would be made in 1804.[25] And on 3 May John Soane and his wife Elizabeth (1760–1815), visited the gallery, with Mrs Soane spending fifty guineas on the *St Huges denouncing vengeance on the shepherd of Cormayer, in the valley of d'Aoust* exhibited at the Royal Academy in 1803 (see fig. 300). She also laid out another thirty-five guineas on the *Refectory of Kirkstall Abbey, Yorkshire* (see fig. 186) exhibited at Somerset House in 1798.[26] This visit proves that the painter and the architect had not let the recent battles within the Royal Academy come between them.

Apparently Farington did not visit Turner's Gallery at this time; perhaps he was slightly afraid of what he might find there. However, by 24 April 1804 Sir George Beaumont had done so.[27] He felt that many of the lower sections of Turner's landscapes and seascapes did not correspond with the skies above them, although as someone who liked to think that the grass in landscape paintings should be the colour of old violins, he would never be able to come to terms with Turnerian colouring. Usefully, he also informed Farington that 'Turner should not have shewn so many of His own pictures together', which makes it clear that the gallery was packed with paintings.

Turner's father often looked after the space. Probably the opening hours were fairly flexible, with visits also being made by appointment. For a few years at least, the showroom would be a boon to its creator. By means of it he could mount regular exhibitions, demonstrate the range of his art to special visitors even when it was closed, and reveal his latest offerings to the selected few as they came off the easel.

With the opening of his gallery, Turner decided that henceforth he would charge 200 guineas for 36 by 48 inch canvases, rather than half that amount, as he had done previously. This was because, as the painter Augustus Wall Callcott ARA (1779–1844) would tell Farington on 8 June 1811, 'if He sold only Half the number He might otherwise do His annual gain would be as much & His trouble less'.[28] Until 1812 the most-favoured dimensions of Turner's oil paintings would be this size because such pictures were easy to produce, store, transport and sell, as time would demonstrate abundantly.

Above left 306 *The Passage of Mount St Gothard, taken from the centre of the Teufels Broch (Devil's Bridge), Switzerland*, signed and dated 1804, watercolour on paper, 38¾ × 27 (98.5 × 68.5), Abbot Hall Art Gallery, Lakeland Arts Trust, Kendal.

Above 307 *Fall of the Reichenbach in the valley of Oberhasli, Switzerland*, signed and dated 1804, watercolour on paper, 40¼ × 27⅛ (102.2 × 68.9), The Higgins, Bedford.

The form of the title given here is the one used for the work in the 1819 Fawkes Grosvenor Place exhibition. It corrected what was probably a printer's error in the title of the work when exhibited at the Royal Academy in 1815.

The 1804 Royal Academy Exhibition
FRIDAY 27 APRIL TO SATURDAY 16 JUNE

Turner's guest at the private view on Friday 27 April was Col. Humphrey Sibthorp (1744–1815), of Canwick Hall, Lincolnshire, who at the time was one of the two Members of Parliament for the city of Lincoln.[29] Either Sibthorp had recently commissioned Turner to make him a very large watercolour of Lincoln (Usher Art Gallery, Lincoln) or was about to do so. Due to its size, it probably cost him upwards of sixty guineas.

This year Turner had submitted just two oils and a watercolour, respectively in the form of a historical nautical subject, a mythological subject, and a view of Edinburgh. Such low numbers demonstrate both his lack of time to paint during the winter and his need to fill the Harley Street gallery. He had stretched himself to the limits as an exhibitor.

In one of his oils he represented water in a new way. The work in question is *Boats carrying out anchors and cables to Dutch men of war, in 1665* (fig. 308), which hung in the Great Room. The scene is set during the Second Anglo-Dutch War of 1665–7. Shortly after the outbreak of that conflict, on 13 June 1665, the fleets of the two nations had clashed off Lowestoft, with the Dutch being defeated. However, they remained undeterred by that setback and quickly rebuilt their navy. In Turner's painting we presumably see the final fitting-out of some of the new vessels. In June 1667 these ships, or others like them, would be sailed up the river Medway in Kent, where they would wreak the greatest ever naval defeat upon the British within home waters. By alluding to the readiness of a foreign power to work unceasingly towards the defeat of Great Britain, Turner was warning his fellow countrymen of the need to face such a challenge again. At a time in which the French were preparing for the invasion of England, it was a timely alert. It was also the first of many such reminders that Turner would issue by drawing lessons from the past. As such, the picture pointed up the continuing relevance of both history and history painting.

In the distance we see the coast of Holland. A storm is approaching from the west, and therefore ultimately from the direction of Great Britain. As in *Dutch boats in a gale* and *Calais Pier*, Turner used a natural phenomenon to give us 'the storms of war' metaphorically. When painting the picture, he also took a shortcut in his depiction of the sea, absolutely plastering the surface of the canvas with white paint in order to achieve an equivalence to the boiling frenzy of white water. It was an amazingly modern approach, for it reveals Turner at his most painterly. However, for some of his contemporaries it constituted a step too far, for they could not make much sense of what they were seeing. Thus James Northcote RA (1746–1841) 'said He shd. have supposed Turner had never seen the Sea,' while Opie 'said the water in Turner's Sea piece looked like a *Turnpike Road* over the Sea' (by which he meant it looked very dry and dusty, for turnpike roads were not asphalted at the time).[30]

308 *Boats carrying out anchors and cables to Dutch men of war, in 1665*, R.A. 1804, oil on canvas, 40 × 51½ (101.5 × 130.5), National Gallery of Art (W. A. Clark Collection), Washington, DC.

The reviewer for the *Sun* on 10 May resorted to metaphor by stating that the sea 'seems to have been painted with *birch-broom* and *whitening*', as though Turner had dipped a wall-painting brush in whitewash in order to depict water. Although the reviewer for the July issue of the *Monthly Mirror* lauded the picture for the 'extraordinary talent and ingenuity' it displayed, he thought its execution verged 'in parts, to hardness'. The *Star* of 10 May, while perceiving 'much grandeur in the design of the picture', was unhappy about its colouring, thinking it rooted more in art than nature. For the *St James's Chronicle* for 12–15 May, the painting was 'fine', but the sailors in the boats all looked 'bald, and like Chinese'. Obviously it totally eluded the critic in question that the majority of those seamen – and especially the helmsman of the nearest vessel – were closely based upon the figures of David Teniers the younger.

Yet in the main, the press was positive about the work. Thus the reviewer for *E. Johnson's British Gazette and Sunday Monitor* for 29 April stated that the painting was 'calculated to increase the reputation of this excellent artist'. The critic of the *British Press* for 3 May called it 'a grand sea-piece ... admirable, at once, for the beauty of its style, and its faithful representation of nature', while the reviewer

for the *Morning Post* of 5 May thought it 'very fine' and 'highly creditable to the talents of this rising artist'. The subject matter proved problematic only for the critic of the *Sun* of 10 May, who commented, 'Why the scene before us should be placed back so far as in 1665, it is difficult to conceive.' Obviously the notion of rooting a history painting in actual history had never occurred to him.

The approach taken to the representation of white water in *Boats carrying out anchors and cables to Dutch men of war, in 1665* is a useful dating tool, for it can equally be encountered in the aforementioned *Fall of the Rhine at Schaffhausen* (see fig. 334) and *Fishing boats entering Calais harbour* where it helps date both of them to 1804. For a period limited to that year, Turner explored the possibilities afforded by the palette knife when depicting water. This approach may have been sparked off by an impatience with the brush or by a desire to test the possibilities of another painting tool, or by both. However, in 1805 Turner would revert to a more detailed, painstaking and brush-driven approach to the representation of water, as we shall determine. We can be grateful he would do so, for in the process he would raise such depiction to levels of representationalism and expressivity far above those manifested in the three 1804 oils.

Turner attended further meetings of the Royal Academy Council on 4, 5, 9 and 11 May. The last of these gatherings would cause him to break with the Council for the rest of his allotted term, and with the Royal Academy as a display space for the next two years.

He arrived after the session had begun at 7:30 p.m., only to find that Bourgeois, Smirke and Farington had gone downstairs to hold a private discussion beyond the hearing of Benjamin West, whom Bourgeois did not trust to keep Council affairs secret. From Farington's diary entry, and from the fact that by all accounts Bourgeois was a very garrulous speaker, it is possible to deduce that the discussion lasted for up to half an hour. All the while, West and Rossi were left to their own devices, as was Turner when he arrived late. We can let Farington take up the story:

> On our return to the Council we found Turner who was not there when we retired. He had taken *my Chair* & began instantly with a very angry countenance to call us to acct. for having left the Council, on which moved by his presumption I replied to Him sharply & told Him of the impropriety of his adressing us in such a manner, to which He answered in such a way, that I added His Conduct as to behaviour had been cause of Complaint to the whole Academy.[31]

Neither Farington's diary entry nor the Council minutes tells us if Turner remained at the meeting after this. Probably he walked out after being so strongly rebuked, for how could he have continued to participate with any dignity? If he was angry to start with, he must have been incandescent with rage after having been publicly reprimanded. But even if he stayed, his subsequent behaviour proves he was furious.

As we have seen, Farington was well aware that Humphry and Northcote had recently complained of Turner's manners. The grumbles about his behaviour were therefore not invented. Perhaps such grievances had even been expressed to the 'whole' Academy, just as the painter-diarist claimed. Undoubtedly, Turner had friends within the institution who would have regarded his genius as excusing any behaviour short of murder, so the objections articulated by Humphry and Northcote would indubitably have fallen upon many a deaf ear. However, Farington's petulance over the occupation of 'his' chair makes one think he did protest too much, for technically Turner was in the right. How could the Council function if its members were to go off and hold private meetings elsewhere? The body had to act in concert or not at all. And what of the distrust and extreme rudeness involved, keeping artists of stature simply hanging around doing nothing? It was intolerable.

Turner's conduct over the next few years makes it clear that he took Farington's rebuke very badly. It is easy to see why, for ever since the early 1790s the elder statesman of Somerset House had acted as his mentor by guiding him through the tortuous politics of the London art world, and those of the Royal Academy in particular, while equally acting as his artistic adviser. That Farington had now turned on him must have felt like a betrayal. But in any event, Turner had suffered enough of the insolence, pettiness and infighting that had almost become the norm on the Council, and throughout the Royal Academy more generally. Farington's remarks were the final straw. Without doubt the evening of 11 May 1804 represented the nadir of Turner's virtually lifelong relationship with the Royal Academy. He unofficially quit the body, probably asking himself why he needed such tribulations as he trudged back to Harley Street that spring evening. He had art to make and a gallery to fill. Henceforth the Royal Academy would have to do without his services, at least until the behaviour of his fellow members improved somewhat.

17

Arcadia-upon-Thames

June 1804 to December 1805

Turner's fellow guests at a 15–18 June 1804 weekend house party at Pitzhanger Manor, Soane's country villa in Ealing, to the west of London, included Admiral Lord Bridport (1726–1814); the Theatre Royal, Covent Garden, opera singers John Braham (?1777–1856) and Nancy Storace (1765–1817), who were living together at the time; and Sir Francis Bourgeois.[1] Perhaps Turner quizzed the retired admiral about nautical matters. Braham was one of the five composers who had contributed to the failed 1802 comic opera *The Cabinet* that received mention in the Prologue above; today he is only remembered as a performing artist. Storace had created the role of Susanna in Mozart's *Le Nozze di Figaro* in Vienna in 1786. Like his hosts and fellow house-guests, Turner might well have enjoyed some fine singing by the two vocalists (and if that was the case, then conceivably it could have included duets from Mozart's *Magic Flute*, the relevance of which will become apparent below). Finally, Turner may also have repaired his relations with Bourgeois after their falling-out the previous winter.

When the Harley Street gallery closed on the evening of Saturday 30 June, it did so exactly a fortnight after the Royal Academy Exhibition had ended on Saturday 16 June. On 1 July Turner had five paintings delivered to the banker, City trader and collector, Samuel Dobree (1759–1827).[2] They included *Fishermen upon a lee-shore* (see fig. 268), displayed at the Royal Academy in 1802; *Boats carrying out anchors and cables to Dutch men of war, in 1665* (see fig. 308), shown there more recently; and a small view of Margate Pier (private collection) that was gifted to Dobree. Such generosity came easily, for Turner might have received as much as 850 guineas for the other four paintings.[3] Sales of this size more than justified the creation of the gallery, as well as provided assurance that if the Royal Academy were to fail, an alternative income path existed.

Judging by Turner's absence from the Royal Academy this summer and during the early part of the autumn, he had virtually lost all interest in the institution. He did not embark upon a summer tour, clearly because he still had plenty of source material to hand. Nor had he tired of the light and space available in Harley Street. He visited Pitzhanger Manor several times over the summer and autumn, on 5 August to watch Soane stock a stream with tench.[4] And perhaps a visit to Knockholt took place between 9 and 23 November. If so, then it is perfectly possible that this was the year in which the fluent and influential landscape watercolourist Joshua Cristall (c.1768–1847) was staying at Ash Grove when Turner visited the house. Cristall would later relate to his friend Samuel Palmer (1805–1881) having witnessed the following occurrence:

> Turner had brought a drawing with him of which the distance was carefully outlined, but there was no material for the nearer parts. One morning, when he was about to proceed with this drawing, he called in the children as *collaborateurs* for the rest, in

Detail of fig. 328.

the following manner. He rubbed three cakes of water-colour, red, blue and yellow, in three separate saucers, gave one to each child, and told the children to dabble in the saucers and then play together with their coloured fingers on his paper. These directions were gleefully obeyed, as the reader may well imagine. Turner watched the work of the thirty little fingers with serious attention, and after the dabbling had gone on for some time, suddenly called out, 'Stop!' He then took the drawing into his own hands, added imaginary landscape forms, suggested by the accidental colouring, and the work was finished.[5]

Turner could afford to gamble, for no childish mess was ever wholly irretrievable, due to the resolubility of watercolour and the strength of the paper he used. And an important aspect of his mind is apparent in a second story related by Cristall to Palmer: 'On another occasion, after dinner, [Turner] amused himself in arranging some many-coloured sugar-plums on a dessert plate, and when disturbed in the operation by a question, said to the questioner, "There! You have made me lose fifty guineas".'[6] Clearly, by dint of having spoken, the questioner had shattered Turner's intense concentration, so that although he still had the candied fruit in front of him, the image it had created in his mind had fled, along with the money it would have obtained when turned into pictorial form and sold.

Isleworth

By the beginning of December 1804, Turner had begun looking into the rental of yet another residence, or even taken one on. This was Syon Ferry House, which stood near the water's edge on the Thames at Isleworth, about a mile to the south-west of Brentford. Turner began renting it between 15 November 1804 and 17 January 1805.[7] What he paid is unknown. Because it is highly improbable that he kept three properties simultaneously on the go, it is very likely that when he began renting Syon Ferry House he finally sundered his links with 75 Norton Street.[8]

Unfortunately, we possess no idea of the exact layout or dimensions of the house, although Turner did depict it in watercolour (fig. 309). From this and other images, we can deduce that it was a fully detached residence with a central front door, two large front rooms on the ground floor, and three smaller front rooms upstairs. An unknown number of spaces existed at the rear. The front garden of the property was walled on three sides, with a small summer-house incorporated within its front wall. Because the Thames flows northwards at Isleworth, Syon Ferry House faced almost due east. If Turner used his front rooms as studios, as appears likely, then once again he had rented a property whose orientation permitted him to work in bright light immediately after dawn, when his mind was at its freshest. In another watercolour he depicted the narrowness of the river between its west bank and Isleworth Ait, an island almost facing the ferry crossing point (fig. 310). It appears likely he obtained much of the water he required for his watercolours directly from the Thames, for by 1804–5 it would still have been very clean at Isleworth, particularly after periods of heavy rainfall.

Mr Turner's Yacht

It was probably not long after renting the Isleworth property that Turner had a boat built nearby. The internal layout he envisaged and in all likelihood had constructed would have been eminently suited to the needs of a painter (fig. 311), for it comprised two wide, flat platforms on either side of a narrow aisle running almost to the prow, plus a partially narrower flat platform encircling a large open space at the stern. The two forward platforms would have been perfect for stacking a number of smallish oil sketches against the sides of the boat, as well as for stowing large amounts of painting and fishing gear beneath them. No less importantly, the wide, flat surfaces of those platforms would have permitted the laying down of several sheets of paper side-by-side so they could be worked upon in sequence, thereby permitting Turner to use the scale practice when making watercolours.

Naturally, the platforms would also have freed Turner to sit in the front half of the vessel and prop up a drawing board or similar support against a gunwale or the mast, while alternatively he could have seated himself on one of the platforms, placed his lower legs in the aisle and, while sitting upright, painted upon a light sketching easel or similar picture-clamping mechanism that was temporarily attached to the mast. Almost certainly, the boat sported a simple gaff rig. By means of a removable pin at its base, the mast could be lowered or even removed altogether. The lowering of the mast would have assisted with working in oils in extremely calm weather, for Turner could have erected a light sketching easel on deck and then painted standing up. The hull was between twelve and fifteen feet in length (fig. 312). It is extremely unlikely that the boat contained a cabin, for it was too short to accommodate one. Internally it may have had all its seating and flat working surfaces covered with a thin mahogany veneer. The relevance of this observation will become apparent shortly.

Turner dined with Soane on both Christmas Eve and Christmas Day 1804. By year's end he had £767-2s-6d lodged in the Bank of England.[9] An ordinary working man would have had to labour virtually non-stop for twenty-nine years to earn that sum. It had taken

309 *Syon Ferry House, Isleworth*, 1805, watercolour on paper, 10⅛ × 14⅜ (25.7 × 36.5), fol. 48 of the *Thames from Reading to Walton* sketchbook, Turner Bequest XCV, Tate Britain, London.

310 *The River Thames with Isleworth Ferry*, 1805, watercolour on paper, 10⅛ × 14⅜ (25.7 × 36.5), fol. 45 of the *Thames from Reading to Walton* sketchbook, Turner Bequest XCV, Tate Britain, London.

311 *Sketch of the internal layout of a boat*, 1804–5, pencil on paper, 4½ × 7½ (11.4 × 19), fol. 85 of the *River and Margate* sketchbook, Turner Bequest XCIX, Tate Britain, London.

312 *Sketch of a boat*, 1804–5, pencil on paper, 4½ × 7½ (11.4 × 19), fol. 84 *verso* of the *River and Margate* sketchbook, Turner Bequest XCIX, Tate Britain, London.

Turner about seventeen years, but in that time he had earned a great deal more, as his extensive outgoings indicate (indeed, since 1798 he had gradually divested himself of £600-worth of stock). And by 17 January 1805 he had fully taken over the Isleworth property, for he paid the property rates on that date.[10] Given the time of year, however, it must be doubted that he had moved in just yet. Instead, he must have been painting hard in Harley Street throughout the winter. On 6 April 1805, he sent Sir Richard Colt Hoare a letter requesting the ninety guineas he was owed in payment for four watercolours dating from between 1802 and 1805, one of which was a depiction of the north gateway to the cathedral close at Salisbury (fig. 313).[11] As always with members of the nobility and gentry, he had to be very relaxed about payment, for they did like to dawdle over it. Such slow settlement formed part of the class culture of the day.

An Investment in Cattle and Slaves

At this time we encounter the greatest moral embarrassment of Turner's life. On 11 April 1805, he attended a meeting held in the Thatched House Tavern, Westminster, to seek investment in a scheme known as a tontine. The plan was to raise £20,000 by selling 200 shares at £100 each, and to employ the major part of that sum for the purchase of a cattle-breeding business, the Dry Sugar Work pen, which covered some 1,500 acres near Spanish Town, Jamaica.[12] Necessarily this would involve the ownership of slaves. It was envisaged that when fully operative, the pen would generate a profit of £10,000 per annum, from which returns would be paid to all the investors or their nominees at 15% per share, or £15 a year. It would therefore take just seven years for the investors to recoup the cost of each share and move into profit. Moreover, when and if any of the members of the tontine died, their shares would devolve to their fellow participants, while the value of each annual return would increase.

Between 5 and 31 May 1805 Turner purchased a single share in his own name. He cannot have entertained any doubts that the tontine involved the ownership of slaves, for the pamphlet that had invited subscriptions had made it clear that 'a large Gang of Negroes' would be purchased to work the cattle ranch.

Obviously Turner joined the Dry Sugar Work tontine because it offered an excellent return. He suffered no moral scruples about investing, for at this stage of his career all he cared about was his success as an artist, as we have already seen in his treatment of his mother. Maybe his lack of conscience went back to 1789 and Mauritius Lowe awakening his revulsion at the poverty and degradation into which artists could fall. That was a fate he was ruthlessly determined to avoid. If one way of doing so was through investing in a business that necessarily involved the exploitation of, say, black people half a world away, then so be it. Out of sight, they were utterly out of mind. But we do need to remember that by 1805 Turner was hopelessly compromised by slavery anyway, for he had readily accepted money from Angerstein, Beckford and two members of the

Facing page 313 *Gateway to the Close, Salisbury*, c.1802, watercolour on paper, 18 × 12½ (45.6 × 31.5), Fitzwilliam Museum, Cambridge. See also fig. 150.

262

Lascelles family, all of whom had directly or indirectly profited from slavery (and in 1810 he would also begin receiving commissions from yet another patron whose wealth was rooted in slavery). He must therefore have thought that to derive even more financial gain from such exploitation could hardly make much difference in moral terms.

Ironically, the 1805 investment would not benefit Turner, for in September 1808 the tontine would be placed in receivership, with his £100 being lost in the process. By the time the scheme would finally be wound up in 1830, his views on slavery would anyway have long since altered, so he might well have eventually concluded that such a loss was merited, for he should never have put his money into such a morally dubious venture in the first place.

On 10 April William Beckford auctioned off more than ninety drawings by J. R. Cozens at Christie's. Turner acquired lot 35, a view of Flüelen on Lake Lucerne.[13] Possibly he paid just £2-12s-6d for it. Soon after the sale he met up with Colt Hoare to discuss the Salisbury commissions. A faint sketch on the reverse of the Flüelen drawing may have been a proposal by Turner for a structure to house all the watercolours of Salisbury acquired by the collector. In the event, Colt Hoare would simply hang his cathedral watercolours in the Column Room at Stourhead, while pasting the smaller city views into an album stored in his library.

By 21 February 1805, Turner had decided not to participate in the forthcoming Royal Academy Exhibition.[14] It would be the first time he had failed to do so since 1790. Nothing could better illustrate his disillusion with the Royal Academy. Instead, he concentrated upon filling his own gallery.

314 William Henry Hunt, *David Wilkie*, c.1809, watercolour on paper, 5 × 3⅝ (12.7 × 92), National Portrait Gallery, London.

The 1805 Turner Gallery Exhibition
?MONDAY 15 APRIL TO ?SATURDAY 8 JUNE

If this opened on the date given here, then it did so exactly two weeks before the public opening of the Royal Academy exhibition, as in the previous year.

Hoppner visited the gallery on Thursday 9 May after attending a watercolour show in Lower Brook Street, Mayfair.[15] He found that the 'delicate and careful' drawings he had just seen, with their great 'attention to nature', made Turner's display look 'like a *Green Stall*, so rank, crude & disordered were his pictures'. Perhaps his simile likening Turner's works to the offerings of a market stall specialising in green vegetables was inspired as much by the colour of the gallery walls as by a number of the exhibits themselves. And Benjamin West also disliked what he saw, saying that the paintings tended to 'imbecility', with the water looking 'like stone'.[16] A little later the twenty-year-old David Wilkie (1785–1841, fig. 314) found Turner's images grand, and his effects and colouring natural, although he could not understand the absence of detail. For that reason he stated: 'although [Turner's] pictures are not large, you must see them from the other end of the room before they can satisfy the eye'.[17]

One of the paintings Wilkie could have viewed with some mystification was Turner's riposte to Poussin's *Deluge*, seen in the Louvre in 1802 (see fig. 294). In 1813 Turner would again exhibit this work, possibly after having repainted it. The canvas will receive discussion below in connection with the 1813 Royal Academy show.

The 1802 *Ships bearing up for anchorage* (see fig. 270) may have been re-exhibited in the 1805 Turner Gallery show, with Lord Egremont paying up to 350 guineas for it. Almost certainly included was *A shipwreck with Boats endeavouring to save the Crew* (fig. 315).[18] It is likely that Turner had been prompted to create this canvas by the appearance in 1804 of a new edition of *The Shipwreck*, the bestselling poem by William Falconer (1732–1769) that had first appeared in 1762. In the picture we witness a return to the brush-orientated and necessarily laborious approach to the depiction of water that Turner had habitually employed in his marine paintings prior to 1804.

315 *A shipwreck with Boats endeavouring to save the Crew*, T.G. 1805, oil on canvas, 67⅛ × 95⅛ (170.5 × 241.5), Tate Britain, London.

Undoubtedly the somewhat wild new method he had adopted in the latter year had permitted him to invest the sea with a sense of boiling energy, but only the more detached way of painting water used before 1804 and resorted to again in 1805 really allowed him to communicate his grasp of underlying hydrodynamic motion. After returning to this approach in 1805, he would employ it for the rest of his life, at least in his exhibited works.

With the fishing boat on the right, and the capsized ship beyond it, we again encounter Turner's penchant for jumbling nautical shapes. And upon both the nearby fishing vessel and the lifeboats to the left of it we see a large number of people who have been formed and clothed in the manner of figures by David Teniers the younger (especially the man with hunched shoulders and a flat, red Lowlands cap with his back to us in the nearest small boat at the centre). The shaping of people in the purposefully clumsy manner of Teniers once again projects their raw inner character, and it points up how puny and powerless we all become when confronted by the colossal violence of nature.

Also probably on display was *The Destruction of Sodom* (fig. 316) in which Lot and his daughters flee the city as fire and brimstone threaten; at the centre of the group, Lot's wife has already been turned into a pillar of salt. The picture contains many disjointed

Left 316 *The Destruction of Sodom*, T.G. 1805?, oil on canvas, 57½ × 93½ (146 × 237.5), Tate Britain, London.

Right 317 Sir Joshua Reynolds, James Northcote and John Simpson, *Sir John Leicester, Lord de Tabley*, 1789–1826, oil on canvas, 114¼ × 57 (290 × 145), Tabley House Collection, University of Manchester.

compositional lines, obviously to enhance our sense of the city coming to an end. The intentionally patchy lighting augments the sense of fracturing and restlessness throughout. It may be that Turner intended the death and destruction to allude to the devastation that was currently being wrought by war and its related ills.

By 1805, Sir John Fleming Leicester (fig. 317) had learned his lesson when it came to making Turner low offers for a painting, and thus losing out in the process (as he had done in 1803 with *The festival upon the opening of the vintage of Mâcon*, see fig. 297). As a consequence, this year he visited Turner's Gallery either when it opened or soon afterwards, and immediately agreed to pay the asking price of 300 guineas for *A shipwreck with Boats endeavouring to save the Crew*. Turner would receive payment on 31 January 1806.[19] Leicester intended the work to act as a focal point of his picture collection in a town house he was currently refurbishing at 24 Hill Street, Mayfair.

Leicester was an important addition to the growing number of prestigious Turner collectors. He might have been introduced to the artist by his friend Colt Hoare, or by Thomas Lister Parker, who was the baronet's first cousin once removed. It might be thought that as Sir John derived about £12,000 per annum from his land and mining interests in the Midlands, he could easily afford to pay 300 guineas for a picture. However, as his expenditures often outran his income he would usually be strapped for cash. Apparently Turner would not mind too much, probably because Sir John was a man of some influence whom he entirely trusted to pay when he could.

Sir John Leicester was not the only person to admire *A shipwreck with Boats endeavouring to save the Crew*, for the engraver Charles Turner was also deeply impressed with it. Accordingly, he asked if he could reproduce it as a large mezzotint print. After obtaining Sir John Leicester's permission, Turner agreed to loan him the painting for 25 guineas.[20] He also reserved the right to purchase a number of the prints, with a view to colouring them himself. The first engravings would appear early in 1807.

New Art Societies

In the autumn of 1804 and the summer of 1805 two new arts organisations came into existence in London: the Society of Painters in Water-colours, which hoped to raise public appreciation of the favoured medium of a number of artists who included William F. Wells; and the British Institution for Promoting the Fine Arts in the United Kingdom.

Turner would never contribute to the exhibitions of the Society of Painters in Water-colours, clearly because he knew that if he did so, then there was a very strong chance that his drawings would make most of the other works on display look weak by comparison. As we shall see, he would occasionally show in the British Institution's annual exhibitions of contemporary art, but in the early days of the organisation at least, he would always distrust it because it could never be controlled by artists. (Due to his disgust with the constant bickering in Somerset House, King George III had only accorded the British Institution his patronage after receiving the assurance that it would be entirely run by noblemen, collectors and connoisseurs, and that artists would play no part in its direction.) And as we shall discover when we reach 1814, Turner would also develop misgivings about the educative side of the British Institution.

As Turner did not exhibit in the Royal Academy this year, he did not attend the dinner on Saturday 27 April. Instead, he sent the Secretary a packet of invitations to his own exhibition, along with a letter requesting they be delivered to all the Academicians.[21] He could not have made his attitude towards Somerset House and its quarrelsome artists more clear: theirs was not the only show in town, and if his professional peers wanted to see what he was up to, then they would have to come to him.

Back in late May 1804, Edward Dayes had committed suicide. By then Turner may not have seen him for years. Dayes had come to feel increasingly marginalised and embittered by a lack of professional success that had led to a gradual but drastic diminution of his earnings. He had left a widow, a number of unsold paintings and watercolours, and a collection of writings. A book of these was published in June 1805, and Turner was among its subscribers.

Amid its 'Professional Sketches of Modern Artists', it contained a section devoted to Turner, in which Dayes declared that the man 'must be loved for his works; for his person is not striking, nor his conversation brilliant'.[22] Probably no offence was taken at this, for by 1805 Turner was surely accustomed to such observations. But the contrast between the man and his art might well have registered, for before many years had passed, Turner would make the difference between outer guise and inner reality the subject of one of his key images, as we shall discern.

On Friday 19 July Turner participated in a General Assembly meeting that must have filled him with disgust, for Farington would characterise it as 'the most unpleasant evening I ever did [spend] in the Royal Academy in the midst of party spirit & personal attack & sneering remarks'.[23] The central matter at issue was whether Fuseli could act as both the Royal Academy's Professor of Painting and its Keeper, the latter in place of Smirke, who had been rejected in that post by the king because of his French republican sympathies. The question so troubled the members that the meeting went on for over six hours, until one-thirty in the morning. As Turner did not vote,[24] we can safely assume that he had slipped away to his bed before the poll was taken. He might well have thought that the Royal Academy could go hang, for he had better ways of employing his time, or even of utterly wasting it.

The upper Thames Valley, 1805

Throughout May, June, July and the first half of August 1805, the weather in south-east England was poor, with a good deal of rainfall. Accordingly, a late harvest was predicted. However, an improvement during the second half of August speeded the harvest, which commenced in the third and fourth weeks of the month. During September there was much fine weather but in October it turned extremely wet again. In temperature the entire summer remained largely on the cool side.

The relevance of all this is that it helps narrow down the times in which Turner undertook two river expeditions during the summer of 1805. He painted directly from nature in oils on both trips, but the pictures emanating from one of the forays show almost constantly cloudy skies. As a consequence, we can safely assign that tour to a period in July and the first half of August, when it rained a great deal. The second trip can firmly be dated to a period between the last week in August and sometime in September because the skies depicted in the other set of oils are predominantly cloudless, and in any case the artist witnessed the harvest during that tour.

An idea of the prevailing conditions in July and early August can be gleaned from a storm scene at Isleworth that shows a large black cloud approaching from the west (fig. 318). Here Turner used stopping-out varnish to denote the ferry from which his house partly took its name. Perhaps he had intended to overpaint the boat eventually but refrained from doing so because somehow it looks perfect in its incomplete state.

Mahogany Veneer

The first expedition up the Thames from Isleworth must have taken place between 22 July and 15 August, a span of twenty-five days bracketed by possible visits by Turner to his stockbroker on 21 July and 16 August. This period would have afforded him plenty of time to create a highly distinctive group of oil sketches on the boat. And the very painting support he employed for those works equally helps to fix the timing of his first water-borne painting expedition that summer.

Above 318 *The Syon Ferry with the Syon Park pavilion in the background*, 1805, watercolour on paper, 6¾ × 10⅜ (17.1 × 26.4), fol. 11 of the *Hesperides (1)* sketchbook, Turner Bequest XCIII, Tate Britain, London.

Below 319 *Windsor Castle from the river*, 1805, oil on mahogany veneer, 10⅞ × 29 (27 × 73.5), Tate Britain, London.

Because of all the recent rainfall in the London area during May and June, by July Turner obviously anticipated that conditions might well continue to be wet (as, indeed, would prove to be the case). He therefore chose his painting support carefully. Primed canvas would have been useless in the open air if it rained, for any water on the back of it would have reactivated the glue size that sealed it, thereby making the primer come away from the support. Even excessive atmospheric moisture would have made canvas far too floppy for painting purposes. That is why Turner instead used some thin pieces of mahogany veneer as his painting supports. Because of the varying sizes of these lengths, possibly they were offcuts obtained from a woodyard on the cheap, or even leftovers from the fitting out of his boat. Yet the fact that mahogany is a hardwood, and is therefore virtually impervious to water, made it safe to use in the rain. Equally, the stacking of pieces of mahogany veneer in damp conditions in the open air would have been safe.

Turner could have temporarily clamped the pieces of veneer onto a drawing board in order to paint on them, and then placed the board upon a light sketching easel that he perhaps stabilised by attaching it to the mast. Due to the fact that oil and water do not mix, it is always feasible to paint with oils in the rain. The extremely hardy Turner would scarcely have worried about getting drenched.

320 *Windsor Castle from the Thames*, signed 'J M W Turner RA ISLEWORTH' lower right, 1805, oil on canvas, 35¾ × 48 (91 × 122), Tate Britain and the National Trust (Lord Egremont Collection), Petworth House.

Initially, he slowly sailed to Windsor before gradually returning downriver. When he neared Weybridge he turned south, into the Wey Navigation canal and its extension, the Godalming Navigation canal. Together these waterways were some nineteen miles in length, and they permitted barges and other vessels to reach London from the very heart of Surrey at Godalming. In almost all of the oil sketches created on the Wey and Godalming Navigations, the skies are cloudy and dull. This surely reflects the fact that Turner painted what he actually saw. He spent his nights in hotels and lesser lodgings rather than the boat, which lacked a cabin. On the return leg from Weybridge to Isleworth, Turner moored near Walton bridges to undertake some more oil sketching and fishing.

Turner's first Thames painting expedition of 1805 was highly productive, for it resulted in the creation of six oil sketches of Windsor and its environs (fig. 319), up to eight oil sketches made on the Wey and Godalming Navigations, and another two oil sketches elaborated on the Thames near Walton bridges. The subjects of two more views cannot be identified. Yet despite the immediacy and fluency of the technique employed to paint all these sketches, Turner never set any public store on them. Instead, he simply regarded them as means to an end, for they heightened his perceptions of appearances, permitted him to solve technical problems, afforded him the pleasure of painting in the open air and, not least of all, allowed him to undertake all the foregoing while waiting for fish to bite. Oil sketching in the open air was becoming widespread in Britain by 1805, as Turner was undoubtedly aware, and his efforts in this sphere made an important contribution to that far-reaching development in landscape painting.

321 *Richmond Hill from the River*, 1805, pen and ink on paper, 5⅞ × 10⅛ (15 × 25.8), fol. 18 of the *Studies for Pictures Isleworth* sketchbook, Turner Bequest XC, Tate Britain, London.

322 *Classical river scene*, 1805, pen and ink on paper, 5⅞ × 10⅛ (15 × 25.8), fol. 16 of the *Studies for Pictures Isleworth* sketchbook, Turner Bequest XC, Tate Britain, London.

323 *Study for Dido and Aeneas*, 1805–6, watercolour on paper, 5¾ × 10 (14.6 × 25.4), fol. 21 of the *Studies for Pictures Isleworth* sketchbook, Turner Bequest XC, Tate Britain, London. See also fig. 430.

Soon after returning from the first 1805 river trip, Turner embarked upon a depiction of Windsor Castle as recently perceived in glittering sunlight (fig. 320). The many trees in this canvas were painted under the influence of Titian, for the textural vibrancy with which they are imbued is often to be encountered in works by the Italian master. (It was surely present to a remarkable degree in the painting of St Peter Martyr by Titian that had made such a deep impression upon everyone who had seen it in the Louvre in 1802, Turner included.) The Windsor landscape afforded the perfect subject with which to emulate Titian's surface dynamism. As we shall see, textural vibrancy would become increasingly important to Turner in later years, but it would never look more resplendent than here, or make an image come more alive. Turner would not only sign the resulting canvas but add the word 'ISLEWORTH' to his name. Such an inclusion of a place name that bears no relationship to the subject of a work is unique in his *oeuvre*, and it almost certainly denoted that the picture had actually been created from start to finish in Syon Ferry House.[25]

Along the river and back in Isleworth, Turner closely perused volumes from the set of Anderson's *Complete Poets* he had brought down with him that summer. Nothing can ever be more conducive to flights of fancy than the reading of fine verse amid beautiful surroundings, and so it proved now. Clearly, that is why landscapes seen and sketched upstream on the Thames or at Isleworth in 1805 frequently evolved into subjects set in ancient Greece, Carthage and Rome, as well as in Arcadia, that mythical, pastoral paradise of poets of the ancient world such as Theocritus, Virgil and Ovid, and the pagan equivalent of the Garden of Eden before the Fall. In the mere moment it took Turner to flick over a sketchbook page, he could transform the Thames valley at Isleworth into the Vale of Tempe, or Richmond, Surrey (fig. 321) into some fabulous city of ancient time (fig. 322). One study (fig. 323) would only be turned into a painting of Dido and Aeneas in 1812–14 (see fig. 430).

It has convincingly been suggested that because the weather by 25 August showed signs of greatly improving, the painter arranged to meet up with his fellow fishing enthusiast, John Soane, at Pangbourne in Berkshire at the end of the first week in September.[26] From there they would fish for trout on the Thames between Mapledurham and Goring, where such angling was at its finest. Accordingly, on 1 September or a day or two later, Turner again sailed upriver.

Above 324 *House besides the Thames, possibly near Datchet, Berkshire*, 1805, oil on canvas, 35⅝ × 45⅞ (90.5 × 116.5), Tate Britain, London.

Below 325 *Barge on the Thames near Cliveden towards sunset*, 1805, oil on canvas, 33½ × 45¾ (85 × 116), Tate Britain, London.

Below right 326 *Goring Mill and Church*, 1805, oil on canvas, 33¾ × 45¾ (85.5 × 116), Tate Britain, London.

White Canvas

As there was now less expectation of rain, Turner could risk using canvas as his painting support. Accordingly, he prepared a roll of white primed linen, from which he could cut off lengths at will. Fourteen of the resulting seventeen canvases would be used on a second 1805 Thames trip or a little later, and another three after a visit to the Medway and the Thames estuary the following winter. Nothing was ever wasted.

The fine weather during the second 1805 tour of the Thames is reflected in the fact that clouds only appear in three of the fourteen or so images that were sketched in oils at this time (and even then, only in one – a view of Caversham Bridge – are there any number of them). Few of the sketches were taken very far; probably Turner was content simply to begin them and hope they would motivate him sufficiently to continue them at a later date (which would not be the case). That approach certainly freed him to get on with his fishing. But there are some memorable images among them, especially a depiction of an elegant house that stood on the water's edge, possibly near Datchet (fig. 324). When Turner arrived at a partially destroyed medieval bridge near Runnymede that had first caught his eye on his previous expedition, he disembarked to sketch it in oils from a meadow to the south-east (fig. 327). In the process he pushed the ruin to one side but sacrificed none of its Italianate associations. And near Cliveden one evening towards sunset, he painted some bargemen preparing their dinner over a small fire on board their vessel (fig. 325). This permitted him to contrast the hot and cool temperatures that had fascinated him since he had first seen the Stourhead Rembrandt in 1795 (see fig. 137). In his oil sketch he

327 *Trees beside the Thames, with a ruined bridge and gatehouse in the middle distance*, 1805, oil on canvas, 34⅝ × 47½ (88 × 120.5), Tate Britain, London.

intensified the warmth of his reds and yellows by placing a contrasting cold blue, in the form of a sail, above the fire. All the time he was learning more and more about the intensification of colours by means of opposed hues and contrasting colour temperatures.

At Goring (fig. 326) Turner elaborated the buildings to a fair degree of completion, in the process capturing the mid-afternoon light to perfection. Amid the golden sunlight that followed on from so much dreary weather, memories of sunlit landscapes and cattle as painted by Aelbert Cuyp frequently surfaced in Turner's mind. Clearly, that was why he took care to include cattle in a view of Windsor by evening light, in a Hampton Court sketch, in the Caversham Bridge depiction, and in a view of an unidentified weir. And he also created some memorable watercolours on this trip. One such is a depiction of an unidentified bridge as viewed through a stand of trees (fig. 328). It ranks as one of the loveliest naturalistic drawings he would ever create.

Probably Turner met up with Soane and a group of his friends – including John Flaxman and his sister-in-law – at Pangbourne on 8 September or shortly afterwards.[27] As Soane had originally hailed from Goring, about four miles upstream from Pangbourne, he was

328 *Unidentified bridge seen through trees*, 1805, watercolour on paper, 10⅛ × 14⅜ (25.7 × 36.5), fol. 46 of the *Thames from Reading to Walton* sketchbook, Turner Bequest XCV, Tate Britain, London.

thoroughly familiar with the fishing on this stretch of the river. Consequently, Turner might well have obtained some choice catches.

From Goring, Turner continued up the Thames to Sutton Courtenay, Culham and Abingdon. He then slowly sailed back to Isleworth, painting, sketching and occasionally making watercolours on the way. Fishing took up much of his time. And one evening, perhaps on the final leg of the trip, Turner witnessed a sight that deeply moved him. The crops were being harvested on the west bank of the river near Kingston upon Thames, and towards sunset a group of harvesters had broken off their labours to eat and drink by the water's edge. But in the midst of nature's bounty they possessed only extremely meagre fare. Either on the boat or back in Isleworth very soon afterwards, Turner picked up his brushes to sketch this paradox in oils.[28] From that rapid study he would subsequently work up a painting upon which he would confer the subtly ironic title of *Harvest Dinner, Kingston Bank* when exhibiting it in his gallery in 1809 (see fig. 368).

The entire round trip could have lasted up to four weeks. As on the previous expedition, Turner must have slept in inns and riverside pubs along the way. And once he arrived back in Isleworth, he

further advanced the picture of Windsor Castle in brilliant sunlight and began many new oil paintings of the Thames, all of which would be completed later in Harley Street.

Turner stayed on in Syon Ferry House right through the following autumn and winter. Such a prolonged sojourn was the best way of putting some necessary distance between himself and the Royal Academy. He may, moreover, have paid his customary visit to W. F. Wells in Knockholt that autumn. On 4 November, and on 2 and 10 December, he attended General Assembly meetings. At the last of these he helped elect a new PRA, for West had resigned for a number of reasons, not least of all his inability to prevent constant bickering inside the Royal Academy. The sole candidate was James Wyatt. Fourteen Academicians voted for him, Turner included.[29] Undoubtedly, he hoped that by electing the architect, peace and amity would be restored to the institution. That the new President would prove utterly ineffectual would sadly become all too evident the following year.

By the very end of 1805, the 30-year old Turner had precisely £1,807-2s-6d invested in the Bank of England, a holding that represented a ninefold increase over the £200 he had possessed ten years earlier.[30] Of that money, he had earned no less than £1,040 in the past year alone. His finances were therefore in an extremely healthy state, as was the art that was creating his fame and fortune.

18

Staying Away
December 1805 to December 1806

Following the Battle of Trafalgar on 21 October 1805, the mortal remains of Vice-Admiral Lord Nelson were transported back to England aboard his battered flagship, the *Victory*. On Christmas Day the man-of-war was moored at Long Reach in the river Medway, just west of Sheerness in Kent, the body of the hero having been removed from her two days earlier to be transported for interment in London. Probably on 30 and 31 December 1805 Turner clambered all over the vessel (fig. 329).[1] In order to board her, he had possibly obtained a *laissez-passer* from Admiral Lord Bridport, whom, it will be remembered, he had met at Pitzhanger Manor in June 1804. Undoubtedly Soane could have obtained such a pass from the admiral but it would have taken a day or two to organise. That may be why Turner visited Soane in London on 27 December,[2] and why he therefore had to wait almost until the end of the month before gaining access to the *Victory*. Naturally, the possession of a letter requesting access to a Royal Navy vessel might well have stood Turner in good stead on further occasions too.

Turner had travelled all the way to Long Reach because he had determined to paint a picture of the Battle of Trafalgar. On board the *Victory* he created two fairly large drawings of the ship. By the time he did so, she lacked all her heavy guns and most of the materiel with which she was normally filled, for she needed to be considerably lightened in order to possess the clearance to be towed upriver to Chatham for a complete refit. On one of the drawings (fig. 330) Turner denoted the previous positions of the cannon by means of X's, and he also depicted the area normally occupied by the captain's cabin on the quarter-deck without its external walls and internal partitions, for the space had already been cleared.[3]

Turner was equally set on finding out as much as possible about the course of the battle, the positions of the major vessels involved, the men who had taken part, the apparel worn on the day, the individual clashes, and the French and Spanish ships that had participated. Of no less interest was the role played by the *Temeraire*, which had entered the fray immediately astern of *Victory* in Nelson's line of battle. In order to follow up on the combatants and their clothing, Turner questioned both the ship's master and the boatswain of the *Victory*, as well as a number of the junior officers, ordinary seamen and marines still remaining on the ship.[4] From these sources he obtained descriptions of the various persons who had crowded around Nelson just after he had been shot, and information about officers who had been wounded during the course of the action. Obviously all this data would prove vital to any depiction of the battle.

The Thames Estuary Winter Tour, 1806

Once Turner had gained all he needed, he began sailing around the Thames estuary on naval and civilian boats, probably for a number

Detail of fig. 335.

329 *The 'Victory'*, December 1805, pencil on paper, 4½ × 7¼ (11.4 × 18.4), fol. 7 of the *Nelson* sketchbook, Turner Bequest LXXXIX, Tate Britain, London.

330 *The Quarterdeck of the 'Victory'*, December 1805, pen and ink, pencil and watercolour on paper, 16⅗ × 22¼ (42.4 × 56.5), Henry Vaughan Bequest, Tate Britain, London.

of days. As a consequence of this hitherto unnoticed winter tour, he provided himself with the subjects of a great many marine pictures for years to come.

Control of the various vessels by others freed him to make rapid pencil drawings when the waters were calm enough to do so, and at all other times simply to memorise the passing show without distraction.[5] On any single day he probably moved from one side of the river mouth to the other, and all over it in random directions. Invariably, he would have wanted to be where the utmost naval activity was taking place, especially around the Nore. Judging by a painting that would grow out of this tour,[6] he must also have stood for some time at low tide upon Bligh or Blythe Sands about two miles north of Cliffe and about twelve miles west of Sheerness. There he watched the many fishing boats at work in the centre of the river, which is not extremely wide at this point. Equally, he enjoyed ample opportunities to gaze towards the Kent and Essex shores from a variety of angles. An unremarkable stretch of the Thames flowing downstream from the north-west between its Essex shore at Aveley and its Kent shore near Purfleet particularly engaged him, for he would subsequently depict it in oils.[7]

In one memorable painting that Turner would entitle *Sheerness as seen from the Nore* when exhibiting it in the Harley Street gallery in 1808 (see fig. 355), he would depict the Royal Navy guard-ship that kept permanent watch at the mouth of the Thames not far to the east of the fleet anchorage, in order to protect the river and its tributaries from surprise attack by the French or the Dutch (for memories of 1667 still created anxiety). In the process, he would virtually silhouette the man-of-war by placing it before a bleak winter sunrise.

Similarly, he made a pencil study of Margate as thrown into shadow by a rising January sun, along with another drawing of machinery down by the harbour there.[8] Back in Harley Street or Isleworth, he would subsequently use oils to rough out a dawn scene that would include the machinery, and do so upon a piece of the primed but unstretched white canvas that had remained in his studio from the upper Thames trip of the previous summer (fig. 331). Until now that painting has always been erroneously identified as a sunset view.[9] Not long afterwards he would elaborate yet another depiction of Margate soon after dawn in winter, but there move our vantage point offshore; he would exhibit this painting in 1808.[10] That he created such winter dawn scenes makes it clear that he toured the Thames estuary early in 1806 and not during the summer of 1805, as has hitherto been asserted. A desire to view the world in winter is unsurprising, for all of Turner's previous tours had taken place in the warmest parts of the year. Obviously he felt it was time for a change, with all the benefits (and dangers) that would follow in its wake.

On this tour Turner also crossed the North Sea, sketching a length of coastline and identifying the towns standing upon it as Flushing and Ostend.[11] Due to the continental blockade, the North Sea was very much under British control in 1806, and its under-fished waters therefore teemed with creatures that understandably

331 *Winter sunrise, Margate* (formerly known as 'Margate, Setting Sun'), here dated to winter 1806, oil on canvas, 33¾ × 45¾ (85.5 × 116), Tate Britain, London.

fetched high prices during wartime. As a consequence, there was no shortage of English crews willing to fish the coast of French-occupied Flanders, and also to take an artist along for the ride, especially if he paid for the privilege. Alternatively, Turner may have cadged a place on a small naval vessel going out to provision one of the frigates blockading the Flemish coast. And a further possible scenario is suggested by the fact that in another of the sketchbooks there exists a moderately detailed drawing of the fish market at Hastings.[12] It is perfectly feasible that in the Thames estuary off Margate, Turner obtained a ride on a passing Hastings fishing boat as it travelled towards the North Sea fishing grounds from London.[13] He may then have regained dry land briefly at the East Sussex town before being taken all the way back to London by the same boat carrying a major part of its catch to Billingsgate fish market. Such a mode of transport would have both furnished him with an excellent means of venturing upon the high seas and provided a perfect way of getting home.

Turner appears to have arrived back in London on 10 or 11 January 1806, after spending two weeks away. By now he was gearing up to send two paintings to the inaugural exhibition of the British Institution that would be held in its 52 Pall Mall premises, not far from St James's Palace. These contained three large galleries aligned on a north-south axis and lit by skylights (fig. 332). The sending-in date was 18 January 1806, and the selection panel comprised three members of the upper nobility, two baronets and two Members of Parliament.[14] Turner cannot have missed noticing that there was not a professional

332 R. Graves after A. C. Pugin, *Gallery of the British Institution*, engraving, 1821.

We look southwards from the fireplace at the head of the North Room.

artist among them, merely connoisseurs. Because of the increasingly negative criticism he was receiving from one of those gentlemen – namely, Sir George Beaumont – the word 'connoisseur' would soon become a pejorative term for him, if it was not one already.

The 1806 British Institution Exhibition
MONDAY 17 FEBRUARY TO MID-APRIL

Both of Turner's submissions were hung in the most badly lit of the three galleries, the South Room.[15] They were *Narcissus and Echo, (from Ovid's Met.)*, which he had shown in 1804 at the Royal Academy, where its (slightly shorter) title had been accompanied by an extensive poetic quotation in the exhibition catalogue; and *The goddess of Discord choosing the apple of contention in the garden of the Hesperides* (fig. 333). The poor lighting would lead Thomas Daniell to observe that both of Turner's paintings looked like 'old Tapestry as to general colour and effect'.[16] Yet even if the lighting had been good, Sir George Beaumont would probably still have remarked that the pictures were 'like the works of an *old man* who had ideas but had lost his power of execution'.[17]

There can be no doubt that during the latter part of 1805 Turner had given a great deal of thought to the pictures he would be sending to the British Institution, for he wanted to allude to contemporary London art politics by means of them. The narcissism that is inherent to the very subject of *Narcissus and Echo* makes this evident, quite simply because it relates to the self-importance felt by many members of the nobility and gentry who supported the British Institution (and especially by Sir George Beaumont). The echoing links to the fact that the British Institution had come into existence after the Royal Academy, and therefore it necessarily echoed the older foundation.

In order to understand how *The goddess of Discord choosing the apple of contention in the garden of the Hesperides* alluded to contemporary London art politics, it is necessary to remember that in ancient mythology the Hesperides were the four nymphs appointed to stand watch over the garden of the gods, as was the dragon, Ladon. Within that realm the earth goddess, Gaia, had planted a tree bearing golden apples from which Eris, the goddess of Discord, had subsequently plucked a fruit that was inscribed 'For The Fairest'. She did so in order to disrupt the wedding feast of Peleus and Thetis, to which she had not been invited, unlike all the other gods. By throwing the golden apple among those guests, she created jealousies that would ultimately lead to the Trojan Wars. The subject of *The goddess of Discord choosing the apple of contention in the garden of the Hesperides* is therefore inherently a *locus classicus* of envy, spite and discord set amid an earthly paradise. In Turner's painting we see the Hesperides and their handmaidens in the garden of the gods; Ladon breathing fire on a distant mountaintop; and, in the centre, Eris about to choose the golden apple with which she will foster jealousy and hatred. By sending such a statement to a new, rival body to the Royal Academy, Turner was subtly pointing up the discord and contention that can arise from the creation of competing institutions.

Simultaneously, Turner might well have wanted a depiction of disharmony in an ideal setting to be linked to the recent contentions that had taken place within the supposedly ideal setting of the Royal Academy of Arts. Certainly it seems remarkably coincidental that he painted a picture of discord in an elevated realm just after a period of intense enmity within an organisation that undoubtedly represented the highest artistic sphere both for himself and for a great many others. Envy had often played a part in that fractiousness too. It even seems possible that within such a pictorial statement, the large reptile seen on the mountaintop could have begun life as a comment upon the '*Great Reptile* with *ill manners*' who had insulted Turner in Somerset House in December 1803, namely Sir Francis Bourgeois. Following that incident, and after a period in which he had been slighted by fellow Academicians while having to watch many of them endlessly bicker and abuse one another, it appears very likely that Turner undertook a little literary research to find some hallowed tale involving trouble in paradise. That the story he discovered included a dragon that could easily be transformed into a large reptile might well have provided an added bonus.

333 *The goddess of Discord choosing the apple of contention in the garden of the Hesperides*, B.I. 1806 (55), oil on canvas, 61⅛ × 86 (155 × 218.5), Tate Britain, London.

To advance the statement about divisiveness even further, *The goddess of Discord choosing the apple of contention in the garden of the Hesperides* contains a unique physical feature among all of Turner's 570-odd oil paintings. By 1804, when the work was probably begun, the artist could easily have afforded to paint it upon a piece of high-quality and perfect linen canvas, as he did most of the other oils he intended for exhibition at the time. Instead, he choose as his support a length of very rough-woven hessian canvas that suffered from a visible join right across its centre.[18] By elaborating his image across such a divided and disrupted surface, Turner was able physically to parallel the division and disruption that stands at the very heart of the goddess of Discord myth, thereby creating a complete congruence between object and subject. Naturally, the division and disturbance of the surface equally paralleled the division and disturbance that underlay the apparent harmoniousness of the Royal Academy, and that might conceivably arise between artistic organisations housed in the Strand and Pall Mall.

By mid-February 1806 Charles Turner had obviously obtained all he needed from *A shipwreck with Boats endeavouring to save the Crew*, for by then the painting had gone on display in Sir John Leicester's gallery in Hill Street, Mayfair. And around this time the J. M. W. Turner garnered a large number of subscribers for the print, listing their names in a sketchbook.[19] They range from the 5th Earl of Essex, the 3rd Earl of Egremont and Lord Yarborough to Dr Monro, John Henderson, Newbey Lowson, Richard Payne Knight, William Leader and Samuel Dobree. Charles Elliott also committed himself, as did Soane, Beechey, Stothard and W. F. Wells. Naturally Sir John Leicester was listed, although he must have received his prints for nothing.

Throughout the rest of the winter Turner undoubtedly laboured around the clock on his depiction of the Battle of Trafalgar, as well as began a number of images that grew out of his Thames estuary tour in January. That is why we briefly lose sight of him again; as on most other occasions when this happened, he presumably painted all day, grabbed the occasional meal, perhaps downed a drink or two, and then went to bed. An artist's life can be very humdrum, especially for those dedicated to their calling.

Towards the end of March 1806, and after successfully plotting to oust George Dance as the incumbent Royal Academy Professor of Architecture, John Soane was elected in his place. Turner voted for his friend in what was a unanimous poll, according to Soane himself.[20] And the painter was so impressed with Soane's achievement that he too wanted to be a Royal Academy Professor. Eventually this desire would lead to huge intellectual and artistic ramifications.

The 1806 Turner Gallery Exhibition
MONDAY 21 APRIL TO SATURDAY 5 JUNE

This year we can be certain of one painting on display and deduce the identities of two others. According to advertisements that Turner would place in various newspapers in May, the principal new offering was *Battle of Trafalgar and Death of Lord Nelson*. As it could only have been begun in mid-January, that explains why Farington thought it 'unfinished' when he visited the Harley Street exhibition on 3 June, just before it closed.[21] He also found the work 'very crude' and 'the figures miserably bad'. But clearly Turner had tackled the subject, exhibited the results in an uncompleted state, and unusually advertised his exhibition this year because he wanted it to be known that he would be competing for a prize of 500 guineas that had been offered for the best painting of the Battle of Trafalgar even before 1805 was out. In the event, Arthur William Devis (1762–1822) would win that prize in 1807.[22] Turner would go on to complete his unfinished picture and exhibit it under a different title in 1808, which is why it will be analysed in connection with that year.

Also possibly on view in the 1806 Turner Gallery show was a depiction of a man-of-war as seen from three directions simultaneously (Yale Center for British Art, New Haven). Although this work has come down to us under the title of 'The Victory returning from Trafalgar', its sole authentic title is *Portrait of the Victory in Three Positions, passing the Needles, Isle of Wight*.[23] Yet because the ship depicted does not closely resemble the *Victory*, there is every reason to believe that the painting had not begun life as a representation of that specific vessel. Instead, it may have been started simply as a generalised image of a man-of-war in three positions. This was a very common way of depicting nautical craft at the time, especially by artists specialising in ship portraiture. Turner may have wanted to demonstrate his supremacy in this type of art, just as he had in many other aspects of marine representation. He could certainly have been attempting to upstage J. T. Serres, who made a speciality of this type of ship portraiture.

Another oil that was probably exhibited in Turner's Gallery in 1806 was the first of two paintings of Walton bridges that derived from the Thames tours of the previous summer (Loyd Collection, on long loan to the Ashmolean Museum, Oxford). It was painted very much in the style of Cuyp, with the landscape bathed in golden evening sunlight. The canvas was purchased by Sir John Leicester, possibly along with another work.[24]

The 1806 Royal Academy Exhibition
FRIDAY 2 MAY TO SATURDAY 21 JUNE

It is unlikely Turner attended the dinner this year, for he must have remained rather wary of some of his fellow Academicians. If he did stay away he missed very little, for Wyatt, proposing the toasts in the Great Room for the very first time in his new role as President, did so in such a soft voice he could barely be heard.[25] Any misgivings that may have been harboured about the architect's replacement of West as the PRA were greatly strengthened by this failure to communicate.

After his pictorial absence the previous year, Turner returned to Somerset House with just two works, one in oils, the other in watercolour. Such a low number reflects the fact that he still preferred to show his new offerings in Harley Street. The sole oil was *Fall of the Rhine at Schaffhausen* (fig. 334) and it may have been hung almost opposite the doorway of the Great Room. If that was the case, then it had been displayed in a choice location.[26] Yet nobody had reckoned upon the adverse response to the painter's facture that was caused by the placing of the canvas below the line, and thus at eye level. This was made clear by the *St James's Chronicle* of 24–27 May, which stated that because the painting was so approachable, many parts of it appeared 'slight and coarse', whereas they might have 'had a more complete effect' if seen from a distance. The same went for the figures. The newspaper did, however, praise the depiction of water, for it was 'painted with great spirit'. *Lloyd's Evening Post* of 5–7 May called the work 'beautiful'. On the other hand, on 8 May the *Star* stated: 'The spray from the cataract more [resembles] a cloud of stone dust than water, the body of the current itself being the block from which it is made to fly.' Yet it did concede that 'the figures ... are well grouped, and firmly painted', even if it would further assert on 21 May that 'the prevailing features of the colouring seem to have been produced by *sand* and chalk'. And the journalists

334 *Fall of the Rhine at Schaffhausen*, R.A. 1806 (182), oil on canvas, 57 × 92 (144.7 × 233.7), Museum of Fine Arts, Boston, Mass.

James Boaden (1762–1839) and John Taylor (1757–1832) agreed between themselves that the picture was 'Madness'.[27] Given the temper of the times, the painter had been prudent to keep his late mother's illness a secret.

Because Turner had extensively employed a palette knife when depicting the waterfall, it seems valid to suspect that the picture had been painted in 1804, when his use of that implement for the representation of water had been at its height. As we have seen with *A shipwreck with Boats endeavouring to save the Crew* (see fig. 315), by 1805 he had returned to a more painstaking, brush-orientated way of depicting water. If *Fall of the Rhine at Schaffhausen* had been created at the same time, let alone slightly later, then it would surely have been painted the same way.

Turner's sole watercolour in the 1806 show was *Pembroke-castle: Clearing up of a thunder-storm* (fig. 335). It hung in the Council Room. As we have seen, a newspaper review of the 1801 Royal Academy Exhibition had mentioned that the *Pembroke castle, South Wales: thunder storm approaching* shown that year (see fig. 247) had included 'the bustle of the fishermen in getting their nets, &c together'. The virtual absence of nets in the depiction of the same castle illustrated here firmly establishes that it was the watercolour exhibited in 1806 (the two works have become muddled). Simultaneously, this 1806 dating is made clear by the fact that fishermen huddle on the beach, obviously because they are still suffering from the effects of the storm. Bright sunlight remains distant, although it is bringing a clearer sky with it.

Undoubtedly the hit picture of the 1806 Royal Academy Exhibition was the 21-year-old David Wilkie's *Village Politicians. – Vide Scotland's Skaith* (fig. 336), which hung in the Great Room. The profound debt it owes to Lowlands genre painters, especially David Teniers the younger and Adriaen van Ostade, was widely recognised, and it even led the *Morning Post* of 6 May to assert that the genius of Teniers had been revived in Wilkie. By 1806 the latter had been a student in the Royal Academy Schools for less than six months, prior to which he had studied painting for five years in Scotland, where he had gained considerable technical expertise. A few weeks

335 *Pembroke-castle: Clearing up of a thunder-storm*, R.A. 1806 (394), watercolour on paper, 25⅞ × 38¾ (65.7 × 98.4), private collection.

before the 1806 Royal Academy Exhibition began, he had sold *Village Politicians* for just thirty guineas to the 3rd Earl of Mansfield, although he could have asked a great deal more if he had waited until the show had opened.[28] And another admirer of *Village Politicians* was Sir George Beaumont. Even before the 1806 Exhibition had commenced, the baronet had already commissioned Wilkie to paint *The Blind Fiddler* (Tate Britain, London), the work with which the young Scotsman would consolidate his Royal Academy reputation in 1807.

Turner has often been charged with becoming bitterly jealous of Wilkie's success in 1806, and consequently of being filled with a vindictive desire to put him down on the walls of Somerset House in 1807. This is wholly incorrect. Turner might well have been slightly annoyed in 1806 but if that was the case, then it was not with Wilkie (for whom he would later show concern, lest his head be turned by premature fame). Instead, any such irritation must have been directed at the critics and 'connoisseurs' who had hailed the young Scotsman as 'the new Teniers' and who had completely overlooked the fact that in 1796 Turner had exhibited *Internal of a cottage, a study at Ely* (see fig. 153), a work in which he had indubitably led the way in revitalising the style of Teniers and upholding the tradition he represented. If that work had been in oils, then it would surely have been Turner who had been hailed as 'the new Teniers' in 1796, not Wilkie ten years later. But obviously memories were short and watercolour did not count.

Moreover, and as we have seen in a number of Turner's most important paintings and drawings, including *Dutch boats in a gale*, for quite some years by 1806 he had been directly modelling the physical formation and clothing of many of his figures upon the coarse facial characteristics, angular anatomies and characteristic garb of the rustics fashioned by Teniers. This emulation is especially noticeable in a number of the marine pictures, where it underlines the severe

336 David Wilkie, *Village Politicians. – Vide Scotland's Skaith*, R.A. 1806 (145), oil on canvas, 22½ × 29½ (57.2 × 74.9), Collection of the Earls of Mansfield, Scone Palace, Perth.

hardships of life at sea by matching the raw outer guise of the figures to their rude inner character, thereby attaining a suitable level of artistic decorum. In particular, the helmsmen and other seamen seen from behind with hunched shoulders and wearing red flat caps were assimilated from Teniers, as has often been shown.

By 1806 it was therefore undoubtedly Turner who had taken the lead where a visual renewal of the art of Teniers was concerned. Because he had largely attained this within the field of marine painting instead of genre painting, it had gone almost entirely unnoticed by 1806, and it continues to be overlooked today. Any annoyance with the critics and connoisseurs felt by Turner in 1806 might well explain why, in the autumn of that year, he would embark upon a very Teniers-like oil painting of common life placed within an interior setting, as well as hasten the completion of a harbour scene at sunrise that contains an input from Teniers. By means of the two works he wanted to reassert his aesthetic and stylistic lead. Naturally we shall examine them both in due course. But that Turner might have felt deeply jealous of Wilkie and bitterly spiteful towards him in 1806 – rather than merely contemptuous of those who heaped praise upon him – is ridiculous, for it completely misses the point. And no less wrong is the claim, much promulgated of late, that Turner suffered from an inferiority complex regarding a number of his more successful contemporaries and many more masters of the past. Supposedly this led him to compete with them. But what is wholly overlooked here is the extent to which he was simply following the precepts of Sir Joshua Reynolds, that an artist must draw upon the art of the past and present in order to propel art into the future. As Turner had shown through his engagement with Rowlandson in 1791, with Rooker in 1792–3, with de Loutherbourg in 1793, with Rembrandt after 1795, with Teniers after 1796, with Dutch marine painting between 1799 and 1801, and with many other artists in addition, he had been successfully doing that for years by 1806.

Turner had become amenable to comparatively low offers for his watercolours by the spring of 1806.[29] Probably this was because the sales of his oils were down, due to the negative criticism he was receiving from Sir George Beaumont, who found his approach to landscape and marine painting 'vicious' and his colouring 'jaundiced'.[30] The diminution of oil painting sales and lowering of watercolour prices led him to give thought as to how he could make savings, even though he possessed the very respectable sum of £2,088-12s-3d in government stock by 18 April.[31] The desire for financial retrenchment emerged by 10 May when Thomas Daniell told Farington of having been informed that 'Turner is going to reside abt. 10 or 12 miles from London, & proposes only to retain in London His Exhibition Gallery. This He does from an Oeconomical motive.'[32] The move would soon come about (although not to such a distance), for 64 Harley Street had its drawbacks and Syon Ferry House must have been too expensive. Turner paid the Poor Rate on the latter residence for the last time on 15 May 1806, and he would vacate it before 30 October.[33] But if he was already planning to make savings in town and country, then he was equally giving thought to cementing his finances more strongly. For that reason, before 1806 was out he would acquire the first of three properties he would be purchasing in the near future.

In all probability the artist spent this summer in London and Isleworth, quietly painting, fishing and sailing his boat. He also saw the Soanes on a number of occasions. On 7 August he wrote to Lord Elgin to thank him for the chance to see the marbles recently imported from Athens. Turner thought they demonstrated 'the most brilliant period of human nature'. To augment his comment he quoted an epigram from the *Ars Poetica* of Horace (65 BCE–8 BCE): 'Graiis ingenium. Graiis dedit ore rotundo Musa loqui' (It was the Greeks to whom the Muse gave genius and polished speech).[34] Given that Turner possessed no Latin, he must have obtained the quote from one of his many contacts or a book. But he was not being pretentious in quoting a language he did not speak; he simply wanted to compliment Lord Elgin in an appropriately classical way. That was a natural thing to do for someone so steeped in decorum.

By the late summer of 1806 the oil painting with which Turner would respond to Wilkie's *Village Politicians* at the Royal Academy in 1807 was well under way. It might possibly depict a blacksmith's shop that in reality stood just a couple of hundred yards to the east

of Ash Grove, William Wells's country cottage in Knockholt.[35] And it was at Ash Grove in October 1806 that Turner embarked upon a project that would heavily involve him for the next thirteen or so years, and greatly inspire him at intervals after that.

Liber Studiorum

According to Clara Wheeler, née Wells, it was nagging by her father that now spurred Turner to begin creating a large-scale print series known as *Liber Studiorum* or 'Book of Studies'.[36] William Wells wanted Turner to set the pictorial standard that would need to be matched by any posthumous reproductions of his images. Visually the work could parallel the Claude-Earlom *Liber Veritatis*. Faced with Wells's nagging, Turner eventually relented, saying, 'Zounds, Gaffer, there will be no peace with you until I begin...well, give me a sheet of paper there, rule the size for me, [and] tell me what subject I should take.' Not only did Wells do this, but he also provided his friend with categories of subject matter within which to place his images.

Before the artist left for home, and with Clara Wells looking on,[37] he had completed the first five drawings from which the prints would be made. William Wells was not being particularly daring in suggesting that Turner should create his own engraving scheme, for through their close friendship he must have known of the Academician's garnering of subscribers to Charles Turner's print of *A shipwreck with Boats endeavouring to save the Crew* (and Wells had been one of those subscribers himself).

It was planned that the *Liber Studiorum* would comprise 100 engravings in total, to be issued in twenty parts with five prints per part. Probably, it was also initially envisaged that 190 sets of the engravings would be printed, although fewer than 160 sets would be sold.[38] But little can Turner have realised the immense production and distribution difficulties that lay ahead. Where all publishing ventures are concerned (but especially self-publishing ones), those involved in the project have to remain completely focused upon selling; the final products cannot be relied upon simply to sell themselves, as Turner would discover the hard way. However, in October 1806 the idea of responding to the Earlom *Liber Veritatis* – and, by means of it, of responding artistically in a large-scale way to Claude and to many other artists including Titian, Rembrandt and Poussin – appeared very attractive indeed.

That Turner had the Earlom *Liber Veritatis* in mind when he embarked upon *Liber Studiorum* is made clear by the fact that he created his preliminary ink and watercolour drawings in a range of hues that never stray very far from the warm browns used by Richard Earlom to ink his plates.[39] Naturally, by eventually according the new work a very similar title and by using the same dead language for its name, Turner wanted to link the two publications openly, if only to declare how much further in visual sophistication he could advance the etching and mezzotint techniques employed by the eighteenth-century engraver. And given that *Liber Studiorum* would include a marine category, he may also have intended his title to relate to a publication by J. T. Serres and his brother Dominique (1763–1823). This was the *Liber Nauticus*, the first part of which had appeared in 1805, while its second part was issued in September 1806.

It is probable that Turner would use the word 'Studies' in his title because *Liber Studiorum* was intended to act as an educational primer in a Britain that was largely starved of instruction in painting and drawing, and where teach-yourself painting and drawing manuals flourished in consequence.[40] By demonstrating the nature of pictorial coherence, by showing how historical subject matter could be emotionally, associatively and formally enhanced by means of landscape settings, by revealing how breadth and grandeur could be achieved within a relatively small space in landscape and marine depictions, by conveying that beauty and grandeur enjoyed boundless aesthetic validity, by setting new standards for the engraved representation of architecture, by imbuing humble pastoral subjects with immense life and charm, and by proclaiming that tonality could generate enormous visual impact with only a little assistance from colour, *Liber Studiorum* would always have much to impart educationally, at least where fairly advanced students were concerned. In this respect, Turner probably intended his 'Book of Studies' to act upon its viewers in much the same way that Earlom's *Liber Veritatis* had acted upon him early in 1799 when, despite its many visual shortcomings, it had enormously expanded his comprehension of Claude's art. In the age before photography, *Liber Studiorum* would undoubtedly become the finest single aid to a wide understanding of Turner's art. Naturally, it would also demonstrate his immense range.

Clara Wells claimed that her father was solely responsible for arranging 'the subjects, Pastoral, Architectural, &c, &c, as they now stand'.[41] If that is true, then from the start Turner's friend had envisaged that all of the images to be created for *Liber Studiorum* would be placed within categories, and that single, identificatory capital letters denoting those groupings would appear on the prints themselves. The planned categories were 'Historical', 'Architectural', 'Mountainous', 'Marine', 'Pastoral' and 'Elegant Pastoral'.[42] The latter term proved necessary in order to distinguish between common or farmyard pastoralism and idealised pastoralism, of the type to be frequently encountered in the works of, say, Claude and Poussin.[43]

If Wells did think up those groupings, then their scope demonstrates his understanding of his friend's range. The fact that someone else devised the categories would also explain why Turner would feel free to cut across them completely (as in a depiction of a stormy

337 *Woman and Tambourine*, October 1806, pencil and watercolour on paper, 7¼ × 10⅛ (18.6 × 25.6), Turner Bequest CXVI-B, Tate Britain, London.

and desolate Solway Moss within the 'Pastoral' classification), or simply refuse to be limited by them (as in a view of Hindhead in Surrey, for its 894-foot height hardly justifies its inclusion in the 'Mountainous' category). If Wells instituted the 'Historical' classification, that would certainly demonstrate his awareness that the loftiest branch of art was of prime importance to his friend, for historical subjects could easily have been subsumed within all the other categories except the one devoted to simple pastoralism (and, even then, Turner could probably have effected such a fusion without too much effort, had he so desired).

Of the five drawings made at Knockholt in front of Clara Wells in October 1806, four were elaborated in reverse, for Turner anticipated that the engraver would have to copy them in that form in order for them not to appear back to front when printed.[44] However, drawing them that way was inhibiting, which was why Turner would make all the further *Liber Studiorum* drawings the correct way around, thereby shifting the reversal problem on to the engraving stages of the proceedings.[45]

Among the first batch of images was *Woman and Tambourine* (fig. 337). This is a variant view of the ruined bridge that had originally been drawn in pencil and later sketched in oils near Runnymede or the ruins of Ankerwycke Priory in 1805 (see fig. 327). Added to the new version were the figures of Pallas Athene, who has laid aside her arms; Eros, who dances before her; and Aphrodite, who supplies the dance rhythm on a tambourine.[46] Collectively they project an allegory of peace, love and harmony instead of war, a very pertinent message in 1806 and one that thematically harkens back to the *Britain at Peace* of 1793 (see fig. 91).

338 *Bridge and Cows*, October 1806, pencil and watercolour on paper, 7¼ × 10⅛ (18.5 × 258), Turner Bequest CXVI-A, Tate Britain, London.

339 *Bridge and Cows*, etching by J. M. W. Turner for *Liber Studiorum*, c.1807, image size 8 × 11¼ (20.5 × 28.5), British Museum, London.

In *Bridge and Cows* (fig. 338) Turner paid William Wells a compliment, for stylistically and compositionally the image owes a great deal to Gainsborough, drawings by whom Wells had recently reproduced as soft-ground etchings.[47] Turner's preliminary etching for the print (fig. 339) demonstrates the immense quality and confidence of his draughtsmanship.

Undoubtedly Turner began a large number of *Liber Studiorum* drawings in the weeks following his return from Knockholt. Until the houses on the far side of Harley Street increasingly blocked off the autumn morning sunlight from his ground-floor watercolour studios, and thus made working there difficult, those rooms must have been filled with sheets of paper all bearing the very dark pen-and-ink lines and the rich brown washes required by the *Liber Studiorum* designs. And during this period Turner sounded out Charles Turner, Tom Girtin's elder brother John (1773–c.1820), and the landscape painter and aquatint engraver Frederick Christian Lewis (1779–1856) about possibly engraving the images. The first of these engravers would reproduce many of the drawings, the second none of them, the third simply one.

On 2 December Turner acquired at auction 'A Freehold Estate comprising A Cottage, with about Half an Acre (more or less) of ORCHARDING / SITUATE AT LEE CLUMP about three miles from *Missenden*, in the County of Bucks'.[48] He paid £95 for the property. At the time, its sole tenant was liable for an annual rent of £4-10s. But Turner would not be able to obtain possession of the holding until 1809, for it would transpire that it had been put on the market by the relatives of an owner who had been committed to a mental asylum. As a consequence, the Lord Chancellor's office had to approve the sale, which it would do on 1 June 1808, with the freehold being released to Turner on 1 May 1809. Only then would he be able to claim the rent due since 26 December 1806. Including the initial £20 deposit paid to the auctioneer, the property would finally cost him £119-5s, including £16 in legal fees.[49]

Because of the delay involved in obtaining possession of this property, Turner cannot have acquired it because he contemplated moving there himself; after all, how could gaining access to it at some point in the future have helped his living arrangements in 1806 or improved his finances at that time? Admittedly, he would obtain long-term rental income from the cottage and its land, although it would take him twenty-six years and five months to recoup his investment by that means. Still, as events would demonstrate, Lee Clump would at least afford him a return, which was more than could be said of the Dry Sugar Work tontine of the previous year.

Yet two other advantages would accrue to Turner from the Lee Clump property. The first was that by obtaining more than forty shillings of rent annually, he would become a forty-shilling freeholder. This would give him the right to vote in parliamentary elections in Buckinghamshire, for previously he had only ever been a tenant who possessed no parliamentary voting rights anywhere. Moreover, he had acquired a solid asset. He wanted to cement his core finances even further, not only in government stock but equally in property. Soon he would add two more pieces of land and a country villa to that holding. The thinking behind such moves is clear: if those who criticised his works caused a lasting depression in his sales, then he would still possess solid assets that would shield him from the dreadful fate faced by artists such as Mauritius Lowe. As always, Turner worked hard to protect himself against all that life could throw at him.

Turner attended the 10 December General Assembly meeting held to celebrate the 38th birthday of the Royal Academy, elect its President and distribute its prizes. Normally the presidential election was a mere formality, but having helped to vote Benjamin West out of office the previous year, Turner now helped restore him to that position, for James Wyatt had turned out to be a complete nullity where the highest and most politically important post in the British art world was concerned. Of all his many sins against the office of PRA, perhaps the worst had been his failure to set foot in Somerset House since June 1806. In his favour it must be said that he fully recognised his defects. That is why he did not contest the election but instead resigned as President on the morning of the poll, while recommending in a letter to the Royal Academy Secretary that West be re-elected in his place.[50] Yet a major benefit had accrued from Wyatt's inactivity within Somerset House: his short turn at the helm had allowed tempers within the Royal Academy to cool, even if his fellow members of the Court party had been gravely disappointed, due to their expectations of all the marvellous things he would be doing for them when President. But after the Battle of Trafalgar, with its ending of the threat of French invasion, the paranoia within the Royal Academy had greatly subsided, and this also helped West regain his former position.[51] He would retain it until his death in 1820.

On the day after the 10 December General Assembly meeting, the minor painter Edward Edwards ARA passed away. Born in 1738, he had been the very first student in the Royal Academy Schools when they had opened way back in 1769. In 1788 he had been appointed the Teacher of Perspective to the Royal Academy. In that role he had furnished courses of private lessons to any Schools students sufficiently interested in the subject. But because no public lectures on the science had been given in Somerset House since 1784, his death would soon force the Royal Academy to take stock. The conclusion it would reach would have huge ramifications for both Turner's life and art.

19

Another Grand Title

November 1806 to December 1807

By now Turner possessed £2,002-7s-5d in the Bank of England.[1] Having divested himself of Syon Ferry House by late October or early November 1806, he transferred his second home to 6 West End, Upper Mall, Hammersmith, probably because it was cheaper and nearer to town. Although he had perhaps looked for a house to rent 'abt. 10 or 12 miles from London', as Thomas Daniell had been told was his intention the previous May, this must be what he found in the end. The new alternative abode stood on the banks of the Thames not far from St Nicholas's Church, Chiswick, just six or so miles from Harley Street. It answered to Turner's continuing need for semi-rural peace and quiet, not to mention the pleasures of being able to fish at any time. For watercolour purposes, the immediate availability of a boundless supply of clean water was no less important.

Unfortunately we possess no images of the house, although the artist did draw the view looking towards a winter sunset either from it or from nearby (fig. 340). According to a member of the Pre-Raphaelite Brotherhood, the art historian and art critic Frederick George Stephens (1828–1907), the new residence was 'of a moderate but comfortable size, and its garden, intersected by the Church Path, extended to the water's edge. The house, a white one, with another house at its side, was on the north of the Church Path' that would later become Chiswick Mall.[2] The garden contained a summerhouse that would be used as a watercolour studio in warm weather.

During his early tenure of the property, Turner would almost certainly make a number of *Liber Studiorum* drawings there, in addition to those elaborated in Harley Street.

340 *View from Upper Mall, Hammersmith, looking westwards towards sunset with a separate sketch of a standing man*, c.1807, pencil on paper, 4⅝ × 7⅜ (11.7 × 18.7), fol. 41v of the *Spithead* sketchbook, Turner Bequest C, Tate Britain, London.

Detail of fig. 347.

Sexuality and the Divine

Two biographically intriguing *Liber Studiorum* drawings appear to have been developed between January 1807 and April 1808. Both of them depict Roman ruins set amid Italianate scenery, as well as men wearing turbans and dhotis. It has convincingly been argued that Turner introduced the Indian-looking men in order to ally himself with the claim that Graeco-Roman mythology and Hinduism shared common roots.[3] The painter might well have derived this idea from 'A dissertation concerning the Customs, Manners, Language, Religion and Philosophy of the Hindoos' by Alexander Dow (1735–1779), published in 1768; from an essay 'On the Chronology of the Hindus' by Sir William Jones (1746–1794) of 1789; and from another essay by the same writer entitled 'On the Gods of Greece, Italy and India', published in 1790.

Around the same time that Turner made the two *Liber Studiorum* drawings, he also began the *Finance* sketchbook that would remain in use until about 1814.[4] On one of its pages he transcribed a passage by Dow relating to the Hindu god of creation, Brahma. On the next page he transcribed a section of Jones's essay 'On the Chronology of the Hindus' that relates to the magnitude and longevity of Brahma, as well as a passage from Jones's 'On the Gods of Greece, Italy and India' that linked Indian gods – most notably Brahma and Kali, the goddess of eternal energy, change and time – to Greek and Roman divinities invested with the same powers. And on the following page he wrote 'Worship of the Lingam or Phallus'.[5] This refers to 'An Account of the Remains of the Worship of Priapus lately existing in Isernia in the Kingdom of Naples' by Richard Payne Knight, which had been published by the Society of Dilettanti in 1786.

During the 1770s Payne Knight, having rejected Christianity, had begun researching the Roman worship of Priapus that had resulted in the creation of a great many depictions of the male organ. For Knight, the worshippers of Priapus had regarded their god as a force of nature that creates, destroys and renews both life and matter throughout the universe, with sexual congress in some form or other playing the central role in the generative process. Turner first came into direct contact with Payne Knight early in 1807 in connection with the commissioning of an oil painting, *The unpaid bill, or the Dentist reproving his son's prodigality* (see fig. 358), which will be discussed below. Because of the close contact of painter and patron at this time and the note concerning the phallus in the *Finance* sketchbook, it seems very likely that Knight gave or lent Turner a copy of his study of the worship of Priapus. In turn, that reading may have led to the creation of a particular sexual image.

Given Turner's commitment to life drawing, by 1807 he had indubitably drawn a great many naked men and women. Most of them were drawn in the life class, or perhaps all of them were. Occasionally he had given a slight emphasis to the genital regions of nude women, but those stresses cannot necessarily be construed as sexual. On one occasion he had caught sight of a woman's genitals when they had been accidentally exposed in public, and on a voyeuristic impulse he had included them in his depiction of the person to whom they belonged.[6] Yet in the *Finance* sketchbook we encounter an image of a man and a woman locked together in sexual congress (fig. 341).

Here the genitals of both parties are tonally emphasised, and the male figure is anatomically distorted in order to prevent his shoulder from blocking our view of the woman's head. Just as Turner could often move around the components of his landscapes for a variety of reasons, so he could equally do so with parts of his figures, as this sketch demonstrates. Given that the sketchbook in which the drawing appears also contains the notes relating to Payne Knight's 'An Account of the Remains of the Worship of Priapus', it is possible that if the rough drawing dated from 1807 or not long afterwards, then it had been inspired by Knight's essay.

Other drawings of a sexual nature in the Turner Bequest might just as easily have derived from ideas expressed by Payne Knight. They include a single sheet containing three sexually explicit drawings that were created at some point between 1805 and 1815,[7] as well as a sequence of very cursory pencil sketches in the *Academy Auditing* sketchbook that would probably be made between about 1809 and 1823.[8] One drawing in the latter group depicts a crouching satyr who is reaching out for a female. He sports a gigantic penis (fig. 342) and seems the very embodiment of priapism. As the size of his organ proves, the entire group of sketchbook drawings emanated from the imagination. That could well have been the case with the rest of Turner's erotic drawings too. But beyond a possible Payne Knight connection, the artist's precise reasons for making such works are not at all clear, although that uncertainty will never prevent biographers, novelists, playwrights and filmmakers from perpetually filling the resulting voids with their own sexual fantasies, often of a highly lurid and lucrative kind.

Having received payment of £280 by 18 January 1807 from Sir John Leicester for the painting of Walton bridges and probably for another work that would perhaps be exhibited in his gallery the following spring, on 28 January Turner used £200 of that money to acquire two types of stock. At around the same time, the baronet exchanged his shipwreck scene (see fig. 315) for *Fall of the Rhine at Schaffhausen* (see fig. 334). Possibly his mistress had asked him to do so, for she had lost a nephew at sea and consequently found the cataclysm picture too hard to live with. On 9 February 1807 Sir John paid Turner fifty guineas for the privilege of swapping the two works.[9]

Tragedy struck within Turner's circle on 7 February, for William F. Wells's wife, Mary, died. The cause of her death is unknown, as

341 *Two figures coupling*, fol. 37 of the *Finance* sketchbook, in use between early 1807 and 1814, pencil on paper, 2¾ × 4⅜ (6.9 × 11.2), Turner Bequest CXXII, Tate Britain, London.

was her age when she passed away, but if she was roughly contemporaneous with her husband, then she was probably in her early forties. It was perhaps within a year or so of her death that Turner penned the following in a sketchbook: 'There is not a quality or endowment, faculty or ability which is not in a superior degree possesst by women.' Beneath this he wrote in pencil: 'Vide Mrs Wells. Knockholt, Oct.'[10] The appraisal of women derives from an unidentified source but this ideal view of them and Turner's everyday perspective on them somewhat differed, as his life would demonstrate.

On 10 February Turner participated in the election of a new Academician, in both polls voting for two opposed candidates. This was a serious transgression of the rules. Farington noticed his behaviour but did not comment upon it.[11] Perhaps Turner was demonstrating his disdain for the election or was in his cups. If the former was the case, then he was right to show his contempt, for both candidates were utter mediocrities.

John Opie gave his first lecture as the Royal Academy Professor of Painting on 23 February and it was generally well received. Almost certainly Turner was present, as he probably was at the three discourses that followed at weekly intervals. When those talks would appear in book form in 1809 he would subscribe to the publication and then annotate it in some detail, as will be seen. But poor Opie's health was undermined by the preparation of his lectures, and he would die on 9 April before delivering the fifth of them.

An Important Step

On 26 February 1807, the Royal Academy decided to elect a Professor of Perspective. Receipt of a notice around 2 or 3 March inviting all of the Academicians to apply for the post set Turner thinking. He wanted the Royal Academy not only to possess chairs of painting, sculpture, architecture, perspective, anatomy, ancient history and literature, but also one devoted to landscape painting, with himself as its first incumbent. Yet there was no prospect of that happening, for the majority of Academicians regarded Turner's chosen métièr as a fairly lowly one. This was because they placed it beneath history, portrait and genre painting, each of which laid more emphasis upon humankind and none of which enjoyed professorships. Turner must therefore have concluded that if he could not get to be the very first Royal Academy Professor of Landscape Painting, then the next best thing would be the professorship in perspective. After all, the science had always played a crucial role in landscape painting, while his favoured genre had made a huge contribution to it in return. Clarifying the relationship between perspective and landscape painting could only benefit the visual arts more generally.

In order to discuss the matter, Turner dined with Soane at 13 Lincoln's Inn Fields on Sunday 15 March.[12] Back in January the architect had stated the need for the vacancy to be filled,[13] and their conversation must now have intensified Turner's desire to apply for the post. Consequently, on the following day he took the decisive step and officially applied. He was the only person to do so.[14] Yet despite the fact that he was the sole candidate, there was no guarantee he would be elected. As a result, he must have realised that if

342 *A satyr approaching a naked woman*, c.1810, pencil on paper, 4½ × 7⅜ (11.5 × 18.7), fol. 34 of the *Academy Auditing* sketchbook, Turner Bequest CCX(a), Turner Bequest, Tate Britain, London.

343 *Sheerness and the Isle of Sheppey, with the junction of the Thames and Medway from the Nore*, T.G. 1807, oil on canvas, 42¾ × 56½ (108.6 × 143.5), National Gallery of Art, Washington DC.

he wanted the professorship he would have to be far more courteous towards his fellow Academicians. That was surely a price worth paying. Consequently, in early March 1807 an important shift took place in the way he started behaving towards his peers, with a return to the false humility of old.

The 1807 Turner Gallery Exhibition
?TUESDAY 21 APRIL TO SATURDAY 13 JUNE

This year Turner was unable to open his gallery exactly two weeks before the public opening of the Royal Academy Exhibition because the funeral of John Opie took place on what was probably the planned opening date of Monday 20 April. Turner attended the funeral in a very cold St Paul's Cathedral,[15] and afterwards he accompanied Soane to 13 Lincoln's Inn Fields, where they dined together.[16]

In all likelihood, the Turner Gallery opened the next morning. Once again, Turner had taken out insurance with the Sun Fire Office, this time for £300 on the building and £700 on the paintings (although in 1804 he had insured them for £1,000).[17] As in previous years, no list of exhibits has come to light, but a newspaper report informs us that Thomas Lister Parker had already reserved *Sheerness and the Isle of Sheppey, with the junction of the Thames and Medway from the Nore* (fig. 343). He would pay 200 guineas for it, as Turner would record.[18]

The 5th Earl of Essex visited the show and committed himself to acquiring a second view of Walton bridges to grow out of Turner's 1805 boat trips up the Thames (National Gallery of Victoria, Mel-

bourne).[19] Here the artist had again taken nature and Cuyp as his joint inspirations, but whereas in the earlier painting cattle are depicted on the Thames, now sheep are being washed there. Turner thus represented both principal forms of non-aquatic life supported by the river.

Also possibly exhibited was a depiction of Newark Abbey on the Wey (Yale Center for British Art, New Haven), an evening scene that Turner might well have witnessed from his boat in 1805. The work had perhaps been commissioned by Sir John Leicester or it was now purchased by him. Another likely exhibit was a representation of Cliveden on Thames that owes much to Titian for its textural vibrancy (Turner Bequest, Tate Britain, London). This picture may have been complemented by a view of the mouth of the Thames that was destroyed by fire during the Second World War. And probably during the duration of the show the 3rd Earl of Egremont optioned a somewhat Claudian view of the Thames near Windsor (Petworth House, Sussex). As he had been a pupil at Eton College in the mid-1760s, he therefore enjoyed happy memories of the stretch of river depicted. If this was his motive for promising to purchase the painting, then it may have prompted the canny Turner to paint a view of the Thames at Eton that would be acquired by the nobleman the following year.

Although Turner did not have the five prints constituting the first part of *Liber Studiorum* ready in time for the opening of his exhibition, he did of course possess the drawings they reproduced. The painter David Cox (1783–1859) visited the exhibition and remembered seeing all five designs mounted within a single frame, as well as a prospectus for the scheme hanging on the wall. Probably it was a single, framed sheet.[20] Unfortunately we possess no newspaper reviews of the show, but Benjamin West went round it and later told Farington that he was 'disgusted with what He found there; views on the Thames, crude blotches, nothing could be more vicious'.[21] By 'vicious' he probably meant ruined by defects.

The 1807 Royal Academy Exhibition
FRIDAY 1 MAY TO SATURDAY 20 JUNE

Turner attended the dinner this year, being seated amid a party of nine of Soane's friends and acquaintances who included Callcott, Phillips and Joseph Gandy ARA (1771–1843).[22] Obviously, he was now making an effort to be more sociable.

He had two works on display and both of them were placed in the Great Room. His fairly small panel painting *A country blacksmith disputing upon the price of iron, and the price charged to the butcher for shoeing his poney* (fig. 344) was hung below the line just to the left of centre on the north wall. Immediately to its right was placed Richard Westall's *Flora unveiled by the zephyrs* (private collection), which formed the centrepiece of that wall. And just to the right of the Westall hung David Wilkie's *The Blind Fiddler* (fig. 345).[23] The Turner and the Wilkie therefore exactly balanced one another at eye level on either side of the Westall. They were hung as pendants like this because they had both been influenced by Lowlands genre painting, and they therefore connected visually upon the wall. The hanging of works within the Royal Academy annual exhibitions was very much based upon the creation of such pictorial links, so the pairing of the two paintings followed accepted practice, especially in the Great Room. There is no truth whatsoever in frequently made claims that Turner attempted to put down the Wilkie by heightening the colour of *A country blacksmith* and his other Great Room exhibit just before the 1807 show opened.[24]

Turner had almost certainly begun *A country blacksmith* between 28 March and 16 May 1806, the seven-week lifespan of a government proposal to introduce a tax of forty shillings a ton upon pig iron that had to be abandoned due to strong opposition. He could have first seen the work that prompted him to start the painting, Wilkie's *Village Politicians*, on or after 7 or 8 April 1806 when it had been accepted for display in that year's Royal Academy exhibition, and thus within the period the iron tax was struggling for life. Turner had wanted to demonstrate that he could continue to build upon the example of Lowlands genre painting. Yet in the process he also aspired to make a serious statement about the socio-economic realities of rural existence, something Wilkie had not attempted to do in *Village Politicians*. Nor would the latter probably be at all serious in the picture commissioned by Sir George Beaumont that he planned to exhibit at Somerset House in 1807, as was widely known in advance.

Naturally, the imposition of an iron tax would have impinged greatly upon the cost of horseshoes and the nails with which they were attached, for during this era they were made exclusively of iron. Because ponies and other hard-working animals had to be shod several times annually, the suggested iron tax would necessarily have represented a considerable increase in the overheads of rural tradesmen such as butchers who needed to make their deliveries fairly rapidly across relatively large geographical areas. By entitling his work *A country blacksmith disputing upon the price of iron, and the price charged to the butcher for shoeing his poney*, Turner was therefore implying that blacksmiths were financially trapped between a government that taxed them and the customers they served. Although there was no longer any prospect of pig iron being taxed during most of the period in which this picture was painted, Turner was still able to use the memory of that threatened impost to make a moral point about a major difficulty of taxation more generally: someone always gets squeezed by it.

Turner might have learned of the iron tax from newspapers such as the *Times*, which on 1 May 1806 had specifically calculated what

344 *A country blacksmith disputing upon the price of iron, and the price charged to the butcher for shoeing his poney*, R.A. 1807 (135), oil on pine panel, 21⅝ × 30⅝ (55 × 78), Tate Britain, London.

the levy would cost blacksmiths in terms of horseshoes and nails when animals needed to be shod at least eight times a year. Probably the strong similarity between the blacksmith in Turner's painting and the artist himself (fig. 346) merely reflects the fact that he had served as his own model, using a mirror for the purpose. The pictorial arrangement of the smithy, its lighting, and the distribution of its foreground objects all demonstrate the influence of Teniers, although the people lack the satirical edge that is often to be found in similar interiors by the Flemish painter. To cement the link with Teniers, a very Teniers-like man wearing a flat, red Lowlands cap stands in the open doorway at the back of the shop. As we have seen, Turner had been putting such rough-hewn figures and their distinctive headgear into his marine pictures for years by 1807. Because he had been irritated the previous year by the critical response to Wilkie and disregard of the fact that he himself had been the painter who had first brought Teniers back into creative circulation within recent British art, in *A country blacksmith* he reasserted his creative link with Teniers and the tradition of genre painting the latter represented. The picture presents us with an unadorned slice of country life, entirely free of class-condescension or humour at the expense of the

345 David Wilkie, *The Blind Fiddler*, R.A. 1807 (147), oil on mahogany panel, 22¾ × 31¾ (57.8 × 79.4), Tate Britain, London.

346 *A country blacksmith disputing upon the price of iron, and the price charged to the butcher for shoeing his poney* (detail of fig. 344).

persons depicted (unlike Wilkie's *Village Politicians*). Indeed, it constitutes a deeply affectionate statement about the verities of rural existence, and an assertion of how dignity, beauty and atmosphere are to be found in even the humblest of surroundings.

Turner's other exhibition submission this year was *Sun rising through vapour; fishermen cleaning and selling fish* (fig. 347). Although its title does not state as much, on several occasions Turner would later make it evident that he thought of the scene as a Dutch one, and that it was consequently populated by Dutch fishermen.[25] However, we cannot be looking at a view on the North Sea coast of Holland, for the sun never rises off that principally west-facing coastline.[26] The pier on the right closely resembles the one at Margate that Turner had depicted in the oil painting he gave to Samuel Dobree in 1804, as related above.[27] But this is not the only pictorial component that makes evident the synthesised nature of the image, and that it is therefore a construct of the type recommended by Royal Academy doctrine and by Reynolds in particular. Thus the smaller boats owe a great deal to the vessels often depicted by the Dutch marine painter Jan van de Cappelle (1626–1679), while the large ship in the distance was modelled upon a craft that had originally been portrayed by Willem van de Velde the younger. And then there is the golden light, which is deeply indebted to Aelbert Cuyp. Clearly, Turner brought together a misty sunrise he might have witnessed on the Medway fairly recently, a pier at Margate he had known since childhood, a group of vessels familiar to him from a long acquaintance with both Dutch marine paintings and prints – the latter of which were probably present in large numbers in his collection by now – and figures and costumes elaborated from a thorough knowledge of the works of David Teniers the younger. This last connection is particularly apparent in the man wearing a flat, red Lowlands cap who stands at the centre with his hands behind his back. In stance, form, clothing, colour of headgear and the angle at which we view him, he closely resembles an onlooker in a depiction of a village fair by Teniers (Staatliche Kunsthalle, Karlsruhe) that Turner had enjoyed more than one opportunity to see in painted form, either in London or in Sussex, or by means of an engraving.[28]

On the whole, the newspaper critics were positive about Turner's two Royal Academy exhibits of 1807, with the *Sun* of 24 April, the *Morning Post* and the *Star* of 7 May and the *Daily Advertiser*, the *Oracle* and the *True Briton* of 21 May all finding *A country blacksmith* praiseworthy, even if some minor complaints were articulated. And *Sun rising through vapour* was found to be 'soft, harmonious, and beautiful' by the *Cabinet; or, Monthly Report of Polite Literature* for February–June 1807. This response was echoed by the *English Chronicle* of 2–5 June, which called it 'an exquisite production'.

The paintings generated mixed responses in Turner's fellow artists. Richard Westall thought that *Sun rising through vapour* was inferior

347 *Sun rising through vapour; fishermen cleaning and selling fish*, R.A. 1807 (162), oil on canvas, 53 × 70½ (134.5 × 179), The National Gallery, London.

to Turner's 'former productions', but he regarded *A country blacksmith* as being 'very clever'.²⁹ And later in the season, Smirke would call both of Turner's exhibits 'excellent'.³⁰ On the other hand, Benjamin West told Lawrence and Farington that 'Turner has greatly fallen off in a large Sea piece. He seems to have run wild with conceit.'³¹ By this he may have meant that Turner's vast talent had led to arrogance – which is to use the word 'conceit' in its most common modern sense – and that such conceit had engendered a disdain for convincing representationalism. On the other hand, West may have been complaining that Turner had let his imagination run wild, for by the early nineteenth century the word 'conceit' often signified an imaginative conception or flight of fancy. If that was West's intended meaning, then his critique was extremely odd, for by 1807 he himself had painted many a work in which he had let his imagination run not merely wild but completely riot, albeit with apocalyptic imagery. Yet while he must have thought it was acceptable to bring imaginative abandon to historical subjects, he may have considered it an entirely different matter to do so in landscapes and seascapes. Predictably, Sir George Beaumont could make nothing of Turner's pictures, asserting they had 'no *execution*

& that *Loutherbergh* was superior to him'. Henry Thomson reacted to this by declaring: 'He wd. Rather have a sketch by Turner than all Loutherbergh had ever done.' Wilkie 'concurred in giving a preference to Turner'.[32]

While the 1807 Exhibition was in progress, Sir John Leicester enquired into the price of *A country blacksmith*. Having ascertained that Wilkie had received 100 guineas for *The Blind Fiddler*, Turner asked the same,[33] which the baronet happily paid on 9 January 1808,[34] almost seven months after the 1807 Royal Academy Exhibition had ended.

Twickenham

On Monday 4 May 1807 – and thus on the very day the Royal Academy Exhibition opened its doors publicly rather than privately – an important transfer of land was finalised for Turner. Recently he had committed himself to purchasing two parcels of 'Copyhold or Customary Land' down in Twickenham,[35] just south of Isleworth and to the west of Richmond. To that end he had sold stock to release £550 in cash.[36] This covered more than two-thirds of the amount needed for the acquisitions.

One of the plots abutting 'north on the road leading from Twickenham to Richmond Bridge' was entitled 'Sand Pit Close', and it was 'more or less' three acres in size.[37] Turner would later build a small country villa on it. A dwelling registered for the local Poor Rate to someone named Brown already existed on the site. The other plot formed part of a larger parcel of land known as Holloway Shot, and it straddled a fork in the road leading from Isleworth to Twickenham in one direction, and to Richmond Bridge in the other.

Turner appears to have paid £400 for the Sand Pit Close site and £500 for the Holloway Shot site.[38] The £550 released by the 1807 stock sales left a residue of £350 payable. That balance would apparently be paid in four instalments by May 1809 or slightly later.[39] Doubtless the vendor was happy to wait for his money because he would be regularly receiving some or all of it in cash.

The painter would be in no hurry to develop the Sand Pit Close site, obviously because he wanted to think carefully about precisely where to build on it, and how to do so architecturally. To the latter end, during the rest of 1807 and over the following four years he would examine a number of books dealing with country villas and cottages.[40] There were many of these to choose from because the construction of such properties was very much in vogue.

Turner consulted Soane during the gestation process of his villa; indeed, a dialogue on the subject took place over dinner at 13 Lincoln's Inn Fields on 4 May, the very same day the land transfer document was signed.[41] It is likely that Soane subsequently visited the Sand Pit Close site with Turner to advise on its potential. If that was the case, then the two of them might have strolled down to the Thames to indulge in some fishing afterwards.

The first part of *Liber Studiorum* appeared on Thursday 11 June.[42] There were five prints in the set, some of the drawings for which we have already discussed. They were *Bridge and Cows*, *Woman and Tambourine*, *Scene on the French Coast*, *Basle* and *Jason*. All of them had been drawn and etched by Turner, engraved in mezzotint by Charles Turner and printed by a specialist printer in a variety of brown inks. Given that the engravings appeared just before the Turner Gallery closed, it must be doubted they went up on the walls, although the painter was able to show a set of them to Farington when the latter visited the exhibition shortly after noon on its very last day, Saturday 13 June (and, of course, Farington could also have seen the framed set of five *Liber Studiorum* drawings hanging on the walls).[43] Perhaps a gradual reconciliation between Turner and Farington began on this day because of the desire by the former to be elected the Royal Academy Professor of Perspective, and his consequent need to have the influential fellow-Academician on his side. But the old warmth between the two of them was gone for ever.

Throughout the late spring and summer of 1807 Turner kept up his usual high rate of production. At Hammersmith he painted in oils in his front garden on the river; he threw 'down his water-colour drawings on the floor' of his summer-house so that he could keep them in view at all times (and simultaneously let them dry); and he memorably remarked that 'lights and a room were absurdities, and that a picture could be painted anywhere'.[44] Working in the open air when the sun was shining greatly accelerated the drying of oils and therefore the speed of working, while the creation of 'water-colour drawings' in the plural demonstrates that the scale-practice, production-line technique remained very much the norm.

Over the summer, Turner acquired stock amounting to £400.[45] There was no shortage of money coming in, or the promise of it, as is made clear by the commission he now received to make four watercolours of the Earl of Essex's family seat, Cassiobury Park in Hertfordshire. These were to be replicated in aquatint and the prints hand-coloured for distribution to the nobleman's friends. In order to gain material for the drawings, the artist visited Cassiobury for a few days during the latter part of August or early in September.[46] And another aristocrat also possibly set Turner to work on his behalf in 1807.

Back in 1800, Sir John Leicester had leased a villa on Cross Deep, the main road that runs along the west bank of the Thames at Twickenham, Middlesex.[47] It is likely he rented the house because the adjacent residence had once belonged to the poet Alexander Pope (1688–1744), who had built it in 1720 and lived in it until his death. Sir John vacated his Twickenham mansion in 1803, where-

348 Study for *Pope's Villa at Twickenham*, summer 1807, pencil on paper, 3⅝ × 6¼ (9.2 × 15.8), fol. 45 of the *River* sketchbook, Turner Bequest XCVI, Tate Britain, London.

Three sketchbooks make it evident that probably in mid-September Turner took his boat up the Thames to Walton, Cobham, Laleham near Chertsey, Penton Hook, Windsor, Eton, Purley near Pangbourne and possibly even further upstream.[51] As one of the sketchbooks contains the pencil study from which the painting of Pope's villa would subsequently be developed, it seems likely that the drawing was made on this trip.

The associations generated by Pope's villa and by thinking about how best to represent that building appear to have intensified Turner's deep-seated need to write poetry during the latter half of 1807 and for some years afterwards. Occasionally he did this in a small notebook he reserved for the writing of verse. It is now in a private collection. The first of its poems, 'The origin of Vermillion or the Loves of Painting and Music', touches upon the sources of the most brilliant and expensive of bright reds, the basis of artists' colours more generally, the maid of Corinth myth regarding the origins of painting in Greek antiquity, William Hogarth's treatise *The Analysis of Beauty* of 1753, the beneficial nature of art, and the role that love plays in the maturation process of the individual.

A further poem on the goddess of Discord in the garden of the Hesperides was probably written many months after Turner's painting of that subject had been exhibited at the British Institution early in 1806.[52] The creation of the poem possibly stemmed from a desire to re-exhibit the canvas but this time with supportive verses in a catalogue. The third poem took as its subject the 'demolition of Pope-House at Twickenham', the underlying theme of which is sorrow, expressed in somewhat exalted terms and using to the full the historical and allegorical associations of place, as befits a versifier who was especially rooted in the works of James Thomson.[53]

Turner was never short of ideas for poems, but only occasionally are they fully accessible, and his rhymes and scans successful. Certainly he possessed a strong feeling for the sounds of words, irrespective of their meanings. Such a grasp of the phonetic potential of language is unsurprising in someone who emerged from a social strata in which the spoken word mostly took precedence over the written one. Always he fully grasped the central roles that associationism and moralism played in the poetry of his time (as well as in much of its painting). Yet on the whole he possessed no distinctive poetic voice, and frequently he was unable to sustain his poetic thoughts for very long. Those limitations can only be partially blamed upon his lifelong failure to master verbal language, let alone his inability to use words in ways that elevate mere rhyming to something more expressive and meaningful. Pictorial images were the vehicles into which he poured his poetics, and they would always act as such. But the writing of poetry did liberate his mind. By doing so, the activity strongly fortified his belief that it was entirely valid to allow his visual imagination

upon it was taken over by Baroness Howe of Langar (1762–1835), the daughter of the late Admiral Lord Howe (1726–1799).[48] In the spring of 1807 she purchased Pope's villa when it came on the market.[49] Because she had no interest in the poet, did not welcome intrusion by his admirers, and required a more modern and spacious residence that would better accommodate her large family and busy social life, she immediately set about razing the villa and replacing it. Such demolition aroused widespread indignation, with the term 'Queen of the Goths' being flung at her. However, in an era before the listing of buildings and preservation orders, nothing could be done to stop her.

Given that Sir John Leicester had recently lived next door to Pope's villa, that he had perhaps resided there because of the poetic connection, that he might conceivably have possessed foreknowledge of Lady Howe's intention to knock down the house, and that the *Examiner* for 8 May 1808 would record him as having recently purchased from Turner an oil painting of the building in the course of its demolition, it seems quite possible that he had commissioned the picture in the first place. As it would be exhibited in the Harley Street gallery in mid-April 1808, it must have been begun by early October 1807 at the very latest, for it would usually have taken the painter at least six months to produce a landscape of such complexity and tonal depth. The sketchbook pencil study from which it was elaborated (fig. 348) contains no indications of light, weather or staffage, but that very bareness would help Turner develop an enormously imaginative and apt response to the demise of the house.[50] The fact that the scene he sketched contained a fallen tree in the foreground would assist him in that endeavour.

349 *Loch Fyne, with Inverary Castle in the distance*, 1807, watercolour on paper, 21½ × 32½ (54.5 × 82.7), Yamanashi Prefectural Museum of Art, Japan.

to roam freely. If he had not scribbled verse, Turner would undoubtedly have been a far more limited painter.

Verses on the subject of Pope's villa also appear as part of a longer poem dealing with James Thomson in the tiny *Greenwich* sketchbook that accompanied Turner on a boat trip from London down to Greenwich that took place almost certainly in late September 1807.[54] The ultimate purpose of this journey appears to have been the creation of a large and fairly detailed pencil study of the view looking towards London from the hill behind the Royal Naval Hospital.[55] Additionally, Turner made several rough sketches of the same vista in the *Greenwich* sketchbook. He was particularly struck by the smog that rose above the distant metropolis, for just such a 'murky veil' would appear in the painting he would subsequently develop from his drawings.

The *Greenwich* sketchbook also contains a list of commissions that must have been written in 1807. Among them is one from Edward Lascelles junior for a large drawing of 'Fort Rock'. This must have been the Fort Roch sketched by the painter in 1802 when travelling from Courmayeur to Aosta in Piedmont.[56] Lascelles had promised the artist the large sum of sixty guineas for this work but he would never own it, for it would not have been made by the time he would largely give up collecting watercolours in 1808. However, the idea would linger in the painter's mind and find its way onto paper by 1815 or not long afterwards, as will be touched upon below. But a drawing commissioned by George Campbell, the 6th Duke of Argyll (1768–1839), would be among the many works created this summer (fig. 349).

The South Coast Tour of October 1807

Possibly on 10 October, Turner embarked upon a tour of East Sussex, south-west Kent, Hampshire and Surrey. He took four sketchbooks with him, one of which was later named the *Spithead* sketchbook.[57] It is likely he began the trip by paying his annual visit to Knockholt.[58] From there he journeyed over the next ten days to Folkestone via Lewes, Newhaven, Seaford, Beachy Head, Eastbourne, Pevensey, Hurstmonceaux Castle, Hastings, Battle, Bodiam Castle, Winchelsea, Rye and Hythe.[59] He probably spent three nights in Hastings, and the same number in Folkestone. En route he took in medieval castles and ruins; the defensive forts known as Martello towers that were placed at strategic intervals around Pevensey Bay and elsewhere; the fish market at Hastings; the site of the Battle of Hastings in 1066; the Royal Military Canal around Romney Marsh, with troops on the march all over the area due to the ever-present fears of French invasion; and the Shorncliffe Barracks at Hythe that housed the Royal Baggage Train, a unit specifically charged with guarding the Royal Military Canal.

At this time the main industries of Folkestone were fishing and smuggling, with many buildings and alleyways within the village being laid out to mask the identities of the smugglers. The illegal trade flourished because of the continental blockade and the resulting high demand for imported goods such as French brandy and Dutch gin, as well as exports such as tea. Being located so near to France, Folkestone was ideally placed to exploit these demands. If, as appears likely, Turner spent the nights of 20–22 October in the village and somehow convinced the locals he was not a spy for the customs and excise service, then he might well have gone out to sea with the Folkestone fishermen. In the process he would have learned a good deal about the methods used to smuggle goods from France. That would explain why, in four watercolours of Folkestone he would make for three different engraving projects between 1822 and 1829, he would demonstrate an unusually intimate knowledge of a particular smuggling technique employed in the area around 1807.[60]

While Turner was at Folkestone the weather broke, and the English Channel turned nasty. As a consequence, two moderately large sea-going vessels were thrown onto the beach a little to the west of the town. There the coastal poor milled around picking up timbers, ropes, nails, bits of canvas and other maritime items they could never have afforded to purchase. Back in his rooms and possibly later the same day, Turner drew what he had witnessed, and did so vividly in pen and ink on several pages within a virtually unused sketchbook (fig. 350).[61]

From Folkestone, Turner travelled to Portsmouth, almost certainly by sea.[62] Perhaps on the morning after his arrival there, he drew a sunrise that would eventually lead to the creation of a painting which has come down to us under the title of *The sun rising through vapour* (see fig. 363), although it enjoys no pictorial relationship to the canvas exhibited under a very similar title at the Royal Academy in 1807. And what Turner apprehended in naval terms at Portsmouth and Spithead in 1807 would remain in his mind for long afterwards. That is why, when he came to depict those great military hubs in the mid-1820s, he would do so not as they appeared in the peacetime conditions of the day but as they had looked martially back in 1807, with huge men-of-war and a plenitude of lesser ships and naval activity much to the fore.[63]

When Turner quit Portsmouth, probably at dawn on Monday 26 October, he began walking to Guildford up the ancient road that led to London via Liphook in Hampshire and Hindhead in Surrey. But first he spent some time exploring the Forest of Bere. He may well have spent a night there after noting a pool in a clearing with men barking chestnut trees for caulking and tanning purposes. It would become the subject of an oil painting exhibited in 1808.

Most likely on the morning of 28 October Turner wandered around Hindhead. In his time this large hill a little to the north-east of Liphook was bare and thus very desolate. He was particularly struck by the Sailor's Stone erected near the summit of the ancillary Gibbet Hill in 1787 to commemorate the murder the previous September of a young sailor on his way to Portsmouth. His three killers had been rapidly apprehended, and after due process they had been tarred and hung in chains from a gibbet on the hill beside the London to Portsmouth road to serve as a warning to others. That

350 *Wrecked vessels aground at Folkestone*, 1807, pen and ink on paper, 4⅝ × 7¼ (11.9 × 18.9), Turner Bequest LXXXVIII-10, Tate Britain, London.

351 *Hind Head hill, on the Portsmouth road*, late autumn 1807 or winter 1807–8, pen and watercolour on paper, 7³⁄₁₆ × 10¼ (18.2 × 25.9), Turner Bequest CXVII-C, Tate Britain, London.

gibbet would remain in place until 1827. Naturally, the corpses no longer hung there by 1807, but Turner was easily able to reconstruct the sight of them swaying in the wind near the Sailor's Stone when he subsequently came to make a drawing of Hindhead and Gibbet Hill as seen distantly across the Devil's Punchbowl from the Portsmouth road in early morning light for the *Liber Studiorum* (fig. 351).[64] Constantly he was on the lookout for ways to bring a landscape into focus, both pictorially and dramatically. The gibbet, corpses and memorial stone certainly achieve that end while injecting a grisly note into the proceedings.[65] And verses that Turner composed and jotted down on the inside back cover of the *Spithead* sketchbook augment the dismal associations of place:

Hind head thou cloud-capt winded hill
In every wind that heaven does fill

On thy dark heath the traveller mourns
Ic[y] night approach & ...groans
The low wan sun had downwards sunk
The steamy Vale looks dark & dank

The doubtful roads scarce [...] seen
Nor sky lights give the doubtful green
But all seem drear & horror

Hark the kreaking Irons
Hark the screaching owl

Turner may have been groping for words here, but knowledge of the 1786 murder and its consequences makes the last two lines appropriately hang in the air, to send a shiver down the spine.

Once Turner reached Guildford, probably by about midday on 28 October, he strolled down the Wey valley to view the ruined chapel on St Catherine's Hill once again. He also looked carefully at a watermill somewhere along the same valley, as well as at farmworkers creating hedges and clearing ditches, respectively to prevent livestock from straying and to improve drainage during the coming winter. The Hindhead, St Catherine's Hill, watermill, and hedging and ditching sketches in the *Spithead* sketchbook would all be transformed into *Liber Studiorum* images within a relatively short time.[66] And when Turner had finished sketching or simply observing, he ambled back to Guildford and caught one of the frequent stagecoaches to London. He could easily have been back in town by about 9 p.m. on 28 October. From the time he left Ash Grove, the tour posited here would have taken fifteen days.

The Hindhead verses were not the only poetry to appear in the *Spithead* sketchbook, for on the inside front cover and flyleaf of the book, Turner wrote out in inaccurate fashion all twelve stanzas of 'A Reckoning with Time' by the poet and playwright George Colman the younger (1762–1836).[67] Possibly the errors derived from the poem having been memorised in Turner's usual fashion. Colman's poem is deservedly forgotten but clearly it held some significance for the painter. This may especially have been the case if he consciously altered the last word of the final stanza from 'Favours' to 'Jewels' (rather than simply changed the word in error). Perhaps he made that alteration in order to heighten the sense of how he would want to be remembered. Here is his version of the last two stanzas, which he ran together:

> For thou hast made me gaily tough
> Inured me to each day that's rough
> In hopes of calm tomorrow
> When Old Mower of us all
> Beneath thy sweeping scythe I fall
> Some few dear friends will <u>follow</u> sorrow
> Then though my idle prose or rhime
> Should half an hour outlive me time
> Pray bid the stone ingravers
> Where'er my bones find church-yard rooms
> Simply to chisel on my tomb
> Thank Time for all his Jewels

Turner was tough and inured to the roughness of life, but clearly the epitaph – be it consciously altered or not – expressed his gratitude for having been granted brilliant talents and experiences in life.

Turner met up with Soane on 30 October.[68] He needed to do so because of the importance to him of obtaining the professorship in perspective. Naturally, the Royal Academy Professor of Architecture was in a good position to give him sage advice. And on the following Monday evening, 2 November, Turner was present when the General Assembly elected three ARAs, one of them James Ward.[69] The Academicians then resolved that Professors of Painting and of Perspective would be elected on 10 December (the need for the first of them having been caused by the death of Opie in April).

Between 2 and 7 September, Britain and Denmark clashed militarily. This ended in Danish capitulation and the seizure by the Royal Navy of more than 160 naval and merchant ships that happened to be in Copenhagen harbour, as well as further vessels in British ports at the time. The first of the Danish prize ships was brought to Spithead, near Portsmouth, on Sunday 1 November.[70] But during the five or so weeks between the General Assembly meeting on 2 November and the professorial elections on 10 December, Turner became fired up by the patriotism that had spread throughout the country upon receiving news of the successful seizure of the Danish fleet. As a consequence, he began a fairly large painting of Danish ships at Spithead he would exhibit in his gallery the following spring, as well as the picture of a pool in the Forest of Bere that would go on display simultaneously. During this autumn he might also have started both a view of London from Greenwich and a homage to James Thomson he would exhibit alongside other pictures in 1809. And as if all this were not enough, he must have been completing a painting of Dorchester Mead he may have begun back in 1805. Views of Richmond hill and bridge, of Purfleet from the Essex shore, of the confluence of the rivers Thames and Medway, of Sheerness, and of Margate under a winter sunrise that had probably all been started in 1806 were significantly advanced at this time, as were depictions of the Thames at Eton and of Pope's villa at Twickenham begun during 1807. Each of the last eight works would be exhibited in the artist's gallery in 1808. And then there were the watercolours. Not only was Turner continuing to make these en masse, but he was also producing new designs for *Liber Studiorum*, fifty of which would go on display in his 1808 exhibition. His rate of production was extraordinary, and it could never have been achieved without the scale practice.

Every one of these works must have been elaborated down in Hammersmith, for the St Marylebone Rate Book for 1807 demonstrates that although Turner paid rates on 64 Harley Street for the Michaelmas quarter beginning on 29 September and for the Christmas quarter beginning on 25 December, he also received a rate rebate of £2-12s-6d 'on account of empty House' during these periods.[71] His rural residency continued into 1808, for the St Mar-

ylebone Rate Book then records that rates of £4-6s-3d were 'Unreceived on account of Empty House'.[72] Clearly, the plan formulated before 10 May 1806 to reside some miles from London and only retain an exhibition gallery in town for 'an Oeconomical motive' had now come to pass.

The painting rooms at 64 Harley Street were not only cramped and fairly dark for most of the day during about three-quarters of each year, but the major part of the rest of the building was dark due to all its wainscotting or oak wall-panelling. That must have depressed Turner somewhat. Only when he would realise in 1809 that the top-lit gallery behind 64 Harley Street could equally act as his studio for most of the year, or even entirely fulfil that function, would he move his main production base back there. Instead, it made sense to work down in Hammersmith throughout the autumn, winter and early spring months. This was particularly the case in winter because the property faced south-east, with nothing standing before it to impede the entrance of any winter sunshine or lesser bright light. As a consequence, it would have provided Turner with a far better winter light than he could have received in Harley Street, where little direct sunlight in winter would ever have penetrated, due to it being blocked by the houses opposite and by those to the south and west.[73] Turner's choice of a rented property that admitted first light at full strength by means of its eastwards frontal orientation can again be noted. Due to his creative needs he was becoming a creature of habit.

For reasons of distance from their normal schools and the like, it seems impossible that any of Sarah Danby's five daughters lived down at Hammersmith, and nor could they have resided at Harley Street, for otherwise the property would hardly have been empty and therefore exempted from rates. In all probability, William cared for the painter down in Hammersmith. Sarah, Hannah and the girls must have lived at another address entirely. That may be why in February 1809 Farington would only be able to grasp a tiny snippet of highly ambiguous information about Turner and Sarah. For any domestic services rendered she cannot have been paid, for her Royal Society of Musicians pension stipulated she could only earn £10 per annum without forgoing her benefits. Instead, Turner probably let her and the girls live rent-free in a house or apartment he owned or rented not too far away from 64 Harley Street. That would have circumvented the financial restriction imposed by the Royal Society of Musicians and gained him the domestic services he needed, as well as kept the girls at a necessary distance from his creative environment.

The extraordinary numbers of works over which Turner was labouring during the winter of 1807–8 surely tell us something about his love life, or lack of it.

Except on a platonic level, clearly he did not trust women, perhaps because of the intense psychological damage wrought by his highly unstable mother during his childhood. He was simply not prepared to sacrifice a moment of his time committing himself to a woman. And when we see the vast amount of work he laboured over during the winter of 1807–8 we can see why. Pictorial ideas flooded into his mind, and their realisation can have left him little or no time for anything but work. That had its compensations, for he could maintain a control over inanimate objects he could never possess over a woman. For Turner, images were far more stable and trustworthy recipients of his ardour and physical energies than members of the opposite sex. As for the pleasures to be derived from a deep-seated sexual and psychological relationship: well, the act of painting can arouse profound mental and physical excitement, while breaking the bounds of what has gone before can even generate euphoria. Then there is the profound satisfaction to be gained from bringing intense beauty into the world. That was probably Turner's greatest reward from his art, and his principal incentive for making it. Through his painting he could create and mentally inhabit worlds far more wondrous than our own. For some creative figures, such pleasures far exceed any gratifications that might derive from a human relationship, even if it is deep-seated. But clearly the liaison with Sarah Danby was not of that order.

More money came in during November and early December.[74] And on 10 December Turner was elected the Royal Academy Professor of Perspective; he had remained the only candidate.[75] Subsequently, Henry Tresham was elected the Royal Academy Professor of Painting, with Turner voting for him. But in a further election to become one of the Visitors in the Schools, Turner was defeated. It might be imagined that his hunger to teach had been sated by his election as Professor of Perspective but not a bit of it. Frustratingly for him at least, Turner the workaholic would have to wait a little longer to realise his hopes of teaching art in practical terms. Still, he had been granted the professorship he craved. That would almost satisfy his quest for cultural status and the possibility of emulating his revered Sir Joshua as a pedagogue.

Although in due course Turner would propagate his view that a command of perspective is integral to the success of representationalism in art, from the outset he cannot have harboured any intentions of limiting his professorial lectures to the science of perspective. He wanted to make those talks something much grander. Sadly, an uncomprehending world would not understand that ambition, or even what on earth he was talking about for most of the time. Yet ultimately such failure would not matter, for in the course of preparing his lectures Turner would reach a long way beyond the mere appearances of things. As a result, his art would move onto a loftier plane entirely.

20

Higher Education
January to September 1808

In connection with his perspective lectures, between 1808 and 1818 Turner embarked upon what was possibly the widest-ranging investigation of the literature on the subject ever undertaken until that time.[1] His two leading books on perspective were those that had formed the mainstay of his own studies with Thomas Malton the younger after 1789: Joshua Kirby's *Dr Brook Taylor's Method of Perspective made easy, both in Theory and Practice* of 1754 and Thomas Malton the elder's *A compleat treatise on perspective in Theory and Practice on the principles of Dr Brook Taylor* of 1775.[2] And further works read by him in the original or in translation would include treatises by Guidobaldo del Monte (1545–1607), Jan Vredeman de Vries (1527–c.1607), Salomon de Caus (1576–1626), Jacques I Androuet du Cerceau (1510–1584), Joseph Moxon (1627–1691), Bernard Lamy (1640–1715), Brook Taylor (1685–1731), John Hamilton, Joseph Highmore (1692–1780), Joseph Priestley (1733–1804), James Ferguson (1710–1776), James Malton (1761–1803 and the younger brother of Turner's former teacher), and John George Wood (d. 1838).[3]

Although relatively little painting from antiquity has survived to the modern day, many anecdotes pertaining to it have come down to us (and the same applies to sculpture and architecture). Turner would use such tales to demonstrate how perspective had often reputedly improved the paintings, sculptures and buildings of antiquity, with important consequences for the stimulation of the imagination, for patronage, for criticism and, above all, for the public perception of the grandeur and dignity of art. And naturally, he was equally interested in the interrelationship of perspective and art since the early Renaissance. To all these ends he read *A Tracte Containing the Artes of Curious Paintings, Carvings, & Buildings* by Giovanni Lomazzo (1538–1600) of 1598; *The Historie of the World* by Pliny the younger (61 BCE–c.112 CE) in a 1601 edition; *The Painting of the Ancients* by Franciscus Junius the younger (1591–1677), published in London in 1638; the *Seven Conferences held in the King of France's Painting Cabinet* by André Félibien (1619–1695), translated from the French in 1740; *The Principles of Painting* by Roger de Piles (1635–1709), first published in English from the French in 1743; *An Essay on Painting* by Count Francesco Algarotti (1712–1764), published in 1764; and the didactic poem *De Arte Graphica* (*The Art of Painting*) by Charles Alphonse du Fresnoy (1611–1668). Originally, this had been written in Latin in 1637, published in French in 1667 and translated into English in 1695 by the poet John Dryden (1631–1700). In his Introduction, Dryden had not only drawn 'A parallel between Painting and Poetry' but also included part of an influential treatise on art by Giovanni Pietro Bellori (1613–1696). In 1783 the poet William Mason (1724–1797) had imaginatively versified du Fresnoy's poem, and Turner had probably long been familiar with this version of the work, for it had appeared in *The Collected Works of Sir Joshua Reynolds*, first published in 1797 (it had been placed there because Reynolds had annotated the du Fresnoy poem in Mason's version,

Detail of fig. 357.

commentaries that were also included in his collected works). At some point, possibly in 1809, Turner would also acquire a newly published edition of Reynolds's *Works*. Certainly he would re-examine Reynolds's *Discourses* at around that time, as well as the latter's annotations to *The Art of Painting* by du Fresnoy.

A large number of the books read by Turner uphold the doctrine of poetic painting. As a consequence, he would praise that theory in his talks, even though it apparently had nothing to do with the science he was meant to be teaching. But quite evidently he thought there was no point in mastering perspective unless it served some great end, at least where painting was concerned. His preferred discipline had to comment upon the world, and the theory of poetic painting provided it with the necessary motives for doing so, while knowledge of perspective would set its results within the most convincing spatial framework.

This is possibly the major reason Turner re-read Reynolds. From the first two *Discourses* he had probably long ago first learned of the need for diligence and the stocking of the mind with knowledge and ideas. The third *Discourse* had perhaps initially furnished him with the requirement that artists should transcend 'mere imitation' and instead pursue ideal beauty, or a beauty to be synthesised from a number of different sources, to result in the capturing of its 'central' or Platonic form. Additionally, he had probably first gained from the third *Discourse* his belief in the equality of painting and poetry. The fourth *Discourse* may have granted him his first insights into the need for invention and the sparking of the imagination, as well as possibly awakened his belief in the need to overcome the temporal limitations that are inherent to fixed images and objects. And as Reynolds's recommendation in the fourth *Discourse* that Claude le Lorrain's method of ideal synthesis be adopted had deeply influenced him, he would promulgate that approach in turn.

Demands made in the sixth *Discourse* for invention, grandeur and the obtaining of knowledge would understandably be reiterated in his own talks, as would Reynolds's celebration of nature as 'the fountain' of art. The consequent need to discern the principles and processes of nature had been of central importance to Turner for many years by 1809, so they too would be disseminated. From the seventh *Discourse* he had acquired a further definition of nature, as well as an exploration of the qualities of poetry, a most useful verification of the huge pictorial benefits of allegory and metaphor, and a statement of the equivalence of beauty and truth, which Reynolds thought to be 'immutable verities'. All of these topics would be fed into Turner's talks on perspective. And Reynolds's discussions in the final three *Discourses* of poetry and painting, ideal beauty, the larger imaginative concept of nature, and the importance of the association of ideas would also inspire Turner in his lectures, as they had been doing in his painting for many years.

From the third and fourth of Reynolds's annotations to du Fresnoy, Turner had in all likelihood first obtained further insights into generalisation and ideal beauty. Soon he would communicate those perceptions to others. The eighth of Reynolds's extended du Fresnoy notes had probably been the source of Turner's thinking on the need for practice always to precede theory. That is why he would reinforce the same point to his audiences in the Great Room cum Lecture Room, for without the acquisition of mechanical skills that would enable the beginner to put theory into practice, theory would remain mere words. Advice on invention and on the necessity of steering carefully between individual nature and nature in general, as found respectively in Reynolds's twelfth and twenty-eighth annotations, had long made its way into Turner's art, which is why it would inevitably do so in his talks as well. And although the Professor of Perspective would understandably explain the great many diagrams and illustrations he would make for his lectures, one cannot but feel that years earlier he had taken heed of Reynolds's admonition in the ninth of the du Fresnoy notes that an artist should 'talk as little as possible of his own works, much less ... praise them'. Admirably – if somewhat frustratingly for our fuller understanding of his art – Turner had almost always followed the first part of this advice where his paintings, drawings and engravings were concerned, and he would continue to do so until he would totter to his grave in 1851.

In 1808 or 1809, Turner would also re-read William Hogarth's *The Analysis of Beauty*, which had first been published in 1753 and which he had probably analysed when a student in the Schools. As the 1810s progressed, a delicate curvilinearity would begin to enter many of Turner's arboreal forms, and it might well have derived from an identification with Hogarth's 'Line of Beauty', an S-shaped or curved line that the latter had considered to be intrinsic to beauty. In Turner's hands subtle serpentine lines would often make his tree forms look extremely graceful, and therefore more beauteous.

Idealism resides at the heart of the theory of poetic painting, and for Turner this meant bringing out what he would term 'the qualities and causes of things', be they the underlying dynamics of buildings, rocks, the elements, water or trees and plants. Such idealism principally derived from demands made by Sir Joshua Reynolds in his *Discourses*, and we shall return to it in due course, as we shall to the prompt for Turner's comment concerning 'the qualities and causes of things' and its exact location. And wholly related to the artist's idealism was the fact that in his lectures he would be particularly attracted to basic forms such as the triangle, the circle, the cube and the cone that are fundamental to the projection of things in space, and therefore in perspective. As we shall presently determine from one of his perspective lectures, for Turner the cube was 'the cornerstone of our fabric', for it contains all the other geometric forms

within it. And because forms such as the triangle, circle, cube and cone are universal, he would detect in that universality evidence of a higher, metaphysical reality.

In support of this belief, in his first talk he would cite verses pertaining to those forms that were taken from Akenside's *Pleasures of the Imagination*, a poem that is wholly orientated towards Platonic philosophy and one in which the selfsame geometric structures are seen to denote the existence of a higher, metaphysical reality. In time, Turner's connection of perspective with Platonic metaphysics, as represented by his identification with Akenside's thinking, would greatly strengthen his art by furthering an idealism that had proven attractive to him ever since he had first come across it in the *Discourses* of Reynolds during the 1790s. In due course we shall determine how this idealism would receive pictorial articulation in his hands. But it would be no coincidence that in the years between 1808 and 1818 when Turner was assiduously reading for his perspective lectures, his visual idealism would come into focus and frequently receive expression in the creation of images of an ideal world, as well as in the finding of a grace and beauty that would make such a place look perfect in all its details. By providing him with the equivalent of a higher education, the study for the perspective lectures and those talks themselves would move his art onto a more elevated plane. While living wholly in this world, he would imagine the existence of a higher one and render it visible in the here and now. The brilliant light and ethereal forms we encounter in late Turner were not prefigurings of French Impressionism; instead, they were visions of another realm entirely.

Understandably, Turner wanted his discourses to rival Reynolds's *Discourses* in their public impact, or at least to be regarded as their continuation. In this respect he would be disappointed, for he lacked the necessary verbal dexterity to attain that end. Moreover, the discussion of perspective was hardly the most efficient vehicle for the realisation of such an ambition. And notwithstanding Turner's high cultural and intellectual aspirations for his perspective lectures, his need for enhanced status both within and beyond the Royal Academy, and his genuine desire to be of service to that institution, understandably he would always itch to get back to his painting. Because of this two-way pull, he would frequently take short-cuts when compiling his preparatory notes and lectures. Thus he would often skip through books or fail to read them all the way through, in the process missing important observations and consequently stressing subsidiary or irrelevant points. Repeatedly, footnotes would catch his eye, while diagrams in some of the foreign-language books would assume an added importance because the texts they supported could not be understood. Due to his unsystematic approach or mere forgetfulness, he would occasionally copy out the same points several times when reading a given book on separate occasions. He would also misread passages or miss their meanings entirely, while periodically going off so tangentially from the passages he was reading that he would reach opposite conclusions to the ones that had set him thinking in the first place. A painter who was always extraordinarily disciplined in his studios could be surprisingly unstructured and sloppy when outside them.

The result of Turner's studies in perspective and his related reading would not be just the half-a-dozen texts required for an annually repeated set of six talks. Instead, he would produce no less than thirty-one such manuscripts or fragmentary texts (and there may originally have been even more of them). They contain upwards of forty separate lecture drafts, for Turner would not necessarily be content to give the same lectures repeatedly. From one year to the next he might reorder the sequence of his talks, or completely rewrite them, or drop an old lecture in favour of a new one on a different topic altogether. Due to the scope of the lectures, the surviving manuscripts cast huge light on his thinking upon a vast range of subjects, not just the science he analysed. And naturally they tell us a great deal about his creative motivations, aspirations and inspirations, as we have seen and shall see time and time again.

The 1808 British Institution Exhibition
MID-FEBRUARY TO MID-APRIL

During the second week in February Turner probably attended one of the daily private viewings of this year's British Institution Exhibition at 52 Pall Mall. In all, 486 works were on display. His two contributions were both placed in the dimly-lit South Room. *The Battle of Trafalgar, as seen from the mizen starboard shrouds of the Victory* (fig. 352) was the completed version of his treatment of the subject that had been exhibited in the 1806 Turner Gallery show, while *Jason, from Ovid's Metamorphosis* (see fig. 272) had been displayed at the Royal Academy in 1802, albeit under a shorter title.

Writing anonymously in the *Review of Publications of Art*, John Landseer stated that Turner had heightened the colour and depth of tone in *The Battle of Trafalgar* since first exhibiting it, as well as revised its composition. Doubtless the artist had also worked hard at improving its figures. Landseer proclaimed it 'a *British epic picture*', called it 'the *first* picture of the kind that has ever, to our knowledge, been exhibited', and stated that it 'suggested the whole of a great naval victory, which we believe has never before been accomplished, if it has ever before been attempted, in a *single* picture'.[4] By this he surely meant that Turner had ignored the constraints of time in order to depict events that had occurred during different phases of the battle, which was certainly a novel approach to the representation of naval engagements. The passable likeness of Lord Nelson that Turner attained might have derived from a popular print, but probably the

352 *The Battle of Trafalgar, as seen from the mizen starboard shrouds of the Victory*, B.I. 1808 (359), oil on canvas, 67¼ × 94 (171 × 239), Tate Britain, London.

painter also remembered the naval hero from having seen him at the 1803 Royal Academy dinner, or even possibly meeting him there.

An overall sense of chaos is one of the great strengths of *The Battle of Trafalgar*, for battle scenes by lesser artists, who had been equally intent upon creating compositional unity and imparting *gravitas*, often look far too neat and tidy. Obviously Turner was aware that on 21 October 1805 there had been little wind off Cape Trafalgar, for that explains why he included so much canvas. Such a massive unfurling of sailcloth afforded the opportunity to create inventive shapes. By placing large amounts of smoke across the image, Turner made the most of his ability to create immensely delicate tones.

Landseer also loved *Jason*, calling it 'a scene of romantic and mysterious solitudes, of a highly poetical character'. Although he questioned the link with Ovid's *Metamorphoses* established by Turner's subtitle – for in that source Jason had not slain the dragon but simply lulled it to sleep with magic potions and spells – Landseer praised the fact that we can only perceive a 'single coil of the dragon-serpent' but are still 'led to imagine much' by 'having already seen him in his dreadful effects' by means of the bones strewn across the foreground. He ended his review by stating: 'Both Mr Turner's performances – Poems we had nearly called them, are calculated to display the vast power which he possesses over the

353 *The Straw Yard*, c.1808, oil on paper, 10¾ × 16¼ (27.3 × 41.2), private collection.

imaginations of his *readers*'.[5] The emphasis Landseer placed upon reading a Turner in order to understand the significance of its imagery, instead of regarding it simply as a source of pleasurable sensory experience, was an important stress that remains wholly relevant today.

The second part of *Liber Studiorum* appeared on 20 February 1808. Once again, Turner etched the five designs and Charles Turner engraved their tones in mezzotint. The images were all ascribed to 'J. M. W. Turner Esq.ʳ R.A.P.P.' as the painter paraded his newfound professorial credentials. By now Charles Turner had also taken over as the publisher of *Liber Studiorum*, probably because his namesake had simply not had the time to sell the first group of prints that had appeared just over eight months earlier. But the engraver did not have the time to go out and sell them either. Understandably, this would test his relationship with Turner.

One of the new engravings was *The Straw Yard*, and Turner made an oil sketch of that image (fig. 353). An object lesson in the scale practice, it is one of his freshest and most delightful efforts. It cannot have taken more than thirty minutes to paint, if that.

Turner acquired Navy £5% Annuities to the value of £164-16s-4d on 2 April.[6] The money behind this purchase derived from the sale of a picture for 200 guineas, with the difference having disappeared into Turner's pocket. According to the painter himself, the buyer was Lord Egremont.[7] The latter is known to have acquired both the 36 × 48 inch, 200 guinea canvas of Windsor Castle from the Thames in brilliant sunlight painted at Isleworth in 1805 (see fig. 320) and an oil of identical proportions now known as *The Thames at Weybridge*.[8] The two canvases still hang at the nobleman's country seat, Petworth House in Sussex. Apparently they were never exhibited by Turner in his gallery. If the 200 guineas did not pay for one of these works, then they must have paid for the other, but they could not have paid for both due to their size and quality.

On Saturday 9 April Turner obtained Sun Fire Insurance Office annual cover for his forthcoming gallery exhibition, and upon the contents of that space when it was employed as a storage area (this latter detail tells us why he could not yet use the gallery as a studio when he was not displaying work there). Again he required £300 building cover, but this year he ramped up the insurance on his

354 *Pope's Villa at Twickenham*, T.G. 1808, oil on canvas, 36 × 47½ (91.5 × 120.6), private collection USA.

paintings back to the £1,000 level for which cover had been obtained in 1804.[9] He gave the insurer his home address as Upper Mall, Hammersmith, which further proves he had stopped residing in the Harley Street house for the time being.

The 1808 Turner Gallery Exhibition
MONDAY 18 APRIL TO SATURDAY 11 JUNE

This year we can be certain that the opening of the Turner Gallery preceded the first public viewing of the Royal Academy Exhibition by exactly two weeks, as had probably been the case in previous years. Due to the closure of the house, visitors now approached the gallery through the side gate on Queen Anne Street West that opened directly onto the narrow yard standing immediately behind 64 Harley Street.

Because John Landseer reviewed this show in the *Review of Publications of Art*, we know the identities of twelve of the paintings on display. Of them, eight were Thames views; one represents a landscape in Hampshire and another an area of sea abutting its shores; and two were historical subjects. Four of the works are reproduced below and two more may be found elsewhere (see figs 333 and 372).

Pope's Villa at Twickenham (fig. 354) had possibly been commissioned by Sir John Leicester because of his love of Pope's verse, and his sadness at the loss of the poet's former residence. It shows the demolition of the house taking place in the distance. We view it from the south-west, and therefore in evening light. According to Landseer, 'the season of the year is also declining' – in other words,

355 *Sheerness as seen from the Nore*, T.G. 1808, oil on canvas, 41½ × 59 (105.4 × 149.8), Museum of Fine Arts, Houston.

it is autumn.[10] On the left, two workmen and a rustic compare relics from the building. They are watched pensively by two young lovers, while two eel fishermen labour on the right. As will be seen, we have Turner's own word for it that the dead tree in the foreground alludes to a weeping willow tree that had long stood in the grounds of Pope's villa and died in 1801, many years after having been planted by the poet.

The work contains one of the finest strokes of associative genius anywhere in Turner's art. This is because, in keeping with the need for dramatic 'propriety' or appropriateness, in *Pope's Villa at Twickenham* he represented the dying house of the dead poet, in the dying part of the day, in the dying part of the year, and with a dead tree that alludes to the dead poet's dead willow in the foreground. Dramatically, everything is of a piece. The associative concept of decorum that can frequently be encountered in the theoretical literature of art since the Renaissance period, and which is often realised in the landscape paintings of Claude and Poussin, was given renewed substance here in a hugely inventive and subtle way. Not for nothing did Landseer go on to state that in *Pope's Villa at Twickenham* the painter had developed 'the arcana of affinities between art and moral sentiment'. It is one of Turner's greatest moral landscapes and, given the relationship of its subject to poetry, it constituted perhaps his most complete fulfilment to date of his belief that painting and poetry were 'Sister Arts'.

There were three depictions of the Thames estuary in the 1808 Turner Gallery show, each of which derived from the January 1806 tour. In *Sheerness as seen from the Nore* (fig. 355) Turner spread out his ships and lesser craft in a wholly uncharacteristic way, so as to

356 *The Confluence of the Thames and the Medway*, T.G. 1808, oil on canvas, 35 × 47 (89 × 119.4), Tate Britain and the National Trust, Petworth House, Sussex.

avoid any jumble whatsoever. Clearly he adopted what was, for him, an unusual approach because he wanted to augment our sense that the Thames was blocked to hostile shipping by the guard-ship on the left (as already noted in connection with the 1806 winter tour). And here too he employed a favourite pictorial stratagem: the immediate juxtaposition of the darkest and lightest areas so as to maximise their impact through contrast. The conjunction greatly enhances the depth of space throughout.

On the other hand, in *The Confluence of the Thames and the Medway* (fig. 356) Turner aligned groups of vessels one in front of another, so as to create jumbled shapes. Such confusion makes the uncluttered areas of the image seem even emptier by contrast. On 8 May the *Examiner* called the *Sheerness* and a view of Purfleet also on display and now in a private collection 'the finest sea-pieces ever painted by a British Artist'.

Another work in the show was *The Forest of Bere* (fig. 357). Turner had completed this canvas in record time, given he had visited the woodland glade he depicted only the previous October. Landseer waxed lyrical about this work, especially its deployment of evening sunlight. The engraver-critic also noted the juxtaposition of the

357 *The Forest of Bere*, T.G. 1808, oil on canvas, 35 × 47 (89 × 119.4), Tate Britain and the National Trust (Lord Egremont Collection), Petworth House.

white horse and dark cow on the right, a tonal contrast that greatly augments the spatiality of the image. He ended by stating that Cuyp would have been humbled by this work. Lord Egremont probably agreed, for he snapped it up. His decision to do so might well have been assisted by the fact that it depicts the productive use of land, which was one of his major interests.

Also on show in Turner's Gallery in 1808 were fifty of the *Liber Studiorum* drawings.[11] It was an incredible achievement to have created so many of them since early October 1806. Such productivity clearly reflects the intense inspiration that the project had generated over those nineteen or so months, as does the imaginative and technical bravura of the drawings themselves.

Financially the exhibition was a huge success, for Turner had probably sold no fewer than seven paintings (although *Pope's Villa at Twickenham* may have been commissioned). A receipt and four Bank of England ledger entries made between 28 June 1808 and 4 February 1809 suggest or prove that 1,150 guineas had been paid in total by the Earls of Essex and Egremont, and by Sir John Leicester. Additionally, Lord Essex paid another 50 guineas for the four Cassiobury watercolours he had ordered the previous summer, while very probably Samuel Dobree paid 300 guineas for *Sheerness as seen from the Nore*.[12] And to top everything, by 29 July Turner would receive 200 guineas from Thomas Lister Parker for *Sheerness and the Isle of Sheppey* which, it will be remembered, had been acquired from the 1807 Turner Gallery exhibition, as had been reported by the *Morning Post* of 6 May that year.[13] If the foregoing figures are correct, that brought the total sum garnered to 1700 guineas or £1785. With this exhibition, therefore, Turner's finances were finally secured for ever. Ironically, he need never have given a thought to being 'Oeconomical' back in 1806.

The 1808 Royal Academy Exhibition
FRIDAY 29 APRIL TO SATURDAY 18 JUNE

According to Farington's unpublished diagram of the proceedings, this year Turner attended the dinner, where he was seated between Thomas Lister Parker and the poet and author William Sotheby (1757–1833). Perhaps Parker was invited for having paid Turner at last. Just beyond Sotheby sat the banker and poet Samuel Rogers (1763–1855). Almost opposite Turner sat Dr Thomas Monro. Somehow it must be doubted that the late Mary Turner ever received mention.

Only a single Turner was on display, even though the painter's own gallery was so packed with pictures they had overspilled into its lower room. His exhibit, *The unpaid bill, or the Dentist reproving his son's prodigality* (fig. 358), was placed in the Great Room.

According to the *Examiner* for 15 May 1808, *The unpaid bill* had been commissioned by Richard Payne Knight to accompany *The Holy Family at Night (the Cradle)* in his collection. It will be recalled that this work was then thought to be by Rembrandt. Yet it may have been the case that Payne Knight also wanted *The unpaid bill* to serve as a pendant to another painting he owned that might have hung on the far side of his supposed Rembrandt. *The Alchemist's Laboratory* (untraced) was then thought to be by David Teniers the younger although today it is ascribed to Gerard Thomas (1663–1721). Possibly Payne Knight wished to juxtapose the sublime – as represented by his (supposed) Rembrandt – with the ridiculous, as denoted by both the Thomas and the Turner, while equally making the point that one serious picture was worth two satires hanging on either side of it.

The clutter in *The unpaid bill* would have made it a very apt pendant to a work that was thought to be by Teniers, for such crowding is often encountered in paintings by the Flemish master, as well as in pictures by his imitators. Moreover, Teniers was renowned for his images of monkeys, and Turner placed just such a creature immediately in front of his seated dentist.

That the dentist reproves his son for prodigality in *The unpaid bill* seems highly ironic, for his own prodigality is made apparent by the immense profusion of objects around him. On the right, Turner visually punned several times by fashioning pieces of furniture and cushions to make them look like molar and canine teeth, just as the canine with its head on the lap of the woman equally constitutes a reference to teeth, albeit in a more oblique manner. Yet there is also a strong likelihood that *The unpaid bill* was created with a serious purpose in mind, for in the Britain of 1808 there was one son who stood out above all others for his father's disapproval of his prodigality, and for his unpaid bills.

This was, of course, George, Prince of Wales, the future King George IV (1762–1830). Payne Knight was no admirer of the heir to the throne, and in 1814 he would gain enormous pleasure from conducting the prince's estranged wife, Princess Caroline (1768–1821), around the British Institution exhibition during a period in which she was almost universally being ostracised due to her rift with her husband.[14] Furthermore, later in the same year Payne Knight would attack the meretricious taste of the Prince of Wales in the *Edinburgh Review*.[15] In 1808 he probably felt the same way, which is why a year or so earlier he had commissioned Turner to paint an indirect attack upon the prince.

In such terms, the young man in Turner's painting who appears to be gazing at himself vainly in a mirror as his father remonstrates with him and his mother looks on sadly could easily constitute a reference to the king's eldest son, the vanity of whom greatly pained his father and mother. Moreover, the empty chair on the right might equally allude to the king by reminding us that the throne of Great Britain periodically remained unoccupied due to the (supposed) madness of King George III. And that *The unpaid bill, or the Dentist reproving his son's prodigality* could have constituted a veiled attack on both George III and his eldest son receives support from the fact that through the window on the left may be seen a building that looks distinctly like the Round Tower of Windsor Castle. That palace was the principal abode of the king at the time.

Naturally, as a Royal Academician, Turner could never have painted a direct attack on the monarch and his heir. But Teniers and his depictions of dentists showed him an indirect way of doing so, and of effecting that purpose in an appropriate manner. This is because, in the era before anaesthetics, he might well have known from painful experience that when dentists root around inside your mouth, they possess absolute power over you. Even absolutists have to give way to them. In that sense a dentist can be master over a king, if only for a while.

By drawing upon Teniers, Turner was also able to comment upon Wilkie. Unsurprisingly, *The unpaid bill, or the Dentist reproving his son's prodigality* has been interpreted as 'a grotesque, parodic *reductio ad absurdam* of Wilkie's proliferation of odds and ends'.[16] By this, the writer was alluding to the Teniers-like jumbles of objects that had been present in the young Scotsman's Royal Academy submissions of 1806 and 1807. However, Turner cannot have created such a jumble in *The unpaid bill* simply because Wilkie had done so before him, for the almost insane mess he painted goes much further than anything to be found in the work of the Scottish artist by 1808. The surgery is almost deranged with clutter and muddle. And therein resides a clue as to Turner's intentions. The disorder was surely intended to parallel the intermittent mental disarray of the monarch. Because the painter knew a thing or two about parental confusion of mind, it was easy for him to connect visual mayhem with psychological disorder. And the unbalanced mood is heightened by the

358 *The unpaid bill, or the Dentist reproving his son's prodigality*, R.A. 1808 (116), oil on canvas, 23⅜ × 31½ (59.4 × 80), private collection USA.

monkey, as well as by a parrot, for such creatures are not usually encountered in dental surgeries either, and they were surely not to be found there even in 1808. Clearly, *The unpaid bill, or the Dentist reproving his son's prodigality* was organised to reflect a chaotic state of mind, just as its title and imagery indirectly comment upon the vanity, prodigality, over acquisition, debt and instability that existed on the political and social pinnacles of British society by 1808. For many, if not even for all of these reasons, Richard Payne Knight must have thought that the painting he had commissioned was perfect, although hardly anyone else has done so for more than 200 years (and least of all the newspaper critics in 1808). When hung next to the supposed Rembrandt, with its profound chiaroscuro, and possibly as a pendant to the rather dark Thomas that was believed to be by Teniers, *The unpaid bill, or the Dentist reproving his son's prodigality* must have looked very brilliant, both in colour and in tone.[17]

By the end of May Turner was becoming very exasperated with Charles Turner for not having yet obtained a quantity of the particular blue paper that was required for the wrappers of the *Liber Studiorum*, the third part of which would be appearing any moment.[18] But even more galling was the engraver's inability to market the publication. Turner was beginning to grasp the limitations of self-publishing.

Officially, the third part of *Liber Studiorum* appeared on 10 June. The preliminary etching of a view of Pembury Mill in Kent (fig. 359) demonstrates the certainty of Turner's draughtsmanship and his ability to attain a sense of distance simply by narrowing the lines in

359 *Pembury Mill, Kent*, etching by J. M. W. Turner for *Liber Studiorum*, 1808, image size 7 × 10¼ (17.9 × 26.1), Tate Britain, London.

360 *The Bridge in Middle Distance*, mezzotint engraving, drawn and etched by J. M. W. Turner, engraved by Charles Turner, issued as Plate 2 in Part III of *Liber Studiorum*, published 10 June 1808, image size 7⅛ × 10⁵⁄₁₆ (18.1 × 26.2), British Museum, London.

places. Arguably the loveliest image in this section of the *Liber* is *The Bridge in Middle Distance* (fig. 360), an ideal landscape that incorporates the bridges at Walton upon Thames.

Following the closure of his gallery on 11 June, Turner was free to go on tour. Probably he did so on Monday 20 June.[19] He must have been tired, what with finishing so many works for his exhibition and with packing up and sending off a number of them afterwards. A fishing trip, a good deal of walking through lovely or interesting scenery, and some painting and sketching, were just what was needed.

The Midlands, Wales and Yorkshire, 1808

Turner probably took a week to make his way to Tabley House, Sir John Leicester's country seat in Cheshire. He travelled there by way of Grantham, which he reached by stagecoach; Belvoir Castle, where he might have viewed a fine collection of paintings by Sir Joshua Reynolds that would be destroyed by fire in 1816 (although, equally, he could have seen them not long before they were turned to ashes); Shelford Manor House, at Radcliffe-on-Trent just outside Nottingham, where he visited relatives once again; Burton-upon-Trent; Egginton; the Dove valley, where he perhaps spent three or four days fishing; and Buxton.[20]

Turner had been invited to Tabley to paint two views of the house, and to do so on site, as also requested by its owner. Being an amateur painter, Sir John probably wanted to watch a master at work and hopefully learn something in the process. Turner quickly determined that both of his pictures would depict virtually the same distant view of Tabley House as perceived in morning light from the far side of Tabley Mere, a lake to the south-west of it. One of them would represent the scene in breezy conditions, the other in a flat calm.

As Sir John Leicester was still in London when Turner arrived at Tabley around 27 June, the painter quickly made an oil sketch in the largest of his four available sketchbooks in order to convey to his patron the view he proposed to depict.[21] When dry, he cut it out, folded it in four and posted it to his patron down in London. And rather than twiddle his thumbs while awaiting the response (and probably the arrival of two blank canvases ordered by Sir John from London as well),[22] he went off to seek piscine pleasures elsewhere.

First he visited Llangollen and Corwen Bridge to fish the river Dee for a few days. While doing so he gave customary thought to the subject of water. Thus he observed that it can reflect light-toned objects in a dark-toned way.[23] Moreover, were it not for the fact that moving water is affected by currents and airflow, it would be possible to employ a polished surface such as a mirror and, say, a ship's model, to gain an idea of what reflections upon water would look like. But such a shortcut would simply send the art of painting toiling 'after truth in vain', as he wrote in a sketchbook.[24] Doubtless some of his lazier colleagues had done just that.

Turner then moved on to Bala, Merionethshire, about sixty miles south-west of Tabley, where Sir John Leicester and his friend from

Grand Tour days, Sir Richard Colt Hoare, jointly owned a 'picturesque cottage in the Italian style' named 'Fach Ddeilliog' or 'small source'.[25] It stands on the south-eastern shore of the largest natural lake in Wales, Llyn Tegid or Lake Bala, which was much favoured by both fly and coarse fishermen, for throughout the year it teemed with brown trout, grayling, salmon, perch, roach and eels (as it still does, although not to the same extent). And from Fach Ddeilliog, Turner may well have subsequently undertaken an excursion to Dolgellau, the Mawddach estuary and Barmouth, about twenty-four or so miles away.[26] On other days he explored the region to the north-west of the lake.

Given that Turner would have been keen to begin the two pictures he was required to paint at Tabley, he cannot have lingered in Wales for very long. Upon returning to Cheshire he may well have found that Sir John Leicester had finally arrived at Tabley (but if not, he surely did so not long afterwards). In any event, the patron soon approved of the proposed depictions of his mansion, but requested that their viewpoints be moved back slightly so as to bring into each of them a large, crenellated water-tower in the gothic style that had been constructed in Tabley Mere at his behest during the 1790s. Probably Turner had omitted it from the preliminary oil sketch because he thought Sir John would not want such a utilitarian building to appear in the image, lest it lower the tone. But the baronet must have been proud of his creation and Turner can only have been delighted to bring it in, for it permitted him to indulge a love of cylindrical structures he had harboured since his youth.

On 11 February 1809 Farington would be told by Callcott that 'Turner while He was at Sir John Leicester's last Summer painted two pictures for Sir John, views of Tabley, of His *250 guinea size*, yet [Henry] Thomson who was there said, That His time was occupied in *fishing* rather than painting. He also began another picture.'[27] One wonders how Callcott had ascertained that Turner had begun 'another picture' at Tabley if his informant was not also Henry Thomson. Yet if the latter did see a third picture being started, then he cannot have thought that Turner's time was *solely* spent fishing. And Farington also got something else wrong, for canvases measuring 36 × 48 inches – and thus of the dimensions of the two Tabley pictures – were not of Turner's '*250 guinea size*'. As we have seen, since the spring of 1804 the painter had been customarily charging 200 guineas for pictures of those dimensions. Moreover, entries in Bank of England stock ledgers might well indicate that 400 guineas is exactly what Sir John would pay for his two views of Tabley.[28]

Upon his return to Tabley, Turner must have immediately sent off to nearby Manchester for a fairly large stretched canvas on which to paint the third picture.[29] This was the *River Scene with Cattle* (Turner Bequest, Tate Britain, London) which would be depicted as hanging in the Picture Gallery at Tabley House in an 1809 signed and dated watercolour by John Chessel Buckler (1793–1894).[30] As it is highly unlikely that *River Scene with Cattle* was begun at Tabley in 1808, taken down to London for further work, and then returned to Tabley by 1809, it must have been entirely painted in the house in 1808. It is not known when it was returned to Turner, but at some point it was sent back to him, eventually to form part of his bequest to the nation. Probably Sir John had been prompted to commission it by seeing sketches made by Turner on the banks of the Mawddach estuary or by Llyn Tegid.

Every morning Turner began painting at first light, and he had usually finished by breakfast time, thereby leaving the rest of each long summer's day free for angling and other pursuits.[31] That is why late risers – who possibly included Henry Thomson – thought he spent all his time fishing. Because he needed the earliest possible light in which to paint, he must have been allocated an east-facing room for use as a studio. He also probably worked on his perspective lectures by re-reading Reynold's *Discourses*, and in particular the second of them. He did so in order to deduce the ideal length of a lecture, and recorded the results in a small sketchbook.[32] Unfortunately, in the process he failed to realise that a good lecture can last for as long as it mesmerises an audience, whereas a bad lecture is overlong after just two minutes, so any theoretical length is irrelevant. And it may also have been at Tabley that Turner read the *Lectures on Rhetoric and Belles Lettres* of 1788 by Hugh Blair (1718–1800), in order to gain tips on how a lecture should be delivered.[33] Sadly but rather predictably, a treatise on language, literary style, taste and rhetoric would not be of much use to a lecturer on perspective. And also at Tabley Turner appears to have written verse and attempted to further his understanding of music, if not even his ability to play it on the flute.[34] But as far as is known, nothing ever came of this initiative.

On Monday 1 August Turner appears to have left Tabley House for Thomas Lister Parker's residence, Browsholme Hall.[35] From there he went on a day or two later to sketch Weathercote Cave, a pothole some seventy feet deep located in one of the wildest and most impressive valleys in the region, and Malham Cove, a large escarpment. Perhaps inclement weather made him forego a visit to Gordale Scar, a narrow limestone gorge some 300 feet in height. However, he would soon explore it, as will be seen. Finally he progressed to Farnley Hall, near Otley, by way of Skipton. Yet when he approached that house, possibly on the afternoon of Friday 5 August 1808, he could little have suspected that he was about to embark upon the closest friendship of his life.

21

'The First Landscape Painter in Europe', 'the First Marine Painter in the World'

September 1808 to June 1809

Turner's new host was Walter Ramsden Hawkesworth Fawkes (fig. 361). Born in 1769, he had attended Westminster School and then gone up to Cambridge to read classics. He had not taken his degree. Subsequently he had toured Switzerland, an experience that later motivated him to collect watercolours of that country. In 1792 he had inherited Farnley Hall (fig. 362). Two years later he married Maria Grimston (1774/5–1813). By 1808 he and his wife had three sons and six daughters. The happy family atmosphere at Farnley struck a deep chord in Turner. Admittedly, he had previously known such domestic pleasures with William Wells, but he had never done so under the roof of any one of his patrons, let alone a patron who would prove to be so enthusiastic about his work.

Fawkes also possessed a large town house at 45 Grosvenor Place, London. The Farnley estate comprised some 15,000 acres of excellent farmland which, by 1796, brought in an annual income of between £7,000 and £8,000.[1] Fawkes was a progressive farmer and promoter of both improved animal husbandry and more harmonious social relations within the farming community.

From the time Fawkes had become 'a reasonable being', he had been 'a Whig, a great big Whig, in defiance of advice, or persecution, of hostility of every kind'.[2] In 1796 he was even reported to have held 'Republican principles', but this comment may simply have been intended to harm him politically.[3] Yet there can be no doubt that many people felt threatened by his liberal-minded outlook, for like Francis Burdett (1770–1844), a radical Member of Parliament with whom he had formed a deep friendship at Westminster school,[4] Fawkes was opposed to slavery, injustice and oppression, to the statutory intolerance of Roman Catholics, to the arbitrary use of power, to the suspension of legal safeguards such as habeas corpus, to the corruptions of a governmental system based upon nepotism, sinecure and political placement, and to the highly undemocratic parliamentary representation of the day. There can be no doubt that over time a number of Fawkes's views would rub off on Turner.

Because of his politics, Fawkes had stood as an independent parliamentary candidate for one of the two Yorkshire county seats in 1796 and 1802. However, he had been forced to withdraw from both elections because of his inability to compete financially with his Tory opponent, Henry Lascelles (1767–1841), who was therefore elected. Yet he did not give up. In September 1806 he had been elected to Parliament on a Whig anti-slavery and economic reform ticket, albeit by default because Henry Lascelles did not stand.

Detail of fig. 365.

Left 361 Attributed to Martin Archer Shee, *Portrait of Walter Fawkes*, c.1817, oil on canvas, 35½ × 27½ (90.1 × 69.8), private collection.

Above 362 The new wing of Farnley Hall near Otley, Yorkshire.

In April 1807, Fawkes lost to Lascelles in the first contested Yorkshire county election to have taken place in sixty-six years. With his paltry £7,000 or £8,000 per annum, he could not match Lascelles. He did, however, force his opponent to spend almost £100,000 to be elected, which probably afforded him some consolation. Fawkes's awareness of such staggering expenditure was the principal reason he terminated his political career, for he could not afford to continue with it. But he maintained his political views, and if anything became even more convinced of the need for parliamentary reform.

Indirectly, Fawkes's Whig interests spilled over into collecting. He was a strong admirer of General Thomas Fairfax (1612–1671), the parliamentarian who had played decisive roles in both the downfall of King Charles I and the restoration of his son. Fawkes was an avid collector of Fairfax memorabilia, and he also owned both the sword and the broad-brimmed hat of Oliver Cromwell (1599–1658), as well as a great many lesser items connected with the Civil War.

Fawkes's career as an art collector had started in 1796, when he began purchasing Old Master paintings.[5] His earliest known connection with Turner had occurred when he had acquired *Glacier, and Source of the Arveron, going up to the Mer de Glace* from the 1803 Royal Academy Exhibition (see fig. 301), although the two men might have met earlier through Thomas Lister Parker, who had possibly been friendly with Fawkes for some years by then.[6] And by 1808 Fawkes also possessed the *Portrait of the Victory in Three Positions, passing the Needles, Isle of Wight* oil painting that had perhaps been displayed in the 1806 Turner Gallery exhibition. Other Turner watercolours in his collection by 1808 included two of the three large alpine views he had commissioned in 1804 for fifty guineas each, both of which had been created for him in that year (see figs 306 and 307).[7]

Turner's 1808 visit to Farnley Hall appears to have lasted three weeks, from 5 to 26 August. On later stays the painter would be accommodated in a bedroom at the north-east corner of a new wing to the house, while an adjacent, smaller room that also faced east would be put at his disposal for use as a studio. However, he may have been allocated those rooms in 1808. Among the places he possibly or certainly visited during this stay were Kirkstall and Bolton Abbeys, Addingham Mill, Barden Tower, and the long ridge on the south side of Wharfedale known as the Chevin, from which excellent views of Otley and a slightly more distant Farnley Hall are obtainable. And fortunately we enjoy a tiny glimpse of Turner at the house this year. Someone named J. T. Allen, about whom we know virtually nothing, would write in 1852 that he had made a 'rude sketch' of

the painter when visiting Farnley. There 'a number of grouse shooters had assembled, – and Turner had adopted the garb of a sportsman. His appearance, as well as his exploits on the moors, were the subject of much mirth.'[8] Given the painter's desire to cut a dash as a sportsman, and his apparently enthusiastic participation in grouse shooting, it may have been this year that saw him acquire a shotgun made by the finest gunmaker of his era, Joseph Manton (1760–1835).[9] And Allen also mentions a group of people accompanying Turner to Gordale Scar so he could sketch the ravine there. That excursion had to have taken place in 1808.[10]

Possibly Turner also went riding, being lent one of the sixteen horses that Fawkes reserved solely for that purpose. He must have gone fishing. Of an evening, there would have been cards and other games in the large, candlelit drawing room. And pleasant domestic music-making might well have served as the background to lengthy conversations between Fawkes and Turner. Given the host's interests, they would have discussed politics, and especially those of Yorkshire, with Fawkes voicing his concerns over the role played locally by the Lascelles family. He might also have sounded off on the seemingly endless war with France.[11] If, as appears likely, he expressed his fierce opposition to slavery, then the painter could have been taken aback, for he would have needed to remain silent about his investment in the Jamaican tontine. But if, on the other hand, Fawkes talked of parliamentary reform, then Turner might have nodded sympathetically, for until he had acquired the Lee Clump property he had been unable to vote.

Fawkes commissioned watercolours of Yorkshire subjects from the sketchbook material the painter had to hand. However, to place orders for continental views, he needed to see the pencil and watercolour sketches made in 1802. Consequently, the two men agreed that a visit to Turner's studio would take place the following winter, when Fawkes next planned to be in London.

Not long after Turner's arrival at Farnley, Walter Fawkes settled his debts by paying him £304-19s-1d.[12] Probably the amount comprised 150 guineas for *the Victory in Three Positions*, 100 guineas for the two large watercolours of Swiss scenery made in 1804, and £42-9s-1d for framing and transportation costs. It might be thought surprising that it took him four years to pay for the drawings, but he had been forced to dig deeply into his pockets to meet the vast expenses incurred in the various parliamentary elections, especially in 1807. We have already commented upon Turner being accustomed to slow payment.

In all likelihood, Turner had returned to town by 28 August. On 28 September he acquired government stock to the value of £204-12s from a payment of 200 guineas he had received from Sir John Leicester on 1 September.[13] This would bring his total worth in government stock to £3,604-16s-11d by the end of 1808.

On 3 December, the General Assembly elected the anatomist and surgeon Anthony Carlisle FRS (1768–1840) to the position of Royal Academy Professor of Anatomy. Turner voted for him.[14] Carlisle's appointment was ironic, for he did not believe that artists needed to know anything about anatomy. In 1800 he had been partly responsible for effecting a breakthrough in the understanding of the electrolysation of water, and in 1804–5 he had given a series of lectures on the musculature of fish. Both topics would have interested Turner if he knew about them, as appears likely. Carlisle would deliver his inaugural set of anatomy lectures early in 1809. Turner is known to have been present at three of them but probably attended all six.[15]

Late in December the Council wrote to both Soane and Turner asking when they would lecture, while on Sunday 8 January 1809 a letter from 'A Constant Reader' in the *Examiner* repeated the question and accused these 'sons of indolence' of sitting around doing nothing but consume turtle soup and venison. Turner responded to this accusation in a speech he delivered soon afterwards to the Royal Academy Club.[16] He stated that a little turtle soup and venison would do the *Examiner* correspondent good, for self-evidently his taste was full of spleen. But in the event, both the Council and the letter writer – who may well have been an Academician – would have to remain patient where he was concerned, for a year was not nearly long enough to prepare a set of lectures on a complex subject like perspective. In fact, it would not be until 1811 that his professorial voice would ring out in the Great Room of Somerset House, although more frequently it would simply mumble.

On 11 February Callcott passed on to Farington the information that Turner had apparently concentrated upon fishing at Tabley House the previous summer, and also begun another picture there. The diarist then went on to record that 'A Mrs Danby, widow of a Musician, now lives with [Turner], she has some children'.[17] Quite evidently, Farington knew nothing more about the liaison, or anything at all about Evelina, for otherwise he would surely have written '*they* have a child'.

The 1809 British Institution Exhibition
THURSDAY 9 FEBRUARY TO MID-APRIL

Turner had a single work on display. *Sun-rising through vapour, with fishermen landing and cleaning their fish* was the same painting he had exhibited at the Royal Academy in 1807 under a slightly different title (see fig. 347). As with his previous exhibits at the British Institution, his entry was placed in the South Room, which was dominated by landscapes. The 1 May issue of the *Monthly Magazine* called the work 'magical'. Yet Turner cannot have relished having his entries to the 52 Pall Mall exhibitions consistently placed in the worst-lit room

363 *The sun rising through vapour*, c.1809, oil on canvas, 27½ × 40 (69 × 102), The Barber Institute of Fine Arts, University of Birmingham.

in the building. Perhaps that is why he would not show there again until 1814. Even then, he would only do so in order to teach the British Institution a lesson, rather than because he particularly wanted or needed to exhibit in its rooms.

In keeping with the promise made the previous August to visit Turner when next in London, on Monday 20 February 1809 Walter Fawkes did so.[18] According to a list dated 'Feb. 20' in the *Greenwich* sketchbook, on this occasion Fawkes ordered four *Liber Studiorum* proofs, a sketch of Addingham Mill and a watercolour of the same building, plus six drawings of further Yorkshire subjects and two alpine landscapes.[19] By about 6 March the Addingham Mill watercolour had been completed,[20] and so the delighted patron commissioned three further Yorkshire subjects and eight more alpine scenes, according to a second list in the same sketchbook.[21]

The dating of these two lists to 1809 is extremely significant, for until now it has often been contended that a number of the alpine landscapes Turner elaborated for Fawkes were made prior to that year, in some cases as much as three years earlier. But three subjects contained on both lists – namely Farnley Hall, Weathercote Cave and Gordale Scar – had never been visited by Turner before August 1808. It therefore follows that the first of the lists had to have been drawn up after that time, namely on the 'Feb. 20' that fell in 1809, rather than during the same month in any previous year. And by definition the two alpine drawings included on the 20 February 1809 list could not have been elaborated prior to that date either (and nor could the eight alpine watercolours that were included on the second list).[22] It has long been observed that in 1809 a major reawakening of interest in alpine scenery occurred on Turner's part, with vital consequences for his art, but these lists explain why it took place.

Fawkes also ordered an oil painting from Turner at this time. Having been impressed by the *Sun rising through vapour; fishermen cleaning and selling fish* of 1807 in the 1809 British Institution show, he now asked Turner to paint him something similar. Moreover, because his only Turner oil, the *Portrait of the Victory in Three Positions*, hung on one side of the drawing room fireplace at Farnley Hall, he asked that the new picture should be made to exactly the same dimensions, so that it could balance the earlier canvas on the other side of the fireplace.[23] Turner quickly set to work, and before long *The sun rising through vapour* (fig. 363) had been completed.[24] Despite its title, this is not a smaller version of the canvas exhibited in 1807 and again in 1809; instead, the two works differ in one crucial respect. The 1807 canvas had been a synthesised image, with elements brought together from the Nore, Margate and the lower reaches of the Thames and Medway, from seventeenth century Dutch art and from the figure-style of David Teniers the younger. But near Portsmouth in October 1807, Turner had rapidly sketched an actual sunrise that had closely resembled the imaginary, composite sunrise he had previously exhibited at Somerset House, both in its overall configuration and in its constituent details.[25] Understandably, he was motivated to set the real scene down on canvas as well, with the result that the picture made for Walter Fawkes necessarily celebrates the fact that life can imitate art.

Another important change in the rules of the Royal Academy was effected on 1 March 1809, when the Council voted to allow all the members of the Royal Academy three or more days prior to the annual exhibition dinner to work on their pictures or varnish them.[26] The first anticipation of these annual Varnishing Days, as they came to be called, had occurred in 1804. By that date they had become necessary as more and more oil paintings jostled for position on the walls of Somerset House, as many of those works were elaborated with increasing speed, and as the techniques employed in their creation frequently led to an uneven drying of surfaces that could only be rectified by varnishing. In time, this change in the rules would permit Turner to augment his public profile, as well as advance the collegiality of the Royal Academy, which he would greatly welcome.

On 15 March Sir John Leicester, under the guise of a 'Man of Fashion',[27] attempted to sell ten paintings at auction. They included four Turners.[28] The reasons given for offering the works for sale were 'want of space' and the possession of 'other Specimens' by the same artists. However, the true cause was lack of ready cash, for Sir John had plenty of hanging space at his disposal, if not in London, then certainly at Tabley. The sale was unsuccessful where any of the works by Turner were concerned, for they failed to meet their reserves and were bought in. The artist cannot have found such a response very heartening.

Perhaps stung into action by the Council letter of enquiry in December 1808, and by the *Examiner* letter in January 1809, at long last Soane lectured as the Royal Academy Professor of Architecture on the evening of 27 March 1809. It was a one-off talk rather than the first of a set of six weekly lectures, but it bought him time before having to lecture more comprehensively. Turner assisted his friend by placing the drawn and engraved lecture illustrations on easels next to the rostrum.[29] Both men took note of the poor lecturing conditions in the Great Room cum Lecture Room and resolved to do something about them. The results of their thinking would begin to make themselves apparent in the autumn.

Two days later, Charles Turner published the fourth part of *Liber Studiorum*. By now the painter lacked all confidence in the engraver's abilities to sell copies of the publication, but because he was overloaded with work, there was nothing he could do to market the venture either. Perhaps the most outstanding of the new prints was *Morpeth* (fig. 364). This is dominated by the large, blank wall of a nearby house that is being repaired and whitewashed. The roofless ruins of Morpeth Castle are visible beyond. Turner's moral is clear: architecturally characterless modern buildings are maintained, while the admirable buildings of yore are simply left to rot.

364 *Morpeth*, etching and mezzotint, drawn and etched by Turner and engraved by Charles Turner, published 29 March 1809 as Plate 21 in Part IV of *Liber Studiorum*, engraved image size 7 × 10¼ (17.7 × 26), British Museum, London.

The 1809 Turner Gallery Exhibition
MONDAY 24 APRIL TO SATURDAY 3 JUNE

This opened exactly a week before the public opening of the Royal Academy exhibition. As in 1808, access to the gallery was by way of Queen Anne Street West, but now an additional reason lay behind that means of access, as will be seen at the end of this chapter. When Farington visited the show on 23 May he was admitted by William Turner, thereby proving that the latter acted as his son's gallery attendant.[30]

There were eighteen exhibits, in the form of a large homage to a major poet, another poetic landscape, but in watercolour, two generalised landscapes, two generalised marine views, eight Thames and Thames estuary scenes, a possible Midlands view, a London panorama, a Welsh landscape and perhaps an early watercolour of a Cambridge subject. One of the Thames estuary depictions was *Fishing upon the Blythe-sand, tide setting in* (Turner Bequest, Tate Britain, London). According to Thornbury, Sir George Beaumont offered to purchase this canvas but Turner refused him.[31] If that was the case, then he must have derived great pleasure from doing so. He had his pride and was not prepared to sell simply to anyone.

By far the largest work on display was *Thomson's Æolian Harp* (fig. 365). Its framed width being above twelve feet, and therefore in excess of the width of the gallery, it must have hung upon one of the 35-foot-long side walls. Why this oil was exhibited within the confines of a space that would never have permitted visitors to step back from it more than about eight feet is hard to fathom, for it would have benefited hugely from being shown in, say, the Great Room at Somerset House, with its far lengthier viewing distances. Moreover, in Turner's Gallery it could only have been seen by a few hundred people at the most, whereas in the Royal Academy it would have been seen by thousands, many of whom might well have responded to it enthusiastically. Possibly Turner kept it back because it still required more work by the first week in April 1809, when all submissions to the Royal Academy had been due.

An Aeolian harp is an instrument that is caused to sound by eddies of air swirling around its strings, thereby creating the necessary vibrations. Understandably, the instrument has long been regarded as the most direct means of musical communication between nature and man. It therefore follows that by linking an Aeolian harp with James Thomson, Turner was declaring the poet to have been the most direct means of verbal communication between nature and man. Aeolian harps had become fashionable as garden accessories in the late eighteenth century, not least of all because Thomson had praised them in his 'Ode on Æolus's Harp' of 1748, as well as in 'The Castle of Indolence' of the same year. Both works were available to Turner in the ninth volume of Anderson's *Complete Poets*.

An eight-quatrain poem by Turner appears beneath the title of this picture in the sole surviving exhibition catalogue. It is dedicated

365 *Thomson's Æolian Harp*, T.G. 1809 (6), oil on canvas, 65⅝ × 120½ (166.7 × 306), Manchester Art Gallery.

to a 'Gentleman at Putney', namely the wealthy distiller, coachmaker and collector William Leader, who had commissioned the work and who would pay for it in September. In the first two quatrains, Thomson's tomb sheds 'tears of Pity' – in the form of dew – over the recently demolished villa of Alexander Pope at Twickenham. In the following two quatrains Turner suggests that some 'liberal hands' should honour Thomson by placing an Aeolian harp amid the upland grove of the gentleman at Putney. Each of the four final quatrains is aptly devoted to a single season and to the effect of that part of the year upon Thomson's Aeolian harp. In its command of language, rhyme, metre and imagery, the poem is one of Turner's more skilful inventions. Possibly it was given a polish by one of his friends.

Stylistically, Thomson's *Æolian Harp* draws heavily upon Claude. Clearly, Turner felt that to equate the poet with the French painter was the highest form of compliment he could pay. But simultaneously he complimented Thomson by including the nine muses implicitly paying homage to the poet. From left to right they can be identified or deduced to be Polyhymnia or 'She of Many Hymns', the muse of heroic hymns; Urania or 'The Heavenly', the muse of astronomy; Euturpe or 'The Giver of Pleasure', the muse of lyric poetry and music; Calliope or 'The Fair-Voiced', the muse of epic poetry who is placing a laurel wreath upon the Aeolian harp erected to the memory of an epic poet; Melpomone or 'The Songstress', the muse of tragedy, who remains in the shadows; Thalia or 'The Flourishing', the muse of comedy and pastoral poetry; Terpsichore or 'The Whirler', the muse of dance; Erato or 'The Lovely', the muse of lyric and love poetry; and Clio or 'The Proclaimer', the muse of history.[32] The youth accompanying Erato is the latter-day equivalent of the putto who traditionally waits upon her. He is attired in garb dating from the time of Antoine Watteau, and thus from the era of James Thomson, for the lives of both artists had overlapped by twenty-one years.[33] Erato and Clio sit before the tomb of James Thomson, brought in from the churchyard of St Mary's, Richmond, where it stands in reality. In the distance may be seen the renowned vista of the Thames looking westwards from Richmond Hill, a view that Thomson had celebrated in *The Seasons*.

In the foreground, honeysuckle and horse chestnut are in bloom, while a silver birch tree buds in the centre.[34] All are signs of spring.

366 *Plowing up Turnips near Slough*, T.G. 1809 (9), oil on canvas, 40⅛ × 51¼ (102 × 130), Tate Britain, London.

On the left a shepherd denotes summer by playing his pipes and tending his flock, while on the right two rustics pass behind Thomson's tomb. One carries a billhook, the other a scythe, tools that are respectively used for pruning and reaping in the autumn. Although there are no obvious denotions of winter, it cannot be far behind in any image alluding to spring, summer and autumn.

Given Turner's desire to pay homage to Thomson in both painting and poetry, and particularly to his love of *The Seasons*, all these allusions are entirely appropriate. It is impossible to understand the picture without them, simply in literal terms. Few painters, if any, have rendered such subtle, appropriate and mellifluous homage to a poet by means of the metaphorical dimensions of art. Clearly, when Turner had pondered the sad fate of Alexander Pope's villa in Twickenham back in 1807–8, he had also been set to thinking about the tomb of James Thomson at Richmond, as can be seen from verses in the *Greenwich* sketchbook, in other sketchbooks and in the 'Verse Book'. One train of thought had led directly to another, producing the desire to pay homage to a further great eighteenth-century poet. The wondrous result was *Thomson's Æolian Harp*.

In *Plowing up Turnips near Slough* (fig. 366), which was also on display, Turner warned of the dangers that indifference to deprivation can entail. We perceive the view looking southwards from near the

367 *Plowing up Turnips near Slough* (detail of fig. 366).

village of Slough soon after dawn, with Windsor Castle dominating the scene. By bringing the word 'Slough' into his title, Turner might well have been introducing associations of the Slough of Despond in John Bunyan's *The Pilgrim's Progress* of 1678.[35] By such means he would have been able to suggest that, due to turnips, English agricultural workers had every reason to be despondent by 1809. This was because, despite the low nutritional value of the root vegetable, at the time it was often a staple food of the poor, especially when agricultural wages were being forced down or stopped altogether, and bad weather caused poor harvests. Moreover, turnips typified rural dispossession, for their cultivation was only viable within a system of land enclosure.

Across the foreground and middle distance Turner set out a range of activities relating to seeding, ploughing and the development of industrial farming.[36] In the centre-distance a confrontation is taking place between old and new methods of seeding, with a farm-worker holding a seedlip or basket from which seeds could be scattered inefficiently and wastefully by hand, while before him a wooden seed drill is being assembled so that a far more systematic and efficient seeding can take place. But it is in the distance that Turner reminded his contemporaries of the possible price that might have to be paid when forcing the rural poor to eat turnips, for beneath Windsor Castle a raging fire is taking place (fig. 367).

Until now the cloud of smoke produced by this conflagration has always been thought to constitute an early morning river mist. However, that is not the case. Instead, close examination reveals that the cloud is issuing from a fire, for it is coloured red at its source and that colour gradually diminishes in intensity to the right. Moreover, the pall billows with a vigour and a profusion that is never to be found in the gentle swirlings of a river mist. By placing such an inferno beneath a castle that particularly stood for the British monarchy, Turner was reminding everyone in metaphorical terms of what had happened fairly recently to the French monarchy when it had turned its back on the poor.[37] In *Plowing up Turnips near Slough* he therefore addressed the huge political, social and economic gulf that existed at the heart of British society in 1809. It is unsurprising he did so, for nobody in Britain who possessed even the slightest modicum of human sympathy could have felt wholly indifferent to the plight of the rural poor, let alone happy about what they were far too frequently forced to swallow.

Turner the moralist also expressed himself very subtly in the *Harvest Dinner, Kingston Bank* (fig. 368) that was on display. As related above, one evening at harvest time in 1805 he had witnessed nature's bounty being gathered near Kingston upon Thames and yet the people bringing it in only possessed meagre fare. Between them, five adults in this work share a small basket that perhaps contains some bread and a single turnip, as well as a jug of water and a few sheaves of wheat. A bag that could conceivably contain a little more food rests at the feet of one of the women. But nowhere in sight is food and drink of the quantity that these people would surely require after spending a back-breaking day toiling in the fields under a baking sun.[38]

In the circles in which Turner moved, 'dinner' frequently comprised multi-course meals made up of an enormous range of highly prized delicacies, all washed down by a variety of fine wines and spirits. Yet at the bottom of the social ladder, the same meal – but under the titles of 'tea' or 'supper' – usually consisted of a great deal less. Given the apparent lack of food and drink among the people depicted, the title of *Harvest Dinner, Kingston Bank* was clearly intended to seem hollow (indeed, it constitutes the most bitterly ironical title that the painter would ever apply to one of his works). In this picture Turner set out to remind the world that prosperity – in this case the wealth that can flow from a successful harvest – is often paid for by the labour, exploitation and hunger of the poor. Such a message was hugely relevant in 1809, and it is no less so today. Turner may have been indifferent to the sufferings of unseen slaves in faraway Jamaica, but when he actually witnessed hunger, toil and hardship on his doorstep, his humanity became fully engaged.

328

368 *Harvest Dinner, Kingston Bank*, T.G. 1809 (10), oil on canvas, 35½ × 47⅝ (90 × 121), Tate Britain, London.

369 *Trout Fishing in the Dee, Corwen Bridge & Cottage*, T.G. 1809 (13), oil on canvas, 36 × 48 (91.5 × 122), Taft Museum of Art.

A major product of the 1808 Welsh excursion was the *Trout Fishing in the Dee, Corwen Bridge & Cottage* (fig. 369) on display in the 1809 Turner Gallery show. Here sunlight filters through a passing shower that is ruining the haymaking taking place beneath it on the left. (Cut grass needs to be thoroughly dry before it is baled and stored, lest it be rendered inedible as animal feed.) The hills a little to the south-east of Corwen are invested with enormous sweep, and very typically Turner unified the composition through amplifying the semi-circular form of the fisherman retrieving his catch by means of the semi-circular sunlit edge of the central rain cloud far above. The painting appealed hugely to the 5th Earl of Essex, for he purchased it and had it hanging on the wall at Cassiobury by 5 July 1809, a little over a month after Turner's gallery show had ended.[39] The artist would receive his standard charge of 200 guineas for the 36 × 48 inch canvas.

Turner developed *London* (fig. 370) from the detailed pencil study and various ancillary sketches he had made in Greenwich Park in September 1807.[40] In the catalogue, he supported the title of the work with a six-line poem he had presumably written himself. It tells of the 'Commercial care and busy toils' of London, of its 'murky veil aspiring to the skies', and of the church spires piercing that smog to afford 'gleams of hope amidst a world of care'.

Walter Fawkes purchased this work from the show for 200 guineas. It seems likely that having commissioned *The sun rising through vapour*, and therefore enjoying the prospect of Turner oils hanging on either side of his drawing room fireplace, he wanted to hang a further picture between them, over his mantelpiece. As we shall see, before too long he would swap this work for a view of Shoeburyness that was also displayed in the 1809 Turner Gallery exhibition.

370 *London*, T.G. 1809 (16), oil on canvas, 35½ × 47¼ (90 × 120), Tate Britain, London.

371 *Spithead: boat's crew recovering an anchor*, T.G. 1808, R.A. 1809 (22), oil on canvas, 67½ × 92⅝ (171.5 × 235), Tate Britain, London.

Obviously he preferred to be reminded of the sea when warm and dry by his fireside.

Picture sales in 1809 were not as good as they had been the previous year. However, a total of 600 guineas promised for three paintings by the Lords Essex and Egremont, and by Walter Fawkes, was still very respectable.[41] And in any case, the show would prove to be far more profitable than the current alternative marketplace for Turner's works just down the road, in the short term at least.

The 1809 Royal Academy Exhibition
FRIDAY 28 APRIL TO SATURDAY 17 JUNE

Like Turner's three other submissions to Somerset House this year, *Spithead: boat's crew recovering an anchor* (fig. 371) hung in the Great Room. This was the selfsame depiction of Danish prize ships at Spithead that had been exhibited in the painter's own gallery in 1808, possibly under the title of 'Two of the DANISH SHIPS which were seized at COPENHAGEN, entering Portsmouth Harbour'.[42] If that was

372 *Spithead: boat's crew recovering an anchor* (detail of fig. 371).

the case, then Turner had now altered its title because victory over the Danes in September 1807 was no longer politically relevant.

On the left is a buoy, with no fewer than five vessels ranged in a line beyond it. On the right are the two Danish prizes that had reached Spithead on the afternoon of 1 November 1807. A lugger passes before them. The groups of vessels on either side of the image balance perfectly. The sailors on the left raise their hats to celebrate the British victory over the Danes.

Clearly, the new title was partly intended to test the perceptual and deductive powers of Turner's audience, for the anchor that is being recovered (fig. 372) remains underwater, at the end of a hawser that is being winched up by the crew of the third boat from the forefront of the image on the left. The taut rope is sliding along a wooden guiding channel that juts out from the prow of that vessel, eventually to wind around a capstan that is slowly being turned by the crew at its stern. A primitive diving suit hangs upside down from the prow of the boat. Presumably someone has recently employed it to attach the hawser to the lost anchor.

The *Repository of Arts* stated that 'The Fleet at Spithead is a most majestic picture.' Obviously the Danish dimension had already sunk from view. The critic for the *Morning Post* on 4 and 6 May commended Turner's massing of light and shade, noting that the 'works of this artist are always marked by genius'. The pseudonymous 'Anthony Pasquin' loved the work, for in the *Morning Herald* of 4 May he called it 'one of the most perfect performances in the Exhibition' and declared: 'Mr Turner may become, if he pleases, the first marine painter in the world.'

The pictorially linked *Tabley, the seat of Sir J. F. Leicester, Bart.: Windy day* (fig. 373) and *Tabley, Cheshire, the seat of Sir J. F. Leicester, Bart.: Calm morning* (fig. 374) appear to have been placed upon different walls in the Great Room. Naturally, the opposed weather effects they show would have created more impact if they had been hung adja-

373 *Tabley, the seat of Sir J. F. Leicester, Bart.: Windy day*, R.A. 1809 (105), oil on canvas, 36 × 47½ (91.5 × 120.6), Tabley House Collection, University of Manchester.

374 *Tabley, Cheshire, the seat of Sir J. F. Leicester, Bart.: Calm morning*, R.A. 1809 (146), oil on canvas, 36 × 46 (91.5 × 116.8), Tate Britain and the National Trust (Lord Egremont Collection), Petworth House.

375 *The garreteer's petition*, R.A. 1809 (175), oil on mahogany panel, painted surface 20⅞ × 30¾ (53 × 78), Tate Britain, London.

cently or as pendants. They constituted the first representations of virtually the same view but in contrasting weather conditions that Turner had ever displayed in the same exhibition.[43] Through their linkage, they mark an important step towards his subsequent development of paired canvases that depict differing times of day or polarised moral themes. The implied movement of Tabley Mere and play of light across its surface in the mid-morning, windy day landscape is superb, as is the placidity of the water in the dawn scene.

On the whole, the critics were kind to both pictures. The reviewer for the *Monthly Magazine* of 1 June found the windy day canvas ravishing, novel and truthful but said nothing of its companion, possibly because he had overlooked it amid the hubbub. On the other hand, the *Morning Herald* of 4 May only mentioned the calm view, calling it 'felicitous' and reminiscent of Cuyp, presumably because of its golden light. But the highest praise issued from the *Repository of Arts*. This stated that 'in comparison with the productions of [Turner's] hands, not only all the painters of the present-day but all the boasted names to which collectors bow sink into nothing'.[44]

Understandably, perhaps, the critics did not respond so positively to *The garreteer's petition* (fig. 375), the title of which was accompanied in the catalogue by these lines:

> Aid me, ye Powers! O bid my thoughts to roll
> In quick succession, animate my soul;
> Descend my Muse, and every thought refine,
> And finish well my long, my *long-sought* line.

Turner must have been amused by the thought that in *The garreteer's petition* on show in Somerset House an unknown and impoverished poet exhorts his muse to descend, whereas in *Thomson's Æolian Harp* on view in Queen Anne Street West all nine of those goddesses pay homage to a recognised poet they had frequently visited.

Of course, where the writing of poetry was concerned, Turner knew all about the problems of making 'thoughts to roll' that would 'finish well' his 'long-sought' lines. As a consequence, *The garreteer's petition* was probably intended to tell us something about himself, as well as about the hopes, self-delusions and uncertainties of a poet's

333

376 *The Artist's Studio*, c.1808, pen and brown ink and wash with watercolour on paper, 11¼ × 11⅞ (18.5 × 30.2), Turner Bequest CXXI-B, Tate Britain, London.

life (and, by extension, any kind of artist's life). Thus, a plan and elevation of Mount Parnassus hangs above the garret door, obviously to denote aspirations towards immortality; a handless clock bearing the inscription 'tempus fugit' or 'time flies' hangs on the wall, equally in reference to hopes of attaining timelessness; a list of fasts and feasts is attached to the back of the door, presumably to indicate the division between dearth and plenty in an artist's life; and a cat tears a piece of cloth, surely to parallel the discordant sound of the garreteer's verses. Such wit echoes the satire to be found in Hogarth's *The Distrest Poet* of around 1736 (Birmingham City Art Gallery).

It has often been claimed that *The garreteer's petition* was influenced not only by Hogarth but also by Wilkie. Yet such assertions have completely diverted attention from another work that exerted a far more subtle and powerful hold over it. This was *The Holy Family at Night (The Cradle)* owned by Richard Payne Knight (see fig. 89), which, it will be recalled, was then ascribed to Rembrandt. As we have seen, Turner may have initially viewed this picture between April and June 1793, and again in 1807 in advance of painting *The unpaid bill* (see fig. 358) for Payne Knight. In both the supposed Rembrandt and *The garreteer's petition* the brilliance of the light is boosted by being placed either behind a very dark form or immediately next to one.

The reviewer for the *St James's Chronicle* of 4 May described Turner's poet as 'poorly conceived' and the composition unoriginal. 'Anthony Pasquin' hated the work, calling it 'sickly and inadequate' and using doggerel of his own to satirise both its pictorial subject and its accompanying verses. He also advised Turner 'to remain in future in the quiet of academic honours in his first floor in Harley Street and never more to wander in garrets to personify poets and their concomitant wretchedness'. The comment usefully demonstrates public knowledge of the exact location of what had constituted the artist's painting studios until recently, but it rather misses a major point about Turner, namely that he never wanted to remain safely 'in the quiet of academic honours'. Instead, he preferred to range widely and take risks in his art, despite the occasional perils of doing so.

Initially, Turner had worked out the composition of *The garreteer's petition* by means of a pen, ink and wash drawing.[45] Around the time he did so, he also used the same materials to sketch out an idea for a companion work.[46] This second drawing has come down to us under the title of *The Artist's Studio* (fig. 376). It depicts a painter

334

gazing lovingly at one of his own creations, while the apprentice who doubles as his studio assistant toasts some buttered rolls in the background. Across the bottom of the drawing Turner wrote that within the planned painting he would include pictures of either 'the Judgement of Paris' or of 'forbidden fruit', that he would strew Old Master paintings across the floor, that he would introduce a reference to 'stolen hints from celebrated Pictures', and that he would include phials, crucibles, retorts, labelled bottles of varnish and the like.

On the reverse side of the sheet he jotted down eleven lines of his own poetry. The first two state that the painter depicted overleaf is so pleased with his work that he views it 'o'er and oer' again, finding 'fresh Beauties never seen before'. In the meantime his assistant gazes at another feast, not caring 'for taste beyond a buttered roll'. Throughout the central part of the poem Turner tested variant verses connecting 'Taste' to the taste for buttered rolls, obviously because he wanted to satirise the possession of taste, or the complete lack of it. Quite evidently, he was aiming his darts at those many artists who attempted to gain the heights but sadly lacked the abilities to do so, just as his distressed poet fell short of attaining creative equality with, say, Milton, Pope or Thomson. But in the end Turner's compassion for unsuccessful artists – which may have stemmed from Mauritius Lowe – got the better of him. Presumably that is why this drawing never led to a painting. From his assured place on Parnassus it was only too easy to treat lesser talents with condescension. Such a danger had to be avoided. Instead, and before too long, Turner would find a way of giving actual, practical effect to his sympathies for limited, struggling and failed artists. That would prove far more useful than mere satire.

By Midsummer's Day 1809, Turner had both vacated the 64 Harley Street house and begun renting storage space in a building that stood just beyond the end of its garden.[47] He did so because at some unknown point that year he had sold the remaining nine or so years of his lease on the 64 Harley Street domain to a dentist, Benjamin Young, who may even have been his own dentist.[48] It is not known what he obtained for the lease, and no stock acquisition in the Bank of England can obviously account for the money received. But part of the deal must have been the agreement that Turner could hire back his gallery until such time as he could build or find a replacement for it. The rent he paid remains unknown.

A likely reason he had opted to sell was because he had been led to believe that by 1818 or not long afterwards he might be able to obtain more space on some portion of an adjacent site in Queen Anne Street West, and that he might then be able to persuade the Portland Estate to grant him permission to erect a house there that would be far larger than 64 Harley Street.[49] This could contain a bigger set of studios, a much grander gallery, and a far more ample storage facility for all the vast numbers of works he was accumulating by now.

In the short term at least, all he needed was extra storage space. For most of the year he could now use his Queen Anne Street West gallery as his London studio, and all the available evidence points to him beginning to do just that. After all, it offered five vital amenities: plenty of space in which to paint; top lighting, presumably in abundance; the 'spring well' that supplied the vital liquid needed for his watercolours, and which did so immediately next to his studio entrance; a working fireplace; and a privy at the southern end of the backyard to the house. Moreover, circumstantial evidence to be introduced below proves that by now Turner was beginning to live and sleep in the ample, 35-foot by 10-foot space below his gallery. For someone reared above a shop in Covent Garden, that would have presented no hardships. When he needed to hang his works on the walls of the gallery, he and his father could move studio equipment and paintings and drawings that were currently in progress downstairs or just along the street to the storage facility. And, of course, Upper Mall, Hammersmith, would continue to serve as his alternative abode and set of workplaces for a few more years to come. By moving out of the 64 Harley Street house and into its gallery, Turner had therefore lost very little, and in the long term he had much to gain. Certainly there was some risk involved if it eventually proved impossible to expand nearby but it was a risk well worth taking, especially as most property problems can be solved by spending money and Turner undoubtedly had plenty of that by now, as he would shortly be determining in some detail.

22

Six Houses, Three Castles and a High Street

June to December 1809

Around this time Turner drew up a six-point list of topics he would be covering in his perspective lectures.[1] Following a general introduction to the subject, he would explore its connections with the other arts and with anatomy; its many spatial forms; optics; atmospherics; light and shade; reflections, both in themselves and in their modification of colours and perspectives; and the vital role of perspective in establishing convincing backgrounds in representational images, by way of buildings and landscapes. And he also thought about how best to illustrate his talks. Although he would press into service a few of the diagrams he had made for Malton in his youth, in the main he would create new ones, and not stint when doing so. That is why more than 180 of them have come down to us. About half of them would be elaborated between the late spring of 1809 and January 1811, at which time the first lecture would be delivered.

The complementary views of Tabley exhibited at the Royal Academy this year inspired three other owners of grand houses to order depictions of their abodes. The first of them was the immensely wealthy Tory politician, landowner and art patron, the 1st Earl of Lonsdale (1757–1844), who commissioned two oils of his country seat in Westmorland, Lowther Castle, that was still under construction to a design by Robert Smirke junior. Lord Lonsdale agreed to pay 500 guineas, or 100 guineas more than was usually asked for two 36 × 48 inch paintings. Turner must have successfully made the case that he would need to travel a very long way simply to obtain a few pencil sketches from which to develop those canvases.

During this summer Turner started thinking intensely about the Sand Pit Close site in Twickenham he had purchased a couple of years earlier (fig. 377). In consequence, he began sketching ideas for the house he was planning to build there (figs 378–80). Initially, he provided just one bedroom. This indicates that in 1809 at least, he did not envisage that his father would be living with him. Possibly that led him to think of calling his country residence Solus Lodge, the Latin word 'solus' frequently being used in stage directions to signify 'alone'. Eventually he envisaged that its studio would face north-east. Clearly he planned to work in that room mainly in the summer, and particularly during the first hours of each day when he could make full use of brilliant dawn sunshine or the brightest, initial light of an overcast sky. Limitations of space preclude an exploration of the evolution of the house as revealed through Turner's sketches here, but it will suffice to state that the various stages included designs for a two-storeyed Palladian villa; a heightened version of that residence; a narrower – and therefore cheaper – version of the same building; a stepped-up modification of this concept also on three levels but with its front door on its north-western side; a reorientation of that structure on a south-east to north-west axis, rather than a south-west to north-east one; balconied chalets, of the type that might have been seen in Switzerland in 1802; two-storeyed

Detail of fig. 384.

Above 377 'Landscape with road in foreground', here retitled *View of the Sand Pit Close, Twickenham site purchased by Turner in 1807, as viewed from the north-west and with the Isleworth-Richmond road on the left*, 1809, pencil on paper, fols. 75v and 76 of the *Windmill and Lock* sketchbook, Turner Bequest CXIV, Tate Britain, London.

This shows the view looking south-eastwards from the road linking Isleworth to Richmond that skirted the northern side of Turner's property. He probably made this sketch in order to fix where he would build his villa, with a tiny indent possibly created by a sharp corner of his thumbnail marking the actual spot.

Left 378 'Ground plan and back view of Sandycombe Lodge', here retitled *Three elevations and two plans for the Sand Pit Close, Twickenham villa*, 1809, pen and ink on paper, fol. 77v of the *Windmill and Lock* sketchbook, Turner Bequest CXIV, Tate Britain, London.

These were probably the earliest designs for the house. Clearly, Turner initially had a two-floor Palladian villa in mind.

Facing page bottom 379 *Rough sketch of an early version of the proposed Sand Pit Close, Twickenham villa from its north-west side*, 1809, pen and ink on paper, fols. 73v and 74 of the *Windmill and Lock* sketchbook, Turner Bequest CXIV, Tate Britain, London.

Here Turner imagined the proposed villa as it would look when seen from the north-west.

Above 380 First sketch of the final design for the proposed Sand Pit Close, Twickenham villa, *c*.1810, fol. 2 of the *Sandycombe and Yorkshire* sketchbook, Turner Bequest CXXVII, Tate Britain, London.

In the central pencil drawing at the very top of the sheet, Turner finally arrived at what he wanted: a three-storied centre block with single-storied chamfered wings. By the time he made this drawing he had realised that he would have to provide accommodation for others.

cottage-ornées, of the kind designed by many jobbing architects of the day; a house with two wings terminating in segmental bays; a narrow, octagonal block with a large ground floor and bedrooms under the eaves; a long and thin, two-roomed Italianate villa that would have stood on the brow of the hill; an octagonal pavilion, with a smaller but almost identical one next to it; a two-storeyed cottage-ornée very much in the style of Soane; a Palladian entrance-frontispiece; a two-storey, narrow building with semi-hexagonal terminating bays; and, finally, a three-storeyed central block with single-storeyed chamfered wings, which was the design that would actually be used.[2]

Between 13 and 21 July, Turner visited Cassiobury 'for a week' in order to see his *Trout Fishing in the Dee* newly hanging in the house and to collect payment for it from the Earl of Essex.[3] He only appears to have created a few sketches during his sojourn; some of them include Cassiobury Park in the distance.[4] Perhaps he did so

needed to respond adequately to Rembrandt's picture of a windmill (see fig. 90). The lock and windmill pencil studies would form the basis of a magnificent oil painting that Turner would exhibit in his own gallery in 1810 (see fig. 389). Possibly after visiting his stockbroker on 22 July,⁷ Turner went to stay with the 3rd Earl of Egremont (1751–1837, fig. 381) at his country seat, Petworth House in west Sussex. The nobleman possessed huge wealth, vast estates in Sussex and Cumberland, a large and wonderful art collection, a wife, several mistresses and innumerable illegitimate offspring. His annual income fluctuated around the £100,000 mark. Like Walter Fawkes, he was a Whig, although unlike the Yorkshireman he was firmly opposed to progressive political ideas. Scandals in the 1780s had denied him a career in politics, for which loss he compensated by undertaking good works. He regularly gave away a fifth or more of his income to noble causes.

The earl had been sufficiently impressed by the Tabley House views exhibited at the Royal Academy that spring to invite Turner down with a view to producing a 36 × 48 inch depiction of his own principal abode. It is possible that he and his guest strolled around the Petworth estate together, so that he could indicate his favourite vistas as the possible subject of the painter's brush. From such a discussion might have emanated a pencil drawing of Petworth House as viewed from across its lake near a monument at Upperton built by Lord Egremont in the 1790s to augment the picturesque qualities of the landscape.⁸ That vista would form the subject of the commissioned painting.

While at Petworth, Turner enjoyed his very first opportunity to view no fewer than nine of his own pictures hanging in the house, with the prospect of adding more in due course. If a painting entitled *Near the Thames Lock, Windsor* that Lord Egremont had purchased from the Turner Gallery show that spring had not yet joined the other Turners on the walls, then perhaps the two men hung it together, for the invitation to visit Petworth could well have been issued partly for that purpose. And once that matter had been decided, then maybe they looked together at the other paintings acquired from the Academician. Such a perigrination could have produced the idea that the artist should create an oil painting of Lord Egremont's other rural residence, Cockermouth Castle in Cumberland.⁹

Naturally, Turner explored Petworth Park on his own, as well as buildings, ruins, quarries, sandpits and other equally picturesque potential subjects nearby. And of course he went off fishing. He appears to have done so on the river Arun, for it was probably while waiting near Fittleworth for the fish to bite that he scribbled verses commemorating the fact that it had been 'on Arun['s] reed strewn shore' and 'sedgy bank' that the Chichester poet William Collins (1721–1759) had once 'thoughtful' roamed.¹⁰ The painter possessed all of Collins's works in the ninth volume of Anderson's *Complete*

381 George Garrard, *George O'Brien Wyndham, the 3rd Earl of Egremont*, c.1790, white marble bust on coloured marble pedestal, height 27⅜ (69.5) × width 17⅜ (44) × depth 13⅕ (33.5), The National Trust, Petworth House, Sussex.

little work because a fair amount of his time was taken up with fishing on the nearby Grand Junction Canal or upon the adjacent river Colne. At the end of his stay, Turner appears to have made his way the twelve miles southwards down the Grand Junction Canal to Heston, in order to visit Henry Scott Trimmer. The two men may have spent the day together, and it could have been on that very same evening while on his way back to Queen Anne Street West⁵ that Turner sketched the sun setting beyond a windmill that stood between two locks on the Grand Junction Canal near Hanwell.⁶ If that was the case, then finally he had found exactly what he

Poets, and it was probably there that he had first encountered Collins's 'Ode on the Death of Mr Thomson' of 1749. That poem may have inspired the creation of *Thomson's Æolian Harp*, at least in part.

Additionally, it may have been at Petworth this summer that Turner read an account of the life and work of the Spanish poet and playwright Lope de Vega (1562–1635). Published anonymously in 1806, its author was the Whig politician, man of letters and passionate Hispanophile, the 3rd Baron Holland of Holland (1773–1840).[11] Turner was so struck by a passage in the biography that he transcribed it, albeit with his usual indifference to punctuation: 'The chief object of Poetry is to delineate strongly the characters and passions of mankind to paint the appearances of Nature and to describe their effects to our imagination. To accomplish these ends the Versification must be smooth the language pure and impressive the images just natural and appropriate.'[12] Obviously, Turner thought that these observations most pithily set the agenda for any aspiring poet such as himself. And if some of Lord Holland's words are converted into terms applicable to painting – such as 'Painting' for 'Poetry' and 'painterliness' for 'Versification' – then the passage applied equally to anyone of Turner's profession who believed in the sister arts.

Annotations

It was probably during this summer that Turner annotated two books published in 1809: *Lectures on Painting*, which constituted the published version of the four talks given by John Opie as Royal Academy Professor of Painting in February and March 1807; and Martin Archer Shee's *Elements of Art: A Poem in Six Cantos*.[13]

Turner only annotated the first two Opie lectures. In his initial talk, the late professor had devoted himself to the origins of painting in ancient times. This had necessitated a related discussion of nature, beauty and the ideal; colour and form; application and industriousness; drawing; anatomy and the shape of the head; and Italian Renaissance painters, including Leonardo and Michelangelo. The second talk had been given over to painterly invention, and to the linked subjects of nature, literature, history, natural history, travel, works of imagination and, above all, 'poetry in all its branches'. Opie discussed poetry because he thought it afforded 'the most copious fund of materials' and imparted 'the most powerful stimulus to invention'.[14] He had then embarked upon a fairly lengthy discussion of poetic painting, a concept he fully endorsed.

Shortly after beginning his first talk, Opie explored the problems inherent to defining beauty.[15] Turner understood the difficulties, for he was well aware that beauty will always reside in the eye of the beholder. However, he did fully agree with Opie's contention that the supreme kind of beauty is ideal beauty, to which all other types of beauty aspire. This concurrence testifies to his overriding aesthetic loyalty, for the concept of ideal beauty resides at the very heart of the theory of poetic painting as propounded by Reynolds and by most of the commentators on aesthetics who had inspired him.

Application was another subject to receive comment from Turner. Opie had felt that 'nothing is denied to perservering and well-directed industry'.[16] Turner disagreed, for although artists would always be helped on their way by intense application, 'perserverance and well directed industry has not, or will not give that power that gathers greatness as it passes onwards'. He knew that no amount of hard work in itself, no 'speculative calculations' by others regarding success or failure, and no 'friendly patron or powerful relitaves' would make an artist great. Only what he called 'an interlectual perception or soul' – by which he respectively meant fresh insights or the opening up of a new realm of feeling – would carry an artist to the heights of perfection, thereby ensuring self-generated and longlasting fame. And he returned to the subject of application and its limits when Opie largely agreed with Fuseli that 'nothing but labour is necessary to attain perfection'. Turner thought that more than mere labour is required to do so, in the form of 'an inate power that enforces, that inspires'.[17] Without that contribution, 'labor would be fruitless and end in vain drudgery'.

When discussing drawing, Opie quoted advice given to students by the Bolognese painter Annibale Carracci (1560–1609): 'First make a good outline, and then (whatever you do in the middle) it must be a good picture.'[18] Turner demurred, not only because Carracci had often departed from that advice himself, but equally because students should never neglect what was done 'in the middle' in favour of simply drawing outlines; the light, shade and colour that exist within those boundaries are just as important. To relegate them would be to 'quit nature, that is alone the test of our perceptions of art'. It was only by 'unabating persiverance' that students could balance line with what constitutes the 'grand, beautiful and simple' in art, namely modelled forms. As Turner concluded, 'Good [outline] drawing must necessarily be the first principle of [art] education' but it should not receive the emphasis it had enjoyed in recent French art, 'where [outline] drawing stands first second and third'. This was because, as he stated in verse,

> Without the aid of shade or tone
> But indivisible alone
> Seems every figure cut like stone.

The response expressed in the final line also relates to points arising from Opie's subsequent declaration: 'The works of the ancients can never be studied too much, but they may easily be studied improperly'.[19] The prime object, the late professor had asserted, was to

rediscover the principles upon which the creations of the ancients had been formed, lest mannerism result. In this respect Opie also warned against the danger of relying too much upon sculptural models, lest sight be lost of the fact that stone and flesh are very different entities. To demonstrate the pitfalls of such over-reliance, he cited the works of recent French painters who had sheared painting 'of her own appropriate beams' and reduced her 'to the hard and dry monotony of sculpture'.[20] And Opie equally criticised his French contemporaries for avoiding 'every thing like effect and picturesque composition' by placing their figures 'in a tedious row from end to end of the picture, as nearly like an antique bas-relief as possible. In short, it seems to be the principal aim of a French artist to rival Medusa's head, and turn every thing into stone.'[21]

Throughout all this, Opie was of the view that it would have been 'absurd' for the makers of ancient bas-reliefs to have availed themselves of colour, tonal contrast and the like (clearly he had been ignorant of the fact that ancient scuptures had frequently been polychromatic). Turner disagreed, commenting in one of the few lucid passages in what is otherwise an exceptionally opaque annotation: 'To give depth distance and effect to basorelivo [by means of colour and the rest] is impracticable but surely not absurd. Sculpture is like painting drawn from nature.' He added that low-relief carving is 'the painting of sculptor's art', obviously because it can only provide an illusion of three dimensions, just like painting (albeit with slightly more spatiality).[22] He observed correctly that the carvers of low-relief sculptures in ancient times must have been sufficiently discriminating to perceive the difficulties of dealing with distance and perspective in their works. That was why 'the most ancient Basorilivo are without foreshortening figures', but equally why the makers of such works had compensated for not being able to foreshorten by exaggerating the 'surface of form'. Yet Turner was forced to concede that the necessarily flattened surfaces of low-relief sculptures meant that 'all the beauty, the excellence of the sculpture, cannot rescue it from being absurd when tried by the test of nature and physical truth'. This is because in the real world surfaces can and do extend fully into space, rather than into the far shallower space available to sculptors in low relief. In his perspective lectures Turner would ruminate further upon these matters.

Consideration was also given to Opie's views on invention in his second lecture.[23] For Turner, invention devolved from 'the interlectual power of the mind' in combination with the 'different conception of forms, color and every occurrence of our lives'. Moreover, he was convinced that 'to the utmost of our lives this power demands fresh supplies of further knowledge by more observation'. Such an outlook explains why he would repeatedly return to particular places to sketch them again. He further commented that 'the mind, so far from being clogged in its effects, gathers and combines all the qualities of each idea to be expressed, from the first impressions of early youth to mature age'. This notion, that accretion also forms the basis of invention, reveals why he would occasionally return to old images and paint new versions of them that accorded with the latest point he had now reached in his stylistic development. Perhaps the most notable example of such a process would occur in the mid-1840s when he would paint new versions of *Liber Studiorum* designs created decades earlier. He had accumulated many experiences since then, and they had led to further insights requiring articulation.

Qualities and Causes

Undoubtedly the most valuable of all Turner's annotations arose in response to Opie's statement that 'nothing can be useless' to a painter or a poet.[24] The late Professor of Painting had then declared that everything must be stored in the mind 'ready for association on every possible occasion, to embellish sentiment, and give effect to truth'. Above all, Opie thought that the study of man should be the overriding concern of artists. As well as all our physical and mental endowments, the entire range of our passions from childhood to old age should be understood, remembered and put to good use. Always the artist should 'endeavor to discriminate the essential from the accidental ... and learn to see nature and beauty in the abstract, and rise to general transcendental truth, which will always be the same'. And all of these should be combined with a thorough knowledge of the art of the past. Opie concluded: 'Thus impregnated and warmed by the contemplation of high excellence, our bosoms expand, we learn to see with other eyes than our own, and our minds, accustomed to the conceptions of the noblest and highest intellects, are prepared, by degrees, to follow them in their loftiest flights, and rival them in their most vigorous exertions.'

Turner had no problem with any of this, for it all closely followed the precepts of Reynolds. As we have seen repeatedly, he was always 'ready for association on every possible occasion, to embellish sentiment, and give effect to truth', while the study of man had equally been of concern to him ever since the outset of his career, even if he often conferred equality upon our natural surroundings or accorded them primacy. And by 1809 he was more committed than ever to the belief that the artist should 'endeavor to discriminate the essential from the accidental ... and learn to see nature and beauty in the abstract, and rise to general transcendental truth'.

A couple of years later Turner would make this clear by endorsing that Platonic agenda in his own lectures to the Royal Academy. Almost from the start he had followed 'earlier artists in their loftiest flights', and attempted to 'rival them in their most vigorous exertions', although this process has been much misunderstood, especially

of late. Yet perhaps most helpfully of all for our purposes, Opie's declaration that 'nothing can be useless' inspired Turner to add the following annotation in the margin right next to that comment:

> He that has that ruling enthusiasm which accompanies abilities cannot look superficially. Every glance is a glance for study: contemplating and defining qualities and causes, effects and incidents, and developing by practice the possibility of attaining what appears mysterious upon principle. Every look at nature is a refinement upon art; each tree and blade of grass or flower is not to him the individual tree grass or flower, but what is in relation to the whole, its tone its contrast and its use and how far practicable: admiring nature by the power and practicability of his Art, and judging of his Art by the perceptions drawn from Nature.

The statement that 'Every glance is a glance for study' paraphrases the declaration made by Reynolds in his second *Discourse* that 'Every object that presents itself [to a promising young painter], is to him a lesson', as well as the passage that immediately follows it.[25] In combination with the first sentence of his annotation, Turner's statement that 'Every glance is a glance for study' demonstrates that he had constantly been driven by his 'ruling enthusiasm' to analyse all of the visual phenomena that passed before him. Being blessed with an unusually retentive visual memory, what was stored there proved immensely useful as a consequence. Moreover, in his statement concerning the need to contemplate 'qualities and causes, effects and incidents' with a view to 'attaining what appears mysterious upon principle', Turner made it clear that he regarded intense observation as merely the springboard to an understanding of process, or what makes things tick: the fundamental dynamics of architecture and geology; the laws governing meteorological behaviour and hydrodynamic motion; the organic processes that dictate arboreal growth; and, not least of all, the historic and social determinants of human behaviour. By arriving at first principles, an artist could communicate a deeper concept of nature, including the actions and works of man, than could ever be afforded by the mere depiction of appearances. And by such means the apprehension of nature could enrich the understanding of art, and vice-versa.

Understandably, this was of the utmost benefit where the creation of visual images was concerned, and it was something Turner had been effecting in his art ever since the 1790s. Thus his depictions of people, buildings, geological structures, cloud formations and water had all been invested with an understanding of 'qualities and causes'. By 1809 Turner had only failed to express such inner dynamics in his depictions of trees and plant forms. Here a somewhat old-fashioned mannerism still prevailed. However, in 1814–15 he would begin to find a way of conveying the inner organic life of trees, bushes and lesser plant forms. Thereafter, the sense of pulse and flowering in his arboreal forms would greatly further the idealistic strain that had already emerged in his landscapes more generally. And such ideality brings us back to 'qualities and causes, effects and incidents' and the attainment of 'what appears mysterious upon principle', for by definition ideal beauty, the essence of things, and process in nature all constitute one and the same thing, as Sir Joshua Reynolds and many other writers on art had insisted, and as Turner quite evidently concurred.

A little further on in his second lecture Opie also discussed the equation of poetry and painting, but observed that the difference between the 'speaking picture' of poetry and the 'mute poesy' of painting is that 'the one operates in time, the other in space; the medium of one is sound, the other colour; and the force of the one is successive and cumulative, of the other collected and instantaneous.' Turner fully endorsed Opie's differentiation between poetry and painting, stating: 'This contrariety of their means intirely separates Poetry from Painting, tho drawn from the same source and both feeling the beauties of nature – but the selection is as different as the means of conveyance diverse; their approximation is nearest when the poet is discriptive.' Naturally, many descriptive passages in poetry principally concern themselves with the appearances of things, which is why they most closely approach the condition of painting. Yet it is wrong to deduce from Turner's acceptance of Opie's differentiation between poetry and painting that 'At this stage of his career he thought that "imagination" and "the association of ideas" were only applicable to poetry and not painting,' as has been asserted.[26]

This is because, and as we have seen, by 1809 Turner had been building upon the association of ideas for years. It was just that he knew poets and painters have to create their metaphors in very different ways, for successful associative imagery in words can look ridiculous when given pictorial form. For example, it is all very well for a poet to describe the rising sun as a 'powerful King of Day/ Rejoicing in the east' (to quote James Thomson in the 'Summer' section of *The Seasons*),[27] but how could a painter like Turner ever pictorialise such a trope without the resulting image looking bizarre?[28] A 'King of Day' standing resplendently in the sky might easily have fitted into a painting of the Baroque era, but Turner could not countenance introducing such a figure into one of his landscapes, for it would simply have looked ridiculous.[29] Instead, he had been forced to find other, more subtle ways of imaginatively enhancing his imagery.

Shee's *Elements of Art, A Poem in Six Cantos* runs to 400 pages, the major part of which comprises footnotes; on some pages, a mere two lines of verse are supported by up to twenty-five lines of commentary.[30] The first canto deals with state patronage, taste, design, proportion, and drawing from the live model, while the following canto covers anatomy, perspective, architecture and nature as expressed in art since ancient times. The third canto explores the education of

painting students, with particular reference to the Italian and Dutch schools. Italian art is again examined in the fourth canto, with passing references to Homer, Virgil, Milton, Shakespeare and Reynolds. The fifth canto touches upon mannerism, empty dexterity, and the nostrums and 'secrets' of painting, while the final canto discusses criticism, envy, malice, fame, vanity, the advantages of moral subject matter, and the higher pursuits of art. It is all heady stuff but as poetry it has deservedly passed into oblivion. Turner did not think much of it as verse either, for he detected a great deal of plagiarism in it.[31] Moreover, he did not agree with some of Shee's views. Although he entered more annotations into the Shee volume than he had done into the Opie, he did not write anything after page 178, which suggests he read under half of it.

The first five flyleaves of Turner's copy of Shee's *Elements of Art* are covered with his annotations.[32] Here, and in somewhat impenetrable writing and prose, Turner took his cue from Shee by noting the increasing demands for a national school of painting during a time in which commerce, manufacturing and wealth were increasing in Britain. However, like Shee, he was aware that riches and opulence had not led to a general improvement in taste. This had become clear from a decline in 'the learning of the art' of painting. Instead, as Turner also stated, there were now 'more dictators than encouragers, more critics than students, [and] more amateurs than artists'.[33] Clearly his desire to maintain professional standards lay behind his negativity towards amateurs.

On the second page of his poem, Shee commented: 'Taste is a quality more easily personified than explained.' He then lamented that although taste was the subject of much discussion in Britain, such discourse had produced 'little practical operation'. Turner fully agreed with this, stating that while 'every one is Eager to evince' the standards of taste 'by Criticism', they did not do so with 'regard either to encouragement of feeling for the mind or the existence of the labourer in the vinyard of taste'.

A little later Turner rejected Shee's poetic fantasy that taste 'comest to Genius' like a goddess descending to earth,[34] for he thought the contrary to be true. For him genius was 'the parent of taste', for 'it gives that enthusiastic warmth to admire first nature in her Common Dress' by leading the artist to be 'conscious of the cause and effect of incidents', and thus 'to investigate not with the eye of erudition' but with the desire 'to form a language of his own'. As he stated by breaking into verse, the artist gains such an ability by means of that practical approach to

> Look with more keeness as the eye pursues
> And gathers taste by knowing how to choose
> By sentiment that quickens [through] the mind
> And like the stream is by degrees refin'd

In other words, genius leads to the close study of 'the cause and effect of incidents' in nature (including man), which in turn generates a greater capacity to imbue images with 'sentiment' or meaning. This process leads to the refinement of taste or discernment, pretty much as water is purified by streaming through the ground. And from this arises the formation of a language of one's own, or an individual artistic style. The similarity between Turner's comment concerning 'the cause and effect of incidents' and his Opie annotation regarding 'qualities and causes, effects and incidents' needs no underlining. It further illustrates the fact that Turner's extraordinary observational powers were driven by an idealistic desire to get to the heart of things.

Shee's passing reference a few lines later to taste leading genius to an appreciation of the picturesque qualities in 'each wild scene'[35] caused Turner to embark upon a fairly lengthy disquisition regarding the difficulties of defining the picturesque, to which end he referred to the ideas of Uvedale Price and Richard Payne Knight. But when Shee returned to the subject of genius and how 'Poets and Painters, privileged heirs of fame, /By right of birth alone, their laurels claim',[36] Turner was moved to think of the 'superior endowments' of Charles Reuben Ryley, who had demonstrated 'how far common interlects can be cultivated from sheer industry and intense application' but whose genius had been prevented from blossoming by the sterile cultural soil in which he had found himself. This had denied Ryley 'bread and mocked the labourer's toil'. And the same subject arose again when Shee contended a few pages later that 'True genius will never be discouraged by difficulties',[37] for Turner emphasised that genius requires positive reinforcement, just as a seed requires nurturing until it can fend for itself. Again he may have been thinking of Ryley when he wrote this. Certainly he would have remembered his own father providing him with such support when young.

Slightly earlier, Shee had referred to the genius of Sir Joshua Reynolds and how it had reputedly been first awakened by a reading of *An Essay on the Theory of Painting* by Jonathan Richardson (1665–1745), first published in 1715. Turner agreed that 'Accident may in many cases determine the course of Genius', but equally he thought that if Reynolds's mind had not been already well stocked, 'he would have read in vain'.[38]

Like Shee, Turner had no time for the notion that being a genius in one art meant one would automatically be a genius in another. Alexander Pope, who had briefly taken up painting in 1713, was cited by Shee as an example of this. As Turner commented in a quote from Pope that he mistakenly attributed to du Fresnoy, 'One Science only to one Genius fits.'[39] Turner the poetaster would have done well to heed his own advice here, although had he done so, we would all have been the poorer in understanding his artistic intentions throughout much of his life.

Shee regarded judgement as being 'supreme o'er all the powers of thought'. Turner begged to differ, perceiving judgement to be 'but a modification of taste'. As far as he was concerned, judgement helps decide what is 'fit appropriate and instrumental for the subject' of a painting by selecting the forms that are most suitable to the subject over the ones that are merely pleasing. Yet without taste, judgement could easily 'sink into systematic rules' or the production of images that follow empty pictorial formulas. Hollow prescriptions were always an anathema to Turner.

Shee also advanced the view that young painters, not knowing how to proceed at the beginning of their careers, might well commit themselves 'to the discretion of a guide, who perhaps, after he has advanced a few steps, is but an obstruction on his way, and interrupts the finest prospects from his view'. By obstructionist 'guide', Shee meant connoisseurs who lay down the law to artists. Here Turner agreed by alluding to some lines from du Fresnoy's *The Art of Painting*. He then made the point in words of his own that time wasted through being artistically misdirected by such a dictatorial advisor would act as 'Poison to the soul that time can't wash away'.

He returned to this theme when Shee stated in verse that a young artist, by not knowing better, might easily mistake error for the truth. For Turner the 'track of truth' could only be found by a young artist allowing himself to be guided by his 'keenness' or passionate commitment, confidence and insight. Therein resided 'for ever a beacon and...the strongest precept the artist can receive'.[40] He must arrive at the truth 'by his own observation [and] perception'. Moreover, 'he will dare to think for himself and in that daring find a method'. If, on the other hand, he should listen 'to every pretender [or connoisseur whose] utmost knowledge is a few practical terms or whose great pride is to point out the beauties of his own collection', then the results would be dire. For Turner, 'to have no choice but that of the Patron is the very fetters upon Genius that every coxcomb wishes to rivet [upon] Choice'. And in order to stress this point he again broke into verse, in what was clearly a heartfelt declaration of his lifelong artistic independance:

> should I even a beggar stand alone
> This Hand is mine and shall remain my own.

In his next major annotation,[41] Turner continued his attack on connoisseurs who attempted to influence the direction taken by artists, and who in the process ended up pushing them in directions inimical to their true propensities and interests. At the same time he attacked books on artistic theory written by non-artists, for like practitioners in many other disciplines he thought that only trained professionals can truly understand their own métier. He ended by stating that 'the many volumes that have been written become trammels while he who gain'd his knowledge by self-attainment gives and regulates all his opinions by a practical possibility'. Here he was undoubtedly drawing upon his own self-education as a painter, and upon his conviction that only a close knowledge of what was and was not possible in practical terms could ever be of any real use to aspiring artists.

When Shee discussed art critics he provoked one of Turner's most impassioned and articulate outbursts: 'It is not the love of Art that tempts the critic but vanity and never ceasing lust to be thought a man of superior taste and immolating with unsparing hand all around him under the mask of attention to the Art but really only to be considered a man of taste.'[42] By 1809 Turner had already been immolated by unsparing hands many times, and he would increasingly suffer such a fate in years to come. Of course, not all his critics had been vain imposters – as John Landseer had demonstrated in 1808, for instance – and nor would they be so in future. Yet there were far too many such critics in circulation for anyone to become complacent, in Turner's view. Naturally, his negativity was a good thing, for it helped him form a protective hide against criticism. As he grew older and increasingly adventurous, that carapace would prove essential.

The confusion suffered by art students when confronted by 'the caprices of the artist and the connoisseur' in their role as teachers was a topic touched upon by Shee.[43] Such uncertainty arose from those advisors often being 'at variance with themselves, and almost always with each other; mistaking their prejudices for principles; displaying their pictures as models of perfection, and delivering their opinions as aphorisms of Art'. Turner agreed. That is why, opposite Shee's observations, he lamented that 'misled must they be who blindly follow all the dictates of a connoisseur'. He concluded that if caprices and prejudices should be taken as principles, only the evidence of the eyes could be trusted, rather than 'sounding opinions signifying nothing'.

Shee then versified on the merits of line versus colour, and of careful drawing versus free painting. This drew from him a long footnote that differentiates between two types of art students: those who predominantly concentrate upon drawing and, as a result, often carry a resulting hardness and dryness into their paintings; and those who concern themselves primarily with mellow colours, rich surfaces and forceful effects, and thus often end up painting pictures that are feebly composed, poorly drawn and slovenly executed. Understandably, Shee advocated steering a middle course between these extremes. Turner concurred with that judgement, but Shee's comments led him to write about the limitations of many members of the French school, such as Eustache Le Sueur (1617–1655) and Nicolas Poussin. He did so because he considered outline to have been the dominant characteristic of their art. And from there his mind jumped back to 1802, and to works he had seen in the Louvre

by French painters such as David, for whom line seemed to be of more importance than colour and painterliness.[44]

Turner also remembered that in 1802 many French artists had looked 'with cool indifference on all the matchless power of Titian's glowing tones' in the picture of St Peter Martyr (see fig. 285). They had done so 'because precision of detail is their sole idol'. As a consequence, 'Nationality with all her littleness' had come upon him, with the result that he had contrasted the French and English schools of painting, to the advantage of the latter. As he declared, 'we may justly claim to be Painters', unlike the French.[45] And to support this point even further, he remembered seeing in the Louvre a portrait of Cardinal Bentivoglio by van Dyck (Pitti Palace, Florence). Through its 'Breadth, color and apparent ease and facility of execution', the painting had amazed a group of British artists, including himself.[46] Some French painters present had been astonished by such positivity, for all they had been able to perceive was an absence of detail. As a consequence, they had pitied the British for their poor taste.[47]

A little further on, Shee and Turner both commented upon another important painting they had seen in the Louvre in 1802. This was Raphael's *Transfiguration of Christ* of 1518–20 (see fig. 284). In his annotation, Turner remembered that it had been cleaned and extensively retouched. Nonetheless, 'for breadth judicious chiaroscuro and colour it must [still] indisputably be looked at with awful veneration of [Raphael's] talents and with a stronger claim to [be] a colorist than any [other] picture by him'.[48] As we shall see in due course, this was not all that Turner discerned in it either.

By now Turner was running out of patience with Shee's book. He did, however, rouse himself to make one more important annotation when he encountered the remark that 'A mechanical sleight of hand, a fluttering dexterity of pencil, or a laborious minuteness of vulgar imitative detail [is often regarded as constituting] the excellence of Art.'[49] As Turner commented, 'The praise of labor in minute ... details is exemplified in the admirations upon Mr Bird & Wilkie where the painter never [confers?] breadth upon the observer.' This usefully demonstrates Turner's true perspective upon two of his contemporaries. Rather than feeling envious of the success of Edward Bird (1772–1819) and Wilkie as genre painters, and finding it galling 'to see a contemporary just out of his teens win hands down at much the same game' when he himself supposedly attempted to rival Wilkie in this sphere,[50] he thought that the works of both artists lacked the breadth he deemed vital to art. For all the weaknesses in figure drawing and the rest in his own genre pictures painted between 1806 and 1809, they had certainly not lacked breadth, as we have observed in three instances (see figs 344, 358 and 375).

The observations that Turner entered into both this book and the one by Opie afford us invaluable insights into his thinking, and most of all where his own art was concerned. It appears very likely that he read the two books not in isolation but as part of his preparation for the perspective lectures, for in several of those talks he would amplify points made by his fellow Academicians. Moreover, in the annotation concerning 'qualities and causes, effects and incidents' he gave us a key insight into his idealism. That idealism already stood at the core of his thinking, and it too would receive further amplification in the perspective lectures. And as he would go on reading and writing in 1809 and 1810, his creative focus would continue to sharpen and his intellectual pace quicken, even if the sentences he would commit to paper would remain as tortuous and as difficult to understand as ever.

The North of England, 1809

It is possible to deduce that the painter quit Petworth on Sunday 30 July or very early the next morning, and that he set off for Farnley Hall on Tuesday 1 August.[51] He probably looked forward to being present at Farnley again when the grouse-shooting season began towards the middle of that month.[52] In one of the sketchbooks he took along, he would draw sportsmen with their shotguns, as well as gun dogs; in another, a shooting party on Hawksworth Moor, near Farnley.[53] He would also scribble verses relating to shooting, some of which suggest he witnessed a minor shotgun accident this year.[54]

Up at Farnley, Turner may have made a number of the watercolours of alpine and Yorkshire subjects that Walter Fawkes had commissioned in February (figs 382–4).[55] These could have been begun in London from the sketchbook material gathered in the Alps in 1802, or in Yorkshire in 1808, and then been conveyed in a partially finished state inside the artist's portfolio cum drawing board.[56] Up north they would have required no further topographical input. Indeed, Farnley was the very best place to work on them, for upon completion they could simply be framed and placed upon the walls.

It is likely that Turner busied himself in another way in Yorkshire this year too. By now he had accumulated masses of notes on perspective made down in London. It would have been easy to bundle them all up and convey them to Yorkshire. At Farnley he would have been able to sort through this material without the distractions faced at home. Additionally, he could have jotted down further observations, made lecture diagrams and refined his texts. It may even have been in nearby Otley or its environs that the first fair copies of the six perspective lectures were written out by someone engaged for that purpose.[57]

It could also have been at Farnley this year that Turner transcribed into the *Cockermouth* sketchbook of 1809 some comments relating to the close proximity of the ridiculous to the sublime, and vice versa. He had read a short essay on 'Gray the Poet' published in the

382 *Mer de Glace, Blair's Hut*, 1809, watercolour on paper, 10¾ × 15¼ (27.4 × 38.9), The Courtauld Gallery, London.

383 *Montanvert, Valley of Chamouni*, signed and dated 1809, watercolour and gouache on paper, 11 × 15½ (28 × 39.5), Whitworth Art Gallery, University of Manchester.

384 *Bolton Abbey, Yorkshire*, signed and dated 1809, watercolour on paper, 11 × 15½ (27.8 × 39.5), British Museum, London.

Here we view the ruins from the north in evening light. This time of day explains why Turner wrote 'Bolton Abbey west' on the second list of drawings commissioned by Walter Fawkes that was compiled in the *Greenwich* sketchbook early in 1809: he was thinking of the direction from which the light would be coming, not the geographical bearing from which we view its subject.

August 1804 issue of the *Monthly Mirror*.[58] This had been penned by 'Q.Z.', an alias employed by a Mrs Blore.[59] Her article traced 'the imitations and similarities to be met with in the works of our most admired poets'.

In this context, one of the poems to which she referred was *Hudibras* by Samuel Butler (1612–1680), which was known to Turner from the fifth volume of Anderson's *Complete Poets*. Mrs Blore cited *Hudibras* because it related to the main work under discussion, namely Thomas Gray's 'The Bard' of 1757 in which the protagonist denounces the invasion of Wales by King Edward I of England. This Pindaric ode had long been known to Turner from the tenth volume of Anderson's *Complete Poets*, and of course he had depicted its central figure in the *Caernarvon Castle, North Wales* watercolour (see fig. 241) he had exhibited at the Royal Academy in 1800.

In her article, Mrs Blore drew attention to lines 19 and 20 of Gray's poem:

> Loose his beard, and hoary hair,
> Streamed, like a meteor, to the troubled air.

Gray claimed to have derived the imagery of these two lines from a representation of the deity by Raphael. However, Mrs Blore found this assertion 'somewhat ludicrous', for in Canto I, lines 241–8 of Samuel Butler's poem, the beard of Hudibras had also been compared to a meteor:

> His tawny beard was th'equal grace
> Both of his wisdom and his face;
> In cut and die so like a tile,
> A sudden view it would beguile;
> The upper part whereof was whey,
> The nether orange, mix'd with grey.
> This hairy meteor did denounce
> The fall of sceptres and of crowns[60]

Mrs Blore argued that Gray might have taken 'the plan of [his] sublime ode' from *Hudibras* because his Welsh bard '*precisely performs* what the *beard* of Hudibras *denounced*' (that is to say, Gray's bard curses a specific monarch, while the bearded Hudibras only damns kings in general). And Mrs Blore equally linked the 'meteoric' beard of Gray's bard to the flag that the sublime figure of Azazel had unfurled 'like a meteor streaming to the wind' in the first part of Milton's *Paradise Lost*. But from the similarly meteoric beards of Butler's ridiculous Hudibras and Gray's lofty bard, she opined that 'the burlesque and the sublime are extremes, and ... extremes meet'. She then introduced a similar thought that had been penned by the radical political thinker, writer, inventor and deist, Tom Paine (1737–1809), in the second part of his 1793 critique of organised religion, *The Age of Reason*. With his customary disdain for punctuation, Turner paraphrased the passage relating to Paine in Mrs Blore's essay:

> Speaking of the sublime Tom Paine who we may reasonably conclude to be destitute of all delicacy of refined taste, yet has conveyed a tolerable definition of the sublime, as it is probably experienced by ordinary and uncultivated minds, and even by acute and judicious without or are destitute of the vigour of imagination, says that the sublime and the ridiculous are often so nearly related that it is difficult to class them separately. One step above the sublime becomes ridiculous and one step above the ridiculous makes the sublime again.[61]

Mrs Blore had characterised Paine as a 'very vulgar and mischievous, but acute genius ... whom I imagine to be destitute of all delicacy and refinement'. Turner simplified this passage but obviously retained part of it in order to heighten the effect of what followed.

Understandably, the exact boundary between what would look ridiculous or sublime was of great relevance to a painter, which is why Turner took an interest in Paine's observation and in Mrs Blore's gloss upon it. As he was doubtless aware, if he had pushed, say, the bard in *Caernarvon Castle, North Wales* over the line that demarcates the dramatic from the melodramatic, he could easily have turned the sublime into the ridiculous. On the other hand, if he had somehow made the protagonist in, say, *The garreteer's petition* of 1809 (see fig. 375) look noble and tragic, then perhaps he would have turned the ridiculous into the sublime, which was not what was required either. It was all a matter of how far things were taken.

At the end of his paraphrase of Mrs Blore on Tom Paine, Turner appended the following lines (the fourth of which he spaced some way below the others on the sketchbook page):

> The beard of Hudibras and the bard of Gray
> The spinning of the Earth round her soft axle
> Ample room and verge enough
>
> So nearly touch the bounds of all we hate

Three of these lines relate to renowned poems or quote from them. 'The spinning of the Earth round her soft axle' is a variation upon verses that form one of the most sublime passages in Book VIII of Milton's *Paradise Lost*.[62] 'Ample room and verge enough' is a direct quotation from the second canto of Gray's 'The Bard'.[63] And 'So nearly touch the bounds of all we hate' miquotes what originally had probably itself been a deliberate misquotation from Pope's *Epistle II: To a Lady* in an anonymous article entitled 'Employment for a Wife' that had appeared in the *Cabinet; or, Monthly Report of Polite Literature* in 1808.[64] Turner may have intended his four lines to contribute towards a poem on the sublime and the ridiculous that in the course of things never got written.

When Milton had stated in *Paradise Lost* that the earth 'spinning sleeps/on her soft axle', he had expressed his awareness that our planet very slightly wobbles around its own axis over long periods of time. This phenomenon is known as axial precession, and it was first discovered by the ancient Greek astronomer Hipparchos (c.190–c.120 BCE). For Turner the 'soft axle' of our planet may therefore have appeared to provide 'Ample room and verge enough' for life on earth, but because of its inherent instability our planetary existence approaches the bounds of an uncertainty that all of us would hate (and should the earth ever find itself breaking those bounds because of, say, collision with a large asteroid, it would doubtless plunge us from the sublime to the ridiculous and back again within a very short time). For the four lines quoted above, Turner may have drawn upon different sources, but he put them together to point to

something larger (or at least he tried to). That was no different from lifting passages from, say, three Old Master paintings and melding them into one, in order to make something greater. We have already seen him do that several times. And it was probably painting that gave Turner the idea of appropriating verses from others. For him, as for all poets and painters, the equation of poetry and painting was constantly a two-way process.

Turner's awareness of Milton's knowledge of axial precession may relate to other astronomical facts he noted in another sketchbook that travelled north with him this year.[65] They concern the distance of the sun from the earth, the size of the moon in comparison with the earth, and the relationship of our planet to its satellite. And Turner also recorded the names of the ancient Greek astronomers Anaxagoras (500–428 BCE) and Aristarchus (c.310–230 BCE), the first of whom had observed that the moon is closer to the earth than it is to the sun, while the second had calculated that the sun is larger than the earth. It is not known where Turner gained his knowledge of these astronomers and their findings.[66]

Probably on Monday 28 August, Turner travelled the little over seventy miles from Farnley Hall to Lowther Castle, the new residence of the Earl of Lonsdale. It is likely that the nobleman was staying at his virtually completed country seat. Less than two years later Turner would refer to a painting of a 'Flemish Marriage Feast' by Teniers he had seen there.[67] However, he may not have lingered at Lowther Castle for more than three nights, for all he needed were a few pencil sketches of the house.[68]

From Lowther Castle, Turner next visited Penrith and the nearby Brougham Castle on the river Eamont before traversing the twenty-eight or so miles westwards to Lord Egremont's castle at Cockermouth. There he probably lodged in the 'Wyndham Rooms', a set of residential spaces that had been created by its owner within the otherwise ruined structure.[69] From this base, Turner undertook drawing expeditions up and down the rivers Derwent and Cocker. One of his studies would form the basis of the painting commissioned by Lord Egremont.[70]

When Turner quit Cockermouth after probably spending two nights there, he made his way to Ennerdale Water, Ennerdale Bridge, Cleator Moor and Whitehaven.[71] In the latter town he almost certainly stayed in another of Lord Lonsdale's grand residences, Whitehaven Castle. Possibly the Earl of Lonsdale was also present. The painter made a number of depictions of Whitehaven harbour in pencil that may have been commissioned or purchased by Lord Lonsdale.[72]

Turner left Whitehaven on Tuesday 5 September, and by the Wednesday night he was at Browsholme Hall, having travelled there mostly on foot by way of Egremont, Calder Bridge, Millom, Ulverston, the Cartmel peninsula, Morecambe Bay at low tide, Lancaster, the Trough of Bowland and Whitewell.[73] Many pencil drawings were made en route. Memories of crossing Morecambe Bay on foot would long remain with Turner, due to the potential treacherousness of the sands.

From Browsholme Hall, Turner returned to London via Manchester. He arrived back on Friday 8 September, having probably been away for eight weeks and three days. Once home, he immediately called upon William Leader in order to collect a cheque for £632-7s-3d. This constituted payment of 500 or 550 guineas plus the framing and transportation expenses for the *Thomson's Æolian Harp* painting that this gentleman with a country house on Putney Hill, Surrey, had commissioned and allowed to be exhibited in the Turner Gallery that spring.[74] With the money, the painter purchased £632-7s-3d-worth of government stock on the very same day.[75]

By 17 October Turner had sent the Council a letter stating his intention to read his lectures in the New Year, as had Soane.[76] And over the next few weeks he, Soane and Carlisle suggested to the Council ways in which the seating for the lectures could be improved, with Turner being responsible for upgrading the lighting in the Great Room.[77] Work on the necessary alterations was subsequently begun.

If the *Literary Gazette* of 27 December 1851 is to be believed,[78] Hannah Danby became Turner's housekeeper in 1809. The relationship between Sarah and Turner had not ended, as will be seen, so the niece could not have replaced her as the person who supported the painter's day-to-day existence in town, albeit in a visiting rather than a living-in capacity. Instead, Hannah could have become Turner's rural housekeeper, for it will be remembered that by 1809 he had been a man of two establishments for years. Moreover, his father would probably have welcomed domestic help down in Hammersmith. Hannah's culinary skills might have ameliorated the hard labours of both father and son by the river and made even more palatable whatever the latter – or possibly both of them – wrested from its waters.

A sketchbook drawing of two figures that was possibly made in 1809 is inscribed 'Woman is Doubtful Love'.[79] If Turner possessed a distrust of the opposite sex, then perhaps it derived from a profound fear induced by the violence of his mother. Moreover if, as appears likely, he had frequently witnessed prostitutes offering their services in Maiden Lane and its environs during his earliest years, then that too could have confirmed a view that certain women represented 'Doubtful Love'. Perhaps he made the sketch of two figures because he was thinking of using 'Woman is Doubtful Love' as the title and subject of a painting that would take the form of a Hogarthian depiction of a prostitute and her client. Between 1802 and 1805 he had roughed out a composition that may show a procuress instructing one of her girls,[80] so it is entirely possible that in 1809 he was again thinking of expressing a negative perspective upon women.

In conformity with habit, Turner may have visited Knockholt in the autumn of 1809, except that this year he possessed an additional reason for doing so. When the two views of Tabley House had been exhibited at the Royal Academy in the spring, they had apparently so impressed a landowner living not far from Ash Grove that, like the Lords Lonsdale and Egremont, he too had invited the painter to make a view of his grand country seat. In all probability Turner visited that house not long before 17 November when he notified a correspondent in Oxford that he had just 'been a few days from home'.[81]

The landowner in question was William Francis Woodgate (1770–1828), who lived at Somer Hill, a Jacobean mansion built between 1611 and 1613 about a mile and a half south of Tonbridge in Kent. Using pencil, Turner made a distant view of Somer Hill in his *Harvest Home* sketchbook, and a closer study of the house from across the lake that stood before it in the pocket *Hastings* sketchbook.[82] He did so with a view to offering his prospective client a choice of images. He would return to the property at a later date to make a larger and more detailed drawing from which to develop the painting itself. Given that he was fiendishly busy at this time and that he made just two pencil drawings at Somer Hill, he could only have spent a few nights at Ash Grove and the nearby mansion, if that.

In mid-November Turner had been contacted by an Oxford art dealer, printseller, gilder and framer, James Wyatt (1774–1853), who wanted to commission a view of Oxford High Street that could be translated into a print for sale in his shop. The artist reacted positively to the idea, advising that he already possessed a detailed pencil drawing of the subject. In an exchange of letters throughout late November and December – of which only the ones from Turner have survived – Wyatt agreed to commission an oil of Turner's 100 guinea size, decided that the painter would make a new pencil drawing for the picture, resolved that a comparatively large print would be elaborated from the painting, selected the engravers to create it, and dealt with a number of lesser matters.[83]

Turner travelled up to Oxford a few days after Christmas 1809 in order to make the new pencil study. This was drawn on a sheet of paper 'about 2 Feet by 19' inches in size he had asked Wyatt to paste onto a board in readiness for his visit.[84] The drawing session took place in a post-chaise parked in the High Street not far from the entrance to the Queen's College.[85] Probably it did not last more than three hours. The artist returned to London the next morning.

Given the enormous pressure of work that Turner faced, he cannot have rested over the New Year period. Instead, he immediately began the Oxford picture while labouring over watercolours and further refining his lecture texts. The past year had been a momentous one for him in terms of painting, travelling and, not least of all, intellectual intake. Even less relaxation was promised in the one to come. But something had to give, and very soon it would do just that.

23

A Year's Grace

1810

On four successive Monday evenings beginning on 8 January, Turner attended the first proper set of lectures given by Soane in his capacity as Royal Academy Professor of Architecture. As a consequence, on 29 January he was present when Soane criticised the new Covent Garden Theatre designed by Robert Smirke junior. For his pains, Soane was barracked for having broken an unwritten rule of the Royal Academy, namely that in their lectures its professors should never say anything negative about Academicians and their associates. This led to him subsequently being censured by the Council and the General Assembly. Because of these rebukes, he refused to continue the series.[1]

Turner was one of those who voted to condemn Soane,[2] and it is easy to see why he did so. As he had witnessed all too painfully in 1803–4, if Academicians criticised each other in public (let alone dragged the newspapers into taking sides, as had now also happened), then the internal harmony and royal status of the institution could easily be endangered. Like many of his peers, Turner had suffered his fill of such discord. Soane's criticisms may have been valid, but the stability and position of the Royal Academy were far more important than any professor's views on the works of another Academician. The impasse caused by Soane would only be partially broken in February 1812 when he would accept limited freedom of speech and give his fifth and sixth lectures. However, not until February and March 1813 would he finally deliver his full annual course of six talks.

The 10 February General Assembly meeting that ratified the Council decision to censure Soane also elected Fuseli the new Professor of Painting, Flaxman the very first Royal Academy Professor of Sculpture, and Callcott a Royal Academician.[3] But 10 February was an important day for Turner as well, for that morning he sought the permission of the Council to postpone his lectures. He only requested a few months' delay but as this would not fit in with the Royal Academy schedule, the Council reluctantly suggested a year's postponement instead, to which he agreed.[4] Of course, the Council really had no choice in the matter, for it could hardly compel him to talk if he was not ready to do so, which he was not.

The postponement did not prompt Turner to relax, however. Over the next six days he employed a professional copyist, William Rolls, to make fresh transcripts of the lecture texts that had been transcribed several weeks earlier from his original notes by an unknown hand, possibly in Yorkshire.[5] That he was prepared to incur the expense of employing yet another professional copyist, and to begin doing so on the very day he had bought himself an extra year before having to talk, demonstrates the seriousness with which he regarded the lectures and the pressure he still put upon himself to deliver them on time. Yet simultaneously he was painting with such energy that by 4 February he had already been able to advise James Wyatt that 'the picture [of Oxford High Street] is *very forward*'.[6] He had even asked that the construction of its frame should begin.

Detail of fig. 392.

Supreme Dictator

It is extremely likely that Turner had voted to elect Callcott (fig. 385) a Royal Academician. If that was the case, then he did so because he admired the works of his slightly younger contemporary, and probably because landscape and marine painters were in short supply among the Academicians. Yet he also possessed an additional reason to support Callcott, and possibly it outweighed the others. This has to do with Sir George Beaumont.

Around 1805 the baronet had greatly encouraged Callcott, but as Turner's influence on Callcott grew, Sir George had dropped the latter and put it about that his images were full of defects. He had also dubbed Callcott a 'White painter' because of the increasingly Turnerian, high-keyed tonalities of his works. As a consequence, Callcott lost sales and began to detest Beaumont both for his fickleness and for the harm he was doing. So if Turner did vote for Callcott in the 10 February election, then he may equally have done so because he wanted to gain an ally against a common enemy, and a stronger one at that.

Sir George (fig. 386) himself was not totally devoid of talent as a painter, having shown many times at the Royal Academy since 1794 and even been praised for his 'exquisite taste', 'the delicacy and power of his pencil' and for having created 'the best picture in the [1795] Exhibition'.[7] By 1797 Farington had reported that the nobility regarded him as 'the only Landscape painter'.[8] He was also a discerning art collector, and a number of his pictures would help form the nucleus of the National Gallery collection in 1824. However, his taste for contemporary art was extremely limited, and it was narrowing all the time.

Essentially, Beaumont was rooted in the Old Master oil painting tradition, with its frequent recourse to chiaroscuro and heavy varnishes. As a consequence, he was afraid of very bright light in landscape and marine pictures. That is why he had dubbed Callcott a 'White painter',[9] and why he would apply the same epithet to Turner in due course, if he had not done so already by 1810. For Beaumont the only acceptable tones in landscape and marine pictures were either the dark varieties associated with a number of Dutch landscape painters, or the mid-ranged kinds encountered in the outdoor scenes of Rubens, Poussin, Claude, Wilson and Gainsborough. The high-pitched tonalities increasingly used by both Turner and Callcott proved incomprehensible because Beaumont never really looked at the world around him, preferring to view it only through the spectacles of art, and the dark glasses of a fairly old art at that.

In reality, Beaumont had never been the 'head of the Landscape [school]', as had been claimed in the London newspaper, *The Oracle*, on 26 April 1796. That is why he became increasingly jealous and resentful of Turner and Callcott, for they had both eclipsed him as landscapists and made him realise his own shortcomings. However, if he could not turn back the artistic clock or gain enormous influence within the London art world with his brush, he could certainly do so with his tongue. As Thomas Hearne commented to Farington in July 1809, Sir George Beaumont 'desires to be supreme Dictator on works of art'.[10] But unfortunately the baronet suffered from a psychological handicap: he was bipolar,[11] and in playing the ultimate arbiter, that condition often came to the fore, leading him never to 'raise one man but to pull down another',[12] to him 'taking up artists for a season & then growing tired of them',[13] to him sweeping 'away those Artists who at the time are not His objects',[14] and to artists being 'taken up & laid down as the disposition varied'.[15]

Such treatment explains the meaning of Hoppner's statement to Farington that 'Sir George Beaumont [has] a most villainous taste.'[16] He was not simply identifying or castigating a type of taste but commenting upon the damage wrought by its intense changeability, for villains necessarily cause harm to others. Callcott, Wilkie and Haydon had all been taken up by Beaumont and then discarded, as had several less-prominent artists. In 1809 Callcott had even written about that dictatorial capriciousness in scathing terms, calling Beaumont a 'Demagogue' who possessed 'a galled and disappointed mind', especially 'in the case of Mr Turner whose works must ever be considered as a national Honor'.[17] Of course, none of Beaumont's 'galled and disappointed' negativity would have mattered had he not exerted great influence within the circles that supported a number of the nation's leading artists. Throughout the art world his tongue did its insidious work against those painters who had surpassed or rejected him, as well as those he had cast aside himself.

In 1806 Sir George had been one of the founder members of the British Institution. That involvement may well have led Turner to question the motives of the new organisation, for artists had no say in its running and he was deeply suspicious of artistic bodies run by aristocrats, connoisseurs and amateur painters, and Beaumont was all three. If in 1809 Turner did refuse Beaumont's offer to purchase *Fishing upon the Blythe-sand, tide setting in*, he would necessarily have known what antagonism he was stoking. But he would never have sold anything to Beaumont, for he was well aware of the collector's fickleness. He had no intention of placing himself within that power. A picture sold to Beaumont in 1809 might well have been back on the market in 1810, if not simply stored in a stable somewhere.[18] Instead, Turner was going to make war on the baronet, with stealth being his watchword. In Callcott he possessed an ally whose newly enhanced status within the Royal Academy could only strengthen the cause. Before too long Robert Smirke would join them too, as would others, for Beaumont aroused antipathy in many quarters. And in 1815, when the necessary forces had been fully gathered, the attack would be mounted, and it would prove successful, as we shall see in

Left 385 Sir Francis Leggatt Chantrey, *Portrait of Sir Augustus Wall Callcott*, c.1830, pencil, 18⅝ × 13⅞ (47.3 × 35.2), National Portrait Gallery, London.

Middle 386 George Dance, *Portrait of Sir George Beaumont*, dated 'July 4th. 1803', graphite on paper, British Museum, London.

Right 387 Charles Turner after Henry Singleton, *John Fuller*, mezzotint, 1808, British Museum, London.

the subsequent volume of this work. After that, little more would be heard from Sir George Beaumont. If there was one thing Turner could not abide, it was 'connoisseurs', amateur painters, collectors and other dilettanti who attempted to gain power over professionals, let alone caused them harm. In this, as with so much else concerning his art, he was implacable, with no quarter given.

By 14 March the Oxford High Street picture was finished,[19] which proves that Turner could complete a fairly complex oil painting in under three months. On the 31st he sent it off to Wyatt, having been paid for it earlier that week.[20] In the main the printseller was delighted with it, and Turner promised to fix anything that proved unsatisfactory when it was returned to London for display in his forthcoming gallery show.[21]

On Saturday 21 April 1810 Turner was visited in his Queen Anne Street West gallery cum studio by John Fuller (1757–1834, fig. 387) of Rosehill, Brightling Park, East Sussex; the latter's town house at 36 Devonshire Place was located just a stone's throw to the north.[22] Fuller was an ironmaster, a manufacturer of cannon for the army and navy, the owner of sugar interests in the West Indies – and therefore a beneficiary of slavery – and one of the two county Members of Parliament for East Sussex. Turner had been recommended to him by Robert Smirke junior, who had recently been employed by the landowner to construct a rotunda on his Sussex estate and was currently building a folly there.[23]

An idea of Fuller's wealth can be gleaned from the fact that his re-election to Parliament in 1807 had cost him between ten and twelve thousand pounds.[24] In the House of Commons, he was passionate to the point of insanity about his sugar interests, and therefore about slavery. That is why he had asserted in 1804 that the living conditions of West Indian slaves were superior to those of the ordinary working people of Great Britain. On the other hand, he was also opposed to political jobbery and the distribution of sinecures, as well as to similarly corrupt practices. For that reason he liked to be thought of as 'Honest Jack' Fuller, although to many he was 'Mad Jack' Fuller, particularly after 27 February 1810, a little over seven weeks before he made Turner's acquaintance. On that date Fuller had achieved national notoriety by entering the House of Commons in a highly inebriated state. This had led him to completely disrupt the debate in progress and to insult the Speaker 'in a very violent and disorderly manner'. As a consequence, he had twice been ejected from the chamber and then been imprisoned for two days in the

388 *Petworth, Sussex, the seat of the Earl of Egremont: Dewy morning*, R.A. 1810 (158), oil on canvas, 36 × 47½ (91.4 × 120.6), Tate Britain and the National Trust (Lord Egremont Collection), Petworth House.

tower of the Palace of Westminster. He was only released after apologising to the Speaker and the House of Commons. The incident considerably embarrassed the Tory party to which Fuller belonged, and it would cause his retirement from politics in 1812.[25]

During his studio visit Fuller asked Turner to make him four coloured engravings of views in East Sussex that he could distribute to friends and neighbours amid the local gentry. Turner pointed out that he did not make topographical prints but only the watercolours from which those reproductions could subsequently be elaborated by others. However, Fuller was not seeking watercolours; he simply wanted prints. In the end it was agreed that Turner would make the watercolours and then hire them to Fuller for copying by an engraver, with the drawings being returned to him after they had been reproduced. For that service, Fuller would be charged the extremely high rental fee of 25 guineas per drawing (which, as it would transpire, was only a little less than the landowner would eventually pay to acquire them). In order to gain the necessary topographical data, Turner agreed to visit Rosehill later in the year.[26]

The 1810 Royal Academy Exhibition
FRIDAY 27 APRIL TO SATURDAY 16 JUNE

All three of Turner's submissions were on display in the Great Room this year. By means of thoughtful hanging they may have triangulated perfectly within that space. Each of the canvases represented a nobleman's country seat, and two of them were linked, being the views of Lowther Castle commissioned by the Earl of Lonsdale.

The third offering was *Petworth, Sussex, the seat of the Earl of Egremont: Dewy morning* (fig. 388). Compositionally, it owes something to the Tabley House depictions of 1809, with the principal subject being placed in the distance, and boats crowding the forefront of the scene. Obviously the vessels were introduced to enliven the landscape, although they seem slightly too large for the lake at Petworth. This may have been the first oil that Turner ever painted on a white ground.[27]

The critical response to all three works varied, with the customary charges of carelessness in the foregrounds receiving expression in various quarters. The *Morning Post* perhaps accorded Turner his most positive comment by declaring on 30 April that all three of his exhibits were 'unsurpassed by any painter of any day, for clearness of tone, richness and harmony of colour, disposition of object, and aerial hue'.

For the first time since making his debut in Somerset House in 1806, this year David Wilkie did not exhibit. Although he had sent in a small, hurriedly painted substitute for a work he had been unable to complete in time, it was so severely criticised – not least of all by Sir George Beaumont – that he had withdrawn it. Understandably he was chagrined, and his unhappiness was compounded by the enormous success of *Village choristers rehearsing an anthem for Sunday* by Edward Bird (Royal Collection), which was hung in a prime position within the Great Room. And to make matters even worse, the young Scotsman thought that Bird's execution was vastly inferior to the careful craftsmanship of his replacement picture, so his withdrawal of that work had been needless.

When and if news of all this reached Turner's ears, as seems likely, then he must have felt justified in suspecting that success, the pressures it produces, and the exacerbation of those stresses by superficial and capricious admirers like Sir George Beaumont had exerted an adverse influence upon Wilkie. Perhaps that is why he wrote the following in one of his sketchbooks around this time or by not much later:

> Coarse Flattery, like a Gipsey came
> Would she were never heard
> And muddled all the fecund brains
> Of Wilky and of Bird
> When she call'd either alike a Teniers
> Each Tyro stopt contented
> At the alluring half-way house
> Where each a room hath rented
> Renown in vain taps at the door
> And bids them both be jogging
> For while false praise sings
> talent songs
> They'll call for t'other works nogging[28]

In other words, Wilkie and Bird should have pushed their talents beyond their existing limits. Instead, they had been content to listen to 'Coarse Flattery' and to 'false praise' singing 'talent songs'. As a consequence, they had remained 'At the alluring half-way house' to true renown, imprisoned by the 'nogging' or shuttered brickwork of self-esteem they had erected as self-imposed barriers to advancement.[29]

From Turner's pictorial responses to Wilkie, from his Shee annotation regarding Bird and Wilkie never conferring 'breadth upon the observer' and from this poetic fragment, we can safely infer his thinking. If these two genre painters had really looked carefully at Teniers, and assimilated his unsentimental human truthfulness and spatial breadth, then they would have made genuine advances in their art, rather than simply adopted the superficial characteristics of his style. But it was easy to stop 'contented at the alluring half-way house' of fame and fortune. This was especially the case when encouraged by false flatterers such as Beaumont whose taste roamed all over the place, just like itinerant 'Gipseys'.

The 1810 Turner Gallery Exhibition
MONDAY 7 MAY TO SATURDAY 9 JUNE

For the first time since initiating his gallery shows in 1804, this year Turner opened the doors of his space a week *after* the Royal Academy Exhibition had begun, rather than seven days or a fortnight prior to its public commencement.[30] Undoubtedly the delay was caused by not being ready in time. And when we perceive the number of works that were shown by him in both Somerset House and Queen Anne Street West this year, as well as a major painting he would supply directly to a client, we can easily perceive why he was running at least a fortnight late.

A catalogue of the 1810 Turner Gallery show has survived.[31] The seventeen exhibits included eight previously displayed oils, two alpine canvases, two Scottish subjects, a fish market depiction and a river scene in the North of England. Another new picture was *Grand Junction Canal at Southall Mill* (fig. 389). As related above, Turner had witnessed a sunset over the Grand Junction Canal near Hanwell, Middlesex, probably in July 1809. That sight had inspired the painting of this picture in response to the challenge posed by Rembrandt's *The Mill* (see fig. 90), which Turner might have last seen at the British Institution in 1806. But nothing in the new painting resembles Rembrandt stylistically; the only connection with the Dutch master is the windmill. Instead, the landscape, golden light and emphasis accorded to the animal at the centre all drew their inspiration from Cuyp.

Also on show for the very first time was *High Street, Oxford* (fig. 390). Most certainly it does not represent what Turner had actually

389 *Grand Junction Canal at Southall Mill*, T.G. 1810 (2), oil on canvas, 36¼ × 48 (92 × 122), private collection, from where stolen in 1991.

witnessed in late December 1809, when he made the pencil study from which it was developed. This is because, instead of depicting the thoroughfare in the depths of winter when only the uppermost reaches of the buildings on the northern, right side of the street could have been lit by a very low sun (if touched by sunlight at all), he portrayed it in springtime. That timing is established by the fairly high, unseen sun causing the tower of University College on the left to cast a relatively short shadow; by many of the buildings on the right being fully bathed in sunshine; by the sheer strength of the light; by the predominantly warm colouring it creates; by the tree on the extreme right being partially in leaf; and by the clothing of all the figures, some of whom are in shirtsleeves. It is unsurprising that Turner made such a seasonal alteration, for when he had painted the work, the spring of 1810 was approaching and in any event he always used his memory and imagination to transcend the constraints of what he had seen. Certainly he found it easy to alter the timing, for he had closely scrutinised the High many times in warmer parts of the year.

390 *High Street, Oxford*, T.G. 1810 (3), oil on canvas, 27 × 39½ (68.5 × 100.3), Ashmolean Museum, University of Oxford.

Nor was this the only change made. In actuality, Oxford High Street must have been filled with dozens of vehicles and animals when Turner had drawn it in December 1809. By omitting all such clutter from the thoroughfare, he was able to invest it with a sense of calmness, as a number of academics and clerics make their way along it. Such peacefulness is surely congruent with the purpose of a university, which is to provide a tranquil setting for the slow but cumulative accretion of knowledge and understanding. Moreover, by keeping the street relatively empty, Turner enhanced the inherent grandeur of the architecture. And by placing our viewpoint where he did, he also made the image an object lesson in perspective and the golden section, thereby demonstrating that his appointment as the Royal Academy Professor of Perspective had been justified. If he could never become a professor at Oxford, then he would prove to the world that he was fully entitled to that rank elsewhere.

Stillness and limpidity are the dominant characteristics of yet another new offering, *Cockermouth Castle* (fig. 391). Here Turner's unsurpassable control of tone served him well, especially where the reflections on the river Derwent are concerned. It is likely that this picture was hung immediately next to the succeeding work in the catalogue, which was the somewhat larger *The fall of an Avalanche in the Grisons* (fig. 392). If that was the case, then its profound peacefulness would have pointed up the cataclysmic violence of its neighbour. The painter could not have created any such juxtaposition in Somerset House, for of course he exercised no control over the hanging of exhibits there, at least in 1810.

In the catalogue, the title of *The fall of an Avalanche in the Grisons* was followed by verses that presumably issued from Turner's pen:

> The downward sun a parting sadness gleams,
> Portenteous lurid thro' the gathering storm;
> Thick drifting snow, on snow,
> Till the vast weight bursts thro' the rocky barrier;
> Down at once, its pine clad forests,

391 *Cockermouth Castle*, T.G. 1810 (13), oil on canvas, 23¾ × 35½ (60.3 × 90.2), Tate Britain and the National Trust (Lord Egremont Collection), Petworth House.

> And towering glaciers fall, the work of ages
> Crashing through all! extinction follows,
> And the toil, the hope of man ——— o'erwhelms.

When Turner had visited Switzerland in 1802, he had not travelled as far east as the Grisons. However, even by the early 1790s he had known of avalanches in that particular canton, for he had encountered verses dealing with them in the 'Winter' section of Thomson's *The Seasons*.[32] Additional inspiration for the painting may have derived from a newspaper account of an avalanche that had occurred in December 1808 at Selva, near Arosa in the Grisons, in which twenty-five people had been killed in a single cottage. And a further stimulus could have been two avalanche scenes by de Loutherbourg. One of them belonged to Sir John Leicester, the other to Lord Egremont, so that influence is likely.[33] However, no artist before Turner is known to have depicted a huge boulder in flight, at least so centrally and on such a comparatively large scale within the overall scheme of things.

Solely in painterly terms, Turner leapt from the early nineteenth century into the middle of the next one with this work. This is because *The fall of an Avalanche in the Grisons* connects with the expressivity of much mid-twentieth-century painting, for undoubtedly it was the most freely painted canvas Turner had produced to date, and one of the most physically dynamic pictures he would ever create. But the work is not simply concerned with painterliness or with the immense power of nature. As the final two lines of the poem connected to the title make clear, the tragedy of human extinc-

392 *The fall of an Avalanche in the Grisons*, T.G. 1810 (14), oil on canvas, 35½ × 47¼ (90 × 120), Tate Britain, London.

tion stands at its core. That is why Turner felt so deeply about what he was painting, why the dynamism is entirely at one with his subject, why he pulled out all the technical stops by manipulating the paint with the palette knife, why he pushed the paint around with his stubbiest – and therefore strongest – brushes, and why he smeared the paint with his fingers. Happily, none of the plasteriness encountered in the marine canvases that Turner had created predominantly with the palette knife in 1804 remains evident. Instead, the paint fully captures the specific densities of snow, rock, ice and timber.

Indirectly, the movement implied in *The fall of an Avalanche in the Grisons* may relate to Turner's reading for the perspective lectures. This is because one of the texts he could well have been studying when elaborating the work was *The Art of Painting* by du Fresnoy. In 1831, and in connection with the title of another of his pictures, Turner would quote an extract from the following passage by du Fresnoy (in William Mason's verse form), although he must have already known those lines by 1810:

> White, when it shines with unstain'd lustre clear
> May bear an object back or bring it near.
> Aided by black, it to the front aspires;
> That aid withdrawn, it distantly retires;
> But black unmix'd of darkest midnight hue,
> Still calls each object nearer to the view.

These observations strongly relate to *The fall of an Avalanche in the Grisons*. The whites of the distant snowfall are pushed forward optically by the intense blacks of the building and trees that are feeling the impact of the massive boulder, which is why those whites look as though they are on the same picture plane as the rock. And within the avalanche, the many angular emphases of paint made with the palette knife suggest the path of the boulder as it tumbles a long way in front of the snow. That Turner intended us to relate the snow to the boulder is proven by the near alignment of the upper edge of the avalanche with the very top of that rock.

The only review of the 1810 Turner Gallery show was written by the journalist John Taylor, and it appeared in the *Sun* on 12 June. He called it 'a rich display of taste and genius' and praised the avalanche painting, recognising that it was not in Turner's usual style but stating that it was no less excellent for all that. Such a response proves that intense expressivity was not completely beyond the understanding of Turner's contemporaries, probably because in this particular case it effects such a total fusion of form, content and technique.

Given the pressures that Turner was under to prepare his perspective lectures by now, it is a wonder he should have completed three new paintings for the 1810 Royal Academy Exhibition, as well as nine or ten new oils for his gallery show. Yet even more incredible is the fact he had kept another, very large picture completely under wraps. Being arguably his most cataclysmic seascape to date, it was by no means a negligible artistic statement. Had it been put on display at the Royal Academy, it would undoubtedly have caused a sensation. As it was, it would remain unseen by the general public for the major part of Turner's lifetime, being sold directly from his studio to its first owner. But perhaps that sale might explain why it was kept out of sight.

The work in question is *The wreck of a transport ship* (fig. 393).[34] Here a mountainous sea boils with fury as fishing boats attempt to rescue passengers from a capsized vessel and marines drown. Not for nothing would Admiral of the Fleet Sir William Bowles, KCB (1780–1869) say of this picture in 1849: 'No ship or boat could live in such a sea'.[35] The ferocity of the wind is made particularly apparent by ropes splaying out from one of the rescue vessels in the distance. Turner thought of every detail that could communicate what he wanted to impart.

The painting was purchased directly from the artist's studio by Lord Yarborough's son and one of the two county Members of Parliament for Lincolnshire, the Hon. Charles Anderson-Pelham (1781–1846). He would become the 1st Earl of Yarborough in 1837. Anderson-Pelham was an enthusiastic yachtsman, and in 1815 he would help found the Yacht Club that would become the Royal Yacht Club in 1820 and the Royal Yacht Squadron in 1833. As the first Commodore of the Yacht Club, he would bestow its membership upon the Prince Regent in 1817. He had been a subscriber to the print of *A shipwreck with Boats endeavouring to save the Crew* back in 1806, and given that fact, plus his nautical enthusiasms, it appears very likely he had commissioned *The wreck of a transport ship*. It could also have been the case that he did not want to share the picture with anyone beyond his circle, which is why it was not displayed in either the Royal Academy or the Turner Gallery in 1810. Because of its large size, Turner charged 300 guineas for it. Anderson-Pelham happily paid that huge sum by 25 May 1810 before having the work sent down to his grand residence on the Isle of Wight.[36] There it would hang for the next thirty-nine years before the public would first be able to set eyes on it in a British Institution exhibition mounted in 1849, just two years before the artist's death. It says much for Turner's self-confidence that he could produce an outstanding masterpiece and yet apparently lose no sleep over the public not seeing it for decades. Obviously he thought there was plenty more where that came from, and he was right.

The Ideal

On 2 July 1810 the Council resolved that Turner's perspective lecture series must begin in January 1811.[37] As a consequence, he would work even harder throughout the rest of the year on the copies of his texts made by William Rolls. Sadly, in the process he would only make a number of passages more confusing than ever. Yet some thoughts he may have jotted down separately at this time are particularly revealing.

They summarise a proposed talk on ideal forms, the way the mind can visualise them, the relationship of poetry to painting, and the role that metaphor plays within both disciplines, either individually or through the assistance that poetic imagery can lend to visual imagery, and vice versa.[38] Possibly Turner had been contemplating the inclusion of a lecture on poetic painting and artistic idealism within his group of discourses, but finally he dropped the idea because those subjects did not relate to perspective. Arguably the most important section of his summary reads as follows:

> and hence the rise of form in Poetic allusions, so feelingly ascribed to the action of the mind. The Pleasures of Imagination com-

393 *The wreck of a transport ship*, 1810, oil on canvas, 68 × 95 (172.7 × 241.2), Museu Calouste Gulbenkian, Lisbon.

mensurating supposed space or continuity of Time from the same sacred source. Ideal qualities. Ideal forms combining conveyed by vision to the mind to enable it by an analytical and comparative enquiry as to form endeavour to modify conjecture into Theory. to express harmoniously and represent practically. thus Painting and Poetry flowing from the same fount mutually by vision constantly comparing Poetic allusions by natural forms in one and applying forms found in Nature to the other. meandering into streams by application which reciprocally improve reflect and heighten each others beauties like the mirrors but not inversion of [conveyors?] of form, generally or abstractly[39]

And immediately below, Turner gave this passage an alternative ending:

> meandering into streams by application ... that reflect and refract each others beauties with reciprocity of splendorous allusion.

What Turner was attempting to say here throws important light on his thinking and development as a painter.

At the outset he addressed the propensity of the mind to function associatively, and thereby to create forms in the imagination, as well as to project a sense of space and time in the process. For him, the pleasures of the imagination of which Akenside had written were all

commensurate with a sense of space and time that ultimately derived from a 'sacred source'. This had to have been a metaphysical, ideal and divine reality. The notion of 'Ideal qualities' would presumably have been developed further in the proposed talk. By 'Ideal forms combining', Turner was undoubtedly alluding to the method by which the Greco-Italian painter Zeuxis (b. 464 BCE?) had supposedly arrived at an image of the most beautiful woman in the world by synthesising the forms of five beautiful women, thereby transcending the limitations of any one of them in order to attain a greater universality. Such synthesised, ideal forms, when 'conveyed by vision to the mind', would enable it by means of analysis and comparison to form a theoretical underpinning for beauty, permit beauty to receive harmonious expression, and allow for its representation in practical terms.

For Turner, part of this practicality derived from the fact that both painting and poetry flow from the same imaginative source, being visionary by nature. The phrase 'comparing Poetic allusions by natural forms in one' demonstrates his conviction that poetry derives much of its metaphorical imagery from natural forms, while by 'applying forms found in Nature to the other', he was stating his awareness that painting could create allusions comparable to those found in poetry out of the associative properties of natural forms or from experiences generated by the natural world. In both disciplines, times of day, lighting and seasonal effects, meteorological forces, objects that resemble or suggest other things, and human and animal actions have all served as metaphors.

Additionally, Turner was aware that each art could draw its metaphors from the other. Thus, allegorical paintings during the Renaissance and post-Renaissance periods had frequently taken their imagery from iconic poetry, just as the latter type of verse had frequently appropriated its imagery from allegorical paintings or from codebooks of symbolic imagery. That is why Turner stated that the metaphors of poetry and painting 'could reciprocally improve reflect and heighten each others beauties like ... mirrors'.[40] However, he was careful to stress that such mirrors would attain their ends without 'inversion' or the reversal of appearances. And by including the word 'refract' in his alternative ending – 'reflect and *refract* each others beauties with reciprocity of splendorous allusion' – he made it clear that imaginative intensification might equally come about by indirect means, for refraction signifies deflection from direct transmission. But the entire text quoted above, along with its variant ending, proves that associationism was absolutely central to Turner's philosophy and practice as an artist, not merely a fancy he only indulged occasionally, if that.

In all probability, Turner quit London for greener pastures on 18 June or soon afterwards.[41] He did so in order to visit Jack Fuller's residence, Rosehill house in Brightling Park, East Sussex, and to make the pencil drawings from which to elaborate the watercolours that would be hired for reproduction purposes. We have no idea how long he stayed with Fuller but it could not have been for more than a month, as he was back in town by 18 July.

Turner appears to have gained entry to several private estates around Rosehill. They included Ashburnham Place, the home of the 2nd Earl of Ashburnham (1724–1812), which was located some five miles west of Battle; Crowhurst Park, the residence of the Pelham family, to which Charles Anderson-Pelham was related; Beaufort House near Hastings, the dwelling of James Bland Burgess (1752–1824), who had served as Under Secretary of State for Foreign Affairs in the administration of William Pitt the younger; and Heathfield Park, the abode of the publisher Francis Newbery (1743–1818). And Turner and Fuller may have picknicked together at Bodiam Castle, for in 1816 the painter would depict that pile for his patron. On other days Turner may well have taken himself off on his own to Battle, Hastings, Herstmonceux Castle, Pevensey Castle and Three Oaks, just north-west of Hastings. He also made a careful pencil drawing of Rosehill house as viewed distantly from the west. Upon showing it to Fuller, the latter commissioned a depiction of the same view in oils, which necessitated the making of a larger pencil study.[42]

At the end of his visit, Turner probably made his way back to London via Eridge Castle, near Tunbridge Wells, and Somer Hill, where he elaborated another pencil study of the view chosen by W. F. Woodgate to form the subject of the oil painting he had commissioned the previous November. Turner could also have stayed a night or two at Knockholt. By 18 July, when he met Soane for dinner at 13 Lincoln's Inn Fields, he had carried back to London at least twenty pencil studies from which he would elaborate watercolours for Fuller over the coming years. At this time he began the commissioned paintings of Rosehill, Somer Hill and several other subjects. He also started watercolours for Walter Fawkes or continued work on those already begun, with a view to a planned return to Farnley Hall slightly later in the year. And because Jack Fuller had seen a painting of a fish market he liked in Turner's gallery show that spring, on Thursday 26 July he returned to Queen Anne Street West to purchase it. Due to its 36 × 48 inch size, it cost him the artist's standard 200 guinea charge for canvases of those dimensions.[43]

Taking Stock

Gallery sales and commissions during 1810 would earn Turner at least 2,120 guineas or £2,226.[44] That was a staggering sum at the time, and its true equivalent today would make any painter happy, especially if the tax on incomes above £200 per annum was merely 10 per cent or two shillings in the pound, as was the case in 1810.

Moreover, because Turner did not have to pay 50 per cent commission on his earnings to the Royal Academy, as is the norm today, every penny from that source went into his pocket. As a consequence, by 26 July 1810 he possessed £7,216-16s-2d in the Bank of England.[45]

Yet Turner was now worth a good deal more than that. At some point between 26 July and 26 November 1810 he listed everything he had accrued in the way of tangible and invisible assets, as well as calculated his potential earnings.[46] Throughout this list of assets he switched from pounds to guineas and back again, without taking the trouble to convert the twenty-one shillings that comprised a guinea into the twenty shillings that signified a pound. This was because he only wanted a rough idea of his worth, and consequently did not bother to change one denomination into the other.

At the head of his list he wrote '7000', clearly to denote the value of his stocks in the Bank of England. Despite the fact that the bank did not accept stock payments in guineas, Turner's figure did denote 7,000 guineas rather than pounds, for all of the amounts listed in a group immediately below it are indubitably expressed in guineas. In guineas, '7000' stands for £7,350 or £133-3s-10d more than the £7,216-16s-2d he actually possessed in the Bank of England by 26 July.[47] However, he might well have held that extra money in a lesser bank account or in petty cash, either about his person or secreted away in his two houses.

Next, Turner itemised 1,300 guineas-worth of 'Odds and Ends'. This was his typically wry way of referring to thirteen paintings and a group of 'Petits Choses' or small things that had remained on his hands (he had recently taken stock of these pictures by listing them in the *Finance* sketchbook).[48] Eight of the canvases – to wit, 'Nelson', 'Calais', 'Spithead', 'Storm', 'Tenth Plague', 'Holy Family', 'Hesperides' and 'Sodom' – had been valued by him at 100 guineas each, and therefore far below their original prices. 'Narciss', 'Cows', 'Richmond' and 'Ploughing' were valued at 50 guineas each, and thus again well below what had originally been asked for them. And 'Deluge' and the 'Petits Choses' had been reckoned to be worth 300 guineas between them.[49]

Such an appraisal shows how realistic Turner could be about his chances of selling works once they had initially missed their market, and how he could cut their prices by up to three-quarters as a consequence. His estimation that nobody would want them or be prepared to pay the original prices for them was fairly accurate, for with the exception of 'Narciss' – the painting entitled *Narcissus and Echo* exhibited at the Royal Academy in 1804 and the British Institution in 1806, which would be sold to Lord Egremont, probably in 1813 – all of the pictures on the list would moulder in his studios or galleries until after his death.

Next came the fifty *Liber Studiorum* drawings created to date, which Turner valued at 500 guineas or ten guineas per drawing.

They were followed by 200 guineas for 'Large Drawings'. By 1810 there can only have been a few of these in his possession, and some – if not all of them – had to have been works that were still in gestation due to their size and pictorial complexity.[50] Turner then listed 400 guineas he was still owed by Sir John Leicester, obviously for the two Tabley House pictures exhibited that spring; 1,000 guineas he was owed by Walter Fawkes, a huge sum that makes evident the enthusiasm of his Yorkshire patron, as it does the trust that Turner reposed in him for future payment; and the 200 guineas that Jack Fuller owed for the painting of Rosehill currently in progress.[51] As the latter sum would be paid on 26 November, we can be certain that 26 July was the earliest date by which this list had been compiled – for the piece of paper on which it was written contains another list on its recto, the last entry of which was written on or shortly after that date by Turner's stockbroker and subsequently annotated by the artist – and 26 November was the latest one.

Having taken into account all the foregoing valuations and reached 10,600 guineas, Turner then switched back to pounds to add the £400 he was worth as owner of the plot of land at Twickenham on which he had determined to build his villa; the £102 he was worth as owner of the Lee Clump property in Buckinghamshire; and the £50 he was worth as the owner of ten £5 shares he had acquired in the Atlas Fire Office insurance company.[52] Subsequently he simplified matters by knocking off £2 from the Lee Clump valuation. This brought the running total to 11,150 mixed guineas and pounds.

Added to that was the 'Probable Advantage' that would accrue from the *Liber Studiorum* prints when all 100 of them had been created and sold. Turner reckoned that this would give him another 2,000 guineas, making him worth a total mixture of 13,150 guineas and pounds. But at this point he remembered a £1,000 'loss'. Probably it related to the premiums and rents he had laid out down the years for 64 Harley Street and the Queen Anne Street West gallery cum studio; for the storage property now rented at 44 Queen Anne Street West; for West End, Upper Mall, Hammersmith; for the Isleworth rental; and for the money spent on the Harley Street gallery conversion. This last amount might have to be written off when the property was vacated if it could not be passed on to another artist or someone equally needful of such a space (as would prove to be the case).

Turner next recalled the £500 he had spent upon 'Richmond'. This was the Holloway Shot site purchased in 1807 in Twickenham, near Richmond, for which he had no present plans (which is why it was considered a 'loss');[53] and he also remembered £1,200 'Expenses of'. Because of the grammatical preposition employed here, and through a process of elimination, we can deduce that this must have denoted the value of the painting materials that Turner

365

possessed, including pigments, ready-made paints acquired from artist's colourmen, oils, solvents, brushes, rolls of canvas, stretchers, frames, sketchbooks old and new, sheets of paper, and the like. Subsequently, the £2,700 represented by these three inroads was deducted from the foregoing mixture of 13,150 guineas and pounds to bring that total down to a 10,450 figure.

Now Turner remembered that he possessed 'color'd sketches' worth 300 guineas. These had to have been the 'Drawings in different Portfolios' listed in a sketchbook that came into use at around this time.[54] They included '59 Mounted old Drawings' that were presumably by himself; '16 Sketches by Rooker'; 36 unmounted drawings by the same artist; a work by 'Hamilton' who may have been William Hamilton but was more likely to have been John Hamilton Mortimer; nineteen 'Academy figures' by Charles Reuben Ryley (which strengthens the likelihood that the 'Mortimer' listed was John Hamilton Mortimer, for Ryley had studied with Mortimer);[55] '3 Mine of Shipping', by which Turner undoubtedly meant three of his own marine drawings; five further such depictions; a drawing by Hoppner; some 'Sketches of Cattle by [Sawrey] Gilpin'; and a view of 'Warfdale', perhaps by himself.

Turner then recalled that his books and furniture were worth £300 and that a 'Picture of last year' was valued at 300 guineas. Finberg thought that this work might have been the *Sun rising through vapour; fishermen cleaning and selling fish* (see fig. 347), which of course originally dated from 1807 but which had been re-exhibited both in 1809 and 1810. He may have been correct. On the other hand, Turner could have been referring to the large *River Scene with Cattle* that was hanging at Tabley at the time of writing. Admittedly, it dated from 1808 and thus not from 'last year' either. However, it was certainly the more recent of the two works, and to a mind filled with the memories of creating dozens of works since 1808, it may well have *seemed* like the *River Scene with Cattle* had been created only a year or so earlier.

By his own unsystematic reckoning Turner was therefore worth 11,350 mixed guineas and pounds by 26 November 1810 at the latest (although some of that amount comprised estimated future earnings). But, of course, we *can* be bothered to sort out the guineas from the pounds, as well as reverse the rounding down of the Lee Clump £102, and thus work out even more precisely what Turner was worth.

The assets list includes 13,200 guineas, which translates into £13,860. To that sum may be added the pounds represented by the £502 the Twickenham and Lee Clump properties were really worth, the £50 Turner owned in Atlas Fire Office shares, and the £300 in books and furniture. This brings the running total to £14,712. After deducting the £2,700 perceived loss, we are left with £12,012. That was not bad for the son of a humble wig-maker and barber from Maiden Lane, Covent Garden, especially when we consider that William Turner may only have earned £100 per annum even in the good years before 1795 when wigs and their powder began to be taxed out of existence.

Although many of Turner's sketchbooks contain records of stock transactions, banknote and banker's draft or cheque numbers, records of painting orders, sales and the like, only in this 1810 list do we possess such a comprehensive inventory of the artist's assets. It suggests that at the age of 35 he wanted to know exactly where he stood financially, so that he could plot his next moves, especially as he might understandably have been growing disenchanted with paying rent in Hammersmith when he owned two perfectly serviceable tracts of land not far away in Twickenham. Moreover, such knowledge could only have strengthened him against any further economic damage wrought by Sir George Beaumont.

This August Turner went to stay briefly with James Wyatt in Oxford. He did so in order to advance an idea floated by the printseller back in April that he should elaborate a companion picture to the view of Oxford High Street, and one that could be similarly engraved. To serve that end, he and Wyatt strolled out into the countryside to find a suitable view of Oxford from a distance, which they did from the Abingdon Road.[56] Turner then made three pencil drawings of the vista.[57] And later in August he went to stay with Walter Fawkes at Farnley Hall.[58] Once again it was the perfect place to work on the perspective lectures, and possibly on some more of the watercolours commissioned by Fawkes. Among them might have been a superbly structured view of the upper fall of the Reichenbach with a rainbow (fig. 394).

On this visit, Turner and Fawkes could well have discussed something that was troubling the Yorkshireman. It will be remembered that in 1809 Fawkes had purchased *London* (see fig. 370) from the artist's gallery exhibition. When he had done so, he had already possessed Turner's depiction of the *Victory* in three positions, and he had faced the happy prospect of it being joined by *The sun rising through vapour* he had commissioned early in 1809. That picture (see fig. 363) was probably delivered early in 1810. But because the Greenwich view depicted an urban panorama, somehow it did not look quite right between two nautical subjects. Fawkes therefore wondered if he might exchange it for another marine painting.

Well, it just so happened that in late August 1810 Turner had a marine painting hanging in a public exhibition less than seventy-five miles from Farnley Hall. It was on display there because in April 1810 a new exhibiting society, the Liverpool Academy of Arts, had been founded to act as a regional equivalent to the Royal Academy in London. To further that end, it had enlisted support from Somerset House. Turner was one of the Royal Academicians who furnished assistance not only in principle but in practice, for he

394 *Fall of the Reichenbach*, c.1810, watercolour on paper, 10⅞ × 15½ (27.6 × 39.4), Yale Center for British Art, Paul Mellon Collection.

participated in the institution's inaugural exhibition. The show opened on 1 August in the Gothic Rooms in Marble Street, Liverpool. Turner's submission was *Fishermen hailing a Whitstable Hoy*, which was another title for the *Shobury-ness Fisherman, hailing a Whitstable Hoy* that had initially been displayed in his own gallery in 1809. Understandably, the work was for sale.

When Fawkes raised the subject of swapping the *London*, Turner probably informed him that *Shobury-ness Fisherman, hailing a Whitstable Hoy* was hanging nearby and that if nobody purchased it, he would be happy to exchange it for the *London*. And because Fawkes would surely have welcomed such a proposition, possibly he and Turner then travelled over to Liverpool and back in the Yorkshireman's coach in order to examine the potential substitute, especially as the painter might anyway have wanted to see how it had been hung and to view the inaugural exhibition of the Liverpool Academy of Arts more generally. If the two men did undertake this trip, then they could easily have stayed at Brownsholme Hall en route, for it will be remembered that Thomas Lister Parker and Walter Fawkes had long been friends and the house would have been the perfect place to break both journeys.[59] Maybe Parker even joined them on their visit to Liverpool if it took place.

In the event, *Shobury-ness Fisherman, hailing a Whitstable Hoy* would find its way to Farnley Hall as a substitute for the *London*. Although we lack any documentation concerning this exchange, the foregoing hypothesis provides the firmest reasons that have yet been posited as to why and how the two pictures were swapped.[60] Moreover, at some point before March 1811, Turner would record being owed fifty guineas by Fawkes. That debt may well have arisen from his patron promising him such a sum for the privilege of exchanging the two works, just as Sir John Leicester had recompensed the artist

by exactly the same amount for being permitted to act in an identical fashion back in 1807.

Turner received the inspiration for one of his major works while staying at Farnley Hall this summer. Around 1860 Thornbury would be told of it by Walter Fawkes's eldest surviving son, Francis Hawkesworth Fawkes (1797–1871), whose nickname was 'Hawkey':

'One stormy day at Farnley,' says Mr Fawkes, 'Turner called to me loudly from the doorway, "Hawkey – Hawkey! – come here – come here! Look at this thunder-storm! Isn't it grand? Isn't it wonderful? Isn't it sublime?"'

'All this time he was making notes of its form and colour on the back of a letter. I proposed some better drawing-block, but he said it did very well. He was absorbed – he was entranced. There was the storm rolling and sweeping and shafting out its lightning over the Yorkshire hills. Presently the storm passed, and he finished. "There," said he, "Hawkey; in two years you will see this again, and call it 'Hannibal Crossing the Alps'."'[61]

The world would indeed see that storm again, for Turner would depict it in *Snow storm: Hannibal and his army crossing the alps* (see fig. 418), an oil painting he would exhibit in Somerset House in 1812. There the storm would pass not across Wharfedale but above the Col de la Seigne pass in Savoy he had traversed back in 1802. Obviously the Yorkshire storm brought back memories of the sketches he had made of the Carthaginian general in 1798, and of scenery witnessed in the Alps, and thus formed a new image in his mind. But what is even more revealing about this anecdote is that by 1810 Turner did not find a grand, wonderful and sublime storm sufficient in its own right to form a subject for his brush. Instead, he immediately placed it at the service of a higher artistic purpose, namely history painting. For Turner the cross-over from landscape experience to poetic painting could be instantaneous, and it proved fundamental to his concept of art. As far as he was concerned, art has to lift us onto the highest imaginative plane, which in his day was ultimately reachable only by way of historical, poetical, literary, biblical or mythological subject matter.

Turner was probably back in London by late September, if not earlier in the month, although the next recorded sighting of him was on 5 November, when he attended a General Assembly meeting.[62] The canvas of Rosehill commissioned in the summer by Jack Fuller was completed in record time, for the work was delivered and paid for on 26 November, as both painter and patron separately recorded.[63] On that same day Turner used the money he received, plus an additional £30 he derived from an unknown source, to purchase stock.[64] By doing so, he moved his total Bank of England holding up to £7,466-16s-2d.

What happened immediately after Turner had delivered the Rosehill oil to its purchaser was characteristic of the painter by now:

He had painted a picture for the famous Jack Fuller; was asked by Fuller to breakfast with him next morning, to bring the picture with him, and told that the cheque for the work would then be ready. To this Turner consented. He took the picture in a hackney coach, breakfasted, received the cheque, thanked the purchaser, and left. He had not gone above five minutes, when a knock was heard at the door. The painter was back – 'I must see Mr Fuller.' He was shown in. 'Oh! I'd forgotten; there is three shillings for the hackney coach.' The sum was paid. Fuller, who was laughing all the while, loved to relate this story to his friends.[65]

As Fuller's financial record for 26 November shows, the cheque Turner received after breakfast was for £220, or £10 over the 200 guineas disbursed for the painting itself.[66] It is perfectly possible that the additional amount paid for a cheap frame that Turner had obtained for the picture. But Turner was not being miserly in asking that every penny he was owed should be paid. Because of the out-of-pocket experience he had suffered years before at the hands of the 3rd Duke of Bridgewater and his heir, he had determined that in future *all* his expenses would have to be covered. It was a principle from which he would rarely deviate. If it cost three shillings to deliver a painting, then that money had to be recuperated as well. When it came to his finances at least, he simply did not care what the world thought of him. And why should he have done so? After all, he had witnessed how the world had treated Mauritius Lowe and the far more artistically admirable Charles Reuben Ryley, both of whom had possessed virtually nothing by the end of their lives.

We catch no further sight of Turner until 30 November and 10 December, when he attended General Assembly meetings. On the second of these occasions, he was formally advised that he would be automatically rotated onto the 1811 Council, as would Soane and Rossi. In conformity with Academy practice, the newest Academician, Callcott, would be joining them.[67] And on Friday 28 December the Council approved an application made by Turner that a cast of a low-relief sculpture be taken up to the Great Room from elsewhere in the building in order to illustrate points he would be making in his first lecture on perspective early in the New Year.[68]

By now he must have been dedicating most of his time to preparing for the lectures. He cannot have grumbled about having to do so, for nobody had forced him to put himself forward as the Royal Academy Professor of Perspective. Instead, he had actively sought that position, and done so for four reasons: he possessed a genuine interest in the science, for it was central to representational art; he felt duty-bound to pass on his knowledge of the subject to

those entering the fine arts and architecture; he wanted to promote his views on art in general; and he sought a role in which he could somehow emulate Reynolds as a pedagogue. An enhanced raising of his standing by being a Royal Academy professor would be no bad thing either. He must therefore have spent New Year's Eve on the final Monday in 1810 feeling satisfied at what he had creatively achieved during the past year, and at the same time somewhat apprehensive about things to come, for just seven nights later he was going to learn at long last exactly what being a Royal Academy professor would truly entail.

24

Just Six Weeks

January and February 1811

By 1 January 1811, when the fifth part of *Liber Studiorum* officially appeared, Turner had taken back the responsibility for publishing and marketing the scheme from Charles Turner.[1] His patience was exhausted. Yet he achieved nothing by this move, for without the aid of a middleman who could devote a good deal of time and energy to selling the prints, the project was doomed. It would be a very long time before Turner would face up to this reality.

Part V of *Liber Studiorum* particularly demonstrates Turner's range from comedy to tragedy. The former is represented by *Juvenile Tricks* (fig. 395), wherein some boys, who may be carpenter's apprentices, duck one of their number in a shallow pool they have constructed in a London park.[2] The gawkiness of the boys contrasts with the perfection of nature beyond our species, as represented by the trees. Because the boys are ranged in a line that runs parallel with the picture plane and they are contained within a very shallow space, they evoke low-relief sculpture, with its similar parallelism and limited depth of field. However, the boy having his head pushed into the water demonstrates that foreshortening works readily in a completely flat image. This cannot be the case in low-relief sculpture due to the perspectival contradiction caused by forms extending narrowly into space. Turner may have ruminated about this limitation ever since 1809 when he had annotated the discussion of classical basso-rilievo in John Opie's *Lectures on Painting*. In *Juvenile Tricks* he subtly made it clear that such a restriction does not present a problem for painters. And despite being placed in a line, neither do Turner's juvenile tricksters form 'a tedious row from end to end of the picture', to quote Opie on the bad practice of contemporaneous French painters.

Tragedy is represented by *Coast of Yorkshire* (fig. 396). On the left a man pulls a half-dead girl ashore while his companions retrieve ropes and similarly re-usable materials from the water. Further away, other men endeavour to save people marooned on a large offshore rock, onto which they have clambered from their smashed and sinking vessel. The unbridgeable maelstrom makes it certain they will drown.

The First Lecture

When Turner stepped up to the podium in the Great Room cum Lecture Room of Somerset House at 8 p.m. on the evening of Monday 7 January 1811 (fig. 397), he probably felt more nervous than on any other occasion during his entire adult life. Behind him stood a large portfolio containing the great many diagrams he had prepared for his talks, as well as engravings that would prove equally necessary. Seated immediately in front of him was Benjamin West, who had formed the habit at Council and General Assembly meetings of wearing his official cocked hat to denote his presidential

Detail of fig. 404.

395 *Juvenile Tricks*, etching and mezzotint, drawn and etched by Turner and engraved by William Say, published 1 January 1811 as Plate 22 in Part V of *Liber Studiorum*, engraved image size 7 × 10¼ (17.7 × 26), British Museum, London.

396 *Coast of Yorkshire*, etching and mezzotint, drawn and etched by Turner and engraved by William Say, published 1 January 1811 as Plate 24 in Part V of *Liber Studiorum*, engraved image size 7 × 10 (17.7 × 25.4), British Museum, London.

397 Thomas Cooley, *Portraits of Joseph Mallord William Turner and Henry Fuseli delivering lectures at the Royal Academy*, 1811, pencil on paper, 8½ × 5 (21.6 × 12.7), National Portrait Gallery, London.

status, and who surely did so during the lectures as well. As was usual on such occasions, his standing was equally signified by his high-backed presidential chair being mounted on a low plinth.³ Ranged on either side of him were a large number of Academicians, with many Associates seated behind them. Among the former were probably all but one of the other professors. The possible exception was John Soane, who may have stood to one side of the podium in order to supply Turner with the necessary prints and lecture diagrams (it will be remembered that in March 1809 the Professor of Perspective had performed this duty for the Professor of Architecture on the very first occasion the latter had lectured, so it is highly likely the courtesy was reciprocated).

On either side of the Academicians and their Associates, and just behind them, were ranged the Schools students. Beyond them sat the many members of the public who had obtained free but necessary tickets by means of application to a Royal Academician (and doubtless Turner himself had handed out quite a few of them). The Lecture Room was therefore fairly full, although it cannot have been nearly as crowded as it had been in 1790 when Turner had almost certainly heard Reynolds hold forth in the same space. But on this occasion the floor would not threaten to give way; the only things to fall during the course of the evening were probably the spirits of quite a few members of the audience.

Soon after beginning the rather lengthy preamble to his talk, Turner admitted his communicative defects. He also observed that speakers on perspective are inherently at a disadvantage when compared to, say, professors of painting, sculpture and architecture, quite simply because the subject can be 'depressing ... complex or indefinite', and is 'trammelled with the turgid'.⁴ Yet perspective was far too important to be ignored, for without an understanding of its laws – or 'mechanical rules', as the professor habitually termed them – 'Art totters at its very foundations.' That was why the Royal Academy had dictated the subject be taught.

Turner then discussed Reynolds and Michelangelo, and only when he reached the fourth page of his text did he finally arrive at his subject proper. This he did by asserting that a knowledge of the 'mechanical rules' of perspective must be acquired when young. Of course, there was an autobiographical note here, for he was well aware that his early studies with Malton had always stood him in good stead. And knowledge of 'mechanical rules' would prove particularly useful when looking to the art of the past for guidance, for the masters of antiquity bequeathed us much proof of the value they had placed upon perspective. That was why Turner next embarked upon a brief historical review of its useage.⁵ Among the artists he discussed here were Albrecht Dürer (1471–1528); Cimabue (before 1251–1302); 'the inventor of Oil Painting', namely Jan van Eyck (before 1395–1441); the latter's brother Hubert van Eyck (c.1385–1426); and Paolo Uccello (1397–1475).⁶

Invention was Turner's next topic. At its root lay imagination, which is why he called it 'the first order of Painting' and why he valued it as 'the most indiscribable and inscrutable cause which produces the Idea, the noblest part of Art'.⁷ That he capitalised the word 'Idea' and accorded it such primacy suggests he may have regarded such conceptualisation as affording a glimpse of a higher, Platonic level of reality, the realm of the supernal Ideas or perfect, archetypal

forms. If that was his intended meaning, then he was merely following Reynolds, who had advocated conceptualisation of the Platonic Ideas many times in his discourses, as had a number of the theoreticians who influenced him.[8] But Turner conceded that knowledge of the rules of perspective would not impart creative inspiration, and least of all on the highest level; all it can do is supply any great idea with 'a local situation; and to each its form, light, shadow and gradation'.

In the following section, mention of anatomy led to discussion of drawings and observations by Leonardo da Vinci (1452–1519) in the Royal Collection.[9] These had recently been analysed in one of the lectures on anatomy given by Anthony Carlisle, who had demonstrated that laws govern human and animal forms. Turner drew a parallel between such 'rules' and the laws governing perspective.

He then moved on to the perspectival distortions of anatomy that had been wrought by Michaelangelo and Raphael.[10] Adjustments of proportion in relation to perspective came next, especially as they had been employed for sculptural representations of the human form placed upon high columns or plinths. In this connection, Turner cited works by the fifth-century BCE Greek sculptors Phidias and Alcamenes.[11] The first of these masters had so enhanced the grandeur of one of his works by this means that it had astonished in those who beheld it. Alcamenes had not done so with his sculpture, and consequently had failed in his purpose.

Turner continued to discuss perspectival distortion, paying particular reference to carvings by ancient and modern sculptors and architectural craftsmen. Objects cited in this part of the talk included the *Farnese Hercules* (National Archeological Museum, Naples), the *Venus de' Medici* (Uffizi Museum, Florence), the 'flaming ball' that caps the Monument in the City of London, and the statue of King George I that surmounts St George's Church, Bloomsbury.[12] The professor then turned to the perspectives employed in basso-relievo sculptures.

It was here that Turner made it clear why he had taken a particular interest in John Opie's views on low-relief carvings since 1809, for in such works painting and sculpture came their closest. As he stated, 'Baso relivos...particularly come with in the pale [of perspective because] they are in most instances Pictures on different supposed planes.'[13] As examples of this, he cited the low-relief sculptures encircling the Trajan and Antonine Columns in Rome.[14] These were thought to possess subtle perspectival distortions, in order to make spatial sense when viewed from below.[15] Turner explored this subject for some time before moving on to representations of architecture in low-relief sculpture, for as he stated, 'Buildings whenever they are introduced should be strictly regulated by the axioms of Geometrical Perspective, and especially in Baso relivo's'.[16] He then discussed the limitations of perspective in basso-relievo sculpture, in connection with which he referred to a work supposedly 'from the Villa Albani now belonging to Lord Cawdor', a plaster cast of which he had had brought up from the Academy of the Antique with the permission of the Council.[17]

By now Turner's written text was beginning to become somewhat inchoate, rambling and tangential. However, it is possible to determine that he talked next about Opie's views on Annibale Carracci and his brother, Agostino Carracci (1557–1602); he explored the influence of Michelangelo on the Carracci; he mentioned *The Chariot of the Sun* fresco by Giulio Romano (1499–1546) in the Palazzo del Te, Mantua, which of course he had never seen in the flesh but a print of which he had presumably placed alongside him; and he discussed Raphael's *Transfiguration of Christ* of 1518–20, which he had viewed in Paris in 1802 (see fig. 284). This he displayed to his audience in its engraved form, naturally.[18] But eventually he returned to the subject of low-relief sculpture, and did so by means of a 'cast in the life Academy of the Muses', which he had had brought upstairs.[19] This permitted him to make further points about the relationship of planes to lines in such works, and about the linkage of both to perspective.

After exploring the way that light, shade and colour distributed across the surfaces of buildings in architectural elevation drawings are governed by perspective, Turner analysed at some length 'different planes at different distances' before making the valid point that 'Parallel lines carry with them no idea of hight [while] the Oblique ones may rise to infinity.'[20] By this he meant that vertical lines that rise at right angles to the bottom of an image and in parallel with its edges (as well as with each other if there are any number of them) might be architecturally correct, but they cannot convey any idea of height; only diagonal lines can do that, especially if they gradually converge from opposite sides of the image. As we have seen, he had acquired this insight from Malton. He would enlarge upon it in a later talk.

In this particular section of his discourse, Turner was offering guidelines to the architectural students on how they could best communicate a sense of height and grandeur in any elevations they might elaborate. But here the moralist in him could not resist making a related point:

> Altitude must be the natural feeling of the mind when viewing any building,[21] for however collosal man may be in interlect he must draw some scale of his inferiority, and in the words of Rousseau feel all 'The littleness of man'[22] before the massy...fragments of the temple of Minerva [Medica in Rome], from the rocky Acropolis [in Athens], or suppose a scale from the part which at present remains of the temple of Jupiter Stator [in Rome][23]

It is worth noting that Turner had never set eyes on the ruins to which he referred. He then went on to declare forcibly that in

architectural elevations of old or new buildings, the eye should *never* be placed on a level with 'the top of the Pediment or highest line that Geometrical drawings could give', for if our viewpoint was so located the drawing would necessarily fail to convey 'any idea of the extent, the dignity, the towering majesty of such Architecture'.[24] For Turner it was axiomatic by 1811 that buildings drawn from fairly close viewpoints should loom over the viewer, which is why they often do so in his own works and why he now recommended the same approach to others. Here again we can detect the long-term influence of Malton, with his recommendation that buildings be drawn from very low viewpoints. Yet when Turner stated this, the thought may have flashed through his mind that no reservation about unusually high viewpoints pertained to landscape painting, as he was currently discovering in the depiction of Hannibal crossing the Alps he was developing after witnessing a thunderstorm pass over Wharfedale the previous summer. In that painting, which would be completed and exhibited in 1812, he would give us a view down an alpine valley as seen from an especially high vantage point.

Turner continued to discuss architectural elevations for some time, obviously because the rules of perspective so evidently apply to them. Unfortunately, in the process he mixed up the words 'hypothesis' and 'hyperbole'.[25] If his listeners were already puzzled by his general inarticulacy, they can only have been completely mystified by such a malapropism. It was ironic that he erred at this stage in the proceedings for he was discussing clarification, or the way that perspectival elevations can make the spatiality, size, scale and physical complexities of an existing or proposed piece of architecture very evident, whereas purely frontal elevations might easily obscure such qualities. In order to demonstrate this difference, he now put up two large drawings of buildings that had rows of columns ranged before them.

The first was a view of Carlton House in Pall Mall (fig. 398), which is elevated in a purely frontal and formalised manner, while the second depicts the Admiralty building on Whitehall (fig. 399), which appears in perspective. Both of these images had light, shade and colour added to them and – it being Turner who performed the addition – they look extremely beautiful as a result. Naturally, through its greater spatial enhancement, the perspectival depiction helps the viewer make much more sense of what is being seen. But understandably where this lover of architecture and master of launching it into pictorial space was concerned, he thought it inadvisable for architects and others to add light, shade and colour to frontal elevations, for any strength the images might gain by way of such augmentation would be forfeited by dint of their inherent formalism and flatness. In his view only perspectival elevations can truly gain from those additions.

From here the Professor of Perspective went on to discuss perceptions drawn from nature versus laws. Ultimately, he thought, they

398 *Carlton House*, lecture diagram, *c.*1810, pen, ink and watercolour on paper, 26⅞ × 54¾ (68.4 × 139.2), Turner Bequest CXCV-148, Tate Britain, London.

399 *The Admiralty*, lecture diagram, *c.*1810, pencil and watercolour on paper, 30¾ × 52 (78.2 × 132.8), Turner Bequest CXCV-173, Tate Britain, London.

have to be balanced judiciously, which of course had been the very point Malton had made to him back in 1790 or thereabouts. Some lessons penetrate deeply and are never forgotten. Like Malton, Turner distrusted 'mechanical rules' if they conflict with what stares you in the face. Presented with any such clash, he would always opt for the evidence of the eye, just like his 'real master' before him. After all, nature is the supreme teacher.

Finally, Turner returned to the sphere of painting, and to images by Raphael that demonstrate how perspective can enhance the visual coherence and meaning of works of art. Ranged around the walls of the Great Room cum Lecture Room as Turner spoke were full-sized copies by Sir James Thornhill (*c.*1675–1734) of the tapestry cartoons representing scenes from the Gospels and the Acts of the Apostles that had been painted by Raphael in gouache on paper in 1515–16.[26] Turner praised the use of perspective in these designs before returning to Raphael's *Transfiguration* (see fig. 284), the engrav-

400 *Diagram of the upper section of Raphael's Transfiguration*, lecture diagram, pencil and watercolour on paper, 29 × 21¼ (73.8 × 53.8), Turner Bequest CXCV-163, Tate Britain, London.

ing of which must have remained on display. Now he began analysing the internal perspectives of that image, its compositional lines, and the interrelationship of the latter components with Christian symbolism.[27] To further clarify these points, he had prepared a drawing of the top half of *The Transfiguration* with an upward-pointing triangle superimposed upon it (fig. 400).

In the lower part of Raphael's painting, the diagonals formed by various raised arms lead the eye upwards to Christ's rearmost foot, the one with which He had quit this earth. Given that the figures to whom those arms belong are located upon the ground, such diagonals help form an implied triangle. A further implied triangle is created by the bodies of Saints Peter and Paul on either side of Jesus in the upper part of the image. By leading the eye upwards, the diagonals focus attention upon the head of the Saviour and upon the climatic space filled by God and the Holy Spirit above Him. And naturally, all the diagonals simultaneously assist the spatial recession of the image by augmenting its internal perspectives. Turner's awareness of the upper triangle is made clear by his analytical drawing, and he certainly did not miss the symbolism of triangles in a painting that deals with the Holy Trinity by implication. Nor did he miss the significance of there being but three figures in the sky, for this constitutes yet another reference to the Trinity. However, he did not underestimate the lack of associative powers in his audience either, for where his own works were concerned he had been forced to face such incomprehension for years. Clearly, that is why he qualified his statement concerning the Italian painter's allusions to the Trinity by disingenuously and slyly declaring that 'whether [Raphael] had any allegorical intention in placing the three figures on the top of the Picture may be too presuming for me to say'.[28]

The analysis of Raphael's *Transfiguration* eventually led Turner to his peroration, which involved a discussion of perspective and its role in assisting the creation of grandeur in specific works by Reynolds, Lawrence and Fuseli, to the titles of which he alluded.[29] As the latter two painters were undoubtedly seated just a few feet away from him, they might well have been flattered by his ending, although like many other listeners they were probably also relieved that the conclusion had finally been reached (as was the Professor of Perspective himself, albeit for a somewhat different reason). And given the likelihood that Reynolds had 'boldly stept forth' to declaim Michelangelo's name at the termination of his final discourse in 1790, it is possible that Turner stepped forwards to declaim the final word 'Grandeur' with some force at the very end of his talk.[30]

Clearly, Turner's first lecture broke down into three sections, each of which was aimed at a principal area of practice and study within the Royal Academy, namely painting, sculpture and architecture. Intellectually the talk was a creditable affair, although occasionally it degenerated into a verbal shambles. However, that is not how everyone perceived it. John Taylor, writing in the *Sun* the next morning, stated that the talk had been written throughout in a strong and elegant style, and that it had been delivered 'with unaffecting modesty'. Most importantly, Turner's attempt to 'show that the highest order of Historical Painters, as well as Architects and Sculptors, availed themselves of the principles of Perspective in their most distinguished productions' was illustrated 'with success'.

When the piece appeared on the Tuesday, its author sent a copy to Turner. He was so delighted with it that he wrote to Taylor on the Wednesday to thank him for his 'kind and honourable' review. That he did so demonstrates how important he deemed such commendation. Because he could not bring to lecturing the same degree of confidence he brought to painting, he needed public approval of his efforts. Consequently, he received it with unusual gratitude.

John Landseer had also attended the lecture and on the following day he informed Farington: 'Turner is desirous of having a Professorship of Landscape Painting established in the Royal Academy; and

to have the law which prevents Landscape painters from being visitors repealed'.[31] Farington advised him there was no such law. Clearly, Landseer had gone up to Turner after the talk to pay his respects. The latter, realising how far short of Reynolds he had fallen, had expressed the wish that he had been able to serve the Royal Academy in an educative capacity better suited to his talents, either as a speaker on landscape painting or as a one-to-one teacher in the Schools.

On that same day, Tuesday 8 January, Turner attended his first meeting as a member of the Royal Academy Council for 1811. Henry Howard RA (1769–1847) acted as the secretary in place of John Inigo Richards, who had died on 18 December. After some mundane business had been transacted, Turner moved that the top-floor apartment to the west of the Great Room on the north side of the Academy staircase that had formerly been occupied by the late Secretary should be 'immediately converted into an additional Exhibition Room'. The resolution was seconded by Callcott and adopted unanimously.[32] It was a brilliant idea, for the Royal Academy had been suffering from an acute shortage of display space for years.[33] By converting the Secretary's apartment into a gallery, the top floor of Somerset House would gain a new area for showing works of art that was almost half as large as its principal exhibition room.[34] As we shall see, Turner would begin to benefit from that addition later in 1811, and continue to do so many times thereafter.

The Second Lecture

On Monday 14 January the proceedings were chaired by Copley and attended by all the other members of the Council.[35] Now Turner began to delve into the technicalities of his subject, which is why he began by apologising for the difficult terminology he would be using.[36] Basically, he would be talking about standard or fixed-position perspective. This is the principal method that enables spatial information received by the eye in three dimensions to be converted into two-dimensional forms of representation. But Turner made it clear that he was not at all interested in how the eye functions as an organ. All that mattered to him was how forms could be laid out upon a flat surface in order to 'express particularly each object and its angles as they appear to the eye'.[37] He went on to examine the relationship of the eye to the point of convergence or 'vanishing point', that spot upon which all perspectival lines converge. Like many previous commentators on perspective, Turner essentially held vision to be a cone emanating from the eye. However, he did not accord any importance to the widespread belief that a standard perspectival representation is simply a vertical plane that cuts across the cone of vision, for he failed to see how such an intervening plane could be of any practical use to an artist.

With the aid of specially prepared diagrams, Turner then set out some basic definitions of standard perspective as they had been given by Joseph Moxon, Brook Taylor and Thomas Malton the younger. In the process he got a number of details wrong, muddied the original arguments or abbreviated them so severely that they became virtually meaningless. Next he analysed in detail how lines of convergence function; the nature of rising, declining and perpendicular perspectival lines; the intricacies of horizontal, vertical, inclined and ground planes; orthographic projection, wherein two or more views of an object at right angles to one another are represented within a single image; ichnography, or the laying out of ground plans of buildings; and stereography, or the depiction of three-dimensional objects by projecting them onto two-dimensional surfaces.[38]

This led to a discussion of picture planes, vanishing planes and perpendicular planes. Subsequently explored were transferred, accidental and diagonal vanishing points, as well as points of incidence, or the intersections of lines with surfaces.[39] Many of these topics were illustrated with original diagrams by Turner or with ones he had elaborated from diagrams in the various treatises on perspective he had studied. He also used a number of the original engravings that adorned those tomes. Understandably, one of the books to which he frequently referred was the treatise by Thomas Malton the elder that the latter's son had patiently led him through years earlier. Eventually this fairly lengthy exposition brought Turner back to a further discussion of planes before he began exploring rectilinear perspective or the perspectival properties of rectangles.[40]

From here he progressed to curvilinear perspective, or the use of standard perspective to represent curved objects and spaces.[41] Turner had a good deal to say about this, quite evidently because it held huge importance for him, as he would make especially clear in a painting he would exhibit in 1817. He then went on to explore the perspectives of circles, cylinders, cones and conic sections.[42] For this part of the talk he had produced further diagrams. A drawing that served as his lecture diagram 20 showing conic sections that had been taken from a diagram by Thomas Malton the elder is a particularly fine example of his strength of hand and feeling for spatial definition (fig. 401).

Marginal distortion, or the way that standard perspective can make things appear larger at the periphery of sight, came next. Turner went into this subject very thoroughly because marginal distortion makes particularly evident the difference between the appearances of things in reality and how they look when depicted on a flat surface. The professor forcefully rejected the notion that images created in standard perspective can be viewed only from a position that aligns exactly with the perspectival viewpoint of the space represented.[43] Turner regarded that as a 'trammel upon painting', and stressed that major artists like Rubens would never have accepted

401 J. M. W. Turner after Thomas Malton the elder, *Conic sections*, lecture diagram, c.1810, pencil and watercolour on paper, 26½ × 39⅜ (67.4 × 100), Turner Bequest CXCV-63, Tate Britain, London.

such a limitation.[44] And towards the end of his talk he made the dichotomy between appearance and reality especially evident by giving his audience a vivid pictorial demonstration of the failure of standard perspective to deal with lateral convergence. This is the way

402 *Upper part of the north wall of the Great Room at Somerset House*, lecture illustration, c.1810, pencil and watercolour on paper, 26⅜ × 39⅜ (66.9 × 100), Turner Bequest CXCV-70, Tate Britain, London.

that horizontal lines both below and above the level of the eye respectively move up or down to a distant meeting point on the same level as our eyes.

In order to demonstrate lateral convergence, Turner brought forth a large watercolour he had made of the upper part of the north wall of the Lecture Room cum Great Room (fig. 402). To see what he was talking about, and thereby to compare appearance with reality, all his audience had to do was look at his drawing upon its stand, and then gaze upwards.

In the watercolour, the north wall is absolutely parallel with the picture plane, and consequently the horizontal lines that constitute its cornice remain parallel too. Yet although the image looks convincing, in fact it constitutes a trick played by the brain upon the eye, as the painter now revealed.[45] Pointing to the wall, he explained that such parallels were not being witnessed in reality. This is because no horizontal line remains straight in nature except where it is on an exact level with the eye, thereby forming our horizon. Thus, although the audience seated in the Great Room saw the upper and lower lines of the cornice above their heads as running parallel with one another, in actuality those lines increasingly curved downwards towards the horizon, where they finally converged distantly at the eye levels of the audience members. Moreover, as Turner further pointed out, this would remain the case even if such lines were viewed from a very great distance. Because of the curvature inherent to lateral convergence, the employment of standard perspective upon a flat surface could not deal with it, although in the late 1820s Turner would make such curvature a striking feature of various depictions of extremely wide vistas at Petworth.

This was but one of a number of objections to standard perspective that Turner expressed throughout his second talk. And he paid little attention to mathematically correct but fairly incomprehensible perspectival theorems in any of his perspective lectures. What he sought were rules that would prove of practical benefit to artists. That was why he maintained that it was only by working from a general grasp of theory towards practice that anyone could ultimately benefit from the study of perspective. But conversely, practice without theory was useless, for it was not grounded in anything.

In conclusion, Turner returned to the necessity of balancing an understanding of the 'rules' of perspective with a comprehension of what nature sets before us. As he stated, 'Rules are the means, nature the end.'[46] Such a stress was necessary, for as he had demonstrated that evening, an observance of strict perspectival rules could easily prove problematical. But that did not mean that the laws of perspective could be ignored; on the contrary, they needed to be adapted to individual needs *after* they had been mastered. As he ended with something approaching eloquence, 'Then the knowledge of rules begins to create a confidence unattainable by any other method,

which conjunctively with our reasoning faculties, enables the mind not only to act for itself, but to duly appreciate with truth and force what nature's laws declare.'[47] He may well have finished by placing the stress upon the final word of this peroration, just as he probably had done with the word 'Grandeur' at the conclusion of his first talk.

After the lecture Charles Rossi told Farington that Turner had got through it 'with much hesitation & difficulty'.[48] Yet in the *Sun* the following day, John Taylor complimented Turner on his 'scientific knowledge' and 'practical skill', stating that he was 'fully qualified to do honour to the situation'. This time the professor was not only moved to send Taylor a letter of thanks, but to do so in forty-eight lines of verse. They end by admitting that the lecture had been 'Fitter to Puzzle than allure'.[49]

The Third Lecture

Unfortunately, the talk given on the evening of Monday 21 January was so long that Turner was forced to carry over its conclusion to the following week. In order to do so, he had to drop his original fourth lecture entirely. As a consequence, the fourth talk he did give would only last thirty-five minutes.[50]

Turner began his third lecture by concentrating upon 'the practical part of Perspective, divided into parallel, angular and aerial'.[51] In parallel perspective, rectangular objects present a facet or combination of them in parallel with the picture plane, while in angular perspective forms stand at an angle or variety of them to the picture plane. Turner was not fully convinced of the theoretical validity of parallel perspective, but nonetheless he appreciated how useful a means of entry to the greater complexities of angular perspective it could provide for students, due to its relative simplicity. He also saw its proven worth to artists such as Raphael and Dürer, as he demonstrated by means of engravings.

He then talked about 'the different practical modes of finding the square by the old masters'.[52] By 'finding the square' he meant the use of parallel and angular perspective to analyse the cube, which is a fundamental form in nature, and therefore of equal importance to both architecture and painting. By 'the old masters' he meant those earlier writers who had analysed the cube in perspectival terms. In connection with the cube, he paraphrased an insight by his former teacher of perspective, Thomas Malton the younger:

> when the cube and circle were thoroughly understood in Parallel and angular Perspective not only the foundation of Perspective was firmly laid but that the superstructure by common practice and observation must follow, for Practical Perspective consists of congeries of cubes and circles which assertion, observation, and Practice, confirms most amply its truth, for the Octagon, Hexacon, Circle, Pentagon, Decagon, Triangle and every figure originates or can be found by the cube.[53]

As always, Turner was attempting to arrive at the essence of things, even if the words with which he might facilitate such a move were not readily comprehensible. And in order to 'find the square' he went on to discuss eleven perspective treatises in detail, with several further studies mentioned in passing.[54]

Most of his points were clarified by means of large diagrams he had made. If he accorded a mere ten minutes to each of the analyses of parallel and angular perspective found in the eleven treatises he discussed in detail – and such examinations could easily have taken that long, especially as diagrams, engravings and the like needed to be located and extracted from his portfolio during the course of each investigation – then his exposition would have taken almost two hours. It terminated with the conclusion of his historical survey. That would explain why, in the *Sun* the next morning, the talk would be described as having been devoted to a survey of 'the progress of the Art [of perspective] from the first Professors abroad, beginning in the fifteenth century, to the latest changes and improvements in this country'.

The Fourth Lecture

On the following Monday evening, 28 January, Farington was in the Chair. In his diary he noted that the fourth talk lasted just thirty-five minutes and that among those present were Turner's father, Soane, Callcott, Thomson, Northcote, Phillips, Howard, Woodforde and Owen.[55] Soane's presence suggests he had attended the previous lectures as well. For obvious reasons, Turner would have especially valued his friend's moral support throughout all his talks.

According to the William Rolls version of the lecture that was originally to have been given this evening,[56] it should have been devoted to a discussion of taste, judgement, the habits of the eye, and the nature of vision and its effects upon perspective (including visual distortion). Several other related and seemingly unrelated matters in this original text have more to do with metaphysics and poetry than perspective. Yet for that very reason they furnish us with valuable insights into Turner's thinking on the Platonic Ideas and on the relationship of the 'sister arts' of poetry and painting.

For example, on the fourth page of the original text we encounter the following:

> Dryden says that art reflecting upon nature endeavours to represent [nature] as it was first created without fault.[57] This idea becomes the original of art and being measur'd by the compass

of the interlect is itself the measure of the Performing hand by immitation of which imagin'd form all things are represented which under human sight and therefore in forms and figures there is something which is excellent and perfect to which imagin'd species all things are referr'd by immitation which immitation of nature is the ground work of our art.[58]

In other words, art should aim to represent nature in an idealised way, as 'it was first created without fault'. Here Turner was following a long aesthetic tradition of using the word 'imitation' to denote the approximation of ideal forms, rather than simply the replication of the transient and imperfect forms that nature arbitrarily sets before us in the everyday world. The best way to approximate ideal forms is through synthesis, the bringing together of what are deemed to be the most beautiful features of many examples of a given form encountered in nature.[59] And in Turner's acceptance of 'imagin'd form' and 'imagin'd species', let alone his active belief in them, resides further proof he regarded art as a means of grasping and expressing the Platonic Ideas, as had Reynolds before him.

On sheets of paper interpolated in his manuscript,[60] Turner then examined the dangers of being tempted by the 'sounds harmonious' of fine verse into directly translating the 'Ideal beauties or connecting Metaphors' of poetry into visual imagery, for he knew how ridiculous such straight conversions might look (as with, say, that possible but somewhat baroque pictorialisation of James Thomson's 'King of Day' trope for the rising sun cited above). But how these insights would have furthered the understanding of perspective is impossible to imagine. Perhaps that is another reason Turner did not deliver the fourth lecture as originally planned.

Instead, he picked up where he had left off the previous Monday, a good way into the text for his third talk. Probably he limited his discourse to thirty-five minutes because he felt he had already tested the patience of his audience the previous week by overrunning massively. But given the amount of material he still needed to cover, the fourth disquisition must have been a somewhat hurried and attenuated affair, at least in places.

Writing in the *Sun* the next day, John Taylor related that in just 35 minutes Turner had talked about 'the respective utility of parallel, angular, and other branches of the art [of perspective], illustrating his positions with appropriate drawings, and a reference to the works of former Artists, among whom he mentioned our late countryman, MALTON, jun. with merited commendation'. Among the 'appropriate drawings' were diagrams developing a simple rectangle into a representation of a house, complete with roof, pediment, cornice, windows, front door and front steps.[61] In the process Turner had made some errors in the perspective, although it must be doubted that anyone noticed.[62] Subsequently, pentagonal and hexagonal forms

403 *Pulteney Bridge, Bath, in perspective*, lecture illustration, c.1810, pencil and watercolour on paper, 26½ × 39⅜ (67.2 × 99.9), Turner Bequest CXCV-114, Tate Britain, London.

were briefly explored before he arrived at shapes that 'occupy the most promanant points in the pursuit of art [such] as the column, the circle and the Dome'.[63] He also discussed the difficulty of representing circular forms 'from the earliest time'.[64] Here he brought up problems detected in a perspectival representation of a circular staircase by Lorenzo Sirigatti (1561–1592).[65] He thought the method the Florentine had used had been overcomplex, and feared it would lead to bewilderment rather than to any procedure that might prove useful to artists. As always, practicality was his watchword.

Next he mentioned problems encountered in other treatises before moving on to an examination of the Tuscan, Ionic, Corinthian and Roman Composite orders in architecture, and how they could best be represented in perspective.[66] Eventually he brought this section to a grand conclusion by analysing two perspective diagrams and a superb watercolour illustration (fig. 403) elaborated from them. All three works had been developed from a 1779 engraved view of Pulteney Bridge in Bath by Thomas Malton the younger.[67]

As Turner explained, he had chosen to illustrate this building 'not for the beauty of its architecture, but from its possessing the principles of the square and circle, and having columns and entablatures in projecting colonnades'.[68] Judging by the linear uncertainties and occasional errors in the internal perspectives of one of the diagrams, it may have been a student exercise created when he had taken perspective lessons from Malton around 1790.[69] Why waste anything?

The diagrams of Pulteney Bridge make apparent the squares, circles, columns and entablatures to which Turner referred, and they

equally project the niceties of perspectival measurement. However, they contain nothing of the light, shade and distant misty atmosphere conveyed by the watercolour illustration developed from them. And when Turner put up that final image on his display stand, the audience might well have felt a shock of recognition that the bumbling speaker standing in front of it was a visual poet of the highest order. Looking at this watercolour, it is easy to understand why the almost completely deaf Thomas Stothard sat happily through Turner's talks; as he told a fellow Academician when he was asked on some indeterminate occasion what pleasure he could possibly obtain from the experience, he replied, 'Sir . . . there is much to *see* at Turner's lectures – much that I delight in seeing, though I cannot hear him.'[70]

Next, Turner briefly touched upon aerial perspective. This, he stated, 'is universal gradation consisting of parts of light, shade and color'. For him it was 'the end, the mead of all our toil'.[71] If the Pulteney Bridge watercolour remained on the stand when he said this, as appears likely, then no better demonstration of what he meant could ever have been placed before an audience, at least by this particular master of aerial perspective. And there was little more to be said on the subject, for the universal gradation 'of parts of light, shade and color' could never be taught; proficiency in it could only be gradually acquired through 'practice and observation', as Turner also stated.

Finally he reached vertical perspective. In this connection, and to conclude his lecture on a suitably upbeat note, he revealed the lesson on the use of both eyes and mind he had been given many years earlier by Malton concerning the depiction of Westminster Abbey in vertical perspective, with its inherent convergence of upward lines. (It must have been this mention of his teacher that figured in the *Sun* review of the following morning.) And having imparted to his audience Malton's dictum that whatever was seen in nature was 'Incontravertible', Turner then concluded by quoting Akenside, verses by whom he had obviously written down from memory in his lecture notes:

> For such is the Throne for Truth amid the
> paths of mutability hath built, secure unshaken still
> and whence he views in natures mouldering structures the
> Pure forms of Circle triangle cube or cone[72]

It is not clear from this whether it was Malton who had originally quoted verses that derived from Mark Akenside's *The Pleasures of the Imagination* of 1757–70, or whether the inclusion of the lines was Turner's gloss upon Malton (probably it was the latter). Yet it is evident that in a particular act of visual acuity the Professor of Perspective found evidence of the existence of a universal Platonic geometry, for it is otherwise difficult to imagine why he would have quoted Akenside at the end, even if Malton had once quoted part of that poem to him.

Turner quoted these lines from Akenside no fewer than seven times in his lecture manuscripts,[73] and although some or all of these citations duplicate others, the very fact that they were carried over from draft to draft indicates the significance they held for him. Because of that importance it is worth supplying the maximum extent of Turner's quotation from Akenside's poem, with the lines that follow in the original work being added within square brackets to complete the meaning:

> . . . Such the rise of forms
> Sequester'd far from sense and every spot
> Peculiar in the realms of space and time:
> Such is the throne which man for Truth amid
> The paths of mutability hath built
> Secure, unshaken, still; and whence he views,
> In matter's mouldering structures, the pure forms
> Of triangle, or circle, cube or cone,
> [Impassive all: whose attributes nor force
> Nor fate can alter. There he first conceives
> True being, and an intellectual world
> The same this hour and ever]

Turner quoted these lines not simply because they provided a grand peroration for a lecture devoted to the geometries of perspective, but equally because they encapsulated his ultimate conception of nature, just as they had for the poet who had written them.

For Turner, nature was not simply the realm of humankind, flora and fauna, meteorology, water, geology and the rest. Instead, and as Akenside articulates, it is a metaphysical entity, the higher existence of which the universality of forms such as triangles, circles, cubes and cones provides tangible proof. By 1811 the painter had not yet fully gained the ability to express that more elevated concept of nature in his images, but very soon he would do so by means of his forms, while eventually he would equally attain that end by increasing his tonalities to levels of brilliance that exist far beyond what is normally witnessed in reality. And by both means he would finally bring into view some measure of 'True being' or the realm of the Platonic Ideas he had been greatly helped to imagine by Akenside and others, not least of all Reynolds.

The Fifth Lecture

The Instrument of Foundation of the Royal Academy in 1768 had dictated that its Professors of Perspective should, as part of their wider remit, talk about 'the Projection of Shadows, Reflections and

Refractions', even though there might appear to be no connection between perspective and the reflection or hindering of light by various types of body. However, a single word in Turner's general introduction to his talk on reflections – or 'reflexies' as he called them – makes the link subtly apparent. After stating that 'Nothing is so difficult or undefined as the Theory of Reflexies and yet they are absolutely necessary to the Painters pursuit,'[74] he went on to observe that reflectivity was understandably neglected in works on perspective and that he who discovers 'positive Axioms for Reflexes as for planes...will deserve not only the thanks for those who follow him but will obtain for himself a name that must be honored as long as the English School exists'.[75]

The key word here is 'planes'. Where pictures and related images are concerned, perspective is the science of converting three-dimensional planes to two-dimensional representations of them that make them look spatially convincing. (In the case of basso-relievo sculptures it involves creating somewhat flattened but convincing simulacra of such planes.) Moreover, the perspectival distortion of planes can also dramatically enhance fully rounded representational sculptures or make them seem more visually convincing from certain viewpoints, as Turner had already stated. Yet because light reflects off planes, such as the surfaces of objects, clouds, water or buildings, then in its reflected form it too comes within the remit of perspective. That is why the professor happily dedicated his fifth lecture to the subject.

Following his introduction, Turner touched upon the Newtonian system of light and the explanation of reflections it provides.[76] He then went on to discuss the dissemination and distribution of reflected light. For him reflections could be divided into three types: those given off by uniformly opaque, solid bodies; those shining off polished objects; and those cast by transparent planes, such as the surfaces of glass or water.[77] Turner was conscious of the fact that whereas opaque bodies reflect a brilliant light source such as the sun in all directions but in a very dull manner, polished ones concentrate any bright light that falls upon them in direct opposition to the source of that light, which is why they reflect it 'only in a point' or small area of intense focus. We shall come to Turner's discussion of reflections off transparent bodies in due course.

Naturally, where reflections are concerned, the physical position of the viewer is crucial, both in angle and distance from the reflective object. Turner used windows to illustrate this point. In his day, panes of glass were 'irregular-waved' or fairly undulant reflective surfaces, with each pane that formed part of a multi-paned window possibly reflecting the sun at 'any period of the day...in all directions'.[78] However, from an 'extreme distance where form is lost', the reflections of windows in aggregate might well create a single, glaring light. In an early draft of the fifth lecture Turner had formulated a couplet on this subject, and it seems possible that at this juncture of the talk he recalled these lines from memory:

> Where form is lost in rising evening haze
> Full to the sun the village windows blaze.[79]

Yet because of the distance involved, only a little movement to left or right on our part would cause those reflections to disappear entirely. Positioning is of the essence, for it is what enables us to see reflections at all.

To demonstrate the difference between reflections off an opaque body and a polished one, Turner used two images. In an engraving of Rembrandt's *Portrait of a man in military costume* of 1650 (the painting of which now hangs in the Fitzwilliam Museum, Cambridge),[80] he pointed to the armour 'where little or no polish can be said to exist'.[81] Here the reflections are large but dim. In a reversed reproduction of van Dyck's 1639 portrait of the 1st Earl of Strafford, the original of which hung and still does so at Petworth, he drew attention to the 'highly polished steel armour and on the arm which crosses the Picture'.[82] Here the reflections glint.

Turner then went on to discuss reflections on gold, silver, copper, brass, pewter and tin before talking about transparent bodies, which, he observed, 'depend so much upon what is opposed to them having no color they take every one offered'.[83] Perhaps this is nowhere more apparent than upon the surfaces of water. At this point Turner stated that 'True [water] is a Mirrour but of natures choicest work do we ever trace the double lines and prismatick reflected rays as on the glass or do we see the liquid and melting reflections or the gentle breese that on the surface of the waters sleeps'.[84] The pencilled annotation 'The falls of the Clyde' that appears in the margin to the left of the word 'surface' in the foregoing passage shows that it was at this point in the proceedings that *The fall of the Clyde, Lanarkshire: Noon. – Vide Akenside's Hymn to the Naiads* watercolour that Turner had exhibited downstairs in the Council Room in 1802 (see fig. 271) was placed in front of the audience. It must have proven very helpful to the discussion of the reflectivity of water that followed.[85] Here the artist spoke of the endless variety and 'incomprehensible contrarities' of the liquid as he analysed its colouristic and tonal reflectivity. Perhaps he even quoted from Akenside's *Hymn to the Naiads*, either from memory or from the ninth volume of Anderson's *Complete Poets* taken along to Somerset House. Any such quotation or reading could further explain why the *Sun* would state on the day after the talk that Turner's lecture had been interspersed with passages of poetry, as will be seen.

Subsequently, Turner considered the reflection of colour upon water in terms of its brightness, dullness and surface variety.[86] He then proceeded to analyse how light falls upon planar surfaces in the open air and enters interiors through apertures to fall as bright rays

that contrast sharply with surrounding shadows.[87] As he was aware, such shadows are also full of light and colour, although they may be dark in tone. In passing, Turner touched upon the reflection of light upon ceilings. He also mentioned the indoor reflectivity of water.

Next to be discussed was the reflection of light by globes.[88] By means of an illustration, Turner communicated the effects of light entering through windows to fall upon three solid metal globes (fig. 404). The same image enabled him to demonstrate how two of those globes reflected light upon each other, or refracted it by their close proximity. A representation in oil on paper of a window reflected by a transparent globe was then placed in front of the audience.[89] Turner went on to remember a similar reflection upon a huge globe included in a van Dyck portrait of the Countess of Southampton of around 1640 (National Gallery of Victoria, Melbourne), which he had seen at the British Institution in 1808.[90]

Another of his illustrations demonstrates the effects of light and its reflections upon two transparent glass globes, one of which is three-quarters full of water (fig. 405). Such globes were employed by engravers at night to magnify artificial light in their workshops.[91] But Turner concluded this vivid demonstration of reflectivity upon metal and glass by expressing his doubts regarding the assistance that rules might give to students. As he stated, 'nature must be refer'd to [at last], for to generalise is all that rules can dare to hope for.'[92] It was a familiar theme, and one he amplified in his peroration:

> although we may feel to want the help of rules it is here where practice must work for its own reward and where given would be endless and where it becomes useless to prescribe methods to those who have no talents and those who have talents will find methods for themselves,[93] methods dictated to them by their own particular disposition and by their own...particular opinion, observations and necessities of practicability.[94]

He knew from experience the degree to which talent, observation and practical necessity could help overcome the ignorance of rules, but it is a sign of his generosity of spirit that he wanted to help others transcend such a lack of knowledge. That desire was undoubtedly a legacy of both Malton and Reynolds, and it would never leave him.

In his review in the *Sun* the next day, John Taylor stated:

> The ingenious Professor, as usual, manifested a profound knowledge of the subject, and rendered his observations more striking and impressive by a reference to several masterly drawings of his own composition, which were submitted to his audience... In the progress of the lecture he made some judicious remarks on the nature of Genius and Taste, and relieved the unavoidable dryness of an abstract discourse by occasional citations of poetry.

404 *Reflections on a single polished metal globe and on a pair of polished metal globes*, lecture illustration, c.1810, oil and pencil on paper, 25¼ × 38⅛ (64 × 96.8), Turner Bequest CXCV-176, Tate Britain, London.

405 *Reflections and refractions on two transparent globes, one three-quarters filled with water*, lecture illustration, c.1810, oil and pencil on paper, 8⅞ × 15¾ (22 × 40), Turner Bequest CXCV-177c, Tate Britain, London.

The journalist surely recognised the autobiographical element contained in Turner's statement that 'those who have talents will find methods for themselves', even if it was only a paraphrase of Reynolds. But clearly he was stimulated rather than baffled by the rich art-historical, scientific and cultural mix offered by the professor, which is why his attention was held. If only that had been the case with many more of Turner's auditors.

The final talk had to be delayed by twenty-four hours because the evening of Monday 11 February was given over to a General Assembly meeting convened to elect five new Academicians in place

of those who had died since February 1810.[95] Among the Associates who were elevated in rank – partly with Turner's support – were Wilkie and Robert Smirke junior. That the landscape and marine painter voted for the Scottish genre painter further undermines claims that he resented his supposed 'rival'.

The Sixth Lecture

Turner began his last talk by stating that he now needed to show 'how the various combinations and arrangements of the different degrees and quality of perspective, light, shade and colour have been effected by various Masters'.[96] In order to set an aesthetic starting point for his exploration, he declared: 'To select, combine and concentrate that which is beautiful in nature and admirable in art is as much the business of the landscape painter in his line as [it is] in the other departments of art.'[97]

Here he was fully identifying with Reynoldsian idealism, with its rejection of the 'accidents of nature' and its assertion that the artist must eschew the particular and the transient in favour of the universal and immutable. Reynolds maintained that such idealism had found its highest form in history painting. By way of prints and through verbal descriptions of colours, Turner demonstrated the vital role that landscape representation had long played within history painting and lesser genres, especially by means of the buildings, objects and backgrounds in many of them. Naturally, the setting of things within a convincing perspective proved integral to such a process.

After touching upon pictures by Pietro Perugino (1446–1524) that had strongly utilised perspective, Turner went on to discuss Raphael, who had been a pupil of the Perugian painter.[98] The presence within the Lecture Room of James Thornhill's copies of the Raphael cartoons proved of great assistance here, for two of those designs – depictions of Jesus delivering the keys to St Peter, and of St Paul preaching at Athens – enabled Turner to demonstrate Raphael's use of perspective, his occasional employment of a pictorially elevated viewpoint, and his use of line to expressive ends.

Questions of propriety and absurdity were then raised in connection with Annibale Carracci before Turner moved on to Titian, who had bestowed 'the highest honour' that landscape painting had yet received, especially in the 'divine picture of St Peter Martyr', which of course he had viewed in Paris in 1802 (see fig. 285).[99] Here there was no question of landscape painting being subordinated to historical subject matter; instead, the two happily coexisted. A similar observation applied to Titian's *Diana and Actaeon* of 1556–9 (National Gallery, London, and the National Gallery of Scotland). And when Turner reached Titian's *Venus with a Lute Player* (Fitzwilliam Museum, Cambridge), he extolled the female beauty he rarely celebrated in

406 Paolo Veronese, *Hermes, Hersé and Aglauros*, 1576–84, 91½ × 68⅛ (232.4 × 173), Fitzwilliam Museum, Cambridge.

paint himself. The 'voluptuous luxury of female charms rich and swelling'[100] of which he spoke affords us an insight into how red-blooded he could be about beautiful women, at least where depictions of them were concerned.

Turner disliked the backgrounds in paintings by Hans Holbein the younger (1497–1543) for he found them too flat.[101] Subsequently he discussed gold backgrounds and their breaking of the unity between foreground and background.[102] He then turned to the depiction of architecture. After commenting on how poorly this had been pressed into service by Dürer, he praised its use by Paolo Veronese (1528–1588). In this connection he especially liked two works: the *Wedding Feast at Cana* of 1563 (Paris, Louvre) and *Hermes, Hersé and Aglauros* of 1576 or slightly later (fig. 406). He was particularly impressed by Veronese's use of colour, about which he spoke for some time.[103]

Next he briefly condemned painters of individual nature such as Paul Bril (1554–1626), before returning to Titian's *St Peter Martyr*, which he now explored in more detail.[104] He spent little time on the Bolognese painters, due to what he deemed to be their 'flat, meagre and frequently misapplied' tonalities. On the other hand – and as we have already noted – he did admire *The Raising of Lazarus* by Guercino (see fig. 292), although he referred to it as being by Domenichino. A passage of landscape painting within a depiction of the death of St Jerome that is, however, by Domenichino (Vatican Museum, but also seen by Turner in the Louvre in 1802) was praised as being 'beautiful', and perhaps without equal for its 'fresh vernal tone'.[105]

The next work to receive analysis by way of a print was *The Agony in the Garden*. This reproduced a copy (National Gallery, London) by an unknown hand of a painting by Correggio, although Turner shared the misapprehension, widespread in his day, that it constituted an original.[106] He was full of praise for the 'dubious and indefinable tone of colour' in its dawn sky, calling it a 'doubtful gleam of light that throws *half an Image on the aching sight*', and an 'evanescent twilight' that was 'tenderly blended'. The use of the words 'dubious' and 'doubtful' to convey great colouristic subtlety here is rather poetic.

Such considerations of low light now led Turner to the Rembrandt *Holy Family Resting on the Flight into Egypt* (see fig. 137) which he had first viewed at Stourhead in 1795. It was at this point in his talk that he spoke of never having seen in any other picture 'that freshness, that negative quality of shade and colour, that aerial perspective enwrapt in gloom', as quoted above. He then went on to compare the distribution of light in the Rembrandt and the minutely controlled tonalities of the (supposed) Correggio, qualities that brought to mind three slightly misremembered lines from the fourth book of Milton's *Paradise Lost*:

> Now came still evening on and twilight grey
> Had in her silvery Livery all things clad
> Silence accompany'd.[107]

Next, Turner moved on to a brief discussion of three paintings by Francesco Mola he had seen in the Louvre in 1802. While celebrating Mola's colouristic and linear mastery, he regretted the way that the Italian artist had occasionally allowed passages of vivid colour to 'break through' and destroy the overall harmonies of his 'beautiful conceptions of pastoral quietude'.[108] For Turner, general effect was everything and nothing should upset it.

After heaping scorn on Antonio Verrio (c.1636–1707), Louis Laguerre (1663–1721), Jacques Rousseau (1630–1693) and Anton Raphael Mengs (1728–1779),[109] Turner discussed Nicolas Poussin, about whom he felt ambivalent.[110] On the one hand, he recognised the French painter's love of the antique and inventive creation of associative meanings, as well as his ability to invest 'simple forms and lines' with 'grandeur and sublimity'. On the other hand, he felt that Poussin's use of colour was far too frequently distanced from the truth of things. Yet he praised four pictures by the French artist[111] before returning to the subject of perspective, especially seeing in the *Landscape with a Roman Road* of 1648 (Dulwich Picture Gallery, London) the 'rules of parallel perspective everywhere regulating and enforcing the wholesome conviction', or providing appropriate spatial definition and depth. And two proofs of Poussin's ability to attain 'Historic grandeur' were then provided.[112]

The first of these was a reversed reproduction of the *Landscape with Pyramus and Thisbe* of around 1650 (the original of which hangs in the Städelsches Kunstinstitut, Frankfurt-am-Main). Here Turner deeply appreciated the 'truly sublime' effect of how a dark stormy sky, lightning, trees bending in the wind, antique ruins and broken ground complement the death of Pyramus, while in the 'depth and doubt of darkness all is lost but returning Thisbe'. Once again he was making clear his relish for decorum or the matching of light, weather effects, buildings and topography to subject-matter. And he found such 'propriety' to be even more apparent in Poussin's *Winter (The Deluge)* of 1660–64 (see fig. 294), which of course he had viewed in the Louvre in 1802.[113] In connection with that visit we have already discussed this later response to the matching of colour and other ancillaries to meaning.

Turner then progressed to Claude. Perhaps unsurprisingly, he arguably came closer to eloquence here than anywhere else in his discourses:

> Pure as Italian air, calm, beautiful and serene springs forward the works and with them the name of Claude Lorrain. The golden orient or the amber-coloured ether, the midday ethereal vault and fleecy skies, resplendent valleys, campagnas rich with all the cheerful blush of fertilization, trees possessing every hue and tone of summer's evident heat, rich, harmonious, true and clear, replete with all the aerial qualities of distance, aerial light, aerial colour, where through all these comprehensive qualities and powers can we find a clue towards his mode of practice?[114]

The answer that Turner provided to this question was ideal synthesis, the creation of 'pictures made up of bits' or the bringing together of 'parts of nature' in such a way that the 'simple subjects of nature' were transcended. Such was the power of Claude's 'mode of composition' that although his images were synthesised from different elements observed in the real world, fragmentation was entirely avoided and a greater unity attained.

From such ideal generalisation, Turner then moved on to the depiction of 'individual nature' as represented by Rembrandt and Rubens, who were supposedly of 'The Flemish School', even though

Rembrandt was Dutch.[115] Both of these artists had 'dared to raise [their supposed national school] above commonality' or the depiction of low life and the merely picturesque, with Rembrandt investing 'his chiaroscuro, his bursts of light and darkness' with profound feeling. But there was far more to Rembrandt than that to an artist for whom mystery had already become vital, as the following comments demonstrate. Turner thought Rembrandt possessed the ability to cast

> a mysterious doubt over the meanest piece of common... his forms, if they can be called so, are the most objectionable that can be chosen, namely, the Three Trees and the Mill [see fig. 90], but over each he has thrown that veil of matchless colour, that lucid interval of Morning dawn and dewy light on which the Eye dwells so completely enthrall'd, and seeks not for its liberty, but as it were, thinks it a sacrilege to pierce the mystic shell of colour in search of form.[116]

The 'mystic shell of colour in search of form' almost provides us with a precise description of late Turner, and it demonstrates how the seeds of that futurity were already deeply planted, not least of all by Rembrandt. And in this connection, note should be taken of the word 'mystic' here. It may have meant 'mysterious' to Turner, but who is to say that it did not denote 'mystical' as well, or even signified his principal sense of the word?

For Turner, no painter but Rembrandt 'knew so well the extent of his own powers and his own weakness'. He thought far less of Rubens, simply because this 'Master of every power of handicraft and mechanical excellence' had thrown 'around his tints like a bunch of flowers'.[117] Turner may have been excited by a Rubens depiction of a village *kermesse* he had seen in the Louvre, but he disdained its 'primitive colour, form and execution'. He also thought that the Flemish painter's disregard for the 'immutable laws of nature's light and shade' in 'the celebrated picture of the Landscape with the Waggon' (*The Carters*, now in the Hermitage Museum, St Petersburg) was ridiculous, for Rubens had brought together both the sun and the full moon within that image.[118] Similarly, he charged Rubens with having lit all the foreground figures from different directions in the *Tournament near a Castle* of the late 1630s he had seen in the Louvre (where it remains to this day). While Turner would permit such solecisms in history paintings, 'in Landscape they are inadmissable and become absurdities' that destroy 'the simplicity, the truth, the beauty of pastoral nature'.

He was far more positive about the pictorial organisation, tonal control, exquisite touch and apparent effortlessness of David Teniers the younger. This was especially the case in the Flemish marriage-feast picture he had seen at Lowther Castle in the summer of 1809, as noted above.[119] And he also spoke positively about the colouring skills and delicacy of Aelbert Cuyp, Paulus Potter (1625–1654) and Adriaen van de Velde (1636–1672).[120] For Turner the first of these painters carried the palm for his ability 'to blend minutiae in all the golden colour of ambient vapour'.

Now that Turner had expressed enthusiasm for some Lowlands painting, understandably he next progressed to an Englishman who had been heavily influenced by art emanating from that region. He regarded Thomas Gainsborough as having transcended the limitations of painters such as Cuyp, Potter and Adriaen van de Velde by 'avoiding their defects, the mean vulgarisms of common low life and disgusting incidents of common nature'. As an instance of this, he cited the 'pure and artless innocence of the Cottage Door now in the collection of Sir John Leicester' (Huntington Gallery, San Marino, California). Among its many other virtues, this painting possessed 'truth of forms arising from [a] close contact with nature', a 'full-toned depth of colour', and an admirable freedom of touch.[121]

Subsequently, Turner compared the Italian painter Francesco Zuccarelli (1702–1788) with Gainsborough and with Watteau, to his detriment.[122] And the professor entered the final straight with Richard Wilson, whose career had been seemingly harmed by the presence and influence of Zuccarelli in London between 1765 and 1771. Turner expressed the hope that Wilson's art might yet receive greater recognition through the dawning of public taste, the rapidly increasing encouragement of that taste, and 'the rising ray of patronage' that had come about since 1782, when Wilson had died.[123] That Turner employed sunrise imagery in the penultimate paragraph of a talk that had mostly been devoted to landscape painters and paintings was highly appropriate.

Finally, the Professor of Perspective aimed his peroration at the Schools students, reminding them that the nation looked to them for the flowering of their profession:

> All that have toiled up the steep ascent have left, in their advancement, footsteps of value to succeeding assailants. You will mark them as positions or beacons in your course. To you, therefore, this Institution offers its instructions and consigns their efforts, looking forward with the hope that ultimately the joint endeavours of concording abilities will in the pursuit of all that is meritorious irrevocably fix the united Standard of Arts in the <u>British Empire</u>.[124]

From the stress that Turner accorded to the last two words here, it seems certain that he 'boldly stept forth' to proclaim them in the manner and spirit of Reynolds finally sounding the name of 'Michelangelo' back in 1790. On Tuesday 12 February 1811, Turner probably ventured the closest he would ever come to acting as the Royal Academy Professor of Landscape Painting. Even if one or two killjoys might complain that he had failed to discuss the complexities of perspective during most of his final talk, in a roundabout way he had realised a cherished and long-held ambition, at least in part.

As usual, John Taylor reviewed the evening's proceedings. In the *Sun* for 15 February he wrote of the talk being 'more general than any other of the course', and consequently proving to be 'more gratifying to the audience at large'. In Turner's analyses of Old Master pictures 'great taste and judgement' had been demonstrated, while the lectures, taken as a whole, had shown 'scientific knowledge and practical excellence'.

Down the years it has been widely contended that Turner's perspective lectures were an abject failure. Partly this was because most of his contemporaries did not think much of them. But they were not as bad as all that. Admittedly, he had read hurriedly, and his timing, diction and accent were not as refined as many would have liked. Clearly, the verbosity that resulted from being overly mindful of Reynolds the master rhetorician had worked against effective communication, but then attempting to follow such a sophisticated speaker was always fraught with peril. It could never be claimed that Turner had supplied the Schools students and other interested parties with a simple working introduction to perspective. Nor was he always fully in command of his subject. Perhaps that is why he frequently became bogged down in the theoretical byways and diagrammatical mazes that make up a good deal of the specialist literature on the science. Paradoxically, had he been a mediocrity like his own teacher of the subject, he might have possessed the single-mindedness required to master perspective more fully. Yet Taylor and, to a lesser extent, a reviewer in the *Examiner*[125] prove that with a degree of concentration and forbearance, it was possible to grasp and appreciate what Turner was saying. This is important, for the first five discourses contain many gems, while the short survey of landscape painting provided by the 'Backgrounds' talk affords us a number of matchless insights into Turner's views on art, and on landscape painting in particular.

Naturally, it would be easy to argue that instead of slaving away at his lectures, Turner should have devoted his energies to painting. But that would be to miss the point. He expended a huge amount of time and effort on his talks because he held perspective to be of profound significance. As he had learned at the age of fourteen, gaining command of it was vital to any mastery of landscape painting, and he wished to pass that on, just as he wanted to promote his chosen genre. Yet perspective was no simple matter for Turner. Down the years it had come to form part of a much larger body of ideas that ranged from the theory of poetic painting and the interrelationship of history painting and landscape painting, to the workings of light and colour. Undoubtedly, getting that across had confused large sections of his audience. But between 1807 and 1811 the detailed investigation of an immense and burgeoning nexus of ideas had greatly sharpened Turner's mind and intensified his idealism. Because of that honing and focusing, if for no other reasons, we should be profoundly grateful that Turner took on the professorship of perspective, and that he worked so hard to enrich it.

25

A New Epoch

February to November 1811

In 1810 the engraver John Pye (1782–1874) had begun elaborating a print of *Pope's Villa at Twickenham* (fig. 407). Once he had laid out the landscape, Charles Heath (1785–1848) engraved the figures. The print would be sold both individually and within a collection of twenty-five engravings that would be published in book form under the title of *The Fine Arts of the English School*. This would contain texts by the antiquarian and writer John Britton (1771–1857), among others. Accordingly, at some point between mid-February and mid-March 1811, Pye left a proof of the engraving at Turner's studio. A few days later the artist rode over to his workshop on horseback to reassure him. 'It is all right,' he said, 'You can see the lights. If I had had any idea there was anyone in this country capable of doing that I would have applied to him before.'[1]

Turner responded so positively because the luminosity of the sky and delicacy of line Pye had obtained were unprecedented. Never had one of his images been translated so successfully from colour into monochrome, from pigment to ink, and with such brilliance and tonal density. Unwittingly, Pye had sparked a revolution in Turner's thinking about having his images copied, and therefore about manufacturing watercolours and the occasional oil painting to be reproduced as line engravings. In time, this change of outlook would reap huge rewards.

Picturesque Views on the Southern Coast of England

Because professionals in every walk of life talk among themselves, word of Turner's favourable response to the *Pope's Villa at Twickenham* engraving could quickly have reached the ears of the print publishers and engravers William Bernard Cooke (1778–1855) and his brother George (1781–1834). Both of them had long wanted to work with Turner. To that end they had 'seldom met without discussing their favourite topic, and many a scheme was formed and abandoned, before their wishes could be achieved'.[2] By 1811 W. B. Cooke had accrued the wherewithal to turn words into action and, in the process, to begin a new epoch in the painter's art and life.[3]

Cooke invited Turner to make twenty-four watercolours for an engraving scheme to be called 'Picturesque Views on the Southern Coast of England'. The invitation was accepted with alacrity, mainly because Cooke envisaged that the 'Southern Coast' scheme would form part of an even larger project to depict the entire coastline of mainland Britain.[4] Here was an ambitious enterprise with which an ever-ambitious painter could readily identify, even if he was only to receive £7-10s for each design. Cooke put up the initial capital, and a syndicate was formed with the publisher John Murray (1778–1843) to raise further money. As principal shareholder, Murray agreed to advertise and distribute all the prints.[5]

Detail of fig. 411.

407 John Pye and Charles Heath after J. M. W. Turner, *Pope's Villa at Twickenham*, line engraving, 1811, 6⅞ × 9 (17.4 × 22.8), British Museum, London.

Although there had been countless schemes devoted to illustrating inland scenery by 1811, the idea of producing a series of views of the English coast was new. That is why the backers anticipated a good return on their investment. However, Turner was not so sure of its success. For that reason he declined to put money into the venture, preferring others to take the risk. He did, however, accept a single share.[6]

As a member of Council, Turner had been rotated onto the hanging committee for the Royal Academy Exhibition this year. Consequently, he had no time to mount his own show in Queen Anne Street West. And during the course of arranging the exhibition he made a stand on behalf of Edward Bird's *The reading of the will concluded* (Bristol Museum and Art Gallery), for although it had been accepted for display, no room could be found for it on the walls. After failing to persuade the other 'hangmen'[7] to make space for it, he did so by quietly removing one of his own pictures from a prime location within the Great Room and substituting the Bird for it.[8] Such selflessness gives the lie to claims that he was always attempting to put others down.

The 1811 Royal Academy Exhibition
FRIDAY 26 APRIL TO SATURDAY 15 JUNE

This year, five days had been appointed for the retouching or varnishing of submissions to the Royal Academy Exhibition. Farington witnessed Turner at work on three of those days,[9] and perhaps he laboured there on the other two as well. His guests at the dinner were Walter Fawkes and W. F. Woodgate. And this year it was his turn to be seated across an end of the top table at the feast.[10]

As a member of Council, Turner exercised some say in who sat where. The three guests he had probably asked to be placed nearest to him were all Whig grandees. Thus, on his right, at the very eastern end of the top table proper, sat the Leader of the House of Commons and former Foreign Secretary, the 2nd Earl Grey (1764–1845), who had expressed a wish to purchase one of his pictures. Diagonally across from Turner sat the 3rd Earl of Bessborough (1758–1844), a prominent landowner and the father of the future novelist Lady Caroline Lamb (1785–1828). On Turner's left sat the 8th Earl of Lauderdale (1759–1839), another important politician. Given the painter's reputation and status as an Academician, the noblemen would undoubtedly have treated him as their equal. One wonders what they all talked about.

Towards the end of the dinner, the entire company stood for several minutes while the Guest of Honour, the Prince Regent, spoke of 'exhibited works of art which [would] have done Honor to any country'. He particularly commended 'Landscapes which Claude would have admired'.[11] As Turner's extremely Claudian *Mercury and Hersé* (fig. 408) was hanging on the north wall of the Great Room just behind and to the left of the prince, his allusion must have been understood by all.

Near the centre of *Mercury and Hersé* we see Hersé at the head of 'the virgin train' that the painter verbally specified in the Royal Academy catalogue by quoting two lines from Joseph Addison's translation of part of Ovid's *Metamorphoses*. To the right of Hersé is Mercury who, upon spotting the maiden when flying above Athens, had wheeled about and alighted. His circular flight path is the subject of an extended simile by Ovid, and clearly Turner alluded to it by placing Mercury in front of a semicircular conch.

Seated on the left is Aglauros, the sister of Hersé, whose aid Mercury will enlist to help him woo the subject of his desires. However, Envy will intervene to prevent that happening. In the painting we already see her doing so, in the form of an aged crone whispering into the ear of Aglauros. To punish the latter's refusal to help him, Mercury will turn her into stone. On the left of the two women is another female. She sits in a very rigid posture, obviously to denote Aglauros *after* her metamorphosis has taken place. The fallen masonry behind her augments the associations of that transformation. As we have seen, Turner had every reason to despise envy and its corrosive effects both within and beyond the Royal Academy, so *Mercury and Hersé* clearly constitutes yet another of his attacks upon that resentment. The freedom with which he played around with time in response to the narrative is particularly noteworthy.

408 *Mercury and Hersé*, R.A. 1811 (70), oil on canvas, 75 × 63 (190.5 × 160), private collection.

409 *Apollo and Python*, R.A. 1811 (81), oil on canvas, 57¼ × 93½ (145.5 × 237.5), Tate Britain, London.

Apollo and Python (fig. 409) also hung in the Great Room, as did the view of Somer Hill Turner had painted for W. F. Woodgate (National Gallery of Scotland). The title of *Apollo and Python* was accompanied in the catalogue by verses the painter had elaborated from two translations of the *Hymn to Apollo* by a Libyan poet of Greek extraction, Callimachus (310/305-240 BCE).[12] It may be that the picture had been begun or even been wholly painted some years prior to 1811, possibly around 1802.

In order to create a temple at Delphi to house his oracle, Apollo has to slay Python, a giant dragon that dwells in a nearby cave. As Turner informs us in his verses and shows us in his image, the sun-god effects that death by means of 'Envonom'd darts'. No less visible is one of the dragon's gigantic claws, two of the vast boulders that the creature presumably brought crashing down upon itself while thrashing about in 'the huge portal of [its] rocky den', a snake at the bottom-right that rears up at the sight of the huge monster before it, and the innards the dragon spilt as it writhed in agony during its death throes. Because these insides emerge from a protective carapace on the far side of the uppermost rock, continue to circle around that boulder and eventually change into a colourless, amorphous shape, it seems likely that Turner drew upon a knowledge of the biological evolution of certain types of insects in order to supply the internal organs of his dragon, as well as to suggest its biological development.

Apollo is appropriately surrounded with light. An area of extremely dark tone at the lower-right intensifies that light by contrast, while conveying the blackening of the earth with the gore of Python that also receives mention in the verses. Perhaps Turner intended Apollo to stand for Britain, and Python for a France that would eventually be destroyed after squeezing the life out of Europe for years.

The figure of Apollo was probably drawn from memory or imagination. That would explain why his extended arm and raised leg are slightly disproportionate. When Turner represented ordinary people, any such errors can match imperfections of character, as we have witnessed repeatedly. However, the depiction of a god required special care. As befits Apollo's divine nature, he really should have been made to look anatomically perfect. Sir Joshua would have expected no less.

Thanks to Turner's initiative, the Royal Academy now possessed an additional display space. This was the 'Inner Room' that had formerly constituted the Secretary's apartment.[13] Because Turner had

410 *Chryses*, R.A. 1811 (332), watercolour on paper, 26 × 39½ (66 × 100.4), private collection.

come up with the idea for the new exhibition area, there is strong reason to believe he was allocated the responsibility for arranging its initial hang, and that consequently he placed five of his watercolours in a precisely-judged symmetrical arrangement there, in order to maximise their impact.[14] One of those drawings was a view of Windsor Great Park (Turner Bequest, Tate Britain, London) in which the landscape elements were elaborated around horses drawn prior to 1799 by Sawrey Gilpin. This large watercolour appears to have been hung directly opposite a slightly larger Turner watercolour of Scarborough that will receive mention below. And also hanging in the Inner Room was a Turner oil, *Whalley Bridge and Abbey, Lancashire: Dyers washing and drying cloth* (private collection, on long loan to the Ashmolean Museum, Oxford). Almost certainly this was the work that had been taken down in the Great Room to accommodate the painting by Edward Bird.[15] If so, then Turner had fractured the perfect symmetry of his watercolour display by introducing it.

The large watercolour *Chryses* (fig. 410) appears to have been flanked by two associatively linked Turner drawings as the centrepiece of the Inner Room's west wall, and therefore as the focal point of the entire space.[16] In the catalogue, its title was accompanied by lines drawn from Alexander Pope's translation of Homer's *Iliad*. These tell of Chryses, a priest of Apollo, whose daughter was abducted by the Greek king, Agamemnon, during the Trojan Wars. Because that monarch refused to return her, Chryses sought the aid of Apollo. His entreaties led the sun god to visit a plague upon the Greeks, whereupon the desired restoration took place.

411 *Scarborough, Town and Castle: Morning: Boys collecting crabs*, R.A. 1811 (392), watercolour on paper, 27 × 40 (68.7 × 101.6), Art Gallery of South Australia, Adelaide.

Turner depicted Chryses seeking the help of Apollo as the sun god resplendently brings the day to life. The thickly wooded rock arch that bends into the sea before the sunrise subtly reinforces the fact that Chryses is kneeling in supplication. As Apollo was also the deity of vegetative life, the rich vegetation upon the rock complements the scene very appropriately. Later in life Turner would declare that the sun is God, and perhaps he already believed that by 1811. Such a conviction could explain why he exhibited two representations of Apollo the sun god in the Royal Academy this year.

With *Chryses* a new and more perfect beauty entered Turner's art. As in *Mercury and Hersé*, the painter's idealism was coming to the fore. It was no accident it did so, for there was an extra burden laid upon practitioners of poetic painting to address ideal beauty when treating of classical subjects. Yet while *Mercury and Hersé* owes a great deal to Claude, in the sheer range of its beauties *Chryses* arguably transcends any landscape by the French master. The depiction of sparkling dawn sunlight upon the waters, the unsurpassable representation of the waves themselves, the gentle tones used for the sea, the soft mist encompassing the Temple of Apollo on the right, and the sense of immense distance on the left all proclaim Turner's genius to the full. Anatomically, Chryses looks fairly convincing, and he demonstrates how well the painter could represent the human figure whenever he was minded to do so. Perhaps he even employed a costumed model for the work. If *Chryses* did hang at the head of a room that owed

its existence to Turner's initiative, and did so because he took advantage of his position on the Committee of Arrangement to place it there, who can blame him? He had earned that right. There can have been no lovelier work on display in Somerset House in 1811.

In *Scarborough, Town and Castle: Morning: Boys collecting crabs* (fig. 411), Turner's matchless tonal control paid huge dividends, for the distant castle and town look particularly ethereal in the early morning sunlight. From left to right, girls lay out washing to dry in the coming warmth of day; boys catch crustaceans and play with hoops; a horse-drawn bathing machine is being towed across the sands; an old woman searches for molluscs; a beached brig is being offloaded because the shallowness of the harbour prevents it from approaching any nearer; and a shrimper prepares his creel. By documenting the socio-economics of place like this, the work prefigures the images that Turner would soon be making for the 'Southern Coast' series.

All three of the critics who mentioned Turner's works in 1811 praised *Mercury and Hersé*, with the *Sun* for 30 April calling it 'one of the most excellent efforts of the artist' and the *Monthly Magazine* for June hailing it as 'a master-piece'. In July it also called it 'a brilliant example of poetical composition, in landscape, as is not excelled in the English School.' The June issue of the *Repository of Arts* praised its various components, including its figures, which were regarded as being 'so perfectly accordant with the scenery, that they form with it a consistent and harmonious whole, very rarely to be found among compositions of this class.' Not all of Turner's depictions of people engendered negativity.

Turner might have welcomed not showing in Queen Anne Street West this year, for he was using the gallery as his studio by now. An idea of what it was like when employed in that way can be gleaned from a note he wrote to James Wyatt of Oxford from 'Queen Ann Street West/corner of 64 Harley St' at some point during May or June of this year. He had received notification from an intermediary that a visit by Wyatt would take place the very next morning. At this he became highly alarmed and immediately wrote to Wyatt at his overnight accommodation in London, asking to be allowed to 'call upon you, for really I am so surround[ed] with rubbish and paint that I have not at present a room free'.[17] Obviously by 'paint' he meant wet paintings and not just lumps of wet pigment or discarded paint bladders, for like 'rubbish', such agglomerations or objects could easily have been cleared up in advance of receiving a visitor. And, of course, he had no 'room free' in which to entertain a visitor because he no longer lived at 64 Harley Street, but instead probably resided in the lower part of his gallery cum studio behind the house.[18]

It is not known where Turner and Wyatt did finally meet but indirectly the note indicates that the artist had thrown himself into a massive bout of work immediately after the Royal Academy Exhi-

412 *Near Blair Athol, Scotland*, etching and mezzotint, drawn and etched by Turner and engraved by William Say, published 1 June 1811 as Plate 30 in Part VI of *Liber Studiorum*, engraved image size 7¼ × 10¼ (18.3 × 26.2), British Museum, London.

bition had begun. Given that he did not like anyone to see his creations during their gestation, and that he could easily have faced logistical nightmares if forced to move wet paintings or watercolours that were in delicate transitional states when Wyatt called, it is entirely unsurprising he asked his client to stay away.

On 1 June, Parts VI and VII of *Liber Studiorum* officially appeared. In Part VI the 'Mountainous' category was represented by *Near Blair Athol, Scotland*, although the only height that appears in the image does so very distantly (fig. 412). Similarly, the 'Marine' category *Martello Towers near Bexhill, Sussex* in Part VII (fig. 413) only marginally includes the sea. Instead, it directs our attention to the string of forts of the title. Before them we see soldiers riding along the coast and a man striking a stubborn mule. His aggression brings suitably violent associations into play, as does the stormy sky. Clearly these ancillaries were intended to remind us of the threat of French invasion the forts had been built to deter. In the *Inverary Pier. Loch Fyne. Morning* image in Part VII the eye is led into the distance by the curve of the foreshore being repeated by the curve of the sail at the centre (fig. 414). And how cleverly Turner created a counterpoint to that curve by means of the contrary sweep of the lower part of Duniquoich Hill above it to the left. He possessed just as much rhythmic and contrapuntal sense as any major composer, which may be one reason his images remain perpetually stimulating.

The first British performances of the opera *Die Zauberflöte* (*The Magic Flute*) by Wolfgang Amadeus Mozart were given in Italian

413 *Martello Towers near Bexhill, Sussex*, etching and mezzotint, drawn and etched by Turner and engraved by William Say, published 1 June 1811 as Plate 34 in Part VII of *Liber Studiorum*, engraved image size 7 1/16 × 10 1/4 (17.7 × 26.2), British Museum, London.

414 *Inverary Pier. Loch Fyne. Morning*, etching and mezzotint, drawn, etched and engraved by J. M. W. Turner, published 1 June 1811 as Plate 35 in Part VII of *Liber Studiorum*, engraved image size 7 1/16 × 10 5/16 (18.1 × 26.1), British Museum, London.

under the title of *Il Flauto Magico* at the King's Theatre in the Haymarket on 6 June and 4 July 1811.[19] It is possible that Turner attended one or even both of them. The opera would not be mounted in London again until 1814. Its key figures are Tamino and his beloved, Pamina, and the birdcatcher Papageno and his beloved, Papagena. The relevance of this will become apparent when we reach 1814, for it could well have been such paired names – and especially those of Papageno and Papagena, with their imitative duet in the opera's second act – that would cause Turner to give paired names to the leading characters of a picture he would largely paint in 1813 and exhibit in January 1814.

On 8 June, Farington complained to Callcott about 'the high prices which Turner had for His pictures'.[20] It was on this occasion that Callcott recalled being told back in 1804 that in future Turner would ask 200 guineas for his 36 × 48 inch canvases, rather than half that amount, reckoning he could save himself half the work if he could sell them at twice the price. That Callcott remembered it now was his way of informing Farington that Turner's seemingly high prices were fully justified for what he provided by way of art. Apparently the painter-diarist had no answer to that.

Callcott then told Farington of 'Sir George Beaumont's continued cry against Turner's pictures, but said Turner was too strong to be materially hurt by it. Sir George ... acknowledged that Turner had merit, but it was of a wrong sort & therefore on acct. of the seducing skill displayed shd. be objected to, to prevent its bad effects in inducing others to imitate it.' Of course, one of those supposedly imitative 'others' was Callcott himself. The latter went on to regret the harm Sir George had wrought by denigrating watercolour as a medium, as well as through disparaging the artists who employed it and the exhibiting societies they formed.

The 1811 Royal Academy Exhibition closed on 15 June. The *Mercury and Hersé* that had been indirectly praised by the Prince Regent was wanted, although perhaps a little too much for Turner's short-term good. Earl Grey was prepared to pay the huge sum of 500 guineas for it, while an existing owner of several Turners, Sir John Swinburne (1762–1860), was willing to go even higher. However, it is probable that the painter had been led to believe by the Prince Regent or by one of his courtiers that the heir to the throne wished to purchase the painting. Until it was known for certain that this was not the case – and there is never any way of hurrying dealings with royalty – then the artist was forced to hold on to the work. In the end it would emerge that the Prince Regent did not want it, which is why Sir John Swinburne would acquire it by the beginning of 1813. That he was willing to pay 550 guineas for it says a great deal about both its beauties and the taste of the time.

Turner had spent the weeks following the opening of the Royal Academy Exhibition painting virtually non-stop. On 8 July, John Fuller bought five watercolours of subjects in East Sussex from him, paying thirty guineas for each of them.[21] Four were the views he

had originally hired for engraving purposes at twenty-five guineas each. Turner's strategy of pitching the hire charge extremely highly in order to tempt the East Sussex landowner into purchasing the works for only a little more had worked.

At some point Turner must have taken time out from his labours to write a letter of condolence to Walter Fawkes, for in June the latter's 16-year-old eldest son and namesake had drowned himself in the Grand Union Canal at Denham, Buckinghamshire, where he had been attending school.[22] The tragedy forced Turner to change his travel plans, for it will be remembered that in 1808 he had visited Farnley Hall in August, while he had stayed in the house during the same month in each of the following two years. With the Fawkes family in mourning, any such trip in August 1811 was out of the question. So if, as seems likely, a stay had been on the cards this year too, then Turner must have deferred it. Instead, he would visit a part of Britain with which he was unfamiliar and which he really did need to explore quite urgently.

The West Country Tour of 1811

Although by now Turner had accumulated a good deal of sketchbook material on the seaboard to the east of Portsmouth that could be used for the 'Southern Coast' project, the same was not true of the south-west. That is therefore where he decided to go. In preparation, he amassed detailed notes on the West Country in a sketchbook he would take on the trip. A good deal of his geographical and historical information was gleaned from the *Guide to All the Watering and Sea-Bathing Places*, a hefty tome by John Feltham (fl. 1797–1799).[23]

The garnering of all this data led Turner to think hard about what he should be looking for in the places he would be visiting, and how he might deal with it. No longer was he satisfied with following the conventions that had hitherto prevailed in topographical drawings created for engraving. Instead, he wanted to imbue such designs with a greater awareness of the underlying social, economic, historical and cultural essentials of place. Undoubtedly this ambition was inspired by the perspective lectures, with their emphasis upon essentials. The consequence of the new resolve would be to raise the watercolours made for the 'Southern Coast' and later topographical engraving schemes to unprecedented levels of meaning and pictorial inventiveness. Moreover, the reproductions of those images would greatly benefit from the new attitude towards engraving created by the *Pope's Villa at Twickenham* print.

And Turner would aim to fulfil another ambition on the 1811 tour, although here he would eventually be thwarted. This was to write a poem about the southern coast of England, extracts from which would accompany the engraved images he would be contributing to the 'Southern Coast' scheme.[24] To further that end, during the tour itself he would begin sketching out his poem in iambic pentameters on the blank, reverse sides of printed pages and upon many bare sheets of paper he had additionally had bound into a book he had acquired, *The British Itinerary or Travellers Pocket Companion throughout Great Britain* by Nathaniel Coltman.[25] Although these verses have always been taken to have formed the finished 'Southern Coast' series poem that Turner would later submit to W. B. Cooke and an editor he employed, that cannot have been the case. This is because he would never have allowed anyone to look within the covers of the sketchbook containing those lines. Instead, his verses can only have served as the basis of a possibly concentrated and certainly more polished draft concerning just the first few places to be depicted. Sadly, that final draft was long ago lost to posterity because it quite possibly ended up in W. B. Cooke's wastepaper basket.

By the summer of 1811 Turner appears to have obtained a gig or light, two-wheeled sprung carriage that was pulled by 'an old horse: an old crop-eared bay horse, or rather a cross between a horse and a pony'.[26] In all likelihood, that animal was the same one on which he had called upon John Pye earlier in the year. According to William Turner, the tour began in the middle of July.[27] Initially, Turner may have stayed for three nights with Trimmer at Heston, from where the two of them went out sketching, along with Henry Syer Trimmer and the Royal Academy Secretary, Henry Howard, who was also spending a few days there. Around 1860 the younger Trimmer would remember the 'very steady pace' of Turner's vehicle, the adults sketching a copse at Penn in Buckinghamshire, 'where luxuriated wild flowers in profusion', and Howard and his father being in raptures over 'a capital watercolour' made there by Turner.[28] And it may equally have been during this visit that Turner helped Howard overcome a difficulty he faced when painting a portrait of a boy holding a cat, the hind legs and tail of which he just could not capture on canvas. Turner cut through the problem by getting Howard to paint a red pocket handkerchief over the rear portion of the animal. All agreed the result was 'one of Howard's best works'. As the younger Trimmer observed, Turner's 'remarks on pictures were admirable: no beauty and no defect, escaped him.'[29] He then went on to recall that perhaps during this same visit Howard and Turner had a heated exchange, with the former maintaining that artists should paint for the public and the latter asserting that 'public opinion was not worth a rush, and that one should paint only for judges'. By 'judges' he undoubtedly meant his fellow artists, and not art critics, connoisseurs and other arbiters of taste who were not professional painters. He would always maintain that position.

After Heston, Turner may have spent a day fishing at Egham, where he stayed a night. He then paid two or three shillings in turnpike charges to take his gig all the way down the various

415 *Weymouth, Dorsetshire*, c.1811, signed, watercolour on paper, 5½ × 8⅜ (14 × 21.3), Yale Center for British Art, Paul Mellon Collection.

stretches of made-up road to Salisbury, by way of Bagshot, Blackwater, Hook, Basingstoke and Andover.[30] Three nights may have been spent in the last of these towns because it was the height of the fly-fishing season and the river Test to the south of Andover offers some of the best fly-fishing anywhere in Britain, if not the world. It is likely that Turner subsequently left his vehicle and nag in a stables in Salisbury, to await collection on his way back to London. Now he required the freedom to roam that precluded responsibility for an animal.

Over the following days, Turner visited Christchurch in Hampshire, Poole in Dorset, Corfe Castle, Swanage and Durlston Head, near where the *Halsewell* East Indiaman had sunk in 1786 with a huge loss of life. As Turner wrote in his copy of *The British Itinerary*:

> Where massy fragments seem disjoined to play
> With sportive sea nymphs in the face of day
> While the bold headlands of the seagirt shore
> Receive engulpht old ocean's deepest store
> Embayed the unhappy Halswell toiled
> And all their efforts Neptune [?herewith] foild
> The deep rent ledges caught the trembling keel
> But memory draws the veil where pity soft does kneel[31]

The mention of 'deep rent ledges' testifies that the artist did venture to the eastern end of the cliffs stretching from Seacombe to Winspit, for those rock faces are particularly marked by ledges in the limestone, as Turner could only have known by actually setting eyes on them.

After revisiting Corfe Castle, Turner gradually made his way to Weymouth via Lulworth Castle, Lulworth Cove and Dorchester. He probably spent three nights in Weymouth (fig. 415), from where he explored the Isle of Portland. Then it was on to Bridport, Lyme Regis, Sidmouth and Exeter, where 'at his father's request' he went to see his paternal uncle, Price Turner.[32] Next he visited Teignmouth, Berry Pomeroy Castle, Totnes, Brixham, Dartmouth, Ivybridge and Plympton.

In Plymouth he almost certainly stayed with the father of an admirer, Charles Lock Eastlake (1793–1865), who was a student in the Royal Academy Schools at the time. Learning of Turner's impending visit to Plymouth, Eastlake had written to his father in July to inform him that the Academician was 'the first landscape painter now in the world, and before he dies will perhaps be the greatest the world ever produced. I hope all at Plymouth will be attentive to him, as it really is an honour to be acquainted with him. He is much higher in his branch of the art than West or Fuseli are in theirs.'[33]

The hope that 'all at Plymouth will be attentive' was surely fulfilled, with Turner being accorded hospitality by the Eastlakes. And in conformity with the Academician's expressed desire to 'go on board some large ship' that young Eastlake had also mentioned in his letter, he must have been granted access to one of the largest vessels in the world, HMS *Salvador del Mundo*. This was the official guardship of Plymouth harbour and the Eastlakes were professionally linked to it. (Until 1797, when she had been captured at the Battle of Cape St Vincent, *Salvador del Mundo* had been a Spanish 112-gun, first-rate ship of the line. Turner therefore could hardly have wanted to visit a larger vessel in order to witness many aspects of naval life.) Moreover, during this stay, Eastlake's father also introduced Turner to his close friend, the Plymouth-born landscape painter, drawing master and occasional exhibitor at the Royal Academy, Ambrose Bowden Johns (1776–1858). As we shall see, when Turner would return to Plymouth in 1813, Johns would make him feel completely at home, both domestically and creatively.

Turner probably spent a week in Plymouth, sketching all around the busy seaport. And when his stay there came to an end, he travelled westwards to Falmouth, by way of Fowey, St Mawes and Truro. He may have spent three nights in Falmouth. This proved very productive, for the harbour was filled with shipping, both of the military and mercantile kinds. Then it was onwards to Land's End, by way of Penzance. En route, Turner walked all around St Michael's Mount at low tide and sketched it, an experience he touched upon in his 'Southern Coast' poetic sketch:

> As on the western side precipitous abound
> Cover with manacles that to the tread give way

> To those adventurers who dare their slippry way
> Upon the muddy steep....³⁴

For 'manacles' read 'barnacles', another charming malapropism, although one enjoying a certain poetic power.

From Land's End, Turner then moved over a period of days up the north coast of Cornwall to St Ives, Bodmin, Tintagel, Boscastle, Launceston and Bude. We can certainly place him in the area of heathland about four miles south of Hartland Point in north-west Devon where the rivers Marsland, Torridge and Tamar all rise within short distances of one another, for between 1811 and 1813 he would develop a watercolour of that spot (Yale Center for British Art, New Haven).

After a stay in Clovelly, on the north Devon coast, it was onwards to Bideford and Barnstaple, where Turner's paternal uncle, John Turner the younger (1742–1818), was master of the poorhouse by now. An affadavit filed in 1854 tells us that in 1811 the painter stayed at the Castle Inn, Barnstaple, 'for about a day', during which time he visited his uncle and his first cousin.³⁵ Understandably, a Royal Academician – and especially this particular one – would not have wanted to be associated with a poorhouse, which is why he put up at an inn.

Turner then slowly moved up the coast to Ilfracombe, Combe Martin, Minehead, Dunster Castle and Blue Anchor Bay, finally arriving at Watchet in Somerset. As was the case in most of the other places he had visited, he sketched assiduously everywhere along the way. At Watchet the coastal part of the tour ended. Subsequently, Turner made his way to Bridgwater, Glastonbury and Wells, in the first and last of which places he probably stayed. After Wells he went on to explore the Cheddar Gorge, from near the top of which he sketched views looking north-westwards across the Bristol Channel, and south-westwards to Glastonbury Tor. On a drawing of the latter vista he scribbled the word 'Avalon', thereby demonstrating a knowledge of Arthurian legend that probably derived from a reading of the poem *Poly-Olbion* of 1613 and 1622 by Michael Drayton (1563–1631). This was available to him in the third volume of Anderson's *Complete Poets*.³⁶

From Wells, Turner finally made his way to Shepton Mallet, Frome, Stonehenge, Amesbury and Salisbury, where he could have picked up his gig and 'old Crop-ear' in order to undertake the slow but pleasurable journey back to London. He appears to have been home by 11 September.³⁷ He returned laden with hundreds of pencil drawings in the two larger sketchbooks he had taken with him, as well as in The *British Itinerary*, which also contained the poetic sketch. By this time it comprised more than 700 lines of verse. Often it is more like a stream of consciousness than a poem, and that is surely how it should be regarded, rather than simply be dismissed as a literary failure.

Upon Turner's return to London, he may have found that Sarah Danby had given birth to their second daughter, for the child was born between 7 June 1811 and 29 January 1812.³⁸ She was named Georgiana, after the monarch. On the other hand, if Sarah was still pregnant when the painter reached home, then her condition may well have left him unmoved. However, her state would certainly not have left the officers of the Royal Society of Musicians unmoved if it was particularly noticeable when she personally collected her pension in March and August 1811. (This is due to the fact that she would have been between four and nine months pregnant when she signed during that period, depending upon exactly when the baby was born.) But clearly she did get away with it. Given the numbers of people signing on her behalf, it is apparent that the Royal Society of Musicians did not enforce the most rigorous of inspection regimes at this time. In all likelihood, Sarah relied upon that laxity to avoid detection.

Throughout the autumn, Turner painted hard and assiduously attended Council and General Assembly meetings. Shortly after 8 November, he went to stay at Farnley. Before leaving London, he called upon John Britton at his home in Tavistock Place.³⁹ Probably he did so in order to hear the antiquarian read the text he was compiling to accompany the engraving of *Pope's Villa at Twickenham* that would form part of *The Fine Arts of the English School* publication. In that draft, Britton defended the kind of landscape painting that had failed to reach the heights attained by the Old Masters and yet was not so lacking in beauty, moral elevation and expressivity that it merely mapped a scene or tamely delineated a given spot. (Such lowly responses to landscape had been disparaged by Fuseli during his fourth lecture as Professor of Painting.) Turner approved of Britton's defence, which had clearly been written with *Pope's Villa at Twickenham* in mind. But Britton would subsequently have second thoughts about including it in his literary accompaniment, probably because it offered a hostage to fortune. Why draw anyone's attention to gaps that supposedly existed between the ultimate heights in landscape painting reached by, say, Titian, Rosa, Poussin and Claude, and those attained by more recent artists such as Turner? If such differences existed, then surely it was better that the readers of *The Fine Arts of the English School* should be left to discover them for themselves.

26

'This Prospero of the Graphic Art'
November 1811 to May 1812

Given the recent suicide of his son, it is highly likely that Walter Fawkes was depressed and particularly needed distraction at Farnley this year. Perhaps he and Turner went out woodcock shooting together, seeing it was the height of the season for such game. And a prevailing melancholy at the time may have caused the painter to copy into a sketchbook a passage from 'Retrospection – A Poem in Familiar Verse' by the dramatist Richard Cumberland (1732–1811),[1] which had appeared in print that August:

> World I have known thee long & now the hour
> When I must part from thee is near at hand
> I bore thee much good will & many a time
> In thy fair promises repos'd more trust
> Than wiser heads & colder hearts w'd risk
> Some tokens of a life, not wholly passed
> In Selfish strivings or ignoble sloth,
> Haply there shall be found when I am gone
> What may dispose thy candour to discover
> Some merit in my zeal & let my words
> Out live the Maker who bequeaths them to thee
> For well I know where our possessions End
> Thy praise begins and few there be who weave
> Wreaths for the Poet['s] brow, till he is laid
> Low in his narrow dwelling with the worm.[2]

As will be seen shortly, in the catalogue of the 1812 Royal Academy Exhibition Turner would fix a passage of pessimistic verse to the title of his principal submission and imply it derived from a much longer poem he had written under the title of 'Fallacies of Hope'. Who is to say that the pessimism expressed in May 1812 had not been brought on by a general melancholia at Farnley Hall the previous November? And if the lines from Cumberland's poem were transcribed while staying in the house, then perhaps it was because they also chimed with an underlying sadness in others, and a passing negativity in Turner himself.

At Farnley, Turner received through the post the penultimate draft of John Britton's text for the *Pope's Villa at Twickenham* engraving.[3] In response, he conceded that the antiquarian had perhaps been right to withdraw his defence of a supposed failure to reach the heights attained by landscape masters of the past.[4] And after requesting some minor changes, he also addressed a reference to Alexander Pope's dead willow tree made by Britton.

It will be remembered that in his painting, Turner had placed a dead tree-trunk in the foreground in order to allude to the poet's dead tree and, by association, to the dead poet himself. However, Britton had gone further by stating explicitly that the tree was the selfsame willow that had famously been planted by the poet many decades earlier. Turner thought this strained credulity, for it was widely known that the real tree had died in 1801, not in 1807, when

Detail of fig. 417.

the house had been demolished. And in any case, he did not want to be so explicit, for he knew that we need to discover the connection between tree and poet for ourselves. Indeed, in making such a link resides one of the principal pleasures to be gained from associationism. When everything is explained – as, alas, it necessarily has to be here – then deduction and imagination are not required. And what is worse, when everything is pointed out in an image, we no longer have to work hard at looking.

That is why Turner now asked Britton if Pope's willow could be referred to 'by allusion'. Accordingly, the text was amended to read 'in strict accordance with the subject, is the prostrate trunk of a willow tree'. Those who knew of Pope's life, death and dead willow would understand why Turner's 'prostrate trunk' was 'in strict accordance with the subject', while those who did not possess such knowledge would have missed the connection anyway. But 'in strict accordance' is the key phrase here, for it was another term for propriety or decorum.

Turner then went on to suggest that Britton strengthen the term 'mellifluous lyre', for it lacked 'energy of thought'; in due course it would be expanded to 'mellifluous and sonorous lyre'. And Turner also took issue with Britton's declaration, in a discussion of lines drawn from the poem *The Cave of Pope: A Prophesy* of 1743 by Robert Dodsley (1703–1764), that 'the Poet and Prophet are not often united', for he felt 'they ought to be'. The notion that a poet was a type of seer was central to Turner, as was its corollary that poetic painters were no less capable than poets of envisioning what the future holds, at least on a moral level. For him, as for so many history painters, exploring the past was a means of foretelling the future, if only because history constantly repeats itself. Turner would increasingly attempt such moral prediction from 1812 onwards.

The painter probably returned from Yorkshire not long before attending a Council meeting on Wednesday 4 December. If that was the case, then he had been away a little over three weeks. Possibly he had carried a potent memory back with him. One dawn, and perhaps while waiting on the Great North Way to the east of Farnley to catch his southbound stagecoach, he had witnessed a severe hoarfrost. Maybe that was the sight that would be captured on canvas and exhibited at the Royal Academy in 1813 under the title of *Frosty Morning*.

On the following Saturday evening, 7 December, Turner chaired a General Assembly meeting for the very first time (although he had presided over a Council meeting back in April 1803).[5] He did so because West was indisposed. By now he had accumulated so much experience of institutional affairs that chairing an assembly of artists probably did not faze him. And at the 10 December General Assembly meeting he fulfilled a long-cherished dream by being elected a Visitor in the Schools, to begin in the New Year.[6]

Solus Lodge Advances

At around this time, Turner recorded on a piece of paper – which we can usefully dub the 'Estimates' sheet – that he had needed £400 to purchase the land down in Twickenham on which he would build his villa; calculated that the same amount would be required for the construction of that abode, including materials; and reckoned that £100 would be needed for its garden.[7] As we have seen, the first £400 had been disbursed in 1807, while £400-worth of stock sold on 10 December 1811 might have provided some of the cash required for the building costs.[8] Receipt in April 1812 of 100 guineas from James Wyatt of Oxford for the second of his oil paintings would neatly cover the cost of the garden, and leave a little left over.

Immediately below the actual or proposed costs on the 'Estimates' sheet, Turner also worked out what he stood to lose each year by investing in property rather than stock.[9] He was cautious to the last. Everything had to be tested. And that he employed a quantity surveyor – who was then simply termed a 'measurer' – to calculate the requisite quantities of building materials and the related labour requirements needed to construct the house, is proven by no fewer than fourteen amounts listed in pen and ink at various other locations on the 'Estimates' sheet (for they could only have been deduced by someone knowledgeable). The figures total £623. Of course, this is over a third more than the £400 Turner had originally estimated the building would cost, and it proved the necessity of obtaining the services of a measurer.[10] Still, the grand sum of £1,123 for the land, construction costs and landscaping was hardly one that was going to break the bank for someone possessing exactly £7,239-18s-1d in government stock by the end of 1811.[11] Indeed, an outlay of less than 16 per cent of one's total savings was a relatively low amount to pay for the acquisition of a place in the country. Moreover, by building that property and duly paying rates on it, Turner would again become a forty-shilling freeholder, with the right to vote in parliamentary elections, this time in Middlesex. So, armed with the necessary plan and costings, Turner could at last begin constructing his country seat. He would probably do so in the late spring of 1812, with the coming of warmer weather.

During the Christmas 1811 period, Turner began the distant depiction of Oxford from the Abingdon Road commissioned by Wyatt.[12] Clearly he did so because it appeared likely that the engraving of the view of Oxford High Street would be completed shortly. If the painter could get his timing right, he would be able to hand over the second picture to the principal engraver at the exact moment when work on its reproduction could begin. Nothing must be wasted, least of all time.

Turner delivered his 1812 perspective lectures on successive Mondays after 6 January, with the final talk being given on Saturday

8 February in order to accommodate a General Assembly meeting on the following Monday evening. It was convened to elect an Academician in place of the late Sir Francis Bourgeois. Conceivably, Turner could have taken up his duties as a Schools Visitor on 6 January, although as he was lecturing that evening, it seems unlikely. Given his long-cherished ambition to become a Visitor, perhaps he assumed his teaching duties in the Academy of the Antique on the morning of Monday 10 February, immediately after the lectures had finished. The Visitors were required to teach twice a week for two hours per visit. On average, the nine Visitors in 1812 went into Somerset House to teach there on about 27½ days throughout the year. Turner is unlikely to have gone in for that purpose less than twenty-one times, and possibly he did so a lot more than that.[13] And Schools teaching was not his only other official duty in 1812, for he also attended Council meetings throughout the year. That was why it was crucial not to waste a moment.

Due to continuing pressure applied by the Council and General Assembly, Soane finally gave his fifth and sixth talks early in January. As he was present at several of Turner's discourses, it appears likely the courtesy was returned. The architect made notes on Turner's fourth, fifth and sixth 1812 lectures,[14] recording that the final 'Backgrounds' talk had a 'very thin audience', and that among other subjects Turner had taken up his own remarks on 'anachronisms in the Arch of Pict'. By this, Soane probably signified a passage in his second lecture in which he had stated that appropriateness of 'Costume is as necessary in architecture as in painting'. For example, it would be just as absurd for an architect to adorn the façade of a prison with Corinthian columns and statues as it would be for a painter to represent an ancient Greek philosopher dressed in the vividly coloured jacket of a 'mer-ryandrew' or clown. Clearly, Turner had declared that, like architecture, painting requires a sense of propriety or suitability in the associative links and matchings it forges – in other words, decorum.

From the inclusion of the 'Backgrounds' talk within the 1812 set, and from the fact that none of the other lecture manuscripts appear to have been altered or augmented at this time, we can safely deduce that the perspective lectures given this year were virtually the same as the ones delivered in 1811, at least in the topics covered. (The word 'virtually' appears here because Turner probably took the opportunity to cut certain sections of the third lecture so that, due to time constraints, he would not be forced to carry over the conclusion of that talk to the following week and thereby prevent the rightful fourth lecture from being delivered at all, as had happened in 1811.)[15] As we have seen, the original fourth talk was on taste, judgement, the nature of vision, idealism, painting and potrey, and much else besides.

There can be no arguing with Soane's final evaluation: 'Upon the whole [the talk on 'Backgrounds'] seemed a lecture for the Professors of Paint[ing] and Arch[itecture], the word Perspective scarcely [being] mentioned.' And other criticisms would follow, with Rossi telling Farington on 10 March: 'Lectures on Perspective delivered in the Academy by Turner are much laughed at as being ignorant & ill written.'[16] Inarguably they were 'ill written' but ignorant they most certainly were not, for if anything they were overly abundant in knowledge. One of Turner's constant problems as a lecturer was never knowing what to omit.

On 14 January 1812 Turner acquired £400-worth of stock.[17] He might simply have been putting back the money gained from selling £400-worth of stock on 10 December. On the other hand, it could well be that the £400 derived from 400 guineas received from Sir John Leicester for the two depictions of Tabley exhibited at the Royal Academy in the spring of 1809.[18] Admittedly, upwards of two-and-a-half years was a long time to wait for payment. Yet as we have seen, in March 1809 the baronet had attempted to sell three of his Turners and another picture he had previously exchanged with the artist, so there can be no doubt he was short of ready cash. Such a constraint did not curb his desire to acquire works by the painter; it simply made it difficult to pay for them. Moreover, Turner had noted Sir John Leicester's debt in the list of assets he had drawn up no later than 26 November 1810. If he had waited that long for payment, then it was no great hardship to wait another fourteen months or so. Turner knew he would receive his money, and equally that it would be counter-productive to harass the baronet for payment. But if he was paid at this time, then it would prove that someone who would often be characterised as a tightwad could be exceedingly patient, if not even generous where the extension of credit was concerned, for how many of us would be willing to let someone have two very expensive works of art on trust without being unduly worried about receiving payment for them?

The eighth part of *Liber Studiorum* officially appeared on 1 February. One of its five designs is important for furnishing our only idea of the appearance of the long-lost *Mildmay Sea-Piece*; we have, of course, discussed that image under its proper title of *Fishermen coming ashore at sun set* within the context of the 1797 Royal Academy Exhibition (see fig. 169), where the original painting was displayed. And no less worthy of attention is *Procris and Cephalus* (fig. 416), for it is one of the most moving designs in the entire *Liber Studiorum*. It took its subject from Ovid's *Metamorphoses*. In order to understand its subtle allusions, it is perhaps worth reminding ourselves of the tale that inspired it.

Aurora, the goddess of dawn, fell in love with Cephalus, the husband of Procris who, in turn, was a favourite of Diana, the goddess of hunting. Diana gave Procris a magic javelin that would always find its target. Procris passed this on to her husband. When out hunting, Cephalus often hailed the breezes that cooled him, but

416 *Procris and Cephalus*, etching and mezzotint, drawn and etched by Turner and engraved by George Clint, published 1 February 1812 as Plate 41 in Part VIII of *Liber Studiorum*, engraved image size 7⁵⁄₁₆ × 10⁷⁄₁₆ (18.6 × 26.5), British Museum, London.

when news of this reached Procris she thought he must be praising another woman. Accordingly, she followed him one day, hid in some undergrowth, heard him welcome a breeze and sobbed. Cephalus, believing he had heard a wild animal, threw his javelin into the bushes and mortally wounded his wife.

In the image we see the dying Procris being comforted by her husband. Turner altered the javelin into an arrow, as had Claude le Lorrain in his treatment of the subject, which was, of course, reproduced in the Earlom *Liber Veritatis*.[19] A shaft of dawn sunlight that terminates in the fatal dart both marks the direction taken by the arrow and alludes to the fundamental role of Aurora in the proceedings. Perhaps the gradual darkening of the dell into the distance was intended to suggest the gradual darkening of Procris's mind, just as a sunlit bush placed above Cephalus amplifies his sense of life. The validity of this interpretation receives support from the dog sitting next to the faithful Cephalus, for such creatures are traditional symbols of faithfulness unto death, as Turner would have known. The repetition of the curve of Cephalus's back by the back of the canine is a typically Turnerian visual simile that equally serves to link man and beast.

Early in March, James Wyatt the printseller sent Turner some choice sausages and a hare.[20] Probably he did so in gratitude for the news that the oil painting of the distant vista of Oxford from the Abingdon Road was nearing completion, and that it could therefore be exhibited in the forthcoming Royal Academy Exhibition, along with the Oxford High Street view. But when Wyatt sent the foodstuffs he also asked that a 'venerable Oak or Elm' be introduced into the foreground of the new image.[21] Turner objected, stating

that a large tree 'would destroy the character [of] That *burst* of flat country with uninterrupted horizontal lines throughout the Picture as seen from the spot we took it from!' Instead, he offered to enlarge some pollarded hedgerow oaks in the mid-distance. However, as those trees are not particularly substantial in the finished picture and there is no large oak or elm, Wyatt obviously deferred to Turner's better judgement.

On 10 March, John Murray published the first two cantos of *Childe Harold's Pilgrimage* by Lord Byron (1788–1824). The poem caused a sensation and immediately sold out. Given Turner's interest in poetry, and not least of all in contemporary verse, it seems unimaginable he did not read such a popular work within a fairly short time. The alienation that Byron projected through the persona of Childe Harold, the poet's romanticism and sensuality, his verbal fluency, his imagery, his anti-war stance, his support for Catholic emancipation, his responsiveness to landscape and, not least of all, his moral view of history, would all touch Turner deeply. Eventually Byron would become his favourite contemporary poet. Although like any Royal Academician, Turner was by definition a pillar of the establishment, paradoxically he would always remain an outsider, as was Byron. In his case he was forced to stand apart not only by his verbal inarticulacy, cockney accent, blunt manners, increasing reclusiveness and parsimoniousness – which in reality fuelled an ambition to help impoverished artists through the acquisition of wealth – but equally he was separated by his constant readiness to strike out artistically in ways that many of his contemporaries could not easily understand, or even comprehend at all.

Throughout March, Turner attended Council meetings. At one of them, on the 13th of the month, he moved that a law passed on 30 November 1810 concerning the appointment of a sales clerk 'to answer enquiries respecting works to be disposed of' in the annual exhibitions should be revoked.[22] However, he found himself to be in a minority on this issue, with the continuing use of a sales clerk being ratified by the General Assembly when it met on 26 March, in his presence.[23] In all likelihood, Turner had realised in 1811 that selling through a lowly intermediary such as a sales clerk was an impersonal process that did not permit the forging of bonds between artists and their clients. Moreover, he probably thought that if the Royal Academy persisted with the new practice, the institution might come to be regarded merely as a shop, rather than as a body following a higher calling. Presumably that is why he had moved that the use of a sales clerk be terminated. But obviously his peers did not much care how they obtained their money.

The rate books of St Paul's, Hammersmith, show that the West End, Upper Mall property was 'empty' by Lady Day, 25 March 1812, so another chapter in Turner's life had closed. Quite evidently the arrangement by which his Queen Anne Street West gallery acted as his studio for most weeks of the year was serving him well, probably because of its top lighting. He sent in his four offerings to the 1812 Exhibition either on Monday 6 April or Tuesday 7 April. As a member of Council he had a say on the following two days as to which works by 'outsiders' were accepted or rejected. However, on Friday 10 April a problem arose with the placing of his own principal submission.

At the Correct Altitude

Smirke, Dance and Farington were responsible for arranging the hang this year, and on that Friday they had placed Turner's *Snow storm: Hannibal and his army crossing the alps* (see fig. 418) above the doorway leading from the Great Room to the Inner Room. Turner objected to the proposed location, quite simply because the internal perspectives of his image demanded that the canvas be displayed at eye level – we need to look *down* into the valley it represents. By being hung way too high, the viewer was forced to look *up* at the landscape depicted, with its internal perspectives being completely thrown out of kilter in the process. Accordingly, the work was taken down and rehung on the east wall opposite the entrance to the Great Room. However, there 'it appeared to the greatest disadvantage, – a scene of confusion and injuring the effect of the whole of that part of the arrangement. We therefore determined to replace it which was done,' as Farington recorded.[24]

On the following evening, Turner met with the members of the Committee of Arrangement after they had dined. He immediately asked Farington about the fate of 'His pictures', in the plural. This made it clear to the older Academician that if Turner withdrew *Hannibal and his army crossing the alps*, he would remove Wyatt's two Oxford views and a landscape in upper Savoy he had submitted as well. Because Turner was never one to spoil a party he desisted from pressing the matter further, and advised the members present that he would make up his mind on the Monday. Possibly with a nod, wink or whisper, Smirke and Dance made it clear to Farington that they could not care less what he decided, and that as far as they were concerned the painting would remain where it was. Turner stayed on to take part in a conversation about health matters.[25]

To cover the eventuality that *Hannibal and his army crossing the alps* and the other three paintings would have to be withdrawn, Turner sketched the layout of his forthcoming gallery show on the Monday or Tuesday and indicated 'Hannibal' on that rough plan.[26] Possibly the Oxford views were to hang on either side of it. And because of his threatened withdrawal, on the Monday he wrote to Wyatt, who would understandably want to know why his canvases were not on display if the withdrawal threat materialised.[27] Rather than tell the

truth, Turner dissembled by making out that the two Oxford pictures suffered grievously from being surrounded by bad submissions that lessened their impact. (The hollowness of this explanation can be gauged from the fact that he must *always* have welcomed his paintings and watercolours being surrounded by second-rate offerings, for they greatly heightened the virtues of his own contributions by contrast.) However, he urged Wyatt to put his own interests first, which in fact was the exact opposite of what he actually wanted. At the same time, he also sought the printseller's permission to act as he saw fit. However, as the situation would soon resolve itself, such assent was not required. But the letter to Wyatt demonstrates that Turner could pull the wool just like the rest of us.

Happily, on the Monday Farington had come up with the solution to the problem. This was to hang *Hannibal and his army crossing the alps* 'at the head of the *new room*', a proposal that was immediately accepted by his fellow 'hangmen'.[28] Accordingly, the picture was taken down and hung below the line on the west wall of the Inner Room. Turner finally agreed to the new position on Wednesday 15 April 'provided other members shd. have pictures near it'.[29] The use of the word 'pictures' had the desired effect, for quite clearly Turner did not want his canvas to be surrounded by watercolours and other graphic works, which were generally thought to belong to a lower order of artistic production than oil paintings. In the context of what could anyway be construed as banishment to the Inner Room, that would have appeared even more demeaning. He had his dignity to uphold.

Farington took the hint. He consulted Smirke, and the two of them then 'resolved that under the present circumstances pictures in Oil only shd. be exhibited in the new room, & that the drawings should all be hung below stairs' (that is to say, in the ground-floor converted life room).[30] Such a course of action may have been hard on the many watercolourists and other graphic artists who would thus be excluded from showing their offerings anywhere on the top floor this year, but as Turner would not be among them, he can hardly have given the matter any thought.

On Tuesday 14 April, Turner attended a Council meeting and requested that his guest at the forthcoming Royal Academy dinner should be the 2nd Marquess of Hertford (1743–1822).[31] This was potentially a very useful invitation, for on 3 March the aristocrat had been appointed Lord Chamberlain of the Royal Household, a post he would hold until 1821. In that position he would oversee all the official business of the royal family and act as the principal intermediary between the sovereign, the Prince Regent and the House of Lords. He would also wield absolute control over the licensing of new plays. Naturally, his nomination was immediately accepted by the Council. Once again we see Turner taking his networking very seriously indeed.

If the date of Turner's arrival in the world is to be believed, on 23 April he celebrated his 37th birthday. Perhaps the official publication of the ninth part of *Liber Studiorum* on that day was timed to mark the event. *Peat Bog, Scotland* (fig. 417) was probably synthesised from memories of various rugged spots seen in Scotland in 1801, for the actual location has never been identified. This is one of the finest works in *Liber Studiorum*, simply because the rich, velvety qualities of mezzotint are particularly amenable to communicating a sense of storminess and atmospheric moisture. For once an engraving in the series improved upon the drawing from which it was elaborated due to the sheer density of tone it could bring to the proceedings.

The Royal Academy Council granted permission for four varnishing days to take place this year, between Monday 27 and Thursday 30 April. Unfortunately we possess no sightings of Turner painting or retouching pictures in Somerset House on any of those days, although undoubtedly he did work there at the time. We can be certain of this because he dined at the Academy on the evenings of the 27th and 28th and it is highly unlikely that at this crucial moment in his artistic year he went into the Royal Academy just to partake of food, rather than to complete his submissions.

The 1812 Royal Academy Exhibition
FRIDAY 1 MAY TO SATURDAY 20 JUNE

The view in Savoy and the two Oxford scenes hung in the Great Room. In its new location at the head of the Inner Room, *Snow storm: Hannibal and his army crossing the alps* (fig. 418) principally received light from a large window situated at about a 45-degree angle to its right, and through a landing doorway at a similar angle to its left when not blocked by visitors. However, the fact that the painting was not evenly lit from above, as would have been the case in the Great Room, confirmed Turner's opinion that his major contribution to the exhibition had ended up in a poor location simply to accommodate a great many vastly inferior works placed beneath the line in the Great Room. Unsurprisingly, that would continue to rankle well into 1813, as we shall see.

The critic writing for the *Public Ledger and Daily Advertiser* of 5 May also thought that 'the situation in which the picture is placed is unfavourable to its being seen with advantage'. On the Monday afternoon, when the exhibition opened to the public, visitors crowded in front of it, thereby preventing an 18-year-old painting student, Charles Robert Leslie (1794–1859), from viewing it properly. As a consequence, he complained to his sister that it was hung 'very low'.[32] Yet by having had the canvas placed beneath the line, the Professor of Perspective was able to impart an important lesson regarding the internal perspective of an alpine landscape, for although

417 *Peat Bog, Scotland*, etching and mezzotint, drawn and etched by Turner and engraved by George Clint, published 23 April 1812 as Plate 45 in Part IX of *Liber Studiorum*, engraved image size 7¹⁄₁₆ × 10½ (17.9 × 26), British Museum, London.

the work does not have to be seen from any fixed frontal or lateral position, the eye of the viewer does have to be roughly halfway up the image if it is to make full perspectival sense of it. That is undoubtedly the major reason Turner made such a fuss over the height at which it was hung. Yet no less important is the fact that Hannibal and his army are *descending* into Italy. We therefore need to look down into the Val d'Aosta with them. The way we see and experience the painting forms an essential part of its meaning.

The title of *Snow storm: Hannibal and his army crossing the alps* was accompanied in the Royal Academy catalogue by the following lines from Turner's pen:

> Craft, treachery, and fraud – Salassian force,
> Hung on the fainting rear! then Plunder seiz'd
> The victor and the captive, Saguntum's spoil,
> Alike, became their prey; still the chief advanc'd,
> Look'd on the sun with hope; – low, broad and wan;
> While the fierce archer of the downward year
> Stains Italy's blanch'd barrier with storms.
> In vain each pass, ensanguin'd deep with dead,
> Or rocky fragments, wide destruction roll'd.
> Still on Campania's fertile plains – he thought,
> But the loud breeze sob'd, 'Capua's joys beware!'
>
> MS. P[oem] Fallacies of Hope.

The first line introduces a keynote of the work – 'Craft, treachery, and fraud' – while the verses that follow indirectly make it clear that Turner subscribed to the belief that in 218 BCE Hannibal had crossed the Alps by way of the Little St Bernard Pass, for the territory of the Salassi was the upper Val d'Aosta, where the north-eastern

418 *Snow storm: Hannibal and his army crossing the alps*, R.A. 1812 (258), oil on canvas, 57½ × 93½ (146 × 237.5), Tate Britain, London.

end of that pass terminates. The painter had of course visited the area in 1802, although he had not ventured into the Little St Bernard Pass itself, but simply looked towards it. The Salassi are attacking both the Carthaginians and their captives from Saguntum, a Graeco-Iberian city whose capture by Hannibal in 219 BCE had brought about the Second Punic War with Rome. However, the Carthaginian general is presumably unaware of what is happening to his 'fainting rear', for he has already pressed on to Italy proper.[33]

The final line tells of a wind-borne warning that Hannibal should beware of 'Capua's joys'. Eventually those pleasures will cause his downfall, for the fifteen years he will spend luxuriating in that city after leading his army through Italy will give the Romans time to regain their strength and defeat him. Ultimately the painting therefore comments upon the irony of Hannibal having wasted his energies in crossing the Alps, and upon the futility of territorial encroachment more generally. Within the context of a war with Napoleon that showed no signs of ending when this picture was painted, Turner's moral must have been directed at contemporary French expansionism, while its statement concerning the undermining effects of luxury and self-indulgence was aimed at those many members of British society who were lulled into complacency by the joys of life on a virtually untouched island.

The moral that citizens of all nations should eschew self-interest, vanity and luxury in pursuit of the common good was frequently encountered in Augustan poetry, from whence Turner had undoubtedly derived it. He would repeat it many times hereafter, not only drawing upon Carthaginian history but also that of the Greeks, Romans and Venetians in order to do so. And the downfalls of those empires were equally intended to act as warnings to any Britons who placed self-interest and the pursuit of pleasure above the

common good. Such moralism amplified the conviction stated in Turner's letter to John Britton of the previous December that it is the duty of a poet – and therefore by implication of a poetic painter as well – to act as a moral seer.

In *Snow storm: Hannibal and his army crossing the alps* Turner had at last found his way of responding to the picture of Hannibal attaining his first sight of Italy by J. R. Cozens he had seen either just before 1798 or during that year, as stated in Chapter 9 above. On the right an avalanche creates a brilliant burst of white, while in the foreground and on the extreme left the Salassi pick off stragglers or pitch boulders onto the Carthaginians. The sun is thinly masked by storm-clouds. This effect is both naturalistic and metaphorical, for the clouds were clearly intended to double as the 'storms of war' that will soon hide the light of peace from the inhabitants of Italy. As Turner was well aware, storms as metaphors for war are commonly encountered in poetry, and he would use them in that capacity many times more.

No manuscript poem entitled 'Fallacies of Hope' has ever been found among Turner's papers, surely because none existed. Instead, the opus merely comprises lines of verse in a good number of the exhibition catalogues published between 1812 and 1850, the final year the painter would show at the Royal Academy. Like the verses themselves, the title of this supposedly epic poem often articulates Turner's view that humanity is self-deluded if it thinks it can defy the forces of external nature, overcome the inherent contradictions and weaknesses of human nature, and ultimately attain some kind of religious redemption. Possibly the title and fragmentary themes of 'Fallacies of Hope' constituted antithetical responses to the title and subject-matter of the 'Pleasures of Hope', a highly popular poem by Thomas Campbell (1777–1844) dating from 1799.[34]

On the whole, *Snow storm: Hannibal and his army crossing the alps* was favourably received by the press, with the *St James's Chronicle* of 2–5 May, the *London Chronicle* for 2–4 May, the *Public Ledger and Daily Advertiser* of 5 May and the *Examiner* of 7 June being responsive to the sublime, poetic, associative and moral aspects of the work. And the *Repository of Arts* for June 1812 claimed that it could hardly be called a painting; rather it should be described 'as the effect of magic, which this Prospero of the graphic art can call into action, and give to airy nothing a substantial form'.[35] It also asserted: 'This will not be regarded as a popular picture.' However, in this respect it was wrong, for many visitors did respond favourably to it. One of them was Washington Allston (1779–1843), an American-born painter who had recently settled in London for the second time.[36] He called the work a 'wonderfully fine thing', and contended that Turner was 'the greatest painter since the days of Claude'.[37] Flaxman thought it 'the best picture in the Exhibition', according to the former war correspondent Henry Crabb Robinson (1775–1867), who was a law student at the time and who would later become a lawyer and diarist. He regarded *Hannibal and his army crossing the alps* as being 'the most marvellous landscape' he had ever seen and wrote many years later that he had never been able to forget it.[38] But his response, and the enthusiasm of many others, did not find the work a buyer. That is why it would form part of Turner's legacy to the nation in 1851.

The 1812 Turner Gallery Exhibition
MONDAY 11 MAY TO SATURDAY 6 JUNE

Although it had not been possible for the painter to mount a show of his own in 1811, this year he did so. But even then he could not open it prior to the opening of the Royal Academy Exhibition because of all the calls on his time by the Council. It began a week to the day after the Somerset House exhibition had opened to the public on Monday 4 May, and ended three weeks and five days later. Because *Mercury and Hersé* remained unsold due to the misunderstanding of the previous year involving the Prince Regent, it was on show, as were six paintings that were mentioned by name in the 9 June issue of the *Sun*.[39] One of these was a river view in Cumberland that had previously been shown in the gallery in 1810, while the other five were landscapes in Devon and Cornwall. Among them were views of Teignmouth and of hulks on a river, possibly the Tamar. They were acquired by Lord Egremont for two hundred guineas each, the prices of such three-foot by four-foot oils (Petworth House, Sussex).

A further canvas in this group of west country scenes was *Saltash, with the Water Ferry* (fig. 419). Here Turner responded to yet another ramshackle embodiment of an England that was fast disappearing under the pressures of change. The picturesque Water Ferry Inn bridged the muddy lane connecting Saltash to its ferry on the Cornish side of the relatively narrow mouth of the river Tamar, north-west of Plymouth. To make it evident we are looking at a pub, the word 'BEER' appears on one of its walls. The link between Saltash and the navy it often supplied with manpower is established by the words 'SALTAS/ ENGLAND/ EXPECT EV' which are to be seen on the wall on the right. Turner left us to complete Nelson's final message to his fleet for ourselves.

The 1812 Turner Gallery show could also have included fresh-off-the-press impressions of the frontispiece to the *Liber Studiorum*, as well as of the five mezzotint engravings that constituted its tenth part, for those prints were officially published on Saturday 23 May, just twelve days after the exhibition opened. That evening Walter Fawkes delivered an important speech on parliamentary reform at a dinner being held in London.[40] His presence in town suggests that he visited the Turner Gallery at around this time.

419 *Saltash, with the Water Ferry*, T.G. 1812, oil on canvas, 35⅜ × 47¾ (89.3 × 120.6), Metropolitan Museum of Art, New York.

The Key

It may appear strange that the artist issued the frontispiece to *Liber Studiorum* (fig. 420) only after ten parts of the work had already appeared. However, it must be remembered that, like the Richard Earlom engraved version of the *Liber Veritatis* after drawings by Claude, Turner had planned his similarly named work to reappear in bound, two-volume form, with the first volume being published at the halfway point of the project (that is, when ten parts had been issued). This procedure was quite common among print publishers of the day.[41]

Although Turner had originally toyed with the idea of employing a marine image for the frontispiece,[42] it is wholly unsurprising that as a fervent adherent of the theory of poetic painting he instead looked for his subject to the highest category of art, namely history painting. But out of the multitude of subjects he could have chosen, why did he employ Europa and the bull to form what necessarily serves as the key to the entire *Liber Studiorum*?

Ruskin and others suggested that because Europa will shortly be violated by Jupiter – in the guise of a bull – and Tyre appears beyond them, Turner's image associatively denotes the decline into 'terror and judgement' of the Phoenician civilisation represented by that city, and therefore the fall of civilisations more generally.[43] Yet this hypothesis overlooks the fact that when Turner would rework the image in oils towards the end of his life, he would omit Tyre entirely, so the city cannot have borne the significance that Ruskin claimed. Instead, the meaning of *Europa and the Bull* must reside in what was almost certainly the literary source of Turner's design.

This was Joseph Addison's translation of sections of Ovid's *Metamorphoses* that are to be found in the seventh volume of Anderson's

420 Frontispiece to *Liber Studiorum*, etching and mezzotint, drawn, etched and the centrepiece engraved by Turner, the rest engraved by J. C. Easling, published on 23 May 1812 along with Part x of *Liber Studiorum*, engraved image size 7⁵⁄₁₆ × 10⅛ (18.6 × 26.3), British Museum, London.

Complete Poets. Jupiter, desiring Europa, transforms himself into a bull and mingles with other cattle on the shores of Tyre. The young virgin, attracted by the animal's virility, beauty and friendliness, mounts him for a ride but is immediately carried off to Crete:

> Through storms and tempests he the virgin bore,
> And lands her safe on the Dictean shore,
> Where now, in his divinest form array'd
> In his true shape he captivates the maid,
> Who gazes on him, and with wondering eyes
> Beholds the new majestic figure rise,
> His glowing features, and celestial light,
> And all the God discover'd to her sight.[44]

The story of Europa and the bull is therefore partly about being transported, as Turner's image also denotes. But being carried away is equally fundamental to art, for it possesses the power to transport us to a higher reality than the one we normally occupy. And at the heart of the Europa and the bull myth simultaneously resides the difference between everyday appearance and higher reality, for Jupiter may look like a bull but he is really a god. For a painter who fully accepted the notion propounded by Sir Joshua Reynolds in the discourse he had probably attended in 1790 that imaginative reality transcends literal reality, and that there exists some higher reality behind appearances – a conviction Turner had been converting into images for years by 1812 – the story of Europa and the bull was the perfect vehicle with which to make apparent that fundamental article of faith.[45]

Moreover, there may exist still another dimension to *Europa and the Bull*. Understandably, Turner would never have considered himself 'majestic', 'glowing', 'celestial' or divine. Yet because the story of Europa and the bull encapsulates the difference between appearance and reality, he may have discerned something of relevance to himself in the myth.

It will be remembered that back in 1805 a book of collected writings by the late Edward Dayes had declared that Turner would have to be 'loved for his works; for his person is not striking, nor his conversation brilliant'. Slightly earlier Turner had himself admitted: 'No one would believe, upon seeing my likeness, that I painted [my] pictures.' Accordingly, he was well aware of the difference between appearance and reality with regard to himself. By making *Europa and the Bull* serve as the key to *Liber Studiorum*, he was thus able to draw an autobiographical parallel: like Jupiter, there was much more to him than met the eye. Yes, he may have been a barber's son with a cockney accent, the manners 'of a groom' and a frequently wayward appearance, but the truth of him was somewhat different. By drawing our attention to the difference between appearance and reality in *Europa and the Bull*, he was reminding us with great subtlety of the unusual qualities of mind and hand that constituted his own 'true shape'. So much for Edward Dayes and those of a similarly dismissive outlook, he might well have thought, and who can blame him if he did so?

Three other images within Part X of *Liber Studiorum* are worthy of mention for the light they throw upon Turner himself, or upon an aspect of his work. Thus *Hedging and Ditching* was developed from the briefest of sketches made when the artist was returning from Portsmouth in 1807.[46] It depicts two farm labourers cutting away at the roots of a pollarded willow tree as they prepare to enlarge a ditch, while a little further away another workman shaves off timber that will doubtless be used to repair an adjacent hedge. In a painting to be exhibited in 1813 (see fig. 422), Turner would show hedging as having recently been completed and ditching taking place.

It would be easy to assume that the *Mer de Glace* print in the new part of *Liber Studiorum* belongs to the 'Mountainous' category of the scheme, especially as the letter 'M' appears on the plate, apparently to denote that classification. Yet if that were the case, then this section of *Liber Studiorum* would contain two works in the 'Mountainous' category. For that reason, the 'M' on the *Mer de Glace* print must stand for 'Marine' instead. This is not as far-fetched as it seems, for of course ice is simply frozen water, as all of us are well aware, Turner included. Naturally, inclusion in the 'Marine' section would have proven most apposite to the depiction of a '*Mer* de Glace'. And Turner was undoubtedly aware of contemporary developments in the understanding of geology, a science that in part studies the constant interactions of earth and water.[47]

By 1811, when the *Mer de Glace* engraving was probably begun, Turner may already have become friendly with the geologist and surgeon John MacCulloch (1773–1835). They could have met through William F. Wells, who worked alongside MacCulloch at the East India Company's military academy in Addiscombe, Kent.[48] It was probably MacCulloch who would give Turner two volumes of the *Transactions of the Geological Society*, to both of which he had contributed articles.[49] And another member of the Geological Society after 1809 was the Royal Academy Professor of Anatomy, Anthony Carlisle. He and Turner might well have discussed geological matters when they frequently met, for after all, geology is the anatomy of our planet. The subject was therefore of interest to both men. Moreover, Turner would later become friendly with other professional and amateur geologists, including William Buckland (1784–1856) and Charles Stokes (1785–1853). And by 1812 the sculptor Francis Chantrey (1781–1841) was just beginning to enter Turner's circle. He too was deeply interested in geology.

In 1813 Anthony Carlisle would tell Farington that 'it had been proved by examination into the state of the earth and its contents, that most of it had at some period been under water.'[50] From this awareness necessarily derived the view that mountains had been shaped by seas, for vast bodies of water could hardly cover anything without acting upon them. Carlisle might easily have articulated that opinion to Turner. So in a real sense the glacier depiction *is* a marine subject, for the Mer de Glace had certainly changed the shapes of the mountains that flanked it. Of course, if the painter did think that, then his exploitation of the ambiguous classifying letters of the *Liber Studiorum* was both witty and wise.

Finally, *Rivaux Abbey* ultimately derived from a sketch made during the journey to Scotland in 1801.[51] The design is a study in frontality, with almost everything beyond the shallow 'V' of the foreground being spread across the image in a spatially equidistant manner. Only a single, recessional diagonal up on the left cuts across the prevailing parallel alignment with the picture plane. Possibly Turner was inspired to use frontality in this way by the consideration he was giving to low-relief sculpture when reading Opie's *Lectures on Painting* in the summer of 1809, for the Rievaulx Abbey drawing may have been made at that time. Indeed, as the fifty-first of the *Liber Studiorum* published designs, it could well have been the very first image to have been elaborated after the initial group of fifty drawings had been brought into existence prior to April 1808.

In keeping with the fact that we are looking at a ruin, the evening light is sombre and the scene entirely lacks animation. The related dramatic and moral points are clear: Rievaulx Abbey may have once teemed with life but it does so no longer.

In the original sepia drawing from which the engraving was developed,[52] a solitary man sits on the ground, holding his head in

one of his hands. Probably he does so in order to express the melancholy brought on by all the ruination before him. Reclining at his feet appears to be a dog. But in the engraving, the creature was altered into a large artist's portfolio, with what is probably a bag or rucksack placed next to it. Now the reclining man appears to be looking at the ruins through some kind of optical instrument. Given the date of the print, this could be one of the Patent Graphic Telescopes that had recently been invented by the watercolourist Cornelius Varley (1781–1873).[53]

If Turner did represent a Patent Graphic Telescope being used here, then he did so in a very timely fashion, for the invention of the device had only been registered in 1811, and thus during the very period in which the *Liber Studiorum* engraving of *Rivaux Abbey* was being elaborated. By means of his Patent Graphic Telescope, Varley drew a portrait of Turner (Graves Art Gallery, Sheffield), although its accuracy has been disputed.[54] It may well be that such a lack of fidelity was caused by the optical instrument itself.

There is no evidence to support the claim that the Varley portrait was made around 1815.[55] Instead, it is perfectly possible that the inventor of the Patent Graphic Telescope showed Turner one of his devices in 1810 or 1811, and when doing so attempted to demonstrate its virtues by making a (facially inaccurate) portrait of him.[56] And Turner, perhaps gauging the distance between the reality and the simulacra brought about by means of an optical instrument, then possibly altered the man in the *Rivaux Abbey* print into an artist using a Patent Graphic Telescope. By this means he could have been getting in a subtle dig at painters like Varley who occasionally relied upon artificial drawing aids in pursuit of their art, for he himself had never required anything more than his eyes to obtain representational accuracy in north Yorkshire in 1801, or anywhere else for that matter.

27

A Man of Property

June 1812 to May 1813

At the king's birthday dinner held in the Great Room on the evening of 4 June, Turner got into an embarrassing spat with John Britton. The antiquarian had long been close to John Soane, and the architect, being unable to attend the event, had passed on his ticket. But having taken Soane's place, Britton was soon informed by a porter that he could not sit there. Shortly afterwards Turner reiterated this point to his face, although he subsequently made it clear that the antiquarian could sit at the very bottom of one of the two arms of the top table. Britton did so, but was so incensed he complained to Soane the next day.[1]

What Soane had not anticipated, and Britton had entirely overlooked, was that although the ticket could be given away, it could not be accompanied by its rightful owner's triple status as a Royal Academician, as a Royal Academy Professor, and as one of the most prestigious architects in the world. For those reasons, Britton most certainly could not take Soane's place. If outsiders who could wield no influence on behalf of the Royal Academy substituted for Academicians at the dinners, then the occasions would quickly lose their social standing and political clout. By moving Britton, Turner was not setting out to insult him or cause him chagrin, let alone denying him time spent in a stimulating manner. He was simply defending the Royal Academy and its unique position within British society.

Several drawings of the female nude appear in the *Lowther* pocket sketchbook that had principally been used in the North of England in 1809.[2] The most likely reason for their presence there is because, in his role as Visitor, Turner took the book into the life room on several occasions during the first half of 1812. Although it has been suggested that some of the drawings may represent Sarah Danby posing sexily for her man,[3] the truth is probably far more mundane. Now the painter was back in the Schools, with years of experience behind him, he could well have been determined to get the life models to take up challenging poses, for it is easy for such low-paid and poorly motivated workers to position themselves in the most undemanding ways possible. And rather than stand around doing nothing while the students laboured over their drawings, Turner simply took up his pencil and joined them.

Solus Lodge Arises

Turner's builders probably began work on Monday 26 June and continued until Saturday 12 September, a period of eleven six-day working weeks.[4] To save money, it is likely that Turner and his father lent their assistance throughout, although it is questionable how much of it could have been supplied by an artist with delicate fingers and an ageing ex-barber. But after the walls and roof had been completed they could have taken over a major part of the labour, especially where house-painting was concerned. Because William

Detail of fig. 422.

421 William Havell, *Sandycombe Lodge, Twickenham, the Seat of J. M. W. Turner, R.A.*, c.1814, pencil and sepia watercolour on paper, 4¼ × 7⅞ (10.8 × 20), courtesy of Turner's House Trust.

Sandycombe Lodge was the name that Turner subsequently bestowed upon Solus Lodge.

Turner enjoyed gardening, he probably undertook that work gladly. At his son's behest, it included the planting of willow trees.[5]

Solus Lodge, which has survived under a change of name, is represented here by a slightly inaccurate watercolour of it by William Havell that dates from 1814 (fig. 421).[6] The villa demonstrates the influence of Soane, and its Italianate appearance is greatly enhanced by pronounced Tuscan eaves and stuccoed brickwork. Originally it was probably painted a cream or light grey colour.

An entrance vestibule leads to a hallway that crosses the main part of the building to link the wings at each end. Near its south-east end, this hallway contains an unusually tall and narrow cupboard that obviously housed Turner's fishing rods. Immediately opposite the rod cupboard was the only 'closett' in the building. Probably it contained a fairly primitive flush toilet, the contents of which flowed to a cesspit at the bottom of the slope immediately to the south-east of the house.

Immediately beyond the hallway was Turner's studio. It measures 17 feet 8 inches in length, 10 feet in depth and is lit by a set of shuttered French windows that permit access to a small balcony. They face precisely 50 degrees from due north (in other words, they are aligned just five degrees south of an exact north-east bearing). Once again Turner obtained the maximum amount of light at daybreak, in summer at least.

Rooms with chamfered corners stand at each end of the ground floor. Originally they both possessed slightly projecting windows on their north-east sides.[7] Probably the northern-most room originally served as the formal dining room, due to its close proximity to the stairs affording access to the basement kitchen. The similar room at the opposite end of the house might well have been Turner's sitting-room, library and study.

The staircase to the upper floor stands at the northern-most end of the hallway, and it sharply curves back on itself at its midway point. Let into the wall just before the beginning of the return is a small niche that once contained a sculpture.[8] The entire staircase is lit by a skylight with long straight sides and short, curved ends. On a small scale it loosely replicates the Royal Academy staircase designed by Sir William Chambers, with its circular skylight.

There are just two rooms on the upper floor. Turner's bedroom is on the north-east side of the landing and is the same size as the studio beneath,[9] while the second bedroom is so small it could not have housed much more than a bed. The French windows of this bedroom permit access to a balcony above the entrance portico. It does not seem fanciful to imagine users of the house sitting up there on fine summer's evenings watching the sun set over the open fields to the west, with the distant buildings of Twickenham visible to the south-west.

Returning to the ground floor, an immediate 180-degree right turn at the bottom of the stairs leads to the stairs down to the basement. On the lower level there are five spaces. One of them was a larder or large food-storage cupboard. Another was a coal cellar that received its contents directly through a coal chute located to the right of the front door. A fairly large room doubled as the kitchen and informal living cum dining room. It must have been cosy in cold weather, for not only did it house an 'oven' or kitchen range but it also possessed a fireplace. Light enters the space through a large Diocletian window on its north-east side. Probably this room is where a servant, such as Hannah, would have slept. The adjacent, unplastered room under the north-east wing served as both a scullery and a pantry for the storage of food, dishes and utensils. Round-headed niches in the walls were used for the cooling of bottles and freshly baked bread.

A small structure at the southern corner of Turner's domain, about two hundred yards from Solus Lodge, could have been the stable for 'old Crop-ear'.[10] The garden was enclosed by wooden paling. Henry Syer Trimmer informs us that 'At the end of [Turner's] garden was a square pond – I rather think he dug it himself – into which he put the fish he caught. The surface was covered with water-lilies.'[11] It is amusing to think that, had he been so inclined, Turner could have painted a body of water covered in water-lilies long before the birth of Claude Monet in 1840.

Officially, Turner moved in to Solus Lodge by 19 October 1812, but illness may have prevented him from gaining much use of it until the summer of 1813.[12] It must be doubted that he undertook any painting in oils anywhere during the summer of 1812, although

doubtless he set to work on a number of watercolours once his Solus Lodge studio was ready. That may have been early in October. By 2 November he was back in town, for on that date he attended a General Assembly meeting, while two days later he was present at a Council meeting.

After the Council deliberations had ended, Turner complained to Farington of 'a nervous disorder, with much weakness at the Stomach. Everything He said, disagreed with Him, turned *acid*. He particularly mentioned an aching pain at the back of His neck. He said He was going to Mr Fawkes's in Yorkshire for a month, and I told Him Air, moderate exercise and changing His situation wd. do most for Him.'[13] Turner's illness would continue for quite some time, although it is impossible to pinpoint its exact nature. Assuredly he was not suffering from either Maltese Plague or the completely unrelated disease of Malta Fever – let alone both simultaneously – as has been asserted by a previous biographer.[14] The unusual combination of neck pains, recurring gastritis, and acidity arising from the stomach suggests a psychosomatic or somatoform disorder, in which mental tension created by, say, overwork or stress finds an outlet in physical illness.

On or around Saturday 14 November, Turner quit London for Farnley Hall. Possibly his stay ended just over four weeks later on Sunday 13 December.[15] Sadly, we again possess no record of his movements in Yorkshire. However, given his neck pains and other discomforts, it appears very likely that he simply took it easy. Being waited upon hand and foot by servants in a grand country house would necessarily have helped him through his discomfort, while raising his spirits in the process. And naturally, woodcock shooting and the local fishing would have also provided distraction if strolling through the woods with gun in hand and idling on the banks of the Wharfe or some lesser river in November and December did not prove to be too cold and taxing. Moreover, evidence suggests that Turner was already in possession of a drug with which to alleviate his aches and pains. This was *Datura stramonium*, a common weed in the *Solanaceae* or nightshade family containing a narcotic not unlike opium that he wrote about in a sketchbook, making particular mention of smoking '2 or 3 pipes every day' and of the need to 'swallow the saliva'.[16] As we shall discover, this drug might have offset pain but it could soon have given rise to another problem.

Back in town, Turner participated in Council and General Assembly meetings throughout the latter half of December. On 28 December – and in his presence – a letter from him was read out to the Council by the Academy Secretary asking if he could 'be allowed to postpone reading his course of [perspective] Lectures, until the season of Janry 1814 on account of indisposition'.[17] As we have seen repeatedly, he had deemed the giving of the lectures to be of great importance, which is why he had slaved over them for years. Only a serious impediment could therefore have moved him to seek their abandonment in 1813, rather than their postponement until later in the year. But what could that 'indisposition' have been?

It cannot have been only the physical disabilities of which Turner had complained to Farington a little while earlier, for during this period he was very active within Somerset House. Thus, as his two-year stint on the Council drew to a close, he took part in all eight of its meetings between 16 and 31 December 1812, plus the New Year's Eve Council dinner that followed the last of these, as well as General Assembly meetings on 23 and 30 December. Such a close involvement with Academy affairs hardly suggests that a mere physical indisposition was to blame. His peers must therefore have seen something else that convinced them of his inability to lecture.

That alternative could easily have been the mental fogginess caused by having to smoke *Datura stramonium* in order to deal with 'much weakness at the Stomach' and with things disagreeable, turning acid and producing 'an aching pain at the back of His neck'. If Turner was suffering from the effects of the drug when the letter requesting postponement of the lectures was read out immediately before his gaze, then such disorientation would certainly have permitted the members of Council to judge for themselves whether the Professor of Perspective was not completely himself mentally, and that he should therefore be excused from lecturing for a year. After all, it was one thing to be fairly befuddled on occasion during Council meetings (and, indeed, Turner might well have aroused admiration for doggedly attending all of them when ill and in a possibly drugged condition). It was quite another to lecture in that state. His wish was therefore granted.

It may have been in late January or early February 1813 that Turner visited Callcott at his home and studio in the village of Kensington Gravel Pits, about four miles to the south-west of Queen Anne Street West.[18] Doubtless he wanted to see what his friend was up to. However, the two Academicians also discussed the exhibiting of their works in future Royal Academy shows and the possibility of formulating a concerted response to the continuing criticisms of their art by Sir George Beaumont. Eventually they agreed not to submit anything to the 1813 Royal Academy Exhibition, for they could see no point in doing so if their works attracted nothing but opprobrium and incivility. (It still galled Callcott that Sir George had cut him dead at the private view of the 1812 display.)[19] In due course Turner would change his mind, for upon reflection he would not allow himself to be denied access to his largest public simply because of criticism by someone who was both a self-appointed arbiter of taste and a bad amateur painter, which was even worse.

On 15 March the directors of the British Institution agreed that the organisation would confer three prizes or Premiums the following year, as it had been doing annually since 1807. Two hundred

guineas would be awarded for 'the best Picture in Historical or Poetical Composition', and another hundred guineas for a lesser work in the same mode. The third prize of a hundred guineas would be awarded 'For the best Landscape'.[20] All the entries would have to be 'painted in the present year' and delivered to 52 Pall Mall by 4 January 1814. The directors instructed that a printed notice concerning the Premiums should be sent 'to the Members of the Royal Academy, and to such Artists as have exhibited in the British Gallery'. Both categories included Turner, as we have seen. The notices were sent out a few days later. It may have been one of these that inspired the painter to enter the 1814 competition, with results we shall determine. Shortly after 15 March 1813 the Premiums were advertised in the newspapers.

According to Farington on 29 March, James Ward informed the Council that Callcott would not be exhibiting at the Royal Academy this year, despite attempts to persuade him otherwise. This was because he was mortified by the continuing, hostile criticism of '*the White painters*', as he and Turner had been dubbed. And Ward also told his fellow Council members that 'Turner meant to send one picture only & that conditionally viz: The having an assurance that it should be placed in a situation to be named by himself.'[21] Understandably, this demand was deemed to be wholly unacceptable.

Of course, those who had nicknamed Callcott and Turner '*the White painters*' and endlessly disparaged them were Sir George Beaumont and his followers. And on 8 April 1813 Callcott himself told Farington that he deemed it prudent not to exhibit in Somerset House this year, for he had not 'sold a picture in the Exhibition in the last three years, or received a commission arising from it'.[22] He was well aware that 'Sir George Beaumont's perservering abuse of his pictures had done him harm', and that a sale to another, more elevated aristocrat had fallen through because of it (although Sir Richard Colt Hoare, who doubtless did not give a fig for Beaumont's opinions, had subsequently purchased the work in question). Moreover, Callcott went on to state that 'Turner had also suffered from the same cause, & had not sold a picture in the Exhibition for sometime past'.[23] He then pointed out that Turner had called upon him at Kensington 'a while since and then said He did not mean to exhibit' because of Beaumont. However, he had 'since altered his mind and determined not to give way, – before Sir George's remarks'.

Clearly, Turner was made of sterner stuff than Callcott when it came to Beaumont and his ilk. That is why he would submit not one picture but two to the Royal Academy in 1813, and why the pair of them in tandem would demonstrate exactly what he thought of Sir George's views on art. But Farington's 29 March diary entry also touches upon another of Turner's discontents. This was that *Snow storm: Hannibal and his army crossing the alps* had been exhibited in relatively poor light in the Inner Room in 1812. Turner was determined never to permit such a state of affairs to arise again. With all his experience of the Royal Academy he knew full well that both the hanging committee and the Council from which it was drawn could not be ordered around. However, both bodies could be sent a strong warning signal.

This Turner had done by advising James Ward – who was one of the 'hangmen' this year – that his contribution would have to be placed 'in a situation to be named by himself '. In the event, both of his submissions would be hung in highly advantageous positions. The warning had worked because Ward and the other members of the Committee of Arrangement were doubtless aware of the fact that many years earlier both Gainsborough and Wright of Derby had stopped exhibiting at the Royal Academy altogether because of dissatisfaction with the placing of their paintings, while in 1812 Turner had threatened to withdraw all his submissions for the selfsame reason. If such a threat were to become a reality in 1813, it would make the organisation a laughing stock with both the critics and the public alike. Turner was just too important to be shown in a poor light ever again. It was simply not worth the risk.

The 1813 Turner Gallery Exhibition
?MONDAY 29 APRIL TO ?SATURDAY 29 MAY

This year the painter appears to have gone back to anticipating the public opening of the major event in the Somerset House calendar by a week, just as he had done in 1809.[24] Sadly, we possess no catalogue of the Turner Gallery show, or even any idea of what it contained. But it is extremely likely that its organiser took it easy this year because of illness, and therefore exhibited a number of old paintings, three of which he seems to have sold.[25] Additionally, *Liber Studiorum* prints were on display, as perhaps were watercolours made in 1813.

The 1813 Royal Academy Exhibition
FRIDAY 30 APRIL TO SATURDAY 26 JUNE

There were four Varnishing Days this year, from Monday 26 April to Thursday 29 April. We possess no record of Turner having taken advantage of them, but if previous years are anything to go by, he was unlikely to have missed them. He did attend the dinner, however, where he sat with Walter Fawkes on his left, Richard Westall on his right and Thomas Stothard facing him.[26] Probably Fawkes was his guest. His two exhibits were hung in the Great Room.

The title of *Frosty morning* (fig. 422) was accompanied in the catalogue by line 1168 from 'Autumn' in Thomson's *The Seasons*: 'The

422 *Frosty morning*, R.A. 1813 (15), oil on canvas, 44¾ × 68¾ (113.5 × 174.5), Tate Britain, London.

rigid hoar frost melts before his beam.' The path of the dawn sunlight across the ground is easily traceable from the melting of the frost. On the right, the spruce state of the hedge makes it clear that hedging has only recently been completed, probably by the two labourers who have now begun clearing a ditch that is presumably clogged with fallen leaves, branches and silt. The leftmost man makes it evident that he and his companion are standing in the ditch, for he is only visible from the knees upwards. Because the autumn morning is very cold, crisp and clear, the ditch will have mostly dried out, or completely done so through having frozen overnight. That is why emptying it of muck and debris will not prove difficult. Doubtless the detritus will be shovelled into the cart.

If the line of the ditch is carried to the left, it connects with urine gushing from a cow. Such a link is highly appropriate, for of course, ditches exist principally to facilitate drainage. To the left of centre, a gamekeeper leans on his empty shotgun and looks on. He has just shot a hare and draped it around the shoulders of a little girl, both to lighten his load and insulate her from the cold. Further off a solitary man stands with his hands in his pockets, thereby augmenting the associations of cold. He may be an itinerant looking for work at a time of growing dearth in both nature and the rural economy. More distantly, a stagecoach approaches.

Around 1860, Henry Syer Trimmer would relate being informed by Turner that he had sketched this scene when travelling by stagecoach in Yorkshire.[27] Sadly, no such pencil drawing has yet been identified. That sketch may have been made in December 1812 if Turner waited at dawn for his stagecoach to appear on the Great North Way to the east of Farnley on the very day he had started

out for home. And Trimmer also remembered being told by his father that the little girl in the painting reminded him of a young female he had once seen at Queen Anne Street West and whom, 'from her resemblance to Turner, he thought a relation'.[28] Naturally, if the painter did model the little girl upon the 13-year-old Evelina Danby – for Georgiana would have been less than two years of age when this work was created – then the reason for that likeness is obvious.

The younger Trimmer equally recognised 'old Crop-ear' as having been the model for both of the horses that appear in *Frosty morning*. He particularly appreciated the way that the artist had captured the stiffness of a foreleg belonging to one of those nags. And perhaps more importantly from the art-historical point of view, Henry Syer Trimmer recollected being told by his father that when the painting had hung in Somerset House in 1813, it had been 'much brighter' than it was around 1860.[29] Somewhat less surprisingly, he was then informed that it had caused 'a great sensation', for although the Royal Academy Exhibitions had long contained works painted in the common pastoral mode, very few of them could ever have matched *Frosty morning* for naturalism, let alone surpassed it in capturing a fairly fleeting and intensely delicate effect like a hoar-frost.

It was by this means that Turner displayed his contempt for Sir George Beaumont, at least in part. If that self-appointed 'supreme Dictator on works of art' would habitually and ignorantly dismiss artists as 'White painters', then he would have to be taught a lesson as to just what 'White painting' could achieve, particularly in technical terms. Given the loss of a brightness remembered by Henry Scott Trimmer, in 1813 some areas of the work were probably much whiter than they are today, with the rimings of hoar-frost looking more tangible and brittle than they do now. And sadly, before discolouration, paint loss and/or fading, the sky also probably looked milkier and brighter than it does today (for perhaps the painter floated a thin white glaze over a firmer, creamier underpainting). But no matter. In *Frosty morning* Turner raised common pastoral to new levels of realism and beauty, while demonstrating to a supposed gentleman who had snubbed Callcott in 1812 that he too could be frosty, especially where baronets who were also mediocre critics and bad painters were concerned.

A further guest at the Royal Academy dinner on 1 May was the 1st Earl of Carysfort (1751–1828). From where he was seated, he would have enjoyed a very good view of Turner's other exhibit, *The deluge* (fig. 423). Its title was accompanied in the catalogue by lines describing the biblical flood that were taken in whole or in part from the eleventh book of Milton's *Paradise Lost*.[30]

It will be remembered that Turner had possibly exhibited this canvas in his own gallery in 1805, having perhaps been commissioned to create it by Lord Carysfort a year or so earlier. Moreover, it will also be recalled that the picture enacts a response to Poussin's *Winter (The Deluge)* of 1660–64 (see fig. 294), which Turner had seen in Paris in 1802. Clearly he wanted to demonstrate how such a subject should be depicted, in terms of greater observational acuity, behavioural logic and spatial awareness than had been employed by the French artist, as well as with a far deeper insight into how people respond under pressure to the vast natural forces that overwhelm them. Of course, where those forces themselves are concerned, Turner was able to depict them with an infinitely more savage power than Poussin could ever have attained, or even wanted to capture.

Understandably, in 1813 it was widely thought that *The deluge* was primarily an exercise in the Sublime. Central to that concept stands a fear of the unknown engendered by darkness. Yet to a painter who avowed his allegiance to the theory of poetic painting, intense gloom was the only appropriate lighting effect for a world being inundated by forty days and forty nights of unceasing rain. And in further keeping with the demand for decorum a red sun has just sunk beneath the horizon, for only a sunset would match a world coming to its end. The lurid light falling across the forefront of the image from offstage-right cannot emanate from a flash of lightning, for it is too warm in colour to look electrical. Maybe it emanates from a fire. Like Poussin, Turner placed Noah's Ark in the far distance, obviously to suggest that the vessel is escaping the inundation that is taking place immediately before us.

In the right-foreground a muscular black youth supports a beautiful white girl who has fainted and is therefore in danger of drowning. She is entirely naked but he is only half so, while a chain that encircles his waist surely denotes his status as a slave.[31] By supporting the girl in such life-threatening conditions, he is demonstrating the selfless and noble side of his nature, for he could easily have looked out solely for himself. When *The deluge* had possibly gone on display for the first time in 1805, Turner had just invested in the slave-owning tontine, so it is extremely unlikely that he had then painted a black slave supporting a beautiful white girl. Instead, it is far more probable that a white youth had supported the girl, for Turner had developed both of these figures from a pencil and white-chalk drawing of a white-skinned couple in the *Studies for Pictures* sketchbook of 1800–2.[32]

Naturally, if the 1805 version of *The deluge* did not represent a black youth, that was surely because Turner had not yet given thought to the sensibilities of the enslaved, let alone to demonstrating that black people are just as capable of selflessness as anyone else. But in the period leading up to the spring of 1813 he had probably undertaken some work on revivifying the old canvas. In the process he might well have altered the white male into a black one. If he did make that change, then perhaps he did so because of the friendship with Walter Fawkes that had been ripening since 1808. By now

423 *The deluge*, T.G. 1805?, R.A. 1813 (213), oil on canvas, 56¼ × 92¾ (143 × 235), Tate Britain, London.

Fawkes's bitter opposition to slavery could well have rubbed off on him (although it must be admitted that he would go on accepting money from Jack Fuller for some years to come). Yet he may have harboured a further reason to alter a white youth into a black one.

This too has to do with Sir George Beaumont. According to the regulations, Turner could have sent up to sixteen works to the 1813 Royal Academy Exhibition; instead he submitted just two. We know from Callcott that Beaumont was in Turner's mind when he was considering showing in Somerset House. It is therefore valid to assume that his choice of entries to the exhibition was formed with Sir George in mind. We have already suggested what lay behind his thinking in *Frosty morning*. And just as that picture demonstrates – or at least once proved – what can be done with white, so *The deluge* shows what can be achieved with black, principally through the chiaroscuro that Sir George greatly admired and to a more subtle degree by means of the noble black youth. A profound polarity links the two paintings. Of course, whether the baronet would have been able to grasp that antithesis or wanted to do so is another matter. Somehow it must be doubted, for he would never have admitted that a so-called 'White painter' could equally be a master of the dark tones he thought to be essential to art.

Of course, the two 1813 Royal Academy submissions are about much more than simply white in relation to black, and both in connection with regressive and small-minded views on art. Thus they indicate Turner's mastery of colouristic and tonal control from white to black; once more they reveal his responses to his two favourite Dutch painters, Cuyp in the case of *Frosty morning* and Rembrandt in *The deluge* (and he would again pay linked homage to both artists in 1818); they demonstrate his command of decorum, whereby a new day matches a world being prepared for a new season in *Frosty*

morning, while a sunset matches a world coming to an end in *The deluge*; they again remind us of Turner's moral range, from humble pastoral to biblical tragedy; and ultimately *The deluge* proclaims his mastery of history painting. In such complexities there would have been much for Sir George to ponder had he possessed the intellect, taste and open-mindedness to do so.

It could have been during the course of the 1813 exhibition that Lord Carysfort decided not to acquire *The deluge*, even though he had possibly commissioned it back in 1804. Perhaps the sexual implications of a semi-naked and well-formed black male with his arms around a naked and beautiful white girl made him uneasy. He was certainly active in the anti-slavery cause, but abolition was one thing, mixed-race relationships quite another. There were many who wanted to do away with slavery without wanting racial barriers to vanish with it. Possibly Lord Carysfort was one of them. Alternatively or additionally, it could simply have been the case that the aristocrat felt that a semi-naked male with a naked female was just a little too risqué, or that the painting was far too gloomy for his town house in London or his country seat in County Wicklow. Doubtless we shall never know. But *The deluge* was left on Turner's hands (as was *Frosty morning*). Not long after Lord Carysfort's demise in 1828 the painter would dedicate the engraved reproduction of it to his memory, surely because he had called the image into being.

In the main, the newspapers were very positive about the two 1813 exhibits. Thus the *London Chronicle* of 6–7 May declared that Turner 'bears off the palm for landscape' from the entire exhibition, while the *Public Ledger* of 3 May called his two submissions 'impressive'. The reviewer for the *St James's Chronicle* of 4–6 May thought highly of *Frosty morning*, stating that

> This is one of the best works of this eminent artist. In silvery brightness of effect it is equal to the best productions of Cuyp or Claude. Mr Turner has an eye to harmony the most penetrating, and it is wonderful to observe how much he has made of materials so scanty. Every thing in the picture appears to feel the effect of the cold: the trees are shrivelled, the child is shrunk up, and all is familiar to our recollection, as perfectly [as] in nature.

In connection with *The deluge* the same critic re-quoted the lines from *Paradise Lost* that Turner had cited in the catalogue. He also asserted that 'This is a grand composition, and treated with that severity of manner which was demanded by the subject. The colouring, however, is not sufficiently attended to'. This last comment seems odd, for the work barely possesses any colour, and what little it does have seems wholly relevant to the horror that is intrinsic to the subject. But the reviewer for the *London Chronicle* of 8–10 May was far more positive, declaring *The deluge* to be a picture 'of very great merit, whether we consider it in its general tone and effect, or in its composition and mechanism'. He did, however, think that 'it does not give an adequate idea of space; it resembles a torrent, carrying destruction through a valley rather than a universal deluge', possibly because of 'the sloping lines on the left side of the picture'. Clearly he had not noticed the vast wall of water approaching from the right.

He was more enthusiastic about *Frosty morning*, which he discussed in relation to the range that Turner brought to landscape painting:

> Equally felicitous in depicting the most opposite appearances of nature, MR TURNER exacts the same homage from our feelings; whether with poetic enthusiasm he aggravates the horrors of the deluge with storm and whirlwind; whether he pours the glowing radiance of Italian skies on blooming vintages[33]; or, whether descending from the regions of beauty and sublimity, he presents us with the familiar image of an English frosty morning – so vividly is the impression of nature conveyed by this picture, that while surveying it we cannot avoid feeling all the sensations excited by the scene itself. – The white, but, at the same time, transparent hue of the atmosphere,[34] the glazed surface of the ground, the chilling appearance of the trees, and the herbage glittering and angular with frozen rime – whether considered individually, or in their general effect, are among the most animated imitations of nature we have ever witnessed in pictorial representation.

Equally enthusiastic about *Frosty morning* was the critic writing for the 28 May edition of the *Sun*, who was probably John Taylor:

> The precision as well as spirit with which this Artist represents nature, is universally acknowledged; and so far as the subject admits, this exactness and animation appear in the work before us. The colouring is in full accordance with the scene it represents, and the whole may be considered as a fine portrait of Nature.

And the critic writing for the 30 May issue of the *Examiner*, who was probably Robert Hunt (1773–c.1850), was enthusiastic about both of the 1813 exhibits:

> Mr TURNER's *Deluge*, defective as it is in that degree of neatness of execution and drawing, which is so agreeable, so spirited, and so universal in Nature, is an epic landscape that could have been produced only by a mind conversant with Nature's noblest features, and a hand obedient to the emotions they produce. Terror and pathos, the two main sources of the sublime, characterise it in the gradually water-subverting heights, the mistily seen objects behind, the impetuous and overwhelming rain, the general gloom contrasting with the lightning's glare in the clouds and on the astonished and dying groups, the unavailing exertions of the sufferers to save themselves and their families from the death-commissioned element, pouring on them from above, around, and

beneath, anticipating the slow and universal ravages of time. – His picture of a *Frosty Morning* has the identity of ground frost and atmosphere, in one of those winter mornings, when the gentle warmth of the sun begins to disrobe the earth of the fleecy covering thrown over it by the hand of winter; the light glittering through the picture, the mistily seen distance, the interspersion throughout of a warm yellow tinting on the unfrosted ground, and which beautifully qualify the grey passages, and the free though too unfinished touches, rank this picture among the nearest imitations of common Nature.

From the use of the word 'glittering' in both the *London Chronicle* and *Examiner* reviews, we can obtain some sense of what has perhaps been most diminished or lost in *Frosty morning*.

On Wednesday 5 May, and thus two days after the Royal Academy exhibition had opened to the public, Joseph Farington was visited by his nephew, Captain William Farington RN (1777–1868).[35] The latter was accompanied by his fiancée, Frances Ann Green. The couple wanted to visit Turner's Gallery. With the entrance ticket lent them by the naval captain's distinguished uncle, they presumably did so later that day or very soon afterwards. This visit proves that the show had been open for some days by that date.

Perhaps Turner personally conducted Captain Farington and his fiancée around his gallery on 5 May. In any event, that evening he attended another Royal Academy Club dinner. This time he was seated at one end of a long oval table between Callcott and the sculptor William Theed ARA (1764–1817), and with Henry Tresham in the Chair nearby.[36] Frustratingly, Farington was once again placed at a distance from Turner and so we have no idea what the latter talked about. However, as this was the first time the Club had met since the Somerset House exhibition had opened, it seems likely that the subject of Sir George Beaumont arose during the conversation between Turner and Callcott. Perhaps they drank a toast to the termination of his influence, or even to the demise of the man himself, so utterly did they both detest him.

28

An English Eden
May to December 1813

Today we take huge one-man retrospective exhibitions for granted but the gathering of 141 portraits by Sir Joshua Reynolds at the British Institution in 1813 was the first such show ever mounted; as the *Examiner* for 23 May stated, it represented 'a new circumstance in the history of the Arts'.[1] The private view and dinner held on Saturday 8 May was the arts event of the year, and Turner was one of thirty Academicians who participated. That attendance, along with his presence at dinners mounted before the Royal Academy Exhibition and by the Royal Academy Club on 1 and 5 May respectively, suggests he had fully regained his health by this time.

Farington and Constable visited the Turner Gallery on 24 May.[2] As had become customary by now, the diarist did not record what he saw, which would have proven particularly helpful this year. But Turner's father did tell him that he had walked the eleven or so miles from Solus Lodge up to town that very morning. Obviously, William was spending a fair amount of time in Twickenham, for Farington was also informed that during the previous week he had walked fifty miles in two days. This could suggest that he looked after the gallery for two days a week, his son did so at weekends, and perhaps Hannah kept an eye during the rest of the week. Moreover, the diary entry proves that Turner's storage area further along Queen Anne Street West lacked accommodation, for otherwise his father could have stayed there while performing his duties as gallery attendant.

By 9 June, W. B. Cooke had returned to London from Cornwall where the mild winter air had greatly improved his health. Probably he had been suffering from a respiratory ailment. In a letter, he now informed John Murray of his return, explained why he had been away, and stated that with his brother's assistance he intended to make up for lost time on the 'Southern Coast' project.[3] Hopefully this would allow him to publish its first part in January 1814. He also asked Murray to pass on his intentions to all concerned, including Turner. This letter explains the hiatus that had occurred between the artist making his first drawings for the scheme in the autumn of 1811 and the publication of their reproductions more than two years later.

We catch rare sightings of Turner in June: attendance at a Royal Academy Club dinner on the 2nd of the month, and the acquisition of stock worth £260 on the 16th, probably with money that derived from the sale to Lord Egremont of the *Narcissus and Echo* oil that had been exhibited at the Royal Academy in 1804, and again at the British Institution in 1806.[4] It seems very likely that the picture had been included in the 1813 Turner Gallery exhibition. That would explain its sale so many years after it had been painted and last shown.

On 28 June Turner participated in a General Assembly meeting, followed by the king's birthday dinner, at which he was seated next to John Constable (fig. 424). Two days later the latter wrote to his future wife, Maria Bicknell (1788–1828): 'I was a good deal entertained

Detail of fig. 425.

424 John Constable, *Self-portrait*, c.1799–1804, pencil and black chalk heightened with white and red chalk, 9¾ × 7⅝ (24.8 × 19.4), National Portrait Gallery, London.

with Turner. I always expected to find him what I did – he is uncouth but has a wonderfull range of mind.'⁵ Clearly, Constable used the word 'uncouth' to signify 'awkward in language, style and manners'. But how we would love to know what was discussed.

Possibly Constable related having been told by his friend John Fisher, the Bishop of Salisbury (1748–1825), that one of the two landscapes he still had hanging on the walls of Somerset House had only been 'surpassed by Turner's Frost',⁶ and that – by way of reference to Napoleon's recent defeat by the Russian winter – he should not fret, because he was 'a great man like Bounaparte & ... [was] only beaten by a Frost'.⁷ Undoubtedly Turner would have relished such a jest, even if he took a somewhat less positive view of Con-

stable's abilities in the landscape department than did the bishop, let alone the Suffolk-born painter himself.

On 21 July 1813, Turner's Bank of England worth totalled £9,299-18s-1d, for between 17 August 1810 and 21 July 1813 he had earned £2,887-1s-11d.⁸ It might be thought that an increase in wealth of just over £2,800 in almost three years was disappointing, and that it reflected the impact that Sir George Beaumont's constant carping had exercised upon Turner's sales.⁹ Yet an average annual income of just over £962 during the three or so years after August 1810 was extremely good indeed, given that the ordinary working man of the day would only have earned about £26 a year. And these earnings prove that the painter did not really need the Royal Academy in order to flourish, for he remained well beyond the financial reach of his most uncomprehending and persistent critic. But because of Beaumont's negativity and the injurious effect he was having upon the visual arts in general, he did remain a perpetual annoyance to Turner, Callcott and several other painters, as he did to a number of discerning collectors and patrons of the arts. Sooner or later someone would have to cut him down to size. It only remained a matter of when they would do so, and who would actually wield the knife.

On Saturday 24 July, seventeen people – who included William F. Wells, members of his family and Turner – undertook an excursion in a four-oared rowing boat from London to Richmond.¹⁰ Six young men in the party shared all the rowing between them. According to one participant, the friends and acquaintances 'dined in a beautiful part of Ham meadows upon half-made hay, under the shade of a group of elms near the river, & had coffee and tea at Turner's new house'.¹¹ Showing off what may well have been his hitherto unsuspected architectural talents was perhaps the Royal Academician's hidden motive for inviting everyone back to Solus Lodge. It is also possible that memories of the al fresco dinner would make their way into a watercolour of nearby Richmond Hill and Bridge 'with a Pic Nic Party' that Turner would elaborate for the 'England and Wales' series around 1829.¹²

Plymouth and Its Environs, 1813

Probably on the following Saturday, 31 July 1813, Turner set off for Plymouth.¹³ The entire trip appears to have lasted a day under six weeks. Just three sketchbooks were in use during that time.¹⁴ In and around Plymouth, Turner was principally afforded accommodation by the solicitor George Eastlake senior (1759–1820), who very likely had been his host during the 1811 visit; by the immensely wealthy Quaker and Whig wine merchant, shipping agent and vice-consul for Portugal, Norway and Sweden, John Collier (1769–1849); by the

painter Ambrose Bowden Johns, whom he had also met in Plymouth in 1811; and by the newspaper editor, wine connoisseur and later writer on the subject, Cyrus Redding (1785–1870).[15]

The stay fell into four distinct phases. The first was spent in Plymouth itself and almost certainly it lasted from Sunday 1 August until Thursday 12 August. Initially, Turner lodged with George Eastlake senior, and perhaps did so for six nights, before residing with Collier for five more. From one or both of their houses, and occasionally with Collier and Redding by his side, he roamed all over the Plymouth area by foot or in boats, with both the vessels and their hands provided by his hosts.

Possibly on 8 or 9 August, Turner and Redding spent an entire day following the windings of the river Tamar up to its highest tidal and navigable point at Weir Head, about eleven miles north of Plymouth, with the painter stopping to sketch all the way. By the time they arrived it was getting dark, and they could not take a boat back to Plymouth due to the danger of running aground on mudbanks during the night.[16] Instead, they elected to spend the night in a 'miserable little inn' about a mile upriver in Gunnislake Newbridge. According to Redding, that evening Turner talked 'with a fluency I never heard from [him] before or afterwards'.[17] How one wishes the journalist had made notes. Due to the fact that all the beds were taken, they had to sleep on chairs in the bar after a simple supper. They went to sleep shortly after midnight. Up before six, they made their way 'down towards the bridge' at Gunnislake. There they found the sunlight strong, the air balmy, the shade cast by trees rich and velvety, and the water brilliant. As Redding recalled, 'Turner sketched the bridge, but appeared, from changing his position several times, as if he had tried more than one sketch, or could not please himself as to the best point.'[18] Eventually the two of them went back to the inn for breakfast before returning to Plymouth. Yet because Turner had not been able to obtain a view of the bridge at Gunnislake that he sensed would prove useful in some further capacity, within a day or two he engineered a return to it, in what would constitute the second phase of his 1813 Plymouth stay.

This further visit probably took place between Thursday 12 August and Monday 16 August. It came about through the offices of Charles Lock Eastlake, who had returned from London to Plymouth at the behest of his parents in January 1813, following the death of a brother. Currently, he was supporting himself by painting portraits, an activity that now enabled him to spend time with Turner. Eastlake recalled accompanying Turner and Johns 'to a cottage near Calstock, the residence of my aunt, Miss Pearce, where we all stayed for a few days. From that point as a centre, Turner made various excursions, and the result of one of those rambles was a sketch of the scene which afterwards grew into the celebrated picture of "Crossing the Brook".'[19] The 'celebrated picture' was a large oil that would be exhibited at the Royal Academy in 1815. By means of his return visit, Turner had at last been able to find the impressive panorama he had been seeking just a few days earlier. His failure to do so on his first foray had clearly resulted from having gone '*down* towards the bridge' at Gunnislake when with Redding. On this second excursion he walked a good distance upstream from that structure, and so was able to sketch it from much higher ground.[20] On other rambles almost certainly undertaken in 1813, Turner visited Buckland Abbey, the home of the Elizabethan courtier and seafarer Sir Francis Drake (1540–1596); industrial buildings south of Gunnislake Newbridge; and local mine workings. The entrance to one of the mines would make its way into *Crossing the brook*, although arguably in a somewhat less mundane guise.

The third phase of the 1813 stay appears to have taken up the rest of that week, from Monday 16 until Friday 20 August. The likeliest scenario is that Turner resided all but the Thursday night with Ambrose Johns in North Hill Cottage at Mutley, a little beyond the northern edge of Plymouth. Early on the Thursday, both he and Johns could have walked or ridden over to George Eastlake's country residence near Plympton, from where they undertook a day-long sketching ramble before spending the night back in the Plympton house. Additionally, Turner and Johns may have stayed on the Saturday night with Collier at Mount Tamar, the wine merchant's country retreat some nine miles north of Plymouth.

It was undoubtedly during this third phase of the Plymouth sojourn that Turner sketched in oils out of doors. As Eastlake recalled:

> Mr Johns fitted up a small portable painting-box, containing some prepared paper for oil sketches, as well as the other necessary materials. When Turner halted at a scene and seemed inclined to sketch it, Johns produced the inviting box, and the great artist, finding everything ready to his hand, immediately began to work. As he sometimes wanted assistance in the use of the box, the presence of Johns was indispensable, and after a few days he made his oil sketches freely ...[21]

Sixteen oil sketches of Plymouth and its surroundings have come down to us.[22] As Eastlake also remembered, Turner 'himself remarked that one of the sketches (and perhaps the best) was done in less than half an hour'. Yet even if all the others took twice as long, they could easily have been painted at a rate of four or five a day. Redding never saw Turner make any of them, for they were solely painted on excursions undertaken during the six days in which the Royal Academician stayed with Johns, with the same companion at George Eastlake's country house near Plympton, and possibly with Johns at Mount Tamar too. A depiction of Plymouth in late afternoon light reproduced here (fig. 425) shows the view not far from Mutley looking in a south-westerly direction. Of all the 1813 *plein-air* oil

425 *View over Plymouth Harbour*, 1813, oil on prepared paper, 6 × 9³⁄₁₆ (15.2 × 23.3), Sterling and Francine Clark Art Institute, Williamstown, Mass., Gift of the Manton Art Foundation.

sketches, it arguably provides the most arresting view of Plymouth. Perhaps it was the one remembered by Eastlake as constituting the 'best' of them.

On Sunday 22 August or thereabouts Turner moved on to stay with Cyrus Redding, also in Mutley. He appears to have been Redding's guest for a day under three weeks in what constituted the fourth and final phase of his trip. From Mutley the two men undertook a number of excursions. During one of them Redding commented upon the remarkable number of artists the West of England had produced, from Reynolds to Samuel Prout (1783–1852). 'You may add my name to the list,' said Turner, '[for] I am a Devonshire man.' Upon being asked what part of the county he hailed from, he replied 'from Barnstaple'.[23] The journalist chose to take this literally.

Turner's evident pride in being associated with Devonshire might have arisen not only from his father's connection with the county but also from a desire to link himself with Reynolds.

Late one summer's evening, after 'the sun had set and the shadows become very deep' but a little light still gleamed in the west, Redding was with Turner on the banks of the Tamar when the Royal Academician entered into conversation with the Anglo-Italian artist James de Maria (1771–1851).[24] By profession a theatrical scene-painter who equally specialised in the decoration of theatre interiors, de Maria had just adorned the interior of the magnificent New Theatre Royal in George Street, Plymouth, which had opened on 23 August. He asserted that an artist should paint everything he knew to be before him, while Turner maintained that only what could be

seen should be depicted. To prove this, he indicated a nearby man-of-war and stated that after sunset, under the hills, the portholes were not discernible. De Maria was forced to concede the point, stating: 'Yes, I see that is the truth, and yet the ports are there.' Turner replied, 'We can take only what we see, no matter what is there. There are people in the ship – we don't see them through the planks.'[25] And to prove his point even further, possibly within a day or two he made a watercolour showing the hulks of two men-of-war simply as dark forms in the gloaming.[26]

On Thursday 26 August, Turner attended a dinner given by Charles Lock Eastlake's oldest brother, William (1779–1845). The Academician told the company that he might occasionally reside in Plymouth, so strongly did he admire its surroundings.[27] Perhaps it was also on this occasion that he remarked to Redding that 'he had never seen so many natural beauties in so limited an extent of country as he saw in the vicinity of Plymouth. Some of the scenes hardly appeared to belong to this island'.[28] And he again expressed that appreciation at a breakfast held on 1 September, when he showed his fellow guests 'all his sketches'.[29] The works in question might have been his oil sketches, which would have dried by now.

Two days later, Turner, Redding, de Maria, Collier and two other men took an undecked 'Dutch boat, a famous seagoing craft' on an excursion to Burgh Island in Bigbury Bay, about twelve miles by land to the south-east of Plymouth but much further by sea, especially in the prevailing stormy weather.[30] On the way Turner was hugely stimulated by the sight of a large rock, the Great Mew Stone, that he would depict in one of the most vivid of the images he would soon create for the 'Southern Coast' series (National Gallery of Ireland, Dublin).

By the time the boat was off Stoke's Point, a little over four nautical miles to the east of the Mew Stone, the sea had become much stormier, with large waves rolling in from the Atlantic. The vessel mounted these well, but de Maria was very seasick, as was another member of the party who had to be physically restrained in the bottom of the boat from jumping overboard due to his nausea. Turner, on the other hand, lodged himself in the stern and was not at all affected by the motion: '[He] looked on with the most artistic watchfulness. When we were on the crest of a wave, he now and then articulated to myself – for we were sitting side by side – "That's fine! – fine!"...Turner sat watching the waves and the headlands, "like Atlas, unremoved".'[31] Finally, the boat reached Burgh Island. There Turner and the others clambered ashore, and eventually they all enjoyed a fine lunch of lobsters washed down with wine or, in the painter's case, with the 'vulgar porter' he usually preferred. By the time the meal had ended, evening was coming on, and because the sea had grown even rougher, it was apparent that it would take the best part of the night to return to Plymouth by boat. Accordingly, all of the passengers decided to spend the night in Kingsbridge, about seven miles to the north-east.

Before breakfast the next morning, Turner and Redding strolled over to Dodbrook, a hamlet that was then separate from Kingsbridge. They did so in order to view the birthplace of the immensely popular satirist and humorous writer John Wolcot (1738–1819), who wrote under the pseudonym of 'Peter Pindar'. In 1808 Wolcot had written *One more peep at the Royal Academy; or, Odes to academicians*. This had praised Turner's landscapes and declared that although Nature had not given the artist a giant body, it had granted him a giant brain. Moreover, Wolcot had also compared Turner to the most celebrated racehorse of the age, Eclipse. This had led the field so consistently and by such immense distances during the three racing seasons between 1769 and 1771 that it had virtually put an end to competitive racing in Britain.[32] Given such commendations, it is entirely unsurprising that Turner should have wanted to see Wolcot's birthplace, and also sketched it.

Subsequently, Turner and Redding rejoined the others in Kingsbridge, before walking back to Plymouth with de Maria. As the journalist commented, 'Turner was a good pedestrian, capable of roughing it, in any mode the occasion might demand.'[33] And when the trio arrived at the ferry point on the eastern bank of the Laira – as the mouth of the river Plym is also known – they then had the good fortune to bump into the Whig politician, the 2nd Lord Boringdon (1772–1840). At the time, he was engaged in embanking the Laira, as well as developing some adjacent land on its eastern side for use as a racecourse that remains there to this day. Possibly that is why he was present by the riverside that afternoon. He promptly invited all three of them to dine the following evening, Sunday 5 September, at his country seat, Saltram House, about a mile to the north-east, and to spend the night there.[34] The reason he was so welcoming is clear: he wanted to show them off to a very special guest, and to dazzle them in turn.

The visitor in question was arguably the foremost bravura singer of the day, the Italian soprano Angelica Catalani (1780–1849, fig. 426), who in 1813 was at the height of her powers.[35] Naturally, Lord Boringdon's invitation was instantly accepted. According to Redding, Madame Catalani 'sang some of her favourite airs' at her Sunday evening concert. The use of the word 'some' – rather than 'many' – may indicate that she charged Lord Boringdon the staggering sum of a hundred pounds per song, as was her wont; probably he could afford no more.[36] But it was certainly a feather in the aristocrat's cap to be able to seat an outstanding Royal Academician, a renowned theatrical designer and scene-painter, and the editor of an important regional and local newspaper immediately in front of her. Clearly, that was why they had been invited with such alacrity.

426 Lewis Alexander Goblet, *Angelica Catalani*, 1820, marble bust, height 19 inches (48.3), National Portrait Gallery, London.

The next morning Turner, de Maria and Redding wandered across the Saltram estate to take in the view to the east, with Turner sketching a number of vistas. And it was probably on that Monday afternoon that Redding took the Royal Academician by horse-drawn gig to Cotehele, an early fourteenth-century house that stands on a hill on the western, Cornish side of the Tamar valley just south of Calstock. Turner was not particularly interested in the house, but the woods and the views from some of the headlands of the river Tamar were another matter. He stalked off to undertake some sketching, followed by Redding in his vehicle. Eventually, however, they managed to get the gig trapped in a very narrow cul-de-sac, from which they could only escape by unhitching the horse, coaxing it over the hedge that barred their way, and lifting the vehicle 'by main strength' after it. They then clambered over the barrier themselves. Redding recalled what happened next: 'upon the hedge, there burst upon the view a noble expanse of scenery, which we had not anticipated. Here the artist became busy at once, but only for a short time. He had taken down all that he desired in ten minutes. "Now," said he, "we shall see nothing finer than this if we stay till sun-down; because we can't, let us go home".'[37] The two men undertook their final excursion the next day. This was to Sheep's Tor, an imposing granite outcrop on the edge of Dartmoor about ten miles to the north-east of Plymouth.[38] That trip 'closed nearly three weeks, for the most part spent in similar rambles'.[39]

Understandably, Turner wanted to demonstrate his gratitude to his Plymouth hosts, friends and acquaintances. To that end he engaged a caterer to lay on a picnic on Mount Edgcumbe, the country park on the western side of Plymouth Sound. This outing probably took place on what was apparently his last full day in Plymouth. There were eight or nine members of the party, including some ladies. The food was accompanied by wine. As Redding recalled,

> In that delightful spot we spent the best part of a beautiful summer's day. Never was there more social pleasure partaken by any party in that English Eden. Turner was exceedingly agreeable for one whose language was more epigrammatic and terse than complimentary upon most occasions... He showed the ladies some of his sketches in oil, which he had brought with him, perhaps to verify them. The wine circulated freely, and the remembrance was not obliterated from Turner's mind long years afterwards.[40]

Turner must have felt very relaxed to have shown oil sketches he would never otherwise exhibit. Probably he wanted to demonstrate that works praised by Johns, Eastlake, Redding and others were as good as had been claimed. After all, short of visiting London, many of his Plymouth acquaintances were not going to see any other pictures by him this year, old or new. Moreover, they might never again see a Turner oil painting in the flesh either.

The 1813 picnic again puts paid to the notion of Turner the tightwad, for a time at least. And as Redding was able to testify further, the painter 'accommodated himself [where the paying for food and drink was concerned] as well as any man I ever saw'.[41] Of course he could be very money-grubbing and penny-pinching, but he also had a fine sense of reciprocity when needs be, especially with people in whose company he felt completely at ease. Clearly his admirers in Plymouth brought out the best in him, as did the place itself.

Redding observed that 'gold lay beneath the rough soil' of Turner's character.[42] He was particularly impressed by his 'powerful intellect, a reflective mind that lived within itself, and a faculty of vision that penetrated to the sources of nature's ever-varying aspects', as well as 'the most extraordinary memory for treasuring up the details of what he saw in nature of any individual that ever existed'.[43] Above all,

Redding noted that Turner's 'mind lived in his art; he did not wish to appear other than he was'.

Turner probably quit Plymouth very early on Thursday 9 September by the Royal Devonshire stagecoach.[44] If that was the case, then he could have arrived home by early evening on the Friday. All in all, the stay in Plymouth had been exceptionally invigorating. It is unsurprising that the memory of it would remain in his mind for 'long years afterwards'. On the Tuesday after his return he wrote to thank Johns and his wife for their hospitality. By way of reward for the considerable assistance he had been given with the oil sketching in Plymouth, he enclosed a view of some trees he had just painted down in Twickenham. Almost certainly it was in oils on paper.[45] Sadly, it has long since vanished.

Not long after returning to London the painter travelled to Highgate, about four miles north of the metropolis. He did so in order to sketch a viaduct designed by the architect John Nash (1752–1835).[46] This was constructed to carry traffic over a new toll section of the Great North Road as it cut through Highgate Hill. Turner had been in Devon when the bridge had opened on 21 August, which is why he drew it in a sketchbook used down in Plymouth.[47]

On 19 October Turner sold £200 of Reduced £3% Annuities.[48] It is not known why he did so. But that is not the only mystery of this time. Possibly during this period, he also wrote out a 'A Cure for Gonorrhoea'[49] that derived from *A Complete Treatise on the Origin, Theory, and Cure of the Lues Venera* by the surgeon and biographer Jesse Foot (1744–1826), which had been published in London in 1792.[50] The remedy is extremely toxic because it involves the intake of vitriol or sulphuric acid, which is highly caustic, even in somewhat weakened solutions and chemically altered states. That makes it unlikely that Turner wrote down the cure because he had contracted the disease himself. Nor can any of the illnesses he suffered between 1808 and 1814 be connected with sexual transmission.

Perhaps he copied it out on behalf of his father. After all, William Turner had been a barber who had worked in the Covent Garden area, with its numerous brothels, prostitutes and clients. He might therefore well have gained considerable experience in treating men and women infected with gonorrhoea. By the early nineteenth century barbers had long been synonymous with healers, if not even with doctors. That is why the treatment of medical conditions that were considered to be shameful – and which consequently required a modicum of secrecy – often formed part of their duties. Perhaps William had not used the formulation for some years and forgotten it, which is why his son researched it. But we shall probably never know why Turner wrote down the cure, exactly when he did so, or for whom it was intended.

It may have been on the day after attending a 1 November General Assembly meeting that Turner quit London again for his annual visit to Farnley Hall. This could have lasted for almost four weeks, from 3 until 30 November. That was about the amount of time he had spent at Farnley in previous years. We know nothing of his movements or actions in the house this year but from his very presence there it appears unlikely that anyone suspected that Walter Fawkes's wife, Maria, would die on 10 December, of causes now lost to us.

Having failed to deliver the perspective lectures for almost two years, Turner needed to get his manuscripts back in order, prior to the resumption of those talks on the first Monday in January. Possibly he did so at Farnley this year. A fellow guest may have been Sir William Pilkington (1775–1850), to whom Fawkes was related by marriage and who had commissioned a view of Scarborough from Turner back in 1809. If Pilkington did stay in the house and go shooting alongside the artist in November 1813, then that activity may have led him to commission identically sized watercolours of woodcock and grouse shooting.[51] Both works could well have been made during this stay at Farnley, and fortunately they have remained together (Wallace Collection, London).

Perhaps on Wednesday 24 November, Turner wrote to W. B. Cooke advising him that he would be leaving Farnley Hall the following Tuesday, 30 November, and that he would not be back at Queen Anne Street West until 8 December or thereabouts.[52] As it transpired, he would miss a General Assembly meeting on 10 December, so possibly his planned trip lasted longer than expected. But where could he have gone in the interim?

Petworth House might supply the answer. This is because the picture that Turner was painting for the British Institution Premiums competition – and which he therefore needed to complete by early in January – would bear an uncanny resemblance to the large *Landscape with Jacob, Laban and his daughters* by Claude le Lorrain that hung in Lord Egremont's country seat (see fig. 427). As will emerge presently, Turner was planning to score a cultural point off the British Institution by making his new painting look very like the Claude. However, he had not set eyes on that picture since 1809. Although it had been reproduced very crudely in mezzotint and sepia-coloured ink in the Earlom *Liber Veritatis* (as well as in black and white but reversed form in two other prints),[53] he badly needed to refresh his memory of the detailing, composition, colour, tonalities and brushwork of the original Claude painting. In order to do that he needed to revisit Petworth.

Lord Egremont would hardly have objected to Turner visiting the house, and it may well be that by 1813 Turner anyway possessed an open invitation to go there (for, after all, the nobleman had acquired a comparatively large number of his oils by now).[54] During the

nine-day period between 30 November and 8 December, it would have been very easy to travel from Farnley to Petworth in three days, spend another three days at the Sussex house looking at the Claude, and then return to London in a day (although if Turner stayed at Petworth for five days, that would explain why he missed the 10 December General Assembly meeting). Yet if this is what happened but in the course of things the painter failed to reveal to Lord Egremont that his true motive for wanting to scrutinise the Claude was to mount an attack upon values held dear by the British Institution, with which the nobleman was officially connected, then that could explain why tension would soon arise between the two men, as will emerge shortly.

The letter that Turner wrote to W. B. Cooke from Farnley Hall, possibly on 24 November, followed the posting to the engraver of a corrected proof of the 'Southern Coast' series print of St Michael's Mount. In his communication, Turner lamented that George Cooke and his printer had not been equally expeditious in forwarding proofs of the view of Poole in Dorset made for the part-work. But Cooke was beginning to feel pressurised by now, for he had recently learned that the illness that had caused him to delay the publication of the first part of the 'Southern Coast' scheme had permitted a rival project to emerge.

This was 'A Voyage Round Great Britain' by William Daniell (1769–1837), which had been conceived when the deferment of the 'Southern Coast' series had become known within engraving circles. Like the Cookes, Daniell also aimed to produce a multipart survey of the entire coastline of Great Britain, although his publication would comprise a set of coloured aquatints. Understandably, colour would lend his work a commercial edge over the 'Southern Coast' series, which would only consist of monochrome images. Daniell planned to issue the first part of his scheme on 10 December 1813. By this means, it would both appear before the 'Southern Coast' series – for the Cooke brothers had announced that the initial part of their venture would come out on 1 January 1814 – and hopefully capture the Christmas market.

W. B. Cooke believed that the appearance of the rival work would lead to the failure of his own project. However, Turner had more faith in the power of his images to make the 'Southern Coast' series successful, for he was well aware of the limitations of Daniell's art from having seen many examples of it in the Royal Academy exhibitions. Accordingly, in his November letter to Cooke he not only stated that it would be physically impossible to bring out the first part of the 'Southern Coast' series on 10 December, but he also asked what difference it would make if it did appear on that date. To him the commercial viability of the two schemes would hardly be decided in a matter of days, or even weeks. And he would be proved right, for such would be the public enthusiasm for both projects that each of them would become successful, the Daniell because it had colour, the Cooke because it had Turner.

On Saturday 4 December, Turner again wrote to W. B. Cooke, although from an unknown address.[55] On this occasion he not only clarified further matters relating to the proofs of the St Michael's Mount and Poole engravings, but also expressed his resignation to the fact that his verse accompaniments to the prints were not going to be used. The suppression of his poetic text had been decided by Cooke the previous day,[56] with the full backing of the editor he had employed to polish Turner's verses.

This was the hack writer, satirical poet, government propagandist, freelance editor and persistent debtor, William Combe (1741–1823). Between 1809 and 1811 Combe had enjoyed great success with *The Tour of Dr Syntax in search of the Picturesque*, a verse satire that had appeared with illustrations by Thomas Rowlandson in the monthly *Repository of Arts*. It had also sold well in book form in 1812. Combe was therefore very much a man of the moment. But although his verse was little better than doggerel, at least it was easily comprehensible doggerel. The same could hardly be said of Turner's efforts.

Combe had tried his editorial best with the verses that were to accompany the St Michael's Mount engraving but found them 'extraordinarily' bad, being defectively punctuated and in many places utterly incomprehensible. Yet before he had a chance to complain to Cooke, the engraver had anyway decided not to use Turner's poem. Given the closeness of the deadline, Combe was therefore forced to write the entire letterpress himself. This he did entirely in prose. Assuming that Turner would be driven 'stark, staring mad' by the refusal to use his poetry, Combe urged Cooke to try and fool the painter into thinking that his verses would be used, but the engraver was too astute for that. Instead, he simply made Turner face up to reality. Probably he achieved that by pointing out the potentially disastrous economic consequences of using his poetry, as well as the imbalance that would be caused if Turner's images were to be accompanied by verses and all the remaining designs by prose texts written by others. Undoubtedly the difference would have looked odd, to say the least. Turner was man enough to accept the truth. Accordingly, he asked Cooke to send him any proof sheets of the poetic accompaniment to the Poole engraving that had been already typeset, or to destroy them.[57] Probably the engraver adopted the latter course of action.

Combe must have been relieved at this resolution of what could have been a very difficult situation. In addition to writing the letterpress for the St Michael's Mount engraving, he would go on to pen the literary accompaniments to all the other 'Southern Coast' prints until his death in 1823. Naturally, they too would be in prose. After his demise, the task would fall to Mrs Barbara Hofland (1770–

1844). A novelist, poet and writer of moralistic children's stories, she was married to the painter Thomas Christopher Hofland (1777–1843) whose name will surface again in the Turner story.

This year, unusually foggy weather during the Christmas and New Year period rendered the already short amount of winter daylight far dimmer than usual. As a consequence, many artists in London who needed to labour over their works were prevented from doing so. Because Turner was endeavouring to complete the relatively large canvas he planned to submit to the British Institution Premiums competition in January, he must have suffered too. Yet he persisted, quite simply because he felt sufficiently annoyed by a particular aspect of the rival organisation to the Royal Academy to keep on working upon the painting with his usual avidity, no matter how deeply his studio became enveloped in gloom.

29

'The Eye Wanders Entranced'

January to November 1814

Turner was due to give his first 1814 perspective talk at 8 p.m. on Monday 3 January. However, that was not to be, for he left the portfolio containing all of his lecturing materials in the hackney cab that conveyed him to Somerset House.[1] Fortunately, Henry Fuseli (see fig. 397), who probably chaired the proceedings, was able to step into the breach almost immediately. This was due to the fact that in his role as Keeper of the Royal Academy, he possessed an apartment in Somerset House wherein his well-worn lecture notes as Professor of Painting were stored. It could only have taken him a few minutes to retrieve the text of his first talk, which he had been due to give the following Thursday anyway.

Turner was able to deliver his initial talk on the succeeding Monday, 10 January,[2] not only because he had advertised for the return of his portfolio in the *Morning Chronicle* two days after his loss,[3] but equally because the honest soul who had found it had also arranged for his own appeal to appear in the same newspaper a day later. Turner cannot have been too amused to see the finder's advertisement describe the contents of his portfolio as being 'waste paper ... of little value', but doubtless his chagrin was ameliorated by relief at its return.

By early January the continuing bad light due to thick fog had led some of the artists who intended to compete in the forthcoming British Institution Premiums competition to write a joint letter to the directors asking if the submission date of 4 January could be pushed back by ten days in order for them to complete their entries. They were given a private assurance that the date could be moved, and granted official permission to work longer on their entries at a meeting of the organisation's directors held two days after the deadline had passed.[4] The governing body now set Friday 14 January as the final submission date for the particular artists concerned. If Turner learned of that extension, he did not request one for himself, for probably he had already decided to miss the deadline anyway.

It must be doubted that the 1814 series of perspective lectures differed much from the one of two years earlier, if at all. This is because, although Turner had enjoyed two years in which to change them, the illness that had prevented him from giving them in 1813 had also probably stopped him from painting as much as he would have liked. As a consequence, he would have felt the need to catch up in his studio throughout the best part of 1813, especially as more than a month of that year was taken up by the Plymouth trip. And then there was the harsh winter and poor light of 1813–14, which also cut down on his painting time. Rather than freeing him to revise his talks, the murk could well have produced an impatience and fracturing of studio effort that would surely have worked against the peace of mind and concentration needed for a wholesale revision of the lectures.

Because of the bad weather in the first part of 1814, probably the audiences for the perspective talks were thin. If Fuseli was forced to

Detail of fig. 430.

427 Claude le Lorrain, *Landscape with Jacob, Laban and his daughters*, signed and dated 1654, oil on canvas, 56½ × 99 (143.5 × 251.5), National Trust, Petworth House, Sussex.

chair Turner's lectures repeatedly, as had certainly happened in 1812, then he was not particularly thrilled at the prospect. He made that apparent by groaning, grunting, frequently saying 'damn', closing his eyes and often twisting his hands immediately in front of the Professor of Perspective as the latter 'boggled at every second sentence'.[5] Turner must have been used to Fuseli's eccentricities, for the Professor of Painting and Keeper was renowned for them. Still, it was somewhat off-putting to have annoyance and frustration expressed quite so openly just under one's nose.

On Saturday 15 January Turner sent off his single submission to the British Institution's annual exhibition. Nominally at least, the canvas doubled as his entry for the Premiums competition. It was accompanied by a covering letter bearing the previous day's date.[6] Addressed to John Young (1755–1825), a mezzotint engraver who had succeeded Valentine Green ARA (1739–1813) as the Keeper of the British Institution after the latter's death the previous year, it advised that the entry was entitled 'Apullia in search of Appullus', gave its framed size and priced it at 850 guineas. This was by far the highest amount Turner had ever asked for one of his works. Like his (supposed) rivals, he would have to wait until 28 March before learning of his fate in the competition.

The 1814 British Institution Exhibition
THURSDAY 3 FEBRUARY TO EARLY APRIL

Turner's new offering was hung in the South Room of 52 Pall Mall, just like his submissions to previous shows there. The painting in question was *Apullia in search of Appullus vide Ovid's Metamorph[oses]* (fig. 428). Its subject had been taken from Book XIV of Ovid's *Metamorphoses* in a translation by Sir Samuel Garth FRS (1661–1719) that was included in the seventh volume of Anderson's *Complete Poets*. A shepherd from Apulia in southern Italy – who singularly in Garth's version is named Appulus – mocks a group of dancing

428 *Apullia in search of Appullus vide Ovid's Metamorph[oses]*, B.I. 1814 (168), oil on canvas, 57½ × 93⅞ (146 × 238.5), Tate Britain, London.

nymphs by verbally insulting them and by jumping around in clumsy imitation of their movements. As a punishment, he is transformed by the gods into a wild olive tree. To this day 'the shrub the coarseness of the clown retains', to quote Ovid and Garth. Any bitterness in the taste of an olive supposedly serves to remind us of the shepherd's ugly mockery and grim fate.

Apullia in search of Appullus bears an extremely close resemblance to the *Landscape with Jacob, Laban and his daughters* by Claude le Lorrain (fig. 427) which Turner had first viewed at Petworth in 1809 and possibly seen there again in December 1813, as suggested above. Although it has been claimed that he had painted his work in the style of a Claude because the British Institution Premiums competition regulations stipulated that entries should be 'proper in point of Subject and Manner to be a companion' to an Old Master, 'preferably Claude or Poussin',[7] the British Institution Minutes demonstrate that the second part of this sentence pertaining to the two French landscape painters is incorrect (and the first stipulation had anyway been dropped in 1808).[8] Unfortunately, a wrong assumption by Finberg has led to the mistake being endlessly repeated in the literature.[9]

In order to understand *Apullia in search of Appullus*, we need to understand Claude's *Landscape with Jacob, Laban and his daughters*, for clearly Turner did so. Claude had taken his subject from Genesis, 29:15–20. Jacob served Laban for seven years in return for the promised hand of Rachel, Laban's younger daughter. However, because Laban did not wish to marry off his younger daughter before his elder one, after that period of service had lapsed – and by means of a ruse the Bible does not explain – he instead contrived to marry Jacob to his elder daughter, Leah. Claude imagined that the deception had been wrought by means of veils. That is why he gave us

Leah standing between her husband and her father with her veil raised, and with Rachel just lifting her veil to the right.

In *Apullus in search of Appullus* Turner took what was, for him, the almost unique step of adding an explanatory inscription to an oil painting. It appears at the lower-left and reads: 'Appulia in search of Appulus/hears from the Swain the cause of his Metamorphosis.' From this, we can gather that the wild olive tree above the inscription represents Appulus *after* his transformation, with the tree still retaining the power of speech. To strengthen the link between olive tree and insolent shepherd, a young man at the foot of the tree traces out the name of 'Appulus' scratched on its trunk. At the base of the tree, a rustic assumes the traditional pose for the denotion of grief by resting his head on one of his hands. Clearly, he externalises the feelings of Appulus at the misfortune that has befallen him.

The girl throwing off her veil immediately next to the nymph who is dancing amid the figures to the right of the tree is Apullia. A rustic seated nearby points to the tree, thereby drawing the attention of Apullia to the fate of her beloved. Apullia is a figure of Turner's devising, for she does not exist in Ovid's poem. The close similarity of her name to that of Appulus identifies her as his beloved, as does the use of the word 'Swain' or rustic lover in the inscription. The similarity of names could conceivably have derived from those of the lovers Papageno and Papagena, and of Tamino and Pamina, in Mozart's opera *Die Zauberflöte* (*The Magic Flute*), which Turner might have seen in 1811, when it had been sung in London in Italian, as related above.

In the intense similarity of *Apullia in search of Appullus* to Claude's *Landscape with Jacob, Laban and his daughters* resided the principal reason Turner entered his painting into the Premiums competition in 1814. He wanted to impart a lesson concerning the perils of imitation as promoted by the British Institution, and to do so in a way that harked back to the original point of its Premiums competitions.

In 1807 the British Institution had borrowed a small number of Old Master paintings from its governors, directors, leading members and supporters. It had then set all the entrants in the competitions the task of attempting to match them, while expecting its students to do so as well, albeit on a less exalted level, both artistically and technically. In subsequent years it had continued to borrow Old Master paintings for the same teaching purposes. Straight copying was not allowed; only a more general stylistic approximation or imitation was permitted. But because it was encouraged, such imitation flourished.

Sadly, it was usually of a very low standard, for not only were virtually none of the noblemen and gentlemen in charge of the British Institution able to teach drawing and painting themselves, but in the main those who availed themselves of the opportunities to imitate Old Master pictures in the British Gallery were either artists who were insufficiently talented to get their works into the Royal Academy exhibitions, or students who were unable to obtain entry to the Royal Academy Schools. They were also surrounded by hordes of amateurs, for unlike the Royal Academy Schools, the British Institution did not possess a discriminating admissions procedure that vetted applicants to its classes. The prevailing attitude was 'anything goes', and consequently it did not go very far.

In this context, Apullia removes her veil. Unlike Rachel's veil which had prevented Jacob from discerning the truth, Apullia's veil has merely kept the truth from herself: she has fallen for a fool and paid the price for it. And Turner equally wanted to lift some veils, for those encouraged by the British Institution to imitate the Old Masters were also deluding themselves. This is because true imitation – of the kind made apparent by *Apullia in search of Appullus* – entails original thinking, a thorough understanding of form and colour, and exceptional technical ability. These were precisely the accomplishments the British Institution had consistently failed to promote.

In all probability the directors and governors of the British Institution sensed that a highly imitative painting by a Royal Academician that warned of the perils of imitation was intended to teach them a lesson concerning their promotion of imitation. Moreover, they may equally have grasped that by demonstrating the perils of guying, *Apullia in search of Appullus* was simultaneously criticising their organisation for its institutional shortcomings in relationship to the Royal Academy.

For Turner this deficiency was caused by the fact that the newer exhibiting and teaching body was controlled not by practising artists but by aristocrats and collectors, none of whom could impart the higher practical skills of art, and some of whom were visual reactionaries who severely damaged the reputations and sales of progressive painters such as himself and Callcott. Outstanding among them was, of course, Sir George Beaumont. And that is why *Apullia in search of Appullus* equally constituted yet another attack on that self-appointed arbiter of taste, with his profound limitations where progressive art was concerned, and his badly painted amateur pictures. For Turner there cannot have been much difference between Beaumont and the Apulian shepherd, if any at all.

Some commentators opined that in *Apullia in search of Appullus*, Turner had simply copied Claude. One of them was the literary critic, essayist, writer and philosopher William Hazlitt (1778–1830), whose unsigned review of the British Institution exhibition appeared in the *Morning Chronicle* on Saturday 5 February 1814. He not only thought that *Apullia in search of Appullus* was a 'specimen of parody' but almost wished that Turner 'would always work in the trammels of Claude or N. Poussin. All the taste and all the imagination being borrowed, his powers of eye, hand, and memory, are equal to any thing.' This was because he found Turner's pictures to be, in general, 'a waste of morbid strength. They give pleasure only by the excess

of power triumphing over the barrenness of the subject. The artist delights to go back to the first chaos of the world, or to that state when the waters were merely separated from the dry land, and no creeping thing nor herb bearing fruit was seen upon the face of the land.' Nor did he have any time for Turner's 'execrable' figures. As he further declared, 'Claude's are flimsy enough; but these are impudent and obtrusive vulgarity.' And he lamented the fact that the painter's 'capacity to draw a distinct outline' did not match the force, depth, fullness and precision of his eye for colour. As we shall see, Turner would take a rather dim view of Hazlitt's powers as a critic, and possibly his discovery of the identity of the author of this review contributed to that low estimation.

The *Examiner* of 6 February also took *Apullia in search of Appullus* to be 'an exquisite copy' of the Claude. And on the following Sunday, 13 February, the closeness of the two images was used to attack Turner in a letter to the same weekly. Penned by 'An Amateur', it made a number of complaints and charges, not least of all that 'rising talent', 'junior Artists' and 'Young men labouring up the steep' slope of art would suffer from being forced to vie in the British Institution Premiums competition with leading painters such as Turner. Probably the writer of the letter was J. C. Hofland, aided and abetted by John Young. Turner's status and dignity as a Royal Academician prevented him from responding to the charges.

On 1 February, the Thames froze over. In a medium-size sketchbook that had been used intermittently for several years and which Turner would subsequently label 'Boats, Ice', he drew vessels trapped in ice. Two of the drawings might have constituted an idea for a painting.[10]

Verses stating that 'Willoughby in frozen regions died' are contained in the *Greenwich* sketchbook, which had been in use since 1806.[11] They suggest that Turner may have intended for some years to depict the tragic end of the Arctic explorer Sir Hugh Willoughby, who in 1553 had led an expedition to find a route to the Far East across the north of Russia. Eventually his flagship, the *Bona Esperanza*, had become separated from its two companion vessels in a storm and been trapped in ice near Murmansk. It is now thought that Willoughby and the other sixty-two men on board all perished in a single night in 1554 from carbon monoxide poisoning caused by sea coal having been used for heating purposes below decks.[12] Their bodies were found by fishermen the following year. The bitterly ironical fate of a ship named 'Good Hope' would undoubtedly have appealed to a painter for whom the fallaciousness of hope held a very real meaning, while the depiction of a ship trapped in ice would have afforded him yet another opportunity of demonstrating to Sir George Beaumont what a 'White painter' could do. But for indeterminable reasons, Turner did not develop his sketches any further. Not until the 1840s would he depict large ships amid frozen wastelands.

429 Monograms drawn on the inside back cover of the *Chemistry and Apuleia* sketchbook, c.1814, Turner Bequest CXXXV, Tate Britain, London.

It may also have been during this winter that Turner toyed with the idea of signing his paintings and prints with a monogram (fig. 429). However, he would never take that idea beyond the sketch stage, although it would have been a rather splendid thing. Both Dürer and Rembrandt had signed engravings by such means, and possibly it was because Turner had used prints by those artists in the perspective lectures that he explored the use of a monogram too.

Judgement Day

On 28 March, seven directors and four governors of the British Institution met to adjudicate the Premiums for 1814.[13] Two of the directors, namely Sir Thomas Bernard (1750–1818) and Richard Payne Knight, had actively supported Turner at one time, and possibly they still did so. Sir George Beaumont was not one of the judges, as has often been claimed.[14] Nor was the Earl of Egremont present in his role as a British Institution trustee.

Eighteen works were in contention for the prizes. It is easy to deduce from their titles into which categories they fell. Nine of them indubitably belonged to the 'Historical or Poetical Composition' class, while eight of the rest competed in the 'Landscape' group. Just as

evidently – and despite the assertion to the contrary made by the writer of the letter to the *Examiner* and by many other commentators ever since – Turner's entry could have belonged in either group. This is because, with two exceptions, all of the landscapes either contain the word 'Landscape' or place names in their titles.[15] Turner's title does not contain any such indication. Moreover, within the context of works named *The Death of Eurydice, Joseph sold by his Brethren* and *Susannah and the Elders*, a painting that took its subject from classical mythology most decidedly constituted a 'Historical and Poetical Composition' in the contemporaneous meaning of those terms. Above all, it almost goes without saying that Turner would have wanted to win 200 guineas for the best 'Historical or Poetical Composition', rather than half that amount for the best landscape. Yet in the event his submission would fail to be included in either category.

Apullia in search of Appullus was disqualified from the competition on the grounds that it had not 'been sent to the Gallery 'till the 15th of January last, being eleven days after the time fixed by the Directors'.[16] There can only be one explanation for Turner's 15 January submission date: although he dated his accompanying letter '14 January', in the final analysis he *wanted* to demonstrate his disdain for the Premium by missing the deadline. That is why he had sent in his work a day after the expiry of the extension date permitted to some of his (supposed) rivals, and long after the official deadline had passed. Presumably he thought that if the directors and governors of the British Institution wished to demonstrate their powers of discernment, they could still award him either the 'Historical and Poetical Composition' Premium or the one for landscape. But either way he did not really care. Certainly he did not need the money. Instead, he wanted to make a point about London art politics and its practical effects.

Of course, had the directors and governors of the British Institution been willing to bend the rules in order to extend to Turner the respect to which he was surely entitled as a proven history painter, the leading British landscape painter and a Royal Academician, then they could easily have done so. After all, they had already accommodated a number of the other competitors. But clearly they were not willing to do anything for Turner, and least of all bestow a prize on him. Instead, they used his lateness to exclude him from the proceedings. Undoubtedly their actions were prompted by some of the reasons given by the 'Amateur' in his letter to the *Examiner* of 13 February, if not by all of them. Obviously that letter had been intended to fire a warning shot across the Academician's bows.

Turner may have had to wait a day or two after 28 March before learning that the first prize of 200 guineas for the top 'Historical or Poetical Composition' had gone to Washington Allston for *The dead man restored by touching the bones of the prophet Elisha* (Pennsylvania Academy of the Fine Arts, Philadelphia); that the prize of 100 guineas in the same category had been awarded to the second son of Dr Thomas Monro, the late Henry Monro (1791–1814) for *The Disgrace of Wolsey* (Tate Britain, London); and that the landscape prize of 100 guineas had been given to J. C. Hofland for *A Storm [off] the coast of Scarborough* (untraced).

Naturally, the directors and governors of the British Institution made themselves appear ludicrous to many of their more enlightened contemporaries by not granting Turner a prize, for surely only those of limited discernment would have placed works by Allston, Monro and Hofland above *Apullia in search of Appullus*. And who would do so today? But Turner had expressed his contempt for the principal educational values espoused by the British Institution and was forced to take the consequences. Moreover, the directors and governors also cannot have welcomed being attacked as promoters of clumsy imitation by means of Turner's outstanding imitation of a painting by Claude. Consequently, they made him pay the price for having put them in their place. And last but not least, the 850 guineas asked for *Apullia in search of Appullus* might have appeared disdainful too, given that to many eyes it looked like a mere copy.

The reason Turner found it necessary to make points about mimicry in *Apullia in search of Appullus* clearly resides in his identification with the Royal Academy. As far as he was concerned, the latter body was the only organisation capable of teaching art properly in Great Britain. After all, the nation's leading artists taught in its schools; it automatically attracted the most gifted students, who only gained admittance after passing through a rigorous screening process; in both of its schools it promoted the art of drawing, and therefore the art of looking; it taught the drawing of inanimate and live models, not merely the superficial imitation of Old Master paintings; it promoted knowledge of the histories of painting, sculpture and architecture through its lecture programme, as it did the understanding of anatomy and perspective; it awarded prizes that carried real weight; and it conferred travelling grants that proved immensely useful, especially to budding architects who needed to visit the Continent if they were truly to master their discipline. In attacking the shallow mimicry he saw as being promoted by the British Institution, Turner was therefore implicitly defending the Royal Academy and everything it stood for in educative terms.

By 1814, not only had Turner completely identified for many years with the organisation that had trained and formed him, but he had also become one of its teachers on both a professorial and an individual level in its Schools. As we have seen, he took these roles immensely seriously. And that is surely the main reason the British Institution annoyed him so profoundly, for by paying lip service to education as well as being essentially class-bound, it permitted amateurism and dilettantism to flourish, especially at the top. As a self-made, ultra-professional barber's son who fully believed in the

meritocracy of art and in the highest art-educational standards, he needed to express his displeasure. In *Apullia in search of Appullus*, he did just that.

Yet although Turner passed up on obtaining a large sum of money in the form of a Premium for challenging the British Institution by means of *Apullia in search of Appullus*, ultimately he would pay a much higher price than that. This was because many people mistakenly but understandably concluded that the close resemblance between his canvas and Claude's *Landscape with Jacob, Laban and his daughters* could only have been achieved with Lord Egremont's connivance. As a supporter of the British Institution on the one hand, and as a patron of Turner on the other, the nobleman had been placed in a deeply embarrassing position. The painter probably anticipated that predicament and realised he had a lot to lose from it, but was willing to take his chances. In the event, the creation of *Apullia in search of Appullus* and its submission to the British Institution in 1814 would lead to an estrangement from the nobleman that would last for about twelve years, until 1826.

Naturally, it could have been the case that during that time Lord Egremont would have gone on regularly commissioning or purchasing pictures from Turner, so that Petworth House would have contained even more of them than it would eventually possess by the time of the earl's death in 1837. We shall never know. But that the world did lose such paintings is beyond question (although of course it gained many others in their place). For Turner it was necessary to risk the loss of Lord Egremont's support because the issues at stake were so important. In this regard he laudably put the interests of art and its furtherance through education above those of his connections and his bank balance. He must have hoped that one day the Earl of Egremont would understand that. And one day the Earl of Egremont would.

The 1814 Royal Academy Exhibition
FRIDAY 29 APRIL TO SATURDAY 9 JULY

There were four Varnishing Days this year, between 25 and 28 April. Turner could have taken advantage of any or all of them. At the dinner, Walter Fawkes – who again was probably Turner's guest – sat facing him; James Ward sat on his left; and Thomas Freeman Heathcote (1769–1825) of Embley Park, near Romsey in Hampshire, sat on his right. Heathcote was a county Member of Parliament for Hampshire and a collector of works by Callcott, Thomson and William Collins ARA (1788–1847). Just beyond them were Thomas Lister Parker, Callcott and Sir John Swinburne. Also present at the dinner were several directors of the British Institution who had participated in the Premium deliberations just over a month earlier.

One or more of them may have advised Turner it was his (supposed) tardiness that had cost him a prize.

His only submission to the Academy show was the oil painting *Dido and Æneas* (fig. 430), which may have been begun as long ago as 1805–6.[17] It hung in the Great Room and its title was accompanied in the catalogue by verses taken from the fourth book of Virgil's *Aeneid* in John Dryden's translation; this was available to Turner in the twelfth volume of Anderson's *Complete Poets*. The lines tell of how the rising sun 'gilds the world below with purple rays' as Dido and Aeneas, accompanied by her entourage, 'to the shady woods for sylvan games resort'. Probably the painter took his pictorial cue from the word 'gilds', for everything in direct sunlight is touched with a very Claudian golden colour.

Dido and Aeneas stand at the near end of the bridge to the right of centre. Turner based Aeneas upon the Apollo Belvedere.[18] Clearly, having drawn the statue many times in his youth (see figs 38 and 39), he could not let his knowledge of it go to waste. The *equi effrenati* or unbridled horses, of which he supposedly possessed knowledge even before Henry Scott Trimmer had told him that Carthaginian horses had no reins,[19] are being led across the bridge. A structure not unlike the Parthenon dominates the distant skyline.[20] Several of the surrounding buildings appear to be uncompleted, as well they might, for at the point in Virgil's poem where Dido falls in love with Aeneas, all construction work on the city ceases.[21] The distant harbour is filled with boats, but Turner took care not to make them too large in relation to Carthage. This is entirely fitting, for during the period in which Aeneas courts Dido, the north African city-state has yet to develop its full potential as a Mediterranean maritime power.

In the *Morning Chronicle* on 2 May, Hazlitt called *Dido and Æneas* 'a most noble composition'. He briefly referred to it again in the same paper the following day, declaring: 'This picture, powerful and wonderful as it is, has all the characteristic splendour and confusion of an eastern composition. It is not natural nor classical.' The *Champion* of 7 May stated that 'The eye wanders entranced and unwearied over the picture, so infinite in variety and beauty are the objects which solicit attention,' and it also declared that *Dido and Æneas* was 'a performance of which our nation has reason to be proud, for we believe no other could at present furnish its equal'.[22]

The 1814 Turner Gallery Exhibition
MONDAY 9 MAY TO SATURDAY 20 JUNE

This year Turner opened his show seven days after the Royal Academy Exhibition had admitted the general public on 2 May. To attract visitors, he sent out invitations supplying its opening and closing dates, and advised that this was the gallery's 'last Season but

430 *Dido and Æneas*, R.A. 1814 (177), oil on canvas, 57½ × 93⅜ (146 × 237), Tate Britain, London.

two'.[23] From the fact that the small card was handwritten, it is clear Turner could no longer be bothered with the expense of having his invitations printed. Yet to think he was losing interest in his gallery because 'Sir George Beaumont with the British Institution at his back was proving too strong for him' is completely erroneous.[24] Undoubtedly, orders for oil paintings had dried up of late, but anyone who admired Turner's art, wanted a painting or two and could afford to commission them would hardly have been dissuaded from doing so by hostile critics within the upper echelons of the British Institution. Moreover, the Bank of England ledgers reveal that by May 1814 Turner possessed exactly £9,599-18s-1d in the funds.[25] That was certainly enough to permit him to soar far above Sir George Beaumont's brickbats, if necessary for the rest of his life.

In fact, money was still coming in, and probably it was doing so through the gallery, despite the fact that by 1814 only relatively old paintings could have been on show. Because of this continuing financial input, Beaumont can have had nothing to do with the 1814 announcement of the closure of the gallery two years hence. The truth of the matter must reside elsewhere.

One clear reason for the impending closure is the fact that by 1813 Turner had stopped painting what might be termed his 'bread and butter' pictures, those 200 guinea, 36 x 48 inch canvases that had always proved eminently saleable (and one day would be so again).[26] Instead, with four exceptions that would each be under 36 x 48 inches in size,[27] until 1826 Turner would only paint and exhibit oils that were well above those dimensions. He was opting to make much grander public statements. Size considerations and the need to reach a far wider public dictated that they be exhibited in Somerset House, not in what was virtually a corridor running off Queen Anne Street West.

In 1811 Turner had simultaneously begun stepping up the production of commissioned watercolours. There was absolutely no need to exhibit these, although some of them would be publicly displayed in the 1820s. The creation of topographical drawings for engraving purposes would increase throughout the 1810s and thereafter, and they would generate income far beyond the reach of Sir George Beaumont's criticisms. Naturally, by purchasing the 'Southern Coast' series prints in great numbers, the general public helped dictate W. B. Cooke's favourable attitude towards Turner's watercolours, which of course he and his brother admired anyway. No less importantly, Walter Fawkes would also continue to commission watercolours on a large scale. The Yorkshireman would never have permitted Sir George Beaumont to dictate his likes or dislikes. Here too was a reason to find the gallery irrelevant to present needs.

Equally responsible for lowering the rate of oil painting production were the increasing pressures that the *Liber Studiorum* and the building of Solus Lodge had placed on Turner's time, as well as the bout of illness that had begun at the end of 1812. That is why the 1814 Turner Gallery exhibition must have been made up of old works. Possibly some of them hung in the positions they had occupied in 1813, if not prior to that date. And then there was the fact that for some years now Turner had been employing the gallery space as his studio. Obviously he had now concluded that there was no point in interrupting that usage merely for a few weeks each year – with all the disruption that such employment caused – when it was far more creatively beneficial simply to make the space his studio on a continuous basis.

Yet the lessening of Turner's interest in showing his works in Queen Anne Street West above all reflects the sense of professional security he now gained from the Royal Academy. It will be remembered that he had brought his gallery into existence in 1804 because he feared the loss of the sovereign status of the Royal Academy, and the general failure of the institution that might well have devolved from that. By 1814 such a danger had long since passed, and with it the need for a separate showcase. Down the years the gallery had therefore altered from being a necessity to an indulgence. Why bother with it for much longer when your latest, much more imposing productions could simply be hung on the top floor of Somerset House? The time for a Turner Gallery had been and gone.

It was probably in 1814 that one of Turner's friends met the artist's father looking very disconsolate in Queen Anne Street West. The reason he was downhearted was simple; he resented the expense of travelling up to London by stagecoach to open his son's gallery. Obviously his legs were giving out by now. By a week later, however, he was seen to be cheerful again, having found that if he stood a Twickenham market gardener a glass of gin whenever he wanted to travel up to town, he could do so at no extra expense on top of the man's vegetable cart (and sitting upon the vegetables at that).[28] We are not told how he returned home at the end of each day, it being unlikely that the market gardener hung around for long after unloading his perishables early in the mornings. Probably William continued to take the stagecoach back. Still, he was saving almost half his fare, for a glass of gin only cost a penny or two. And not unimportantly, this story provides further proof that no accommodation was available for him in his son's gallery cum studio or at the nearby storage facility. While the exhibition was in progress the downstairs space must have acted as both Turner's living quarters and as a store for heavy items of studio equipment such as easels and the like that were normally housed upstairs, not to mention any works still in progress. The place must have been bursting at the seams.

Turner sold £50-worth of Reduced 3% Annuities on 9 June.[29] It is not known why he did so, but the sale must have been forced on him and seemed intensely annoying, for a receipt from William Marsh of 5 Sweetings Alley that remains tucked into the cover of the *Finance* sketchbook tells us that the £50-worth of stock was sold at only $68^{1/4}$ per cent of its face value, thereby producing just £34-2s-6d.[30] After Marsh had deducted his commission of 1s-3d, Turner received just £34-1s-3d. That surely explains why this was the only sale of stock to take place in 1814. Understandably, the painter couldn't bear to lose money. Something very pressing must have made him liquidise the asset.

On Friday 24 June, the Prince Regent, along with Emperor Alexander I of Russia (1777–1825) and King Friedrich Wilhelm III of Prussia (1797–1840), reviewed the fleet at Portsmouth. It comprised fifteen battleships, and about the same number of frigates in 'a line of seven or eight miles in extent, in front of the Isle of Wight', according to *The Times* of 27 June. The warships were followed by well over 200 vessels of all sizes. Unsurprisingly, Turner travelled down to Portsmouth to witness the naval review, for it was unprecedented in his lifetime. Probably he was absent from London for a week or more during the Monday 20 June to Sunday 3 July period. Possibly he had entertained the notion of producing a large painting of the Allied sovereigns and the Prince Regent undertaking their duties, but if so, nothing would come of it.

The West Country, 1814

Four sketchbooks that have always been associated with the 1813 stay in Plymouth were actually used in 1814, and a further one was employed on both trips.[31] Because Turner limited his movements to Plymouth and its relatively immediate surroundings in 1813, many of the places drawn in them can only have been visited the following

431 Fol. 23 of the *Devon Rivers, No. 1* sketchbook, Turner Bequest CXXXII, inscribed by Turner in pencil 'Cran Mere Pool' at the bottom-centre, here dated to 1814, Tate Britain, London.

year. They therefore establish the route taken in 1814. It its scope, the 1814 tour almost rivalled the one undertaken three years earlier.

Around the beginning of August 1814, Turner travelled by stagecoach from London to Bristol, where he probably stayed a couple of nights.[32] Then it was on to Tiverton in Devon before spending a couple of days trout fishing on the river Exe near Oakford. Next he walked to Barnstaple via South Molton, his father's birthplace. After touring the locale, he strolled to Okehampton and subsequently traversed Dartmoor, where his presence is proven by a sketch inscribed with the words 'Cran Mere Pool' (fig. 431).[33] This is located in a very isolated spot about five miles south of Okehampton and it only forms after a good deal of rain has fallen. A further sketch includes indications of a downpour when Turner was actually up on the moor.[34] This could have given him the cold he is known to have subsequently developed on the 1814 tour.

Turner then made his way to Lydford, from where he progressed to Launceston. After a stay there, he moved southwards down the Tamar valley, making sketches all the way. Finally he arrived in Gunnislake Newbridge, which of course he had visited the previous year. Probably he returned there to experience for a third time the beauty that had already inspired the genesis of *Crossing the brook*, one of the oils he would be displaying at the Royal Academy in 1815. Following a deviation from his path to visit Tavistock – possibly for an overnight stay – Turner returned to the Tamar valley to make his way to Calstock and the environs of Plymouth, where he once again resided with A. B. Johns.

According to a postscript to a letter Turner would send to Johns shortly after 2 October 1814, he suffered from a head cold while staying with the Plymouth artist this year.[35] Perhaps he had caught it by getting soaked to the skin when on Dartmoor. In all, the number of sketches he made in Plymouth in 1814 tends to indicate that he resided with Johns for about a week. The fact that he appears to have had a boat and boatman at his disposal suggests he might have seen George Eastlake and John Collier too, even if he did not stay with them.[36]

From Plymouth, Turner then made his way to Plympton, Ivybridge and Totnes. From there he took a boat down the Dart to Dartmouth, although about halfway down the river a gale sprang up. This compelled the boatman to surrender control of the vessel to the tide that carried them rapidly downstream to their destination. As a consequence, Turner was 'obliged to land from the boat half drownded with the spray', while the cold he had developed in Plymouth became much worse. Perhaps he spent a couple of nights in Dartmouth to recover. A good bed, some decent food and a little hot grog might have helped. But cold or no cold, Turner sketched all around Dartmouth, Kingswear, the river mouth, and the surrounding hills and inlets.

From Dartmouth, Turner returned to Totnes. As his sketches demonstrate, he then set off for Buckfastleigh to the north-east. Subsequently it was onwards to Buckfast Abbey and Ashburton, in both of which places he also drew. He spent a night in Exeter, possibly with his uncle. And from there he walked northwards up the valley of the river Exe to Tiverton, a distance of about thirteen miles. By returning to Tiverton he had completed a full circle. Possibly he did so in order to fish the Exe near Oakford once again before returning to London. Finally, he appears to have made his way to Honiton, where he probably caught a stagecoach back to London. In all, his tour may have lasted twenty-seven days, between 4 and 30 August.[37]

Upon returning home, Turner resumed work with renewed vigour on *Crossing the brook*. Given the pictorial complexity and detailing of a large Carthaginian seaport scene that was also being prepared for exhibition in Somerset House in 1815, it too received much attention. Moreover, Turner was simultaneously elaborating a small oil for Sir Richard Colt Hoare. And it was almost certainly during this period that he proofed two more 'Southern Coast' series prints. One of them was a depiction of Lyme Regis that was being engraved by W. B. Cooke.

In connection with the third proof of this print, Cooke recorded that Turner was highly gratified by it, whereupon the engraver was offered pieces of white chalk and black crayon, and invited to choose between them for further proofing purposes. Cooke chose the white, at which Turner threw the black across the room. He then proceeded to heighten the lighter tones of the image. But when he had finished, and Cooke asked him to touch another proof with the black, he replied: 'No . . . you have had your choice and must abide by it.' As

Cooke observed, 'how much the comparison would have gratified the admirers of the genius of this great and extraordinary Artist.'[38] Because Cooke chose the white chalk, the image enjoys huge brilliance and sparkle. However, the dark tones are already so deep it is difficult to imagine how the tonal range could have been intensified had the black crayon been selected instead.

Starting Fair

We have already referred to the postscript to a letter that Turner sent to A. B. Johns at some point after 2 October 1814. The undated missive is headed with the single word 'Sandycombe'. Clearly, Turner had changed the name of his Twickenham residence from Solus Lodge to Sandycombe Lodge by now. The new name was arrived at by amalgamating the first word of Sand Pit Close with a slightly simplified version of the Old English word 'coombe'. This denotes a hillside hollow, of which a fine example exists immediately behind the Twickenham villa. It is not known why the name was altered. Perhaps Turner wanted to signal that the dwelling was no longer a place of retreat from the world, and that visitors would consequently be welcome there.

The main body of his letter to Johns concerns two matters. The first was a loan of Opie's *Lectures on Painting* he had promised the Plymouth artist.[39] Because Turner had annotated his copy of the book in ways that might be misconstrued, he had now changed his mind about lending it to Johns – he did not want anyone to read his negative comments on Opie's thinking. Instead, he advised his friend that the book could be borrowed from a mutual acquaintance in Plymouth who had also subscribed to it. However, if that failed, then he would obtain a copy of the work from a third party and send it on. But to prevent immediate disappointment, he forwarded Johns his own copy of the three-volume, fourth edition of Reynold's writings, dating from 1809. And he also accompanied it with a copy of the 2 October edition of the *Examiner*, some of the contents of which establish the earliest date of his letter.

The weekly contained a letter signed by 'A Visitor' who attacked the Royal Academy for the supposedly limited extent of its library, for the extremely restricted opening hours of that resource, and for the need for the Royal Academy librarian to perform his duties instead of simply enjoying a sinecure.[40] Turner sent Johns this issue of the *Examiner* in order to demonstrate how the 'High-mightiness of Art' – to wit, the Royal Academicians – were treated in 'the hot bed of scurillity *London*'. It is easy to see why he regarded the attack by the 'Visitor' with disdain, for what was the Royal Academy meant to do? Go out and purchase thousands of pounds worth of books in response to a single letter to a Sunday journal? And even if the institution did buy more books, where on earth could it house them? As it was, the existing library was filled to overflowing. Moreover, the books also had to be hidden from view when the annual exhibitions were mounted. Clearly the 'Visitor' had completely overlooked the physical constraints of Somerset House. Turner found it completely ridiculous that those who could not value art, understand how difficult it is for it to flourish, or respect the enormous, lifelong amount of work that goes into the making of it, should feel free to scorch 'any man's reputation' merely to sell a penny's worth of newsprint for eight-and-a-half pence. No less 'deplorable' was the propensity of the public to relish such attacks, 'even as a joke upon Joe' – that is, upon himself, in the only recorded instance we possess of him using the popular diminutive of his first name. Here he was probably remembering the attack that had been launched on him by 'An Amateur' in the *Examiner* of 13 February, as mentioned above.

To conclude the main part of his letter to Johns, Turner addressed denials of the need for artistic support and encouragement that had recently been expressed in an unsigned essay entitled 'Fine Arts: Whether they are promoted by Academies and Public Institutions'. Written by William Hazlitt, this had appeared in the *Champion* newspaper in two parts, on 28 August and 11 September. In his letter to Johns, Turner poured scorn on Hazlitt's views. For him, the *Champion* essay had been written by an ignoramus who pretended to possess an all-encompassing artistic overview but who had only perceived a tiny part of the whole. Turner ended his letter by expressing his confidence that he himself was far more capable of grasping the bigger picture. He also joked that, like Johns and everyone else, he would have to be allowed to catch up artistically without any assistance from the writer of an essay in the *Champion* on how genius might gain a fair start. And to make the same point even further, he alluded to the doubtless apocryphal story of a Cornish curate who, when somebody had shouted into his church in the midst of his sermon that a shipwreck had just been sighted, begged his congregation to wait until he had shed his surplice, for he wanted everyone to 'start fair' or with equal advantage when rushing off in search of rich pickings amid the wreckage. For Turner it was simply a fact of life that nobody was equal when it came to art, and the world would just have to come to terms with that harsh reality.

30

The Tremendous Range of his Accomplishments

November 1814 to May 1815

By November 1814 it had become apparent to W. B. Cooke that Turner's contributions to the 'Southern Coast' series were greatly boosting its success. Accordingly, he re-negotiated the painter's contract.[1] Instead of making twenty-four images for the scheme, Turner would now produce forty of the forty-eight designs, including one of the vignettes. In return, Cooke would increase his remuneration to ten guineas per watercolour. Not only was this amount more in keeping with what Turner was receiving for drawings of comparable dimensions from elsewhere, but by being paid in guineas rather than pounds, it now aligned with his status as a Royal Academician.

Turner travelled up to Farnley Hall for his annual visit this November, possibly leaving home on 4 November and quitting Yorkshire about four weeks later, on 3 December. Once again we possess no record of the painter's activities there, but making watercolours for Fawkes could well have comprised a major part of them by now.

Four large finished watercolours were probably completed over this winter. Turner may have laboured on them intermittently over a number of years, which would explain why each of them contains stylistic traits from different points within the 1808–15 period. In the spring of 1815 *Lake of Lucerne, from the landing place at Fluelen, looking towards Bauen and Tell's chapel, Switzerland* (fig. 432) would be exhibited at the Royal Academy as the pendant to *The Battle of Fort Rock,* *Val d'Aoste, Piedmont, 1796* (fig. 433). The pairing would be appropriate, for the lake scene, which appears to have been brought to perfection as a long war was coming to its end, is one of utter calm after a storm, while the battle scene contains stormclouds that equally match the subject dramatically, while enhancing it emotionally.

In *Lake of Lucerne, from the landing place at Fluelen,* Turner may have drawn upon the Cozens view of the same body of water from the same village he had acquired in 1805, for there are similarities between the two images. And while working on the lake and battle scenes, Turner might also have brought to completion a representation of the Mer de Glace as seen from the Montanvert mountain (fig. 434). All three drawings revolve around a median size of 27 × 40 (68.5 × 101.5), as does an upright-format depiction of the Devil's Bridge in the Schollenen Gorge of the St Gotthard Pass (fig. 435). Here the dynamism is intense, the scale colossal, the space limitless. The image embraces both grandeur and moralism, for because we really have to search for the Devil's Bridge, we are forced to conclude that all the ingenuity of our species counts for little amid the overwhelming vastness and occasional ferocity of the natural world.

The 1815 perspective lectures began on 2 January, with the further five talks being given on the succeeding Monday nights. Although it is possible that a new introductory lecture may have replaced the old one, sadly we possess nothing tangible with which to follow up such a suspicion, which is very slight anyway.[2]

Detail of fig. 434.

432 *Lake of Lucerne, from the landing place at Fluelen, looking towards Bauen and Tell's chapel, Switzerland*, signed on barrel to right 'JMWT', c.1815, exhibited R.A. 1815 (316), watercolour over pencil on paper, 26 × 39⅜ (66 × 100), The Timothy Clode Collection.

On a receipt dated 25 February 1815, Turner acknowledged having been paid 150 guineas by Sir Richard Colt Hoare for 'a Landscape representing the Lake of Avernus'. This is the oil now known as *Lake Avernus: Æneas and the Cumaean Sibyl* (Yale Center for British Art, New Haven).[3] Three days later, on 28 February, Turner paid £100 and £30-7s for two types of government stock.[4] Because of the dates of these two transactions, the money behind them had to have derived from Colt Hoare's *Lake Avernus* payment.

It will be recalled that back in 1798 Turner had elaborated a pencil outline transcription of a drawing of Lake Avernus made by Sir Richard in 1786 (see figs 194 and 195). He then went on to paint a somewhat Wilsonian picture of the lake, probably within a few months of having copied his patron's drawing. As already suggested, perhaps Colt Hoare had commissioned that canvas but then rejected it because it could not hold its own against a Wilson view of Lake Nemi he also possessed. But possibly after seeing *Dido and Æneas* hanging at the Royal Academy in 1814, the baronet resolved to try again, for Turner the painter of ideal landscapes had come a long way since 1798. Now he could certainly produce a work fit to hang alongside a fine oil by Wilson.

In *Lake Avernus: Æneas and the Cumaean Sibyl* the vista depicted in the earlier version is transformed. Now everything is more solid and assured, the tonal recession from foreground to background is far more evenly controlled, the colouring much richer and more harmonious.

433 *The Battle of Fort Rock, Val d'Aouste, Piedmont, 1796*, signed and dated 1815, R.A. 1815 (192), watercolour on paper, 27⅜ × 39¾ (69.5 × 101), Turner Bequest LXXX-G, Tate Britain, London.

The entire landscape looks radiant in the soft evening light. Colt Hoare hung Turner's painting alongside his Wilson Lake Nemi view for the rest of his days, so he must have thought very highly of it.

In March, Turner gained a new near neighbour down in Twickenham, and one with whom he would subsequently enjoy friendly relations. This was Louis Philippe, the Duc d'Orléans and Duc de Chartres (1773–1850), who would be known as Louis Philippe I during his reign as King of France between 1830 and 1848. Louis Philippe would remain in Twickenham until 1817. It is not known when or where he and Turner first met, but possibly it was through the Royal Academy or in Twickenham before 1815, for the future monarch had lived there for a time during the 1800s.

In 1815 the Royal Academy Exhibition Varnishing Days were held on Saturday 15 April and on the four weekdays that followed between 17 and 20 April. Turner is known to have taken advantage of one or more of them, for the critic of the *Sun* would write of having viewed one of his submissions before a passage within it had been toned down. And by Wednesday 19 April, the painter Thomas Uwins RA (1782–1857) had picked up on the Somerset House grapevine that the Academicians who had seen the forthcoming annual exhibition were 'loud in praise of . . . that greatest of all living geniuses, Turner, whose works this year are said to surpass all his former outdoings'.[5]

434 *Mer de Glace, in the Valley of Chamouni, Switzerland*, c.1815, watercolour on paper, 27 × 40 (68.5 × 101.5), Yale Center for British Art, Paul Mellon Collection.

The 1815 Royal Academy Exhibition
FRIDAY 28 APRIL TO SATURDAY 24 JUNE

Turner attended the dinner, with Walter Fawkes seated on his left, James Ward on his right and Callcott facing him. On Callcott's right sat Sir John Swinburne, with Thomas Lister Parker to Swinburne's right. Turner was therefore in the company of some of his closest friends and admirers. Almost certainly Fawkes was his guest once again. If this was the case, then it is unsurprising, for the collector may have lent three works to the show.

Inasmuch as three out of Turner's eight submissions this year were old works, possibly he celebrated the fact that he had recently turned forty by making evident the tremendous range of his accomplishments through a display of the old and the new. The two earliest offerings were *The passage of Mount St Gothard, taken from the centre of the Teufels Broch (Devil's Bridge), Switzerland* of 1804 (see fig. 306) and *The great fall of the Riechenbach, in the Valley of Hasle, Switzerland* of the same year (see fig. 307). Both were lent by Walter Fawkes, both were placed in the Inner Room, and both have already received mention. Not quite as old was *Bligh Sand, near Sheerness: Fishing boats trawling*, which hung in the Great Room. This was, of course, the selfsame canvas that had been exhibited in Turner's Gallery in 1809

Facing page 435 *The Devil's Bridge, St Gotthard*, c.1815, watercolour on paper, 41¾ × 30 (106 × 76.2), Yale Center for British Art, Paul Mellon Collection.

under the title of *Fishing upon the Blythe-sand, tide setting in*, and more simply as *Blyth Sand* in the same space the following year. If Sir George Beaumont had offered to buy it in 1809 and Turner had rebuffed him, then showing it at the Royal Academy in 1815 might well have been intended to remind the baronet of that snub. Being a very white, 'White' marine painting, it would have rubbed sea salt into Sir George's wound most effectively.

Just inside the principal doorway to the Inner Room and on either side of it hung *Lake of Lucerne, from the landing place at Fluelen, looking towards Bauen and Tell's chapel, Switzerland* (fig. 432) and *The Battle of Fort Rock, Val d'Aoste, Piedmont, 1796* (fig. 433). In the lake scene a heavy storm has just moved away, leaving in its wake an atmosphere laden with moisture and mists being burned off by the rising sun. At the centre, travellers drenched while out on the lake are alighting from a small ferry boat, strewing their belongings and cargo across the beach as they go. On the right a girl sniffles into a handkerchief, perhaps crying over milk spilling from a jug but more probably because her recent experience in the boat has given her a head cold (or possibly for both reasons). Further off, more boats approach, while near the very tip of the headland in the far distance to the right is the chapel dedicated to the memory of the Swiss fighter for liberty, William Tell, who had died in 1354. Everywhere the sense of scale is staggering, Turner having doubled or trebled the sizes of the real mountains around Lake Lucerne. The tonalities are as rich and as deep as any to be encountered in oil paintings. Walter Fawkes must have been amazed by the work. That would certainly explain why he would pay 120 guineas for it and possibly commit himself to doing so this year, perhaps even before the Royal Academy Exhibition had opened (and if that was the case, then he necessarily lent the work to the show, for technically he was its owner).[6]

In the catalogue, the title of *The Battle of Fort Rock* was accompanied by verses from *Fallacies of Hope* stating that in 1796 the alps had failed to prevent 'the van progressive' of an invading French army from forcing its way down into Italy. The ending of the poetic fragment makes it clear that Turner regarded the French as barbarians. As no battle is known to have taken place at Fort Roch during the French invasion of Italy in 1796, it appears likely that the engagement was invented by the artist. Immediately before us the remains of a tree smashed by the forces of nature or in battle amplifies both the destruction of the soldier lying next to it, and the responses of the woman who mourns over him while clutching their baby dressed in swaddling. The savagery of humanity finds parallels in the wildness of the mountains and in the passing storm overhead.

While the metaphorical levels to *The Battle of Fort Rock* are readily perceivable, those of *Lake of Lucerne, from the landing place at Fluelen* are scarcely more difficult to apprehend. Here Turner could well have celebrated the return of peace to Europe, as denoted by the vast storm clouds that are moving off in the distance. After all, until Napoleon had escaped from Elba in March 1815, it had been almost universally thought that the 'storms of war' had finally passed away (and after the Battle of Waterloo on 18 June, they would do just that). Similarly, the jumble of travellers and their effects strewn across the beach might well have been intended to hint at the chaotic after-effects of war. If such allegorical meanings were intended, then *The Battle of Fort Rock* and *Lake of Lucerne, from the landing place at Fluelen* are thematically complementary. Before long Turner would find a more visually direct way of alluding to related matters such as war and peace. Perhaps the placing of these pendants in the Royal Academy in 1815 helped him attain that end by making the pictorial requirements of antithesis clearer than ever.[7]

Also hanging in the Inner Room was a Turner oil of a major volcanic eruption that had occurred in 1812 on the island of St Vincent in the Windward Islands of the Caribbean. This picture had been elaborated from a sketch by a sugar planter, slave owner and barrister who had both witnessed the eruption and commissioned the painting. But Turner's two major submissions to the show in oils were *Crossing the brook* (fig. 436) and *Dido building Carthage; or the Rise of the Carthaginian Empire* (fig. 437). They were each placed in highly advantageous positions in the Great Room.

Several works could have influenced the composition and imagery of *Crossing the brook*. In layout, it resembles at least two images by Claude le Lorrain with which Turner was familiar. It is likely that one of them particularly inspired the composition of the painting. This was the *Landscape with the Rest on the Flight into Egypt* now in the Cleveland Museum of Art but which Turner most likely knew from its mezzotint reproduction in the Earlom *Liber Veritatis*.[8] Moreover, Reynolds, de Loutherbourg, Henry Thomson and William Hamilton had each created images of girls or of children crossing brooks.[9] Turner was definitely acquainted with at least two of them. And the Reynolds and both of de Loutherbourg's versions of the subject include animals, a characteristic shared by *Crossing the brook*.

It may be remembered that the young girl in *Frosty morning* had reminded Henry Scott Trimmer of 'a young girl whom he occasionally saw at Queen Anne-street, and whom, from her resemblance to Turner, he thought a relation'. In narrating this observation to Thornbury, Henry Syer Trimmer stated that the girl on the left of *Crossing the brook* was 'the same female figure'.[10] Naturally, if the girl was Turner's daughter, Evelina, then such a resemblance is unsurprising. In 1815 she would have been about sixteen, which seems to fit the age of the girl depicted. The seated girl on the far bank looks to be somewhat younger. As Georgiana would only have been about four when this picture was painted, she cannot have been the model. But why would Turner have required her services?

436 *Crossing the brook*, R.A. 1815 (94), oil on canvas, 76 × 65 (193 × 165), Tate Britain, London.

He was perfectly capable of obtaining older models, or of completely inventing a figure if needs be.

It has convincingly been suggested that Turner intended this picture to allegorise female puberty, with the seating of the girl on the right denoting the wait for that life-enhancing moment, and the girl on the left crossing the flowing waters after having reached her new stage in life.[11] Such an interpretation is supported by many of the pictorial details. Thus, on the right may be seen a deeply shadowed and therefore somewhat mysterious opening. In the context of an idealised landscape, this looks far more like a grotto than the entrance to a mine, of the type that Turner had undoubtedly seen in Devon. If he intended it to represent a grotto, then it is the only such structure he ever painted. As he would undoubtedly have been aware from his readings in poetry and the classics, ever since ancient times grottos have been regarded as sacred wellsprings and sources of life. It is therefore very possible that he intended the opening to suggest this, rather than simply to represent an industrial entranceway. After all, if he had wanted it to form part of a statement about the intrusion of industry upon the landscape, then he would surely have complemented it with a lot of ugly mechanical litter elsewhere.

In front of the opening, the seated girl has a white cloth draped across her lap and a large white bag immediately next to her. The bag is accompanied by a red, stoppered bottle. In pubertal terms, the unsullied tones of cloth and bag, and the blood-coloured but sealed bottle, may respectively allude to a premenstrual and unpunctured state. Midstream is a dog which, it was further suggested, is a reminder of the animal side of existence. Immediately beyond the dog, a cleft in a boulder suggests the female sexual cleft. And under the arm of the girl who has virtually crossed the brook is a large red bag. By terminating at her lap, this may allude to the womb. Moreover, on the surface of the brook between the girl's legs, is a red, phallic-shaped reflection that has no visible source. Just as the other girl sits, so this girl stands, a difference that could well have been intended to emphasise the difference between them in height, and therefore in age. The distant bridge furthers associations of river crossing. Finally, we arrive at the trees on the left. Due to the gently undulant shapes of their trunks and boughs, to the somewhat streamlined overall shapes made by the bunches of leaves, and to the tonal and spatial differentiation of that foliage, these are undoubtedly the most luxuriant, florescent and graceful arboreal forms that Turner had created to date. Because they subtly communicate growth, they might well have been intended to externalise and amplify the human development taking place beneath them. And in keeping with the need for decorum, the growing light of what we know to be a dawn scene complements the burgeoning life-force within the young woman.

An 1845 letter referring to this particular canvas makes it clear that Turner would think of life as a brook to be crossed.[12] Perhaps he already did so by 1815, in *Crossing the brook* expressing his awareness of the significant divide between girlhood and womanhood and, beyond that, of the organic existence that humankind shares with much of the natural world. And why not? For an artist who had openly avowed his allegiance to the theory of poetic painting many times by 1815, there could have been no more effective way of uniting landscape painting with a universal aspect of human experience, given that female sexual burgeoning lies at the very core and continuance of our existence as a species.

The subject of *Dido building Carthage; or the Rise of the Carthaginian Empire* was taken from Virgil's *Aeneid*. This, it will be remembered, was available to Turner in Dryden's translation within the twelfth volume of Anderson's *Complete Poets*. Queen Dido has fled from Tyre with the remains of her dead husband, Sychaeus, who was murdered by her brother. Sychaeus's tomb dominates the right side of the image, and his name is inscribed upon it. Beneath it may be seen a cloaca or drain conduit. Turner undoubtedly knew that in ancient times sewers had been constructed upon the founding of city-states in the hope they would enjoy power and longevity. That must be why he placed Sychaeus's tomb immediately above such an opening. To the left of the mausoleum stands a dead tree, while from the top of the tomb a sapling grows, surely to indicate that Carthage ultimately emanates from the death of Sychaeus. Nearer the centre, in the distance, is the stately grove of trees that stood at the heart of Carthage, according to the *Aeneid*.

On the left, Queen Dido faces a retinue of architects, masons and builders who are planning further development of the city rising before them. In front of her, wearing a helmet and a dark cloak but separated from her by a slab of masonry, is the only man standing in her presence. Almost certainly he is Aeneas, for at the point in Virgil's poem that inspired this painting, the Trojan prince tours the rising city but has yet to meet its queen. Their lack of contact to date could be signified by the block resting between them, just as the fact that we cannot see his face suggests that his identity still remains hidden from her. The lines of two masts lead the eye down to the monarch and the standing man. By doing so, they strengthen the identification of both figures as the major protagonists of the scene, for the masts dominate the harbour just as Dido and Aeneas rank above everyone within it.

In front of this group, four boys play with toy boats while two nubile girls gaze at them. Together these males and females may respectively personify power and generation, for the boys now playing with toy boats will soon become the young men who will sail the real vessels that will spread Carthaginian hegemony across the Mediterranean, just as the girls will doubtless provide two of them or others like them with the male heirs who will later help maintain that power. And in keeping with the need for decorum,

437 *Dido building Carthage; or the Rise of the Carthaginian Empire*, R.A. 1815 (158), oil on canvas, 61¼ × 91¼ (155.5 × 232), National Gallery, London.

the sun has to be rising, for a sunset would have been wholly inappropriate to a depiction of the rise of the Carthaginian empire.

On the left, everything teems with life and energy, while on the right all is deserted and still, a contrast that augments the dramatic range of the image. The composition is underpinned by an implied structure made up of crossed horizontal, vertical and diagonal lines that is not unlike the basic layout of the Union flag. During the 1813–15 period in which this picture was painted and Napoleon Bonaparte was thought to have been defeated – or after March 1815 when it was once again hoped he would be vanquished – a subtle reminder of the flag of Great Britain would have been highly appropriate. All the straight lines imbue the depiction of a growing city with an apt sense of underlying tautness and strength.

By 1815, Turner had long wanted to paint a seaport scene worthy of comparison with Claude.[13] In *Dido building Carthage* he succeeded in attaining that end, just as in *Crossing the Brook* he had painted his most successful Claudian landscape to date. Yet *Dido building Carthage* also probably summarised everything Turner had been attempting so hard and so opaquely to articulate in his perspective lectures. With its complex (if slightly imperfect) perspectives,[14] its superb exploration of light, colour, shade and reflectivity, its moral and physical contrasts between life and death – as respectively signified by the teeming city and the tomb – and its congruence of timing, meaning and pictorial structure, it is far more eloquent than any of Turner's tortuously opaque verbal discourses. Not for nothing would he one day call it his 'chef d'oeuvre'.[15]

Criticisms of the brightness of the sky in *Dido building Carthage* appeared in the *Morning Chronicle* on 1 May, in the *Morning Herald* on 4 May, and in *The Times* on 6 May. On 16 May the reviewer for the *Sun* (who was probably John Taylor) agreed, although he also asserted that since he had first seen the picture the yellow on the water had been toned down by means of glazing. He concluded his critique by calling the painting 'one of the chief ornaments of this year's exhibition'. The *Morning Chronicle* concurred by declaring the canvas to be 'one of those sublime achievements which will stand unrivalled by its daring character' and 'a work which years and ages will improve'. The *Morning Herald* held that 'in grandeur and ideal beauty' it was better than anything Claude had ever been able to achieve, while the *St James's Chronicle* repeated that opinion. The critic for the *Times* insisted that by means of the work Turner had maintained 'his rank as the first landscape painter of the period'.

The *Morning Herald* critic was aware of the fact that the landscape represented in *Crossing the brook* was to be found in Devonshire, and the *Examiner* critic praised the work as constituting 'a chaste identification of English nature'; both of them therefore displayed insider knowledge as to the precise county or country depicted. Such identifications suggest that artists and amateurs who knew the exact place represented had put that information about within Somerset House before the critics had set to work. Perhaps Turner was among them. And as well as raising a great many other points in his lengthy review, the *Examiner* critic showed himself to be aware of Turner's use of decorum in *Dido building Carthage*, for as he stated, 'The splendor of the rising empire seems to be propitiously promised by the smiling and splendid augury of nature; for the sky, overspread with a solar and golden glory, most richly illuminates the whole scene.'

Of the eight works that Turner displayed at the Royal Academy in 1815, all four oils failed to sell, in the case of *Dido building Carthage* probably because the artist placed an 800 guinea price upon it. Clearly he thought that if he was going to be forced to part with it, then he would have to be amply compensated for doing so. However, nobody in his circle of collectors was willing or able to spend such a sum. Yet he cannot have been too worried. By 1815 he already enjoyed the kind of wealth he could only have dreamed of at the outset of his career. Moreover, in the eyes of his beloved father at least, he had long ago attained riches beyond imagining.

The Counter-Attack Begins

On Wednesday 3 May – and thus two days after the Royal Academy Exhibition had admitted the general public (as opposed to just its members and selected guests) – the Prince Regent opened a major display of Flemish and Dutch Old Master paintings at the British Institution. It is likely that a number of Royal Academicians were in attendance, with Turner among them. Although he and his peers may have responded favourably to a few of the works on display – for many of the exhibits were fakes – they were also annoyed that once again the British Institution had chosen a crucial moment to draw people away from Somerset House. The *Morning Post* made this attraction clear on 10 May when it stated: 'we visit [the British Gallery] almost daily, and the rooms are crowded with persons of the highest rank and fortune, and artists of the first distinction and ambition'. By rights, all 'persons of the highest rank and fortune' and any leading artists who were not Academicians should have been in Somerset House, although doubtless many such people did visit both venues. But this year the British Institution was not going to be allowed to get away scot-free with poaching the Royal Academy's audience, for an anonymously written response to the Flemish and Dutch paintings exhibition was in the process of being prepared for publication. Where three particular directors of the British Institution were concerned, it would make for very uncomfortable reading indeed.

The first shot in the assault was fired by the *Morning Chronicle* on 17 May. Under the title of 'Declaration issued in the preface to the catalogue of the British Institution for April 1811',[16] the piece in question constituted an attack on the directors of the British Institution for going against the seventeenth article of their Constitution of April 1805, namely that 'The rooms [of the British Institution are] to be shut up during the time of the Annual Exhibition of the Royal Academy'.[17] The newspaper went on to attack the British Institution for showing 'not only a number of the very worst specimens they could obtain' of the works of Rubens, van Dyck, Rembrandt and many other artists, but also for including among them several 'rubbed-out pictures... [and] imitative daubs'. To intensify that assault, the motives of the directors of the British Institution were called into question by the suggestion that the exhibition had been organised to increase the market values of works they had lent to it. The article ended by stating that 'in the course of a few days we shall have the honour of transmitting a Catalogue raisonnee [*sic*] of the Pictures now on exhibition in Pall Mall'. As we shall see in the subsequent volume of this biography, that pamphlet would savagely ridicule the British Institution, and in particular Sir George Beaumont. The final effect of this pouring of scorn upon the baronet's frequent attacks on Turner and other artists, and on his opinions on art more generally, would be to severely depress him, and thereby to shut him up for good.

On Wednesday 17 May, following many months of planning, the first annual fund-raising dinner of a recently created charity, the Artists' General Benevolent Institution or AGBI, took place. The stated aim of this body was 'to relieve decayed Artists; and to afford assistance to their Widows and Orphans'.[18] The location for the event

was the Albion Tavern in Aldersgate Street in the City of London, an establishment that survives to this day. Chairing the proceedings was the fourth of the royal princes, the Duke of Kent and Strathern (1767–1820), who a few years later would father the future Queen Victoria (1819–1901). He was supported by his younger brother and the sixth son of the king, the Duke of Sussex (1773–1843). Among the fifty volunteer stewards were a number of Turner's patrons and friends, including Lord Egremont, Soane, Chantrey, John Landseer and Charles Heath.[19]

Unfortunately, no newspaper reports of the event have come to light but an idea of the numbers of persons in attendance can be gleaned from the Minute Book of the AGBI, which noted on 4 May that 700 dinner tickets were to be printed.[20] And although we possess no record of Turner's presence at the dinner, he was surely there, given that he would soon actively support the charity and that he had been present at the annual dinner of a rival organisation, the Artist's Benevolent Fund, just over a month earlier.[21] As on that occasion, he must have heartily welcomed the financial support of impoverished artists. On 1 May the Minute Book of the AGBI would record that the dinner had been a huge success, with a 'liberal contribution' to the funds resulting from it.

As a consequence of the success of this dinner, the first General Meeting of subscribers to the AGBI would be held on 13 July at the Craven Hotel.[22] It would be chaired by T. C. Hofland. On that occasion Turner would undoubtedly be present. In accordance with the Constitution, the subscribers would elect directors of the AGBI for a year, and Turner would be one of them, as would Soane, Chantrey, Charles Heath and twenty-one other artists and gentlemen who participated in the meeting. Auditors would also be elected. This directorship would not be the end of Turner's involvement with the AGBI, however, for on 25 July he would be elected the Chairman of its Council, or day-to-day governing body. He would take that responsibility very seriously, as would be indicated by his attendance at all but sixteen of the fifty-three Council meetings held between 1815 and 1820 alone.

Turner's commitment to the AGBI would be total because he knew what the poverty of artists entailed. Perhaps that awareness went all the way back to Mauritius Lowe in 1789. Be that as it may, he had undoubtedly been made aware of the scale of artistic failure and penury when he had served on the Royal Academy Council, for that body regularly handed out money to destitute Academicians and Associates, to impoverished former Schools students, to aged or crippled workers for the Academy, and to the dependents of all the foregoing. Occasionally Turner could prove unsympathetic in such matters, as had apparently happened with the widow of the Royal Academy Secretary back in 1811.[23] Yet on the whole he would prove extremely charitable. Indeed, after the mid-1820s he would dedicate a good portion of his life to supporting artists who were unable to fend for themselves.

The problem was that he hated spending money. In time, the conflict between his charitable impulses and his tendency to hoard would create major problems. But there is no doubt that he *wanted* to be charitable. For well over 150 years Turner has been thought of as a miser, hoarding money and appearing wildly eccentric in his pursuit of filthy lucre. But what this attitude completely overlooks is his obsessional commitment to helping his fellow artists by means of his charitable work, initially by raising money for the AGBI, which he would help to administer; and then through creating his own charity, Turner's Gift. By the latter means he would aspire to attain the same altruistic and noble end, albeit on a much more limited scale but entirely under his own steam and, ultimately, as the practical half of his legacy. His devotion to helping less fortunate artists would underlie a significant part of his existence after 1815, and his remaining thirty-six years must be perceived in the light of that commitment, for biographically it will provide us with a crucial key to understanding him as a man in the second half of his life.

Turner's Mind

For a long time the painter's confused and often labyrinthine way with words has led to suspicions that he was intellectually unformed, dyslexic or even brain-damaged. The complexity of his images, the vast range of his reading and the huge amount of ground covered by his perspective lectures prove that he was fully formed intellectually, while recent scholarship has disproven the dyslexia.[24] As for the possible brain damage: well, perhaps the mental circuits that processed his verbalising and writing faculties were partially blocked or imperfectly wired, so that his ability to form coherent sentences was somewhat impaired. The brain might well have compensated for that handicap by having him think more in images than in words, thereby enhancing his pictorial faculties by augmenting his extraordinary powers of visual invention and boosting his remarkable responsiveness to form, colour, tone, line, pictorial composition, visual rhythm, paint handling and mark-making. In any case, he was endowed with an unusually intense sense of beauty, a vivid imagination, and that necessary corollary of the latter, an extraordinarily strong power to connect all kinds of experiences and pieces of information, as well as to perceive visual similarities between very dissimilar kinds of objects. When his associative faculties were fed by his acute awareness of poetry, history and geography, he could become an extremely inventive allegorist, as has been discerned repeatedly.

Despite the problems that Turner faced with verbal and written expression, his mind teemed with words. That is why he was par-

ticularly attracted to epic poems such as Virgil's *Aeneid*, Spenser's *Faerie Queene* and Milton's *Paradise Lost*, as well as to equally long works such as Akenside's *Pleasures of the Imagination* that are wholly neglected today because they are generally deemed to be too long, turgid or even completely impenetrable. This attraction to poetry of great length proves that Turner suffered no problems with words *entering* his mind; the difficulties arose only when they left it in spoken and written form. The increasing reliance upon allusiveness in his everyday speech indicates the complexity of his mind, for allusion is never a matter of direct communication, as anyone who has ever attempted a cryptic crossword puzzle can testify. Certainly, many of Turner's images are densely allusive, but therein lies an important part of their reward – the ingenuity that underlies them confers enhanced levels of gratification when their intended meanings are grasped. Turner in full associative flow is definitely not for the imaginatively faint-hearted or the intellectually lazy. To grasp his intended meanings requires courage, patience, a knowledge of poetry, history and geography, a necessary modicum of imagination and – perhaps most crucially of all – the correct cultural mindset. Yet only on rare occasions does he prove a little too difficult to understand, for usually he supplies us with clues he was thinking associatively. In this respect he was not very different from a setter of cryptic crossword puzzles.

More than anything, Turner enjoyed a capacity for mental envisioning that his outstanding technical armoury enabled him to translate rapidly and efficiently into images.[25] In this process he was greatly assisted by his lifelong sketching practice and by his sketchbooks, as well as by his unusually retentive memory. Unsurprisingly, his intense mental visions accorded fully with his thinking about poetic painting and ideal beauty, and they would constantly develop beyond the point we have reached in 1815. Of equal importance, towards the end of the 1810s Turner would begin to raise the intensity of his palette, a process that would be greatly enhanced by his first contact with the brilliance of Mediterranean light in 1819. Naturally, Turner the visionary and Turner the colourist are totally interconnected, which is why they will both receive detailed analysis in the following part of this work.

Long before entering his fifth decade, Turner had gained the summit of his profession, and where landscape and marine painting were concerned he stood alone on that pinnacle. Undoubtedly John Constable could not compete with him professionally, although his long-term influence would be greater. The Bank of England ledgers establish that around the time Turner reached his fortieth birthday – say, on 23 April 1815 – he possessed precisely £10,186-8s-10d in government stock,[26] all of which had been acquired since 1794 but earned in the twenty-eight years since 1787. (By way of comparison, over the same period an ordinary workman on £26 per annum would have earned a mere £735-10s, none of which could easily have been retained in the form of savings or investments.) And there can be no question that Turner also had some cash hidden away too. However, the fame signified little in his eyes, and the money only did so because he perhaps harboured a profound fear that illness would suddenly debilitate him, as it had done his poor mother.

As virtually nothing can be discerned of Sarah Danby after she gave birth to a second daughter by the artist in 1811 or early 1812, it is quite possible that by 1815 their relationship had ended. And despite the lurid fantasies of some, sex appears to have meant very little to Turner, for clearly he found it far less stimulating than painting. Nor was he much interested in political influence, the joys of true love, marriage, bringing up children, serious art collecting, fine food and wines, jewels, the latest in fashion and menswear, a beautiful home, liveried servants, smart equipage and a stables, a proper yacht, and all the other appurtenances of fame and wealth he could so easily have afforded. Only the beauty, immensity, power and complexity of nature (including our own species), the well-being of his father, the support and friendship of a few kindred spirits, the academy to which he belonged, art education, charity towards lesser talents, fishing, poetry, and the life of the paintbrush and of the mind counted, as did the travel that made his existence possible. The rest was just flummery, and would always remain so.

Appendix

Chronology of Turner's government stock transactions between March 1794 and April 1815, as recorded by the Bank of England

In black: acquisitions of stock
In bold: sales of stock

All the dealings were with stock traders whose names are recorded in the Bank of England ledgers but are not given here. Also not shown are individual transaction numbers and the routine bookkeeping ledger transfers of sums accrued. Date queries placed within square brackets are due to omissions or uncertainties in the ledgers.

Abbreviations:
C £3% = Consolidated £3% Annuities or 'Consols'
N £5% = Navy £5% Annuities
R £3% = Reduced £3% Annuities

DATE	AMOUNT	TYPE OF STOCK	COMMENTS	RUNNING TOTALS OF EACH TYPE OF STOCK (£)		
				R £3%	N £5%	C £3%
1794						
4 March	100	C £3%				
7 March	100	C £3%				200
1796						
31 May	50	C £3%				250
16 November	52-1s-2d	C £3%				302-1s-2d
20 December	50	R £3%		50		

DATE	AMOUNT	TYPE OF STOCK	COMMENTS	RUNNING TOTALS OF EACH TYPE OF STOCK (£)		
				R £3%	N £5%	C £3%
1797						
24 January	145-17s-11d	C £3%	Payment for *Fishermen at sea*?			447-19s-1d
27 [Jan]	62-12s-10d	C £3%				510-11s-11d
16 March	50	C £3%				560-11s-11d
9 May	50	C £3%				610-11s-11d
19 September	100	C £3%	Payment for the Mildmay seapiece, B.J. 3?			710-11s-11d
28 November	50	C £3%				760-11s-11d
1798						
15 May [year?]	100	C £3%				860-11s-11d
18 August	39-8s-1d	C £3%				900
2 October	50	C £3%				950
No date but probably 2 October	50	C £3%				1000
1799						
1 August	50	R £3% sold		00		
17 August	50	C £3% sold				950
1802						
11 May	50	C £3% sold				900
1803						
16 March	205-7s-10d	N £5%	Payment from W. Leader for *Conway Castle*, B.J. 141?		205-7s-10d	
3 May	50	C £3% sold				850
19 [Nov?]	150	C £3% sold				700
1804						
21 February	100	C £3% sold				600
6 March	100	C £3% sold				500
8 September [year?]	50	C £3% sold				450
10 October	111-14s-8d	N £5%	Payment from John Allnutt for one of two alpine scenes, or from Walter Fawkes for *Bonneville*, B.J. 148?		317-2s-6d	
1805						
24 May	640	N £5%	Payment from S. Dobree for four paintings?		957-2s-6d	
24 May	150	R £3%	Ditto?	150		

DATE	AMOUNT	TYPE OF STOCK	COMMENTS	RUNNING TOTALS OF EACH TYPE OF STOCK (£)		
				R £3%	N £5%	C £3%
3 July	50	R £3% sold	Money required for tontine share?	100		
11 [July 1805?]	50	R £3% sold	Ditto?	50		
21 July [year?]	350	N £5%	Payment from Lord Egremont for *Ships bearing up for anchorage*, B.J. 18?		1307-2s-6d	
16 August [1805?]	100	R £3%	Payment from John Allnutt for one of two alpine scenes, or from Walter Fawkes for *Bonneville*, B.J. 148?	150		
11 [December 1805?]	100	R £3% sold		50		
1806						
14 January	61-17s-5d	R £3%	Residue from payment from Sir Richard Colt Hoare in December?	111-17s-5d		
11 February	161-18s-11d	R £3%	Residue of 300 guineas received from Sir John Leicester in payment for *Shipwreck*, B.J. 54?	273-16s-4d		
21 February [year?]	107-13s-5d	N £5%	Payment for *Fishermen on the beach*, B.J. 145?		1414-15s-11d	
[no month]	50	C £3% sold				400
8 March [year?]	50	C £3% sold				350
11 April [year?]	50	C £3% sold				300
18 April	100	C £3%				400
21 May	50	R £3% sold		223-16s-4d		
8 September [year?]	37-11s-6d	N £5%			1452-7s-5d	
22 November [year?]	73-16s-4d	R £3% sold		150		
1807						
2 January	50	R £3%		100		
28 January	150	N £5%	Payment from Sir John Leicester of £280 for *Walton Bridges*, B.J. 60, and for B.J. 65?		1602-7s-5d	
28 January	50	R £3%	Ditto?	150		
No date	50	C £3% sold				350
20 March	50	C £3% sold				300

DATE	AMOUNT	TYPE OF STOCK	COMMENTS	RUNNING TOTALS OF EACH TYPE OF STOCK (£)		
				R £3%	N £5%	C £3%
21 March	50	N £5% sold	'Sold for Deposit' [on Twickenham land?], T.B. CXXII-7v		1552-7s-5d	
6 April	100	C £3% sold				200
4 May	100	N £5% sold	'Sold for Land' [at Twickenham?], T.B. CXXII-7v		1452-7s-5d	
No date [4 May?]	200	N £5% sold	'Sold for Land' [at Twickenham], T.B. CXXII-7v		1252-7s-5d	
5 June [year?]	100	R £3%	Payment from W. Penn for *Dunstanborough*, B.J. 6?	250		
4 September	50	C £3%				250
4 September	200	N £5%	Payment from Lord Essex for *Walton Bridges*, B.J. 63		1452-7s-5d	
8 September	50	C £3%				300
10 October	50	N £5% sold	Used towards Twickenham land purchases?		1402-7s-5d	
11 November	50	N £5% sold	Ditto?		1352-7s-5d	
25 November [year?]	158-7s-4d	N £5%	Payment from 'Parker' of 150 gns for *Fishermen becalmed previous to a storm, twilight*, B.J. 8?		1510-14s-9d	
3 December [year?]	159-0s-11d	R £3%	Payment from Lord Egremont for *Thames near Windsor*, B.J. 64?	409-00s-11d		
1808						
12 January	153-9s-9d	R £3%	Payment from Sir John Leicester for *A country blacksmith*, B.J. 68, plus ancillaries?	562-10s-8d		
8 February	100	C £3% sold	For Twickenham land?			200
2 April	164-16s-4d	N £5%	?Payment from Lord Egremont for either *Windsor Castle*, B.J. 149; or *Weybridge*, B.J. 204?		1675-11s-1d	
13 May	50	N £5% sold			1625-11s-1d	
28 June [year?]	250	R £3%	Payment from Lord Essex for *Purfleet*, B.J.74, and Cassiobury watercolours?	812-10s-8d		
12 July [year?]	157-4s-1d	R £3%	Payment from Lord Egremont for *The Thames at Eton*, B.J. 71	969-14s-9d		
29 July [year?]	200	N £5%	Payment from T.L. Parker for *Sheerness*, B.J. 62		1825-11s-1d	

DATE	AMOUNT	TYPE OF STOCK	COMMENTS	RUNNING TOTALS OF EACH TYPE OF STOCK (£)		
				R £3%	N £5%	C £3%
15 August [year?]	304-19s-1d	N £5%	Payment from 'Fawkes' for B.J. 59, and two large 1804 Swiss watercolours		2130-10s-2d	
28 September [year?]	204-12s	N £5%	Payment from Sir John Leicester for *Pope's villa*, B.J. 72, receipted 1 September		2335-2s-2d	
11 November [year?]	100	R £3%		1069-14s-9d		
1809						
4 February	600	N £5%	Payment from Lord Egremont for *Confluence*, B.J. 75; *Bere*, B.J. 77; and *Margate*, B.J. 78		2935-2s-2d	
22 [February?]	70-7s	N £5%	Taken from £100 'Per contra' payment from Fawkes for commissioned watercolours		3005-9s-2d	
7 May	100	C £3% sold				100
No date but probably 22 July	200	N £5%	Payment from 'Essex' for *Trout fishing*, B.J. 92		3205-9s-2d	
26 [no month or year]	70-12s-1d	N £5%	'interest'		3276-1s-3d	
31 [no month or year]	201-12s-10d	N £5%	'Egremonts': payment for *Thames Lock*, B.J. 88		3477-14s-1d	
8 September [year?]	632-7s-3d	N £5%	Payment by [William] 'Leader' for *Thomson's Æolian Harp*, B.J. 86		4110-1s-4d	
1810						
3 January	100	R £3% sold		969-14s-9d		
19 January	50	C £3%	'Oxford': payment by Clarendon Press?			150
16 May	143-12s-6d	R £3%	Payment by G. Philips for *Linlithgow*, B.J. 104	1113-7s-3d		
No date [18 May]	142-12s	R £3%	Ditto	1255-19s-3d		
25 May	423-5s-7d	C £3%	Payment by Pelham for *Transport ship*, B.J. 210			573-5s-7d
[15 June?]	428-11s-5d	R £3%	Payment by Lord Egremont, including for *Cockermouth*, B.J. 108	1684-10s-8d		
18 [June 1810]	598-18s-7d	R £3%	Payment by Lord Lonsdale for two *Lowther Castles*, B.J. 111 and 112	2283-9s-3d		
26 July	250	C £3%	Payment by J. Fuller for *Fish market*, B.J. 105			823-5s-7d

DATE	AMOUNT	TYPE OF STOCK	COMMENTS	RUNNING TOTALS OF EACH TYPE OF STOCK (£)		
				R £3%	N £5%	C £3%
26 November [year?]	250	C £3%	In part, payment by J. Fuller for *Rosehill*, B.J. 211			1073-5s-7d
1811						
12 March	26-14s-5d	C £3%				1100
9 July	265-2s-5d	N £5%	Includes £191-7s paid by J. Fuller on 8 July for five watercolours		4375-3s-9d	
12 [no month or year]	31-5s-1d	N £5%			4406-8s-10d	
17 August	**50**	**C £3% sold**	Money used for building at Twickenham?			1050
25 [August?]	**50**	**C £3% sold**	Ditto?			1000
12 September [year?]	**50**	**C £3% sold**	Ditto?			950
10 December	**400**	**R £3% sold**	Ditto?	1883-9s-3d		
1812						
14 January [year?]	400	R £3%	Payment received from Sir John Leicester for the two Tabley pictures, B.J. 98 and 99?	2283-9s-3d		
26 February	80	C £3%				1030
26 March	**80**	**C £3% sold**				950
23 September [year?]	125	C £3%	Payment by John Gibbons for *Bonneville*, B.J. 124?			1075
14 October	**25**	**C £3% sold**	Twickenham expenses?			1050
3 November [year?]	**50**	**C £3% sold**	Ditto?			1000
15 December	**100**	**R £3% sold**	Ditto?	2183-9s-3d		
1813						
5 March	450	R £3%	Payment by Lord Egremont for *Hulks Tamar*, B.J. 119, and for *Teignmouth*, B.J. 120	2633-9s-3d		
23 March	600	C £3%	Payment by Sir John Swinburne for *Mercury and Hersé*, B.J. 114.			1600
16 June [year?]	260	R £3%	Payment by Lord Egremont for *Narcissus and Echo*, B.J. 53	2893-9s-3d		

DATE	AMOUNT	TYPE OF STOCK	COMMENTS	RUNNING TOTALS OF EACH TYPE OF STOCK (£)		
				R £3%	N £5%	C £3%
21 July [year?]	400	R £3%	Alternative payment on this date by Sir John Leicester for the two Tabley pictures, B.J. 98 and 99? Or payment by John Green for *Bonneville*, B.J. 46, and *Venus and Adonis*, B.J. 150?	3293-9s-3d		
19 October	200	R £3% sold		3093-9s-3d		
1814						
4 January	200	R £3%	Payment by Fawkes?; or from others for B.J. 91, 107 or 206?	3293-9s-3d		
19 [month, year?]	100	R £3%	Payment by Fawkes?	3393-9s-3d		
12 May	200	N £5%	Payment by Fawkes?; or from others for B.J. 91, 107 or 206		4606-8s-10d	
No date	100	R £3%		3493-9s-3d		
9 June (and sale also recorded on add. doc. 2 in T.B. CXXII)	50	R £3% sold		3443-9s-3d		
30 August [year?]	50	R £3%		3493-9s-3d		
20 November [year?]	76-3s-9d	R £3%	'interest'?	3569-13s-0d		
1815						
28 February	100	N £5%	Payment by Colt Hoare for *Lake Avernus*, B.J. 226		4706-8s-10d	
28 February	30-7s	R £3%	Ditto?	3600		
21 March [year?]	130	N £5%	Payment by Fawkes?		4836-8s-10d	
15 April	150	C £3%	Ditto?			1750

Notes

For the keywords used here as abbreviations – usually in the form of just an author's surname and short title – please see the Bibliography.

Preliminary Pages

The Tom Kempinski quote appeared in an interview with the playwright and actor in *Time Out* magazine, London, 19 September 1980. The mallard drawing by Turner appears in an undated letter to Augustus Wall Callcott (see Gage, *Correspondence*, 231, letter 329). For the statement by Thomas Cole, see page 14 of an 1829 notebook kept by the painter that now belongs to the New York State Library, Albany. It is quoted in Kelly, 'America', 233. The statement by William Havell appears in a letter to John Pye of 24 December 1851; see *MS:* MSL/1939/1211/12. For the statement by Turner, see Reeve, 'Obituary', 924.

1 Antecedents and Early Years

1 According to a codicil to a will that was signed and sealed on 30 September 1829. It has not survived except in an imperfect copy that was probably written by Turner. See Finberg, *Life*, 8, 329; and also Whittingham, *Will*, 2: 3. In this document Turner bequeathed money to the Royal Academy of Arts to enable it to hold an annual dinner on '23rd of April (my birthday)'. The day seems curiously serendipitous, for it marks both St George's Day, the name day of the English patron saint, and also the birth and death days of William Shakespeare. Additionally, between 1818 and 1830, 23 April acted as the official name day of the Prince Regent, who in 1820 would become King George IV. Turner would pictorially allude to that celebration on at least two occasions.

2 William's father, John (1715–1762), had also been a perruquier and barber in the same town before taking up the manufacture and sale of horse saddles and their accoutrements. He had married Rebecca Knight on 1 August 1739. Her date of birth is unknown; she died in 1802. They produced seven children: Eleanor (1740–1784); John the younger (1742–1818); William, the painter's father (1745–1829); Price (1746–1831); Mary (birth date unknown but died around 1805); Joshua (1757–1816); and Jonathan (1760–1831). John the younger followed his father into the saddling business, as well as taking up the combing of wool. Later he became the Master of the Poorhouse in Barnstaple, north Devon, where J. M. W. Turner would visit him when touring the West Country in 1811 and 1814. Price Turner also became a saddler, but in Exeter, south Devon. Joshua moved to London where he became a Customs Clerk in the Storekeeper's department of the Excise Office. Jonathan became a prosperous baker in Bath where he nursed his mother in her final days. Both of John and Rebecca Turner's daughters married.

3 Thornbury, *Life*, 1862, 1: 6.

4 Turner's maternal great-great-great-great-grandfather was a skinner and glover named John Mallard, who was born around 1577 and died in 1657. He resided in the parish of St Botolph-extra-Bishopsgate, London. In about 1628 John Mallard married, but the maiden name of his wife, Mary, is unknown. Between 1629 and 1640 they had seven children. John Mallard's eldest son, also named John, was possibly born in Chignell, Essex, but was baptised in 1615 in St Giles's Church, Cripplegate. Like his father, he too was a skinner. He appears to have married three times, with five children issuing from those unions. His second son, Joseph, was probably born in 1646. Apprenticed as a butcher in 1663 and employed as both a butcher and meat wholesaler by 1670, Joseph Mallard lived at St Leonard's, Eastcheap, and thus near a major thoroughfare down which cattle were herded into London for sale or slaughter at the nearby Smithfield market. His wife Martha's premarital surname is unknown. Joseph Mallard

died in 1688, leaving a daughter and a son, Joseph, who is referred to in the main text below.

5 Joseph Mallard/Mallord had also been a butcher and meat wholesaler, and was twice elected Master of the Worshipful Company of Butchers. In 1695 he married Sarah Marshall.

6 The first of their children was yet another Sarah Marshall, who was born in 1733. Subsequently she married the Revd Henry Harpur (1732–1790), the Curate of St Mary's, Islington, who subsequently became the vicar of the parish church in Tonbridge in Kent. She died in 1809. Their grandson, Henry Harpur (1792–1877), would eventually become Turner's solicitor and one of his executors. The third child was Ann, who was born in 1737 and died in 1762.

7 As can be seen from the foregoing, Joseph Mallord William Turner's forenames were deeply rooted in his family history, as were those of his maternal uncle. The painter did not like 'Joseph' and would never use it. Perhaps he considered it too biblical, plebeian or prosaic, or did not much care for its popular diminutive, 'Joe'. Although he would hardly ever employ the 'Mallord' part of his name either, he would occasionally pun upon it pictorially by using depictions of mallard ducks as surreptitious signatures in the forefront of his images. His preferred Christian name was 'William', just as it was for the uncle whose forenames had been bestowed on him. William was the name all Turner's friends used for him. But judging by his surviving letters, he would never sign them with that name, not even when writing to his father. Instead, he would always use 'J. M. W. Turner', or occasionally just 'J. M. W. T.' When it came to written communication, he would always remain impeccably formal.

8 Finberg, *Life*, 8.

9 Maiden Lane is a narrow thoroughfare aligned along a north-east to south-west axis. The houses that lined the street by the 1770s mostly dated from between 1631 and 1728. Throughout Turner's lifetime it was closed to vehicular traffic at its eastern end. Its name was first registered in 1636. Possibly it derived from a corruption of 'Midden Lane' (the area later covered by the street having originally been used for dumping waste from the nearby convent); from a statue of the Virgin Mary that had once stood on a corner when it was first constructed; or from the prostitutes who had habitually used it (and would go on doing so throughout Turner's era). The poet Andrew Marvell (1621–1678) had lived there in 1677, while in 1696 a meeting of conspirators against King William III (1650–1702) had taken place in a 'Jacobite tavern' in the street. When Voltaire (1694–1778) was exiled from Paris in 1727–8, he resided in the White Wig Inn, an establishment that also came to be known as the White Peruke or White Peruque Inn (the various names were due to the fact that the hostelry simply identified itself by means of a street sign sporting a wordless image of a white wig). It was in these lodgings that the French philosopher and writer had penned his 'Essay upon the Civil Wars of France', which was first published in England in 1727 and in France the following year.

10 Previously the ground floor of the building had formed Moreing's Auction Room, in which the Free Society of Artists had mounted exhibitions in 1764 and 1765. A similar organisation, the Incorporated Society of Artists of Great Britain, had also rented that space between 1769 and 1772 for the teaching of painting, drawing and modelling; aspiring painters who worked from the life there included George Romney (1734–1802), Joseph Farington, Ozias Humphry and Francis Wheatley. Below Moreing's Auction Room lay a cellar of identically large proportions, while above it stood a set of smaller rooms. At some point between 1772 and early 1774 the spacious saleroom and the spaces above and below it were divided down the middle from front to back in order to bring 20 and 21 Maiden Lane into existence.

11 They had officially taken over the property on Lady Day, 25 March, 1774. The annual rateable value was £30, which required the yearly payment of £2 in rates (Rate Book for the Parish of St Pauls', Covent Garden, reels H127 and H128 for 1795, City of Westminster Archives Centre; and also Bailey, *Life*, 3). We do not know what was paid in rent. The claim has erroneously been made by previous Turner biographers that William Turner was paying a rent of £30 per annum, which is not the same as an annual rateable value to the same amount.

12 See E. J. Burford, *Wits, Wenchers and Wantons*, London, 1986, 233–4. Wheatley, *London*, 20, also informs us that the Cider Cellar was 'much in vogue for devilled kidneys, oysters and Welch rabbits, cigars, "goes" of brandy and great supplies of London stout'. James Hamilton's claim, in *London Lights*, London, 2007, page 10, that Turner slipped into the Cider Cellar 'in the 1790s' and became 'richly knowledgeable in the classics' by sitting at the feet of the alcoholic Cambridge professor, Richard Porson (1759–1808), who frequented the dive, is unsupported by any evidence.

13 Almost certainly William Turner now became a subtenant in the new abode, with his landlord paying the Poor Rate. Not until Lady Day, 1795, would William Turner's name appear once again in the Maiden Lane Poor Rate book, which suggests that his landlord may have moved or expired by then, leaving William to take over the head lease, and thus the payment of the Poor Rate as well. See the Rate Book for the Parish of St Pauls', Covent Garden, reels H97 and H98 for 1776, City of Westminster Archive Centre.

14 Armstrong, *Turner*, 18.

15 See Cunningham, 'Memoir', 20.

16 Thornbury, *Life*, 1862, 1: 74.

17 This discovery was made by Anthony Bailey; see Bailey, *Life*, 8 and n.15, the latter passage of which is worth quoting here in full: 'Previous biographers have been led astray about the date of Mary Ann's death. After Turner's death, when lawyers were seeking to establish whether he had living siblings, the parish clerk at St Paul's, John Spreck, looked through the registers, missed the 8 August 1783 entry for Mary Ann and found another "Mary Ann Turner from St. Martin in the Fields" who was buried in St Paul's on 20 March 1786 and has since been assumed to be J M W T's sister' [Church of St Paul, Covent Garden, Parish Registers Volume 5, Burials, 11 May 1767 to 31 Dec 1796, City of Westminster Archives Centre]. I am indebted to Mr Bailey for permitting me to quote his footnote.

18 When sulphur dioxide comes into contact with water, and therefore with lung moisture, it turns into sulphuric acid. The Laki eruption threw more than 120 million tons of sulphur dioxide and eight million tons of hydrogen fluoride into the upper atmosphere, from where a thick vapour slowly returned to ground level (see J. P. Grattan and M. B. Brayshay, 'An Amazing and Portentous Summer, Environmental and Social Responses in Britain to the 1783 Eruption of an Iceland Volcano', *The Geographical Journal*, 161, 2, 1995, 125–34). That summer was anyway the hottest on record, and in the absence of winds, the noxious cloud caused by one of the largest volcanic eruptions of the last millenium drifted slowly in a great arc over Scandinavia, Germany and northern France before crossing the shores of

south-east England on Sunday 22 June 1783. By the following day it had blanketed the entire British Isles, and it hung around for months, which is why that summer was called 'the sand summer' due to the fine film of volcanic ash coating everything.

19 Thornbury, *Life*, 1862, 1: 6.

20 Mary Ann Widgery, Chancery Affadavit, 24 January 1854, Dossier f.72, quoted in Bailey, *Life*, 426, n.28.

21 Marshall paid for seat 46, at the back downstairs in St Lawrence's Church, Brentford, from 1783 until June 1794, when he moved to seat 34 at the front downstairs in that church until 21 April 1803. His last Poor Rate payment in Brentford was in June 1802. He would hardly have paid for a pew seat and disbursed money on the Poor Rate if he was not resident in Brentford. See Marshall, 'J. M. W. Marshall', 5. Tim Marshall's findings also appear in Whittingham, *Geese*, I: 2, 19.

22 In 1938, Falk (*Hidden Life*, 23) stated that 'Mrs Turner...subsequently deteriorated in health, a suspicious symptom being the advent of a stillborn male child.' He furnished no evidence in support of that claim.

23 J. M. W. Marshall rented a 'dwelling house, yard and sheds' from a brewer with extensive property interests in the area, Abraham Harvest (1697–1790). Turner's uncle was first listed as paying rates there in 1777; by 1785 the rateable value of the property was £7 per annum (See Hammond, 'Connections', 9). The house would be demolished and replaced, probably in the 1820s.

24 For the pupil numbers, see Thornbury, *Life*, 1862, 1: 20. Funding for the institution derived from fees paid by those parents who could afford them, from the parish Poor Rate for those who could not, and from gifts and bequests. Until February 1788 the school occupied one of nine houses in Boar's Head Yard near warehouses down by the Thames. It then moved to larger premises, an old baker's shop next to the Magpie and Stump pub in Brentford High Street and opposite the Three Pigeons Inn (to both of which establishments the schoolmaster is said to have frequently repaired). Many years after Turner had left Brentford, the building would become a clothier's shop. This was accorded the address 125 Brentford High Street when the north side of the marketplace became absorbed into a major thoroughfare. The building was demolished in 1951 when the highway was widened.

25 Thornbury, *Life*, 1862, 1: 19.

26 Thornbury, *Life*, 1877, 10.

27 Thornbury, *Life*, 1862, 1: 18.

28 See Shanes, *Explorations*, 34–5 for an extensive discussion of the tragedy and of Turner's depiction of it in *Loss of an East Indiaman*, W. 500, which is now in The Higgins, Bedford.

29 *Historical Descriptions of New and Elegant Picturesque Views of the Antiquities of England and Wales, &C.* by Henry Boswell, Robert Hamilton and several anonymous contributors, had first appeared in 100 parts at intervals throughout the 1770s and 1780s. Accompanying the illustrations were letterpress texts on more than 400 cathedrals, churches, monasteries, castles, fortifications, palaces, great houses, ruins, ancient remains and the like, as well as sections on various British counties, cities and towns. Also included were maps, plans, diagrams, reproductions of ancient seals of office, representations of old carvings, floral decorative images and the like. The majority of prints appeared two to a page, but some were placed three or even six to a page. Mostly the images were by anonymous draughtsmen and engravers, and almost all of them were poorly drawn and crudely cut. The '&C' included at the end of the title permitted the publication to accommodate a great many Scottish and Irish subjects as well. Lees had obtained his copy of Boswell's *England and Wales* late in 1786 or during the following year.

30 See *Minutes of Brentford Urban District Council*, vol. 87, 1920–21, 419, minutes for 15 November 1921 containing a report of the Library and Museum Committee meeting of 2 November 1921. This states that the grandaughter of John Lees, Elizabeth Lees, who lived in Boston Park Road, had presented a 'very valuable and unique copy of Boswell's Antiquities of England and Wales to the Library' and that it contained 'about 70 plates which were coloured by J. M. W. Turner when he was a boy attending school, about the year 1785'.

31 This was first suggested by Finberg, *Inventory*, 1: 1.

32 Thornbury, *Life*, 1877, 9 tells us that '"Margate Church", executed by the artist when he was about nine years old, is one of his early drawings. Indeed, it is one of the boy's earliest works that I have yet heard of. I have not myself seen drawings of an earlier date than his eleventh or twelfth year.' It may be that the depiction of 'Margate' church that Thornbury had 'heard of' but clearly not seen was this view of Sunningwell church, and that his informant was Ruskin, who enjoyed access to the Turner Bequest and who could easily have made the misidentification, given that he knew virtually nothing of the Sunningwell connection.

33 See Connor, *Rooker*, 109 and 113. Boswell's *England and Wales* contains a far less sophisticated representation of the same view, but there is no way of knowing whether it was Turner who tinted that image.

34 Sarah Trimmer's husband, James (1737–1792), was the owner of a Brentford tileworks and a number of brick kilns just downriver from Kew Bridge. The Trimmers had nine surviving children when Turner attended school in Brentford. Originally Sarah Trimmer had hailed from Ipswich and her father had been a close friend of Sir Joshua Reynolds PRA, William Hogarth and Thomas Gainsborough RA. Indeed, the friendship between Kirby and Gainsborough was such that when the latter was drawing up his will, he requested that he be buried alongside Kirby in Kew churchyard, a wish that was fulfilled. Kirby wrote an influential treatise on perspective, a copy of the 1765 third edition of which would make its way into Turner's library, probably around 1808, although almost certainly he read it well before then. Kirby also taught perspective to George III when Prince of Wales, and he later acted as Clerk of Works to the prince when the latter modernised the old palace at Kew (which is why the architect moved just across the Thames to Brentford in 1759).

35 Thornbury, *Life*, 1862, 2: 57–62.

36 At that time Members of Parliament were elected by counties, by urban and rural boroughs, and by the universities of Oxford and Cambridge.

37 See notes 34–6 to Chapter 3 of the electronic version of this biography for detailed evidence regarding Marshall's voting pattern.

38 For example, see 'Journey from London to Brentford' by Sir Joshua Reynolds. This is a short parody of a travel book by Giuseppe Baretti (see Hudson, *Reynolds*, 246) in which Sir Joshua stated that John Wilkes's name 'is wrote on every door window shutter and dead wall throughout the Town either with letters or Hiroglifick figures'. Clearly, the 'Hiroglifick figures' were the number

'45' daubed multitudinously. Admittedly, Reynolds wrote this in 1770 or 1771, and therefore at least fifteen years before Turner ever set foot in Brentford. However, even by 1770 more than a year had passed since the most recent parliamentary election, so Reynolds's testimony proves how long the pro-Wilkes political graffiti could remain visible. Wilkes's name and the 'Hiroglifick figures' must also have been widely daubed during the 1784 election, and they surely remained apparent for a long time afterwards as well. At the time of publication by Hudson, Reynolds's manuscript was owned by Mrs A. T. Copland-Griffiths. Its present whereabouts are unknown.

39 T.B. I-I, which was accorded the title *House among Trees* by A. J. Finberg in his 1909 inventory of the holding. Unfortunately, it was destroyed in the Tate Gallery flood in 1928.

40 It will be recalled that Turner had moved to Brentford in 1785. According to his uncle, he spent three years there (see Farington, *Diary*, 6: 2028, 12 May 1803). Thornbury was 'assured' that Turner was 'at school at Margate at thirteen' (*Life*, 1862, I, 49). His source had to have been Henry Scott Trimmer, who was in a strong position to know when Turner went to school in Margate, as will be seen shortly. Despite this, most of the painter's biographers have placed him there in 1786 at the age of 12. This overlooks the 25 November 1786 publication date of Boswell's *England and Wales*, which means that Turner cannot have begun laboriously colouring seventy or so plates in that book until very late in 1786, or more likely in 1787 and possibly into early 1788 as well. Moreover, watercolours to be explored below that were made by Turner in Margate in the late 1780s will demonstrate that their creator was clearly in the Kent resort in a summer month or months, and that the summer in question had to have been the one in 1788.

41 Thornbury, *Life*, 1877, 14. Coleman (dates unknown but probably died in 1804 or 1805) hailed from the village of St Nicholas at Wade, to the west of Margate. In his youth he had lived in London. Possibly back in east Kent, he had converted to Methodism, the preacher John Wesley being very active in that part of the county. Around 1767 Coleman had moved to Margate to set up his school.

42 Coleman had founded Methodist chapels in these villages in 1778. See Bretherton, *Margate*, 13. A copy of Bretherton's pamphlet is to be found in Margate Reference Library (the British Library lacks one).

43 In 1805 Coleman's school would be sold by his executors, subsequently to become Faulkner's Chapel, a Calvinist place of worship. A conveyance of 1843 tells us that by that time the property would comprise forecourts, a kitchen cum dwelling-room, a storeroom and the schoolroom that subsequently became Faulkner's Chapel (see Charles James Feret, 'Love Lane Chapel' in 'Bygone Thanet', *Isle of Thanet Gazette*, 14 February 1914, 8, for the report of a conveyance of 15 April 1843 to one Richard Woodward). The fact that the schoolroom would later house a religious congregation demonstrates that it must have been fairly large in size.

44 See Yarde, *Sarah Trimmer*, 17–18.

45 Ibid., 83 for Henry Scott; and 63–4 for Elizabeth.

46 As Doris Yarde informs us (ibid., 63), 'The prevalent malady of the time, consumption [or tuberculosis] was a complaint from which many Brentonians died during the latter part of the eighteenth century.'

47 John having been born in February 1775, he was only two months or so older than Turner.

48 This possibility gains support from the fact that Thornbury knew of Turner having attended Thomas Coleman's school, for only Henry Scott Trimmer could have furnished him with that information within the biographer's circle of acquaintances. Such knowledge betokens having shared the same school, and possibly the same roof too.

49 See Thornbury, *Life*, 1862, 1: 25. Yarde (*Sarah Trimmer*, 19) notes that the Trimmers owned their own coach, so the family probably travelled by that means from Brentford to the Pool of London for embarkation on a Margate hoy. The alternative, that they travelled to Margate entirely overland, would have taken two to three days longer and necessitated staying in hostelries, as well as a great deal more discomfort when travelling.

2 London Again

1 Turner must have returned to London from Margate in the autumn of 1788, for so much would happen between his homecoming and his entry to the Royal Academy Schools at the end of 1789 that it is difficult to fit all those events into a timeframe that can begin any later. For the Soho Academy, see Martin Clare and the Revd Cuthbert Barwis, *Rules and Orders for the Government of the Academy in Soho Square, London*, London, published between 1744 and 1751; *Survey, St Anne's*, 61; and Thornbury, *Life*, 1862, 1: 24. There is no reason to doubt Thornbury's claim that Turner attended the Soho Academy, especially in light of the biographer's awareness of the way that Turner was taught drawing there and by whom (for which, see note 2 below). Thornbury could well have picked up his knowledge of Turner's attendance at the Soho Academy from someone who had known Turner in 1788–9, such as Henry Scott Trimmer. Probably because Thornbury only ever referred to 'the Soho academy' – with the latter word remaining uncapitalised – all previous biographers of Turner have overlooked his mention of a particular school.

2 Thornbury, *Life*, 1877, 14 states that Turner's teacher was 'a Mr Palice, a floral drawing-master' who taught 'drawing flowers and other objects, after the tambour-frame manner'. Tambour frames were not employed as drawing supports but for the stretching of silks, muslins or other fabrics for embroidery purposes. For pupils to have drawn flowers and other objects 'after the tambour-frame manner' must therefore mean that they depicted 'flowers and other objects' in the manner stated.

3 Watts, 'Sketch', ix–x; and Thornbury, *Life*, 1: 1862, 13–4; 1877, 6.

4 See D'Oench, *Smith*.

5 Thornbury, *Life*, 1862, 1: 53. The biographer obtained this information from Henry Syer Trimmer, who had received it from Turner in the late 1810s at the earliest.

6 It enjoys an impeccable provenance. When Turner was about to destroy it towards the end of his life he was begged by his housekeeper, Hannah Danby, to give it to her instead, which he did. In 1854 she bequeathed it to Ruskin, from whom it passed through various hands to the Indianapolis Museum of Art.

7 Thornbury, *Life*, 1862, 1: 258, which states: 'As early as the age of thirteen, Turner had been copying pictures of Morland in oil.' It is difficult to imagine where Turner could have copied paintings by Morland other than in Smith's workshop, for it is extremely unlikely that his parents possessed any at home. And if Thornbury's assertion regarding Turner's age is also correct, then

the boy was labouring for the engraver before April 1789 when he reached the age of 14.

8 Lloyd, 'Memoir', 22.

9 Thornbury, *Life*, 1877, 31.

10 John Ruskin asserted that Turner's first drawing-master was Mauritius Lowe (*Works*, 5: 409, note), and obviously he did so on the basis of information received from the latter's daughters. They surely told the truth, for Lowe was qualified to furnish the assistance that Turner badly needed in 1789 if he was to obtain entry to the Royal Academy Schools.

11 Thornbury, *Life*, 1862, 1: 57.

12 A Mr Crutchley quoted in the entry for Lowe in Samuel Redgrave, *A Dictionary of Artists of the English School*, London, 1878, 277.

13 Signs that Turner's command of perspective was beginning to improve appear in drawings dating from about June 1789, while the last perspectival and stylistic input from Malton is evident some two-and-a-half years later, early in 1792. At the latter time, Turner created *The Pantheon, the morning after the fire* (fig. 56), a watercolour that is so Maltonian in its treatment of perspective, buildings and figures that it could almost be a postgraduate exercise in which Turner sought to show off everything he had learned from his former teacher. If that was the case, then the tuition period could well have been completed only a short time before, say in December 1791.

14 Thornbury, *Life*, 1862, 1: 47.

15 It should be noted that in Malton's original drawing (fig. 24), the colour red was used to fringe the cloak of the woman crossing the street with the little boy, for the uniforms of the distant soldiers (understandably), for the jacket of a gentleman emerging from under the portico at the centre-left, for the hair of a woman walking with a gentleman further to the left, for the hair of both men looking down on the drawing boy, for that boy's hair and trousers, and for the gloves of the man on the extreme left. Clearly, Malton had a very restricted range of pigments on his palette when elaborating the watercolour. This limitation should forestall any criticism that the boy drawing on the pavement could not be Turner because he has red hair. Obviously his hair was represented that colour because red was the only pigment Malton could use when making the drawing.

16 Folio 22 of the *Oxford* sketchbook, T.B. II.

17 Pressly, 'Rigaud', 105.

18 Thornbury, *Life*, 1877, 32.

3 In Sir Joshua's House

1 The portrait has to date from after December 1789 when Turner entered the Schools, for if Dance had been known to him before that time, then he could have been asked to back Turner's Schools application rather than Rigaud. The work also had to have been created before August 1792, when Dance would make a signed and dated portrait of Turner (see p. xiv).

2 For analysis of this possibility, see the electronic version of this work.

3 B.L., Add. MS. 46,151-K, fol. 2.

4 All the discourses had been published within a year or so of having been delivered, sometimes in pairs. The Royal Academy Library might well have possessed copies of the individual *Discourses* prior to 1797 (when the institution was presented with the first collected edition of Reynolds's writings), but no records of such holdings have survived. Additionally, a collection of seven of the lectures had been brought out in 1778 by Thomas Cadell.

5 See Eric Shanes, '*The Dover Mail* – by Turner or by 'Girtoin'?', *Turner Society News*, 121, Spring 2014, 4–9.

6 See the Malton posthumous sale catalogue, Christie, Manson and Wood, London, 4 and 5 May 1804, lots 10 to 16. There is a copy of it in the National Art Library, Victoria and Albert Museum, London.

7 Leslie, *Recollections*, 1: 145. Turner could not have worked in Reynolds's studio before he enrolled in the Royal Academy Schools in December 1789, for had he painted there by that time he could have asked Reynolds to sponsor his Schools application instead of having to cast around for a sponsor and come up with J. F. Rigaud.

8 Finberg had access to a 30 May 1860 letter written by Ann Dart to John Ruskin which has subsequently disappeared (see *Life*, 27–8 and 50–51). Within the letter it is possible to differentiate between Narraway family memories of having met Turner from 1791 onwards, and Ann Dart's recollections of having met him, an encounter that Finberg quite rightly dated to 1798 (she had erroneously placed it in 1800).

9 Atkinson, 'Bristol', 71, tells us that Turner later lent Miss Narraway £35 and that as no evidence of the debt was found among the painter's papers following his death, it appears likely he had destroyed the promissory note upon which the loan had been secured. Atkinson further relates that Turner lent money to Narraway's son from time to time.

10 See Finberg, *Life*, 27.

11 See Atkinson, 'Bristol', 70. A note stating that Turner had 'crooked legs' was reputedly scrawled by John Narraway on the reverse of the frame of the *South Porch of St Mary Redcliffe Church, Bristol* watercolour that was once owned by the Bristol fellmonger (W. 16, City Museum and Art Gallery, Bristol).

12 It was burned down at the behest of its backers, who also owned the rival opera house, the Haymarket Theatre. They had engineered its destruction because it drew business away from its rival. See Price, 'Pantheon', 7. Although Price suggested that Turner had actually worked in the Pantheon Opera House as a scene-painter between 30 April and 18 June 1791, the idea does not withstand scrutiny (see Milhous, 'Pantheon'). Instead, it is highly likely that the William Turner employed at the Pantheon Opera House in 1791 was the 'Mr Turner' who had painted in 1785–6 at the Covent Garden Theatre and who may have been the William Turner (1763-c.1816) who had studied at the Royal Academy Schools in 1785, almost five years before J. M. W. Turner entered them. In 1787 this other William Turner had exhibited *Dover Castle* (cat. no. 471); and *View of Wanstead house, the seat of Sir James Tinley Long* (No. 601). Both works were displayed in the Exhibition Room of Sculptures and Drawings. For an example of the confusion with J. M. W. Turner in this context, see Sandby, *Royal Academy*, 1: 317. The other William Turner may also have been the painter of the *Naumachia* or 'sea battle' that was exhibited in premises in Bouverie Street, London, in 1799–1800 (see Gage, 'Picturesque', I, 24 and Appendix).

13 T.B. CXCV-156.

14 Soane, notebook 18, 4.

15 See Shanes, 'More art' for a detailed analysis of the Sandby drawing. Among many other matters – including the identification of most of the works depicted by Sandby – that essay establishes that just such a divide, plus the angled display of works above the line, was created in the Antique Room after it began to be used as a display area in 1792. The line had first been introduced in the Great Room and Anti-Room on the top floor, as well as in the Exhibition Room on the ground-floor. Subsequently it appeared in the first-floor rooms as they were gradually

brought into use as display areas. Such divisions standardised the room displays throughout the Royal Academy Exhibitions. The phrase 'to put one's reputation on the line' derived from the practice of creating large paintings that would hang upon the line, and thus create or consolidate a reputation within the exhibitions. Works were hung above or below the line but rarely across it. Above the line all the works were attached to a subframe that tilted outwards from the wall (with that supporting structure itself being fixed to the wall and hidden from view principally by the works themselves, as well as by drapes hung behind them in the Great Room). This support permitted the works to hang at an identically oblique angle, and therefore to be viewed frontally from virtually any distance, rather than appear in a convergent perspective that distorted their appearance as they ascended the wall. The screen on which *Malmsbury Abbey* and *The Pantheon, the morning after the fire* were hung served to hide all the plaster casts and drawing paraphernalia normally used in the Academy of the Antique.

4 Six Advantages and a Demand

1 As Ian Warrell has suggested to the author, Turner had possibly taken a day trip down to Petworth from Windsor or Guildford earlier in 1792, and drawn Petworth Church on that occasion.

2 At some point after 1836, W. L. Leitch (1804–1883) would see Turner work upon four watercolours during the same work session (see Sparrow, 'Later Water-Colours', section w, vii–viii). We also possess testimony, to be quoted in the subsequent volume of the present work, that Turner underpainted sheets of paper with colour washes in batches.

3 W. L. Leitch quoted in Webber, *Orrock*, 60–61.

4 See Reeve, 'Obituary', 924.

5 W. 53. The work was catalogue 388 in the 1794 Royal Academy Exhibition and is now in a private collection.

6 Reynolds, *Discourses*, 135.

7 Thornbury, *Life*, 1862, 1: 162.

8 The author is grateful to Ian Warrell for drawing his attention to this link.

9 For a further example of this approach, see the treatment of foliage in the 1792 drawing of Craig y foel, as reproduced and discussed in Wilton, *Wales*, 37.

10 The Rowlandson drawing is now in the British Museum Department of Prints and Drawings (accession number, 1931, 1114.88). The complementary work by de Loutherbourg was *A summer's evening, with a view of a public road*, now untraced. In the 1776 show the paintings had formed exhibits 174 and 175 respectively; they are Lefeuvre, *Loutherbourg*, cats. 131 and 132. Rowlandson could also have known the many satirical prints after designs by de Loutherbourg that were then in circulation. A good number of them are also in the British Museum.

11 These appear on a small piece of card, T.B. XVII-S, with a few lines from the poem quoted on the back.

5 The Only Turner Prize

1 Gage, *Correspondence*, 70, letter 71, 21 November 1817 to James Holworthy. Mention of 'ringing in my ears' establishes that Turner had actually heard Barry deliver his lecture, rather than simply read it after it was published in book form in 1809.

2 There is no Hambleton in Surrey but there is a Hambledon. However, analysis of eighteenth-century maps of Surrey in the British Library Map Room – maps that bear the names of all the farms across the county – disclosed no property of that name either (especially useful in this respect was John Rocque's 'A Topographical Map of the County of Surrey/In which is Expressed all the /Roads, Lanes, Churches, Nobleman's And Gentleman's Seats' &c., &c.', London, 1762). There is a Lodge Farm at Hambleton in Rutland, but Turner is not known to have visited that county by 1793.

3 In 1923 its velvet mount and frame were described as being 'not at all faded', which suggests it had long been hidden away. See Carey, 'Relic'.

4 The array of tones breaks down as follows:

A warm underpainting of light yellow ochre	1
The sky	3
The tower, including variants of the red used for the tiled roof slightly to the right	40
The shadowed side of the gatehouse and buildings into the distance	4
The blocks in front of the gatehouse	3
The buildings on the left and right	3
The trees and shrubbery	7
TOTAL	61

5 See Foss, *Double*, 40.

6 See Kitson, 'Rembrandt', 7; and Ziff, 'Backgrounds', 145.

7 The author is very grateful to Pieter van der Merwe for identifying this building as a mill, and for sharing his knowledge of the Avon Gorge in relation to the watercolour. Moreover, he is equally grateful to Professor Sam Smiles for drawing his attention to architectural similarities between this building and The Colonnade at Hotwells, Bristol, a link that strengthens the Avon Gorge association, as Professor Smiles also points out. A depiction of The Colonnade was made in 1788 by the Swiss artist Samuel Hieronymus Grimm (1733–1794).

8 See R. S. Fitton, *The Arkwrights: Spinners of Fortune*, Manchester, 1989, 30, 50, 146, 201–2.

9 In his fourth discourse, Sir Joshua Reynolds had quoted this phrase from *The Principles of Painting* of 1699 by the French writer on art Roger de Piles (1635–1709), which had been translated into English in 1743.

10 See Gilpin, *Observations*. Turner's drawings were T.B. I-D and H, and they were probably destroyed in the Tate Gallery flood of 1928. They were made from plates appearing opposite pages 85 and 227 in the second volume of Gilpin's book.

11 No books by these writers were in his library by the end of his life (see Wilton, *Time*, 246–7). Moreover, like many professional artists Turner would later be particularly averse to taking advice on the creation of images from non-painters. If that antipathy was already extant by 1793, then he might well have been uninterested in aesthetic theories promulgated by a cleric and amateur watercolourist (Gilpin), a wealthy Herefordshire landowner (Price), and a Member of Parliament and connoisseur (Knight).

12 Gilpin, *Prints*, xii.

6 A Mere Six to Eight Tones by Candlelight

1 Douglas wrote books on military tactics and on travel, on the antiquity of the Earth, and on the funerary customs of the ancient Britons prior to the rise of Christianity. He also penned three novels and was an amateur portrait painter.

2 He resided at 3 College Yard, Rochester, and was in the habit of staying with a Strand bookseller when attending Court in London. Before doing so he would often spruce himself up with a visit to William Turner's hairdressing salon. However, when he called around at the shop one day he found the barber absent and spied Turner at work 'through the glass panels of a door which led to the back sitting-room' (see Archer, 'Turner', 31–2). Being struck by the young man's outstanding abilities, he asked to see more of his output. As a consequence, he invited Turner to make the oil.

3 Miller, *Sixty Years*, xxvi; also quoted in Thornbury, *Life*, 1862, 1: 77.

4 See Whittingham, *Tonbridge*.

5 Thornbury, *Life*, 1862, 1: 75.

6 Consolidated £3% Annuities Stock Ledger AC27/1650, fol. 42481, Bank of England Archive, London.

7 Access to the Bank of England stock ledgers is obtained by means of indexes that were also maintained by the bank; these list the names and addresses of all the stockholders, as well as the numbers of the pages in the stock ledgers upon which the records of the transactions undertaken by those individuals were recorded. It is only in the indexes that the addresses of the stockholders appear. Turner used different addresses for each type of stock, often long after he had moved on from those places. In 1794 he gave his name and address as 'Joseph Mallord William Turner, Gent., Maiden Lane, Covent Garden' (see the Consolidated £3% Annuities Stock Index for the 1792–98 period, AC27/1618, Bank of England Archive, London).

8 See W. 87–122 for a listing of the watercolours; and R. 1–15a for the prints made from them.

9 See Farington, *Diary*, 1: 281, 26 December 1794; 2: 461, 31 December 1795; and 3: 703, 27 November 1796.

10 Ibid., 1: 283, 30 December 1794.

11 Ibid., 3: 1090, 12 November 1798. An anonymous writer in the 1830s mentioned that the sessions took place 'on certain evenings'; see 'Recollections of the Late Thomas Girtin', *Library of the Fine Arts*, 15 April 1832, 311. For 'stated evenings', see Redgrave, *Century*, 1: 388.

12 Farington clearly misheard or misremembered Turner's earnings, for every other report of Dr Monro's 'Academy' – including those emanating from the artist and from his father – asserts that he received not three shillings and sixpence for an evening's work, but half-a-crown, which was a shilling less. Turner also mentioned eating oysters at Dr Monro's house, and this has been taken to mean that he *invariably* supped on oysters and nothing else there. However, it seems certain that many other types of fare were on offer, for many people cannot stand the molluscs. Perhaps Turner just had a preference for oysters when under Dr Monro's roof.

13 Miller, *Sixty Years*, xiv.

14 Roget, *OWCS*, 1: 82.

15 See W. Foxley Norris, 'Dr Monro', *The Old Water-Colour Society's Club Second Annual Volume 1924–1925*, London, 1925, 6; and Arthur K. Sabin, 'Notes on Dr Monro and his Circle', *Connoisseur*, November 1917, 123, for a reproduction of the Hearne in question.

16 T.B. XXVII-H.

17 See T.B. XXVIII-M, *Moonlight between Trees* of 1794–6; W. 88, *Chepstow Castle* of about 1795 (Courtauld Gallery, London); W. 140, *Llandeilo Bridge and Dynevor Castle* of 1796 (National Museum and Gallery of Wales, Cardiff, for which, see Mackay, 'Llandeilo'; and T.B. L-B and C, which are depictions of Norham Castle dating from 1797–8. And see also Bower, *Papers*, 50–51.

18 John Pye, quoted in Roget, *OWCS*, 1: 87.

19 Miller, *Sixty Years*, xv, who further informs us that Girtin copied works by Thomas Malton, Giovanni Battista Piranesi, William Marlow and George Morland at 4 Adelphi Terrace.

20 Christie's, 17 April 1802. The auctioned works were views of Marlow, Paris, Yarmouth, Dover and of an unspecified place. The four watercolours that Henderson's son would bequeath to the British Museum in 1878 are *Tintern Abbey, West Front* (fig. 96), W. 60; *Christ Church, Oxford*, W. 71; *Worcester Cathedral, West Front*, W. 67; and *Cathedral Church at Lincoln*, W. 124. The fact that there was only one Oxford view among these drawings tends to disprove Thornbury's claim (*Life*, 1862, 1: 67) that 'One of [Turner's] earliest tours was that made to Oxford to execute drawing commissions for ... Mr Henderson.' Additionally, the younger John Henderson would leave the British Museum a view of Magdalen Tower and Bridge, W. 70, presumably as a copy by his father, although it is now claimed erroneously by the museum (BM 1878, 1228.39, Department of Prints and Drawings) to be a Turner and was reproduced as such by Harrison, *Oxford*, 49.

21 They are:

Turner original, *Dover Castle from the Sea* based on T.B. XVI-A, sold Sotheby's, 14 March 1984, lot 53.

Henderson copy, British Museum 1878–1228.45. This was bequeathed to the museum by Henderson's son.

Turner original, *Magdalene College and Bridge, Oxford*, signed and dated 1794, Whitworth Art Gallery, W. 69, where a photograph of the Henderson copy in the British Museum is reproduced in error.

Henderson copy, British Museum 1878–1228.39, erroneously listed as being by Turner in Wilton, No. 70, where a photograph of the Turner original in the Whitworth is reproduced in error.

Turner original, *Dover Harbour*, signed and dated 1793, based on T.B. XVI-C, last known to belong to 'G. Tite', photo Clore Study Room Finberg Scrapbook 1.

Henderson copy, last known to be in the C. Mallord Turner collection, untraced, photo, Clore Study Room Finberg Scrapbook 1.

Turner original, *Dover Beach with Fisherman's Cottages*, John Witt collection.

Henderson copy, sold (as being by Turner) Sotheby's, 18 July 1974, lot 125; there is also a version by Girtin in the Whitworth Art Gallery, Manchester.

Furthermore, Henderson may have copied *Old Blackfriars Bridge* of 1794 (Whitworth Art Gallery, Manchester) – see W. 146. Additionally, the British Museum owns a Henderson view of York Minster (1878–1228–23) that is a copy of a watercolour by Girtin sold at Sotheby's on 9 November 1955, lot 46. In turn, the latter work could have been developed from T.B. XXXVI-B of 1797.

22 An attempt is made to do so in the electronic version of this text.

23 Girtin might well have had something to do with this, inasmuch as when he was later teaching the Dowager Duchess of Sutherland, he 'used to point out the time of the day, the cast shadows and particular effect suited to the time and scene &c.' (See John Joseph Jenkins, 'Notes for a History of the Old Water Colour Society', Royal Water Colour Society, MS RWS 39/16, Bankside Gallery, London, quoted in Hill, *Girtin*, 9). On the other hand, Turner could have imparted that awareness to Girtin just as easily.

7 Coming of Age

1 Thornbury, *Life*, 1862, 2: 36.

2 Redgrave, *Century*, 2: 83–4. The Redgraves further tell us that the architect concerned 'some time after' tried colouring windows in the manner advocated by Turner, and was so pleased with the results that he sent the resulting drawing to the Royal Academy. Only one architect named Dobson exhibited at the Academy 'some time after'. This was John Dobson FRIBA (1787–1865), who exhibited a perspective view of Seaton Delavel House at the Royal Academy in 1818 (exhibit 1034). However, because of his age, he cannot have been the architect who had employed Turner in the 1790s.

3 Thornbury, *Life*, 1862, 1: 66.

4 Folio 17 of the *Marford Mill* sketchbook, T.B. XX.

5 Quoted in Thornbury, *Life*, 1862, 1: 128. Thornbury's informant may have been Julia Isabella Levina Bennet, later Lady Gordon (1776–1867).

6 Ibid.

7 B.L., Add. MS 46,151-M, 44.

8 T.B. XXI-H (2).

9 Thornbury, *Life*, 1862, 2: 53–5 for this and her other quotes. The fact that Turner was such a frequent visitor in the evenings strengthens the belief that he preferred to paint (rather than sketch or draw) by daylight, which is one reason he liked to rise with the sun. Obviously the watercolour under discussion establishes that Turner also visited Mount Street by day.

10 They were the *Smaller South Wales* sketchbook, T.B. XXV, and the *South Wales* sketchbook, T.B. XXVI.

11 The Royal Academy had appointed its first Professor of Anatomy upon its foundation in 1768, and it continues to do so to this day. To illustrate their talks, the professors used live models, skeletons, cadavers, and human and animal corpses that had been skinned to reveal their musculature.

12 This copy was made in a sketchbook now at Princeton; see Hamlyn, 'Early Sketchbook'. Andreas Vesalius's *De Humani Corporis Fabrica* was originally published in Basel in 1543; the edition in the Royal Academy Library that Turner may have worked from dates from 1555.

13 For the argument behind this assertion, see n. 36 to Chapter 12 of the electronic version of this work.

14 B.L., Add. MS 46,151-P, 12.

15 Turner and his patron would later discuss the creation of a depiction of Lord Coningsby's monument to his son Richard (1706–1708) in the church of Hope-under-Dinmore, Herefordshire, although in the event, that drawing does not appear to have been made. See the letter to Colt Hoare of 23 November 1805 (Gage, *Correspondence*, letter 11, 27–8).

16 W. 193–216.

17 Miller, *Sixty Years*, xix.

18 Whitman, *Charles Turner*, 3.

19 See Shanes, *Turner Masterworks*, 66, and *Life and Masterworks*, 78.

20 Pasquin's real name was John Williams (1761–1818). At the age of 17 he had briefly studied painting before abandoning it for poetry and translation work. Subsequently he turned to theatrical criticism and satire, libelling a great many people in the process. In 1798 he would initiate a libel action he would lose. As a consequence, he would flee to America. He would again take up art criticism after his return to England around 1808.

21 According to Edward Bell, a 'General Stewart' purchased *Fishermen at sea* for £10 (see Thornbury, *Life*, 1862, 1: 75). The soldier in question might have been General Sir William Stewart (1774–1827), although if that was the case, then he cannot have bought the painting before 1798 when he returned from overseas.

22 On 31 May Turner paid £50 for £3% Consolidated Annuities (see Stock Ledger AC27/1650, fol. 42481, Bank of England Archive, London). On 16 November he would purchase more of the same type of stock for £52-1s-2d, while on 20 December another £50 would acquire Reduced £3% Annuities (for the 16 November transaction, see ibid; and for the 20 December purchase, see Reduced £3% Annuities Stock Ledger AC27/1650, fol. 42481, both Bank of England Archive, London). It could be that two or even all of these acquisitions emanated from money paid in exchange for *Fishermen at sea*, with the purchaser paying in instalments because of the relatively large sum involved. Another possibility is that the £145-17s-11d paid by Turner for Consols £3% on 24 January 1797 emanated from the transaction (see Consolidated £3% Annuities Stock Ledger AC27/1650, fol. 42481, Bank of England Archive, London). Of this, 100 guineas or £105 could have derived from the sale of *Fishermen at sea*, and some or all of the rest from the cost of its frame, plus income accruing from the sale of watercolours.

8 Grandeur

1 Thornbury, *Life*, 1862, 1: 157.

2 Ibid., 1: 24, footnote carried over from previous page.

3 Viscount Malden might well have visited Hampton Court, Herefordshire, in the high summer of 1796, so it is likely Turner's visit took place not long before.

4 For the entire tale, see Thornbury, *Life*, 1862, 1: 70–74.

5 All the holes in Thornbury's Victorian melodrama are picked apart in Chapter 13 of the electronic version of this work.

6 Finberg, *Life*, 35.

7 For 'slight and timid', see ibid., 34. The sketchbook in question is the *Studies near Brighton* sketchbook, T.B. XXX. For unslight and untimid sketches it contains, see fols. 3, 4, 7, 27, 29, 52v, 87, 90v, 92, 93, 95, 96, 96v, among others.

8 See T.B. XXIII-L, N and U; and XXXIII-f, K, O, P, Q and R.

9 W. 195 lists this variant as possibly being the *Ely Cathedral, South Trancept* exhibited at the R.A. in 1797, even though the south transept does not appear in it. For the possible view of the south transept of Ely Cathedral that was shown at the Academy in 1797, see the main text below.

10 See fol. 11 of the *Smaller South Wales* sketchbook, T.B. XXV.

11 The window had been commissioned in 1788. Roman soldiers were depicted in the pendants to the Resurrection scene. Francis Eginton

(1736/7–1805) created the glass from Reynolds's designs, which were probably in oil on canvas. The window was removed in 1854 and probably destroyed soon afterwards. See Mannings and Postle, *Reynolds*, cat. no. No. 2144, text volume, 557–8.

12 The metaphor was first rediscovered in modern times by Matthew Imms, who wrote that 'the window seems to be illuminated by an unearthly light of its own' ('Foundations', 32).

13 Bourgeois had requested the exchange because the actor John Philip Kemble (1757–1823), portrayed in the role of Shakespeare's Coriolanus, held himself in such high regard that only the Great Room was deemed good enough to house his image. As a consequence, Bourgeois had feared the thespian's wrath if the Coriolanus picture were to be hung in the outer chamber and so he asked Turner to make the swap. Doubtless the latter was willing to oblige, for keeping Academicians happy was always a wise move when hoping to advance within Somerset House, as he did.

14 It was sold as lot 82 at Christie's on 24 March 1860 to 'Shepherd' and has not been seen in public since.

15 Possibly 100 guineas was paid for the original painting in 1797, for on 19 September of that year Turner would acquire government stock for £100 (see Consolidated £3% Annuities Stock Ledger AC27/1651, fol. 43502, Bank of England Archive, London. For unknown reasons, that entry was carried over from AC27/1650, fol. 42481, where it belonged by reason of its date). If 100 guineas was paid for the work, then it would strengthen the belief that *Fishermen at sea* may have been sold for 100 guineas in 1796.

16 T.B. XXIII-H is clearly by one of Turner's pupils and it bears the dates 'June 30' and 'September 1st, 1797' on its *verso*. David Hill (*North*, 197, n.3) has suggested that this inscription may record the dates of the North of England tour.

17 Given that the painter also depicted haymaking there, it is likely he had stayed at Norbury Park earlier that summer as well; see a pencil and wash drawing of haymakers at work at Norbury Park that was with Agnew between 1970 and 1975 and which might be W. 153. A photo of the drawing is to be found in the Witt Library.

18 For the Norbury Park watercolours, see W. 152–7, 161, 163.

19 Hill, *North*, 181 and 204, n.1.

20 Hill, 'Taste', 4, 2, 29.

21 Several of these points are made by Hill (ibid., 1: 28).

22 Roget, *OWCS*, 1: 121. Reference is made to William Blake of Newhouse and/or of Portland Place on fol. 67v of the 1797 *North of England* sketchbook, T.B. XXXIV, and on fols. 47v and 50v of the 1798 *Hereford Court* sketchbook, T.B. XXXVIII. Blake commissioned a watercolour of Harewood Castle (Harewood collection, not in Wilton); and also a view of Conwy Castle (untraced), made around 1799, W. 268, sold at Christie's, 30 June 1981 (lot 155). Additionally, he may have acquired the watercolour *A fishing boat in a choppy sea* of around 1796, W. 149 (private collection).

23 This comprised £760-11s-11d in Consols £3% and £50 in Reduced £3% Annuities. On 27 January 1797 he had acquired £62-12s-10d of stock; on 16 March 1797 another £50 of stock; on 9 May 1797 a further £50 of stock; on 19 September 1797 £100 of stock; and on 28 November stock for £50 (see Consolidated £3% Annuities Stock Ledger AC27/1650, fol. 42481, Bank of England Archive, London.) The sources of all these amounts are unknown.

24 In a letter from Turner to the Revd Robert Nixon at Foots Cray, Kent (Tate Britain Archives A-941-1), the painter complains of the knee injury and regrets he would not be able to travel down to Lewisham to see him. The reverse side of the sheet contains an ink wash drawing by Nixon of Allington Castle, near Maidstone, Kent. It was annotated by Turner who was obviously giving the clergyman drawing lessons and, in this instance, having to do so by post. The Nixon drawing is a copy of Turner's 1790 signed and dated view of the same subject, a photo of which is in the Witt Library. The Tate letter was erroneously stamped 'F 29 98' and 'FE 98' – that is, February 29 1798 – for 1798 was not a leap year. However, it remains the earliest Turner missive that has come down to us.

25 As Finberg suggested (*Life*, 47), this was surely T.B. XXVI-72, a view of Cardinal Morton's tomb in the crypt of Canterbury Cathedral, which was washed in watercolour.

26 Pressly, 'Rigaud', 106. The verb 'to stand' can mean both 'to pay for' and 'to suffer from', so the construction that Rigaud put upon it, if at all accurate, could have arisen from Turnerian verbal ambiguity.

27 Council Minutes, 2, 353, 20 January 1798. The members present were Benjamin West in his role as President, Joseph Wilton in his position as Keeper, the Academicians J. F. Rigaud, Richard Cosway, Edmund Garvey, James Northcote and Paul Sandby, plus the (non-voting) Secretary, John Inigo Richards. A few quotations had appeared in the R. A. catalogues in 1769 and during the 1770s. Thus Edward Penny had quoted three lines of verse in the 1769 catalogue (cat. no. 87); Reynolds had quoted five lines from Dante's *Inferno* in connection with the title of his *Count Hugolino* in 1773 (cat. no. 243); and Nathaniel Dance had quoted four lines from Virgil's *Georgics* in 1774 (cat. no. 56). But no quotations appeared after 1779. It may be that the practice had lapsed 'more by accident and to save costs in typesetting, apparently, than because of any disapproval of the idea in principle' (see Wilton and Turner, *Poetry*, 11).

9 The Sister Arts

1 For extensive exploration of this aspect of Turner's art, see Shanes, *Human Landscape*.

2 Annotation by Turner on page 58 of his copy of John Opie's *Lectures on Painting*, London, 1809, which remains in his library (private collection). See below and also Venning, 'Annotated Books', 2, 1: 38–9.

3 B.L., Add. MS 46,151-K, 14, paraphrasing Jean-Jacques Rousseau in an unidentified work.

4 Farington, *Diary*, 3: 1001, Sunday 22 April 1798.

5 The artists who had a single work with verses accompanying its title in the catalogue were J. F. Rigaud RA, John Downman ARA, John Nixon ARA, William Theed, Robert Smirke RA, Hendrick de Cort, Stephen Rigaud, Mrs A. Noel, Tom Taylor, Jeffrey Wyatt and George Garrard, while those with two such entries were Richard Westall RA, William Hamilton RA, J. S. Copley RA, Henry Tresham ARA and E. A. Rigaud.

6 Milton's epic poem was available to Turner in the fifth volume of Anderson's *Complete Poets*. The word 'streaming' in the second line was clearly either a printer's error or a mistake by Turner, for Milton's original is 'steaming'.

7 As David Hill has pointed out (*North*, 23, caption to plate 24), in this work Turner actually depicted the dormitory undercroft to the ruin, rather than its refectory.

8 Lines 81–5. There are only four lines in Turner's version because he carried over its first two words, 'Betoken glad', from line 85. The opening of line 84 in Thompson's original is 'Illumed with fluid gold', but Turner appears to have altered 'Illumed' and suppressed the next three words in his quote because their inclusion would have been unnecessary, given his golden sky.

9 In this work Turner actually depicted the cellarium and lay brothers' dormitory spanning the river Skell, with part of the refectory on the right (see Hill, *North*, 36).

10 Lines 1648–50 and 1653–4.

11 Lines 189–90; 192–4 and 204–5.

12 At the Royal Academy in 1797 Wyatt had exhibited a perspective view of Fonthill from the south-west (cat. 1143) that equally looks to possess a landscape input by Turner. The watercolour, W. 332, is now in Bolton Museum and Art Gallery. And Turner also worked for John Nash in the 1790s.

13 For the specific Wilsons owned by these men, see notes 28, 31–38, 40, 44, 47, 52 and 54 to Chapter 14 of the electronic version of this work.

14 B.L., Add. MS 46,151-P, 19v; and Ziff, 'Backgrounds', 146.

15 The *Wilson* sketchbook, T.B. XXXVII.

16 Turner visited this country house just outside Newbury in Berkshire in order to see Anthony Bushby Bacon II (1772–1827), who in 1793 had leased the family enterprise, the Cyfarthfa Iron Works near Merthyr Tydfil in south Wales, to the industrialist Richard Crawshay (1739–1810). Apparently nothing came of a commission to make four watercolours of the huge ironworks, which then formed the largest such complex in the world.

17 Folios 12–13 of the *Swans* sketchbook, T.B. XLII.

18 According to Ann Dart, quoted in Finberg, *Life*, 50.

19 These appear on fols. 8, 9, 24, 25, 26, 27, 28 and 29 of the *Swans* sketchbook, T.B. XLII.

20 R. 48–50, W. 119–121. See Shanes, 'Picture in Focus', *Turner Studies*, 1: 1 (1980), 50–52. The engraved view from the south-west, R. 49, is the one containing the surreptitious portrait.

21 Finberg, *Life*, 50–51.

22 See the inside front cover of the *Swans* sketchbook, T.B. XLII.

23 Gage, *Correspondence*, 219, letter 307 of 27 December 1847.

24 Ann Dart's testimony, quoted in Finberg, *Life*, 51.

25 This is established by the fly-leaf of the *Lancashire and North Wales* sketchbook, T.B. XLV; and the inside end cover of the *Dolbadarn* sketchbook, T.B. XLVI.

26 This building dated from 1785. It incorporated an octagonal library designed by John Nash (1752–1835). Turner had collaborated with Nash around 1794 on a watercolour of a new design for the mansion. In the event, the building would never be constructed (although it would be realised elsewhere by Humphry Repton, who used it to build Corsham Court, near Bath, a house completed in 1797).

27 Farington (*Diary*, 3: 1075, 24 October 1798) was possibly told by Turner that during the tour the latter had moved 'on to Dolgelly and by the River to Harlech'. However, Turner would have had to travel north of Harlech to get down to it by river. There is no river directly connecting Dolgelly to Harlech. The statement recorded by Farington could indicate a boat journey down the river Mawddach from Dolgelly to Barmouth and thence up the coast by the same vessel to Harlech. Turner made a number of drawings of boats on the 1798 tour, and possibly one of them denotes the vessel used.

28 W. 182, Whitworth Art Gallery, Manchester. It would be engraved by J. Storer and appear in Britton and Brayley's *Beauties of England and Wales* in 1801 (R. 63).

29 Ann Dart stated that this animal, along with all its accoutrements, was never returned to John Narraway, who for ever afterwards regarded Turner as 'an ungrateful little scoundrel' (see Finberg, *Life*, 51). However, in 1879 'an old lady, a friend of the Narraways, of eighty years or upwards' recalled that the saddle had been restored to its owner (see Atkinson, 'Bristol', 71).

30 Turner's link with Jackson might explain why no fewer than six depictions of Christ Church were eventually created, of which three show the college from a distance, one the interior of its cathedral, and two the exterior and interior of its hall. They are respectively T.B. L-Q, V, X, G, W and J.

31 The Christ Church Cathedral watercolour is T.B. L-G; the New College drawings are T.B. L-E and F, Tate Britain, London.

32 Orders of the Delegates of the Oxford University Press 1795–1810, accounts for 1799 (at the back of the volume, unpaginated), Oxford University Press Archives, Oxford.

33 Harrison, *Oxford*, 64.

34 The *Dinevor Castle* sketchbook, T.B. XL.

35 This was exhibited at the Royal Academy in 1776 (68) but is now untraced. It contained 'mountains, and soldiers and elephants, one of which was falling down a ravine, and Hannibal in purple on horseback' (see Lynn R. Matteson, 'The Poetics and Politics of Alpine Passage, Turner's *Snowstorm, Hannibal and His Army Crossing the Alps*', *The Art Bulletin*, September 1980, 387). In 1812 Turner would depict the Carthaginian crossing of the Alps, although he would not make Hannibal readily identifiable there (for discussion of this topic, see the main text below in relationship to Turner's submissions to the Royal Academy that year).

36 T.B. XLII.

37 He called upon Farington that day; see the latter's *Diary*, 3: 1060.

38 Ibid., *Diary*, 3: 1074–5.

39 These were the *Hereford Court* sketchbook, T.B. XXXVIII; the *North of England* sketchbook, T.B. XXXIV; and the *Tweed and Lakes* sketchbook, T.B. XXXV.

40 Turner went on to make this watercolour, which is W. 249, Royal Academy of Arts, London.

10 Vindication

1 Farington, *Diary*, 3: 1080.

2 Ibid., 3: 1084.

3 On 24 April 1796, William Beechey had used this phrase to denigrate Farington (see Farington, *Diary*, 2: 530).

4 For 12 November 1798, see Farington, *Diary*, 3: 1089–90.

5 Ibid., 1098.

6 Ibid., 4: 1289.

7 Thornbury, *Life*, 1862, 1: 141.

8 For Angerstein in Greenwich, see Brunston, *Angerstein*, 39.

9 'Recollections of J. M. W. Turner' by George Jones, in Gage, *Correspondence*, 4.

10 The provenance of this painting after 1781 is extremely confused but it appears likely that Angerstein had acquired the work in the early 1790s, although the earliest recorded sighting of it in his possession was on 19 November 1802. (For the provenance and this sighting, see Hum-

phrey Wine, *The Seventeenth Century Paintings in the National Gallery*, London, 2001, 94). The story that Turner wept in front of the *Seaport with the Embarkation of St Ursula* has been rejected by Ian Warrell (*Turner Inspired in the Light of Claude*, exh. cat., National Gallery, London, 2012, 70) on the grounds that the painting did not hang in either of Angerstein's houses until after November 1802. However, that was merely the date of the first recorded *sighting* of it in one of those locations. There is no reason to believe that it had not been owned by Angerstein for a number of years by that date. Instead, Warrell suggests that Turner burst into tears in front of Claude's *Landscape with the Landing of Aeneas in Latium* (for which, see the main text below). Yet by all accounts the room in William Beckford's house in London in which this painting was displayed in May 1799 was extremely crowded at all times, and it is impossible to believe that Turner would have wept when surrounded by large numbers of people. Moreover, the Jones story gives the impression that Turner and Angerstein were alone when the painter responded tearfully to a painting by Claude, although this may be a subjective response.

11 This comprised £1,000 in £3% Consols, and £50 in Reduced £3% Annuities. On 18 August the £3% Consols holding of £860-11s-11d had been purposefully rounded up to £900 by the further purchase of stock worth £39-8s-1d. Subsequently that total had been boosted by two more £50 acquisitions of £3% Consols, on 2 October and upon a subsequent date in 1798 that was not specified in the ledger (see Consolidated £3% Annuities Stock Ledger AC27/1676, fol. 47224, Bank of England Archive, London). Clearly the artist was conscious of his worth, and wanted it to look extremely tidy on paper, let alone in his mind. Where the £3% Consols were concerned, a round figure of '£1000' fulfilled that aim to perfection.

12 'Anecdotes of Artists of the Last Fifty Years', *Library of the Fine Arts*, 4: 1832, pages 27–8.

13 The architect was Robert Smirke, the second son of the painter and Academician of the same name, while the painters were John 'Warwick' Smith, William Daniell, and Richard Smirke, the eldest son of Robert Smirke.

14 Farington, *Diary*, 4: 1212, 27 April 1799, while for Lord Elgin see St Clair, *Elgin*, 28. Farington could be extremely inaccurate where figures were concerned (as will be seen repeatedly), so it is entirely possible that Lord Elgin was correct and that Turner envisaged the Athens project would involve him in making eighty drawings at ten guineas each. That is more than likely, given the huge scale of the undertaking.

15 In Messina, Sicily, in October 1799, Lord Elgin would obtain the services of the Italian landscape painter Giovanni Battista Lusieri (1754–1821), whom he would pay £200 per annum, which makes Turner's demand appear less excessive.

16 Thirteen artists, including the painter, engraver and poet William Blake (1757–1827), had attached quotes to the titles of just one of their works, while three painters linked quotes to two of them, and two exhibitors connected passages of verse or prose to three of them.

17 Turner's future patron Samuel Rogers, as quoted in Farington, *Diary*, 4: 1136, 17 January 1799. In contrast to the 'soft and melting' skies in Claude's pictures, Rogers saw this 'flutter and flickering' as a deficiency in Wilson's art.

18 It has long been thought that this work was a watercolour now in the Whitworth Art Gallery, Manchester, and that a representation of the same subject shown in Somerset House in 1801 was a drawing now in the Victoria and Albert Museum, London. However, as Ian Warrell has pointed out, the Manchester watercolour was elaborated from studies in the *Salisbury* sketchbook, T.B. XLIX, that could only have been in use after the 1799 Royal Academy Exhibition had closed, thereby proving that the view of the chapter house displayed in that show had to have been the work now in London (see Warrell, *Wessex*, 51, 53–5).

19 The Mallet poem was available to Turner in the ninth volume of Anderson's *Complete Poets*.

20 Kitson, 'Claude', 5. In Turner's view of Norham Castle exhibited in 1798 (fig. 187), of course, the sun is masked by the castle.

21 Farington, *Diary*, 4: 1229.

22 However, Turner must have already known that it was one thing to emulate a Claude seaport scene in watercolour and quite another to do so in oils, especially on a grand scale. Such a realisation would stay with him for another fourteen or so years until he felt his oil painting technique could more than meet that challenge.

23 Farington, *Diary*, 4: 1219, 8 May 1799.

24 For the identification of Smirke as this visitor, see n. 52 to Chapter 15 of the electronic version of this work.

25 Farington, *Diary*, 4: 1229.

26 Ibid., 1234.

27 Ibid., 1249. The sixty drawings might have comprised a remaining ten or so of the twenty Salisbury watercolours commissioned by Colt Hoare; the drawings promised to Hoppner, Farington and possibly other Academicians; sundry individual commissions; and the watercolours commissioned by many of the forty-one people whose names are listed in the *North of England* sketchbook of 1797 (T.B. XXXIV), in the *Tweed and Lakes* sketchbook of the same year (T.B. XXXV), and in the *Hereford Court* sketchbook of 1798 (T.B. XXXVIII).

28 W. 282. The watercolour was dedicated on the reverse to 'Joseph Farrington Esqre, with W. Turner's Respects'.

29 If this watercolour was ever elaborated, it is now untraced. However, a possible study for it is T.B. XXXVI-V.

30 Farington, *Diary*, 4: 1255.

31 Ibid., 4: 1303.

32 Around 1818 Turner would create a watercolour study, T.B. CXCVI-N, which he would later inscribe 'Beginning for Dear Fawkes of Farnley Hall'. From the first word A. J. Finberg developed the term 'Colour Beginnings' to describe a large group of watercolours in the Turner Bequest. For discussion of this terminology see Shanes, *Explorations*, 9ff.

33 There also exist two other possible explanations for the absence of any mention of the scale practice in Farington's diary entry. Turner surely knew that in 1797 Farington had been duped into paying good money for a bogus 'Venetian Secret' oil painting process, and perhaps he wanted to appear unmethodical to his auditor, so as not to rub salt in his wounds. Alternatively, a full explanation of his complex technical procedure for making watercolours might well have made the technically limited Farington feel insufficient, and Turner wanted to spare his feelings, so he only revealed part of his approach.

34 W. 334, R. 62, engraved by and for William Angus, *The Seats of the Nobility and Gentry in Great Britain*, London, 1800, which tells us (Plate 'L') that 'The Drawing is in the Possession of William Beckford, Esquire'.

35 See Ostergard, *Beckford*, 51, n.2 and 67, n.3, the text of which has clearly been inadvertently transposed with that of 67, n.2.

36 Farington, *Diary*, 4: 1277, 11 September 1799.

37 Ibid. Given his continuing nervousness over the issue, he cannot have wasted any time in hurrying around to Farington's house in Upper Charlotte Street. It was on this visit that Turner told Farington how long he had been at Fonthill, which fixes the time he must have arrived at that mansion three weeks earlier.

38 The collector always wrote his surname as Townley rather than 'Towneley', as did his brother and mother, so that spelling has been followed here.

39 See Farington, *Diary*, 4: 1285, 6 October 1799, which states that Turner had been in Manchester 'three weeks ago'. That takes us back to 15 September.

40 See Robinson, *van de Velde*, 2: 829, which states, 'The picture was in the Duke of Bridgewater's collection at Old Hall, Worsley, by 1801.' The author would like to express his gratitude to Pieter van der Merwe of the National Maritime Museum for going through the papers that Michael Robinson (1910–1999) had amassed when researching his catalogue raisonné in order to try to locate the source of this assertion, although the search proved unsuccessful. However, it is impossible that Michael Robinson simply made up the statement, and so one has to take it on trust. Finberg assumed that Turner saw the van de Velde in London, and everyone else has followed him in that belief.

41 Whitaker, *Whalley*, 445–6.

42 In 1829 Turner would return to the same 1799 pencil study from which he would develop the drawing of around 1800 and use it to elaborate a complex allegory of the Roman Catholic Emancipation Act that had just been passed through Parliament in order to extend full civil rights to Catholics. The subtle message of that later version of this selfsame view is the new equality that the Act had effected between Protestantism and Catholicism. To further that end, Turner would replace with crosses the eagles that are evident atop each of the Stonyhurst College cupolas in both the 1799 pencil study and the slightly later *History of Whalley* watercolour.

43 See Morris, 'Wyatt'.

44 See Finberg, *Life*, 345.

45 T.B. XLVI, fol. 114v. Williams-Wynn had been helping to suppress rebellion in Ireland in 1798, so Turner could not have visited Wynnstay during his Welsh tour that year. Turner's knowledge of a version of Richard Wilson's view of Cicero's villa at Arpinium that also hung at Wynnstay makes it doubly clear he must have been there in 1799.

46 He signed into the Schools life class on that date.

47 Farington, *Diary*, 4: 1289.

48 Ibid., 1292.

49 Ibid., 1297.

50 General Assembly Minutes, 2: 69.

51 Farington, *Diary*, 4: 1298.

11 The Dark Side

1 The Rate Books reveal that the annual rateable value on 75 Norton Street during the 1800–4 period was £60, and that the payees of the rates were as follows:

1800: 'Danby'. £9 paid at Michaelmas (29 September) and Christmas.
1801: 'Mr. Danby'. £11-10s paid midsummer and Christmas. Remarks, 'Wm Turner'.
1802: 'William Turner'. £10-10s paid midsummer and Christmas.
1803: 'William Turner'. £5-5s paid midsummer, with note 'Empty Mids.'
1804: 'William Turner'. £2 paid midsummer and £4 at Christmas.

See Rate Book for the Parish of St-Mary-le-Bone, Berners Street Division, reels 28–31, City of Westminster Archives Centre. For the identity of 'Danby', see the main text below. According to *Holden's Triennial Directory 1802–4*, 3rd edition, London, 1804, Turner jointly rented the Norton Street property with a longtime friend of the Danbys, Roch Jaubert, who had been a butterman and cheesemonger, and who had published a book of John Danby's glees after the latter's demise. Today Norton Street is named Bolsover Street.

2 Sir John Soane's Museum Archive, document 7/P/1. Much of the information contained in the following paragraphs has been gleaned from this document and those numbered 7/P/2, 7/P/3 and 7/P/4, as transcribed in Dorey, *Friendship*, 34–6. The Schedule demonstrates that the rateable value of the house – confusingly denoted as 'rent' in the lease – was £70. Turner must have obtained a good deal less than the complete property for the £50 or £55 in rent he paid per annum. He had no need of the basement, as both the ground and first floors possessed their own kitchens. Moreover, the second floor was rented out to others, as will be discovered in the main text below.

3 '64 Harley Street Plan', 1: 138, Howard de Walden Estate Archive. It is roughly dateable from the fact that adjacent plans in the same estate book can be firmly dated to 1813.

4 It would be renumbered 35 Harley Street in 1866.

5 See Wheeler, *Wells*, 7. Ultimately this information derived from Roget, *OWCS*, 1: 132.

6 See the Rate Books for the Parish of St-Mary-le-Bone, Wimpole Division, reel 28 for 1799–1800 in the City of Westminster Archives Centre, for the listing on 31 May 1800 of the 'Revd Mr Hardcastle' as the landlord of 65 Harley Street, and the listing of Robert Harper as the landlord of number 64. For Hardcastle as Turner's 'landlord', see also Farington, *Diary*, 4: 1303, 16 November 1799.

7 Farington, *Diary*, 4: 1303.

8 See fol. 120 of the *Dolbadarn* sketchbook, T.B. XLV.

9 See Russett, *Serres*, 110 ff.

10 For Mary Turner's commitment, see the Admission Register for 1799, St Luke's Hospital, now in the archives of Camden and Islington NHS Trust, St Luke's Woodside Hospital, London. For the process of fraud involved, see the electronic version of this work.

11 These were William Wickstead of 8 Cecil Court, Covent Garden, and Richard Twemlow of 2 Air Street, Piccadilly.

12 Information about conditions in St Luke's throughout the following paragraphs is taken from French, *St Luke's*.

13 Thornbury, *Life*, 1877, 4.

14 See Thornbury, *Life*, 1862, 1: 6 and 10; 1877, 319.

15 For the most comprehensive account of the dates and history of Sarah Danby, see Golt, 'Shadows'. Her year of birth depends on whether one believes a statement made by a friend in 1861 that she had recently died aged 100, or whether one accepts the statement made by the lady herself when first applying for charity in 1798 that she was then thirty-one years of age and had therefore been born in 1766–7 (see ibid.).

16 'Obituary of J. T. Willmore', *Art Journal*, n.s. 2, 1863, page 88.

17 Falk, *Hidden Life*, 42.

18 See Golt, 'Shadows', 5.

19 The courts were another matter, for if fraud had been detected, there was virtually no risk of being prosecuted at the time. This is because the crime of fraud had not yet been formulated by statute, and would not be laid down as such until the late nineteenth century. The author is grateful to the late Ben Levy for clarifying this point.

20 Thornbury, *Life*, 1862, 2: 184–5.

21 The oil study is now in the Fuji Art Museum, Tokyo. Evidently it was elaborated into a finished oil painting at a later date, which is why it bears stylistic characteristics of the 1803–4 period.

22 Gage, *Range*, 213, and see Bindman, 'Guillotine', 178.

23 The 1799 catalogue had contained thirty quotations by eighteen artists, while the 1800 booklet provided forty-four such passages by twenty-four artists. And so it went on

24 See Gage, 'Dolbadarn', 41.

25 That Beckford had commissioned the work is proven by the list compiled by Turner between 1798 and 1799 and completed later with asterisks, which appears at the front of the *Smaller South Wales* sketchbook, T.B. XXV. This list comprises works for which Turner was still awaiting payment or had received it (as denoted by the asterisks placed against names). The relevant entry reads 'Mr Beckford for the★/Plague of Egypt.★' For the price eventually paid, see Farington, *Diary*, 4: 1538, 13 April 1801. The final destination of the work was public knowledge by 29 April 1801, for on that day the anonymous critic of the *St James's Chronicle* wrote in his review of the Royal Academy Exhibition that the canvas was 'to occupy a place near the celebrated Claudes, in the gallery at Fonthill'.

26 Until now it has always been claimed that Turner mistakenly painted only the seventh plague in this picture (for example, see B.J. 13). However, Ian Warrell was the first to note that Turner did depict the fifth plague here, while simultaneously representing the seventh; see Warrell, *Wessex*, 109–10. Warrell also reminds us that if anyone 'highlighted the disparity between text and image, Turner stuck to his guns, and he retained the title [of *Fifth Plague*] when he engraved the image for his *Liber Studiorum* in 1808'. For the first recognition of the allusion to the sixth plague, see Gage, Paris, cat. no. 5, 63. The verses provided by Turner were from Exodus, 9:23. Probably he quoted them from memory, which would explain mistakes in the citation.

27 See Shanes, *Human Landscape*, 62–69.

28 Unless the untraced *Morning, from Dr Langhorne's Visions of Fancy*, exhibited at the Royal Academy in 1799 (356), was a Claudian image.

29 Stanza II, lines 9–12:

Hark, how each giant oak, and desert cave,
Sighs to the torrent's awful voice beneath!
O'er thee, oh King! their hundred arms
 they weave,
Revenge on thee in hoarser mumurs breathe;

The poem was available to Turner in the tenth volume of Anderson's *Complete Poets*.

30 See Wilton, *Time*, 1987, 36, caption to fig. 48.

31 This is judging by the report of his visit that would later be communicated to Farington by William Hamilton; see Farington, *Diary*, 4: 1452, 8 November 1800.

32 For example, Turner certainly knew that the central tower of Ely Cathedral had collapsed in 1322, and probably that the Octagon that replaced it dated from 1328.

12 Tragedy and Triumph

1 It may have been the case that St Luke's did not have any further capacity for incurables at the time, for the ratio of curables to incurables was always tightly controlled. A detailed account of the process whereby Mary Turner was transferred appears in the electronic version of this work.

2 Richard Twemlow again posted bond for Mary Turner. For unknown reasons his previous collaborator, William Wickstead, was now replaced by Robert Brown of 24 Bedford Street, Covent Garden, who gave his occupation as an upholsterer, while Twemlow stated that he was a perruquier.

3 French, *St Luke's*, 39, which quotes Dr Robert Gardiner Hill (1811–1878) on the noise some years later at the Bethlem and relates that 'the same state of things existed' at St Luke's.

4 Compositionally, the view of the siege is similar to an engraving of a watercolour by Alexander Allen (1764–1820) that was on the London art market in 1988.

5 The *Colour Bill* sketchbook, T.B. LXIII.

6 Farington, *Diary*, 4: 1523; 1527; 1529 and 1532.

7 They are W.307 (Tate Britain, Oppé Collection); W.308 (sold to a British dealer, Sotheby's 9 July 2014, lot 224); W.309 (The Courtauld Gallery, London); W.310 (untraced); W.311 (untraced); W.312 (sold to a private collector, Sotheby's 9 July 2014, lot 223); and W.313 (Ashmolean Museum, Oxford).

8 W. 280.

9 This point was made by Hill, 'Taste', 5, 1: 41–3.

10 A printer's error probably accounted for the fact that the fifteenth chapter of Jeremiah was cited in the catalogue rather than the twenty-fifth.

11 The same critic also compared this approach to Raphael's supposed depiction of the crossing of the Red Sea by covering an entire wall with yellow-ochre to denote that the Israelites had already gone off to the promised land, and that the Pharaonic host had just completely drowned.

12 June issue of the 1801 *Monthly Mirror*.

13 See Farington, *Diary*, 5: 1775 for a diagram of the Cleveland House hang.

14 Ibid., *Diary*, 4: 1539.

15 This was the Thomas Hope collection at Duchess Street, Marylebone.

16 Farington, *Diary*, 4: 1541, 25 April 1801.

17 In discussion with the author, Pieter van der Merwe observed that these ships are Dutch vessels dating from well before the late eighteenth century, and that in all probability Turner had obtained their nautical details from old Dutch marine engravings.

18 Had the helmsman time to do so, he could also back his jib in order to avoid collision, but the wind needed for this manoeuvre is in any case being stolen by the bulging sails of the other boats (see Bachrach, *Holland*, 29).

19 Farington, *Diary*, 4: 1542, 25 April 1801. Farington was not present, for he was in mourning for his wife who had died recently. He did, however, make a point of finding out from Thomas Daniell who had attended the dinner.

20 Ibid., which also includes a cutting from the *True Briton* of 27 April 1801 that lists the Stadtholder as one of the guests of honour.

13 Gaining the Summit

1 The sale was held at Squibbs's Great Auction Room at the lower end of Savile Passage, Savile Row. Turner further purchased some slight pencil sketches; a detailed drawing of the chapter house of the ruined abbey at Margam, Glamorganshire; and four other pencil, pen and watercolour studies of Newport Castle. See also Connor, *Rooker*, cat. no. 12, 158–9.

2 Youngblood ('Oxford', 13) deduces that because of reference to the Merton College Chapel drawing in the Clarendon Press accounts for 1801, Turner speculatively produced the work in that year and then submitted it to the Delegates for consideration of publication as an *Almanack* headpiece. However, this appears unlikely, for the artist was always far too busy to make drawings speculatively for engraving schemes. The scenario proposed in the main text seems more likely, with the 1801 selection of the Merton College image by the Delegates after they had had it in their possession for some time explaining the recording of payment for the work being unusually placed in the 'disbursements' section of the 1801 accounts.

3 See Farington, *Diary*, 6: 2380, 17 July 1804.

4 Henry Edridge made the accusation; he had obtained his information about Turner frequently seeking payment for the frame from the politician, collector and co-founder of the *Sun* newspaper, the Rt Hon. Charles Long (1760–1838).

5 Farington, *Diary*, 4: 1559.

6 Ibid., 1563. That Mr Smith was a fellow angler is suggested by the comparatively slow progress of the two men northwards from Chesterfield to Edinburgh, as established in the detailed analysis of the 1801 tour that appears in the electronic version of this work.

7 Ibid., 1564. In all probability Turner used the word 'imbecility' to denote mental exhaustion caused by over-work.

8 This is according to a note on the inside back cover of the *Scotch Lakes* sketchbook, T.B. LVI, which also establishes that the artist arrived in Gretna Green on 5 August.

9 This was one of three watercolours created for engraved reproduction in Joseph Mawman's *An Excursion to the Highlands of Scotland and English Lakes*, published in 1805. See Edward Yardley, 'Picture Note', *Turner Studies*, 5: 2, winter 1985, 54–6.

10 Respectively, the watercolour and print are W. 345 and R. 664.

11 Turner had arrived in Gretna Green on 5 August, and Farington would note on 4 February 1802 (*Diary*, 5,1731) that on the previous 23 August he had received a letter in Matlock, Derbyshire from Turner in Chester. The two *Britannia Depicta* views of Chester (W. 312, R. 69; and W. 313, R. 70) were respectively made from fols. 51 and 52 of the *Chester* sketchbook, T.B. LXXXII.

12 Farington, *Diary*, 5: 1742.

13 Whittingham, *Geese*, 30. If Evelina was carried to full term and was born on 29 August 1800 or not long afterwards, then her 'conception must have followed with almost indecent haste' (Golt, 'Shadows', 8) on the birth of Sarah Danby's youngest daughter – that is, she must have been conceived in December 1799, and thus not long after Turner had moved into 75 Norton Street to begin cohabiting with Sarah.

14 At the time, the population of the village was 257 souls, who lived in 39 dwellings; see Worlow, *Knockholt*, 48.

15 This was suggested by Andrew Wilton (*Time*, 43).

16 Thornbury, *Life*, 1862, 2: 55.

17 Thornbury, *Life*, 1877, 235–6.

18 Wiltshire and Swindon History Centre, 383/4/1/fol. 194 (not in Gage). This letter was found by Ian Warrell in 2014 and is quoted in full in Warrell, *Wessex*, 53.

19 The watercolour, W. 203, is now in the Salisbury and South Wiltshire Museum, Salisbury.

20 Admissions Register (unpaginated but organised by date), Bethlem Royal Hospital Archives and Museum, London.

21 Farington, *Diary*, 5: 1746.

14 High Places and High Art

1 Watts, 'Sketch', xvi.

2 Farington, *Diary*, 5: 1747.

3 Ibid., 1745. The nine were Lawrence, Smirke, Garvey, Dance, Daniell, Shee, Westall, Flaxman and Farington. Nollekens had voted for Bonomi. Also present at the dinner was James Heath ARA, who would be in Paris when Turner was there in the late summer.

4 Ibid., 5: 1752.

5 The letter cannot now be traced. For the information that Turner sent in his submissions at different times and the acceptance of one of them, see the Council Minutes, 3: 137, 30 March 1802.

6 The relevant Rate Books for the Parish of St Paul's, Covent Garden (reels H139, H141 in the City of Westminster Archives Centre) show that William Turner stopped paying rates on 26 Maiden Lane in 1802, so he probably moved out just before Lady Day of that year when the first annual payment became due.

7 General Assembly Minutes, 2: 164.

8 Farington, *Diary*, 5: 1788, 15 June 1802.

9 It has long been thought that the 3rd Earl of Egremont purchased *Ships bearing up for anchorage* from the 1802 Exhibition, but he may not have acquired it until 1805. This possibility receives support from an entry in the Bank of England ledgers for that year, as will be determined.

10 For a far more detailed account of this tour, and of the other men associated with it, see the electronic version of this work.

11 Lowson was an enthusiastic huntsman, and that is surely how he had first met the earl, who was passionate about hunting and who consequently ran his own hunt (in 1816 it would be formalised as the Raby Hunt, and in 1832 it would become the Bedale Hunt).

12 For Turner and Lowson on this trip, see Thornbury, *Life*, 1862, 1: 222 and 223. Thornbury's informant was a Keeper at the National Gallery, Ralph Wornum (1812–77), to whom the information may have been handed down by family connections in County Durham. Wornum laboured under the misapprehension that Turner and Lowson had toured Italy together in 1801.

13 Note by Turner on fol. 58 of the *Calais Pier* sketchbook, T.B. LXXXI.

14 For a more detailed analysis of the works studied by Turner in the Louvre, see the electronic version of this work. In Coiffeur's, an artist's materials shop situated at 121 rue du Coq Honoré, he purchased two sketchbooks, one large and the other of medium size; the name of the business, its purpose and street number appear on a label attached to the binding of the *France, Savoy and Piedmont* sketchbook, T.B. LXXIII.

15 See Farington, *Diary*, 5: 1936, 22 November 1802.

16 They were forced to part with their transport, for they planned to cross the high mountains to the south and there were no roads by which they could do so. Moreover, Chamonix then stood in a cul-de-sac, inasmuch as the main road

stopped there, with no extension yet having been built across the intervening fourteen or so miles of mountains to Martigny, to the north-east.

17 Farington, *Diary*, 5: 1888 and 1890. The further meetings took place on 1 October, 22 and 23 November.

18 The foregoing figures have been taken from a report prepared for Napoleon by his Minister of the Interior, Jean-Antoine Chaptal, as quoted in Gould, *Trophy*, 75–7. Napoleon responded to the report in a decree dated 1 September 1800.

19 It would be shortened by more than a third in the 1860s.

20 See fols. 16v and fol. 17 of Turner's 'Backgrounds, Introduction of Architecture and Landscape' lecture given at the Royal Academy in and after 1811, B.L., Add. MS 46,151–P. And see also Ziff, 'Backgrounds', 144–5.

21 Folio 28v of the *Studies in the Louvre* sketchbook, T.B. LXXII.

22 Ibid., fol. 51v.

23 A variant of this phrase is 'Historical colour', as appears on fols. 27 and 28v of the *Studies in the Louvre* sketchbook.

24 Folio 54 of the *Studies in the Louvre* sketchbook.

25 The passage partially reads as follows, with the key phrases appearing here in bold:

> 'Christ is dignified but wants energy and is treated as a subordinate part than as the cause...the figure of Lazarus is **the principle and the light**....the sombre tint which reigns thro out acts forcibly and impresses the value of this mode of treatment that may surely be deem'd Historical colouring which in my idea [is] only [to] be applied when nature is not violated but contributes **by a high or low tone** to demand sympathetical ideas.'

26 Folio 28v of the *Studies in the Louvre* sketchbook.

27 Ibid., fols. 26v and 27.

28 Ibid., fols. 41v and 42.

29 See fol. 15 of the 'Backgrounds, Introduction of Architecture and Landscape' lecture, B.L., Add. MS 46,151–P.

30 See the entry for the work by David Blayney Brown in the section devoted to the *Studies in the Louvre* sketchbook in the revised Inventory of the Turner Bequest, Tate Britain, London.

31 W. 1157, T.B. CCLXXX-146. It seems likely that Turner made this vignette during the same work-session in which he created W. 1152–5 and 1158–160, for they all represent places he had seen on the 1802 tour, or were associated with them.

32 Farington, *Diary*, 5: 1900.

33 According to the author's reckoning, the total breaks down as follows:

Daily expenses averaging

10s-6d per day for 12 weeks	£44
Half-cost of servant hire	£12-12s
Half-cost of cabriolet, if £20 gns was obtained on final resale	£10-10s
London-Paris return travel, say	£10
Miscellaneous extras, say	£5
TOTAL	**£82-2s**

15 Dispute and Disillusion

1 See Cunningham, 'Memoir', 33, for a claim that Turner offered to erect a monument to Girtin in St Paul's Churchyard but was put off by the cost, and Thornbury, *Life*, 1862, 1: 127, which states that a tombstone was erected but that it had been removed by the time of writing. Thornbury also cites a friend as having seen the memorial and sketched it. Given Turner's lifelong regard for Girtin, it seems highly improbable that he would not have contributed towards the cost of his tombstone.

2 Thornbury, *Life*, 1862, 1: 117.

3 Ibid., 2: 36.

4 Ibid., 1: 115.

5 A highly detailed and thoroughly annotated account of the following Royal Academy disputes is provided in the electronic version of this work.

6 Farington, *Diary*, 6: 2456, 30 November 1804.

7 In addition to depicting Sir Edward Knatchbull and his ten children, Copley had also represented the baronet's two dead wives up in heaven, as well as his third one down here on earth. This caused great merriment, to the intense embarrassment of the third Mrs Copley.

8 According to the diagram of the event that appears on page 335 of the original manuscript version of Farington's diary for the period between 1 December 1799 and 1 June 1803 in the Royal Library at Windsor Castle. It is not reproduced in the diary's published form.

9 The image is indebted to a number of landscapes that Turner could have seen in Richard Earlom's engraved version of Claude's *Liber Veritatis*, most notably *L.V.* 134, *Landscape with Jacob, Laban and his daughters*; and, for its grouping of the principal figures, *L.V.* 142, the *Landscape with the Apulian Shepherd changed into an olive tree*. During the period in which the *Mâcon* was in gestation, the latter work by Claude hung immediately next to Turner's *Dutch boats in a gale* in the Duke of Bridgewater's picture gallery in London. *L.V.* 134 has hung at Petworth House, Sussex, since at least 1730, while *L.V.* 142 is now in the Duke of Sutherland collection, Mertoun, Scotland.

10 As David Hill has demonstrated (*Alps*, 27, 29), rather than representing the river Saône at Mâcon – which was what Turner believed he had done – he had depicted the same river near Tournus, about twenty miles to the north.

11 Cunningham, 'Memoir', 78–9.

12 Subsequently the canvas was mounted in an upright position upon an easel when dry, with the dead-colour priming being overpainted with regular oil paint.

13 We can deduce this from a comment made by Farington concerning the hanging position of another painting by Turner; see *Diary*, 6: 2013, 17 April 1803.

14 Turner adapted the word 'poissard' from its usual signification of a fishwife. By means of his title he indicated that all four of the French fishing vessels are leaving harbour.

15 At 67¾ inches (172 cm), *Calais Pier* is just over ten inches (26 cm) greater in height than the *Mâcon*, while both pictures are virtually identical in width. As *Mâcon* would sell for 300 guineas, it is likely that Turner asked 350 guineas for *Calais Pier*.

16 See Hill, *Aosta*, 279.

17 For this suggestion, see Warrell, *Wessex*, 56–7.

18 Turner had probably seen just such a snake near the Glacier du Bois in 1802, for a similar reptile appears in the foreground of *Mer de Glace, in the Valley of Chamouni, Switzerland* (fig. 434).

19 Farington, *Diary*, 6: 2013, 17 April 1803.

20 Ibid., 2026, 17 April 1803.

21 Ibid., 2023, 3 May 1803.

22 Ibid., 2034, 22 May 1803; and 2030, 13 May 1803.

23 Ibid., 2021, 30 April 1803.
24 Ibid., 6: 2024, 4 May 1803.
25 Ibid., 2023, 2 May 1803.
26 Ibid., 2034, 21 May 1803.
27 Raimbach, *Memoirs*, 18.
28 Farington, *Diary*, 6: 2031, 15 May 1803.
29 Ibid., 2021, 30 April 1803.
30 This power struggle is described in detail in the electronic version of this work.
31 At the General Assembly meeting held on 27 April, Soane had read a paper denouncing the behaviour of the Council. Although Lawrence and Farington informed him that he had made one good point, they also told him that the rest of his criticisms were rather like accusations made by a parish-pump demagogue. He had been 'sorely hurt at this and [thrown] down his paper in anger, & was rebuked by Lawrence sharply for his peevishness'(ibid., 6: 2019). See also Farington's entries for 28 April, 9 and 31 May, and 4 and 10 June.
32 See General Assembly Minutes, 2: 229–30 (all also crossed through on 1 December 1803 on the orders of the king, although still perfectly legible); and Farington, *Diary*, 6: 2046.
33 Farington, *Diary*, 6: 2086.
34 Ibid., 6: 2091.
35 Ibid., 6: 2055. Farington received the information from Nathaniel Marchant (1739–1816), who had obtained it from Smirke. And also see the entry for 25 October 1803.
36 Sir Joshua Reynolds's gallery has already been touched upon in the main text above and is discussed in more detail in the electronic version of this work. In 1784 Gainsborough had built a two-storey annexe to his residence in Schomberg House, Pall Mall, and he used it as both a painting studio and a private gallery until his death in 1788. Possibly it was toplit. (See William T. Whitley, *Thomas Gainsborough*, London, 1915, 224–7; Giles Walkley, *Artist's Houses in London, 1764–1914*, Aldershot, 1994, 16–17; and Michael Rosenthal, *The Art of Thomas Gainsborough*, London and New Haven, 1999, 75). West moved into 14 Newman Street in 1774 and converted one of its outbuildings into a gallery for the display of works he had collected by other artists. He also built a long gallery to house his own creations (see Jenny Carson, *Art Theory and Production in the Studio of Benjamin West*, PhD thesis, City University of New York, 2000, 16–31). Copley's gallery comprised the largest room in his house at 24 George Street, Hanover Square, and it was toplit (see Martha Babcock Amory, *The Domestic and Artistic Life of John Singleton Copley RA*, London, 1882; reprinted Freeport, New York, 1970, 99; and Alfred Frankenstein, *The World of Copley 1738–1815*, New York, 1970, 140).

16 Another Great Room

1 Farington, *Diary*, 6: 2028.
2 Orders of the Delegates of the Oxford University Press 1795–1810, accounts for 1804 (at the back of the volume, unpaginated), Oxford University Press Archives, Oxford.
3 Possibly Turner lodged with a Mr Williams above his print and framing shop in St Mary Hall-Lane, as he had probably done in 1798.
4 See Harrison, *Oxford*, 72–4. The replacement artist was Hugh O'Neill (1784–1824).
5 Farington, *Diary*, 6: 2112.
6 Ibid., 2159. Yenn entered the room to inform the PRA that the king wanted to see him at Windsor the following Sunday, 13 November. From the very fact that it was a member of the Court party who had brought the news, the monarch's decision had been revealed, at least in part.
7 Ibid., 2161, 11 November 1803.
8 See ibid., 2080, 14 July 1803.
9 Ibid., 2202.
10 Studies for the painting appear in the *Hesperides (1)* sketchbook, T.B. XCIII, which has previously been dated solely to 1805. However, as the paper within the book is watermarked 1799, there is no reason the artist could not have used the book during 1804, especially as it could easily have taken him two years to complete the painting.
11 Sir John Soane Museum Archive, London 7/P/2, transcribed in Dorey, *Friendship*, 36. The auction took place at Garroway's Coffee House in Change Alley, Cornhill, in the City of London.
12 Elliott was one of the principal cabinet makers of the eighteenth century (see Geoffrey Beard and Christopher Gilbert, *The Dictionary of English Furniture Makers*, Leeds, 1986, 273). He conducted his business at 97 New Bond Street. He was a member of the Clapham Sect, a group of Anglican reformers whose other members included the anti-slavery campaigner William Wilberforce (1759–1833) and the religious writer, poet and abolitionist, the Revd Thomas Gisborne (1758–1846). Turner is known to have greatly appreciated Gisborne's 1794 poem *Walks in a Forest*, and in the 1841 Royal Academy catalogue he would quote a line from it beneath the title of an oil painting he had on display, *Dawn of Christianity (Flight into Egypt)*, B.J. 394. And Elliott was on equally good terms with the 3rd Earl of Egremont who, in the 1820s, would give him the land on which to build a church in Brighton. In the seven years between 1797 and 1804 that were sampled by the author in the Middlesex Land Register in the London Metropolitan Archives, Elliott sold, acquired or part-purchased ten properties in the county of Middlesex area of London alone.
13 Sir John Soane Museum Archive, London 7/P/3, transcribed in Dorey, *Friendship*, 36. The lease was signed and sealed by both Elliott and Turner. It was recorded in the Middlesex Land Register, vol. 4 for 1803, transaction 272, London Metropolitan Archives.
14 Farington, *Diary*, 6: 2271.
15 Ibid., 2302. It should be noted that this passage appears near the end of a very long diary entry that may have been written late at night or early the next morning. That might explain why Farington misremembered or misunderstood the gallery dimensions, as will presently emerge.
16 This is posited upon the basis that during the conversion of the schoolroom into a gallery, its four windows and its existing doorway on the west side were bricked-up and plastered over to provide more wall space.
17 For the first three sales, see Consolidated £3% Annuities Stock Ledger AC27/1676, fol. 47224, while for the fourth transaction, see stock ledger AC27/1792, fol. 47350, both Bank of England Archive, London.
18 Entry 760572 in the Sun Fire Office Insurance Ledger series, Guildhall MS 11936/431, London Metropolitan Archives.
19 Russett, *Serres*, 154. Serres quit the property between April 1802 – when he submitted his works to the Royal Academy from 64 Harley Street – and the following October, by which time he was living in Berners Street.
20 Farington, *Diary*, 6: 2287–8.
21 He had, of course, seen the two paintings hanging adjacently at Cleveland House in May 1802.
22 Farington, *Diary*, 6: 2290. The 'moonlight' was exhibit 132, *The ghost; from Bloomfield's Farmer's Boy. Winter. Moonlight*.

23 There is no evidence to support the claim that has occasionally been advanced that Mary Turner had by 1804 been transferred from the Bethlem Hospital to Brook House, the private clinic in Hackney run by Dr Monro, and that she died there. The Bethlem Hospital Admissions Register for Incurable Patients clearly states that Mary Turner died there on the date given. This has been verified by Colin S. Gale, the Archivist of the Royal Bethlem Hospital who drew upon the researches of his predecessor, Patricia Allderidge.

24 Farington, *Diary*, 6: 2328, 22 May 1804. For the way that Turner played off Sir John Leicester against Lord Yarborough over the purchase of this painting, see the parallel passage in the electronic version of this work.

25 One of the commissioned watercolours closely resembles an oil painting of the view looking southwards from the Devil's Bridge (B.J. 147) that may have been hanging on the wall of Turner's Gallery. If the latter work was on display there, then Fawkes could have admired it so much that he commissioned a version of it in watercolour.

26 Mrs Soane, notebook 1: 17–17v, entry for Thursday 3 May 1804.

27 Farington, *Diary*, 6: 2306.

28 Ibid., 11: 3945.

29 Ibid., 6: 2309.

30 Ibid., 2307, 26 April 1804.

31 Farington, *Diary*, 6: 2319–20, 11 May 1804.

17 Arcadia-upon-Thames

1 See Soane, notebook 63, 13v.

2 This can be inferred from Gage, *Correspondence*, 23–4, letter 6.

3 It seems likely that Dobree paid Turner 200 guineas per painting for *Chateaux de St Michael, Bonneville, Savoy*; *Fishermen upon a lee-shore*; and *A Coast Scene with Fishermen hauling a Boat ashore*. The *Boats carrying out anchors* being larger, it may have cost 250 guineas.

4 Soane, notebook 65, 6v.

5 Hamerton, *Life*, 190. In 1804 Harriet Wells was seven, Charles Wells was five, and Louisa Wells was three. They were therefore exactly of an age to have been thought of as 'children' with 'thirty little fingers' between them. John Gage (*Correspondence*, 295) suggested an 1807 date for this painting session, and did so in connection with Emma Wells, but she would then have been fourteen years of age and therefore hardly a child. Moreover, the fact that Turner took a drawing to Knockholt for completion there also works against an 1807 dating, for in the latter year he visited Ash Grove when on tour, and he would hardly have taken such a work to the cottage in the knowledge that he would have to carry it around with him thereafter. The watercolour in question has not been identified.

6 Ibid., 190–91.

7 See Hill, *Thames*, 24 and 173, n. 6.

8 He could have attained this by moving his father to 64 Harley Street, and Sarah, Hannah and the girls elsewhere.

9 This comprised £450 in Consolidated £3% Annuities, and £317-2s-6d in Navy £5% Annuities.

10 See Hill, *Thames*, 173, n. 6.

11 Gage, *Correspondence*, 25, letter 8. The 90 guineas included 25 guineas for a fairly large depiction of Salisbury Cathedral, W. 200 where dated to 1797–8 but which on stylistic grounds may date from 1804; an identical sum perhaps for an 1802 signed-and-dated watercolour of the same building from its cloisters, W. 202; 30 guineas for an 1805 representation of the view looking across the interior towards its north transept, W. 203; and ten guineas for the cathedral close drawing of c.1802, W. 208 (fig. 313).

12 See Smiles, 'Slave trade'.

13 T.B. CCCLXXX 20. The information in this paragraph derives from Warrell, *Wessex*, 114.

14 Farington, *Diary*, 7: 2522. The diarist was told this by Henry Thomson.

15 Ibid., 2555, 11 May 1805.

16 Ibid.

17 Quoted in Cunningham, *Wilkie*, 1: 79.

18 The title given to the picture here is the one accorded it on the second state of Charles Turner's engraving of the image, R. 751. In the absence of any 1805 exhibition catalogue title, that engraving title is the earliest one for the work that has survived. When the painting was unsuccessfully auctioned in 1809 it was similarly entitled 'BOATS endeavouring to save the Crew of a Ship in Distress' (see Butlin, 'Sale', 31). The modern title 'The Shipwreck' was only bestowed upon the work in the Schedule of the Turner Bequest in 1854 and is therefore inauthentic. In February 1807 Turner called the painting 'the Storm' when exchanging the work with Sir John Leicester, but clearly this was just a conveniently short title (see B.J. 54).

19 See Butlin, 'Sale', 31.

20 See Gage, *Correspondence*, 26, letter 10 for notes made by Turner concerning the aristocrat's wishes regarding the print. These appear on the verso of a letter from a Mr Gilly of Twickenham who was probably the owner or head leaseholder of Syon Ferry House. And see also R. 751.

21 Farington, *Diary*, 7: 2544.

22 Dayes, *Works*, 352–3.

23 Farington, *Diary*, 7: 2591.

24 Ibid for Farington's breakdown of the votes.

25 For this to have been accomplished, Turner would have had to have begun the painting very shortly after returning from his first summer trip upriver in 1805.

26 See Darley, *Soane*, 165.

27 The architect was accompanied by his solicitor, financial advisor and close friend, the City of London Remembrancer or head of protocol, Timothy Tyrrell (1755–1832), who was an equally avid fisherman. It may be that Turner joined the group for a visit to the parish church in Basildon, Berkshire, about a mile to the west of Pangbourne, where Flaxman had recently installed a monument to a local landowner. All the foregoing information derives from Darley, ibid.

28 B.J. 160.

29 See Farington, *Diary*, 7: 2657.

30 This comprised £1,307-2s-6d in Navy £5% Annuities; £450 in Consolidated £3% Annuities; and £50 in Reduced £3% Annuities.

18 Staying Away

1 For a more detailed analysis of the movements of the *Victory* following the removal of the body of Lord Nelson on 13 December 1805, as well as for the reasons behind the precise dating of Turner's boarding of the ship, see the electronic version of this work.

2 Mrs Soane, notebook 4: 27v and 28.

3 The other drawing is T.B. CXX-C in which Turner represented the view looking towards the prow of the vessel. Here, and with characteristic economy, he simply denoted the uppermost and lowest sections of the shrouds or rope ladders that

afforded access to the tops or lookout platforms, as well as to the yards or masts from which the sails were suspended; if required, he could have filled in the rest of the shrouds later.

4 The notes relating to these enquiries appear on fols. 4, 13, 14, 15, 17 and 20 of the *Nelson* sketchbook, T.B. LXXXIX.

5 Without doubt, Turner realised that it would have been extremely foolhardy to have attempted to sail his own boat both to and across the Thames estuary, for he lacked the experience to do so. After all, swanning around by oneself in the relatively sheltered reaches of the upper Thames and its tributaries in a little dinghy during high summer was one thing. Taking such a relatively small craft through the intensely crowded waters of the Pool of London and out into the strong tides, treacherous currents, tidal shallows, shifting mud and sandbanks, packed shipping lanes and rapidly changing weather of the Thames estuary was quite another, especially in the depths of winter.

6 B.J. 87, *Fishing upon the Blythe-Sand, tide setting in*, Turner Bequest, Tate Britain, London.

7 B.J. 74, *Purfleet and the Essex shore as seen from Long Reach*, private collection, Belgium.

8 See fol. 67 of the *River and Margate* sketchbook, T.B. XCIX, for Margate partially in the shadows cast by a winter rising sun, with Hooper's Mill evident to the right; and fol. 9v (lower sketch) of the same sketchbook for Margate and for harbour machinery also depicted in the canvas to which reference is made in the following note. Additionally, the sketch on fol. 30 of the book clearly depicts Margate from the sea.

9 B.J. 174 (Turner Bequest, Tate Britain, London) – which is wrongly entitled 'Margate, Setting Sun' – undoubtedly depicts a dawn scene in winter.

10 B.J. 78, *Margate*, Tate Britain and the National Trust, Petworth House, Sussex.

11 See fols. 31 and 30 of the *Shipwreck (No. 1)* sketchbook, T.B. LXXXVII.

12 See fol. 81 of the *River and Margate* sketchbook, T.B. XCIX.

13 In the 1808 view of Margate soon after dawn in winter as seen from offshore that is mentioned in note 10 above, Turner would depict fish being purchased from a passing Hastings fishing boat by Margate fishermen in their wherries. He therefore knew that it was possible to transfer from a local fishing boat to a seagoing one and had surely experienced doing so by the time he painted the picture.

14 They were the Earl of Dartmouth; the Marquess of Stafford; Lord Lowther; the Rt Hon. Charles Long, who was then the MP for Wendover, Hants; Sir George Beaumont, Bt; Sir Francis Barns, Bt; and Richard Payne Knight, who at the time was the MP for Ludlow, Shropshire. The committee had been appointed on 21 January 1806.

15 By mid-February, any sunlight passing into the British Institution would have entered at a fairly shallow angle and slanted mainly into the North and Middle rooms, while leaving the South Room mostly in shadow. This was because the skylights rose more than twenty-four feet from the floor.

16 Farington, *Diary*, 7: 2683. Because of their positioning, Turner's two oils can only have received limited amounts of ambient light from any sunshine, while on sunless days the general gloom must have deepened considerably. But whatever the weather, the top-lighting obviously raked Turner's paintings at an acute angle and resulted in shadows being cast by the weave of the canvas, with the consequent graininess rendering the imagery difficult to see. Such a stress would explain why Turner's two paintings reminded Daniell of 'old Tapestry', for one cannot remain unaware of the fabric surface in tapestries, especially in poor light. On the positive side, however, the raking light of the South Room must have significantly accentuated a major disruption of the otherwise smooth surface of *The goddess of Discord*. As we shall see, this could only have had a welcome effect where the intended meaning of the work was concerned.

17 Ibid., 2710.

18 In all probability the support had once comprised two pieces of sacking that had been sewn together, perhaps in order to contain building materials used in the creation of the Harley Street gallery in 1803–4. And see Shanes, 'British Institution', 30–36.

19 See fols. 2, 4 and 24 of the *Shipwreck (No 1)* sketchbook, T.B. LXXXVII.

20 See Darley, *Soane*, 171. Farington was not present at this meeting.

21 Farington, *Diary*, 7: 2777.

22 By mid-August 1807, the organiser of the competition, Josiah Boydell (1752–1817), would already have obtained 800 subscribers to an engraved reproduction of Devis's picture, which is now in the National Maritime Museum, Greenwich (see ibid., 2837, 16 August 1806). William Bromley's engraving of it would only appear in 1812.

23 This is the title accorded the work on the only occasion it was displayed during Turner's lifetime, in 1823 at the Northern Society in Leeds, having been loaned by Walter Fawkes; see Hill, *Birds*, 10 and 26, n.5. That therefore remains its sole authentic title.

24 Sir John Leicester would pay Turner £280 on 18 January 1807 (see Hall, 'Tabley', 93). The receipt was endorsed by Turner for 'Walton Bridge'. As £280 would have been a rather high amount for a 36 × 48-inch canvas, possibly the collector purchased two pictures rather than one for that sum; see Evelyn Joll's entries for B.J. 60 and 65, which links this work to *Newark Abbey on the Wey* (Yale Center for British Art, New Haven). Earlier, on 11 February 1806, Turner spent £161-18s-11d on Reduced £3% Annuities (see Reduced £3% Annuities Stock Ledger AC27/6839, fol. 11598, Bank of England Archive, London). Probably this money had accrued from the sale of *A shipwreck with Boats endeavouring to save the Crew* to Sir John Leicester for 300 guineas or £315, payment for which had been made on 31 January 1806 (see Hall, 'Tabley', 93).

25 Farington, *Diary*, 7: 2746.

26 During the course of arranging the display, a member of the hanging committee, Edmund Garvey, had led Turner to believe that this painting would be admirably placed without actually making a promise to that effect; see ibid., 2738.

27 Ibid., 2748. As will be seen below, Taylor would become a great admirer of Turner's work within a short time.

28 Ibid., 2775–6, 1 June 1806.

29 Thus it is likely that Edward Lascelles junior paid Turner 60 guineas on 8 April for the *Pembroke-castle, Clearing up of a thunder-storm* exhibited at the Royal Academy in 1806 (to which he may have lent it), and for a drawing of Lake Geneva with Mont Blanc in the distance that probably also dated from the same year (W. 370, where it is erroneously stated that the watercolour was owned by Walter Fawkes and was exhibited at his Grosvenor Place exhibition in 1819; the work is now in the collection of the Yale Center for British Art, New Haven). Sixty guineas was a comparatively low price for two

watercolours of this size and quality. And, of course, it must be remembered that in May 1797 Lascelles had begun collecting Turners by purchasing *St Erasmus and Bishop Islip's Chapel, Westminster Abbey* (fig. 151) for a paltry three guineas. Accordingly, there was a precedent for him obtaining choice specimens of the artist's work for low prices, even if the amount paid in 1797 was artificially low, perhaps because Turner wanted to tempt him into buying more.

30 Farington, *Diary*, 7: 2777. By 'vicious', Sir George clearly meant disgusting or foul. It should be remembered that Turner had not sold some of his major exhibition pieces of the period, such as the *Narcissus and Echo* of 1804, *The Destruction of Sodom* of 1805, and *The goddess of Discord choosing the apple of contention in the garden of the Hesperides* of 1806.

31 This comprised £1,414-15s-11d in Navy £5% Annuities; £400 in Consolidated £3% Annuities; and £273-16s-4d in Reduced £3% Annuities.

32 Farington, *Diary*, 7: 2756.

33 See Hill, *Thames*, 173, n. 6.

34 Gage, *Correspondence*, 31, letter 17, 7 August 1806. Turner quoted lines 323–4 of the Horace.

35 As told to Evelyn Joll by Derek Chittock prior to 1984 and related by Martin Butlin in his entry for B.J. 68. The 'smithy' is clearly indicated just off Harrow Road on the 1869 *Ordnance Plan of the Parish of Knockholt*.

36 Thornbury, *Life*, 1862, 2: 55; and Rawlinson, *Liber*, xii–xiii.

37 Clara Wells tells us that she 'sat by Turner laughing and playing whilst he made the drawings' (Rawlinson, *Liber*, xiii).

38 See Finberg, *Liber*, lxxxiii; Forrester, *Liber*, 19; and Gillian Forrester, entry on 'Liber Studiorum' in the *Oxford Companion*, 167.

39 As established by Dr Joyce Townsend (see Forrester, *Liber*, 14), Turner employed umbers, siennas, ochres, Indian red, vermilion and sepia in various strengths and mixtures for the *Liber Studiorum* drawings.

40 See Forrester, *Liber*, 33–6.

41 Rawlinson, *Liber*, xiii.

42 For Clara Wells Wheeler, 'E.P.' denoted 'Elegant Pastoral' and not 'Epic' or 'Elevated' Pastoral, the signification of which terms would later be contended by others. Because she was in on the project from the very start, there is every reason to believe she had heard her father and Turner use the term 'Elegant Pastoral' rather than the alternatives. See Thornbury, *Life*, 1862, 2: 55 and the following note.

43 The 'E.P.' classification has been the subject of enormous debate in the Turner literature, with 'Epic Pastoral' and 'Elevated Pastoral' being the favoured interpretations of the acronym. However, as Clara Wells Wheeler is the only identifiable person connected with the genesis of *Liber Studiorum* to have left a record of what the letters 'E.P.' signified, her testimony has to stand, for we possess no means of proving her wrong. Additionally, Thornbury (*Life*, 1862, 1: 278) explicates 'E.P.' as meaning 'Elegant Pastoral', probably because he received this signification from Clara Wells Wheeler. Today the word 'elegant' is usually employed in connection with the fashion industry, but in Turner's day it frequently denoted grace and refinement. If we substitute 'Graceful Pastoral' or 'Refined Pastoral' for 'Elegant Pastoral', the use of those terms would seem perfectly suited to all the images belonging to the 'E.P.' category. Consequently, 'Elegant Pastoral' *is* apt, despite the objections of John Lewis Roget, as stated in Pye-Roget, *Liber*, 33–4.

44 These were *Bridge and Cows*, *Scene on the French Coast*, *The Straw Yard* and *Bridge and Goats*.

45 The fifth preliminary drawing for *Liber Studiorum* made at Knockholt in October 1806 had to have been *Woman and Tambourine* (fig. 337), for the reproduction of that image would appear in the first published set of *Liber Studiorum* engravings. The print of *The Straw Yard* would appear in the second part, while the engraving of *Bridge and Goats* would only see the light of day in the ninth part, which would not come out until 1812. The two further designs that would be reproduced in the first part would be a variant version of the 1802 oil painted image, *Jason* (fig. 272), the *Liber Studiorum* drawing for which Turner would elaborate back in London when the canvas would be in front of him once again; and a depiction of Basle, which he must have drawn in Harley Street directly onto an etching plate prepared by Charles Turner (for it was only in that location that Turner possessed the topographical material needed for the image, as he had not anticipated making the *Liber* drawings when going down to Knockholt in October, and had not therefore taken his 1802 sketches of Basle with him).

46 This interpretation was first advanced by W. G. Rawlinson (*Liber*, 15).

47 Forrester, *Liber*, 47–8.

48 *Sale particulars, Small Compact and Desirable Freehold Estates and Cottages, Bucks*, auction catalogue in the Turner family papers. The author is grateful to James Hamilton for supplying a transcript of the relevant catalogue entry.

49 See fol. 8v of the *Finance* sketchbook, T.B. CXXII. There Turner evidently noted from memory the total he had spent on acquiring the Lee Clump property. This comprised the payment back in 1806 of the £20 deposit (which in 1809 he would erroneously note as having been £19); £8-5s interest; the £75 remaining on the freehold (which in 1809 he would erroneously note as having been £76); and £16 for the 'Law Ex.' (that is, legal expenses). In total, this still comes to the correct figure of £119-5s paid for the property.

50 Farington, *Diary*, 8: 2929, 17 December 1806.

51 West was re-elected by 17 votes; his opponent, de Loutherbourg, only received four votes, probably from Copley, Beechey, Rigaud and Bourgeois.

19 Another Grand Title

1 This comprised £1,452-7s-5d in Navy £5% Annuities; £400 in Consolidated £3% Annuities; and £150 in Reduced £3% Annuities.

2 Quoted in Whitley, *England 1800–1820*, 195–6. Stephens was also the Keeper of the British Museum Print Room for many years. His family residence was at 9 Hammersmith Terrace, just along the street from the house formerly lived in by de Loutherbourg. Whitley derived the information from an untraced article by Stephens written over forty years prior to 1928, and by the time he re-published the information, the property formerly occupied by Turner had been replaced by a seed-crushing mill.

3 See Chubb, 'Minerva Medica', 26–9.

4 T.B. CXXII.

5 The passages cited appear on fols. 40, 41 and 42 respectively.

6 Folio 54v of the *River and Margate* sketchbook, T.B. XCIX, that was in use in 1805 and 1807. See Warrell, 'Checklist', 17, where first discussed.

7 T.B. CCCLXV-A [Additional number]. The recto contains two of the drawings, the verso the third, which shows a woman fellating a man. Of

the two drawings on the recto, one contains a male who sports pointed ears and a short tail, and was therefore probably intended to denote a satyr. For discussion as to whether this drawing might be by Charles Reuben Ryley, see Warrell, 'Checklist', 18–19.

8 T.B. CCX(a). The sketchbook contains exactly the same kind of laid paper made at Crabble Mill, Kent, as is to be found in the *Cockermouth* sketchbook, T.B. CX, which was in use in 1809, as well as the same type of cover that protects it. The two books are also virtually identical in size. A number of the figures in the *Academy Auditing* sketchbook depict Mercury or satyrs.

9 Turner acquired £150-worth of Navy £5% Annuities and £50-worth of Reduced £3% Annuities (see, respectively, Navy £5% Annuities Stock Ledger AC27/5197, fol. 15485; and Reduced £3% Annuities Stock Ledger AC27/6839, fol. 11598, both Bank of England Archive, London). For the picture exchange, see Hall, 'Tabley', 93 and 120. For the reasoning behind the claim that it was the baronet's mistress, Emily St Clare, who asked her lover to swap the painting because she had lost a nephew at sea, see the corresponding passage in Chapter 25 of the electronic version of this work.

10 Folio 67v of the *Derbyshire* sketchbook, T.B. CVI. It may be that the month referred to in the reference to Mary Wells was October 1806, when Turner had last seen her, but the *Derbyshire* sketchbook was probably not in use by then.

11 Eighteen candidates stood this year. According to Farington (*Diary*, 8: 2695–6), in the first ballot Turner voted for Samuel Woodforde, despite having concluded in 1804 that he was a 'leaden' painter who was 'incapable of rising to a height'. At the same time he also voted for Woodforde's principal opponent, Thomas Phillips. In the second, run-off ballot he voted for both Woodforde and Henry Howard.

12 Soane, notebook 78, 11.

13 Farington, *Diary*, 8: 2942, 11 January 1807. The architect had been talking to Samuel Woodforde at the time.

14 Council Minutes, 4: 13.

15 Farington (ibid., 3027) saw Turner join the funeral party at Opie's house in Berner's Street, but due to a headache he himself was forced to drop out of the cortège and ceremony. For the cold, and for the time the funeral terminated, see ibid., 3028. Farington's informant was Richard Westall.

16 Soane, notebook 79, 3v.

17 Entry 800988 in the Sun Fire Office Insurance Ledger series, Guildhall MS 11936/440, London Metropolitan Archives.

18 See fol. 7v of the *Finance* sketchbook, T.B. CXXII. The page records Turner's Navy £5% Annuities acquisitions and sales between 28 January 1807 and 22 February 1809. The seventeenth item on the list is '1825.11.1 Bt Parker. 200'. This denotes the £1,825-11s-1d that Turner had invested in such stock between 29 July and 15 August 1808, when the sum increased through the sale of another picture and conversion of the money received into the same type of stock (see Bank of England Navy £5% Annuities Stock Ledger AC27/5230, fol. 17052, Bank of England Archive, London). Parker acquired two paintings from Turner, of which only the *Sheerness* could have cost 200 guineas, due to its size (and in any case the sale of the other one is recorded below).

19 The reasons for thinking that the *Walton Bridges* now in Melbourne was exhibited in 1807, and that it was purchased by Lord Essex in that year, are given under B.J. 63.

20 See Solly, *Cox*, 27.

21 Farington, *Diary*, 8: 3038.

22 Soane, notebook 79, 10.

23 The hang of Turner's *A country blacksmith*, Westall's *Flora unveiled by the zephyrs* and Wilkie's *The Blind Fiddler* was mentioned in a review in the *Cabinet*, June 1807, 245.

24 For the arguments behind this assertion, see the discussion of the 1807 Royal Academy Exhibition in the electronic version of this text.

25 In 1810 Turner would exhibit the painting in his gallery under the title 'Dutch Boats', while in a letter of 12 December 1810 written to Sir John Leicester he would again accord it that title (see Bachrach, *Holland*, 34–5). In a description of the work he would give to Sir John Leicester in 1818, he would entitle it 'Dutch Boats and Fish Market – Sun Rising thro' Vapour' (see B.J. 69).

26 Bachrach, *Holland*, 34.

27 Ibid.

28 The picture had passed through a London saleroom in May 1794. Turner may have viewed it at that time, or known it through its engraved reproduction by Jacques-Philippe Le Bas (1707–1783), or seen it after May 1794 in the collection of the Earl of Ashburnham, either at Ashburnham House in Westminster or at Ashburnham Place in East Sussex if he had visited that mansion in 1796 and the painting was hanging there at the time.

29 Farington, *Diary*, 8: 3006, 7 April 1807.

30 Ibid., 3071, 19 June 1807.

31 Ibid., 3007, 7 April 1807.

32 Ibid., 3071, 19 June 1807.

33 Ibid., 3040, 8 May 1807.

34 See Hall, 'Tabley', 93.

35 Technically, copyhold land was land owned by the lord of the manor (who, in Turner's case, was the Duke of Northumberland). The latter issued grants entitling occupancy. A copyholder could then sell on that right, which is what Turner had purchased. The sale was effected by the vendor 'surrendering' the land to the lord of the manor, who then issued a new grant to the purchaser. The transaction was 'registered' (that is, recorded) in the manorial records or 'Court Roll'. The 'Deed of Absolute Surrender' which effected this process was equivalent to a modern conveyancing document. The copyhold system was abolished in 1925, when all copyholds were converted to freeholds by statute. All the foregoing information was supplied by Nicholas Powell, to whom the author is indebted.

36 Turner sold Consols £3%, Navy £5% Annuities and again Consols £3%, to the value of £50 per transaction on 20 and 21 March 1807, as well as on an unspecified date before that (see the Consolidated £3% Annuities Stock Ledger AC27/1792, fol. 47350, while for the 21 March sale see Navy £5% Annuities Stock Ledger AC27/5197, fol. 15485, both Bank of England Archive, London). Additionally, on 6 April he sold £100-worth of Consols £3%, while on 4 May another £100 was released, this time by selling Navy £5% Annuities (for the 6 April transaction, see Consolidated £3% Annuities Stock Ledger AC27/1792, fol. 47350, while for the 4 May sale, see Navy £5% Annuities Stock Ledger AC27/5197, fol. 15485, both Bank of England Archive, London). And on an unrecorded date that may also have been 4 May, a further £200 was converted into cash by the sale of Navy £5% Annuities (Ibid. Both the £200-worth of stock possibly sold on 4 May, and the £100-worth that was definitely sold on that date must constitute the '300' that was 'Sold for Land', as recorded in the list of Navy £5% Annuities sales and acquisitions recorded on fol. 7v of the *Finance* sketchbook, T.B.CXXII).

37 According to the 4 May 1807 'Deed of Absolute Surrender' that effected the transfer of

ownership to Turner, as submitted to the Deputy Chief Steward of the Manor of Isleworth Syon for registration. This was discovered in 1981 by Patrick Youngblood; see his 'Sandycombe', 22. The document is now in the London Metropolitan Archives (ACC/1379/112/01–03).

38 At some point between 25 August 1810 and March 1811 he would record on fol. 3 of the *Sandycombe and Yorkshire* sketchbook, T.B. CXXVII, having spent £500 some years earlier on land in 'Richmond' (for which read 'Twickenham'), while on additional document 4 in the *Finance* sketchbook, T.B. CXXII, in February 1812 he would write '400 Purchase' amid a list of expenses accrued in connection with the villa he was building on the Sand Pit Close site. That had to have been the purchase-price of the land upon which the residence stood.

39 The first of these would be handed over on or shortly after 10 October 1807, when £50 would be liquidated from stock; on or shortly after 11 November 1807, when the same amount converted from stock would be paid; on or shortly after 8 February 1808, when £100 would be turned from stock into cash; and on or shortly after 7 May 1809, when another £100-worth of stock would be sold and almost certainly paid in cash. For the Navy £5% Annuities sales of 10 October and 11 November 1807, and of 13 May 1808, see Stock Ledger AC27/5230, fol. 17052; and for the Consolidated £3% Annuities sales of 8 February 1808 and 7 May 1809, see Stock Ledger AC27/1792, fol. 47350, all Bank of England Archive, London.

40 Principal among them was John Soane's *Sketches in architecture containing plans and elevations of cottages, villas and other useful buildings*, published in London in 1793. Among the other books that Turner definitely consulted during the 1807 to 1811 period, or that he may have read at that time, were J. Miller's *The country gentleman's architect, in a great variety of new designs; for cottages, farm-houses, country-houses, villas, lodges*, published in 1787 and republished in 1791; Charles Middleton's *Picturesque and architectural views for cottages, farm houses and country villas* of 1795; John Plaw's *Sketches for country houses, villas, and rural dwellings, also some designs for cottages*, which had appeared in 1800; James Malton's *A collection of designs for rural retreats as Villas*, published in 1802; Edmund Bartell's *Hints for picturesque improvements in ornamented cottages, and their scenery* of 1804; William Fuller Pocock's *Architectural Designs for Rustic Cottages, Picturesque Dwellings, Villas, &c*, published in 1807; Robert Lugar's *The Country Gentleman's Architect* of 1807; Edward Gyfford's *Designs for small picturesque cottages and hunting boxes*, also published in that year; and C. A. Busby's *A Series of Designs for Villas and Country Houses . . . with plans and explanations to each*, which came out in 1808. All of these titles were published in London. And see Helmer, 'Sandycombe', 10.

41 Mrs Soane, notebook 7: fol. 29v.

42 See Farington, *Diary*, 8: 3067, Saturday 13 June 1807, which mentions that the first number of *Liber Studiorum* had appeared 'Thursday last' – that is, on 11 June.

43 Ibid. Farington made a mistake here, for he stated that the prints that comprised *Liber Studiorum* had been etched and aquatinted from Turner's designs, whereas of course they had been etched and mezzotinted (but perhaps Turner had not identified the process employed, leaving Farington to work it out for himself, and thus get it wrong).

44 Thornbury, *Life*, 1862, 1: 162. His informant is unknown.

45 On 5 June Turner acquired £100-worth of Reduced £3% Annuities (see Reduced £3% Annuities Stock Ledger AC27/6847, fol. 38209, Bank of England Archive, London). He may have done so using the best part of 100 guineas he had probably received from William Penn of Stoke Poges (1776–1811). The latter had recently acquired the *Dunstanburgh Castle, N.E. coast of Northumberland. Sun-rise after a squally night* that had been exhibited at the Royal Academy in 1798. Although the picture is 36 × 48 inches in size, and should therefore have fetched 200 guineas, Turner had probably sold it for half that sum because it was relatively old. It is very likely he had re-exhibited the picture in his gallery show, from which Penn had purchased it. And on 4 September Turner acquired £200-worth of Navy £5% Annuities with money deducted from the 200 guineas he had received from Lord Essex for the second *Walton Bridges* painting, which had been exhibited that spring (see Navy £5% Annuities Stock Ledger AC27/5230, fol. 17052, Bank of England Archive, London; for proof that Turner had bought the stock with money derived from Lord Essex, see fol. 7v of the *Finance* sketchbook, T.B. CXXII, where the date of both payments is established by the running total of £1,552-7s-5d in Navy £5% Annuities that is recorded immediately before the words 'Bought Ld. Essex' as the sixth item on the list). As with the 5 June stock acquisition, the painter pocketed the difference between pounds and guineas because the Bank of England did not accept payment in the latter. Moreover, on 4 September Turner would also buy £50-worth of Consols £3%, while four days later a further £50-worth of the same type of stock would be purchased (both Consolidated £3% Annuities Stock Ledger AC27/1792, fol. 47350, Bank of England Archive, London). The money for the latter two acquisitions might have derived from the sales of watercolours.

46 Farington, *Diary*, 8: 3141, 15 November 1807, in which the diarist recorded being told by Henry Edridge that 'Turner has lately made drawings of Cashiobury', and that Lord Essex and the Rt Hon Charles Long had been pleased by them. The prints are R. 818–21.

47 Page 16 of the Poor Rate Book for the Parish of Twickenham for 1800 (London Borough of Richmond upon Thames Local Studies Library) records '1800 Sir John Leicester £4-0-0' and 'land '0-6-0'. The house had once been owned by the portrait painter Thomas Hudson (1701–1779).

48 Page 36 of the Poor Rate Book for the Parish of Twickenham for 1803 (London Borough of Richmond upon Thames Local Studies Library) records '1803 Howe Baroness, late Sir John Leicesters, – late Mr Mays, – lands £15-12-0'. John May was a nephew of Thomas Hudson, from whom he had inherited the villa. The transactions between May and Baroness Howe are recorded in the Middlesex Deeds Register (MDR 1802/6/886, London Metropolitan Archives).

49 During the short period in which the vendor had possessed the property, he had converted its grounds 'into a common garden'; see 'On the Report that the beautiful Grounds at Twickenham, planted by Pope, had been converted into a common Garden', the *Sun*, 19 June 1807.

50 Folio 45 of the *River* sketchbook, T.B. XCVI.

51 They were the *River* sketchbook, T.B. XCVI; the *Windsor, Eton* sketchbook, T.B. XCVII; and the *Frittlewell* sketchbook, T.B. CXII. Other than to write verses inside one of its covers and on some adjacent pages, Turner would not use the last of these sketchbooks until 1809.

52 A transcription of the poem by Rosalind Mallord Turner appears in Wilton and Turner, *Poetry*, 149.

53 Ibid., 150.

54 T.B. CII.

55 T.B. CXX-N.

56 The commission is listed on T.B. CII, fol. 1. The idea would linger in the painter's mind and find its way onto paper by 1815 or not long afterwards, as will be touched upon below.

57 In possible order of use, they are the *Hurstmonceux and Pevensey* sketchbook, T.B. XCI; the *Sussex* sketchbook, T.B. XCII; the *Shipwreck (No. 2)* sketchbook, T.B. LXXXVIII; and the *Spithead* sketchbook, T.B. C. Originally, Turner had titled the latter 'Shipping' on its spine; and 'River Thames / Margate' on its back cover. Collectively, these sketchbooks point to a short tour of East Sussex, south-west Kent, Hampshire and Surrey as having occurred between 1805 and 1810, and of these years, 1807 was the only one in which it could have taken place. This is because in 1805 Turner had sailed up the Thames and the Wey; in 1806 he had undertaken a winter exploration of the Thames estuary and a North Sea voyage; in 1808 he would visit Cheshire, north Wales and Yorkshire; in 1809 he would stay at Petworth, West Sussex, as well as travel up to Westmorland and Cumberland; and in 1810 he would return to East Sussex but in connection with a project that did not generate any of the drawings in the four sketchbooks. For a reason we shall come to, it appears most likely that Turner undertook the 1807 tour in October of that year.

58 It may well be that he caught a stagecoach to Sevenoaks – from which vehicle he could have alighted very near to Knockholt en route – on the morning of Saturday 10 October, immediately after seeing his stockbroker to arrange a sale of Navy stock in furtherance of another payment of £50 to John Baker for the parcels of land in Twickenham (for which, see Navy £5% Annuities Stock Ledger AC27/5230, fol. 17052, Bank of England Archive, London).

59 A detailed exploration of this tour appears in the electronic version of this work.

60 The sequence of a 'sinking and creeping' smuggling operation is made evident by W. 512, created around 1823 for the 'Marine Views' series (T.B. CCVIII-Y); W. 509, signed and dated 1824, and elaborated for the same scheme (untraced); W. 480, drawn around 1822 for the 'Picturesque Views on the Southern Coast of England' series (Taft Museum, Cincinnati, Ohio); and W. 826, developed around 1829 for the 'Picturesque Views in England and Wales' project (Yale Center for British Art, New Haven). They are all discussed and reproduced in colour in Shanes, *England*, 120–21, 271, 69 and 203 respectively.

61 The *Shipwreck (No. 2)* sketchbook. That Turner did make the pen-and-ink drawings indoors is proven by the fact that none of the ink from any of them was offset onto the backs of the previous pages in the sketchbook, thereby demonstrating that each of them had been calmly permitted to dry before the next one was begun. Such an approach bespeaks indoor working, not a constant struggle with fluttering paper, a quill pen and some very runny ink on an extremely windswept beach.

62 The argument behind this assertion appears in Chapter 26 of the electronic version of this work, and it includes important implications for the dating of the Portsmouth to London part of the tour.

63 See W. 477, *Portsmouth*, made around 1824 for the 'Picturesque Views on the Southern Coast of England' series; W. 756; *Portsmouth*, elaborated around 1825 for 'The Ports of England' scheme; W. 816, *West Cowes, Isle of Wight*, drawn around 1828 for the 'Picturesque Views in England and Wales' series; and W. 828, *Gosport (Entrance to Portsmouth Harbour), Hampshire*, developed around 1830 for the same project. They are discussed and reproduced in colour in Shanes, *England*, respectively 67, 135, 193 and 205.

64 The *Liber Studiorum* drawing shows the Sailor's Stone on the brow of Hindhead, as well as a shepherd in the foreground who, by his supine position on the ground, may allude to the murdered sailor.

65 In the drawing, but not in the *Liber Studiorum* print, the Sailor's Stone additionally resembles a shrouded figure walking across the hilltop.

66 These would respectively form plates 25, 33, 37 and 47 of the *Liber Studiorum*. All four of the drawings reproduced by these prints would be made during the winter of 1807–8.

67 See Piggott, 'Lyric', 12–13.

68 Soane, notebook 82, 16.

69 General Assembly Minutes, 2: 343–50. Perhaps prompted by anxiety, Turner may well have arrived at the proceedings early, which is why his name heads the list of Academicians present.

70 Although it has often been claimed that Turner was present to witness the arrival of the Danish prize ships, for reasons explored at some length in the electronic version of this work, that cannot have been the case.

71 Rate Books for the Parish of St-Mary-le-Bone, Wimpole Division, reel 32 for 1807 and 1808, City of Westminster Archives Centre.

72 Ibid.

73 Only in the mid-morning, when the low sun was located above the southern end of Harley Street – which runs on a south-south-east to north-north-west axis – would winter sunlight have fallen directly upon the street, and even then it would have done so merely for a short while.

74 On 11 November Turner sold £50-worth of Navy £5% Annuities, possibly to enable a further payment for the Twickenham land to John Baker (see Navy £5% Annuities Stock Ledger AC27/5230, fol. 17052, Bank of England Archive, London). He bought the same type of stock to the value of £158-7s-4d on 25 November (ibid). Against this sum on fol. 7v in the *Finance* sketchbook, T.B. CXXII, he wrote the name 'Parker', thereby identifying the money as having emanated from the sale of a work to Thomas Lister Parker. (With this stock acquisition, the running total of Navy £5% Annuities owned by Turner came to £1,402-7s-5d, as he listed in the preceding line to the one in which 'Parker' appears alongside the '158.7.4'.) The picture in question had to have been the *Fishermen becalmed previous to a storm, twilight* that had been exhibited at the Royal Academy in 1799, for that is the only Turner other than the view of Sheerness that might possibly have belonged to Parker. The painter had probably obtained 150 guineas for it and the extra 17s-4d for its transportation (it had, of course, been framed in 1799). Sadly, it has long since vanished. And a further £159-0s-11d was spent on acquiring Reduced £3% Annuities on 3 December (see Reduced £3% Annuities Stock Ledger AC27/6874, fol. 38209, Bank of England Archive, London). The money used for this purchase almost certainly derived from 200 guineas paid by Lord Egremont for the view of the Thames near Windsor that he had committed himself to purchasing from Turner's Gallery show in the spring.

75 General Assembly Minutes, 2: 355.

20 Higher Education

1 This point was first made by Dr Maurice Davies; as he states, Turner 'studied almost twenty different historical methods of perspective. His research was wider in scope than anything that had been published on the history of perspective and may represent the most ambitious study of the subject undertaken before the middle of the nineteenth century' (see Davies, *Perspective*, 44). For a more detailed listing than is possible here of the literature read by Turner in connection with his perspective lectures, see the electronic version of this work.

2 By the time of his death Turner would possess a copy of the 1765, third edition of the treatise by Kirby which he had apparently borrowed from the Revd Henry Scott Trimmer and never returned, for it bore Trimmer's *Ex Libris* stamp or label. It has subsequently disappeared. See Wilton, *Time*, 247. Probably he would consult the Malton book in the British Museum, for he had presumably worked from his teacher's copy after 1789.

3 These books were, respectively, Guidobaldo del Monte, *Perspectivae Libri Sex* of 1600; Jan Vredeman de Vries, *Perspective*, in a 1619 edition; Salomon de Caus, *Le Perspective*, in a 1612 edition; Jacques I Androuet du Cerceau, *Leçons de perspective positive* of 1576; Joseph Moxon, *Practical Perspective, or perspective made easy* of 1670; Bernard Lamy, *A Treatise of Perspective* of 1702 but in a 1710 translation; Brook Taylor, *Linear Perspective* of 1715; John Hamilton, *Stereography; or, a compleat body of perspective* of 1738; Joseph Highmore, *The Practice of Perspective* of 1763; Joseph Priestley, *A Familiar Introduction to the Theory and Practice of Perspective* of 1770; James Ferguson, *The Art of Drawing in Perspective* of 1775; James Malton, *The Young Painter's Maulstick, being a practical treatise on perspective* of 1800; and John George Wood, *Six Lectures on the Principles and Practice of Perspective*, first published in 1804 and reissued in 1809.

4 John Landseer, review in the *Review of Publications of Art* (1808), 1: 83; reprinted in Luke Herrmann, 'John Landseer on Turner, Reviews of Exhibits in 1808, 1839 and 1840 (Part I)', *Turner Studies*, 7: 1 (Summer 1987), 26–33.

5 Ibid., 85.

6 Navy £5% Annuities Stock Ledger AC27/5230, fol. 17052, Bank of England Archive, London.

7 See fol. 7v of the *Finance* sketchbook, T.B. CXXII, where mention of 'B' 164' is made alongside the name of 'Ld Egrmt'.

8 *The Thames at Weybridge* is B.J. 204, Tate Britain and the National Trust, Petworth House, Sussex.

9 Entry 814990 in the Sun Fire Office Insurance Ledger series, Guildhall MS 11936/445, London Metropolitan Archives.

10 John Landseer, review in the *Review of Publications of Art*, 1808, 2: 157.

11 We know from a draft advertisement drawn up by the painter in March 1808 (see Forrester, *Liber*, 12, fig. 5) that not only was the second number of the publication ready for delivery by that date, but that he intended to exhibit fifty of the *Liber Studiorum* drawings in his gallery exhibition in April. He would hardly have made that commitment had he not completed them by then, or not envisaged having them ready in time. And given that David Cox had seen five of the *Liber Studiorum* drawings mounted within a single frame in 1807 (see Solly, *Cox*, 27), it appears likely that for the 1808 show the fifty exhibited drawings were displayed within ten such surrounds. As the individual works revolve around a median size of 7¼ × 10¼ inches, five of them placed in a line within a single frame could have been spaced, say, two inches apart, with a further two inches at each end between the drawings and the frame, plus a total frame width of seven inches. That would have resulted in each framed set of drawings measuring exactly six feet in width. It therefore appears possible that five of these groups of five *Liber* drawings hung on either side of the 35-foot-long gallery at regular intervals. If that was the case, then they must have done so above the paintings, quite simply because the presence of the fireplace would have prevented some of them from being displayed underneath those oils. At a height, and tilted outwards from the wall in conformity with the accepted exhibition practice of the day, they would have contributed most harmoniously to the ensemble.

12 Thus, on 28 June Turner would acquire Reduced £3% Annuities to the value of £250 (see Reduced £3% Annuities Stock Ledger AC27/6874, fol. 38209, Bank of England Archive, London). This appears to have emanated from the payment of 250 guineas or £262-10s from the Earl of Essex. Of this, 200 guineas or £210 could have constituted the payment for *Purfleet and the Essex Shore, from Long Reach*, with the extra 50 guineas or £52-10s deriving from payment for the four Cassiobury watercolours that had been ordered by the nobleman the previous summer. Clearly these drawings had all been delivered by now. On 12 July Turner would purchase Reduced 3 per cents to the value of £157-4s-1d (Reduced £3% Annuities Stock Ledger AC27/6874, fol. 38209). The money for this transaction must have emanated from the sale to Lord Egremont of *The Thames at Eton* for 150 guineas or £157. Here size dictates certainty, for because the painting measures just 24 × 36 inches, it would have fetched 150 guineas. The four shillings and a penny might well have accrued from the repayment of expenses, such as a cab charge incurred when transferring the painting to Lord Egremont's Belgravia townhouse, for onward shipment to Petworth. As will be demonstrated in the main text below, Turner was not in London when the 28 June and 12 July purchases were made, so they were possibly effected on his behalf by his father passing on the cheques to his stockbroker, along with the necessary instructions. On 1 September Turner would issue a receipt to Sir John Leicester for the 200 guineas or £210 he had received in payment for *Pope's Villa at Twickenham* (see Hall, 'Tabley', 93). This must account for the £204-12s that the painter would spend on acquiring Navy £5% Annuities on 28 September (Navy £5% Annuities Stock Ledger AC27/5230, fol. 17052). And on 4 February 1809, Turner would purchase Navy £5% Annuities to the value of £600 (Navy £5% Annuities Stock Ledger AC27/5230, fol. 17052). This huge sum also emanated from the 3rd Earl of Egremont, as Turner himself recorded on fol. 7v of the *Finance* sketchbook, T.B. CXXII, third entry from the bottom of the list. It was paid in exchange for the other three paintings the nobleman had acquired from the 1808 show, namely *The Confluence of the Thames and the Medway*, *The Forest of Bere* and the *Margate*. Each of these paintings being 36 × 48 inches in size, they each fetched 200 guineas, with Turner subtracting the difference between guineas and pounds in his usual fashion when using the money to buy stock. The only purchase from the 1808 exhibition that would not be translated into an identifiable stock acquisition was the sale of *Sheerness as seen from the Nore*, which probably went to Samuel Dobree. If it was sold to him, then it may have fetched 300 guineas or £315 because of its 41½ × 59 inch size.

13 On 29 July Turner would spend £200 on Navy £5% Annuities (see Navy £5% Annuities Stock Ledger AC27/5230, fol. 17052, Bank of England Archive, London). Again, in the painter's absence the cheque behind this acquisition was possibly passed to his stockbroker by his father acting on his instructions.

14 See Farington, *Diary*, XIII, 5404, 3 May 1814.

15 See Payne Knight's anonymous review of James Northcote's *The Life of Sir Joshua Reynolds*, London, 1814, in the *Edinburgh Review*, September 1814, 288–91. In the 1790s Payne Knight had sided with the Foxite Whigs against the Tories and was attacked at the time for his Jacobinism; see Clarke and Penny, *Knight*, 10–11, 13.

16 See Tromans, *Wilkie*, 18.

17 The two or three paintings could have hung either in the cottage standing in the grounds of Downton House, Herefordshire, that Payne Knight took over as his country residence in 1808, or more probably they did so in his town house located at 3 Soho Square, London.

18 Note by Turner on an engraver's proof of *Lake of Thun* made for *Liber Studiorum*; see Finberg, *Liber*, 60.

19 For correspondence relating to the closure of the gallery, the making of packing cases subsequent to the ending of the show, and the 20 June dating of the beginning of Turner's tour, see the electronic version of this work.

20 A detailed analysis of this tour appears in the electronic version of this work.

21 Only this scenario would explain the detachment of the oil sketch from the *Tabley No. 1* sketchbook, T.B. CIII – of which it had originally formed fol. 18 – its folding into four, and its ultimate return to Turner's hands.

22 The two blank canvases on which the images were to be painted were ordered on Turner's behalf by Sir John from a London art supplier and sent up to Tabley. As was noted by Peter Cannon-Brookes, 'The stretcher of the [*Windy Day* picture] is blind-stamped "LEICESTER" – presumably before the painting was executed, and thus indicates a canvas provided by Sir John Leicester – and it is inscribed in ink "Sr J Leicester Bart/21 Hill Street Berkeley Square" in a contemporary hand' (see *Paintings from Tabley*, exh. cat., Heim Gallery, London, 1989, 66). The present stretcher of *Calm Morning* dates from 1956, when the canvas was relined and conserved by John Brealey at the Tate Gallery. Unfortunately, no record of the original stretcher was made. However, given that Sir John Leicester commissioned Turner to make two views of Tabley House, he must have acquired both supports for those paintings simultaneously.

23 Folio 88 of the *Tabley No. 2* sketchbook, T.B. CIV.

24 Fly-leaf of the *Tabley No. 3* sketchbook, T.B. CV. Turner also wrote about the reflectivity of water on the inside front cover of the same book.

25 Carey, *Memoirs*, 110. Although Colt Hoare made mention in a 4 August 1808 journal entry (Thompson, *Journeys*, 242) of 'a fortnight's rest at *my* delightful villa at Vach deiliog' (author's italics), doubtless this was a conventional simplification, rather than a statement of sole ownership of the property. As Carey undoubtedly derived much of his information from Sir John Leicester, there is no reason to doubt that the latter built the residence jointly with Sir Richard Colt Hoare. A drawing of the view looking across the town of Bala and down Llyn Tegid on fol. 2 of the *Tabley No. 1* sketchbook, T.B. CIII, which was in use in 1808, fixes Turner in that location. Today the John Lewis Partnership owns Fach Ddeilliog and uses it as a recreational facility for its employees.

26 As suggested by David Brown in a personal communication to the author, sketches of cattle on a bank of a river on fols. 46v, 47, 47v, 48v and 49 of the *Tabley No 2* sketchbook, T.B. CIV, were possibly made around the Mawddach estuary.

27 Farington, *Diary*, 9: 3397–8.

28 It is probable that Callcott had originally informed Farington of the correct 200 guinea charge for a three-foot by four-foot Turner canvas and the diarist simply misremembered the figure in his customary fashion.

29 There were several art suppliers in Manchester at the time; see the National Portrait Gallery's Directory of British Artists' Suppliers, 1650–1950 at http://www.npg.org.uk/research/programmes/directory-of-suppliers/a.php. As Manchester was the nearest city containing stockists of stretched canvases, it would have been much quicker to obtain such a support from there than from, say, London.

30 B.J. 84. The Buckler watercolour remains on display in the Picture Gallery at Tabley to this day. David Brown was the first to notice the Turner depicted within it. The author is grateful to him for drawing attention to this detail.

31 In the few weeks Turner had available to paint the works at Tabley, he could only have roughed out the compositions and advanced some preliminary layers of underpainting. That is why *River Scene with Cattle* still looks so sketchy. The two Tabley canvases must have been completed some months later down in London.

32 See fol. 71v of the *Derbyshire* sketchbook, T.B. CVI.

33 Ibid., fols. 67, 67v and 68.

34 See fols. 52v and 53 of the *Tabley No. 2* sketchbook, T.B. CIV, where Turner ruled out staves and then wrote out the mordent before setting down a melody in common time. He also wrote out the enharmonic scale from D# above middle C to higher F#, and underneath these notations he set out the fingerings for the flute; see fols. 85 and 85v of the same book for staves; and fol. 24 of the *Tabley No. 3* sketchbook, T.B. CV, where he inscribed 'Gamut for the Flute' and then wrote down the gamut for the instrument three times, as well as two melodies.

35 Originally, Turner had thought of travelling directly to Farnley Hall either via Manchester, Halifax, Bradford and Otley (a journey he estimated would take eight and a half hours); or by way of Huddersfield, Morley, Leeds and Otley (which would have taken ten and a half hours); see fol. 1 of the *Kirkstall* sketchbook, T.B. CVII.

21 'The First Landscape Painter in Europe'...

1 Farington, *Diary*, 2: 570, 5 June 1796.

2 Letter of 3 February 1806 to Thomas Creevey, Creevey MSS, Whitfield Hall, Hexham, Northumbria.

3 Farington, *Diary*, 2: 601–2, 10 July 1796.

4 In July 1802 Turner's uncle, J. M. W. Marshall, had voted for Burdett in the election held at Brentford for John Wilkes's old County of Middlesex seat; see n. 36 to Chap. 3 of the electronic version of this work; and Whittingham, *Geese*, 2: 21. In 1807 Burdett had gone on to represent the borough of Westminster as an independent radical, that constituency being far more amenable to the democratic ideas for which he stood.

5 In 1796 Fawkes had purchased a Jacob van Ruisdael for 300 guineas, while in 1798–9 he had

acquired paintings from the Orléans collection that were by, or ascribed to, Guido Reni, Frans Snyders, Guercino, Cornelius Jansen, Sir Anthony van Dyck, Carlo Dolci, Aelbert Cuyp, Ludolf Backhuizen, Willem van de Velde the younger and Jan Weenix.

6 In 1802, Parker had given Fawkes a miniature of Napoleon Bonaparte he had recently acquired in Paris; see Finberg, *Farnley*, 2.

7 In addition, Fawkes owned a view of Lausanne that is signed and dated 1807, W. 377 (private collection). All the other watercolours known to have belonged to him but ascribed to dates prior to 1808 in the Wilton catalogue have been misdated for reasons that will become apparent in the main text below.

8 *Willis's Current Notes*, January 1852, 1, where Allen's initials appear as 'I. T'. The correct form of his initials is established on an etching of the 'rude sketch', a copy of which is in the National Portrait Gallery (see Walker, 'Portraits', no. 10, p. 24). The whereabouts of Allen's original drawing are now unknown.

9 A 'Gun by Jns [sic] Manton, case and fittings' would be listed in the 1854 inventory of the contents of Turner's 47 Queen Anne Street West studio; see Wilton, *Time*, 248.

10 According to Allen, he met Turner at Farnley either in 1805 or 1806. However, as Turner did not visit the house in either of those years, Allen must have meant 1808. As will be seen, Turner would receive a commission from Fawkes to make a watercolour of Gordale Scar on 20 February 1809 and obviously he did so because he had first visited the gorge not long before. He could not have been near the gorge prior to 1808. Despite an assertion by J. T. Allen that Turner later 'produced a finished painting' of Gordale Scar, no such work in oils is known to us, merely a large watercolour sketch, T.B. CLIV-O.

11 Fawkes had served as the Brevet Colonel of the 4th West Riding of Yorkshire Militia in 1797-8, and as the Colonel of the Wharfedale Volunteers in 1803-4, following his raising of that corps to help meet the threat of French invasion.

12 For Fawkes's name against that sum, see fol. 7v of the *Finance* sketchbook, T.B. CXXII. For the stock purchase to the same amount on 15 August 1808, see Navy £5% Annuities Stock Ledger AC27/5230, fol. 17052, Bank of England Archive, London. This acquisition must have been made postally.

13 Ibid. There can be no doubt that the £204-12s involved in this purchase derived from Sir John Leicester, for on fol. 7v of the *Finance* sketchbook, T.B. CXXII, Turner wrote out the selfsame sum against the words 'Sir John'. And see Hall, 'Tabley', 93.

14 For Turner's vote, see Farington, *Diary*, 9: 3380. The diarist had received this information from Carlisle by letter.

15 See T.B. CII, fols. 29-28v; and T.B. CXIV, fol. 6v.

16 A draft of the speech appears on the inside front cover of the *River and Margate* sketchbook, T.B. XCIX, which had received use in the Thames estuary in January 1806. The book lay open in Turner's studio because he was simultaneously working upon three oils of Thames estuary subjects at the time, and was therefore drawing topographical information from that source. These paintings were B.J. 85, *Shobury-ness Fisherman, hailing a Whitstable Hoy* (National Gallery of Canada, Ottawa); B.J. 87, *Fishing upon the Blythe-sand, tide setting in* (Turner Bequest, Tate Britain, London); and B.J. 91, *Guardship at the Great Nore, Sheerness, &c.* (private collection, England).

17 Farington, *Diary*, 9: 3397-8.

18 Although Turner was indubitably living in Hammersmith, he must have met Fawkes in Queen Anne Street West, for this is where he kept all the sketchbooks he was not using at the time (and naturally he could have brought some of those up to town as well).

19 See the *Greenwich* sketchbook, T.B. CII, inside back cover. The ordered drawings were, in order of appearance on the list, possibly W. 549, a view of Addingham Mill on the River Wharfe (private collection); the *Addingham Mill on the River Wharfe* watercolour (Manchester Art Gallery), which is wrongly entitled 'Arthington Mill on the Wharfe' under W. 548 and erroneously dated there to c.1815-20; W. 550, *Bardon Tower on the Wharfe* (private collection); W. 587, *Farnley Hall* (private collection); a view of Gordale Scar that was apparently never made; possibly W. 616, *The Deer Park, Caley Hall* (private collection); W. 541, *Weathercote Cave, Yorkshire* (Graves Art Gallery, Sheffield); W. 382, *Lake of Geneva with Mont Blanc in the distance*, which is the watercolour traced by Timothy Wilcox to the collection of the Salar Jung Museum, Hyderabad, India but incorrectly dated by him to c.1807-8 (see Timothy Wilcox, 'Picture Note', *Turner Studies*, 6: 1, summer 1986, 56-7); W. 531, *Bolton Abbey, Yorkshire*, in which the light comes from the east (University of Liverpool); and W. 373, *The Lake of Thun, Switzerland* (private collection). Turner omitted the number 6 from his list. Clearly he had the *Greenwich* sketchbook to hand when drawing up both lists because, like the *River and Margate* sketchbook used to draft the riposte to the *Examiner* in January, it was being employed to supply topographical data for one or more of the four pictures of the Thames estuary he was completing for exhibition in his gallery that spring. And by writing 'Per Contra C. Draft. Feb. 20. £100' next to the list, Turner also recorded receiving a cheque for £100 from Fawkes as a down payment against the group of watercolours that had just been commissioned. Three days later he used £70-7s of that money to acquire Navy £5% Annuities (see Navy £5% Annuities Stock Ledger AC27/5230, fol. 17366, Bank of England Archive, London).

20 See T.B. CII, fol. 52, where the artist wrote 'Mill. finished' at the head of the second list.

21 The second list, on fol. 52 of the *Greenwich* sketchbook, T.B. CII, comprises W. 548, as referenced above; possibly W. 549, as also referenced above; W. 550, as also referenced above; an unidentified work; W. 587, as also referenced above; work not made, as also referenced above; W. 530, *The Strid, Bolton Abbey, Yorkshire* (untraced); W. 541, as also referenced above; W. 532, *Bolton Abbey West*, so-called on the list because the light is coming from the west (British Museum, London); W. 373, as also referenced above; W. 382, as also referenced above; work unknown; W. 381, *Bonneville, Savoy* (private collection); *Ingleborough from Chapel-le-Dale* (Yale Center for British Art, New Haven) which is wrongly entitled 'Patterdale Old Church' under W. 547; W. 531, as also referenced above; W. 371, *Mer de Glace, Blair's Hut* (fig. 382); W. 384, *Fall of the Staubbach, in the valley of Lauterbrunnen, Switzerland* (private collection); possibly W. 379, *Mont Blanc from the bridge of St Martin, Sallenches* (private collection); W. 392, *Lake of Geneva from above Vevey* (private collection); work unknown; and W. 388 *Chateau de Rinkenberg, on the Lac de Brientz, Switzerland* (Taft Museum, Cincinnati) or W. 374/375 (which are one and the same work, namely *Town of Brienz, Switzerland*, a watercolour now in a private collection that has been incorrectly entitled 'Lake of Brienz by moonlight'). This is listed as both W. 374 and 375, although they are obviously the same work, given they are exactly the

same dimensions. As the drawing was displayed in the 1819 Fawkes London town house exhibition under the title of *Town of Brienz, Switzerland* (cat. no. 35), to avoid confusion the work should bear that title and not the 'Lake of Brienz, Moonlight' that has traditionally been affixed to it.

22 It is worth noting that no large watercolour of Lake Lucerne is included on these lists. However, just such a work, *Lake of Lucerne, from the landing place at Fluelen, looking towards Bauen and Tell's chapel, Switzerland*, would be acquired by Walter Fawkes, who would probably lend it to the Royal Academy Exhibition in 1815, as discussed below. If it dated from 1808–9, as has often been contended, it would surely have been included on one or other of these lists.

23 Turner would show the two paintings hanging on either side of the fireplace in a watercolour he would make of the drawing room at Farnley Hall in 1818 (W. 592, private collection). Today there are very slight differences in the sizes of the two oils, the *Portrait of the Victory in Three Positions, passing the Needles, Isle of Wight* measuring 26⅜ × 39½ (67 × 100.3); and *The sun rising through vapour* measuring 27½ × 40 (69 × 102). However, such small differences could easily have been caused by canvas relinings and re-stretchings over time.

24 Doubtless Turner did not put *The sun rising through vapour* on his 20 February list or upon the subsequent list because it was a one-off oil painting and no oils are included on either list.

25 Fol. 70 of the *Spithead* sketchbook, T.B. C.

26 Council Minutes, 4: 100.

27 Sir John Leicester was later identified as the 'Man of Fashion' on a copy of the catalogue owned by the library of the Koninklijk Oudheidkundig Genootschap that is now being held in the Rijksmuseum, Amsterdam; see Butlin, 'Sale', 30–31.

28 They comprised *A shipwreck with Boats endeavouring to save the Crew* (fig. 315), purchased from the artist's gallery in 1805 but later part-exchanged for the large, 1806-exhibited *Fall of the Rhine at Schaffhausen* (fig. 334), which was also in the sale; the depiction of Walton Bridges that had been purchased in 1806; and the view of Newark Abbey on the Wey that had probably been bought in 1807. Of course, by rights the shipwreck painting should not have been auctioned, for Sir John no longer owned it. However, it has convincingly been argued that he felt embarrassed he had landed Turner with an unsaleable picture by way of part-exchange, and so he (mis)represented it as one of his possessions (see Butlin, 'Sale', 31). Its inclusion may also have been a way of compensating the painter for attempting to sell three of his other canvases so soon after acquiring them.

29 See Farington, *Diary*, 9: 3426, 28 March 1809. John Landseer was Farington's informant. The diarist states that Turner 'was very active in assisting in arranging & exhibiting various drawings made to illustrate Soane's observations'.

30 Ibid., *Diary*, 9: 3466.

31 Thornbury, *Life*, 1862, 1: 297.

32 The reasoning behind these identifications is provided in the electronic version of this work.

33 Watteau lived between 1684 and 1721, Thomson between 1700 and 1748.

34 See Hamilton, *Italy*, 31.

35 See Miller, 'Turnips', 579. Although the copy of *The Pilgrim's Progress* in Turner's library would date from 1834, given its renown he had surely read the book long before then.

36 A close examination of these activities will be found in the electronic version of this work.

37 In the 'England and Wales' series watercolour, *Nottingham, Nottinghamshire*, made in the summer or autumn of 1832, Turner would place the burning of stubble immediately below Nottingham Castle in order to allude to the burning down of that building by a mob in October 1831. They would torch it because of the failure of the second attempt to pass the Reform Bill and because it was owned by the very reactionary 4th Duke of Newcastle (1785–1851) who was strenuously opposed to the bill. See Shanes, *England*, 228–9.

38 This reading of the painting was first advanced by David Hill (*Thames*, 143). Perhaps because of a vernacular interpretation of Turner's use of the word 'Dinner' in its title, Hill timed the scene as being midday, despite the absence of an overhead sun and the inclusion of long evening shadows. But Hill is undoubtedly correct in stating: 'For five manual labourers and a baby there is . . . remarkably little food in evidence, especially when one considers that this would have been the main meal on one of their hardest day's work of the year. The sea of grain which they harvest is destined to fill others' purses and bellies.'

39 Farington visited Cassiobury with Hearne and Edridge on 5 July 1809 (*Diary*, 10: 3505–6) and discussed *Trout Fishing in the Dee, Corwen Bridge & Cottage* with the latter on 7 July (ibid., 3509). He did so in terms that strongly suggest that he was familiar with the painting, having just seen it.

40 T.B. CXX-N. Related sketches of deer also exist in the *Greenwich* sketchbook, T.B. CII, especially fols. 43 and 44.

41 In addition to the sales mentioned above, Turner also sold *Near the Thames Lock, Windsor* (cat. no. 8), B.J. 88, to the 3rd Earl of Egremont (Petworth House, Sussex).

42 This is how the title had appeared in John Landseer's review of the 1808 Turner Gallery show.

43 Of course he had previously exhibited virtually identical views of Pembroke Castle in opposed weather conditions, but done so some years apart, in 1801 and 1806.

44 Quoted in Whitley, *England 1800–1820*, 146.

45 T.B. CXXI-A.

46 T.B. CXXI-B.

47 This was one of two buildings that had been constructed in the side garden of 44 Queen Anne Street West. The latter property is an extremely grand and elegant six-storey house dating from 1765 that since 1804 had been the home of the 4th Earl of Effingham (1748–1816). Both of the two new buildings were divided from front to back to form four separate units. A third building stood behind one of them, and it must have enjoyed access to the street through the one fronting it.

48 That Turner had sold the lease to Young, and had not merely sublet the property to him (as asserted by Hamilton, *Life*, 100), is proven by the fact that the dentist became the ratepayer for 64 Harley Street in 1809. Moreover, the sale is equally proven by various documents in the Howard de Walden Archive, the earliest of which dates from 7 August 1813. These all refer to Young as the 'Occupier'. They would not have done so if he was simply renting the house from Turner.

49 These deductions are based upon studies of the Howard de Walden estate books, upon knowledge of the predicaments faced by the holders of leases with only a very short time to run, and following discussions with the Howard de Walden Estate Archivist. For a more extended exploration of the subject, see the electronic version of this work.

22 Six Houses, Three Castles and a High Street

1 A transcription appears in the electronic version of this work, while the original list appears in B.L., Add. MS 46,151-B, 2. It has been published in many places and can most easily be found in Davies, *Perspective*, 18–19.

2 A detailed exploration of the evolution of the house as revealed through Turner's sketches is undertaken in the electronic version of this work.

3 See Gage, *Correspondence*, 34, letter 23. Turner did not date this letter or specify to whom he was writing. However, from its contents it is easy to deduce that its recipient was an employee of the Longman publishing house. Longman had brought out John Opie's *Lectures on Painting delivered at the Royal Academy of Arts* on 1 May or shortly afterwards. As one of the subscribers to the book, Turner must have received his copy fairly soon after publication. In a postscript to his letter, he requested that his professorial title be included alongside his name in the list of subscribers at the front of any future edition of the book, for it had been omitted. Clearly, now that he was the Royal Academy Professor of Perspective, he wanted everyone to know about it.

4 Folios 60v and 61 of the *Lowther* sketchbook, T.B. CXIII; and fols. 3, 5 and 6 of the *Kirkstall Lock* sketchbook, T.B. CLV.

5 Turner had to have been returning to Harley Street, for the journey to Upper Mall, Hammersmith, would not have taken him along the Grand Union Canal at Southall.

6 For Henry Syer Trimmer's claim that Turner 'made the sketch [for the painting] one evening returning from my father's', see Thornbury, *Life*, 1862, 1: 179. The studies appear across fols. 71v and 72, and across fols. 72v and 73 of the *Windmill and Lock* sketchbook, T.B. CXIV.

7 Navy £5% Annuities Stock Ledger AC27/5230, fol. 17366, Bank of England Archive, London. Unfortunately we do not know the exact day on which this transaction was effected, for the Bank of England ledger clerk entered the purchase without dating it. Probably he did so because the entry that preceded it had recorded a routine ledger transfer on Saturday 22 July. If the new stock purchase was made on the same day, then there was no need to enter the date again; it could simply have been taken for granted. The next two stock purchases would be recorded as having taken place on '26' and '31' of an unrecorded month before a subsequent stock transaction would take place on '8 September' (but without any year being entered). In all likelihood, the month and year of these transactions were also taken for granted, with the entries being placed on the books on 22, 26 and 31 July 1809, as well as on 8 September 1809.

8 Folio 4 of the *Petworth* sketchbook, T.B. CIX.

9 What might have sparked off this notion was discussion of the 24 × 36 inch *The Thames at Eton* that had been acquired by the earl in 1808. This was the only Turner painting of that size the patron owned (for with the exception of the large *Ships bearing up for anchorage* of 1802, all of his other Turner acquisitions were 36 × 48 inches in size). Possibly it was the aristocrat who came up with the idea of producing an identically sized view of Cockermouth Castle that would serve as a pendant to *The Thames at Eton*. Turner would have readily agreed, for because he would soon be going up to Lowther Castle in Westmorland for the Earl of Lonsdale anyway, he would easily be able to obtain the requisite topographical material in nearby Cumberland. (Moreover, Lord Egremont may well have known of that visit, which is why he commissioned the Cockermouth view.) For an oil of that size Turner would charge his customary 150 guineas. As Lord Egremont had recently commissioned a painting of his principal country house from the artist, he obviously welcomed the idea of owning a depiction of his second rural residence from the same hand as well.

10 Folio 3 of the *Petworth* sketchbook, T.B. CIX. The connection with William Collins was made in Wilton and Turner, *Poetry*, 138.

11 Lord Holland was a nephew of the late Charles James Fox (1749–1806), who had been the leader of the parliamentary opposition and whom he greatly resembled physically (see Farington, *Diary*, 9: 3216, 6 February 1808).

12 Fol. 88v of the *Frittlewell* sketchbook, T.B. CXII. The passage transcribed by Turner was taken from Henry Richard Fox Vassall, the 3rd Baron Holland of Holland, *Some Account of the Life and Writings of Lope Felix de Vega Carpio*, London, 1806, 12–13.

13 Turner's copies of both books are now in the same private collection. For a very thorough analysis of Turner's readings of these two books, see Venning, 'Annotated Books'.

14 Opie, *Lectures*, 61.
15 Ibid., 14.
16 Ibid., 21.
17 Ibid., 43.
18 Ibid., 23.
19 Ibid., 29.
20 Ibid., 31.
21 Ibid., 32.
22 Ibid.
23 Ibid., 55.
24 Ibid., 57–8.
25 See Reynolds, *Discourses*, 36–7.
26 Venning, 'Annotated Books', 2, 1: 39.
27 Lines 81–2.
28 It will be remembered that in 1798 Turner had exhibited *Norham Castle on the Tweed, Summer's morn* (fig. 187) at the Royal Academy and accompanied its title in the catalogue with the lines taken from 'Summer' that describe the sun as the 'powerful King of Day/Rejoicing in the East'. Only by this indirect approach could he have brought such a metaphor into the realm of painting.

29 In his 1829 painting *Ulysses deriding Polyphemus* (National Gallery, London), Turner would complement his image of the rising sun with allegorical imagery derived from a painting by Nicolas Poussin. However, he would do so with such subtlety that the horses pulling Apollo's chariot can only be discerned with effort.

30 For example, see page 302. Moreover, some pages – for instance, 65–6 – are entirely taken up with an overflow of Shee's comments.

31 Thus, and as Venning observes ('Annotated Books', 2, 2: 40), Shee appropriated from William Collins's *Ode to Music* and Edward Young's *Night Thoughts*.

32 Additionally, each opening of the copy of the book owned by Turner had a blank leaf inserted, and it was upon these that he entered his annotations.

33 Shee, *Elements*, flyleaf fol. 2.
34 Ibid., 6.
35 Ibid., 7.
36 Ibid., 8.
37 Ibid., 11.
38 Ibid., annotation opposite page 9.
39 Ibid., annotation opposite page 10.
40 Ibid., annotation opposite page 25.
41 Opposite page 26.
42 Annotation opposite pages 27–8.
43 Page 31.

44 Annotations opposite pages 32–3 of Shee.

45 Ibid.

46 The work had been looted by the French, and was returned to Italy after the fall of Napoleon.

47 The annotations in this paragraph appear opposite pages 32–3 of Shee. For the entire passage, see Venning, 'Annotated Books', 2, 2: 45.

48 Annotation opposite page 37 of Shee.

49 Shee, *Elements*, 66.

50 Solkin, *Masters*, 154.

51 On 31 July Turner acquired yet more Navy £5% Annuities, to the value of £201-12s-10d (Navy £5% Annuities Stock Ledger AC27/5230, fol. 17366, Bank of England Archive, London). That the sum behind this purchase had originated with the owner of Petworth House is proven by an entry reading '201 12 10 Egremonts' on fol. 13 of the *Finance* sketchbook, T.B. CXXII. The money had been received in payment for *Near the Thames Lock, Windsor*, probably just before leaving Petworth House for home. The evidence relating to Turner's movements in the North of England suggests that he spent a period at Farnley Hall, followed by twelve days on the road from there. If we work backwards from 8 September, when Turner appears to have been back in London to convert an exceedingly large amount of money into stock in his Bank of England account, twelve days prior to that takes us back to Monday 28 August. If Turner had initially quit London for Farnley Hall on Tuesday 1 August, then that would have allowed him to spend twenty-seven days, or a day short of four weeks, with Walter Fawkes. Such a stay would have spanned the opening of the grouse-shooting period. As will be seen, that also has to be taken into account this year. In sum, therefore, it is likely that the 1809 North of England tour began on Tuesday 1 August, with Turner leaving Farnley Hall on Monday 28 August, and arriving back in London early on Friday 8 September.

52 As David Brown has observed in his Introduction to the *Lowther* sketchbook, T.B. CXIII, in the Tate Britain online catalogue of the Turner Bequest, a comment in Turner's letter written to Longman at Cassiobury that he was 'upon the wing to Yorkshire' might have alluded to his presence at Farnley for the grouse-shooting (see Gage, *Correspondence*, 34, letter 23). The parliamentary legislation that would establish 12 August, or the 'glorious twelfth', as the official opening date of the grouse-shooting season, would only be passed in 1831.

53 These appear in the *Lowther* sketchbook, T.B. CXIII, fols. 49v, 50v, 51v and 52v; and on fol. 10 of the *Large Farnley* sketchbook, T.B. CXXVIII, which has now been re-dated to *c.*1809 by Ian Warrell (see *Turner's Sketchbooks*, London, 2014, 74–5).

54 The *Lowther* sketchbook, T.B. CXIII, fol. 62v.

55 These might have included W. 550, *Bardon Tower* (private collection); 'Aromatic Rock', unidentified but alternatively W. 616, made around 1818; W. 530, *The Strid, Bolton Abbey, Yorkshire* (untraced); W. 531, *Bolton-Abbey, Yorkshire* (University of Liverpool); W. 532, *Bolton Abbey, Yorkshire* ('Bolton Abbey west' on the second 1809 list, British Museum, London); W. 541, *Weathercote Cave* (Graves Art Gallery, Sheffield); W. 547 where erroneously titled 'Patterdale Old Church', but really *Ingleborough from Chapel-le-Dale* (Yale Center for British Art, New Haven); W. 371, where erroneously dated to 1806, *Mer de Glace, Blair's Hut* (fig. 382), W. 387, *Montanvert, Valley of Chamouni* (fig. 383); W. 379, where erroneously dated to 1807, *Mont Blanc from the bridge at St Martin, Sallenches* (private collection); W. 381, *Bonneville* (private collection); W. 373, where erroneously dated to 1806, *Lake of Thun* (private collection); W. 374 and 375, where erroneously dated to 1806, *Lake of Brienz* (private collection); W. 384, *Staubbach waterfall* (private collection); and W. 392, *Lac Léman* (private collection).

56 The artist's portfolio cum drawing board may appear in the foreground of *Bolton-Abbey, Yorkshire*, W. 531, University of Liverpool which, as stated above, may have been made at Farnley this year. See Milner, *Merseyside*, 22 and plate 5.

57 As Maurice Davies has discerned (Thesis, 236–86), the first set of fair copies from Turner's original manuscripts was made by an unidentified copyist whom Davies identifies as 'Hand B'. Furthermore, as Jerrold Ziff had observed ('Writing') and Davies notes (248), 'the first drafts were probably made in the spring and summer [of] 1809'. If the latter was the case, then it is perfectly feasible that 'Hand B' was hired while Turner was staying at Farnley Hall.

58 This discovery was made by Matthew Imms.

59 As Matthew Imms has also discovered, 'Q.Z.' was identified as 'Mrs. Blore, a noted female writer' in an April 1801 letter by Henry Kirke White (see Robert Southey, *The Remains of Henry Kirke White, of Nottingham*, London, Cambridge and Nottingham, 1808, 1: 76).

60 The lines from *Hudibras* quoted here are those appearing on page 513 of the fifth volume of Anderson's *Complete Poets*. This was the version that was probably known to Turner.

61 Folio 1v of the *Cockermouth* sketchbook, T.B. CX.

62 In context, lines 159–64 of Book VIII of *Paradise Lost* read,

> But whether the sun, predominant in Heaven,
> Rise on the earth; or earth rise on the sun;
> He from the east his flaming road begin;
> Or she from west her silent course advance,
> With inoffensive pace that spinning sleeps
> On her soft axle . . .

63 Lines 51–2 of Gray's *The Bard* read 'Give ample room and verge enough/The characters of hell to trace.'

64 This link was discovered by Matthew Imms, who kindly communicated it in an email to the present writer on 22 November 2010. The author of the anonymous article in the *Cabinet; or, Monthly Report of Polite Literature*, 4: July–December 1808, 299–301 had written: 'Never so sure our wonder to create/As when he touch'd the bounds of all we hate'. Pope's original reads, 'Yet ne'er so sure our passion to create/As when she touch'd the brink of all we hate'.

65 Fol. 48v of the *Lowther* sketchbook, T.B. CXIII.

66 The major source of such information was *The Almagest*, a treatise by the Romano-Egyptian astronomer Claudius Ptolemy (*c.*90 CE–*c.*168 CE). An abridged Latin translation of this work by Georg von Peuerbach (*c.*1421–1461) and by Regiomontanus (1436–1476) had appeared in Venice in 1496 – it would not be published in English until 1984 – so Turner had probably gained his insights into ancient astronomy and astronomers this summer from some passing acquaintance with a deep interest in the subject. Perhaps this was a patron or one of his fellow house guests who had read Ptolemy in the Latin.

67 See B.L., Add. MS 46,151-P, 18v. John Smith (*Supplement*, ch. 9, 441, cat.104) identified

the Earl of Lonsdale's painting as representing 'A Village Kermesse, or probably a Festival in honour of the Marriage of the Seigneur du Village'. It measured 3ft 1½ in. by 4 feet and was described as being 'Painted in a clear and silvery tone of colouring'. Smith also noted its inclusion of a man carving a ham on the left. It is now untraced.

68 Drawings that have come down to us include three distant views of the castellated building; see Herrmann, Ashmolean, 91–2, cats. 72–4, of which no. 73 appears to have formed the basis of B.J. 111. There is also a much nearer depiction of the house in the Fogg Art Museum (1907.19), for which information the author is grateful to Ian Warrell. For drawings of parts of Lowther Castle, see fols. 25 and 26 of the *Lowther* sketchbook, T.B. CXIII.

69 Turner drew the view looking over the river Derwent 'from Ld Egremont's room, Cockermouth' on fol. 22 of the *Cockermouth* sketchbook, T.B. CX.

70 Folio 24 of the *Petworth* sketchbook, T.B. CIX. And fols. 16, 17 and 21 of the *Cockermouth* sketchbook, T.B. CX, may also have contributed towards the painting.

71 This route is suggested by a map drawn on the inside front cover of the *Cockermouth* sketchbook, T.B. CX.

72 These take the form of several carefully delineated pencil drawings that would become detached from their sketchbook and not remain in Turner's bequest to the nation. See Rowell, Warrell, Brown, *Petworth*, 2002, 51–2, where discussed and where a drawing of 'Hurries' in the Yale Center for British Art is identified by them for the first time as constituting a representation of Whitehaven.

73 This route is borne out by sketches made on the way and by the following itinerary on fol. 1 of the *Cockermouth* sketchbook, T.B. CX: 'Tuesday E[gremont] Ulv[erston]/Wednesday Whitewell/Thursday Manchester'.

74 On Friday 8 September 1809 the Bank of England records reveal that Turner acquired £632-7s-3d-worth of Navy £5% Annuities, a sum he later verified by writing '632-7-3 Leader Sep. 9' on fol. 13 of the *Finance* sketchbook, T.B. CXXII (a memory slip must have caused 'Sep 9' to be entered in the sketchbook, for the Bank of England ledger records the transaction as having taken place on the previous day). The individual named 'Leader' had to have been William Leader, the distiller and art collector whose country house, Lower Park, was located on Putney Hill, Surrey. He was the only collector in Turner's circle who enjoyed a strong link with Putney, and thus with various references to that village contained in the poem that Turner attached to the title of *Thomson's Æolian Harp* in the catalogue of his 1809 studio show. *Thomson's Æolian Harp* was the only new, large oil painting that Turner could have parted with for £632-7s-3d in 1809. For a more detailed analysis of the links between William Leader and *Thomson's Æolian Harp*, see the electronic version of this work.

75 Navy £5% Annuities Stock Ledger AC27/5230, fol. 17366, Bank of England Archive, London.

76 Council Minutes, 4: 146.

77 Turner 'produced his Design for Lighting the Room' on 15 December; see Council Minutes, 4: 167. Shee moved the acceptance of both this plan and one submitted by Soane for improvements in the arrangement of the Great Room when used as a lecture space. Beechey seconded his proposal, and the other members of Council – namely Daniell, Woodforde and Fuseli – voted in favour.

78 Page 924.

79 Folio 59 of the *Lowther* sketchbook, T.B. CXIII.

80 B.J. 152, provisionally entitled *The Procuress*, Turner Bequest, Tate Britain, London.

81 Gage, *Correspondence*, 35, letter 24.

82 Respectively, fol. 19 of the *Harvest Home* sketchbook, T.B. LXXXVI, and fols. 85 and 84v of the *Hastings* sketchbook, T.B. CXI. This sketch was merely entitled 'River scene' in Finberg, *Inventory*, 1: 302.

83 See Gage, *Correspondence*, 36–43, letters 25 to 34.

84 Ibid., 38–9, letter 28.

85 Rawlinson, *Engraved Work*, 1: 37. This information was substantiated by Henry Syer Trimmer, who stated that his father had been told by Turner that the subject had been drawn 'in a post-chaise in [Oxford] High-street'. He added that he thought the vehicle had been placed 'opposite [Wyatt's] corner Print-shop' at the time (see Thornbury, *Life*, 1862, 1: 179). A story in Redgrave (*Century*, 2: 86) that 'when the drawing was paid for the painter insisted on receiving three shillings and sixpence which he had disbursed for the use of the old vehicle' cannot be true for reasons given in the electronic version of this work.

23 A Year's Grace

1 See Council Minutes, 4: 184, 3 December 1809; and General Assembly Minutes, 3: 1–3, 10 December 1809. Soane instead gave his fifth lecture in his own house to invited friends and interested parties on Monday 5 February at 8 p.m. Turner was present, a fact that points to his having attended all the previous talks.

2 Farington, *Diary*, 10: 3596–7.

3 Henry Tresham had been forced to stand down as Professor of Painting due to illness, and the new Royal Academician was elected in place of the late Paul Sandby.

4 Council Minutes, 4: 187 state that Turner was 'admitted at his request' to the meeting in order 'to confer, with respect to perspective lectures, which he agreed to postpone till the next season'. The phrase 'agreed to postpone' makes the Council's counter-proposal clear.

5 Davies, Thesis, 248–9. The suggestion that the earlier version might have been made in Yorkshire has already been advanced by the present writer.

6 Gage, *Correspondence*, 39, letter 29.

7 See the 30 April 1796 editions of both the *Sun* and the *Free Briton* for the first two encomiums, and Owen and Brown, *Beaumont*, 88 for the third of them. In 1795 Beaumont had shown *A landscape*, which had been hung as exhibit 66 in the Great Room.

8 Farington, *Diary*, 3: 828, 28 April 1797.

9 This description doubtless had its origins in Sir George's complaint about 'the white look of Calcott's pictures', as reported by Farington on 13 April 1806 (*Diary*, 7: 2718); and see *Diary*, 12: 4322, 29 March 1813.

10 Farington, *Diary*, 10: 3508, 6 July 1809.

11 See Owen and Brown, *Beaumont*, 227.

12 The actor John Philip Kemble to Farington, 21 June 1806 (*Diary*, 7: 2791).

13 Sir Nathaniel Dance-Holland to Farington, 19 May 1809 (*Diary*, 9: 3460).

14 Thomas Hearne to Farington, 6 July 1809 (*Diary*, 10: 3508).

15 James Northcote to Farington, 25 May 1806 (*Diary*, 7: 2770).

16 Ibid., 2776, 1 June 1806.

17 Quoted in Owen and Brown, *Beaumont*, 166.

18 In 1811 Lord Mulgrave would return B. R. Haydon's *Dentatus* – which he had commissioned

in 1808 – to its original packing case and store it in his stable. As Farington commented (*Diary*, 11: 3854, 15 January 1811), 'So much for capricious patronage; and thus was exhibited the ill effects of over commending which certainly made Hayden self opinionated & presumptuous.' Much of the 'over commending' had been done by Beaumont.

19 Gage, *Correspondence*, 41, letter 31.

20 For both the 100 guinea payment and the sending of the picture, see ibid., 41–2, letter 32.

21 Ibid., 42, letter 33 of 6 April 1810.

22 Farington, *Diary*, 10: 3640, 21 April 1810.

23 Other follies would include a pyramidical tomb in Brightling Churchyard that still stands. The story that upon his death in 1834 Fuller was interred wearing a silk top hat seated in an armchair clutching a glass of wine and surrounded by an assortment of his favourite clarets turned out to be a myth when the tomb was opened in the late-nineteenth century by a clergyman intent upon obtaining the wine. As might have been expected, it was found that Fuller had been buried conventionally in a horizontal casket.

24 Farington, *Diary*, 8: 3072, 21 June 1807.

25 For a detailed analysis of Fuller's behaviour on 27 February 1810, see Geoff Hutchinson, *Fuller of Sussex, A Georgian Squire*, privately published, Hastings (?), second edition, 1997, pages 71–4; and also Hansard, HC Deb 27 February 1810 vol 15 cc641–2 641, for which see http://hansard.millbanksystems.com/commons/1810/feb/27/proceedings-respecting-mr-fuller-for.

26 All the information in this paragraph, plus the facts that Fuller visited Turner's studio on 21 April and was accompanied there by Robert Smirke, is gained or can be deduced from the final paragraph of Farington's diary entry for that day (ibid., 10: 3640). Clearly, Farington had learned about the agreement between Turner and Fuller from Smirke, who could only have known about it in such detail because he had been present when it was reached. Smirke surely brought up the subject with Farington that evening because the meeting had occurred earlier that day. Given Smirke's current employment by Fuller, he must have accompanied his client to Turner's studio because the Sussex landowner had taken up his idea that the painter be employed to make the required East Sussex views. Obviously the architect put forward that suggestion because he rated Turner's works very highly.

27 See B.J. nos. 113 and 117.

28 Folio 65v of the *Hastings* sketchbook, T.B. CXI.

29 Nogging is defined by the *Oxford English Dictionary* as 'Brickwork built up between wooden quarters or framing', and Turner may well have encountered it when having work undertaken on his gallery conversion back in 1803–4.

30 Fortunately an invitation specifying the opening and closing dates of Turner's gallery show has survived, for otherwise they would be unknown (see Finberg, 'Gallery', 383). It was discovered by J. B. Watson in an album that had belonged to Farington. Its present whereabouts are unknown. It had been sent to Farington, along with a single-sheet catalogue listing seventeen exhibits. From the known sizes of all but one of those offerings, we can estimate that the framed widths of the works on view would have totalled a little over 80 feet, so they would have fitted very neatly into the 90 feet of semi-continuous horizontal hanging space provided by the gallery. As usual, the framed *Liber Studiorum* drawings were probably also on view above all the paintings.

31 Ibid. Along with the invitation mentioned in the preceding note, the catalogue was discovered by J. B. Watson in the album that had belonged to Farington. Its present whereabouts are also unknown.

32 'Winter', lines 414–23. The connection between *The fall of an Avalanche in the Grisons* and these verses was first made by Lindsay, *Life*, 107.

33 The painting acquired by Sir John Leicester was *An avalanche, or ice-fall, in the Alps, near the Scheideck, in the valley of Lauterbrunnen*. Dating from 1803, this had been exhibited at the Royal Academy in 1804 (116) and acquired by the baronet the following year. It is Lefeuvre, *Loutherbourg*, cat. no. 275 and now belongs to Tate Britain. The painting purchased by Lord Egremont was *A water-spout in the mountains of Switzerland*. Exhibited at the Royal Academy in 1809 (87), it was acquired by the earl the same year. This is Lefeuvre, *Loutherbourg*, cat. no. 306 and it still hangs at Petworth. It has been suggested by Leo Costello ('Turner and the Masters' colloquium, Tate Britain, 12 January 2010) that Turner painted *The fall of an Avalanche in the Grisons* to outshine de Loutherbourg's 1809 effort. However, if that had been the case, then the painter would surely have exhibited his riposte in Somerset House in 1810 and not simply shown it to a far smaller public in his gallery.

34 This was the title given to the work – presumably with Turner's approval – when it was exhibited for the very first time in the 1849 British Institution *Old Masters* exhibition, where it formed exhibit 38.

35 Quoted in Cunningham; 'Memoir', 75. The admiral had seen the painting hanging in the 1849 British Institution *Old Masters* exhibition.

36 In fact, Anderson-Pelham also paid a further £123-5s-7d over and above the 300 guineas for the picture's frame, packing-case and delivery to his home at Appuldurcombe House, near Ventnor on the Isle of Wight. For the payment and its date, see fol. 59 of the *Hastings* sketchbook, T.B. CXI.

37 Council Minutes, 4: 221.

38 It is impossible to date this text, although Turner may have been prompted to jot it down in 1809 by reading Opie's thoughts on the relationship of poetry and painting. That it is likely to have been written early on during the gestation of the perspective lectures is suggested by the fact that both in and after 1811 Turner would be criticised for not sticking to the subject of perspective. He was therefore unlikely to have expanded his subjects to include a discussion of poetry, painting and their related topics after that year.

39 B.L., Add. MS 46151-K, loose sheet interpolated between fols. 38 and 39. It is no longer possible to ascertain whether this page was originally located here, or whether was interpolated after Turner's death.

40 Like many painters, he was probably also aware that by viewing a painting or some other image in a mirror – especially one that had been worked on for hours – any defects can immediately become apparent because the reversal provides an entirely fresh view of the image.

41 The Earl of Lonsdale's canvases must have gone off to the aristocrat's town house in Charles Street, Mayfair, directly from Somerset House after the Royal Academy Exhibition closed on 18 June. On 15 and 18 June Turner acquired Reduced £3% Annuities for substantial sums. In all probability, it was therefore on the latter date or soon afterwards that he quit London.

42 Fol. 10 of the *Views in Sussex* sketchbook, T.B. CXXXVIII.

43 In his account book, Fuller listed having paid Turner £200 on 26 July (see Brooks, 'Fuller'), while on fol. 59 of the *Hastings* sketchbook, T.B.

CXI, the painter recorded receipt of £250. This discrepancy could be explained by the fact that Fuller paid Turner the £200 by cheque, and the remaining £50 in cash, while only recording the cheque payment in his account book. On additional document 4 in the *Finance* sketchbook, T.B. CXXII, Turner recorded having purchased £250-worth of Consols £3% on 26 July with money received from 'Fuller'; this is confirmed by an entry in Consolidated £3% Annuities Stock Ledger AC27/1792, fol. 47350, Bank of England Archive, London. Undoubtedly Turner bought this stock with the £250 received from Fuller. Of this sum, £210 would have constituted the 200 guineas he was paid for the painting, while the other £40 must have accounted for its frame and possibly a delivery charge.

44 This total derives from the recent, forthcoming or promised purchases of works by the following patrons for prices (in guineas) that are either recorded or probable, due to their sizes, with asterisks denoting works sold from the 1810 Turner Gallery show:

Wyatt	100	*High Street, Oxford,* B.J. 102*
Fawkes	300	*Lake of Geneva,* B.J. 103*
Fuller	400	*Fish Market,* B.J. 105*; and *Rosehill,* B.J. 211
George Philips	200	*Linlithgow Palace,* B.J. 104*
Egremont	300	*Petworth,* B.J. 113; and *Cockermouth,* B.J. 108*
Pelham	300	*The wreck of a transport ship,* B.J. 210
Lonsdale	520	the two *Lowther Castle* pictures and possibly 20 guineas for drawings

Naturally, there may have been many sales of watercolours that Turner did not record at this time, or that remain unrecognised.

45 This comprised £823-5s-7d in 3% Consolidated Annuities; £4,110-1s-4d in Navy £5% Annuities; and £2,283-9s-3d in Reduced £3% Annuities.

46 Additional document 4v housed in the cover of the *Finance* sketchbook, T.B. CXXII. This list had to have been made between 26 July and 26 November 1810 because Turner would acquire a further £250-worth of stock on the latter date, thereby significantly increasing his worth above the '7000' guineas or £7,350 he recorded (and for the reason behind the earlier date, see the main text below). It is not known why Finberg assumed that the list was drawn up between 25 August and December 1810 (see *Inventory,* I: 337, footnote) as he did not supply the evidence or reasoning behind his conclusion.

47 Turner's worth in terms of stocks in 1810 had reached this level. But also included elsewhere on the list are the 400 guineas owed by Sir John Leicester, as well as 1000 guineas that the painter was owed by Walter Fawkes, and 200 guineas he was owed by Jack Fuller.

48 See fol. 36 of the *Finance* sketchbook, T.B. CXXII. This list only contains paintings made prior to 1810. Finberg (*Life,* 171–2) thought it constituted an extension to the list of assets written between 26 July and 26 November 1810 that appears on the verso of additional document 4 housed in the *Finance* sketchbook, T.B. CXXII. However, it was more likely to have been a rough draft for that list.

49 The foregoing paintings were, respectively, *The Battle of Trafalgar, as seen from the mizen starboard shrouds of the Victory* of 1806 and 1808 (fig. 352); *Calais Pier, with French poissards preparing for sea* of 1803 (fig. 298); *Spithead, Boat's crew recovering an anchor* of 1808 (fig. 371); *A shipwreck with Boats endeavouring to save the Crew* of 1805 (fig. 315); *The tenth plague of Egypt* of 1802; *Holy family* of 1803; *The goddess of Discord choosing the apple of contention in the garden of the Hesperides* of 1806 (fig. 333); *The Destruction of Sodom* of 1805 (fig. 316); *Narcissus and Echo* of 1804; possibly the *Union of the Thames and Isis* of 1808; *Richmond Hill and Bridge* of 1808; *Plowing up Turnips near Slough* of 1809 (fig. 366); and *The deluge* possibly of 1805 but completed in 1813 (fig. 423).

50 For want of alternatives, they were *Scarborough Town and Castle, Morning, Boys collecting crabs* (fig. 411) which would be exhibited at the Royal Academy in 1811; *Lake of Lucerne, from the landing place at Fluelen, looking towards Bauen and Tell's chapel, Switzerland* (fig. 432), which would be completed in 1815 and shown at the Royal Academy that year; *The Battle of Fort Rock, Val d'Aouste, Piedmont, 1796* (fig. 433) which would be completed in 1815 and shown at the Royal Academy the same year; *Mer de Glace, in the Valley of Chamouni, Switzerland* (fig. 434), which would apparently be completed in 1814 or 1815; and *The Devil's Bridge, St Gotthard,* which would possibly be completed in 1814 or 1815 (fig. 435). Another such work, *Mont-Blanc, from Fort Roch, in the Val d'Aosta* (private collection, W. 369), would apparently be begun after the Royal Academy Exhibition had opened in 1815 and completed in 1816. Drawings as detailed and complex as these could easily have taken a long time to make, and lengthy gestation periods would explain any stylistic disparities they might contain.

51 This listing demonstrates that the speculation that Sir John Leicester only paid 300 guineas for the two Tabley House pictures – as raised in B.J. 99 – is erroneous, for they were the only paintings for which the baronet could have owed Turner 400 guineas during the period between 26 July and 25 November 1810. The Fawkes debt could have comprised 150 guineas for *The sun rising through vapour;* 300 guineas for the *Lake of Geneva, from Montreux, Chillion, &c.*; a 50 guinea exchange fee for being permitted to swap the *London* for the *Shobury-ness Fisherman, hailing a Whitstable Hoy* (for which, see the main text below); and 500 guineas for 20 watercolours at 25 guineas per drawing.

52 This acquisition was noted on fol. 8 of the *Finance* sketchbook, T.B. CXXII. Prior to 1833 the only fire brigades were run by insurance companies. With the acquisition of cover came a 'fire mark' or badge that the insured party could affix to the outside of their property to inform such fire brigades of their cover at all times. Probably Turner had purchased the Atlas Fire Office insurance shares not only because they afforded him a good return on his investment, but equally because they entitled him to a discount on fire brigade cover for his gallery and its contents.

53 Given that the Holloway Shot parcel of land containing Turner's plot straddled the main road leading from Isleworth to Richmond and was not far from the latter, the listing of it as a 'Richmond' property is understandable.

54 See fol. 8 of the *Woodcock Shooting* sketchbook, T.B. CXXIX.

55 However, for numerical reasons these cannot have been the drawings purchased at the Ryley sale on 15 November 1795.

56 This joint walk or ride emerges from a letter written by Turner to Wyatt on 6 March

1812 (Gage, *Correspondence*, 52, letter 44). There the painter would state that the view of Oxford from the Abingdon Road depicted the view 'seen from the spot *we* took it from' (author's stress).

57 See fols. 31v, 32v and 33v of the *Hastings* sketchbook, T.B. CXI, the subjects of which are here identified for the first time.

58 He had to have done so after Friday 17 August when Farington bumped into him, perhaps within Somerset House (*Diary*, 10: 3712). Turner told him that he had just been in the country and that he would soon be going up to Yorkshire.

59 If this journey did take place, then it would have had to have done so not long before the Liverpool show closed so that Turner could have been afforded the opportunity of selling the painting first.

60 Two possibilities arise concerning this exchange:

1. That *Shobury-ness Fisherman, hailing a Whitstable Hoy* was taken directly from Liverpool to Farnley, with the *London* remaining in the house for some time afterwards until Walter Fawkes had finally made up his mind over the swap. This is the likeliest scenario. Although the mezzotint subtitled the 'Picture [of London] in the possession of Walter Fawkes Esq.r of Farnley' would appear in the fifth part of *Liber Studiorum* published on 1 January 1811, that print was not elaborated from the painting as claimed, but from a sepia wash drawing, T.B. CXVII-D (as proven by substantial differences between painting and print). However, the plate subtitle does suggest that the *London* oil might still have been hanging at Farnley Hall by January 1811.

2. The other possibility is that the *Shobury-ness Fisherman, hailing a Whitstable Hoy* was returned to London at the end of the Liverpool show and later just happened to be chosen by Fawkes and was then taken up to Farnley in exchange for the *London*. This is far less likely because of all the extra travel required for the canvas, not to mention the remarkable coincidence that out of all the Turner marine paintings from which Fawkes could have chosen a substitute, he just happened to have selected one that had hung for a time quite near to Farnley Hall.

61 Thornbury, *Life*, 1862, 1: 87–8.

62 General Assembly Minutes, 3: 11.

63 For Turner see fol. 59 of the *Hastings* sketchbook, T.B. CXI; for Fuller see Brooks, 'Fuller'. Turner recorded receipt of £167-16s-3d, while Fuller recorded payment of £220. Of the latter sum, £210 was indubitably payment – in the form of 200 guineas – for the 36 × 48 inch canvas, and the additional £10 could have constituted the reimbursement of framing costs. The discrepancy between Turner's £167-16s-3d and Fuller's £220 is accountable by the fact that Fuller paid Turner the £167-16s-3d by cheque and the remaining £52-3s-9d in cash, with the painter only recording the cheque payment in the *Hastings* sketchbook. And see n. 43 above.

64 Consolidated £3% Annuities Stock Ledger AC27/1749, fol. 48214, Bank of England Archive, London.

65 Cunningham, 'Memoir', 34. The statement that Turner 'had painted a picture for Jack Fuller' proves that it was the view of Rosehill that was involved in this story, rather than the *Fish Market* Fuller also acquired, for the East Sussex landowner cannot have commissioned the latter painting before it was exhibited in Turner's Gallery in 1810.

66 See Brooks, 'Fuller', and n. 63 above.

67 General Assembly Minutes, 3: 24.

68 Council Minutes, 4: 264. Unfortunately, these do not identify the work in question. However, Turner did go some way towards doing so on fol. 11v of the William Rolls copy of his first perspective lecture, B.L., Add. MS 46,151-K. There he mentioned a 'beautiful Baso relivo from the Villa Albani now belonging to Lord Cawdor'. The work to which he referred may have been either the basso-relievo depicting the sleeping Endymion and a dog that had been presented to the Royal Academy by Lord Templeton in 1777, or been purchased by Flaxman and Banks from the Romney sale in 1801; or alternatively it could have been the cast of a Roman version of a Greek relief dating from between 420 and 400 BCE that depicts Orpheus, Eurydice and Hermes. This cast entered the Royal Academy collection at an unknown date. The *Endymion asleep* was described by Baretti (*Guide*, 16) as hanging by 1781 above the half-space that divided the two sets of stairs linking the mezzanine and principal floors of Somerset House. It may still have been hanging there when Turner was a Schools student during the early 1790s.

24 Just Six Weeks

1 This was made clear by the legend 'Published...by Mr. Turner, Queen Ann Street West' that now appeared on each print.

2 For the possibility they are carpenter's apprentices, see Forrester, *Liber*, 71; for Green Park, see Stopford Brooke, *Liber*, 75; for Hyde Park, see Rawlinson, *Liber*, 59.

3 The elevation of the presidential chair is visible in George Johann Scharf's drawing of Sir Thomas Lawrence attending a lecture by Richard Westmacott some time between 1827 – when Westmacott would become the Royal Academy Professor of Sculpture – and 1830 (British Museum, acc. no. 1862, 0614.184). Lawrence had also adopted the habit of wearing his presidential hat on such occasions.

4 B.L., Add. MS 46,151-K, fol. 1v.

5 Ibid., fol. 4v

6 Ibid., fols. 5 and 5v. It appears likely that it was in this section of the talk that engravings were initially used as illustrations, and it was certainly in connection with Dürer that Turner mounted the first numbered example of the many diagrams he had purposefully drawn for the talks on a nearby stand. The diagram in question constitutes an analysis of a foreshortened figure and it is inscribed with the name of the German artist (T.B. CXCV-164).

7 B.L., Add. MS 46,151-K, fol. 6.

8 See Hipple, 'Discourses', 231–47; and Shanes, *Human Landscape*, 241 ff.

9 B.L., Add. MS 46,151-K, fol. 6v.

10 Ibid., fol. 7.

11 Ibid., fols. 7v and 8.

12 Ibid., fols. 8v and 9.

13 Ibid., fol. 9.

14 Ibid., fol. 9v.

15 Ibid., fols. 9v-11.

16 Ibid., fol. 11.

17 Ibid., fol. 11v. For the sculpture, see Chapter 23, n. 68 above.

18 B.L., Add. MS 46,151-K, fols. 11v-12.

19 This 'Antique Fragment, representing some of the Muses' was described by Baretti (*Guide*, 16) as hanging by 1781 above the half-space that divided the two sets of stairs linking the mezzanine and principal floors of Somerset House.

20 Ibid., fol. 14. The word 'while' was entered in the margin here.

21 Here the words 'any building' replaced the words 'only a fragment of the temple of Minerva from the rocky Acropolis', which were crossed out.

22 It has not proven possible to trace this quote in the works of Jean-Jacques Rousseau (1712–1778), although similar phrases can be found in *The Social Contract*, the *Essay on the Origins of Inequality*, and *Emilius and Sophia*.

23 Turner also wrote the word 'pieces' between the words 'massy' and 'fragments'. Throughout this passage, commas have been inserted by the author to help communicate the sense.

24 B.L., Add. MS 46,151-K, fols. 14–14v.

25 Ibid., fol. 14v.

26 At the time, Raphael's original drawings hung in the Royal Collection at Hampton Court Palace. They are now in the Victoria and Albert Museum. Thornhill had created his copies between 1729 and 1731. In 1800 the 5th Duke of Bedford had donated them to the Royal Academy, which still owns them.

27 B.L., Add. MS 46,151-K, fols. 19v–21v.

28 Ibid., fol. 19v.

29 Ibid., fol. 23.

30 That Turner used the word 'Grandeur' here is significant, for he never employed the term 'sublime' except in conventional terms (and then only did so very sparingly compared to the number of times he used 'grandeur'). Of course grandeur and sublimity are much the same thing, but Turner's preferred term rather gives the lie to those many commentators on the artist who maintain that he was deeply influenced by Edmund Burke's writings on the sublime. Since 1980, Turner and the sublime has become a byword for intellectual laziness where the painter is concerned, with sublimity being used to explain almost everything in his work, and often taken to ridiculous lengths in the process. Sublimity was merely part of a much larger aesthetic framework for Turner, and its importance is now frequently over-emphasised at the expense of that complex nexus of ideas and responses.

31 Farington, *Diary*, 11: 3847.

32 Council Minutes, 4: 266.

33 Moreover, the Council had exacerbated the problem on 30 March 1810 when it had decided that the Council and General Assembly Room would be withdrawn from use as part of the annual Exhibition (see ibid., 207). Instead, the space would be employed for the permanent display of the Diploma Works. In addition, the institution had been given many paintings and sculptures down the years, and a selection of these would also go on display. The General Assembly – including Turner – had ratified the Council's decision on 19 April 1810.

34 In width the Secretary's apartment was exactly the same size as the Anti-Room, while in length it was about a third larger, for it took up space to the north of the staircase. It enjoyed three medium-size windows overlooking the Strand.

35 Farington, *Diary*, 11: 3853.

36 B.L., Add. MS 46,151-L, fol. 1.

37 Ibid., fols. 1 and 1v.

38 Ibid., fols. 2 to 3v.

39 Ibid., fols. 3v–6.

40 Ibid., fol. 7.

41 Ibid., fols. 7v–9.

42 Ibid., fols. 9–10v.

43 Ibid., fols. 10–15.

44 Ibid., fol. 15.

45 Ibid., fol. 15v.

46 B.L., Add. MS 46,151-M, fol. 32. Before modern rebinding by the British Library, this originally followed MS 46,151-L, fol. 16v.

47 B.L., Add. MS 46,151-L, fol. 17.

48 Farington, *Diary*, 11: 3853.

49 See Gage, *Correspondence*, 46–7, letter 38 for the full poem.

50 Farington, *Diary*, 11: 3862–3, 28 January 1811. Farington's 35-minute timing of the fourth lecture in this entry, and *Sun* reviews by John Taylor of Tuesday 22 January 1811 and Tuesday 29 January 1811, demonstrate that the William Rolls manuscript that has hitherto been thought to constitute the text used for the entirety of the third lecture contains passages that – according to the *Sun* – were read out during the fourth talk. As a consequence, the Rolls manuscript text that was previously thought to have been used for the fourth talk must have been dropped in 1811 to make way for the excess material from the third lecture. This would explain why the fourth talk, as given, was so short – it comprised the overflow from lecture three.

51 B.L., Add. MS 46,151-M, fol. 1.

52 Ibid., fol. 2v.

53 Ibid., fol. 7v.

54 The eleven treatises were *De Artificiali Perspectiva* of 1505 by Jean Pèlerin, known as Le Viator (1445–1524); *Leçons de perspective positive* of 1576 by Jacques I Androuet du Cerceau; *Perspectivae Libri Sex* of 1600 by Guidobaldo del Monte; *Opera Mathematica* of 1614 by Samuel Marolois (1572–1627); *Le due Regole della Prospettiva Pratica* of 1583 by Giacomo Barozzi Vignola (1507–1573), probably read in one of its later editions; *Perspective* of 1600 by Jan Vredeman de Vries, perused in a 1619 edition; *Dr Brook Taylor's Method of Perspective made easy* of 1754 by Joshua Kirby; *La Pratica della Prospettiva* of 1596 by Lorenzo Sirigatti, which was probably encountered in *The Practice of Perspective from the Original Italian of Lorenzo Sirigatti* by Isaac Ware (1704–1766), published in London in 1756; *La Perspective Curieuse* by Jean François Niceron (1613–1646) which had first appeared in Paris in 1638 but which Turner had consulted in an edition published in 1643; *Practical Perspective* of 1670 by Joseph Moxon; and *Perspectiva Pictorum et Architectorum* of 1693–1700 by Fra Andrea Pozzo (1642–1709), which had been translated into English in 1707.

55 Farington, *Diary*, 11: 3862–3.

56 B.L., Add. MS 46,151-N.

57 Preface by John Dryden in Charles Alphonse du Fresnoy, *The Art of Painting*, London, 1695, xxxiii. This was available to Turner in Reynolds, *Works*, 3: 255.

58 B.L., Add. MS 46,151-N, fol. 4.

59 See Shanes, *Human Landscape*, 241 ff.

60 B.L., Add. MS 46,151-N, fols. 7 and 8.

61 Respectively these are T.B. CXCV 79, 80 and 82.

62 See Davies, *Perspective*, 44–5.

63 B.L., Add. MS 46,151-M, fols. 11v–12.

64 Ibid., fol. 12v.

65 Ibid., fol. 13.

66 Ibid., 13v to 18v.

67 The lecture analysis appears ibid., fol. 19v. The two perspective diagrams are T.B. CXCV 111 and 113. Malton's original drawing of Pulteney Bridge, Bath, is signed and dated 1777; it is now in the Victoria Art Gallery in Bath. The design was engraved under the title of 'The New Bridge at Bath' by the architect James Gandon (1743–1823), who also co-published the print. Turner omitted or altered a number of architectural details in the Malton image.

68 Ibid., fol. 20v.

69 Diagram 58, T.B. CXCV 113.

70 Redgrave, *Century*, 2: 95.

71 B.L., Add. MS 46,151-M, fol. 23.

72 Ibid., 25v.

73 They appear in B.L., Add. MS 46,151-C, where they were written out twice on fol. 16;

B.L., Add. MS 46,151-K, where they were quoted twice on a fol. added at the end; B.L., Add. MS 46,151-M, where they are to be found on fols. 25v and 31; and B.L., Add. MS 46,151-S where they appear on fol. 14.

74 B.L., Add. MS 46,151-O, fol. 1.

75 Ibid., fol. 1v.

76 Ibid., fols. 2v–3v.

77 Ibid., fols. 4 and 4v.

78 Ibid., fol. 4v.

79 This draft is in a private collection, and is quoted in Davies, *Perspective*, 51 and 108, n. 85.

80 As David Scrase, Assistant Director of Collections at the Fitzwilliam Museum, Cambridge, has kindly advised the author, that museum continues to attribute the painting to Rembrandt as no one has convincingly suggested an alternative hand. Moreover, nothing in its facture precludes it from being a Rembrandt. There are at least three prints after the *Portrait of a man in military costume*: a mezzotint by William Pether of 1764; an apparently undated mezzotint by G. H. Dawe; and a line engraving by A. Cardon of 1811. The author has only seen the Pether print, which reverses the original image.

81 B.L., Add. MS 46,151-O, fol. 5.

82 Here Turner must have shown his audience the mezzotint made by an unknown engraver between 1680 and 1690, during which period it was published in London by Alexander Browne.

83 B.L., Add. MS 46,151-O, fol. 5v.

84 Ibid., fol. 6. Above 'the water sleeps', Turner also wrote 'or gleams a languishing sun'.

85 Ibid., fols. 5v to 6v.

86 Ibid., fol. 7.

87 Ibid., fols. 7v to 8v.

88 Ibid., fols. 9 and 9v.

89 T.B. CXCV-177v.

90 See B.L., Add. MS 46,151-O, fol. 10, where Turner wrote that the portrait was 'lately in the British Institution'. A 'Picture of the Lady & Globe by Van dyke' was lent to the British Institution in the summer of 1808 by Lady Lucas, for the benefit of students who wished to draw and paint from it (see B.I. Minutes, 2: 39–40, 23 May 1808). John Gage (*Colour*, 198 and 271, n. 3) drew attention to a reference to the Van Dyck that appears on fols. 15–16 of the *Greenwich* sketchbook, T.B. CII. This was in use between 1808 and 1810, as Gage also noted.

91 See Walter Crane, *An Artist's Reminiscences*, London, 1907, 48 and illustration opposite page 52 (page 56 in the second edition, also of 1907). The author is grateful to Dr Jan Piggott for drawing his attention to this passage, and thus to the function of the globes drawn by Turner.

92 B.L., Add. MS 46,151-O, fol. 10v.

93 Turner was here quoting Sir Joshua Reynolds, who had stated in his twelfth *Discourse*: 'It is no use to prescribe to those who have no talents; and those who have talents will find methods for themselves' (see Reynolds, *Discourses*, 209, lines 59–61).

94 B.L., Add. MS 46,151-O, fol. 11v.

95 Richards, Zoffany, Humphry, Rigaud and Hoppner. Turner may well have mourned Rigaud and Hoppner, for they had both contributed to his advancement and, in the case of the latter, bestowed friendship and active encouragement upon him, at least for a time.

96 B.L., Add. MS 46,151-P, fol. 2.

97 Ibid., fol. 2v.

98 Ibid., fol. 3.

99 Ibid., fol. 4v.

100 Ibid., fol. 5.

101 Ibid., fols. 6v to 7.

102 Ibid., fol. 7v.

103 Ibid., fols. 7v to 10.

104 Ibid., fols. 10 and 10v.

105 Ibid., fol. 11.

106 Ibid., fol. 11v. The original is now in Apsley House.

107 Ibid., fols. 11v to 12. The lines are taken from Book IV, lines 598–600 of *Paradise Lost*.

108 B.L., Add. MS 46,151-P, fol. 12v.

109 Ibid., fols. 12v to 14.

110 Ibid., fols. 14, 15 and 15v.

111 These were the *Saving of the Young Pyrrhus* of around 1634 (Louvre, Paris); *Landscape with a man killed by a snake* of around 1648 (National Gallery, London), sketched at Wynnstay in 1799; either the *Landscape with the Body of Phocion Carried Out of Athens* (on loan to the National Museum of Wales, Cardiff) or the *Ashes of Phocion Collected by his Widow* (Walker Art Gallery, Liverpool); and the *Landscape with a Roman Road*, to which reference is made in the main text. The images may well have been represented in the lecture by engravings, respectively, the *Saving of the Young Pyrrhus* in one of three forms: by Gérard Audran (1640–1703), by Guillaume Chasteau (1635–1683) or anonymously, published by Chéreau; the *Landscape with a man killed by a snake*, as engraved by Étienne Baudet (?1636–1711), who around 1684 also made prints of the *Landscape with the Body of Phocion Carried Out of Athens*, *Landscape with the Ashes of Phocion Collected by his Widow* and the *Landscape with a Roman Road*; and additionally, the two Phocian pictures and the Dulwich painting as engraved by Simon Vallée (before 1739). See Blunt, *Poussin*, respectively cats. 178, 209, 173, 174 and 210. Blunt's titles for the works have been followed here.

112 B.L., Add. MS 46,151-P, fols. 15 and 15v.

113 The *Landscape with Pyramus and Thisbe* was engraved by Vivares and Chatelin in 1769. That Turner used a reversed image, in the form of an engraving, is proven by the fact that in his talk he mentioned the lightning being in 'the right-hand corner' of the sky, whereas in the painting it appears to the left of centre. The engraving of *Winter (The Deluge)* was by Jean Audran. For these two paintings, see Blunt, *Poussin*, cats. 177 and 6 respectively.

114 B.L., Add. MS 46,151-P, fols. 15v and 16.

115 Ibid., fols. 17 to 18. This cannot have been a momentary lapse of memory, due to the written text having been prepared long before it was read.

116 Ibid., fol. 17. *The Three Trees*, an etching dating from 1643, is arguably Rembrandt's finest and most complex landscape print.

117 Ibid., fol. 17v.

118 Turner knew the work through its engraving by Schelte à Bolswert, which reverses the image.

119 B.L., Add. MS 46,151-P, fol. 18v.

120 Ibid.

121 Ibid., fol. 19.

122 Ibid., fols. 19–19v.

123 Ibid., fol. 19v.

124 Ibid., fol. 20.

125 This was probably Robert Hunt, whose piece had appeared on Sunday 13 January, after Turner's first lecture. His mention of the geometry imposed upon Raphael's *Transfiguration* and revealed towards the end of the talk suggests he had remained intellectually engaged all evening, even if he lacked the space, inclination or ability to impart to his readers much of the complexity of what he had heard.

25 A New Epoch

1 Anonymous account (but possibly by John Lewis Roget) in Pye, *MS*. A later, less authentic and variant version of this passage appears in

Rawlinson, *Engraved Work*, 1: xxvi, where no source is provided. Pye's house was situated at 17 Gloucester Crescent, Regent's Park.

2 *The Gentleman's Magazine*, June 1834, 649.

3 It has always been claimed that the 'Southern Coast' series was brought into being by both of the Cooke brothers working together, but it is clear from the first tense employed throughout W. B. Cooke's letter to Turner of 1 January 1827 that the scheme had been his 'own original plan', that he had put up all the money, that he had undertaken all the negotiations, and that he had commissioned all the works (see Thornbury, *Life*, 1862, 1: 400–3). George Cooke had simply lent his brother moral support and committed himself to working on the project.

4 For further reasons for this enthusiasm, see Finberg, *'Southern Coast'*, xiv.

5 All the foregoing details of the project are gleaned from W. B. Cooke's 1 January 1827 letter to Turner (for which, see n. 3 above).

6 The share and its profitability is made clear by Cooke's letter to Turner of 1 January 1827.

7 This term was used for members of the 1790 Royal Academy Exhibition Committee of Arrangement in a newspaper commentary of 10 April 1790; see Royal Academy 'Critiques', 1, 127, where the cutting is pasted. The newspaper remains unidentified.

8 Bird's *The reading of the will concluded* hung as exhibit 122, probably at eye level but certainly on the chimney-piece at the very centre of the east wall of the Great Room (see Farington, *Diary*, 11: 3910, 12 April 1811). There it would have acted as one of the inherent focal points of the entire space simply by dint of its centrality on the wall, just like the painting it had replaced.

9 See Farington, *Diary*, 11: 3916–8, 22, 24 and 25 April 1811. The 1811 Varnishing Days were Saturday 20 April and the four days between Monday 22 April and Thursday 25 April.

10 Farington drew a diagram of this year's gathering, and so we can ascertain exactly where many of the guests were placed. (See the entry for 27 April 1811 on page 241 of the original manuscript volume in the Royal Library, Windsor Castle. This covers the period between 1 December 1809 and 20 February 1813. The diagram is not reproduced in the published version of the diary.)

11 Farington, *Diary*, 11: 3919: 27 April 1811.

12 These translations were *The Hymns of Callimachus* by William Dodds, published in 1755, and the one by Christopher Pitt that appeared in Anderson's *Complete Poets*.

13 This could be entered either through the doorway leading from the north-western end of the Great Room or through the one affording access from the staircase landing. The exhibition catalogue indicates that the works contained therein were divided into three groups: 45 oil paintings, 161 drawings or prints, and a further 42 oils. Given the presentational practice of the Royal Academy everywhere else in Somerset House, we can be certain that the walls of the room were divided by a line. And from the numberings and the placing of the Turners within the space, it is also possible to deduce that only oil paintings were hung across the two sections of wall that stood on either side of the doorway at its eastern end. All of the other oils were ranged above the line upon the south and north walls, with just works on paper or similar supports being placed below the line beneath them. Watercolours and other works on paper covered the west wall, to balance the fact that the two sections of east wall at the opposite end of the room were solely hung with oils. This typically symmetric display explains why the exhibits were divided into three distinct groups in the catalogue. It also makes it clear why slightly fewer oils hung on the north wall than on the south one. Moreover, such a symmetry supports the belief that all but one of the Turners – the exception being a last-minute addition to the room in oils mentioned below – were hung symmetrically as well.

14 For further details of this arrangement, see the electronic version of this work.

15 At 24 × 36 inches, *Whalley Bridge and Abbey, Lancashire: Dyers washing and drying cloth*, B.J. 117, is almost exactly the same height as Bird's *The reading of the will concluded* and only slightly narrower than that painting (but any differences in their dimensions may have been masked by identical frame sizes, although it is not known if both works are still in their original frames). The *Whalley Bridge* was displayed as exhibit 244 on the line in the Inner Room, where it necessarily fractured the symmetry created by the other Turners therein. That disruption is the reason to believe it was the work taken down to accommodate the Bird and placed in the Inner Room at the last minute. And see the more detailed analysis of the Inner Room hang in the electronic version of this work.

16 These were catalogue 312, *November, Flounder-fishing* (private collection, Japan); and catalogue 351, *May, Chickens* (same private collection, Japan), which had been exhibited in Turner's Gallery in 1809 under the title of *Cottage Steps, Children feeding Chickens*. In addition to being almost the same size, *November, Flounder-fishing* and *May, Chickens* link antithetically in two ways: they depict events that occur exactly six months apart; and the May image shows children in the springtime of their lives, while the November scene represents men approaching the winter of their lives during a month that stands on the very edge of winter. The moral contrast is obvious, as is the observance of decorum in both works.

17 Gage, *Correspondence*, 49, letter 41.

18 Moreover, this phrase also tells us that Turner possessed no space in which to receive visitors at his nearby storage facility either.

19 See the *Morning Chronicle* of 24 May and 8 June, as well as the *Morning Post* of 5 June and 3 July 1811.

20 Farington, *Diary*, 11: 3945.

21 As Fuller's account book demonstrates (see Brooks, 'Fuller'), he paid the artist £191-7s on 8 July, with the extra £33-17s probably having been spent on prints. No payments appear to have been made for framing and transportation costs in connection with Fuller's later Turner watercolour acquisitions, so there is reason to believe they were not made in 1811 either. Three factors permit us to deduce that thirty guineas were given for each of the five Turner watercolours acquired in 1811: Fuller had paid for the two oils he had purchased by now; he would eventually own thirteen Turner watercolours; and he would record paying Turner five further sums of money between 9 June 1815 and 11 April 1823. Of these, the first and second payments would respectively take place in 1815 and 1816, and they would be for ninety guineas or £94-10s each. Such sums are triple multiples of thirty guineas. The third and fourth payments would respectively be made in 1817 and 1819, and they would simply be of thirty guineas each. The fifth and final payment in 1823 would consist of just £20, possibly in payment for prints or sundries that remained outstanding. These payments account for eight of the thirteen drawings if they cost thirty guineas per watercolour, as they appear to have done. By a process of elimination, the 8 July 1811 payment of £191-7s must therefore have

paid for the very first batch of five drawings at thirty guineas each.

22 See the death notice in the *Gentleman's Magazine*, July 1811, 89.

23 Matthew Imms was responsible for discovering this connection. Turner appears to have used a revised edition of the book that dated from 1810.

24 Given that Turner would be making images of places ranged across the entire southern coast of England, his overall intention must have been to write a poem on the entirety of that coastline and not merely the south-western part of it, as actually transpired, at least in sketch form. That July, W. B. Cooke had sounded out John Landseer about writing the necessary texts but he had declined the task, thinking he could only perform it adequately if he could first visit the places to be depicted. The finances would not support that. Cooke had countered by asking Landseer to elaborate the texts from 'the published reports of others', which he had also refused to do (see Farington, *Diary*, 11: 3798, 1 August 1811). This decision left the way open for Turner to propose his services instead. Cooke must have thought that as the painter already knew the south-eastern coast, and that he would be touring the south-west coast anyway, the offer might as well be accepted.

25 Because of the many landscape sketches contained in Turner's copy, Finberg (*Inventory*) gave it the title *Devonshire Coast No. 1* sketchbook, and the number T.B. CXXIII.

26 Thornbury, *Life*, 1862, 1: 170.

27 On 14 May 1812, William Turner would tell Farington that his son had been 'out of town two months last Summer viz, from the middle of July to the middle of Septr. making views on the coast of Dorsetshire – Devonshire – Cornwall & Somersetshire – for Cooke's work' (see *Diary*, 11: 4127).

28 See Thornbury, *Life*, 1862, 1: 170–72.

29 Ibid., 172. The painting in question may have been Howard's *Portrait of a child* that would be displayed as exhibit 224 in the 1812 Royal Academy Exhibition. It is now untraced.

30 A previously overlooked listing of a charge of two shillings (and possibly of a further shilling) on the very first page of *The British Itinerary* for the use of a 'Turnpike' shortly after Turner began his tour indicates that he must have possessed his own means of transport – in the form of the gig – for which he had to pay a turnpike charge. If he had been a stagecoach passenger, any turnpike cost would necessarily have been incorporated within his fare, while walking along the road would have been free.

31 T.B. CXXIII-56v, transcribed in Wilton and Turner, *Poetry*, 171.

32 See Finberg, *Life*, 183, citing an affadavit sworn in the Chancery proceedings of 1854.

33 Eastlake, *Contributions*, 23.

34 T.B. CXXIII-132v, transcribed in Wilton and Turner, *Poetry*, 174.

35 See Finberg, *Life*, 182–3.

36 T.B. CXXIII-119v. Matthew Imms expanded upon the 'Avelone' noted by Finberg. The drawing of the view looking north-westwards is T.B. CXXIII-118.

37 On 12 September Turner sold £50 of Consols £3%, possibly after visiting his stockbroker in person (see Consolidated £3% Annuities Stock Ledger AC27/1749, fol. 48214, Bank of England Archive, London).

38 Whittingham, *Geese*, 1: 115. Georgiana's dates were deduced from information gleaned from her 1840 wedding certificate, from her 1841 Census record, and from the 1843 record of her death.

39 Much of what transpired during this meeting can be deduced from a letter Turner would write to Britton in late November 1811 (see Gage, *Correspondence*, 50–51, letter 43).

26 'This Prospero of the Graphic Art'

1 Richard Cumberland's original had appeared, with a commentary, in the *British Critic*, XXXVIII, August 1811, 129 ff., where it follows immediately upon a review of the works of James Barry (ibid., 115–29). This may have drawn Turner's attention to the poem. Cumberland had died on 7 May 1811, so clearly the appearance of his poem around three months later would have borne a commemorative meaning at the time. The author is grateful to Professor Sam Smiles for identifying the author, title and date of this poem.

2 Folio 66v of the *Hastings* sketchbook, T.B. CXI.

3 Britton's draft was accompanied by a letter from the antiquarian, the full text of which appears in Gage, *Correspondence*, 49–50, letter 42.

4 Ibid., 50–51, letter 43. The points made in the rest of this main text paragraph, and throughout the following three paragraphs, have been taken or deduced from Turner's reply.

5 General Assembly Minutes, 3: 59.

6 Ibid., 62.

7 Folio 3 of the *Sandycombe and Yorkshire* sketchbook, T.B. CXXVII.

8 Reduced £3% Annuities Stock Ledger AC27/6874, fol. 38364, Bank of England Archive, London.

9 Turner wrote the following in ink:

$$\begin{array}{lr} & 1000 \\ \hline \text{Interest} & 30 \\ \text{\sout{Taxes}} & \text{\sout{20}} \\ & 5 \\ \text{Per Annum} & 50 \end{array}$$

Clearly the £50 total was written *after* the deletion of the £5 estimated for the annual poor rate but *before* the deletion of the £20 calculated for taxes (for otherwise the total would have come out differently). But what is of particular interest here is the '1000' in relation to the '30' for 'Interest'. As we have seen, Turner owned two types of stock that paid 3% interest. The bank interest on a Consolidated £3% Annuities or a Reduced £3% Annuities annual investment of £1,000 was £30. The painter was therefore calculating what he had to lose each year by investing his money in property rather than stock.

10 Such a person would have worked regularly for architects, calculating the quantities and labour budgets that were required for building purposes. The forerunner of the Royal Institution of Chartered Surveyors was the Surveyors Club, founded in London in 1792. By definition, some or many of the early professional surveyors must have been quantity surveyors, or doubled as such.

11 This comprised £4,406-8s-10d in Navy £5% Annuities; £950 in Consolidated £3% Annuities; and £1,883-9s-3d in Reduced £3% Annuities.

12 Gage, *Correspondence*, 51–2, letter 44, 6 March 1812, stating the work had been begun at Christmas.

13 Unfortunately the Royal Academy Treasurers never listed what was paid to individual Visitors in their account books, and nor did they record the days on which those tutors worked. All we know is that in 1812 a total of £202-13s was paid in Visitors fees at the fixed rate of half-a-guinea or 10s-6d per Visitor per day. Consequently,

on average they each earned £22-10s per annum (see the emolument totals for Schools Visitors for 1812 recorded within the 'Royal Academy Quarterly Account Book, 1796–1818' in the Royal Academy Archives, London). The average of 27½ days has been arrived at by dividing the 248 days in the 1812 Schools year between the nine Visitors, namely Turner, Callcott, Phillips, Shee, Beechey, Flaxman, Howard, Stothard and Westmacott.

14 See Sir John Soane, 'Minutes of the Royal Academy' notebook, 6v, 12, 12v and 13, Sir John Soane Museum Archives, London.

15 From Soane's evidence we can determine that a long passage on colour was not added to the 'Backgrounds' lecture in 1812 (and nor was an entire lecture on colour substituted for it), as maintained by Gage, *Colour*, 199. Probably the revision and substitution respectively quoted and suggested by Gage took place in 1818.

16 Farington, *Diary*, 11: 4091.

17 Reduced £3% Annuities Stock Ledger AC27/6874, fol. 38364, Bank of England Archive, London.

18 There are no receipts for payment for these paintings in the Tabley papers.

19 Claude's *Landscape with the death of Procris* (*L.V.* 100) remains untraced. The version in the National Gallery, London, is apparently an eighteenth-century copy. Turner would have known the original painting only at two removes through the Earlom *Liber Veritatis*. For further discussion of the Claude and Turner engravings, see Shanes, *Human Landscape*, 172–4.

20 Gage, *Correspondence*, 51–2, letter 44. This letter also contains the information that Pye had called earlier that day.

21 Because Turner and Wyatt had gone out into the countryside together in August 1810 in order to select the view that would be represented, the Oxford dealer and printseller knew that Turner would be depicting a 'burst of flat country with uninterrupted horizontal lines throughout' (to quote the painter's 6 March letter). Obviously, Wyatt had been brooding about this, and expressed his disquiet in the letter accompanying the sausages and hare.

22 Council Minutes, 4: 340.

23 General Assembly Minutes, 3: 68.

24 Farington, *Diary*, 11: 4107.

25 Ibid., 4108.

26 See fol. 45 of the *Woodcock Shooting* sketchbook, T.B. CXXIX. Unidentified works that are indicated on either side of *Hannibal* in the central register of exhibits in this drawing are of the correct ratio in relationship to that canvas to denote the Oxford views commissioned by James Wyatt. The drawing itself has long been thought to date from either 1812 or 1813 but it was indubitably made in the first of these years, as is proven by its inclusion of paintings designated as 'Hannibal' and 'Tynem'. Clearly, the latter designation denotes the 3 foot by 4 foot canvas entitled *Teignmouth* that would be sold to Lord Egremont from the 1812 Turner Gallery show. The nobleman would pay for this work, as well as for an oil of identical dimensions that has come down to us under the title of *Hulks on the Tamar*, by 5 March 1813 when Turner bought £450-worth of Reduced £3% Annuities with monies that could only have emanated from that source. Obviously, because *Teignmouth* must have been hanging at Petworth by the spring of 1813, it could not have been displayed in the Queen Anne Street West gallery exhibition at that time.

27 Gage, *Correspondence*, 53, letter 46.

28 Farington, *Diary*, 11: 4109.

29 Ibid., 4110.

30 Ibid.

31 Council Minutes, 4: 363.

32 Leslie, *Recollections*, 2: 12

33 It is often claimed that Hannibal is riding the elephant silhouetted in the distance, but there is no visual evidence to support that contention.

34 The author is indebted to Dr Jan Piggott for reminding him of this connection.

35 *Repository of Arts*, 7 (June 1812), 341.

36 Allston had first settled in London between 1801 and 1803, before moving to the Continent. He had returned to London in 1811 and would continue to live there until 1818.

37 Leslie, *Recollections*, 2: 12.

38 Robinson, *Diary*, 1: 381, for his own opinion of *Hannibal*, and ibid., 384, for Flaxman's opinion as originally related to him on 15 May 1812. Robinson developed his book towards the end of his life from the diaries he had maintained years earlier.

39 This was the sole review of the show, and it appeared three days after the gallery had closed. Almost certainly it was written by John Taylor. It was here that the account was furnished of the conflict between 'two Noblemen' and 'a great personage' over the acquisition of *Mercury and Hersé*, as discussed in the main text above.

40 See Fawkes, *Speech*. The dinner was held at the Crown and Anchor Tavern in Arundel Street, just along the Strand from Somerset House. It had been organised to celebrate the fifth anniversary of the election to Parliament of Fawkes's old school friend, Sir Francis Burdett, a county Member for Middlesex who represented the pro-reform tendency in the House of Commons. (Sir Francis had originally been elected in 1802, but that victory had been disallowed on a technicality, leading to further efforts to enter Parliament. The 1812 dinner therefore celebrated the tenth anniversary of that original triumph as well.) Before long, Fawkes's speech would be published and reprinted.

41 Forrester, *Liber*, 45.

42 See the drawing made between 1806 and 1811 that is now in the Museum of Fine Arts, Boston, Mass. It is reproduced as ibid., Plate I i.

43 Ruskin, *Works*, 5: 434–5.

44 Anderson, *Complete Poets*, 7: 206.

45 See lines 110–15 of Discourse XV: 'it [is] necessary to distinguish the greater truth ... from the lesser truth; the larger and more liberal idea of nature from the more narrow and confined; that which adresses itself to the imagination, from that which is solely addressed to the eye' (Reynolds, *Discourses*, 268). Turner paraphrased this passage in B.L., Add. MS 46,151-AA, 3.

46 Fol. 47 of the *Spithead* sketchbook, T.B. C.

47 See Gage, *Range*, 219 ff.; and Hamilton, *Scientists*, 115 ff.

48 See Thornbury, *Life*, 1862, 2: 57.

49 The first of these had appeared in 1811, so in fact MacCulloch could already have given a copy to Turner by the time the *Mer de Glace* print was begun. The second volume would be published in 1814. The books are listed by Falk as being in Turner's library (*Hidden Life*, Appendix 1, 256) but not by Wilton, *Time*, 246–7.

50 Farington, *Diary*, 12: 4306, 27 February 1813.

51 This drawing originally belonged in the *Smaller Fonthill* sketchbook, T.B. XLVIII. It became detached at some unknown date and is now in the Museum of Fine Arts, Boston, Mass.

52 T.B. CXVII-Z.

53 This possibility was suggested to the author by Dr John Gage in a Skype conversation held in September 2011.

54 The person represented lacks Turner's characteristic hooked nose, for example. Andrew Wilton (Letter, *Turner Society News*, 57, March

1991, 4) finds it impossible to believe that the portrait depicts Turner. On the other hand, John Gage ('Varley's Patent Portrait', *The Burlington Magazine*, January 1996, p. 31) believed it 'to be the most convincing likeness of the painter in his maturity, quite free from the element of caricature which the other, usually profile, effigies of Turner have so often presented'. Moreover, a forensic research student at Dundee University, Kelly Freeman, has found many identical features between the Varley portrait and Turner's death mask (see Maev Kennedy, 'Portrait is JMW Turner as a young man', *The Guardian*, 15 August 2010, http://www.theguardian.com/artanddesign/2010/aug/15/jmw-turner-portrait. Gage makes the point that the Varley 'optical device was, of course, no guarantee of accuracy', and one also needs to allow for a degree of idealisation even in portraits created by means of mechanical devices.

55 See Walker, 'Portraits', 24–5.

56 The instrument was in use by June 1810, for a Varley portrait of Matilda Lowry that was with Agnew in 1997 (124th Annual Exhibition, cat. no. 42) is inscribed on the verso 'Miss Matilda Lowry/June 1810/Done in the Camera/Lucida'. Presumably this note was added by Varley himself.

27 A Man of Property

1 See the letter from John Britton to John Soane, Sunday 5 June 1812, Prv. Cor. III, B.I. (6), Sir John Soane Museum Archive, London. Turner himself was seated almost at the top of the western arm of the top table between Henry Thomson and a Mr Jeffry, and opposite Thomas Phillips and Henry Howard (see Farington, *Diary*, 11: 4137, for a plan). If he looked behind him from that position he would have gained an unimpeded view of *Hannibal and his army crossing the alps* at the far end of the Inner Room.

2 T.B. CXIII, fols. 40v, 43v, 44, 44v, 45v and 46v.

3 Bailey, *Life*, 201.

4 On fol. 13 of the *Lowther* sketchbook, T.B. CXIII, Turner recorded the payment of 'Tayler wages. 11 weeks 17-10'. This has erroneously been calculated as payment of 3s-1d per day for eleven five-day weeks (Youngblood, 'Sandycombe', 22) but in fact £17-10s divided by eleven and then subdivided by five comes to 6s-3½d a day. However, in the very hard-working but sabbath-observant 1810s, it seems much more likely that six-day weeks were the norm on the Solus Lodge construction site. If that was the case, then Mr Tayler's payment for eleven weeks was for 5s-4d per day. Yet it is impossible that just one man put up a comparatively large building such as the Twickenham residence, so Turner's list can only have constituted a partial record and not been an estimate (for if it had represented the latter, *all* the labour costs would surely have been included, not just some of them). If Mr Tayler was paid the relatively high wage of 5s-4d per day, that would suggest he was Turner's foreman of works, with responsibility for supervising a group of up to six other men labouring under his command (possibly Tayler paid for an assistant out of his £17-10s, but that was not enough to cover more than one such employee).

5 Thornbury, *Life*, 1862, 1: 167.

6 Thus Havell moved the Thames in the left-distance much too far to the north-east, although this error or piece of artistic licence in 1814 was corrected by W. B. Cooke in his engraving made in 1828.

7 The W. B. Cooke engraving of William Havell's drawing suggests that between 1814 and 1828 another window had been let into the end wall of the south-east room, but that too may have been artistic licence. On the other hand, if such an aperture was created, then it appears likely that a balancing window was created in the north-west room as well.

8 However, this was probably not *Paul at Iconium* by Chantrey that the sculptor gave to Turner (now untraced), for it must be doubted that their friendship had flourished sufficiently by 1812 for such a gift to have been bestowed by that date.

9 Turner did not stint on the mattress he purchased for his bed, spending £1-11s-6d on it, alongside sixteen shillings on pillows and a shilling on candles (see the pencil note on fol. 31 of the *Sandycombe and Yorkshire* sketchbook, T.B. CXXVII). For his lunch or dinner after that shopping expedition, he spent two more shillings on trout.

10 This appears on the 1818 map of Twickenham now in Richmond Local Studies Library.

11 Thornbury, *Life*, 1862, 1: 168.

12 Turner paid the quarterly £2 Poor Rate that was due on 19 October 1812 on both the house and land. For rating purposes he must therefore have been living in Solus Lodge by that date. There is no record of any January 1813 Poor Rate payment. The next Poor Rate of £2 on 'Turner Esqr' late Brown House' and on 'Land late Wicks's' would fall due on 1 March 1813 but remain unpaid. As we shall discover, illness could have been the cause of that failure to pay. However, by 12 July 1813 the property would simply be listed under 'Turner Esqr' and the quarterly £2 Poor Rate would be paid, as it would again by 13 December 1813. Thereafter, the surviving records show that it was paid regularly.

13 Farington, *Diary*, 12: 4249.

14 Hamilton, *Life*, 156. Unfortunately these assertions were repeated by James Hamilton in his entry on the 'Health of Turner' in *The Oxford Companion*, 136–7, from which source they may well receive endless circulation. The remedy for plague written out by Turner, to which Hamilton refers, appears on fol. 1 of the *Chemistry and Apuleia* sketchbook, T.B. CXXXV. Recent research shows this sketchbook was in use between 1813 and 1815, and not between 1812 and 1813, as claimed by Hamilton.

15 From the knowledge that on 4 November Turner had told Farington he would be 'going to Mr Fawkes's in Yorkshire for a month', that he called on Soane the very next evening (see Soane, notebook 113, 30v), that he would miss the Council and General Assembly meetings held on 1, 5, 8 and 10 December, that he would sell £100-worth of Reduced 3% Annuities on Tuesday 15 December, perhaps to help with further expenses incurred in Twickenham (see Reduced £3% Annuities Stock Ledger AC27/6874, fol. 38364, Bank of England Archive, London), and that Farington would record his presence back in London on Wednesday 16 December (*Diary*, 12: 4267), we can deduce that Turner's 1812 visit to Farnley Hall probably began around Saturday 14 November and possibly ended just over four weeks later on Sunday 13 December.

16 Folio 2v of the *Hastings* sketchbook, T.B. CXI.

17 Council Minutes, 4: 392.

18 See Farington, *Diary*, 12: 4328, 8 April 1813, when Callcott told Farington that Turner had called upon him 'at Kensington a while since'. Although it is impossible to deduce from such a statement exactly when Turner had visited Callcott, mention of 'a while since' does suggest several months earlier, rather than simply a few weeks.

19 Ibid.

20 B.I. Minutes, 3: 67.

21 Farington, *Diary*, 12: 4322.

22 Ibid., 4328.

23 By April 1813 Callcott may have aware that the *Mercury and Hersé* exhibited at the Royal Academy two years earlier had finally been sold (for on 23 March Turner had converted into stock the 550 guineas he had recently received from Sir John Swinburne in payment for the work). However, he was otherwise correct in stating that Turner 'had not sold a picture in the Exhibition for sometime past'. In 1809 both *Spithead* and *The garreteer's petition* had failed to sell, in 1811 Turner had failed to sell his other three exhibited oils and in 1812 he had been left with *Hannibal and his army crossing the alps* and another canvas on his hands. Undoubtedly he could have hoped to sell some of these pictures, especially *Hannibal*. Beaumont could have prevented the sale of any of them, as Turner might have strongly suspected or even known for certain.

24 Farington would visit Turner's Gallery on Monday 24 May (ibid., 4355). As he had attended those exhibitions during their closing week for several years past, he probably did so this year too. If that was the case, then the show would have ended on Saturday 29 May. On average, Turner Gallery exhibitions now lasted about five weeks. By working backwards some five weeks from 29 May – and taking into account the fact that the Turner Gallery exhibition would hardly have lasted for just three weeks or opened on the very same day as the Royal Academy – it is possible to deduce the probable opening date.

25 They were, firstly, the *Narcissus and Echo* (B.J. 53) exhibited at the Royal Academy in 1804, and again at the British Institution in 1806; payment by Lord Egremont for this work appears to have taken place on 16 June 1813. And by eliminating any other purchasers of any other paintings during the 1803 to 1813 period, it is possible to deduce that by 21 July 1813 a John Green of Blackheath might well have purchased a view of Bonneville in Savoy exhibited at the Royal Academy in 1803 (B.J. 46), as well as a painting of Venus and Adonis of 1803–5 (B.J. 150). For the reasoning behind these deductions, which are linked to large stock purchases made by Turner in the summer of 1813, see the corresponding section in the electronic version of this text.

26 Farington's diagram of the 1813 Royal Academy dinner does not appear in the published version of his diaries. It is to be found on pages 34–5 of the original manuscript volume for 1 March 1813 to 13 July 1813 (Royal Library, Windsor Castle).

27 Thornbury, *Life*, 1862, 1: 170–71.

28 Ibid., 171.

29 Ibid., 170–71.

30 Lines 750–52 and 754–7.

31 The author is grateful to Professor Sam Smiles for drawing his attention to this detail.

32 T.B. LXIX-66.

33 Here the critic may have been remembering Turner's 1803 oil painting *The Festival upon the opening of the vintage at Mâcon*, even though it is lit by French skies rather than Italian ones (but of course, as a painting in the Claudian style, it is indubitably Italianate in character).

34 It is this observation that leads the author to believe that originally the atmosphere was transparently white, perhaps because Turner had thinly glazed white over the extensive yellows in his sky, with this layer later being lost from the painting.

35 Farington, *Diary*, 12: 4341.

36 Ibid. The table erroneously appears as oblong in shape in the published version of the diary.

28 An English Eden

1 *Examiner*, 23 May 1813, 334.

2 Farington, *Diary*, 12: 4355.

3 John Murray Archive, National Library of Scotland, Edinburgh. The letter is reproduced almost in its entirety in Shanes, *Rivers*, 7.

4 For the Club dinner, see Farington, *Diary*, 12: 4362; and for the stock acquisition, see Consolidated £3% Annuities Stock Ledger AC27/6874, fol. 38364, Bank of England Archive, London. Turner had called the picture (B.J. 53) 'Narciss' on the list of unsold paintings he had compiled on fol. 36 of the *Finance* sketchbook, T.B. CXXII, where he had placed the low value of 50 guineas on it because it had long passed what he had deemed to have been its sell-by date. However, faced with a supportive patron who was accustomed to handing over 200 guineas for 36 × 48 inch canvases, it seems impossible he had communicated to Lord Egremont his private thoughts on its loss of value and sold it for the lower amount. Instead, he must have received the original 200 guineas, with the £260 that was translated into stock on 16 June also including £50 that had additionally been paid for its framing and transportation costs.

5 Beckett, *Constable*, 2: 110.

6 These were exhibit 266, *Landscape – boys fishing* (untraced); and exhibit 325, *Landscape – morning* (untraced). For *Landscape – boys fishing* see Reynolds, *Constable*, I, 179, cat. no. 13.1; for *Landscape – morning* see ibid., cat. no. 13.2. Both paintings were displayed in the Inner Room, with cat. no. 266 possibly being hung above the line on its south wall and cat. no. 325 probably above the line on its north wall.

7 Beckett, *Constable*, 2: 110.

8 On 21 July 1813 Turner broke down his Bank of England holdings on fol. 14 of the *Finance* sketchbook, T.B. CXXII, the same sketchbook in which he had stored the sheet of paper containing the list of assets compiled in 1810. Now he noted the possession of £1,600 in Consolidated £3 % Annuities, which was correct; £4,406-8-10d in Navy £5% Annuities, which was also correct; and £2,693-9s-3d in Reduced £3% Annuities, which was incorrect, for on that date he possessed £3,293-9s-3d in the last type of stock. (In fact, he had never possessed £2,693-9s-3d in reduced three-per-cents but only amounts of stock that were always above or below that level.) Not until 19 January 1814 would his sketchbook figures tally with the entries in the relevant Bank of England stock ledgers.

9 On the basis of incorrect figures in the *Finance* sketchbook but without knowledge of the Bank of England ledgers, Finberg would calculate (*Life*, 204) that between 17 August 1810 and 21 July 1813 Turner had earned £2,183-1s-11d (whereas the true figure was £2,887-1s-11d).

10 The party included Robert Finch (1783–1830), a cleric, antiquary, traveller and the eventual owner of two Turners, and Henry Venn Elliott (1792–1865), the son of Charles Elliott from whom Turner had acquired the lease of 64 Harley Street. In 1813, Henry Venn Elliott was a Scholar at Trinity College, Cambridge, from where he would graduate the following year. Eventually he would become a Church of England clergyman. Gage (*Correspondence*, 251–2) confused him with Henry George Elliott (1817–1907), who would work with Lord Palmerston at the Foreign Office in 1840. Others in the party were the Herbsts, about whom nothing is known; Maria Perks; a

Mr Wilson; the three brothers Thomas, Charles and James Wheeler; and a young man named Edward. There may have been up to four members of the Wells family present.

11 Letter of 27 July 1813 from Henry Venn Elliott to Robert Finch in the Bodleian Library, Oxford, quoted in Gage, *Correspondence*, 294.

12 W. 833, where dated to *c.*1831, and see Shanes, *England*, 207, where reproduced in colour.

13 This date has been deduced by working backwards from dateable events later in the tour, from our knowledge of the lengths of various stays within it, and from the probable date of its termination. A far more detailed account of the 1813 stay in Plymouth is provided in the electronic version of this work.

14 These were the medium-sized *Vale of Heathfield* sketchbook, T.B. CXXXVII; the medium-sized *Plymouth, Hamoaze* sketchbook, T.B. CXXXI; and the small *Chemistry and Apuleia* sketchbook, T.B. CXXXV. It will be argued below that sketchbooks previously connected with the 1813 West Country tour – the *Devon Rivers, No.1* sketchbook, T.B. CXXXII; the *Devon Rivers, No. 2* sketchbook, T.B. CXXXIII; and the *Devonshire Rivers, No. 3, and Wharfedale* sketchbook, T.B. CXXXIV – were instead used on the 1814 tour of Somerset, Devonshire and parts of east Cornwall.

15 George Eastlake lived in Frankfort Row, a few hundred yards north of Plymouth Hoe. Collier resided in Old Town Street, about half a mile north of Plymouth Citadel and just around the corner from Frankfort Row. Johns lived in North Hill Cottage, about a mile to the north of Plymouth Citadel and on North Hill, a road that formed part of the highway linking Plymouth and Tavistock. Redding lived 'in a cottage, in a beautiful situation called Mutley, on the Tavistock road. It commanded a fine view of the Sound, Mount Edgcumbe, and the heights' (see Redding, *Recollections*, 1: 165). This was located about half a mile north of John Collier's house and somewhat less of a distance from North Hill Cottage.

16 Redding, 'Obituary', 153.

17 Ibid., 154.

18 Ibid.

19 Thornbury, *Life*, 1862, 1: 219. Miss Pearce remains unidentified.

20 See Cook and Kirk, *Tamar*, 18 ff., although they reinforce their argument with several sketches that would be made on the 1814 tour.

21 Thornbury, *Life*, 1862, 1: 220.

22 B.J. 213, 214r and v, 215, 216, 217, 218, 219, 220, 221, 222, 223 and 224, which are, respectively, T.B. CXXX-A to Add. L. Also B.J. 225, 225a and 225b.

23 Redding 'Obituary', 151.

24 Redding, *Recollections*, 1: 204–5.

25 Ibid.

26 *Hulks on the Tamar*, T.B. CXCVI-E. If the Tamar is the river depicted, then in the view represented we must be looking southwards.

27 Woollcombe, Diary, 27 August 1813.

28 Redding, 'Obituary', 154.

29 Woollcombe, Diary.

30 Redding, *Recollections*, 1: 199–200; and Redding, 'Obituary', 152.

31 Redding, 'Obituary', 152. The quotation 'like Atlas, unremoved' was taken from line 987 of the fourth book of *Paradise Lost* by John Milton.

32 Eclipse had won all twenty-six of his starts and beaten every one of his rivals by at least 200 yards. Moreover, in ten of his races he had carried jockeys weighing upwards of 168 pounds. And like all his contemporaries, he had necessarily been a tremendous long-distance runner, for in those days racecourses were much longer than they are today (which is why, like all his competitors, Eclipse had only begun his career as a five-year-old). In all, Eclipse won eleven King's Plates. He had died at the age of 25 in 1789.

33 Redding, 'Obituary', 153.

34 This date can be deduced from the fact that on the following night Madame Catalani – for whom see the next paragraph – would be giving the first of four concerts at the New Theatre Royal, Plymouth. By working backwards from the date of the invitation extended to Turner, de Maria and Redding to stay at Saltram, we can establish the date of their boat trip to Burgh Island.

35 She had made her London debut in 1806, and her powerfully flexible voice encompassed three octaves. On 6, 7, 8 and 10 September, she was due to sing at the New Theatre Royal in Plymouth, with appearances at the Dock Theatre in nearby Devon Dock on the nights of 9 and 11 September. It can therefore be deduced that she must have stayed at Saltram the night before any of those public engagements began, and consequently before she moved into hotels in Plymouth and Devon Dock. (She could not have stayed at Saltram on the Sunday after her Plymouth engagements had ended, for she was in Exeter on Monday 13 September. She must therefore have travelled to that city the day before.)

36 Gronow (*Reminiscences*, 1: 34–5) states:

Catalani was very fond of money, and would never sing unless paid beforehand. She was invited, with her husband, to pass some time at Stowe, where a numerous but select party had been invited; and Madame Catalani, being asked to sing soon after dinner, willingly complied. When the day of her departure came, her husband placed in the hands of the Marquis of Buckingham the following little billet, – 'For seventeen songs, seventeen hundred pounds.' This large sum was paid at once, without hesitation.

Given that she was a professional singer, Madame Catalani is unlikely to have charged other members of the landed gentry any less.

37 Redding 'Obituary', 153. Turner's sketches have not been identified. The reference to a 'sundown' suggests that this part of the excursion took place late one afternoon, and therefore that the outing was undertaken on the afternoon of Monday 6 September after returning to Plymouth from Saltram.

38 Ibid.

39 Ibid. By 'nearly three weeks' Redding undoubtedly meant the period in which he and Turner had spent a good deal of time together, rather than the total time the painter had spent in Plymouth and its environs in 1813. This is because, judging by all that was seen and done, Turner had to have spent far more time in and around the town than a little under three weeks.

40 Ibid., 155. Although this passage appears near the middle of Redding's memoir, and therefore suggests that the picnic took place about halfway through Turner's Plymouth sojourn, it seems unlikely that the artist would have hosted his picnic during the middle of his stay, rather than at the end of it as a way of thanking all those who had contributed towards making it a success. The showing of the oil sketches supports this contention, for they had to have been dry to have been easily transported across the Hamoaze to Mount Edgcumbe park.

41 Ibid.

42 Ibid., 151.

43 Ibid., 155.

44 The Royal Devonshire stagecoach departed from the Commercial and the Globe inns, Plymouth, at 7:15 a.m. daily, to reach London by way of Exeter, Bristol and Bath. Given that Turner had travelled to Plymouth via Bristol, this was probably how he returned home. The reason to believe he left the town on 9 September has to do with a letter he wrote to Ambrose Johns on the following Tuesday, 14 September (see *Turner Society News*, 119 (Spring 2013), 22–3). It mentions his safe arrival in Twickenham, which could have taken place by early evening on the previous Friday; that he had then been forced to travel from Twickenham to London and back again, which had to have taken place on the Saturday and/or possibly on the Sunday; that he had painted in Twickenham on the Monday; and that he was in a hurry to catch the post on the Tuesday. By working back from that Tuesday, we can deduce a 9 September departure from Plymouth. As we can place Turner at Saltram on 5 September, and as the picnic he hosted would hardly have taken place before the Burgh Island expedition, those events also point to a 9 September departure from Plymouth, as do the 'nearly three weeks' he spent staying with Redding.

45 Turner's 14 September letter – for which, see the preceding note – states in part: 'I had time to put upon paper the Trees…which I now inclose…but [was] prevented [from] doing the said sket[ch] until yesterday.' Eastlake commented that 'long afterwards, the great painter sent Johns in a letter a small oil sketch, not painted from nature, as a return for his kindness and assistance' (Thornbury, *Life*, 1862, 1: 220). The date of the letter obviates Eastlake's claim that the sketch was sent 'long afterwards'.

46 This discovery was made by Matthew Imms; see 'Fire', 9.

47 A number of sketches of the archway are to be found in the *Plymouth, Hamoaze* sketchbook, T.B. CXXXI, with the most detailed of them appearing on fol. 138v. The archway would be replaced in 1897 by the present single-span cast-iron bridge.

48 Reduced £3% Annuities Stock Ledger AC27/6874, fol. 38364, Bank of England Archive, London.

49 Folios 8v and 8 of the *Hastings* sketchbook, T.B. CXI. The formula is given in the electronic version of this work, along with a professional medical commentary upon it.

50 Matthew Imms discovered this source; see his entry for the *Hastings* sketchbook in the online revised Inventory of the Turner Bequest, Tate Britain, London.

51 The first of them would show Otley Chevin, the ridge on the south side of Wharfedale; to that end, Turner sketched a rough track that ran across the Chevin on fol. 47 of the *Woodcock Shooting* sketchbook, T.B. CXXIX. However, for the second watercolour he did not need to record the characteristics of any particular place as he would be setting the shoot in a rather featureless expanse of open moorland.

52 Gage, *Correspondence*, 53, letter 47. The timing of the letter is only given as 'Wednesday morning'. This led Finberg (*Life*, 203) to suggest it was written on either 16 or 23 November 1813. However, in that year both of those dates fell upon a Tuesday. Unfortunately, this mistake was repeated by Gage. If the letter was written on Wednesday 10 November, then Turner would have hardly enjoyed much time at Farnley; if it was written on Wednesday 17 November, then he would have been back in London by 1 December, which would render it strange he would miss a Royal Academy General Assembly meeting ten days later. However, if it was written on Wednesday 24 November, then he might well have hoped to return to London by 8 December in order to be present at that meeting. This final scenario is therefore the likeliest of the three.

53 It was engraved by William Woollett in 1783, and in aquatint – possibly after Woollett – by J. P. M. Jazet (1788–1871) at an unknown date.

54 Of course it is possible that Lord Egremont was not resident at Petworth at the time but was staying in his London town house instead. However, that would not have prevented Turner from visiting Petworth with his patron's permission (or without it if he was indeed the recipient of an open invitation).

55 Gage, *Correspondence*, 54, letter 48.

56 This is made clear by a passage contained in a letter from William Combe to W. B. Cooke quoted in Thornbury, *Life*, 1877, 190. That missive, and the preceding one also written by Combe to Cooke (ibid., 189–90), are simply assigned to 'Friday morning' and 'Friday afternoon'. However, it is evident from Turner's letters to Cooke of 4 and 16 December exactly when the Combe missives were written. (Incidentally, it is clear from the sequence of ideas expressed within the Combe letters that Thornbury managed to get the timings of those communications reversed in his customarily careless way.)

57 Gage, *Correspondence*, 55–6, letter 49.

29 'The Eye Wanders Entranced'

1 The bulkiness and unwieldiness of the portfolio containing all of the professor's perspective diagrams and illustrations, as well as his lecture texts, dictated that he had to take a Hackney cab from Queen Anne Street West to Somerset House. Because of its size, Turner probably placed the battered portfolio across the seat behind him and rested his back against it. If that was what happened, then he had placed himself in the common danger of putting things out of sight and out of mind. And perhaps also because of impatience brought on by extremely slow progress through the streets caused by the heavy evening traffic, by the fairly impenetrable fog, and by snow having been thrown off the roofs of many older buildings in order to lighten their load – which added to the blockage of the streets caused by existing snow and ice – when he did finally alight from his cab he forgot to take his portfolio with him. It is easy to visualise him clomping halfway up the Academy staircase on his way to the Great Room, only to realise his mistake with horror. By the time he had rushed back to the street, the cab had disappeared into the night.

2 See the letter by 'Cato' in the March 1814 edition of the *New Monthly Magazine* (page 140). Clearly the writer had obtained his information secondhand. That is why he made a mistake over the date of the incident, and also split the tale into two parts, with the loss of the portfolio having supposedly occurred in 1813 (when Turner did not lecture), and the loss of a manuscript having allegedly occurred on 10 January (which was in fact the date upon which Turner did deliver his first lecture, having recovered his lost portfolio by then). However, some elements in the account are true, especially the time the 3 January Fuseli replacement talk began. Turner's remaining lectures were given on 17, 24 and 31 January, and on 7 and 14 February. Finberg was wrong (*Life*, 206) in stating that Turner gave his sixth and final lecture on 7 February, for by that date he had only given five talks.

3 The fact that in his advertisement he gave his address as 'Mr Turner's, Queen Anne-street west, corner of Harley-street' proves that he was living in his gallery cum studio, and that neither his father nor any females resided there, for where could they all have possibly slept? Instead, Turner must have slept downstairs and done so alone, with Sarah and the girls residing elsewhere, and with William and possibly Hannah living down in Twickenham.

4 Minutes of the 6 January 1813 meeting of the directors, B.I. Minutes, 3: unpaginated.

5 Whitley, *England, 1800–1820*, 223. As Whitley established on page 81 of his book, the source of this passage was an anonymous memoir that would appear in the *Polytechnic Journal* in 1840. Possibly it was written by Thomas Douglas Guest (1781–1845), a history and portrait painter who had studied at the Royal Academy Schools at the beginning of the century. As a Schools student he was awarded a Gold Medal.

6 Gage, *Correspondence*, 56, letter 50.

7 Nicholson, 'Appulia', 680.

8 The B.I. Minutes, 2: 46, reveal that from 31 May 1808 the paintings submitted for the Premiums had to fall instead into one of the following three categories: 'Historical or Poetical composition'; the best picture 'in familiar life' (that is, genre painting); and the best landscape. Additionally, a prize was set up for the best 'Model' (i.e. sculpture) in 'Heroic or Poetic composition'. Further modifications to these categories were made between 1809 and 1813, with the sculpture prize being dropped in 1809.

9 Finberg, *Life*, 209. Finberg did not enjoy access to the British Institution Minute Books, for they only entered the National Art Library collection after his death in 1939. His erroneous assumption was undoubtedly the source of the identical mistake made by Kathleen Nicholson (for which, see n. 7 above), and consequently by the many other writers on the subject who have been influenced by her essay.

10 Fol. 17 and 18 of T.B. CI, dated by Finberg in the Inventory to 1806–8 but now thought to date from between 1806 and 1814. Prior to 1814, the *Boats, Ice* sketchbook had simply contained a few delineations of Thames barges and boats, verses concerning Pope's villa that probably dated from 1807–8, and a large number of blank pages (of which, many still remain there).

11 See fols. 1v and 6v of the *Greenwich* sketchbook, T.B. CII.

12 See Eleanora C. Gordon, 'The Fate of Sir Hugh Willoughby and His Companions, A New Conjecture', *The Geographical Journal*, 152, 2: July 1986, 243–7.

13 The seven directors were the Earl Cowper, the Earl of Mulgrave, The Rt Hon Charles Long, Sir Thomas Bernard (who in 1810 had succeeded to the baronetcy conferred on his father in 1768), Sir Thomas Baring, Richard Payne Knight and the Revd William Holwell Carr. The four governors were the Marquis of Blandford, the Earl of Upper Ossory, Samuel Whitbread and John Symmons.

14 Because this claim was first made by Finberg (*Life*, 207), it has been endlessly repeated.

15 They were exhibit 15, *The disposal of a favourite lamb* by William Collins (which was one of the exceptions); exhibit 76, *Forenoon, Landscape* by William Collins; exhibit 129, *A view of Edinburgh* by J. C. Hofland; exhibit 153, *A winter piece* by Joshua Shaw (which was the other exception); exhibit 157, *A Storm [off] the coast of Scarborough* by J. C. Hofland; exhibit 160, *A Landscape, Morning scene in Lancashire* by Joshua Shaw; exhibit 197, *Landscape, morning composition* by Newton Smith Fielding; and exhibit 209, *[Cefalu], on the North coast of Sicily* by Benjamin Barker.

16 B.I. Minutes, 2: unpaginated, Minutes for 28 March 1814.

17 David Hill first put forward this suggestion; see *Thames*, 119–20.

18 Ibid.

19 Thornbury, *Life*, 1862, I:173.

20 Given that Turner had written a letter of appreciation to Lord Elgin in August 1806, it may be that by depicting a building not unlike the Parthenon a few years later, he intended to signify to the public that the earl's ambition to stimulate British art by means of the importation of the Athenian marbles had succeeded.

21 This feature of the image was first discerned by Finberg (*Life*, 211).

22 Finberg (*Life*, 210) was of the opinion that this piece was also written by Hazlitt. Between 3 and 6 May the critic had been sacked from the *Morning Chronicle* for harshly criticising a portrait by Lawrence, who happened to be a close friend of its editor. As a consequence, Hazlitt appears to have moved to the *Champion*.

23 Ibid., 212.

24 Ibid.

25 This comprised £3,393-9s-3d in Reduced £3% Annuities; £4,606-8s-10d in Navy £5% Annuities; and £1,600 in Consolidated £3% Annuities.

26 Turner appears to have painted no three-foot by four-foot canvases between B.J. 124, *A view of the Castle of St. Michael, near Bonneville, Savoy*, exhibited at the Royal Academy in 1812; and B.J. 235, *The seat of William Moffatt Esq., at Mortlake. Early (summer's) morning*, exhibited at the Royal Academy in 1826. Naturally, the latter work must have been begun a year or so earlier.

27 These were B.J. 132, *The eruption of the Souffrier Mountains*, exhibited in 1815, which measures 31¼ × 41¼ (79.4 × 104.8); B.J. 229, *What you will!*, exhibited in 1822, which measures 19 × 20½ (48.2 × 52); and B.J. 234, *View from the terrace of a villa at Niton, Isle of Wight, from sketches by a Lady*, exhibited in 1826, which measures 17¾ × 23½ (45.5 × 61). Additionally, Turner painted B.J. 226, *Lake Avernus, Æneas and the Cumaean Sibyl* for Sir Richard Colt Hoare, which measures 28¼ × 38¼ (72 × 97).

28 Thornbury, *Life*, 1877, 117–18.

29 Reduced £3% Annuities Stock Ledger AC27/6874, fol. 38537, Bank of England Archive, London.

30 See additional document 2 in the *Finance* sketchbook, T.B. CXXII.

31 The sketchbooks used solely in 1814 were the pocket *Review at Portsmouth* sketchbook, T.B. CXXXVI; the *Devon Rivers, No.1* sketchbook, T.B. CXXXII; the *Devon Rivers, No.2* sketchbook, T.B. CXXXIII; and the *Devonshire Rivers, No.3, and Wharfedale* sketchbook, T.B. CXXXIV. The pocket sketchbook taken on both tours was the *Chemistry and Apuleia* sketchbook, T.B. CXXXV.

32 See fols. 3v-8 of the *Chemistry and Apuleia* sketchbook T.B. CXXXV, the Bristol subjects of which were all identified by Matthew Imms as part of the Turner Bequest re-cataloguing project.

33 Fol. 23 of the *Devon Rivers, No.1* sketchbook, T.B. CXXXII.

34 Fol. 131v of the *Devon Rivers, No.1* sketchbook, T.B. CXXXII. It includes figures and three oblique pencil lines in the sky, perhaps to denote rain. Turner annotated this drawing with the words 'Travellers sheltering themselves with Turf'.

35 See Gage, *Correspondence*, 57, letter 52.

36 Such a possibility receives support from the fact that many of the forty-five drawings of Plymouth Sound, Plymouth harbour, the Hamoaze, the St Germans or Lynher river and other locations contained in the *Devon Rivers*,

No.2 sketchbook indicate that Turner had a boat and boatman at his disposal. As far as we know, Johns possessed no such vessel or man, whereas both Eastlake and Collier did so. On the other hand, Turner may have hired his own boat and boatman, in which case no link with Eastlake and Collier can be discerned.

37 For the reasoning behind this possible dating, see the far more detailed account of the 1814 tour in the electronic version of this work.

38 Comments written on the third touched proof now in the Department of Prints and Drawings, British Museum, London.

39 At some point during Turner's stay with A. B. Johns in Plymouth that summer, the two of them had met up with the banker John Tingcombe (1766–1846). In the course of their discussion, Johns asked if he might borrow Opie's *Lectures on Painting* from 'the Library'. By this he meant the Plymouth Proprietary Library, a subscription library that had been founded in 1810. It was housed in a building designed by John Foulston, the architect of the New Theatre Royal. Johns could not afford to join the library, and because its rules prevented non-members from borrowing its books, Tingcombe was forced to refuse his request. Turner thereupon offered to lend Johns his copy, which he said he would post to him upon his return to London.

40 As the 'Visitor' commented sarcastically, it could prove beneficial to a number of Academicians to fill the post, 'for there are some few among you, whom it would really infinitely benefit to quit the brush.' He recommended Farington for the position, for not only would the latter prove adept at clearing away the cobwebs but he would also greatly benefit from acquiring more knowledge of literature. As the 'Visitor' concluded tartly, 'it must surely be better for [Farington] to be a good keeper of books than a bad painter of landscapes.' Turner was not amused, for although he might not have thought much of Farington as a painter, as a fellow Academician he had to be defended. And why should an artist have to forego his calling in order to serve as a mere librarian? That was absurd.

30 *The Tremendous Range of his Accomplishments*

1 See W. B. Cooke's letter to Turner of 1 January 1827, in Thornbury, *Life*, 1862, 1: 400–3.

2 As Maurice Davies has noticed (Thesis, 275), the sheets of paper used for fols. 15–56 that are bound into B.L., Add. MS 46151-R are watermarked 1812 and 1813. However, the text must date from after 1813, for of course Turner did not lecture in that year. It appears to have constituted a new introductory lecture, but evidence that it might have been delivered in 1815 or 1816 still awaits discovery.

3 Receipt now in the Wiltshire and Swindon History Centre, Chippenham, Wilts.

4 These transactions were respectively recorded in Navy £5% Annuities Stock Ledger AC27/5284, fol. 45024; and Reduced £3% Annuities Stock Ledger AC27/6874, fol. 38537, both Bank of England Archive, London.

5 Uwins, *Memoir*, 1: 39.

6 David Hill (*Yorkshire*, 56) has discerned that some three years or more after 8 December 1813, Turner twice recorded on the *verso* of T.B. CXCV(a)-J that he was still owed 120 guineas for 'Lucerne'. From this Professor Hill deduced that *Lake of Lucerne, from the landing place at Fluelen* was almost certainly a new work when it was exhibited in 1815.

7 The author is grateful to Timothy Clode for drawing his attention to the possible underlying meaning of *Lake of Lucerne, from the landing place at Fluelen*.

8 The *Landscape with the Rest on the Flight into Egypt* is L.V. 88 and it dates from the early 1640s. By 1815 it had long been in the Cavendish collection at Holker Hall, Norfolk. The other painting was L.V. 47, the *Landscape with the Finding of Moses* of around 1639. It is now in the Prado, Madrid. The composition of L.V. 88 was derived from it. The drawing Claude made from this work was also reproduced in the Earlom set of engravings. Additionally, Turner may have remembered the *Landscape with Hagar and the Angel*, L.V. 106 (National Gallery, London), which he had seen in the collection of Sir George Beaumont years before, although the organisation of masses is somewhat different. Naturally, this image was also available to him through the Earlom *Liber Veritatis*.

9 The Reynolds is his 1767 portrait of Hester Frances Cholmondeley which Turner would have seen at the British Institution Reynolds exhibition in 1813 (where it was displayed as exhibit 50 under the title of *Portrait of Miss Fanny Cholmondely*). It is now in a private collection (see Mannings and Postle, cat. no. 364, text vol.: 133). Turner could also have been acquainted with the image through its 1768 engraved reproduction by Giuseppe Marchi. De Loutherbourg's versions of the subject are both early works and are untraced (see Lefeuvre, *Loutherbourg*, cat. nos. 20 and 63; the second of these images may have been known to Turner through its engraved reproduction in reverse by Anne Philiberte-Coulet). The Thomson had been exhibited in 1803 at the Royal Academy, from where it was acquired by Sir John Leicester. Turner had many further opportunities to see it in the baronet's 24 Hill Street gallery. The Hamilton was not exhibited at the Royal Academy, and is now untraced.

10 Thornbury, *Life*, 1862, 1: 171.

11 Lindsay, *Life*, 152.

12 Gage, *Correspondence*, 207, letter 283.

13 Turner had first toyed with the idea of creating a Claudian seaport scene around 1806; see fols. 11v, 17, 18v, 21v, 30v, 31v, 32v, 33v, 38v, 40v, 41v, 48v, 49v, 50v and 84v of the *Studies for Pictures, Isleworth* sketchbook, T.B. XC.

14 The perspectives of the tomb on the right are slightly erroneous, for all of its horizontal lines above eye level rise, whereas they should descend, to meet at the notional vanishing point of the eye at the height of the distant bridge and a little to the right of the riverbank well to the left of centre. This error perhaps came about because the picture rested on the floor when the tomb was painted, and consequently the perspectives of the structure were misjudged until it was too late to correct them without repainting everything. The suggestion by Brian Sewell ('Turner Inspired, In the Light of Claude', *London Evening Standard*, 15 March 2012) that the tomb was dragged into a 'leaning' position by poor re-stretching at some point in the picture's history is not convincing, for everything below and above it would be equally out of alignment if that were the case, which it is not.

15 Alaric Watts, 'Biographical Sketch of J. M. W. Turner' in Leitch Ritchie, *Liber Fluviorum*, London, 1853, XXIX.

16 This title originally appeared entirely in upper case.

17 The regulation had been printed once again in the catalogue of the British Institution's

Old Masters exhibition held in 1811, which is why the *Morning Chronicle* referred to it by way of that catalogue and date.

18 Anonymous, *Account of the AGBI*, 10.

19 AGBI Minutes, 7 February and 12 April 1815, 10 and 16.

20 Ibid., 17, Minutes for 4 May 1815.

21 For an account of Turner's participation in the 15 April 1815 dinner held by the Artists' Benevolent Fund, see the section entitled 'Charity' in Chapter 38 of the electronic version of this work.

22 AGBI Minutes, 13 July 1815, 22–3.

23 Around the beginning of July 1811 the widow of John Inigo Richards had contacted Turner. She was in dire straights, for her late husband had made little provision for her, and his illegitimate adult daughter had laid claim on what little money remained. Mrs Richards did receive a small pension from the Royal Academy, but obviously she was finding it difficult to make ends meet. Eventually, she called upon Farington and, after telling him of her problems, she let slip that 'she had been harshly treated by Turner' (*Diary*, 11: 3962–3). It may have been in connection with this incident that Thornbury related that 'A poor woman once interrupted [Turner's] painting by teasing him with a begging petition. He roughly chid her and sent her away; but before she got to the hall door, his conscience had goaded him, he ran after her and presented her with a 5l. note, a great sum for a thrifty close man to give away on a sudden impulse' (Thornbury, *Life*, 1862, 2: 131). As there was no 'hall door' to the Queen Anne Street West gallery and studio, this story may date from the period when Turner was ensconced in 47 Queen Anne Street West, which did possess a hallway. On the other hand, there cannot have been many destitute widows calling upon Turner. And perhaps by 'harsh treatment' Mrs Richards signified that she had expected Turner to assist her more liberally. In any event, Farington recommended she call upon Benjamin West, with a view to having the midsummer payment of her quarterly pension brought forward.

24 See Brian Butterworth, 'Was Turner Dyslexic?', *Turner Studies*, 11: 1 (summer 1991), 3–6.

25 At some point between 1834 and 1840 Turner would ascend a hill at North Hinksey, outside Oxford, on three successive days in order to obtain a mental image he could translate into a drawing of the city that had been commissioned for subsequent engraving. It was only on the third ascent that he was able to form the concept he sought. See Frederick Goodall, *Reminiscences*, London, 1902, 54–5, quoted in Eric Shanes, 'Picture Note', *Turner Studies*, 1: 2, 1980, 52.

26 This total was made up of £4,836-8s-10d in Navy £5% Annuities (for which see Navy £5% Annuities Stock Ledger AC27/5284, fol. 45024); £3,600 in Reduced £3% Annuities (for which see Reduced £3% Annuities Stock Ledger AC27/6874, fol. 38537); and £1,750 in Consolidated £3% Annuities (for which see Consolidated £3% Annuities Stock Ledger AC27/1879, fol. 47263), all Bank of England Archive, London.

Bibliography

The keywords for each entry below are used as abbreviations throughout the Notes.

Abell
Monro: Moira Abell, *Doctor Thomas Monro, 1759–1833: Physician, Patron and Painter*, Bloomington, Ind. 2009.

A.G.B.I. Minutes
Artists' General Benevolent Institution Minute Book, 1814 to 1841, Archive of the Artists' General Benevolent Institution, Burlington House, London.

Algarotti
Essay: Francesco Algarotti, *An Essay on Painting*, London, 1764.

Alger
British Visitors: John Goldworth Alger, *Napoleon's British Visitors and Captives 1801–1815*, London, 1904.

Altick
Shows: Richard D. Altick, *The Shows of London*, Cambridge, Mass., 1978.

Anderson
Anderson's *Complete Poets*: Robert Anderson (ed.), *A Complete Edition of the Poets of Great Britain*, 13 vols, London and Edinburgh, 1792–5.

Angelo
Reminiscences: Henry Angelo, *Reminiscences*, 2 vols, London, 1828.

Anonymous
Account of the AGBI: Anonymous, *An Account of the [Artists'] General Benevolent Institution for the Relief of Decayed Artists of the United Kingdom whose works have been known and esteemed by the public; and for affording assistance to their widows and orphans. Supported by voluntary contributions. Instituted 1814*, London, 1818.

Archer
'Turner': J. Wykham Archer, 'Joseph Mallord William Turner, R.A.', *Once a Week*, 1 February 1862, pp. 162–6 (reprinted, *Turner Studies*, vol. 1, no. 1, 1981, pp. 31–6).

Armstrong
Turner: Sir Walter Armstrong, *Turner*, London, 1902.

Atkinson
'Bristol': Beavington Atkinson, as related to P. G. Hamerton, 'Turner at Bristol', *Portfolio*, 1880, pp. 69–71.

Bachrach
'Holland 1': A. G. H. Bachrach, 'Turner's Holland', *Dutch Quarterly Review*, vol. 6, no. 2, 1976, pp. 83–115.
Holland: A. G. H. Bachrach, *Turner's Holland*, exh. cat., Tate Gallery, London, 1994.
'Ruisdael': A. G. H. Bachrach, 'Turner, Ruisdael and the Dutch', *Turner Studies*, vol. 1, no. 1, summer 1981, pp. 19–30.

Bailey
Life: Anthony Bailey, *Standing in the Sun: A Life of J. M. W. Turner*, London, 1997.

Baretti
Guide: Joseph Baretti, *A Guide through the Royal Academy*, London, n.d. but thought to be 1781.

Barry
Works: James Barry and William Burke, *The Works of James Barry*, 2 vols, London, 1809.

Beckett
Constable: R. B. Beckett (ed.), *John Constable's Correspondence*, 6 vols, Ipswich, 1964.

Bell and Girtin
Cozens: C. F. Bell and Thomas Girtin, 'The Drawings and Sketches of John Robert Cozens: A Catalogue with an Historical Introduction', *Annual Volume of the Walpole Society*, vol. 23, 1935, pp. iii-v, vii, ix-xi, 1–25, 27–81, 83–7.

Bindman
Guillotine: David Bindman, *In the Shadow of the Guillotine*, exh. cat., British Museum, London, 1989.

Bloom

Piozzi: Edward A. Bloom and Lillian D. Bloom, *The Correspondence of Hester Lynch Piozzi, 1784–1821*, vol. 4, Newark, NJ, 1996.

B.I. Minutes

British Institution Minutes of meetings held between 30 May 1805 and 13 July 1870, 7 vols, National Art Library, London.

Blunt

Poussin: Anthony Blunt, *The Paintings of Nicolas Poussin: A Critical Catalogue*, London, 1966.

B.L.

Add. MS 46,151 series: J. M. W. Turner's perspective lecture manuscripts in the British Library Manuscripts Division, London.

Bolton

Soane: Arthur T. Bolton, *The Portrait of Sir John Soane, RA*, London, 1927.

Bower

Papers: Peter Bower, *Turner's Papers: A Study of the Manufacture, Selection and Use of his Drawing Papers, 1787–1820*, exh. cat., Tate Gallery, London, 1990.

Bray

Stothard: Mrs [Anna Eliza] Bray, *The Life of Thomas Stothard, RA*, London, 1851.

Brazell

Weather: J. H. Brazell, *London Weather*, London, 1968.

Bretherton

Margate: F. F. Bretherton, *The Origin and Progress of Methodism in Margate*, Margate, 1908.

Britton

Fine Arts: John Britton, *The Fine Arts of the English School*, London, 1812.

Wiltshire: John Britton, *The Beauties of Wiltshire*, 3 vols, London, 1801.

Brooks

'Fuller': Julian Brooks, 'Letter to the Editor', *Turner Studies*, vol. 10, no. 2, winter 1990, p. 54.

Brown

Alps: David Blayney Brown, *Turner in the Alps*, exh. cat., Fondation Pierre Gianadda, Martigny, and Tate Gallery, London, 1998.

Callcott: David Blayney Brown: *Augustus Wall Callcott*, exh. cat., Tate Gallery, London, 1981.

Brunston

Angerstein: John Brunston, *John Julius Angerstein at Woodlands*, exh. cat., Woodlands Art Gallery, London, 1974.

Buchanan

Memoirs: William Buchanan, *Memoirs of Painting*, 2 vols, London, 1824.

Butlin

'Sale': Martin Butlin, 'A Hitherto Unnoticed Sale from the Collection of Sir John Leicester', *Turner Studies* vol. 11, no. 1, summer 1991, pp. 30–31.

Carey

Memoirs: William Carey, *Some Memoirs of the Patronage and Progress of the Fine Arts in England and Ireland during the Reigns of George II, George III and George IV*, London, 1826.

'Relic': C. W. Carey, 'Discovery of a New Turner Relic', *Connoisseur*, vol. 65, February 1923, pp. 79–82.

Chapel

'Gillot': Jeannie Chapel, 'The Turner Collector: Joseph Gillot, 1799–1872', *Turner Studies*, vol. 6, no. 2, winter 1986, pp. 43–50.

Chignell

Turner: Robert Chignell, *J. M. W. Turner RA*, London, 1902.

Chubb

'Minerva Medica': William Chubb, 'Minerva Medica and the Tall Tree', *Turner Studies*, vol. 1, no. 2, winter 1981, pp. 26–35.

Clarke and Penny

Knight: Michael Clarke and Nicholas Penny, *The Arrogant Connoisseur: Richard Payne Knight, 1751–1824*, exh. cat., Whitworth Art Gallery, Manchester, 1982.

Connor

Rooker: Patrick Connor, *Michael Angelo Rooker 1746–1801*, London, 1984.

Constable

Wilson: W. G. Constable, *Richard Wilson*, London, 1953.

Cook and Kirk

Tamar: Diana Cook and Dorothy Kirk, *Turner in the Tamar Valley*, Gunnislake, 2009.

Copley

Vindication: John Singleton Copley the Younger, *A Concise Vindication of the Conduct of the Five Suspended Members of the Council of the Royal Academy*, 2nd edn, London, 1804.

Costello

'Cross-fire': Leo Costello, 'This Cross-fire of Colours: J. M. W. Turner and the Varnishing Days Reconsidered', *British Art Journal*, vol. 10, no. 3, winter–spring 2009/10, pp. 56–68.

'Sublime': Leo Costello, 'Confronting the Sublime', in Ian Warrell (ed), *J. M. W. Turner*, exh. cat., National Gallery of Art, Washington, DC, Dallas Museum of Art and Metropolitan Museum of Art, New York, 2007–8, London, 2007, pp. 39–55.

Council Minutes

Minutes of the Royal Academy Council meetings, Royal Academy of Arts Archive, London.

Cumming

'Sale': Robert Cumming, 'The Greatest Studio Sale That Christie's Never Held', *Turner Studies*, vol. 6, no. 2, winter 1986, pp. 3–8.

Cunningham

'Memoir': Memoir by Peter Cunningham in John Burnet, *Turner and his Works*, London, 1852 and 1859, 1–32.

Wilkie: Allan Cunningham, *The Life of Sir David Wilkie*, 3 vols, London, 1843.

Dale

Wyatt: Antony Dale, *James Wyatt*, Oxford, 1956.

Darley

Soane: Gillian Darley, *John Soane: An Accidental Romantic*, New Haven and London, 1999.

Davies

Perspective: Maurice Davies, *Turner as Professor: The Artist and Linear Perspective*, exh. cat., The Tate Gallery, London, 1992.

Thesis: 'J. M. W. Turner's Approach to Perspective in his Royal Academy Lectures of 1811', Ph.D thesis, Courtauld Institute of Art, University of London, 1994.

Dayes

Works: Edward Dayes, *The Works of the Late Edward Dayes*, ed. E. W. Brayley, London, 1805.

D'Oench

Smith: Ellen G. D'Oench, '*Copper into Gold*': *Prints by John Raphael Smith 1751–1812*, London and New Haven, 1999.

Dorey

Friendship: Helen Dorey, *John Soane and J. M. W. Turner: Illuminating a Friendship*, exh. cat., Sir John Soane's Museum, London, 2007.

Eastlake

Contributions: Sir Charles Lock Eastlake, *Contributions to the Literature of the Fine Arts* (second series), London, 1870.

Journals: Charles Eastlake Smith (ed.), *Journals and Correspondence of Lady Eastlake*, London, 1895.

Edmunds

'Picture Note': Martha Mel Edmunds, 'Picture Note', *Turner Studies*, vol. 4, no. 2, winter 1984, pp. 59–60.

Elwin

Haydon: Malcolm Elwin (ed.), *The Autobiography and Journals of Benjamin Robert Haydon*, London, 1950.

Falk

Hidden Life: Bernard Falk, *Turner the Painter: His Hidden Life*, London, 1938.

Farington:

Diary: Joseph Farington RA, *Diary*, 17 vols, London and New Haven, 1978–98.

Reynolds: Joseph Farington RA, *Memoirs of the Life of Sir Joshua Reynolds*, London, 1819.

Fawkes

Speech: Walter Fawkes, *Speech of Walter Fawkes Esq, Late Representative in Parliament for the County of York; on the Subject of Parliamentary Reform, delivered at the Anniversary Celebration of the Election of Sir Francis Burdett, Bart. at the Crown and Anchor Tavern, May 23rd 1812*, York, 1812.

Finberg

Drawings: A. J. Finberg, *Turner's Sketches and Drawings*, London, 1910.

Farnley: A. J. Finberg, *Turner's Water-Colours at Farnley Hall*, London, n.d. [1912].

'Gallery': Hilda F. Finberg, 'Turner's Gallery in 1810', *Burlington Magazine*, December 1951, pp. 383–7.

Inventory: A. J. Finberg, *A Complete Inventory of the Drawings of the Turner Bequest*, 2 vols, London, 1909.

'Isle of Wight': A. J. Finberg, 'Turner's "Isle of Wight" Sketchbook', *Annual Volume of the Walpole Society*, vol. 1, London, 1912, pp. 85–91.

Liber: A. J. Finberg, *The History of Turner's 'Liber Studiorum', with a Catalogue Raisonné*, London, 1924.

Life: A. J. Finberg, *The Life of J. M. W. Turner, R.A.*, 2nd edn, London, 1961.

Print Room: A. J. Finberg, 'Some So-Called Turners in the Print Room', *Burlington Magazine*, June 1906, pp. 191–3, 195.

South Wales: A. J. Finberg, 'Some Leaves from Turner's "South Wales" Sketch-book', *Annual Volume of the Walpole Society*, vol. 3, 1914, pp. 89–97.

Southern Coast: A. J. Finberg, *An Introduction to Turner's 'Southern Coast'*, London, 1927.

'1797': Hilda F. Finberg, 'With Mr Turner in 1797', *Burlington Magazine*, February 1957, pp. 48–9, 51.

Fletcher

Conversations: Ernest Fletcher (ed.), *Conversations of James Northcote, R.A. with James Ward*, London, 1901.

Ford

Wilson: Brinsley Ford, *The Drawings of Richard Wilson*, London, 1951.

Forrester

Liber: Gillian Forrester, *Turner's 'Drawing Book', The Liber Studiorum*, exh. cat., Tate Gallery, London, 1996.

Foss

Double: Kenelm Foss, *The Double Life of J. M. W. Turner*, London, 1938.

French

St Luke's: C. N. French, *The Story of St Luke's Hospital*, London, 1951.

Gage

Colour: John Gage, *Colour in Turner: Poetry and Truth*, London, 1969.

Correspondence: John Gage (ed.), *Collected Correspondence of J. M. W. Turner*, Oxford, 1980.

'Dolbadarn': John Gage, 'Turner's Dolbadarn Castle: Sublimity and Mystery', in Paul Joyner (ed.), *Dolbadarn: Studies on a Theme*, exh. cat., National Library of Wales, Aberystwyth, 1990, pp. 39–52.

Further Correspondence: John Gage, 'Further Correspondence of J. M. W. Turner', *Turner Studies*, vol. 6, no. 1, summer 1983, pp. 2–9.

Paris: John Gage, contributor to *J. M. W. Turner*, exh. cat., Grand Palais, Paris, 1983.

'Picturesque': John Gage, 'Turner and the Picturesque', *Burlington Magazine*: Part I, January 1965, pp. 16–25; and Part II, February 1965, pp. 75–82.

Range: John Gage, *J. M. W. Turner: 'A Wonderful Range of Mind'*, London and New Haven, 1987.

'Stourhead': John Gage, 'Turner and Stourhead: The Making of a Classicist', *Art Quarterly*, vol. 37, 1974, pp. 59–87.

Garlick

Portraits: Kenneth Garlick, 'Lawrence's Portraits of the Locks, the Angersteins and the Boucherettes', *Burlington Magazine*, December 1968, pp. 669–85.

Gemmett

'1807 sale': Robert J. Gemmett, '"The old palace of tertian fevers", The Fonthill sale of 1807', *Journal of the History of Collections*, vol. 22, no. 2, 2010, pp. 223–34.

General Assembly Minutes

Minutes of the Royal Academy General Assembly meetings, Royal Academy of Arts Archive, London.

Gilpin

Observations: The Revd William Gilpin, *Observations relative chiefly to Picturesque Beauty made in the year 1772 on several parts of England, particularly the Mountains and Lakes of Cumberland, and Westmoreland*, 2 vols, London, 1786.

Prints: The Revd William Gilpin, *An Essay on Prints*, London, 1768.

Girtin and Loshak

Tom Girtin and David Loshak, *The Art of Thomas Girtin*, London, 1954.

Golt

'Shadows': Jean Golt, 'Sarah Danby: Out of the Shadows', *Turner Studies*, vol. 9, no. 2, winter 1989, pp. 3–10.

'Picture Note': Jean Golt, 'Picture Note', *Turner Studies*, vol. 5, no. 2, winter 1985, p. 53.

Gould

Trophy: Cecil Gould, *Trophy of Conquest*, London, 1965.

Granville

Correspondence: Castalia, Countess Granville (ed.), *The Private Correspondence of Granville Leveson-Gower, the First Earl Granville, 1781–1821*, 2 vols, London, 1916.

Green

Diary: Thomas Green, *Diary of a Lover of Literature*, Ipswich, 1810.

Gronow

Reminiscences: R. H. Gronow, *The Reminiscences and Recollections of Captain Gronow*, 2 vols, London, 1889.

Hall

'Tabley': Douglas Hall, 'The Tabley House Papers', *Annual Volume of the Walpole Society 1960–62*, vol. 38, 1962, pp. 59–132.

Hamerton

Life: Philip Gilbert Hamerton, *The Life of J. M. W. Turner, R.A.*, London, 1879.

Hamilton

Italy: James Hamilton, *Turner & Italy*, exh. cat., National Gallery of Scotland, Edinburgh, 2009.
Life: James Hamilton, *Turner: A Life*, London, 1997.
Scientists: James Hamilton, *Turner and the Scientists*, exh. cat., Tate Gallery, London, 1998.
'Volcanoes': James Hamilton, 'The Lure of Volcanoes', *History Today*, no. 60, July 2010, pp. 34–41.

Hamlyn

'Early Sketchbook': Robin Hamlyn, 'An Early Sketchbook by J. M. W. Turner', *Record of the Art Museum, Princeton University*, vol. 44, no. 2, 1985, pp. 2–31.

Hammond

'Connections': Celia Hammond, 'J. M. W. Turner – Connections with Brentford', *Brentford and Chiswick Local History Journal*, no. 19, 2010, pp. 8–12.

Hanley and Holland

'Banknotes': Howard J. M. Hanley and Paul M. Holland, 'Turner's Banknotes and the West Country Tour of 1811', *Turner Society News*, no. 76, August 1997, pp. 14–16.

Harrison

Oxford: Colin Harrison, *Turner's Oxford*, exh. cat., Ashmolean Museum, Oxford, 2000.

Helmer

'Sandycombe': Madeleine Helmer, 'J. M. W. Turner's Sandycombe Lodge and the "House designed for an Artist": An Architectural Precedent Discovered', *Sir John Soane's Museum Newsletter*, no. 28, autumn 2011, p. 10.

Herrmann

Ashmolean: Luke Herrmann, *Ruskin and Turner*, London, 1968.
'Landseer': Luke Herrmann, 'John Landseer on Turner: Reviews of Exhibits in 1808, 1839 and 1840 (Part I)', *Turner Studies*, vol. 7, no. 1, summer 1987, pp. 26–33.

Hill

Alps: David Hill, *Turner in the Alps*, London, 1992.
Aosta: David Hill, *Turner, Le Mont Blanc et la Vallée d'Aoste*, exh. cat., Aosta, 2000.
Birds: David Hill, *Turner's Birds*, Oxford, 1988.
Footsteps: David Hill, *In Turner's Footsteps*, London, 1984.
Girtin: David Hill, *Thomas Girtin – Genius in the North*, exh. cat., Harewood House, Leeds, 1999.
North: David Hill, *Turner in the North*, New Haven and London, 1997.
'Taste': David Hill, '"A Taste for the Arts": Turner and the Patronage of Edward Lascelles of Harewood House', *Turner Studies*, vol. 4, no. 2, winter 1984, pp. 24–33; and vol. 5, no. 1, summer 1985, pp. 30–46.
Thames: David Hill, *Turner on the Thames*, London and New Haven, 1993.
Yorkshire: David Hill, *Turner in Yorkshire*, exh. cat., York City Art Gallery, York, 1980.

Hilles

Reynolds: F. W. Hilles, *The Literary Career of Sir Joshua Reynolds*, London, 1936.

Hipple

'Discourses': Walter J. Hipple, Jr, 'General and Particular in the Discourses of Sir Joshua Reynolds', *Journal of Aesthetics and Art Criticism*, vol. 11, no. 3, March 1953, pp. 231–47.

Hoare

Diaries: Sir Richard Colt Hoare diaries in the Wiltshire and Swindon History Centre, Chippenham, Wilts.
Wiltshire: Sir Richard Colt Hoare, *A History of Modern Wiltshire*, 6 vols, London, 1822–43.

Holme

Genius: Charles Holme (ed.), *The Genius of J. M. W. Turner, R.A.*, London, 1903.

Hudson

Reynolds: Derek Hudson, *Sir Joshua Reynolds: A Personal Study*, London, 1958.

Hutchison

Sidney C. Hutchison, *The History of the Royal Academy, 1786–1986*, 2nd edn, London, 1986.

Imms

'Fire': Matthew Imms, 'The 1841 Tower of London Fire and Other New Turner Bequest Subjects', *Turner Society News*, no. 122, autumn 2014, pp. 8–9.
'Foundations': Matthew Imms, 'Foundations 1790–1802', in Ian Warrell (ed.), *J. M. W. Turner*, exh. cat., National Gallery of Art, Washington, DC, Dallas Museum of Art and Metropolitan Museum of Art, New York, 2007–8, London, 2007, pp. 25–38.

Irwin and Wilton

Scotland: Francina Irwin and Andrew Wilton, *Turner in Scotland*, exh. cat., Aberdeen Art Gallery, Aberdeen, 1982.

Jefferiss

Monro Academy: F. J. G. Jefferiss, *Dr Thomas Monro and the Monro Academy*, exh. cat., Victoria and Albert Museum, London, 1976.
Typescript: F. J. G. Jefferiss, 'Biography of Dr Thomas Monro', undated and unpaginated, National Art Library, London.

Joppien

Loutherbourg: Rüdiger Joppien, *Philippe Jacques de Loutherbourg*, exh. cat., Kenwood, the Iveagh Bequest, London, 1973.

Kelly

'America': Franklin Kelly: 'Turner in America', in Ian Warrell (ed.), *J. M. W. Turner*, exh. cat., National Gallery of Art, Washington, DC, Dallas Museum of Art and Metropolitan Museum of Art, New York, 2007–8, London, 2007, pp. 231–46.

Kitson

Claude: Michael Kitson, 'Turner and Claude', *Turner Studies*, vol. 2, no. 2, winter 1983, pp. 2–15.
Rembrandt: Michael Kitson, 'Turner and Rembrandt', *Turner Studies*, vol. 8, no. 1, summer 1988, pp. 2–19.

Krause

Indianapolis: Martin F. Krause, *Turner in Indianapolis*, Indianapolis, 1997.

Landseer

1808 Review: John Landseer, *The Review of Publications of Art*, no. II, London, 1808, reprinted in Luke Herrmann, 'John Landseer on Turner: Reviews of Exhibits in 1808, 1839 and 1840 (Part I)', *Turner Studies*, vol. 7, no. 1, summer 1987, pp. 26–33.

Lefeuvre

Loutherbourg: Olivier Lefeuvre, *Philippe-Jacques de Loutherborg 1740–1812*, Paris, 2013.

Leslie

Recollections: C. R. Leslie, *Autobiographical Recollections*, ed. Thomas Taylor, 2 vols, London, 1860.

Levey

Michael Levey, *Sir Thomas Lawrence*, London and New Haven, 2005.

Lewis
Miss Berry: Lady Theresa Lewis (ed.), *Extracts of the Journals and Correspondence of Miss Berry from the year 1783 to 1852*, 3 vols, London, 1865.

Lindsay
Life: Jack Lindsay, *J. M. W. Turner, His Life and Work*, London, 1966.

Lloyd
'Memoir': 'M. L.' [Mary Lloyd], 'A Memoir of J. M. W. Turner, RA', *Sunny Memories*, London, 1880, reprinted in *Turner Studies*, vol. 4, no. 1, summer 1984, pp. 22–3.

Lord
De Wint: John Lord (ed.), *Peter De Wint 1784–1849: 'For the Common Observer of Life and Nature'*, exh. cat., The Collection, Lincoln, 2007, Aldershot, 2007.

Loukes
Sussex: Andrew Loukes, *Turner's Sussex*, exh. cat., Petworth House, Petworth, 2013.

Lyles
Young Turner: Anne Lyles, *Young Turner: Early Work to 1800*, exh. cat, Tate Gallery, London, 1989.

Macdonald
'Effects': Simon Macdonald, 'To "shew virtue its own image": William Hodges's *The Effects of Peace* and *The Consequences of War*, 1794–1795', *British Art Journal*, vol. 9, spring 2008, pp. 57–66.

Macdonald and Shanes
'Ossian's "The Traveller"': Murdo Macdonald and Eric Shanes, 'Turner and Ossian's "The Traveller"', *Turner Society News* no. 120, autumn 2013, pp. 4–7.

McIntyre
Reynolds: Ian McIntyre, *Joshua Reynolds: The Life and Times of the First President of the Royal Academy*, London, 2003.

Mackay
'Llandeilo': Christine Mackay, 'Turner's 'Llandeilo Bridge and Dynevor Castle', *Burlington Magazine,* June 1998, pp. 383–6.

Macpherson
Ossian: James Macpherson, *The Poems of Ossian*, 2 vols, Edinburgh, 1797.

Mannings and Postle
Reynolds: David Mannings and Martin Postle, *Sir Joshua Reynolds: A Complete Catalogue of his Paintings* (with the subject pictures catalogued by Martin Postle), 2 vols, London and New Haven, 2000.

Marks
'Rivalry': Arthur S. Marks, 'Rivalry at the Royal Academy: Wilkie, Turner and Bird', *Studies in Romanticism*, vol. 20, 1981, pp. 333–62.

Marshall
'J. M. W. Marshall': Tim Marshall, unpublished manuscript essay, 'J. M. W. Marshall – Brentford and Before', in the London Borough of Hounslow Archive held at Chiswick Public Library, London.

Milhous
'Pantheon': Judith Milhous, 'Painters and Paint at the Pantheon Opera House, 1790–92', *Theatre Research International*, vol. 24, no. 1, 1999, pp. 54–70.

Miller
'Turnips': Michele L. Miller, 'J. M. W. Turner's *Ploughing Up Turnips, near Slough*: The Cultivation of Cultural Dissent', *Art Bulletin*, vol. 77, no. 4, December 1995, pp. 573–83.
Sixty Years: Thomas Miller (ed.), *Turner and Girtin's Picturesque Views Sixty Years Since*, London, 1854.

Milner
Merseyside: Frank Milner, *Turner Paintings in Merseyside Collections*, Liverpool, 1990.

Morris
'Wyatt': Susan Morris, '"Two Perspective Views": Turner and Lewis William Wyatt', *Turner Studies*, vol. 2, no. 2, winter 1983, pp. 34–6.

Murdoch
Line: John Murdoch, 'Architecture and Experience: The Visitor and the Spaces of Somerset House, 1780–1796', in David Solkin (ed.), *Art on the Line: The Royal Academy Exhibitions at Somerset House 1780–1836*, New Haven and London, 2001.

Nicholson
'Appulia': Kathleen Nicholson, 'Turner's "Appulia in Search of Appulus" and the dialectics of landscape tradition', *Burlington Magazine*, October 1980, pp. 679–84.

Northcote
Reynolds: James Northcote, *The Life of Sir Joshua Reynolds*, 2 vols, London, 1818.

Nugent and Croal
Manchester: Charles Nugent and Melva Croal, *Turner Watercolours from Manchester*, exh. cat., Memphis, Tenn., Indianapolis, Omaha, Manchester (UK), 1997–8, Washington, DC, 1997.

Opie
Lectures: John Opie, *Lectures on Painting delivered at the Royal Academy of Arts*, London, 1809.

Ostergard
Beckford: Derek E. Ostergard (ed.), *William Beckford, 1760–1844: An Eye for the Magnificent*, New Haven and London, 2001.

Owen and Brown
Beaumont: Felicity Owen and David Blayney Brown, *Collector of Genius: A Life of Sir George Beaumont*, London and New Haven, 1988.

Oxford Companion
Evelyn Joll, Martin Butlin and Luke Herrmann (eds), *The Oxford Companion to J. M. W. Turner*, Oxford, 2001.

Paley
Morton D. Paley, *The Apocalyptic Sublime*, New Haven and London, 1986.

Pasquin
Critical Guide: Anthony Pasquin [pseud. John Williams], *A Critical Guide to the Exhibition of the Royal Academy for 1796*, London, 1796.

Payne
Toil: Christiana Payne, *Toil and Plenty: Images of the Agricultural Landscape in England, 1780–1890*, exh. cat., Nottingham University Art Gallery, Yale Center for British Art, New Haven, 1993–4, New Haven and London, 1993.
Sea: Christiana Payne, *Where the Sea Meets the Land: Artists on the Coast in Nineteenth-Century Britain*, Bristol, 2007.
Rowlandson: Matthew and James Payne, *Regarding Thomas Rowlandson, 1757–1827*, London, 2010.

Piggott
'Lyric': Jan Piggott, 'A Lyric in Turner's *Spithead* Sketchbook Identified', *Turner Society News*, no. 74, December 1996, pp. 12–13.

Powell
'Knight': Nick Powell, 'Knight for a Day', *Turner Society News*, no. 111, March 2009, pp. 10–14.
'Travelling Companion': Cecilia Powell, 'Turner's Travelling Companion of 1802: A Mystery Resolved', *Turner Society News*, no. 54, February 1990, pp. 12–15.

'Women': Cecilia Powell, 'Turner's Women', *Turner Society News*, no. 62, December 1992, pp. 10–14.

Pressly

'Rigaud': William L. Pressly (ed.), 'Facts and Recollections of the XVIIIth Century in a Memoir of John Francis Rigaud Esq., RA, by Stephen Francis Dutilh Rigaud', *Annual Volume of the Walpole Society*, vol. 50, 1984, pp. 1–164.

Price

'Pantheon': Curtis Price, 'Turner at the Pantheon Opera House', *Turner Studies*, vol. 7, no. 2, summer 1987, pp. 2–8.

Pye

MS: John Pye, *A [manuscript] collection of his correspondence and papers relating to Turner etc.*, National Art Library, Victoria and Albert Museum, London.

Pye-Roget

Liber: John Pye and J. L. Roget, *Notes and Memoranda respecting the 'Liber Studiorum' of J. M. W. Turner, R.A.*, London, 1879.

Raimbach

Memoirs: M. T. S. Raimbach (ed.), *Memoirs and Recollections of the Late Abraham Raimbach, Esq*, London, 1843.

Rawlinson

Engraved Work: W. G. Rawlinson, *The Engraved Work of J. M. W. Turner, R.A.*, 2 vols, London, 1908 and 1913.

Liber: W. G. Rawlinson, *Turner's 'Liber Studiorum': A Description and a Catalogue*, 2nd edn, London, 1906.

Redding

Beckford: Cyrus Redding, *Memoirs of William Beckford of Fonthill*, 2 vols, London, 1859.

Celebrities: Cyrus Redding, *Past Celebrities Whom I have Known*, 2 vols, London, 1866.

'Obituary': Cyrus Redding, 'The Late Joseph Mallord William Turner', *Fraser's Magazine for Town and Country*, vol. 45, February 1852, pp. 150–56.

Recollections: Cyrus Redding, *Fifty Years' Recollections, Literary and Personal, with Observations on Men and Things*, 3 vols, London, 1858.

Redgrave

Century: Richard and Samuel Redgrave, *A Century of Painters*, 2 vols, London, 1866.

Reeve

'Obituary': Lovell Reeve, 'Obituary Memoir of Turner', *Literary Gazette*, 27 December 1851, pp. 923–4; and 3 January 1852, pp. 19–21.

Reynolds

Constable: Graham Reynolds, *The Early Paintings of John Constable*, 2 vols, London and New Haven, 1996.

Discourses: Sir Joshua Reynolds, *Discourses on Art*, ed. Robert R. Wark, New Haven and London, 1975.

Literary: Sir Joshua Reynolds, *The Literary Works of the Late Sir Joshua Reynolds*, ed. Edward Malone, 2 vols, London, 1797.

Works: Sir Joshua Reynolds, *Works*, ed. Edward Malone, 3 vols, London, 1809.

Robinson

Diary: Henry Crabb Robinson, *Diary, Reminiscences and Correspondence*, ed. Thomas Sadler, 3 vols, London, 1869.

van de Velde: Michael S. Robinson, *A Catalogue of the Paintings of the Elder and the Younger Willem van de Velde*, 2 vols, London, 1990.

Roethlisberger

Claude: Marcel Roethlisberger, *Claude Lorrain: The Paintings*, 2 vols, London, 1961.

Roget

OWCS: John Lewis Roget, *A History of the Old Water-Colour Society*, 2 vols, London, 1891.

Rowell

'Egremont': Christopher Rowell, 'The 2nd Earl of Egremont and Egremont House', *Apollo*, April 1998, pp. 15–21.

Rowell, Warrell and Brown

Petworth: Christopher Rowell, Ian Warrell and David Blayney Brown, *Turner at Petworth*, exh. cat., Petworth House, 2002, London, 2002.

Royal Academy

'Critiques': Album of newspaper reviews and cuttings, Royal Academy of Arts Archives, London.

Ruskin

Works: E. T. Cook and A. Wedderburn (eds.), *The Works of John Ruskin*, 39 vols, London, 1903–12.

Russett

Serres: Alan Russett, *John Thomas Serres, 1759–1825*, Lymington, 2010.

St Clair

Elgin: William St Clair, *Lord Elgin and the Marbles*, 3rd edn, Oxford, 1998.

Sandby

Royal Academy: William Sandby, *The History of the Royal Academy*, 2 vols, London, 1862.

Shanes

'British Institution': Eric Shanes, 'Turner at the British Institution in 1806: A Canvas United In A World Divided', *Apollo*, October 1999, pp. 30–36.

'Chamonix': Eric Shanes, 'Identifying Turner's Chamonix Water-colours', *Burlington Magazine*, November 2000, pp. 687–94.

'Dissent': Eric Shanes, 'Dissent in Somerset House: Opposition to the Political *Status-quo* within the Royal Academy around 1800', *Turner Studies*, vol. 10, no. 2, winter 1990, pp. 40–46.

England: Eric Shanes, *Turner's England*, London, 1990.

England and Wales: Eric Shanes, *Turner's Picturesque Views in England and Wales, 1825–1838*, London, 1979.

Explorations: Eric Shanes, *Turner's Watercolour Explorations 1810–1842*, exh. cat., Tate Gallery, London, 1997.

Great: Eric Shanes (ed.), *Turner: The Great Watercolours*, exh. cat., Royal Academy of Arts, London, 2000.

Human Landscape: Eric Shanes, *Turner's Human Landscape*, London, 1990.

Liber: Eric Shanes, 'Oils based on *Liber Studiorum*', in E. Joll, M. Butlin and L. Herrmann (eds), *The Oxford Companion to J. M. W. Turner*, Oxford, 2001.

Life and Masterworks: Eric Shanes, *The Life and Masterworks of J. M. W. Turner*, New York, 2008.

'More Art': Eric Shanes, 'More Art on the Line: The 1792 Initial Royal Academy Antique Room Exhibition', *Burlington Magazine*, April 2008, pp. 224–31.

'Nelson': Eric Shanes, 'Lord Nelson, may I introduce Mr Turner the Academician?', *Turner Society News*, no. 124, Autumn 2015, pp. 4–9.

Rivers: Eric Shanes, *Turner's Rivers, Harbours and Coasts*, London, 1981.

'Scale Practice': Eric Shanes, 'Turner and the 'Scale Practice' in British Watercolour Art', *Apollo*, November 1997, pp. 45–51; and editorial correction, *Apollo*, December 1997, p. 69.

Turner Masterworks: Eric Shanes, *Turner: The Life and Masterworks*, New York, 2004.

Shee

Elements: Martin Archer Shee, *Elements of Art: A Poem in Six Cantos*, London, 1809.

Smiles

'Additional': Sam Smiles, 'Turner in Devon: Some Additional Information Concerning his Visits in the 1810s', *Turner Studies*, vol. 7, no. 1, summer 1987, pp. 11–14.

'Devonshire': Sam Smiles, 'The Devonshire Oil Sketches of 1813', *Turner Studies*, vol. 9, no. 1, summer 1989, pp. 10–26.

'Picture Notes': Sam Smiles, 'Picture Notes', *Turner Studies*, vol. 8, no. 1, summer 1988, pp. 53–7.

'Slave Trade': Sam Smiles, 'Turner and the Slave Trade: Speculation and Representation, 1805–40', *British Art Journal*, vol. 13, no. 3, winter 2007–8, pp. 47–54.

Smith

Catalogue: John Smith, *A Catalogue Raisonné of the Works of the Most Eminent Dutch, Flemish and French Painters*, 9 vols, London, 1829–42.

Girtin: Greg Smith, *Thomas Girtin: The Art of Watercolour*, exh. cat., Tate Britain, London, 2002.

Recollections: Thomas Smith, *Recollections of the British Institution for promoting the fine arts in the United Kingdom*, London, 1860.

Supplement: John Smith, *Supplement to the Catalogue Raisonné of the Works of the Most Eminent Dutch, Flemish and French Painters*, London, 1842.

Soane

Soane: John Soane, notebooks, journals, minutes and letters, Sir John Soane's Museum Archives, London.

Mrs Soane: Elizabeth Soane, notebooks, Sir John Soane's Museum Archives, London.

Solkin

Line: David Solkin (ed.), *Art on the Line: The Royal Academy Exhibitions at Somerset House 1780–1836*, New Haven and London, 2001.

Masters: David Solkin (ed.), *Turner and the Masters*, exh. cat., Tate Britain, London, 2009.

Wilson: David Solkin, *Richard Wilson*, exh. cat., Tate Gallery, London, 1982.

Solly

Cox: N. Neal Solly, *Memoir of the Life of David Cox*, London, 1873.

Sparrow

'Later Water-Colours': Walter Shaw Sparrow, 'Turner's Later Water-Colours', in C. Holme (ed.), *The Genius of J. M. W. Turner, R.A.*, London, 1903.

Stopford Brooke

Liber: The Revd Stopford Brooke, *Notes on the 'Liber Studiorum' of J. M. W. Turner R.A.*, London, 1885.

Sunderland and Solkin

'Spectacle': John Sunderland and David Solkin, 'Staging the Spectacle', in David Solkin (ed.), *Art on the Line: The Royal Academy Exhibitions at Somerset House 1780–1836*, New Haven and London, 2001, pp. 23–37.

Survey

St Anne: *Survey of London*, vol. XXXIII, *The Parish of St Anne, Soho*, London, 1966.

St Paul: *Survey of London*, vol. XXXVI, *The Parish of St Paul, Covent Garden*, London, 1970.

Thornbury

1862: Walter Thornbury, *The Life of J. M. W. Turner, R.A.*, 1st edn, 2 vols, London, 1862.

1877: Walter Thornbury, *The Life of J. M. W. Turner, R.A.*, 2nd edn, London, 1877.

Thompson

Journeys: M. W. Thompson (ed.), *The Journeys of Sir Richard Colt Hoare through Wales and England 1793–1810*, Gloucester, 1983.

Townsend

'Materials': Joyce H. Townsend, 'The Materials and Techniques of J. M. W. Turner: Primings and Supports', *Studies in Conservation*, no. 39, 1994, pp. 145–53.

Tromans

Wilkie: Nicholas Tromans, *David Wilkie: Painter of Everyday Life*, exh. cat., Dulwich Picture Gallery, London, 2002.

Uwins

Memoir: Mrs Sarah Uwins, *A Memoir of Thomas Uwins, RA*, 2 vols, London, 1858.

Venning

'Annotated Books': Barry Venning, 'Turner's Annotated Books: Opie's "Lectures on Painting" and Shee's "Elements of Art"', *Turner Studies*, vol. 2, no. 1, summer 1982, pp. 34–46; vol. 2, no. 2, winter 1982, pp. 40–49; and vol. 3, no. 1, summer 1983, pp. 33–44.

'Shipwrecks': Barry Venning, 'A Macabre Connoisseurship: Turner, Byron and the Apprehension of Shipwreck Subjects in Early Nineteenth-Century England', *Art History*, vol. 8, no. 3, September 1985, pp. 303–19.

Vine

P. A. L. Vine, *London's Lost Route to Midhurst: The Earl of Egremont's Navigation*, Stroud, 1995.

Vrettos

Elgin: Theodore Vrettos, *The Elgin Affair*, London, 1997.

Walker

'Portraits': R. J. B. Walker, 'The Portraits of J. M. W. Turner: A Check-List', *Turner Studies*, vol. 3, no. 1, summer 1983, pp. 21–32.

Warburton

Whitaker: Stanley Warburton, *Turner and Dr Whitaker*, exh. cat., Towneley Hall Art Gallery and Museum, Burnley, 1982.

Warrell

Brighton: Ian Warrell, contributor to *Brighton Revealed: Through Artists' Eyes c.1760–c.1960*, ed. David Beevers, exh. cat., Brighton, 1995.

'Checklist': Ian Warrell, 'A Checklist of Erotic Sketches in the Turner Bequest', *British Art Journal*, vol. 4, no. 1, spring 2003, pp. 15–46.

Wessex: Ian Warrell, *Turner's Wessex: Architecture and Ambition*, exh. cat., Salisbury and Wiltshire Museum, 2015, London, 2015.

Watkin

Soane: David Watkin, *Sir John Soane: Enlightenment Thought and the Royal Academy Lectures*, Cambridge, 1996.

Watts

'Sketch': Alaric Watts, 'Biographical Sketch of J. M. W. Turner, R.A.', in Leitch Ritchie, *Liber Fluvorium*, London, 1853, pp. vii-xlvii.

Webber

Orrock: Byron Webber, *James Orrock, R.I.*, London, 1903.

Wheatley

London: Henry B. Wheatley, *London Past and Present*, 2 vols, London, 1891.

Wheeler

Wells: J. M. Wheeler, *The Family and Friends of William Frederick Wells*, Cambridge, 1970.

Whitaker

Whalley: Thomas Dunham Whitaker, *An History of the Original Parish of Whalley and Honor of Clitheroe, in the Counties of Lancaster and York*, Blackburn, 1801.

Whitley

England 1800–1820: William T. Whitley, *Art in England 1800–1820*, Cambridge, 1928.

'Lecturer': W. T. Whitley, 'Turner as a Lecturer', *Burlington Magazine*, January 1913, pp. 202–8; and February 1913, pp. 255–9.

Whitman

Charles Turner: Alfred Whitman, *Charles Turner*, London, 1907.

Whittingham

Brentford to Oxford: Selby Whittingham, *Brentford to Oxford: J. M. W. Turner's early career under the guardianship of his uncle, J. M. W. Marshall*, London, 2010.

Geese: Selby Whittingham, *Of Geese, Mallards and Drakes: Some Notes on Turner's Family, IV – The Marshalls and the Harpurs*, London, 2 vols, 1999.

'Leicester': Selby Whittingham, 'A Most Liberal Patron: Sir John Fleming Leicester, Bart., 1st Baron de Tabley, 1762–1827', *Turner Studies*, vol. 6, no. 2, winter 1986, pp. 24–36.

'Maternal Cousins': Selby Whittingham, 'J. M. W. Turner's Maternal Cousins', *Journal of Kent History*, March 1998, pp. 11–13.

Tonbridge: Selby Whittingham, *J. M. W. Turner's Tonbridge & District*, 2nd edn, London, 2007.

Will: Selby Whittingham, *An Historical Account of the Will of J. M. W. Turner, R.A.*, 2nd edn, 2 vols, London, 1993–6.

Wilkinson

Sketches: Gerald Wilkinson, *The Sketches of Turner, R.A., 1802–20: genius of the Romantic*, London, 1974.

Wilton

BM: Andrew Wilton, *Turner in the British Museum*, exh. cat., British Museum, London, 1975.

'Bonneville': Andrew Wilton, 'Turner at Bonneville', in John Wilmerding (ed.), *Essays in Honor of Paul Mellon*, Washington, DC, 1986, pp. 402–27.

'Letter': Andrew Wilton, 'Turner as a Letter Writer', *Apollo*, January 1981, pp. 56–9.

Life: Andrew Wilton, *The Life and Work of J. M. W. Turner*, Fribourg and London, 1979.

'Monro School': Andrew Wilton, 'The "Monro School" Questions: Some Answers', *Turner Studies*, vol. 4, no. 2, winter 1984, pp. 8–23.

Sublime: Andrew Wilton, *Turner and the Sublime*, exh. cat., Art Gallery of Ontario, Toronto, Yale Center for British Art, New Haven, British Museum, London, 1980–81, London, 1980.

Time: Andrew Wilton, *Turner in his Time*, London, 1987.

Wales: Andrew Wilton, *Turner in Wales*, exh. cat, Llandudno, 1984.

Wilton and Turner

Poetry: Andrew Wilton and Rosalind Mallord Turner, *Painting and Poetry: Turner's 'Verse Book' and his Work of 1804–1812*, exh. cat., Tate Gallery, London, 1990.

Woodbridge

Stourhead: Kenneth Woodbridge, *Landscape and Antiquity: Aspects of English Culture at Stourhead 1718 to 1838*, Oxford, 1970.

Woodgate

Woodgates: The Revd Gordon Woodgate and Giles Musgrave Gordon Woodgate, *A History of the Woodgates of Stonwall Park and of Summerhill in Kent*, Wisbech, 1910.

Woollcombe

Diary: Henry Woollcombe, manuscript diary, Plymouth and West Devon Record Office, Plymouth.

Worlow

Knockholt: G. H. Worlow, *History of Knockholt*, Bromley, 1934.

Wyllie

Turner: W. L. Wyllie, *J. M. W. Turner*, London, 1905.

Wyndham

History: H. A. Wyndham, *A Family History 1688–1837: The Wyndhams of Somerset, Sussex and Wiltshire*, Oxford, 1950.

Yarde

Sarah Trimmer: Doris Yarde, *Sarah Trimmer of Brentford and her Children*, Heston (Hounslow and District History Society), 1970.

Yorke

France: Henry Redhead Yorke, *France in Eighteen Hundred and Three Described in a Series of Contemporary Letters*, London, 1906.

Young

Stafford: John Young, *A Catalogue of the Collection of Pictures of the Most Noble Marquess of Stafford at Cleveland House, London*, 2 vols, London, 1825.

Youngblood

'Oxford': Patrick Youngblood, 'The Stones of Oxford: Turner's Depictions of Oxonian Architecture 1787–1804 and After', *Turner Studies*, vol. 3, no. 2, winter 1983, pp. 3–21.

'Sandycombe': Patrick Youngblood, '"The Painter as Architect": Turner and Sandycombe Lodge', *Turner Studies*, vol. 2 no. 1, summer 1982, pp. 20–35.

Ziff

'Ancients': Jerrold Ziff, 'Turner, the Ancients and the Dignity of Art', *Turner Studies*, vol. 3, no. 2, winter 1983, pp. 45–52.

'Backgrounds': Jerrold Ziff, 'Backgrounds, Introduction of Architecture and Landscape: A Lecture by J. M. W. Turner', *Journal of the Warburg and Courtauld Institutes*, vol. 26, 1963, pp. 124–47.

'Poussin': Jerrold Ziff, 'Turner and Poussin', *Burlington Magazine*, July 1963, pp. 315–21.

'Proposed Studies': Jerrold Ziff, 'Proposed Studies for a Lost Turner Painting', *Burlington Magazine*, July 1964, pp. 328–33.

'Quotations': Jerrold Ziff, 'Turner's First Poetic Quotations: An Examination of Intentions', *Turner Studies*, vol. 2, no. 1, summer 1982, pp. 2–11.

'Writing': 'The Writing and Dating of Turner's First Perspective Lecture', unpublished essay, copy in the author's possession.

Acknowledgements

This book owes its existence to Dr Brian Allen, Director Emeritus of the Paul Mellon Centre for Studies in British Art. From the very first, he supported the project, and he never wavered in his commitment to it. Our discussions on the subject have been some of the most enjoyable and memorable of my life. The implicit vote of confidence he and his advisory board members have accorded me is on a scale granted to few biographers, and I can only hope that their decision to allocate vast funds to see the work into both print and electronic forms is fully vindicated. Certainly there are no words with which I could ever thank Brian sufficiently. And naturally I must also extend that gratitude to Brian's successor as Director of the Mellon, Professor Mark Hallett, who made his support of the project clear from the very outset.

Although I drafted a synopsis for this book in 1995, its actual seeds were laid over a lunch I had in August 2005 with Ian Warrell, who worked at that time for Tate Britain – indeed, we had originally planned to write the book together. However, because of professional commitments to the Tate, Ian had to drop out. Perhaps that was just as well, for although the book would undoubtedly have been better had he written half of it, our friendship has never been tested as a result. During the course of writing, Ian answered innumerable questions, selflessly pointed me to new material, discussed this aspect and that, provided new perspectives, and always proved himself a staunch supporter and ally. I cannot thank him enough.

I also owe an incalculable debt to the late Dr John Gage. Our friendship, which began in 1962 when he was a graduate student working on Turner at the Courtauld Institute of Art and I was a scruffy art student attending the Regent Street Polytechnic School of Art, lasted a few months short of fifty years, and it only ended with his untimely death in 2012. Without doubt he was the greatest friend I ever had within the art world, and I also consider him to have been my intellectual mentor. His superb writings on Turner laid the groundwork for all my activities as a Turnerian (as they have done for many others), and his enthusiasm for this book greatly sustained me through thick and thin. Throughout his final illness he was extremely avid to see what I had written, and I am immensely thankful that he lived long enough to read all but the last two chapters of the long version in draft. Naturally, he made many helpful suggestions, the majority of which I have taken on board. All errors are mine, and mine alone.

With the exception of two art historians who flatly refused to help me in any way whatsoever, I have met with the most incredibly supportive responses from all kinds of people during the course of writing this book. When they learned of the scope of my project, they went out of their way to assist me. Outstanding among them is Dr Richard Stephens, whom I have never met but who initially tipped me off about Turner's insurance records. He later informed me that during the 1990s, when working on his doctorate on Francis Towne, he had repeatedly come across Turner's name in Bank of England stock ledgers, and that consequently I ought to check them out. Even the Bank of England Archive was surprised to discover that Turner had owned stock, but after quickly exploring the books

for 1810 in order to determine if that was indeed the case, the archivists showed me where to begin searching. As a consequence, we are now able to form a precise idea of the painter's finances for the very first time.

I must thank Her Majesty the Queen for her gracious permission to examine the Farington Diaries in the Royal Library at Windsor Castle. Also to be thanked are the Librarian, Lady Jane Roberts, and the Archivist, Bridget Wright, both for facilitating that access and for supplying me with study photographs of the diagrams from the diary that were not reproduced in its published version.

I can never sufficiently thank Julia Beaumont-Jones and Christine Kurpiel of the Study Room, Tate Britain, or Mark Pomeroy, Nick Savage and Andrew Potter of the Royal Academy of Arts Archive and Library. Their labours on my behalf have been quite extraordinary. Nothing has ever been too much trouble. Mark was especially assiduous on my behalf, and even occasionally cut into his invaluable vacation time to answer my queries. I am perpetually in his debt.

Dr David Blayney Brown of Tate Britain, and Professor Nigel Llewellyn, Head of Research at Tate Britain, must be thanked for allowing me access to the revised catalogue of the Turner Bequest while it was still in the process of gestation, and for patiently ironing out all the moral and legal issues involved. Matthew Imms, also of Tate Britain, pointed me towards much invaluable material he unearthed and drew my attention to a great many sketchbook drawings, the topographical subjects of which he was able to identify with great diligence and ingenuity.

Others whom I must thank are Mrs Rosalind Turner for all her invaluable help, despite often finding herself in the most trying of circumstances; Dr Jan Piggott for reading the manuscript and for making a great many helpful suggestions (as well as for catching lots of typing and other errors); Susan Palmer, the Archivist of the Sir John Soane Museum, London, for facilitating my access to the Soane Archive and for answering innumerable queries with unceasing good humour and patience; one of my oldest friends, Jonathan Cree, MD, MA, the Chair and Residency Director of Idaho State University Department of Family Medicine, for patiently and most helpfully answering all my questions concerning Turner's apparent interest in a sexually transmitted disease in 1811-12; Frances Butlin, for loaning me all her transcripts of reviews of Royal Academy and British Institution exhibitions involving Turner; Fiona Trier for freely giving of her time to research on my behalf for a period in the British Library Newspaper Division at Colindale; and the late Henry Wemyss of Sotheby's, who was an exceptionally fervent supporter of this project. He helped in every way possible, and I will always remain deeply grateful for his encouragement. He is sorely missed.

Others to whom I shall remain eternally grateful are Dr Maurice Davies for the extended loan of his doctoral thesis on Turner's 1811 perspective lectures; Hattie Drummond of Christie's; Emmeline Hallmark of Sotheby's; James Hamilton, who, although a previous biographer of Turner himself, went out of his way to supply me with material, thus saving me the trouble of having to duplicate labour unnecessarily; and Emma Floyd, Kasha Jenkinson, Maisoon Rehani and all the other wonderful staff at the Paul Mellon Centre for Studies in British Art.

I am particularly indebted to Lorna Williams and Ben White of the Bank of England Archive for their unstinting patience and help in assisting me through the intricacies of the stock indices and ledgers, and especially for helping me track down one listing that had been inadvertantly placed in the wrong volume; Professor Sam Smiles for his endless help with West Country material, on which he remains the leading authority; Susan Bennett, the Honorary Secretary of the William Shipley Group for Royal Society of Arts History, for supplying much of the biographical data that appears in the section of the book dealing with John Henderson, on whom she is the foremost authority; Paul Spencer-Longhurst for his help with various queries relating to paintings by Richard Wilson; Brad Feltham, Brenda Evans and Jacki Gosling of the Artists' General Benevolent Institution for help with their archival material; the two anonymous Mellon Centre readers who approved the first two-and-a-half chapters of the book that were necessary to get the project initially off the ground in 2006; and Sheldon Greenberg for helping me make the huge leap in 2010 from a stone-age MS-Dos computer running the primitive but highly effective Locoscript Professional, to a twenty-first century Apple 27-inch Imac running the over-sophisticated and far less user-friendly but nonetheless highly serviceable Word for Mac.

Others to whom I must extend my profound gratitude are Mora Abell for allowing me to read her biography of Dr Thomas Monro when in draft form; Vaughan Allen for his most serendipitous help; Louise Ayres, House and Collections Manager at Saltram House, Plympton, Plymouth, Devon; Sarah Barahona of the Office of National Statistics; my old friend, Adrian Barnes CVO, City of London Remembrancer between 1986 and 2003; Jane Baxter, Local Studies Librarian, London Borough of Richmond upon Thames Local Studies Library; Chris Bonfatti; Richard Bowden, Archivist of the Howard de Walden Estate, London; Hannah Brocklehurst, Curator in the Department of Prints and Drawings at the Scottish National Gallery; Dr Caroline Campbell, Schroder Foundation Curator of Paintings, The Courtauld Gallery; William Clarke, Prints and Drawings Conservator and Head of Conservation at the Cour-

tauld Gallery; Andrew Clayton-Payne; Mrs Merinda Cox; David Crane and Peter Jones of the Llangollen Museum, Llangollen, Wales; Iwan ap Dafydd of the National Library of Wales; the master gardener of Windsor, John Denyer, for his extremely helpful input; Helen Dorey and her research assistant, Julia Brock, at the Sir John Soane Museum, London; Amanda Draper, Keeper of Fine Art at the Harris Museum and Art Gallery, Preston, Lancashire; Jane Ellis-Schön of the Salisbury and South Wiltshire Museum; Jenny Ellard of Tonbridge Library, Kent; Morgan Feely, Collection Manager for Works on Paper at the Royal Academy of Arts; Gillian Forrester and the staff of the Yale Center for British Art, especially Melissa Fournier; Colin S. Gale, Archivist of the Archives and Museum, Bethlem Royal Hospital; Jenny Gaschke of Bristol Museum and Art Gallery; the late and sorely missed Jean Golt; Jane Greenberg; Robin Hamlyn; Adrian le Harivel, National Gallery of Ireland, Dublin, for his help on numerous occasions; Roger Hedley-Jones for the loan of a particularly helpful document; Natasha Held of the Royal Academy of Arts; Rebecca Hellen, Paintings Conservator, Conservation Department, Tate Britain; Professor Luke Herrmann; Dawn Heywood, Collections Access Officer of The Collection: Art and Archaeology in Lincolnshire; Sammi Hide, East Sussex Library; Helene Klein Hodes and Peter Hodes for their invaluable and endlessly patient assistance in laying out the financial Appendix that appears at the end of this work; Dr Holger Hoock; Roger Hull, Archivist, Liverpool Record Office; Christopher Hunwick, Archivist, Archives of the Duke of Northumberland at Alnwick Castle, Northumberland; John Hutchings for advice on long-distance walking and many other matters; Anne Jensen of the Salisbury and South Wiltshire Museum, Salisbury; the late Evelyn Joll; Lavender Jones; Linda Jones of the East Anglia Property Company for allowing me to peer out of the back windows of the property that now stands on the site of 26 Maiden Lane; Kok-Tee Khaw of Tate Britain; Charles Kidd of Debrett's Ltd for clarifying authoritatively that numerals and not words should *always* be used to denote aristocratic lineage (as in 'the 3rd Earl of Egremont', rather than 'the Third Earl of Egremont'), except where matters of general succession are involved (as in 'the second earl was followed by the third earl'); Geoff Lee; the late Ben Levy; Jeremy Lewison; Lowell Libson; Andrew Loukes, formerly of Manchester Art Gallery and now the House and Collections Manager of Petworth House, Sussex (and I should also like to thank all his National Trust colleagues in the house); Alison McCann, the Assistant County Archivist in the West Sussex Record Office, Chichester; the late Professor John McCoubrey, who always extended me the most wonderful friendship and support; Anthony McDonald of Westminster Music Library; Professor Murdo Macdonald of the University of Dundee; Beth McIntyre of the National Museum of Wales, Cardiff; Leonora Martin, Curator of the Corsham Court collection; Pieter van der Merwe of the National Maritime Museum, Greenwich, who has always given fully of his unsurpassed and quite astounding knowledge of naval and nautical affairs; Jane Monro of the Fitzwilliam Museum, Cambridge; Nicola Moorby; Andrew Moore and Camille Lynch of the National Gallery of Ireland, Dublin; Martin Myrone; Gay Naughton, formerly of Agnew Ltd; Peter N. Ogilvie of Salford Museum and Art Gallery; Catherine and Maurice Parry-Wingfield for much help concerning Sandycombe Lodge and Twickenham in general; Steve Peak; Robert Pendered; Julia Peyton-Jones; Lenéke Pinxteren; Dr Martin Postle; Dr Cecilia Powell; Nick Powell; David Scrase, Assistant Director, Collections, Fitzwilliam Museum, Cambridge; Joanna Selbourne, Curator of Prints, Courtauld Gallery; Anna Shanes and Mark Shanes, two very wonderful people; Richard Shone and the editorial staff of the *Burlington Magazine*; Kim Sloane at the British Museum; Eldon Smith, my old headmaster at Whittingehame College, Brighton, who has always been a source of inspiration and who, as a historian, has answered many of my questions with unfailing insight and wit; Greg Smith; Professor David H. Solkin; John Sunderland; Catherine Taylor, Archivist of the London Borough of Hounslow Archive at Chiswick Library, as well as Carolyn Hammond, Janet McNamara and Ann Greene at a later stage there; Annette Lloyd Thomas; Kylie Timmins of Queensland Art Gallery; Laura Valentine of the Royal Academy of Arts; Jancis Williams, Assistant House Steward, Research and Archives at Stourhead; Anthony Beckles Willson; Andrew Wilton for answering all my queries with great patience, and for his help in obtaining a photograph and a rare catalogue; Ian K. Wood for genealogical help; the late Andrew Wyld; and Edward Yardley for taking some very helpful study photographs on my behalf.

Then I must thank all the librarians: at the British Library, and especially its Newspaper Reference Division at Colindale; at the British Library Map Room; at the Guildhall Library; at the Kreitman Research Library and Archive at Tate Britain; at the London Metropolitan Archives; at Margate Reference Library; at the Royal Society of Arts Library; at the Wiltshire and Swindon History Centre, Chippenham; at the Witt Library, University of London; and last but never least, at the finest book-lending institution on the planet, the London Library, and especially Guy Perman for helping me with preliminary research concerning the weather during the summer of 1805. The standard of service one receives from the staff of the London Library has always been superb, but Mr Perman's labours were quite outstanding.

Gillian Malpass of Yale University Press has been unfailingly supportive, insightful and level-headed; my debts to her are incalculable. Emily Lees has contributed amazing design and editorial skills, for

which I am profoundly grateful. I must also thank Nancy Marten for all her patience, skill and insight in copy-editing my manuscript. And finally I must thank my incomparable friend and magical wife of more than forty-five years, Jacky Darville. Perenially she has given me the most sage counsel and kept the show on the road, constantly with patience, frequently with intense humour, and always with enviable courage at everything life has thrown at her. There is nobody to whom this little effort could have been more aptly dedicated.

<div style="text-align: right;">
Acton, London

24 May 2006–25 August 2014
</div>

Index

All the plate numbers in this book appear below in bold type, as do a number of key dates. Sub-categories are capitalised, with the titles of paintings, drawings, engravings and books being italicised throughout. The majority of image titles have been abbreviated, and place names are given precedence in many of them. Additional information is only furnished for differentiation purposes.

Aberdulais 110, 117, 118, **142**
Abergavenny 54, 110, 159, 168, **206**
Aberystwyth 54, 159,
Abingdon 7, 9, 24, 27, 203, 274, 366, 402, 404
Addingham Mill 322, 324
Adelphi Terrace, no. 4 96
Adelphi Terrace, no. 8 95, 96, 98, 99, 100, 102, 103
Aeneas 166, 441, 454, 202, **212**, **214**, **323**, **430**, 448, 454
Akenside, Mark 122, 226, 309, 363, 381, 382, 454, 458
Albion Tavern 457
Alcamenes 374
Alderson, Amelia (Mrs John Opie) 198
Alexander I of Russia 443
Algarotti, Count Francesco 307
Allen, J. T. 322
Allston, Washington 409, 440
Almanacks see Oxford
Alnwick 214
Altdorf 230

Alum Bay 116, 117, 118, 129, **141**
Amesbury 399
Amiens, Treaty of xi, 223
Anaxagoras 350
Anderson, Robert:
 WORKS: *The Complete Poets of Great Britain* 131, 132, 227, 271, 325, 348, 382, 399, 411, 436, 441, 454
Anderson-Pelham, Charles 362, 364
Andover 110, 398
Angerstein, John Julius 164, 165, 170, 171, 172, 173, 175, 249, 250, 262
Ankerwycke Priory 287
Anonymous artists:
 Portrait of Sarah Mallord Marshall? 1–2, **2**; *Portrait of Mary Marshall Turner?* 2, **3**; *26 Maiden Lane, Covent Garden, and Hand-court* 3, **4**
Antonine Column, Rome 374
Aosta 229, 230, 301, **281**
Aosta, Val d' 244, 407
Apollo 114, 157, 172, 392, 393, 394, **409**
Apollo Belvedere 33, 34, 152, 232, 441
Apollonius Rhodius 227
Anglesey 159, 197
Appuldurcombe Park 116
Argyll, George Campbell, 6th Duke of 301
Aristarchus 350
Arkwright, Richard 74
Arlington Street, Mayfair 141
Artists' General Benevolent Institution (AGBI) 456, 457

Arve, river 244
Arveron, river 244, 245, **301**, 322
Ashburnham, John Ashburnham, 2nd Earl of 364
Ashburnham Place 364
Ashburton 444
Ash Grove, Knockholt, Kent 220, 250, 259, **267**, 286, 304, 351
Athenaeum Club, Pall Mall 100
'Avalon' 399
Aveley 278
Avenches 230
Avernus, Lake 158, 165, 166, **194**, **195**, **202**, 448, 465
Avon Gorge 40, 41, 74
Awe, Loch 214, 216, 218, **262**, **263**
Axial precession 349, 350

Backhuizen, Ludolf 208
Baden 230
Bagshot 398
Bailey, Anthony xii
Bangor 180
Barden Tower 322
Barmouth 159, 319
Barnstaple 399, 428, 444
Barry, James 15, 71, 198
Basingstoke 398
Basire, James junior 178, 179
Basle 230
Batavian Republic xi, 210, 211
Bath 40, **51**, 53, 122, 127, **156**, 380, **403**

Battle, Sussex **58**, 302, 364
Beachy Head 302
Beaufort House 364
Beaumaris Castle 159
Beaumont, Sir George 156, 246, 253, 254, 280, 284, 285, 295, 298, 325, 354–5, 357, 366, **386**, 396, 417, 418, 420, 421, 422, 423, 426, 428, 438, 439, 442, 443, 452, 456
Beckford, William 156, 173, 175, 193, 198, 199, **213**, 244, 262, 264
Bedford Square, no. 53 95
Bedfordshire 227
Bedgellert 159, 180
Beechey, Sir William 239, 281:
 Portrait of Sir Peter Francis Bourgeois **167**
Bell, Edward 81, 84
Bellori, Giovanni Pietro 307
Belvedere Antinoüs 31, 33, 232
Belvedere Torso 232
Belvoir Castle 318
Bembridge 116
Bere, Forest of 302, 304, **357**
Berkshire 74, 271
Berne 230
Berry Pomeroy Castle 398
Berwick, North 214
Berwick-upon-Tweed 141, 214
Bessborough, Frederick Ponsonby, 3rd Earl of 390
Bethlem Hospital ('Bedlam') 201, 220, 254
Betws-y-Coed 159, 180
Bicknell, Maria 425
Bird, Edward 346, 357, 390, 393
 WORKS: *Village choristers rehearsing an anthem for Sunday* 357; *The reading of the will concluded* 390
Birmingham 91
Blackwater 398
Black Mountains 54
Blair Atholl 214, **412**
Blair, Charles 229
Blair, Hugh 319
Blair, Robert 69, 71
Blake, William (of Newhouse and/or Portland Place) 146
Blore, Mrs ('Q.Z.') 348–9
Blue Anchor Bay 399
Blythe Sands 278
Boaden, James 283
Bodiam Castle 302, 364
Bodmin 399
Bona Esperanza 439
Bonneville 229
Bonomi, Joseph 221
Borch, Gerard ter 237
Borghese Gladiator 31
Boringdon, John Parker, 2nd Lord 429
Boscastle 399

Boswell, Henry:
 Picturesque Views of the Antiquities of England and Wales 6, 7, 16
Bouet, Joseph:
 Portrait of Newbey Lowson **274**
Bourgeois, Sir Francis, 139, **167**, 239, 240, 241, 247, 250, 251, 252, 253, 257, 259, 280, 403
Bowland, Trough of 350
Bowles, Admiral of the Fleet Sir William 362
Box Hill 145
Boyd, Sir John 227
Brading 116
Braham, John 259
Brahma 292
Brasenose College, Oxford 249
Brecon 110, 159
Brentford, Middlesex, New 5, 6, 7; county elections 7; idyllic environs of 5; political radicalism of 7
Bridgend 110
Bridgwater 399
Bridgewater, Francis Egerton, 3rd Duke of 178, 190, 207, 208, 213, 225, 242, 244, 368
'Bridgewater seapiece' 209
Bridgnorth 91
Bridport 398
Bridport, Admiral Alexander Hood, 1st Viscount 259, 277
Brienz 230
Briggs, Henry Perronet:
 Portrait of William Frederick Wells **130**
Brighton 132, 133, **160**, **161**
Bril, Paul 385
Bristol 40, 41, 44, **48**, **49**, **50**, **52**, 53, 72, 74, 110, 158, 159, 160, 444
Bristol Channel 399
British Institution 266, 267, 279, 316, **332**, 354, 357, 362, 365, 383, 417, 425, 431, 432, 433, 435, 436, 437, 438, 439, 440, 441, 442, 456; 52 Pall Mall 436
 EXHIBITIONS: **1806**: 280, 300; **1808**: 309; **1809**: 323, 324; **1814**: 436, 437
The British Press 242, 244, 256
British Itinerary ... throughout Great Britain 397
Briton Ferry 110
Britton, John 389, 399, 401, 402, 409, 415
Brixham 398
Broadstairs 81
Brocklesby Park 140, 142, 160
Brocklesby Mausoleum 160
Brougham Castle 350
Browsholme Hall 178, 319, 350
Buckfastleigh 444
Buckinghamshire 289, 365, 397
Buckland Abbey 427
Buckland, William 412
Buckler, John Chessel 319
Bude 399
Buildwas 91

Bunyan, John 328
Burcroft 142
Burdett, Francis 321
Burgess, James Bland 364
Burgh Island, Bigbury Bay 429
Burney, Edward Francis:
 The Antique School at Somerset House **35**
Burney, Fanny 217
Burton-upon-Trent 318
Butler, Samuel 348
Buxton 91, 318
Byron, George Gordon, Lord 405

The Cabinet (comic opera) xi, 259
The Cabinet; or, Monthly Report of Polite Literature 297, 349
Caernarfon and Caernarfon Castle 157, 159, 164, 171, **198**
Caerphilly 159
Cadair Idris 157, 159, 189, 191, **196**, **233**
Calais 228, **275**, **298**
Calder Bridge 350
Callcott, Augustus Wall 255, 295, 319, 323, 353, 354, 355, **385**, 368, 377, 379, 396, 417, 418, 420, 421, 423, 426, 438, 441, 450, 466
Callimachus 392
Calstock 427, 430, 444
Cambridge 91, **107**, 321, 325
Campbell, Thomas 409
Camperdown, Battle of 210, 211
Canaletto, Antonio 95, 102, 114, 131
Canterbury 54, 59, **64**, **65**, **66**, 70, 73, 81, **88**, **103**, **105**, 147, 199
Capel Curig 159, 180
Cappelle, Jan van de 297
Cardiff 110, 159
Cardigan 159
Cardiganshire 88
Carew 110
Carisbrooke Castle 116, **140**
Carlini, Agostino 28
Carlisle 214
Carlisle, Anthony 323, 350, 374, 412
Carmarthen 110, 159
Caroline, Princess 316
Carracci, Agostino 374
Carracci, Annibale 341, 374, 384
Cartmel peninsula 350
Carysfort, John Proby, 1st Earl of 420, 422
Cassiobury Park 131, 132, **159**, 299, 329, 339
Catalani, Angelica **426**, 429
Caus, Salomon de 307
Cavendish Academy 186
Caversham Bridge 272, 273
Cerceau, Jacques I Androuet du 307
Chambers, Sir William 416

Chale 116, 118
Chamonix 229, 244, **279**
Chantrey, Francis 412, 457:
 Portrait of Sir Augustus Wall Callcott **385**
Charles I, King 322
Chartreuse, Grande 229, 244
Chatham 12, 277
Chaucer, Geoffrey 131
Cheddar Gorge 399
Cheshire 242, 318, 319
Chester 91, 204, 217
Chesterfield 213
The Chevin 322
Chillon 230
Chirk 91
Christ, Jesus 137, 138, 234, 237
Christchurch, Hampshire 398
Christianity 180, 292
Christie, Manson and Wood (Christie's) 96, 121
'Cider Cellar', Maiden Lane, Covent Garden 2, 3
Cilgerran Castle 157, 159, **205**
Cimabue (Cenni di Pepo) 373
Clarendon Press 160, 213, 249
Claude Gellée, le Lorrain 78, 95, 114, 117, 141, 152, 157, 158, 164, 167, 170, 172, 174, 197, 232, 241, 242, 249, 286, 308, 313, 326, 354, 385, 390, 394, 399, 404, 409, 410, 422, 437, 438, 439, 440, 452, 455, 456
 WORKS: The Altieri Claudes 172; *Liber Veritatis* 165; *The Landing of Aeneas* 172, 173, 174, **212**; *Rest on the Flight into Egypt* 452; *Landscape with the Father of Psyche* 172, 173, 174, **211**; *The Marriage of Isaac and Rebekah* 249, 250, **303**; *Jacob, Laban and his daughters* **427**, 431, 432, **437**; *Landscape with a Rural Dance* 141, 142, **173**; *Procris and Cephalus* 404; *Seaport with the Embarkation of St Ursula* 164, 165, 170, 171, **200**; *Seaport with the Embarkation of the Queen of Sheba* 249, 250, **304**
Cleator Moor 350
Cleveland House 190, 213
Cliffe 278
Clifton, Nuneham Courtenay 7, **8**
Clitheroe 178
Cliveden 272, 295
Clovelly 399
Cobham 300
Cockermouth and Castle 340, 350
Col de la Seigne pass 229, 368
Cole, Thomas ix, 466
Coleman, Thomas 8
Collier, John 426, 427, 429, 444
Collins, William (ARA) 441
Collins, William (of Chichester) 340
 'Ode on the Death of Mr Thomson' 341
Colman, George the younger 304
Colne, river 340

Coltman, Nathaniel 397
Colwell Bay 116
Combe Martin, Devonshire 399
Combe, William 432
Companion to the 1796 Exhibition 127
Coningsby, Thomas Coningsby, 1st Earl of 116
Coniston Old Man 153, **185**
Constable, John 246, 425–6, 458
 Self-portrait **424**
'Constant Reader' letter to the *Examiner*, 1809 323
Contamines-Montjoie, Les 229, **280**
Conwy and castle 159, 180, 202, **245**
Conwy valley 180
Cooke, George 389
Cooke, William Bernard 389, 397, 425, 431, 432, 444–5, 447
Cooley, Thomas 373
 Turner and Fuseli lecturing **397**
Copenhagen 304
Copley, John Singleton 239, 240, 241, 247, 250, 251, 252, 253, **296**, 377
 The Knatchbull Family portrait 240, 241
The Copper-Plate Magazine 86
Corfe Castle 398
Correggio, Antonio Allegri da 232, 385
Corwen Bridge 318, 329, **369**
Cosway, Richard 15
Cotehele House 430
Cotman, John Sell 96
Courmayeur 229, 244, 301
Cox, David 295
Cozens, John Robert 95, 96, 100; posthumous sale 100, 264
 WORKS: *Flüelen on Lake Lucerne* 264, 447; *Hannibal attaining his first sight of Italy* 160, 409
'Cran Mere Pool' **431**, 444
Criccieth 159
Crickhowell 54, 159
Cristall, Joshua 259, 260
Critical Guide to the 1796 Exhibition 127
Cromford 74–5
Cromwell, Oliver 322
Crowhurst Park 364
Crowland (or Croyland) Abbey 91
Culham 274
Cumaean Sibyl 166, **202**
Cumberland, Richard 401
Cumbernauld 214
Cuyp, Aelbert 142, 273, 282, 295, 297, 315, 333, 357, 386, 421, 422

Dalkeith 214
Dalmally 214
Danby, Evelina 217, 323, 420, 452
Danby, Georgiana 399, 420, 452
Danby, Hannah 203, 305, 350, 416, 425

Danby, John 188, 189
Danby, Sarah, née Goose 188–9, 203, 217, 220, 305, 350, 399, 415, 458; birth of daughter, Evelina 217; birth of daughter, Georgiana 399; pension 189; possible motives for liasing with Turner 188
Dance, George the younger 34, 54, 190, 252, 282, 405
 WORKS: *Portrait of Sir George Beaumont* **386**; *Portrait of John Singleton Copley* **296**; *Portrait of Joseph Farington* **184**; *Portrait of Thomas Girtin* **235**; *Portrait of Ozias Humphry* **302**; *Portrait of John Soane* 54; *Portrait of J. M. W. Turner* 1790? **41**; *Portrait of J. M. W. Turner*, 1792, **xiv**; *Portrait of J. M. W. Turner ARA*, 1800 **234**; *Portrait of Benjamin West* **242**
Daniell, Thomas 183, 221, 231, 280, 285, 291
Daniell, William 432,
Darlington, William Harry Vane, 3rd Earl of 227
Dart, Ann 40, 158, 159
Dart, river 444
Dartmoor 430, **431**, 444
Dartmouth 398, 444
Datchet 272
David, Jacques-Louis 237
Dayes, Edward 16, 79, 95, 96, 100, 102, 183, 267, 412
Deal 81
Decorum, artistic 116, 151, 152, 174, 234, 285, 313, 384, 385, 402, 403, 420, 421, 454, 456
Dee, river 159, 217, 318, **369**
Denbigh 180
Denbighshire 106
Denmark, war with, 1807 304
Derby 91, 141
Derbyshire 75
Devil's Bridge, Wales 54
Devil's Bridge, Switzerland 230, 447
Devis, Arthur William 282
Devonshire 428, 456
Devonshire Place, no. 36 355
De Wint, Peter 96
Dido, Queen of Carthage 271, **323**, **430**, **437**, 441, 454
Dilettanti, Society of 292
Dinas Brân 106, **126**
Discobolus, Standing 31
Dobree, Samuel 259, 281, 297, 315, 460
Dobson, architect named 105
Dodbrook 429
Dodsley, Robert 402
Dolbadarn Castle 159, 180, 189, 191, **228**, **229**, **232**, **239**
Dolgellau 159, 319
Domenichino (Domenico Zampieri) 232, 385
Doncaster 141
Dorchester 398
Dorchester Mead 304
Douglas, Revd James 81

Dove valley 318
Dover **45**, 81, **99**, 102, **124**
Dover, sequence of views of 102
Dow, Alexander 292
Drake, Sir Francis 427
Drayton, Michael 399
Dryburgh Abbey 141
Dryden, John 307, 379
Ducros, Louis 114
Duddingston 214
Dumbarton 214
Duncan, Admiral Adam 210
Dunkeld 214
Dunster Castle 158, 399
Dürer, Albrecht 373, 379, 384, 439
Durham 141, **176**, 199, 213
Durham, County 227
Durlston Head 398
Dyck, Sir Anthony van 131, 232, 456
 WORKS: *Cardinal Bentivoglio* 346; *Countess of Southampton* 383; *1st Earl of Strafford* 382
Dying Gaul 31, 232
Dynavor 110

Earlom, Richard:
 Liber Veritatis engravings after Claude le Lorrain 165, 170, 172, 286, 404, 431, 452
Eastbourne 302
Eastlake, Charles Lock 398, 427, 428, 430
Eastlake senior, George 426, 427, 444
Eastlake, William 429
East India Company 412
Eclipse (racehorse) 429
Edgcumbe, Mount 430
Edward I, King 191, 197, 198, 348
Edinburgh 214, **255**, **256**, 256
The Edinburgh Review 316
Edridge, Henry 254
Edwards, Edward 289
Egginton 318
Egham 397
Egremont, Cumberland 350
Egremont, George Wyndham, 3rd Earl of 211, 241, 264, 281, 295, 311, 315, 330, 340, 350, 351, 360, 365, **381**, 409, 425, 431, 432, 439, 441, 457, 461, 462, 463, 464
Elcot Park 158
Elgin, Thomas Bruce, 7th Earl of 166, 285
Elliott, Charles 252, 253, 281
Ely 91, **109**, 126, 133, **153**, **155**, **162**, **165**, 199
The English Chronicle 297
Ennerdale Bridge and Water 350
Eridge Castle 364
Essex 1, 122, 278, 304
Essex, George Capell-Coningsby, 5th Earl of 110, 211, 281, 294, 315, 329, 330, 339, 462, 463

Eton 5, 203, 295, 300, 304
Eton College 295
Evesham 77
Ewenny 110
Ewenny Priory 135, 159, **163**
The Examiner 300, 314, 316, 323, 325, 387, 409, 422, 423, 425, 439, 440, 445, 456
Exe, river 444
Exeter 111, 398, 444
Exeter College, Oxford 249
Eyck, Hubert van 373
Eyck, Jan van 373

Fach Ddeilliog 319
Fairfax, General Thomas 322
Falconer, William 264
Falk, Bernard xii
Falmouth 398
Farington, Joseph 95, 96, 99, 100, 156, 160, 161, 163, 164, 166, 171, 173, 174, 175, 177, 182, 183, **184**, 186, 187, 213, 214, 217, 221, 223, 230, 240, 246, 249, 250, 252, 253, 254, 255, 257, 267, 282, 285, 293, 295, 298, 299, 305, 319, 323, 325, 354, 376, 379, 390, 396, 403, 405, 406, 412, 417, 418, 423, 425
 AND: the Monro 'Academy, 1794–7 95–6, 99, 100; meeting Turner for the first time, 1798 152–3; Turner on teaching amateurs, 1798–9 163–4; advising Turner on moving, 1799 160, 174, 182–3; Turner on the Altieri Claudes, 1799 173; Turner's watercolour techniques, 1799 174–5; Turner's oil-painting palette, 1802 223; Turner's supposed gallery measurements, 1804 252–3; Turner's most-favoured canvas dimensions, 1804 255; chastising Turner, 1804 257; Turner's desire to be 'Oeconomical', 1806 285; visiting Turner's gallery in 1807 299; Turner at Tabley, 1809 319; Mrs Danby and her children, 1809 323; the *Hannibal* hang, 1812–13 405–6, 418; Turner's illness, 1812 417
Farington RN, Captain William 423
Farnese Hercules 374
Farnley Hall **362**
 Farnley Hall visits: **1808**; 319, 321, 322, 323, 324, 397; **1809**: 346, 350; **1810**: 364, 366, 367, 368; **1811**: 399, 401, 402; **1812**: 417, 419; **1813**: 431, 432; **1814**: 447
Fawkes, Francis Hawkesworth 368
Fawkes, Maria Grimston 321, 431
Fawkes, Walter Ramsden Hawkesworth 254, 255, 321, 322, 323, 324, 329, 330, 340, 346, 348, **361**, 364, 365, 366, 367, 368, 390, 397, 401, 409, 418, 420, 431, 441, 443, 447, 450, 452, 460, 461, 463, 465
Félibien, André 307
Feltham, John:
 A Guide to All the Watering and Sea-Bathing Places 397

Ferguson, James 307
Ffestiniog 159
Fielding, Anthony Copley 96
Finchley 95
The Fine Arts of the English School 389, 399
Fisher, Bishop John 426
Fittleworth 340
Flaxman, John 231, 273, 353, 409
Flint Castle 159
Flushing 278
Freshwater 116
Freshwater Bay 116, 118, 129
Frome 399
Finberg, Alexander J. xii, 366, 437
Flüelen 230, 264, **432**
Folkestone 302, **350**
Fonthill House and Abbey 158, 175, 176, 190, **190**, 199, **216**, **217**, **218**, **219**, **236**, **237**, **238**
Foot, Jesse 431
Foots Cray 24, 147, 148
Fowey 398
Friedrich Wilhelm III of Prussia, King 443
Fresnoy, Charles Alphonse du 307, 308, 344, 361
Fuller, John 355–6, 364, 365, 368, **387**, 396, 421, 463, 464
Fuseli, Henry 174, 198, 209, 231, 246, 267, 341, 353, 376, **397**, 398, 399, 435

Gainsborough, Thomas 7, 11, 78, 95, 131, 247, 354, 386, 418
 WORKS: drawings 289; landscapes (unspecified) 7; lightbox 95, 100; *The Cottage Door* 386; *An Open Landscape* (part-destroyed), c.1753–4 **11**
Gandy, Joseph 295
Garrard, George:
 Portrait of the 3rd Earl of Egremont **381**
Garvey, Edmund 221
Gawthorpe Hall 178, 179
The General Evening Post 196
Geneva 229
George III, King xi, 7, 16, 186, 187, 190, 225, 239, 240, 247, 250, 251, 252, 267, 316–17, 457
Gérard, Marguerite 237
The Reader 295
Gilpin, Sawrey 174, 183, 366, 393
Gilpin, Revd William 78
Girtin, John,
Girtin, Thomas 16, 38, 79, 95, 96, 100, 102, 103, 105, 116, **117**, **118**, **119**, **120**, 125, 163, 166, 168, 190, 198, **235**, 247; death of 239
 St Paul's Cathedral from St Martin's-le-Grand, London **125**
Glacier du Bois 244
Glasgow 214
Glaslyn estuary 180
Glastonbury 399

Gloucester 110
Goblet, Lewis Alexander:
 Portrait of Angelica Catalani **426**
Godalming 269
Godalming Navigation Canal 269
Godshill 116
Goldsmith, Oliver 131
Golt, Jean 189
Goodrich Castle 110
Gordale Scar 319, 323, 324
Goring 271, 273, 274, **326**
Goyen, Jan Van 95
Graeco-Roman mythology 292
Grand Junction Canal 340, 357, **389**
Grantham 318
Gray, Thomas 197, 198, 346, 349
Green, Frances Ann 423
Green, Valentine 346
Greenwich 366
Grenoble 229
Gretna Green 214, 217
Grey, Charles Grey, 2nd Earl 390, 396
Grindelwald 230
Grosvenor Place, no.45 255, 321
Guercino, Il (Giovanni Francesco Barbieri) 232, 237
 The Raising of Lazarus 234, 385, **292**
Guérin, Pierre-Narcisse 237
Guildford 302, 304
Gunnislake Newbridge 427, 444

Habeas Corpus, suspension of 198
Hackney 95
Haddington 214
Hafod 159
Haines, Mary 7
Haines, Sarah 7
Halsewell East Indiaman 6, 398
Hamilton [forename unknown] 336
Hamilton, James xii
Hamilton, John 307
Hamilton, Lanarkshire 214
Hamilton, William 175, 183, 336, 452
Hammersmith Terrace 66, 67, 127
Hammersmith, 6 West End, Upper Mall *see under* Turner, J. M. W.
Hampshire 302, 312, 398, 441
Hampton Court, Middlesex 273
Hampton Court, Herefordshire 110, 116, 131, **148**, 160
Hannibal Barca 160, 229, 368, 375, 407, 408, 409
Hanwell 340, 357
Hardcastle, Revd 186
Hardwick, Thomas 19, 105, 163
Harewood House 140, 141, 146, **182**, **183**
Harper, Robert 186, 252

Harlech 159, **204**
Harley Street, no.64 *see under* Turner, J. M. W.
Harpur, Sarah Marshall 81
Harpur, William 81, 84
Hartland Point 399
Hastings 279, 302, 364
Havell, William ix, 416
 Sandycombe Lodge, Twickenham **421**
Haverfordwest 110
Hawksworth Moor 346
Hay-on-Wye 159
Hazlitt, William 438, 441, 445
Hearne, Thomas 95, 96, 100, 102, 354
Heath, Charles 389, 457
Heathcote, Thomas Freeman 441
Heathfield Park 364
Helmsley 213, 214
Henderson, John 96, 102, 103, 105, 109, 281
 Portrait of Dr Thomas Monro **114**
Hereford 54, 77, 88, **95**, 110, 160
Herefordshire 77, 110, 116, 117, 131
Hertford, Francis Ingram-Seymour-Conway, 2nd Marquess of 406
Hertfordshire 95, 131, 299
Heston 340, 397
Highgate viaduct 431
Highlands, Scottish 213, 214, 216, 217
Highmore, Joseph 307
Hill Street, Mayfair, no. 24 266, 281
Hindhead 287, 302, 303, 304, **351**
Hinduism, common roots with Graeco-Roman mythology 292
Hipparchos 349
Hoare, Sir Richard Colt 112, 114, 116, 125, 156, 158, 165, 166, 168, 174, 220, 262, 264, 266, 319, 418, 444, 448, 449, 461, 465
 The Lake of Avernus **194**
Hofland, Mrs Barbara 432–3
Hofland, Thomas Christopher 433, 439, 440, 457
Hogarth, William 334
 WORKS: *The Distrest Poet* 334; *The Roast Beef of Old England* 243
Holbein, Hans the younger 384
Holland, Henry Vassall-Fox, 3rd Baron Holland of 341
Holme in Cliviger 178
Honiton 444
Hook 300, 398
Hoppner, John 96, 161, 163, 164, 174, 183, 198, 231, 246, 247, 264, 366
 WORKS: *Portrait of William Beckford* **213**; *Portrait of Edward Lascelles junior* **171**; *Self-portrait* **115**
Hove 133
Howard, Henry 377, 379, 397
Howe, Richard, 1st Earl Howe 300
Howe, Baroness Sophia Charlotte, of Langar 300
Humphry, Ozias 246, 247, 252, 257, **302**

Hunt, William Henry:
 Portrait of David Wilkie **314**
Hurstmonceaux Castle 302
Hythe 302

Ilfracombe 399
Imperial currency xii
Inverary 214, **349**, **414**
Inversnaid 214
Iron tax (proposed), 1806 295
Isleworth 267, 269, 271, 274, 278, 285, 299, 311, 338
Ivybridge 398, 444

Jackson, Cyril 160
Jedburgh Abbey 141
Johns, Ambrose Bowden 398, 427, 430, 431, 444, 445
Johnson's British Gazette and Sunday Monitor 256
Jones, George 164
Jones, Thomas 197
Jones, Sir William 292
Junius, Franciscus the younger 307

Kali 292
Kamperduin 210
Kelso Abbey 141
Kempinski, Tom ix
Kenmore 214
Kensington Gravel Pits 417, 418
Kent and Strathern, Prince Edward, Duke of 457
Keswick 141
Kew, Surrey 5
Kidwelly 110, **134**, **135**
Kilchurn Castle 214, 216, **262**, **263**
Killiecrankie 214, **265**
Kingsbridge 429
Kingston upon Thames 274, 328, **368**
Kingswear 444
Kirby, Joshua 7, 9, 307
Kirkstall Abbey **186**, 322
Knatchbull, Sir Edward 241
Knight, Richard Payne 78, 281, 292, 316, 317, 334, 344, 349
Knockholt 220, 250, 259, 275, 286, 287, 289, 293, 302, 351, 364

Lacock 158
Laguerre, Louis 385
Lake District 141, 174
Laki, Iceland, eruption in 1783 4
Laleham 300
Lamb, Lady Caroline 390
Lamy, Bernard 307

Lanark 214
Lanarkshire 226
Lancaster 350
Lancashire 177, 178, 179, 180
Landseer, John 116, 118, 309, 310, 311, 312, 313, 314, 345, 376, 377, 457
Land's End 398, 399
Laocoön 232
Laporte, John 95
Lascelles, Edward, 1st Earl of Harewood 141–2, 175, 262
Lascelles, Edward junior 140, 146, 175, 262, 301
Lascelles, Henry 321, 322
Lascelles family 323
Lauderdale, James Maitland, 8th Earl of 390
Laufenburg 230
Laugharne 110
Launceston 399, 444
Lausanne 230
Lauterbrunnen 230
Lawrence, Thomas xii, 144, 145, 156, 177, 183, 246, 250, 298, 376
 Portrait of John Julius Angerstein **199**
Leader, William 156, 281, 326, 350, 460, 463
Leatherhead 145, **180**
Ledbury 77
Lee shore, a 210
Leeds 141
Lees, John 6
Leicester, Sir John Fleming 211, 242, 266, 281, 282, 292, 295, 299, 300, 312, 315, **317**, 318, 319, 323, 324, 331, 332, 360, 365, 367, 386, 403, 461, 462, 463, 464, 465
Leominster 110
Leonardo da Vinci 341, 374
Leslie, Charles Robert 406
Lewes 302
Lewis, Frederick Christian 289:
 Portrait of Sir Thomas Lawrence **177**
Liber Nauticus 286
Lichfield 91
Lievens, Jan 232
Ligny-en-Barrois 230
Lincoln 91, 244, 256
Lincoln cathedral 91, 109, **127**, 199
Lincoln's Inn Fields, no. 13 293, 294, 299, 364
Lincolnshire 140, 142, 160, 188, 256, 362
Lindsay, Jack xii
Linlithgow 214
Liphook 302
The Literary Gazette 350
Little Hawkwell, near Tonbridge 81
Llanberis Pass 159, 180, **228**, 229
Llandaff 110, 122, **132**, **133**
Llandeilo 110, 122, 159
Llandovery 110, 159
Llandowro 110

Llangollen **108**, 110
Llanrwst 180
Llanstephan 110, **143**
Llanthony Abbey 54, **63**
Lloyd's Evening Post 171, 241, 282
Llyn Ogwen 159
Llyn Tegid (Lake Bala) 319
Lock, William 144, 156, 157, 164
Lomazzo, Giovanni 307
Lomond, Loch 214, 216, 257, **257**, **258**, **259**, **261**
London 1, 2, 4, 5, 7, 8, 12, 15, 19, 21, 25, 31, 36, 53, 54, 66, 74, 77, 84, 88, 91, 92, 95, 110, 111, 112, 116, 117, 121, 141, 142, 158, 159, 160, 164, 165, 170, 172, 173, 175, 177, 180, 182, 185, 187, 188, 198, 190, 198, 199, 201, 208, 210, 213, 214, 217, 228, 237, **246**, 249, 257, 259, 266, 268, 269, 277, 279, 280, 285, 291, 297, 301, 302, 304, 305, 318, 319, 321, 323, 324, 329, 335, 346, 350, 351, 354, 355, 364, 366, 368, **370**, 371, 374, 386, 395, 396, 398, 399, 409, 417, 422, 425, 426, 427, 430, 431, 432, 433, 438, 440, 443, 444, 445, 457
London art politics and the art market 172, 257, 280, 354, 440, 445
The London Chronicle 409, 422, 423
The London Packet 127, 196, 204
Long Reach on the river Medway 277
Lonsdale, William Lowther, 1st Earl of 337, 350, 351, 356, 463
Lotto, Lorenzo 232
Louis Philippe, Duc d'Orléans and Duc de Chartres 449
Louis Philippe Joseph, Duc d'Orléans 74
Loutherbourg, Philippe Jacques de 66, 67, 68, 69, 73, 81, 95, 110, 127, 152, 197, 252, 285, 360, 452
 WORKS: *Coalbrookdale by Night* **84**; *Self-portrait* **81**; *Storm, and passage boat running ashore* **82**; *Storm and shipwreck, with banditti and figures* **83**
Loutherbourg, Mrs Lucy de 66
Lowe, Mauritius 20, 28, 74, 262, 289, 335, 368, 457
Lowson, Newbey 227–31, 281
Lowther Castle 337, 350, 356, 386
Lucerne 230
Lucerne, Lake 264, **432**, 452
Lugg, river 110
Lulworth Castle 398
Lulworth Cove 398
Luss 214
Luttrell, John Fownes 158
Lydford 444
Lyme Regis 398, 444
Lyons 229, 241

MacCulloch, John 412
Machynlleth 159
Maiden Lane, Covent Garden:
 No. 21: 2, 3

No. 26: 3, 4, **4**, 5, 15, 24, 49, 73, 81, 95, 102, 110, 117, 127, 131, 160, 164, 174, 183, 185, 186, 187, 188, 225, 350, 366
Malden, George Capell-Coningsby, 5th Viscount 110, 121, 131, 160; *see also* 5th Earl of Essex
Mallard (later Mallord), Joseph 1
Mallet, David 170
Mallord, Mary Marshall 1
Malmesbury 40, **53**, **55**, 58, 71, **III**
Malton, James 307
Malton, Thomas the elder 307, 377, **401**
Malton, Thomas the younger, 20, 21, 25, 34, 45, 49, 126, 163, 183, 377, 379, 380, 383
 AND HIS: admiration for Rowlandson 38–9, 69; 'Picturesque Tour through the Cities of London and Westminster' scheme 21; prioritisation of perceptions drawn from nature 20–1, 374, 375, 381; possible quotation from Akenside 381
 AND TURNER'S: augmentations of height 36, 126; aversion to prolixity 106; low viewpoints 21, 375; period of study 20; perspective diagrams 337; training in perspective 20, 307, 373
 WORKS: *Melbourne House looking along Whitehall* **24**, **25**; *Westminster Abbey* 21; *Old Palace Yard, Westminster* **22**
Malham Cove 319
Malvern, Great 77, **104**
Manchester 178, 319, 350
Manton, Joseph 323
Mapledurham 271
Margam 110
Margate 8, 10, 11, **12**, 13, **13**, 15, 24, 36, **44**, 81, 122, 132, 147, 259, 278, 279, 297, 304, 324, **331**
Maria, James de 428, 429, 430
Marsh, William 443
Marshall, Ann (Turner's maternal aunt) 5, 7
Marshall, Joseph Mallord William (Turner's maternal uncle) 2, 5, 6, 7, 249
Marshall, Mary (Turner's mother) *see under* Turner, J. M. W.
Marshall, Sarah (Turner's maternal grandmother) 1, 2
Marshall, William (Turner's maternal grandfather) 1, 2
Martigny 229, 230
Mason, William 307
Matlock 91
Mawddach estuary 319
Meiringen 230
Meleager 31
Melincourt 110
Melrose Abbey 141
Menai Strait 159
Mendip Hills 110
Mengs, Anton Raphael 385
Mer de Glace 229, **278**, **301**, **382**, 412, **434**, 447

Merionethshire 182, 319
Merthyr Tydfil 159
Metsu, Gabriël 237
Mew Stone, the Great 429
Michelangelo di Lodovico Buonarroti Simoni 35, 36, 152, 341, 373, 374, 386
Millom 350
Milton, John 122, 154, 335, 344, 349
Minehead 399
Mitton 178
Moel-y-Geraint (Barber's Hill), Llangollen 91, **108**
Moffat 214
Mola, Pier Francesco 232, 385
Molton, South 1, 444
Monarchy, the British 316–17, 328, 390, 396, 406, 409, 443, 456
Monet, Claude 416
Monken Hadley 95
Monmouth 54, 110, 159
Monro, Henry 440
Monro, Dr Thomas 95–103, 106, **114**, 140, 156, 160, 201, 220, 281, 316, 440
 WORKS: *Portrait of John Henderson* (attributed) **123**; *Portrait of J. M. W. Turner* (attributed) **116**
Mont Blanc 229, **279**
Montanvert mountain 229, 244, **279**, 447
Monte, Guidobaldo del 307
Monthly Magazine 323, 333, 395
Monthly Mirror 225, 256, 348
Monument, City of London 374
Morecambe Bay 350
Morlais 159
Morland, George 15, 17, 131, 152
The Morning Chronicle 435, 438, 441, 456
The Morning Herald 244, 331, 333, 456
The Morning Post xi, 89, 140, 257, 283, 297, 315, 331, 357, 456
Morpeth 214, 325, **364**
Mortimer, John Hamilton 121, 366
Mottestone 116
Mount Street, Mayfair, no. 34 109, 110
Mount Tamar 427
Moxon, Joseph 307, 377
Mozart, Wolfgang Amadeus
 WORKS: *Le Nozze di Figaro* 259; *Die Zauberflöte* (as *Il Flauto Magico*) 259, 395–6, 438
Murray, John 389, 405, 425
Musée Central des Arts, Paris 231
Mutley 427, 428
Mynach Falls and the Devil's Bridge 54

Nancy 230
Napoleon Bonaparte 455
Narraway, John, and family 40, 41, 53, 110, 158, 159
Nash, John 431
The National Gallery, London 164

Neath 110
The Needles 116, 118
Nelson, Vice-Admiral Lord Horatio 241, 242, 277, 309, 409
Netley Abbey 116
Newark-on-Trent 91
Newbery, Francis 364
Newbury 158, 203
Newcastle 213
Newcastle Emlyn 159
Newhaven 302
Newport, Gwent 110, 213
Newport, Isle of Wight 116
Nixon, Revd Robert 24, 28, 147
Norbury Park 144, 145, 157, 164, **179, 181**
Norfolk, Charles Howard, 11th Duke of 72
Norham Castle 146, **187**, 214
Northcote, James 256, 257, 379
 Portrait of Thomas Dunham Whitaker **220**
North Foreland 12
Northampton 91, 92, **110**
Norton Street, Marylebone, no. 75 *see under* Turner, J. M. W.
Nottingham 1, 91, 318

Oakford 444
Okehampton 444
Opie, Mrs Amelia *see* Alderson, Amelia
Opie, John 174, 198, 231, 246, 254, 256, 293, 294, 304, 344, 346
 Lectures on painting 341–3, 371, 374, 412, 445
The Oracle 297, 354
Orléans collection, 1793 74
Ostade, Adriaen van 95, 283
Ostend 278
Otley 319, 322, 346
Ottley, William Young 244
Owain ap Gruffudd (Owain Goch) 191, 192, 198
Owen, William 246, 379
Oxford 5, 7, **7, 10**, 24, 25, **28, 29, 32, 69, 72, 73, 74**, 54, 77, 100, 116, **122**, 160, 249, **305**, 351, 353, 359, 366, **390**, 402, 404, 405, 406
 AND: *Almanack* watercolours 160, 213, 249–50, 463; Folly Bridge and Bacon's tower 7, 160; University *Almanacks* 7, 160
Oxfordshire 5, 7

Paganus de Turbeville of Coity, Sir 135, **163**
Paine, Tom 240, 349
Palladio, Andrea 114
Palmer, Samuel 259, 260
Pangbourne 271, 273, 300
Pantheon Opera House 44, **56**
Paris, France 227, 229, 230, 231, 232, 237, 240, 247, 374, 384, 420

Paris, judgement of 335
Parker, Thomas Lister 178, 266, 294, 315, 316, 319, 322, 367, 441, 450, 462
Parliamentary elections 7, 289, 321, 322, 323, 402
Parmigianino (Girolamo Francesco Maria Mazzola) 36
'Pasquin, Anthony' (John Williams) 127, 140, 331, 334
Patent Graphic Telescope 413
Pearce, Miss 427
Pembroke Castle and town 110, 157, 205, **247, 335**
Pembury Mill 81, 317, **359**
Penegoes 159
Pennant, Thomas:
 A Tour In Wales 159
Penrith 350
Penton Hook 300
Penygroes 180
Penzance 398
Perugino, Pietro 384
Peterborough 91, 199
Petworth 49
Petworth House 311, 340, 341, 346, 357, 378, 382, **388**, 431–2, 437, 441
Pevensey 302, 364
Phidias 152, 374
Phillips, Thomas 246, 295, 379
Piles, Roger de 307
Pilkington, Sir William 431
Piranesi, Giovanni Battista 114, 133
Pitt, William the younger 364
Pitzhanger Manor 259, 277
Pliny the younger 307
Plym, river 429
Plymouth 398, 409, **425**, 426–31, 435, 443–4, 445
Plympton 398, 427, 444
The Pocket Magazine 116
Pollock, Jackson 241
Pontypridd 159
Poole 398, 432
Pope, Alexander 299, 300, 326, 335, 344, 402
Porden, William 19, 105, 163
Porthmadog 159
Portsmouth 117, 302, 303, 304, 324, 330, 397, 412, 443
Potter, Paulus 386
Poussin, Nicolas 78, 114, 142, 152, 157, 158, 164, 205, 232, 237, 244, 286, 313, 345, 354, 385, 399, 420, 437, 438
 WORKS: *The Israelites Gathering Manna* 235–6, **293**; *Landscape with a Man Killed by a Snake* 182; *Landscape with Pyramus and Thisbe* 385; *Landscape with a Roman Road* 385; *Winter (The Deluge)* **294**, 385, 420
Powis Castle 160
Pratt, John 252
Praxiteles 152

Pre-Raphaelite Brotherhood 291
Priapus, worship of 292
Price, Uvedale 78, 344
Priestley, Joseph 307
Primaticcio, Francesco 232
Prince Regent 362, 390, 396, 406, 409, 443, 456
Prout, Samuel 428
The Public Ledger and Daily Advertiser 226, 297, 406, 409
Pugin, Augustus Charles:
 The Gallery of the British Institution **332**
Purfleet 278, 304, 314
Purley 300
Putney 5, 326, 350
Pye, John 389, 397, 466

Queensferry 214

Raby Castle 227
Radcliffe-on-Trent 318
Raglan 159
Ramberg, Johann Heinrich:
 The Exhibition of the Royal Academy, 1787 **36**
Ramsgate 81
Raphael (Raffaello Sanzio da Urbino) 36, 164, 232, 349, 374, 375, 379, 384
 WORKS: *The Transfiguration of Christ* 231, **284**, 376; Cartoon for the *School of Athens* frescoes 375; *see also* Thornhill, Sir James
Redding, Cyrus 427–31
Reichenbach, the great fall of the 230, **307**, 366, **394**
Rembrandt van Rijn 74, 95, 133, 140, 156, 161, 164, 198, 208, 209, 232, 285, 286, 316, 382, 385–6, 421, 439, 456; as a major influence on Turner 129
 WORKS: *Christ in the Storm on the Sea of Galilee* **252**; *The Holy Family at Night* (attributed) 74, **89**, 316, 317, 334; *The Holy Family Resting on the Flight into Egypt* 114–16, 117, 129, 133, **137**, 139, 140, 154, 158, 193, 272, 385; *A Man in military costume* 382; *The Mill* 74, **90**, 193, 340, 357, 386; *The Three Trees* 386
The Repository of Arts 331, 333, 395, 409, 432
Reuss, river 230
Reynolds, Sir Joshua 15, 28, 34–6, 59, 76, 103, 122, 131, 135, 149, 152, 247, 297, 307–9, 318, 341, 342, 343, 344, 369, 373, 374, 376, 377, 380, 381, 383, 384, 387, 428, 452
 AND: associationism 152, 308; death and funeral of 44; drawing upon the art of the past 285; grandeur, the need to attain 36, 56, 152, 308; ideal beauty 36, 152, 297, 308, 341, 343, 374, 380, 381, 384, 411; overcoming the 'accidents of nature' 76, 103, 308; observation, the need for 343; painting and poetry 59, 149, 151, 308;

Turner's creative aims 152, 308; the 47 Leicester Fields house and studio 40; the 1813 British Institution retrospective exhibition 425
 WORKS: *Self-portrait* **42**; *Portrait of the future Lord Yarborough* **172**; *Portrait of Sir John Leicester* **317**; Oxford, New College Chapel, west window Nativity scene 160; Salisbury Cathedral, Resurrection window design 135–7, 160
Rheinfelden 230
Rhuddlan and Rhuddlan Castle 159, 180
Richards, John Inigo 250, 251, 377
Richardson, Jonathan 344
Richmond, Surrey 271, 299, 304, 326, 327, 365, 426
Richmond, Yorkshire 174
Rievaulx Abbey 412
Rigaud, John Francis 28, 147, 239, 251
Rigaud, Stephen Francis 147, 148
Ripon 141
Robert, Hubert:
 The Grand Gallery of the Louvre **283**
Robin Hood's Bay 214
Robinson, Henry Crabb 409
Rogers, Samuel 316
Rolls, William 353, 362, 379
Roman Catholic emancipation 405
Roman Catholic equality with Protestantism 180
Romano, Giulio 374
Romney Marsh 302
Romsey 116, 441
Rooker, Michael Angelo 7, 79, 95, 96, 138, 213, 285, 366; posthumous sale 213, **254**
 WORKS: *Battle Abbey-gate, Sussex* 49, 50, 52, **58**, 63, 72; *Newport castle* **254**
Rosa, Salvator 78, 95, 121, 142, 152, 193, **273**, 399
 Landscape with St Anthony and St Paul 227, **273**
Rosehill 355, 356, 364, 365, 368, 464
Ross-on-Wye 110
Rossi, Charles 163, 174, 221, 225, 247, 252, 257, 368, 379, 403
Rousseau, Jacques 385
Rousseau, Jean-Jacques 374
Rouw, Peter:
 Portrait of Francis Egerton, the 3rd Duke of Bridgewater **221**
Rottingdean 133
Rowlandson, Thomas 38, 39, 64, 69, 89, 152, 285, 432
Royal Academy of Arts in London, Somerset House 4, 20, 24, 28, 31, 33, 34, 36, 40, 44, 49, 54, 56, 59, 67, 68, 69, 71, 72, 78, 88, 92, 99, 100, 109, 111, 121, 122, 127, 131, 139, 142, 144, 145, 147, 148, 152, 157, 160, 161, 163, 164, 165, 170, 174, 183, 189, 190, 198, 204, 207, 221, 242, 225, 227, 237, 239, 244, 246, 247, 249, 250, 251, 253, 254, 257, 259, 264, 267, 275, 280, 281, 282, 284, 285, 289, 294, 295, 299, 305, 309, 312, 316, 323, 324, 330, 333, 337, 342, 354, 357, 359, 362, 365, 366, 368,

371, 376, 377, 378, 382, 390, 392, 395, 398, 401, 402, 403, 404, 406, 409, 415, 416, 417, 418, 420, 421, 423, 426, 429, 432, 433, 435, 438, 440, 441, 442, 443, 444, 445, 449, 452, 456
 AND: Academy of the Antique 20, 28, 31, 36, 39, 44, 45, 53, 88, 106, 374, 403; Academy of Living Models 31, 34, 53, 77, 93; aims and benefits, its institutional 31, 163; 'Antique Room' (during Exhibition periods prior to 1795) 45, 49, **57**; 'Antique Academy' (during Exhibition periods in and after 1795) 106, 122, 156, 190, 226; 'Anti-Room' (during Exhibition periods) 72, 127; catalogues, literary quotation in the Exhibition 148–9, 153, 166, 190, 191, 349 280, 381, 382; Club, Royal Academy 100, 223, 250, 323, 423, 425; Committees of Arrangement, Exhibition 241, 390, 395, 405, 406, 418; Council 20, 28, 149, 223, 224, 239, 240, 241, 246, 247, 250, 251, 252, 253, 257, 323, 324, 325, 350, 353, 362, 368, 371, 374, 376, 377, 390, 399, 402, 403, 405, 406, 409, 417, 418, 457; Council and General Assembly Room xi, 106, 122, 133, 154, 168, 190, 196, 204, 226, 240, 244, 283, 382; Council Dinners, New Year's Eve 417; democratic sympathies within 190, 198, 239, 240, 247, 250; Dinners, Exhibition 139, 204, 211, 213, 241, 242, 267, 282, 295, 310, 316, 324, 390, 406, 418, 420, 425, 441, 450; Dinners, the King's birthday 174, 415, 425; Diplomas 190, 224, 225; Diploma Work 224; doctrine, prevailing aesthetic 297
 ELECTIONS: Associates: 31, 156, 163, 174, 177, 182, 183, 185, 225, 304; Academicians: xi, 66, 221, 223, 293
 EXHIBITIONS: **1790**: 34; **1791**: 36; **1792**: 45, 93; **1793**: 72–3, 98; **1794**: 88–9, 95, 98; **1795**: 106–9, 110, 114; **1796**: 122–9, 133, 140; **1797**: 133–40, 403; **1798**: 153–6; **1799**: 166–72, 178, 205; **1800**: 190–8, 348; **1801**: 204–11, 213, 283; **1802**: 225–7, 237, 309; **1803**: 241–6, 310, 322; **1804**: 256–7, 280, 425; **1805**: 267; **1806**: 282–4, 283, 284; **1807**: 295–9, 302, 323; **1808**: 316–17; **1809**: 330–4, 337, 340, 351, 403; **1810**: 356–7; **1811**: 390–5, 396; **1812**: 406–9; **1813**: 418–23; **1814**: 441, 448; **1815**: 450–6
 AND: General Assembly meetings xi, 161, 177, 183, 224, 225, 237, 239, 240, 241, 246, 247, 250, 251, 252, 267, 275, 289, 304, 323, 353, 368, 371, 383, 399, 402, 403, 405, 417, 425, 431, 432; Great Room 34, 72, 127, 139, 153, 156, 167, 191, 193, 207, 208, 221, 225, 241, 242, 244, 246, 252, 253, 256, 282, 283, 295, 308, 316, 323, 325, 330, 331, 350, 356, 357, 368, 371, 375, 377, 378, 390, 392, 393, 405, 406, 415, 418, 441, 450, 452; Great Room as Lecture Room 35, 71, 308, 325, 371, 373, 375, 378, 384; Great Room posted list for consideration of election as ARA 156; pro and

529

anti-democratic sympathies 198, 239–40, 247, 250; Keeper 20, 28, 187, 241, 267, 435, 436; Library 45, 72, 241
 PROFESSORS: of Anatomy 323, 412; of Architecture 282, 304, 325, 353, 415; of Painting 203, 293, 304, 305, 341, 353; of Landscape Painting 293, 386; of Perspective 293, 299, 304, 305, 359, 368, 369, 373, 381; of Sculpture 353
 AND: institutional quarrels between 1802 and 1805 221, 239–41, 246–7, 250–2, 257, 267, 275, 443; regulations 28, 241, 421; sales clerk for the Exhibition 405; Schools 19, 20, 28, 283, 289; Varnishing Days 324, 406, 418, 441, 449
Royal Baggage Train 302
Royal Military Canal 302
Royal Society of Musicians 188, 189, 305, 399
Rubens, Sir Peter Paul 164, 232, 354, 377, 385, 386, 456
 WORKS: *The Carters* 386; *Tournament near a Castle* 386; *Village Kermesse* 386
Ruisdael, Jacob van 208, 232
Runnymede 272, 287
Rye 302
Ryde 116
Ryley, Charles Reuben 121, 344, 366, 368

Sackingen, Bad 230
Saftleven, Herman 114
St Asaph 159
St Bernard Pass, Great 230, 237
St Bernard Pass, Little 407, 408
St Catherine's Hill 304
St David's 111
St George's Church, Bloomsbury 374
St Giles's Cathedral, Edinburgh 214
St Gotthard Pass 435, 447
St Hugh of Châteauneuf 244
St Hugh of Lincoln 244
St Ives, Cornwall 399
The St James's Chronicle 89, 139, 155, 196, 226, 244, 256, 282, 334, 409, 422, 456
St John-Mildmay, Sir Henry 139, 241
St Luke's Hospital for Lunatics 187, 189, 201
St Leonard's Church, Sunningwell, Oxfordshire 7, **9**
St Marylebone Rate Books, 1807 304–5
St Mawes 398
St Michael's Mount 398, 432
St Nicholas's Church, Chiswick 291, **340**
St Paul's Cathedral 16, 17, **18**, **19**, 44, 204, 294
St Paul's Church, Covent Garden 1, 239
St Vincent, Battle of Cape 398
St Vincent, Windward Islands 452
Salisbury 116, 122, 135, 158, 174, 175, 199, 220, 398, 399, 426
Saltram House 429, 430

Salvador del Mundo, HMS 398
Sandby, Paul 95, 100, 182–3, 197
Sandby, Thomas:
 The Antique Room in the 1792 Royal Academy Exhibition 45, 49, **57**
Sand Pit Close site, Twickenham 299, 337, **377**, 445
Sansovino, Jacopo 33
Sarcophagus of the Muses, Roman 232
Scarborough 213, **411**
Schaffhausen 230, **334**
Seacombe 398
Serres, Dominique 286
Serres, John Thomas 186, 187, 253, 282, 286
Serres, Olivia Wilmot 186–7
Severn, river 54, 109, 110, 159
Shakespeare, William 344
Shee, Martin Archer 163, 198, 231, 344–6, 357
 Portrait of Walter Fawkes (attr.) **361**
Sheep's Tor 430
Sheerness 277, 278, 304, **343**, **355**
Sheffield 141
Sheldon, Dr John 111
Shelford Manor House 91, 318
Shepton Mallet 399
Shrewsbury 91, **128**
Shropshire 202
Sibthorp, Col. Humphrey 256
Sidmouth 398
Simmons, Dr Samuel Foart 187
Singleton, Henry:
 Portrait of John Fuller **387**
Sirigatti, Lorenzo 380
'Sister arts' 151, 313, 341, 379; *see also under* Turner J. M. W., poetic painting, theory of
Skipton 319
Smirke, Mary:
 Portrait of Robert Smirke **215**
Smirke, Robert 174, 183, 190, 198, 221, 225, 231, 240, 247, 252, 254, 257, 267, 298, 354, 405, 406
Smirke, Robert junior 190, 337, 353, 355, 384
Smith, John Raphael 15–16, 17, 19, 20
Smith, John 'Warwick' 174, 204
'Smith, Mr, of Gower-Street' 213
Snowdon, Mount 157
Snowdonia 159
Soane, Elizabeth 254
Soane, John 44–5, 88, 221, 225, 247, 250, 251, 252, 254, 259, 260, 271, 273, 277, 281, 293, 294, 299, 323, 339, 364, 368, 373, 379, 415, 416, 457
 AND: Bank of England Stock Office 88; Covent Garden Theatre criticism 353; lectures on architecture 325, 350, 353, 403; Professor of Architecture, as 282, 353
Society of Arts 71–2, 122
Society of Painters in Water-colours 266, 267
Soho Academy 15
Somer Hill 351, 364

Sotheby, William 316
Southampton 116
Spithead 117, 302, 304, 330, 331, **371**, **372**
Stadtholder William V, the Prince of Orange-Nassau xi, 210, 211
Stafford, George Granville Leveson-Gower, 2nd Marquess of 213, 244, 368
The Star 207, 225, 242, 256, 282, 297
Standing Discobolus 31
Staubbach waterfall 230
Stephens, Frederick George 291
Stirling 214
Stokes, Charles 412
Stonehenge 399
Stonyhurst College 178, 179, 180, **222**, **223**
Storace, Nancy 259
Stormont, David Murray, Viscount (later 3rd Earl of Mansfield) 116, 284
Stothard, Thomas 198, 223, 281, 381, 418
Stourhead 112, 114–16, 158, 165, 264
Strasbourg 230
Stuart, Gabriel:
 Portrait of Thomas Malton **21**
The Sublime 111, 237, 420
Sueur, Eustache Le 345
The Sun 167, 196, 256, 257, 297, 362, 376, 379, 380, 381, 382, 383, 387, 395, 409, 422, 449, 456
Sun Fire Insurance Company 253, 294, 311
Sunningwell, Oxfordshire 5, 7, 24, 25, 54, 77
Sussex, Prince Augustus Frederick, Duke of 457
Sutton Courtenay 274
Swallow Falls 159
Swanage 398
Swanevelt, Herman van 232
Swansea 110, 159
Swift, Jonathan 246
Swinburne, Sir John 396, 441, 450, 464
Switzerland 227, 229–30, 231, 237, 321, 337, 360, 366
Sydenham, Thomas 202

Tabley House 242, 318–19, 323, 324, 333, 366, **373**, **374**
Taff, river 159
Tamar, river 399, 409, 427, 428, 430, 464, 444
Tantallon Castle 214
Tarbet 216, **259**, **261**
Tavistock 444
Taylor, Brook 307
Taylor, John 283, 362, 376, 377, 379, 380, 383, 387, 422, 456
Teignmouth 398, 409
Temeraire, HMS 277
Tenby 110
Teniers, David, the younger 69, 114, 125, 152, 208, 243, 256, 265, 283, 284, 285, 296, 297, 316, 317, 324, 357, 386

WORKS: *Barn interior with a maid preparing vegetables* **154**; *Flemish marriage-feast* 350, 386; *Kermesse* 297
Tewkesbury 77
Thames, the river 5, 8, 11, 12, 16, 84, 95, 260, 267–75, 277–9, 282, 291, 294, 295, 299, 300, 304, **310**, 311, 312, 313, 314, **320**, **321**, 324, **324**, **325**, **326**, **327**, **328**, 326, 328, **343**, **354**, **355**, **356**, 439
Theatre Royal, Covent Garden xi, 259
Theed, William 423
Thomas, Gerard 316
Thomson, Henry 246, 254, 299, 319, 379, 441, 452
Thomson, James 122, 300, 301, 304, 325–7, 335
 'King of Day' trope 155, 343, 380
 WORKS: *Ode on Æolus's Harp* 325; 'The Castle of Indolence' 325; *The Seasons* 326, 327: 'Spring' 156; 'Summer' 155–6, 172, 343; 'Autumn' 418–19; 'Winter' 360
Thornbury, Walter 4, 5, 19, 28, 66, 132, 164, 239, 325, 368, 452
Thornhill, Sir James:
 Raphael copies 375
Three Oaks 364
Thun 230
The Times 140, 244, 295, 443, 456
Tintagel 399
Tintern Abbey 54, 78, **96**, 127, **157**, 159, 182
Titian (Tiziano Vecellio) 95, 164, 232, 234, 237, 271, 286, 295, 384, 399
 WORKS: *Christ Crowned with Thorns* 234, **290**; *The Death of St Peter Martyr* 231–2, 234–5, 244, 271, **285**, 346, 384, 385; *Diana and Actaeon* 384; *The Entombment of Christ* 232, 234, **286**; *The Holy Family with a Shepherd* 244; *Venus with a Lute Player* 384; *Woman with a Mirror* 232, **288**
Tiverton 444
Tonbridge 81, 351
Totland Bay 116
Totnes 398, 444
Townley, Charles 178, 179
Traeth Mawr 180, **225**
Trafalgar, Battle of 277, 282, 289, 310
Trajan's Column, Rome 374
Treaty of Amiens 223
Tresham, Henry 175, 241, 305, 423
Trimmer, Elizabeth 10
Trimmer, Revd Henry Scott 5, 7, 9, 10, 156, 340, 397, 420, 441, 452
Trimmer, Revd Henry Syer 5, 397, 416, 419–20, 452
Trimmer, John 10
Trimmer, Sarah 7
Trimmer family 10, 19
Truchsess, Count Joseph 250
Truchsessian Gallery 250, 253
The True Briton 244, 297
Truro 398
Tuberculosis 5, 10, 239

Tummel, Loch 214, **264**, **266**
Tunbridge Wells 364
Turner, Charles 121, 266, 281, 286, 289, 299, 311, 317, 325, 371
 WORKS: 'A Sweet Temper' (formerly attributed to) 121, **149**; *Portrait of William Turner* 1; *A shipwreck with Boats endeavouring to save the Crew* (mezzotint engraving) 266, 281, 286, 362
Turner, John the younger (paternal uncle) 399
Turner, Joseph Mallord William
 AND: 'Academical', becoming 249; accident in 1798 146; 'accidents of nature' 76, 111, 151, 384; activity versus stillness 115; allegory 74, 76, 122, 139, 152, 154, 167, 180, 287, 308, 327, 362, 364, 390, 401–2, 452, 454, 457; anatomy 111, 323, 337, 374, 412; ancestors 1, 2; animals 158, 159, 160, 397, 399, 416, 420; application, views on 341; architects, work for 19, 105; architecture, draws inspiration from ecclesiastical 91, 126, 199; articulates awareness of inner processes and physical laws 151–2, 308, 342–3; astronomy 326, 349–50; art critics and connoisseurs, views on 344, 345, 397; artificial light 96, 98, 103, 383; associationism 59, 76, 115, 122, 135, 151, 152, 165, 197, 234, 235, 237, 244, 250, 300, 313, 343, 362–4, 376, 385, 402, 403, 409, 457, 458; 'Backgrounds' lecture 384–6, 387, 403; Bank of England 88, 365
 BANK OF ENGLAND TRANSACTIONS AND HOLDINGS: **1794**: 88; **1797**: 146; **1798**: 165; **1803**: 253; **1804**: 260, 262; **1805**: 275; **1806**: 285, 291; **1807**: 292, 299; **1808**: 315; **1809**: 319, 335, 319, 323, 350; **1810**: 365, 368; **1811**: 402; **1812**: 403; **1813**: 425, 426; **1814**: 442, 443; **1815**: 448, 458
 AND: Bible, familiarity with the Holy 8, 10, 122; birth 1, 3, 122; birthday, putative 1, 17, 211, 406, 458; boat 260, 267–75, 285, 294, 295, 300, **311**, **312**; boyhood schooling 5, 8, 10–11, 15; breaks with the Royal Academy in 1804 257; British Institution Premium Competition attack on the British Institution itself, 1814 417–18, 413, 433, 435, 436–8, 439–41; catalogue quotations, Royal Academy Exhibition 148–9, 153, 155, 155–6, 166–7, 170, 190–1, 349 280, 325–6, 329, 381, 382, 407–9, 418–19, 420, 422, 441, 452, 454; 'Chef d'oeuvre' xi, 455; clothing, 1799 inventory of 186; cockney accent 31, 40, 246, 405, 412; colour 16, 100, 105, 114, 115, 126, 129, 133, 135–6, 139, 145, 164, 190, 199, 223, 232, 234–7, 260, 273, 286, 317, 328, 342, 343, 346, 362, 374, 375, 382–3, 384, 385, 386, 387, 389, 416, 420, 422, 431, 438, 441, 455, 457; concentration, intense mental 21, 187, 228, 260; Council, first sits on Royal Academy, 1803 239; Council, breaks with in 1804 257; Council, begins second term on Royal

Academy, 1811 377; Council, completes second term on 417; *Datura stramonium* 417; decorum, artistic 59, 76, 116, 122, 126, 138, 139, 151, 152, 166, 168, 170, 174, 191–2, 197, 220, 234–7, 244, 250, 285, 308, 313, 316, 327, 345, 362, 364, 384, 385, 392, 394, 402, 403, 412, 419, 420, 421–2, 447, 454–5, 456; Diploma, receives ARA 190; Diploma, receives RA 225; Diploma painting, RA 224–5, **243**; directionality in images 103; drawing, views on 341; economy, artistic 111; election as Associate Royal Academician 156, 163, 174, 177, 182–3, 185, 186; election as Royal Academician 207, 221, 224; election as Chairman of the AGBI Council 457; engraving 15, 16, 25, 38, 39, 116, 118, 133, 139, 157, 158, 165, 204, 253, 266, 286, 295, 297, 299, 308, 311, 325, 356, 365, 371, 373, 377, 379, 389, 409, 418, 431, 432, 439, 443, 444
 FARNLEY HALL VISITS: **1808**: 319–23; **1809**: 346, 348, 349–50; **1810**: 364, 366–8; **1811**: 397, 399, 401; **1812**: 417; **1813**: 431; **1814**: 447
 AND: Elgin, Lord 166, 285; 'Fallacies of Hope' 401, 407, 409, 452; fishing 1, 5, 16, 110, 133, 214, 260, 269, 271, 272, 274, 285, 299, 318, 319, 323, 340, 397, 398, 416, 417, 444, 458; frames, payment for 213; fraud, party to 187, 189, 201, 220; French artists, negative views on contemporary 237, 341, 342, 345–6, 371; Fulham visit, 1799 174; gallery in father's shop window (1787 or 1788) 4; General Assembly meeting, Chairs first 402; genius, views on 344; 'Gift, Turner's' 457; Girtin 239; 'Gonorrhoea, Cure for' 431; grandeur, need for 36, 44, 56, 71, 81, 100, 112, 131, 133, 140, 146, 152, 168, 171, 205, 256, 286, 307, 308, 359, 374, 376, 379, 385, 447, 456; Great Room/ Lecture Room lighting improvements 350; 'Greater Silver Pallet' of the Society of Arts 71–2, **87**; Hammersmith, 6 West End, Upper Mall 291, 299, 304, 305, 312, 335, 350, 365, 366, 405; Hand-court 3, 73, 160, 164, 174, 183; Hand-court, rents additional studio-space in 131; No. 64 Harley Street 183, 185–7, 198, 209, 223, 225, 247, 253, 256, 257, 259, 262, 275, 278, 282, 285, 289, 291, 300, 304–5, 312, 334, 335, 365, 395; No. 64 Harley Street lease 252; No. 64 Harley Street, Portland Estate Plan of **231**; 'Historical colouring' 234–7; history painting 71, 151, 152, 157, 211, 237, 256, 257, 368, 384, 387, 410, 422 ; Hogarth's *Analysis of Beauty*, reads 300, 308; idealism and ideal beauty 5, 16, 36, 111, 114, 126, 152, 157, 158, 165, 204, 280, 286, 293, 308, 309, 318, 341, 343, 344, 362–4, 373–4, 379–80, 384, 385, 387, 394, 403, 448, 454, 456, 458; ideal synthesis 76, 103, 111, 297, 308, 324, 364, 380, 385, 406; illnesses 146, 417; Industrial Revolution 66–7, 78, 79;

invention and accretion, views on 342; Isleworth, Syon Ferry House 260, **261**, 262, 267, 269, 271, 274, 278, 285, 299, 311, 365; judgement, views on 345; Lee Clump property 289, 323, 365, 366; *Liber Studiorum* 139, 286–9, 291, 292, 295, 299, 303, 304, 311, 315, 317–18, 324, 325, 342, 365, 371–2, 395, 403–4, 406, 409, 410–13, 418, 443; light 11, 24, 45, 77, 81, 88, 100, 103, 105, 114, 115, 116, 122, 155, 160, 161, 165, 170, 193, 318, 337, 341, 374, 375, 381–3, 384, 385, 386, 387, 428–9; Liverpool Academy of Arts 366–7; love life or lack of 132, 305, 350, 458; low-relief sculpture, views on 342, 368, 371, 374, 382, 412; observation, memory and imagination 8, 19, 71–2, 92, 103, 111, 122, 140, 141, 149, 173, 190, 225, 292, 295, 298, 300–1, 307, 308, 341, 343, 358, 362–4, 373–4, 392, 398, 430, 431, 457, 458; metaphor 116, 122, 126, 135–9, 154, 244, 308, 362–4; mind of 457–8; misogamy of 188; monograms 439; moral landscape painting 6, 45, 68, 69, 89, 106, 122, 125, 127, 133, 135, 151, 152, 175, 211, 225, 230, 295, 300, 313, 325, 328, 333, 374, 402, 405, 408–9, 412, 422, 447, 455; music 202–3, 300, 319; 'Mystic shell of colour in search of form' 386; nature, concept of 381; No. 75 Norton Street, Marylebone 185, 188, 198, 203, 220, 225, 260; 'Obligation', Royal Academy 225; 'Oeconomical motives' 1806 285, 315; oil sketches on mahogany veneer 267–9; oil sketches on white canvas 267, 272–5, 278; oil sketching outdoors 267–9, 272–5, 427–9, 431; Opie annotations 341–3, 344, 346, 371; Oxford colleges 160, 213, 249–50; oil painting palette, 1802 223; painting and poetry 59, 69, 135, 149, 151, 197, 211, 225, 308, 313, 341, 343, 350, 362, 363, 364, 379; Paris, subsidy of 1802 visit to 227, 237; Perspective, as Professor of 11, 106, 114, 282, 289, 293–4, 299, 304, 305, 307–9, 311, 319, 323, 337, 342, 346, 359, 361, 362, 366, 368, 373, 397, 403, 406–7, 417, 431, 439, 440, 455, 457

PERSPECTIVE LECTURES: **1811**: first lecture 371–7; second lecture 377–9; third lecture 379; fourth lecture 379–81; fifth lecture 381–4; sixth lecture 384–7; **1812** 402–3; **1813** series cancelled due to illness 417; **1814** 435–6; **1815** 447

AND: pictorial rhyming and simile 81, 152, 390, 404; the Picturesque 78–9, 344; Platonic idealism 36, 114, 152, 308, 309, 342, 373–4, 379, 394, 380, 381, 411; poetic painting, theory of (*Ut pictura poesis*) 135, 149, 151–2, 153, 160, 167, 171, 191, 308, 341, 343, 362–4, 368, 379, 387, 394, 410, 420, 454, 458; poetry, attraction to 122, 300, 457–8; poetry of 160, 191, 196, 300, 301, 303, 304, 326, 327, 329, 333, 334, 335, 340, 344, 345, 346, 349–50, 359–61, 379, 382, 392, 397, 399, 401, 407–9, 409, 432, 439, 452; poetry, prophecy and painting 402; politics, liberty and its constraints 8, 190, 191, 198, 221, 247, 390; politics, London art 122, 161, 163, 257, 280, 440

PRINT SERIES AND BOOK PROJECTS: *Britannia Depicta* 203–4, 217; 'Picturesque Views in England and Wales' 7, 112, **135**, 426; 'Views in the Isle of Wight' 116–18; 'Southern Coast of England' 389, 395, 397–9, 425, 429, 432–3, 443, 444, 447; *History of Whalley*, 177–8, 179, 180

AND: 'qualities and causes' (Opie annotation) 151, 152, 308, 342–3; Queen Anne Street West 185, 186, 253, 312, 325, 333, 335, 355, 357, 364, 365, 390, 395, 405, 417, 420, 425, 431, 442, 443; Queen Anne Street West storage facility 335, 443; No. 44 Queen Anne Street West 335, 365; quill pen, drawing with a 21, 24; reflectivity 19, 25, 88, 105, 110, 382–3, 455; Reynolds's *Discourses*, 36, 152, 285, 308–9, 319, 343, 373–4, 411; Reynolds's fifteenth discourse on 10 December 1790, attending 34–6, 373–4, 376, 386, 411; Reynolds's 47 Leicester Fields house 40; Reynolds's portraits 40; 1793 Rochester Castle oil painting 81; Royal Academy Inner Room conversion 377, 392–5; Royal Academy Schools, training for entry to the 19–20, 28; Royal Academy Schools attendances 31–4, 39, 44, 53, 94–5; Royal Academy under threat, 1803 247; scale, enhancements of 36, 41, 44, **66**, 71, 81, 89, 111, 112, 133, 146, 151, 152, 168, 170, 205, 253, 286, 374, 376, 447, 452; scale practice, the tonal 49–53, 54–65, **64–80**, 66, 67, 69, 73, 81, 174–5, 260, 299, 304, 311; 'Scilica' 220; 'Scottish Pencils' drawings 214, 216–17; sea, representation of the, *c*.1804 254, 256, 257, 283; secrecy, need for 5, 187, 188, 201, 220; sexual imagery 292, 454; Shee annotations 343–6; skies, drawings of 17, 19; slavery 140, 175, 262, 264, 321, 323, 355, 420–1, 422; smuggling at Folkestone 302; Society of Arts competition, 1793 71–2; Solus Lodge/Sandycombe Lodge 337–9, **377–80**, 402, 415–17, **421**, 425, 426, 443, /445; 'Southern Coast' poetic sketch 397, 398, 399, 432; stained glass 126, 135–7; standard 200 guinea charge for 36 by 48 inch canvases 255, 396; stipple technique 20, 53; stocktaking, 1810 364–6; Sugar Work Tontine, Dry 262, 264, 289; summer of 1796, mysterious 132; taste, views on 344; teaching of amateurs 105–6, 163–4; 'testimony of moral character' 28; 'tonal variety' method 51

TOURS AND PAINTING EXPEDITIONS: **1791**: Bristol and environs 40–4; **1792**: Wales 53–4, Canterbury 54; **1793**: Wales, Herefordshire and Worcestershire 77, Rochester and east Kent 81, 84; **1794**: Midlands and North Wales 91–2; **1795**: Wales 110–11, Isle of Wight 116–17; **1797**: North of England 140–4; **1798**: Kent 147–8, Wales 158–60; **1799**: Lancashire and North Wales 178–82, Kent 182; **1801**: North of England and Scotland 213–17; **1802**: France, French Savoy, Piedmont and Switzerland 227–31, Paris stay 231–7; **1805**: Upper Thames Valley, first tour 267–71, second tour 272–5; **1806**: Long Reach, Medway visit and Thames estuary in winter tour 277–9; **1807**: Upper Thames 300, south-east coast of England 302–4; **1808**: Midlands, Wales and Yorkshire 318–19, 319–23; **1809**: North of England 346–50; **1810**: East Sussex 364, Yorkshire 366–8; **1811**: West Country, Yorkshire 397–9; **1812**: Yorkshire 417; **1813**: West Country 426–31, Yorkshire 431; **1814**: Portsmouth 443, West Country 443–4, Yorkshire 447

AND: training, views on art 345; Turner Gallery (1804) 247, 252–3, 274, 278, 285, 292, 299, 300, 304, 305, 311, 316, 318, 322, 335, 340, 350, 355, 364, 365, 366, 395, 405, 423, 443; Turner Gallery dimensions and attributes 252–3

TURNER GALLERY EXHIBITIONS: **1804**: 254–5, 256, 257, 259; **1805**: 264–6, 420; **1806**: 282, 309, 322; **1807**: 294–5; **1808**: 312–15; **1809**: 325–30, 340, 350, 367, 450–1; **1810**: 357–62; **1811**: no exhibition 390, 395; **1812**: 409; **1813**: 418, 425; **1814**: 441–3

AND: Twickenham land acquisitions 299; 'Verse Book' 300, 327; Visitor, as Schools 305, 377, 402–3, 415; water, reflectivity of 110, 318, 359, 382, 383; watercolours, primary and secondary approaches to making 174–5; watercolours, experimental approaches to making 174–5, 220, 160; words, attraction to 457–8; '60 drawings now bespoke' in 1799 174; '1809 Fawkes lists 324

WORKS:

Drawings: *Alum Bay, Isle of Wight* 116, **141**; *Aosta with Mt Emilius in the distance* 229–30, **281**; *Army of the Medes*, possible study for the 207, **249**; *Army of the Medes* 205, 207; *The Artist's Studio* 334–5, **376**; *Avernus, Lake*, after Colt Hoare 158, **195**; *Blasted oak tree* 178, **224**; *Boat, internal layout of a* 260, **311**; *Boat, sketch of a* 260, **312**; *Carisbrooke Castle* 116, **140**; 'Calais Bar, Our Situation at' 228, **275**; *Cassiobury Park, Beech Trees at* 131, **159**; 'Chamoni Mt Blanc' 229, **279**; *Classical river scene* 271, **322**; 'Contamine – avec Mt Blanc' 229, **280**; 'Cran Mere Pool' 444, **431**; *David, kneeling male nude, posed as* 160, **197**; *Dido and Aeneas*, study for 271, **323**; *Dolbadern Castle, North Wales*, pastel study for 189, **232**;

Ely Minster: Transept and Choir 92, **109**;
Folkestone, Wrecked vessels aground at 302, **350**;
Fonthill Abbey from the south-west 176, **217**;
Fonthill House 175, **216**; *Kidwelly Castle* 112,
134; *Kilchurn Castle* 216–17, **262**;
?Killiecrankie 214, **265**; *Llandaff Cathedral, west
front* 110, 111, **132**; *Loch Lomond from near
Inveruglas* 214, **257**; *Loch Lomond, Promontory
of Rubha Mor on* 214, **258**; *Loch Lomond from
near Tarbet* 216, **259**; *Loch Tummel* 214, **264**;
Lock and windmill pencil studies 340;
Louth, Lincolnshire 142, **174**; 'Mer de Glace'
229, **278**; *Monograms* 439, **429**; *Pope's Villa at
Twickenham, Study for* 300, **348**; *Richmond
Hill from the River* 271, **321**; *Rochester* 86;
St Leonard's Church, Sunningwell 7, **9**; *St
Paul's Cathedral with the King* 16–17, **18**, **19**;
Sand Pit Close site, View of the 337, **377**; Sand
Pit Close proposed villa, three elevations and
two plans 337, **378**; Sand Pit Close, rough
sketch from the north-west 337, **379**; Sand
Pit Close villa, first sketch of the final design
337, 339, **380**; *Satyr approaching a naked woman*
292, **342**; Titian's *Christ Crowned with Thorns*,
Copy of 234, **291**; Titian's *Entombment of
Christ*, Copy of 232, 234, **287**; Titian's
Woman with a Mirror, Copy of 232, 234, **289**;
Two figures coupling 292, **341**; *Upper Mall,
Hammersmith, View from* 291, **340**; *The
'Victory'* 277, **329**; *'Victory', The Quarterdeck
of the* 277, **330**; *Voreppe, The Post-House* 229,
277; *Westminster Abbey with Henry VII's
Chapel* 24, **23**; *Winchester Cathedral* 116, **139**

Drawings, cast: 'Apollo Belvedere' 33, **38**;
'Belvedere Antinoüs' 31, **37**; Torso and Head of
the 'Apollo Belvedere' 33, **39**

Drawings, life: Male nude seated cross-legged 53,
62; Male nude seated with a staff 93–4, **112**;
Male nude, standing 94, **113**

Engravings after: *Elgin Cathedral, Morayshire*
116, **138**; *Kilchurn Castle, Loch Awe* 217, **263**;
Lyme Regis 444; *Poole* 432; *Pope's Villa at
Twickenham* 389, 397, 399, 401–2, **407**; *St
Michael's Mount* 432; *Shipwreck with Boats
endeavouring to save the Crew* 266, 281, 286,
362; *Stonyhurst* 179–80, **223**

Lecture diagrams and illustrations: *The Admiralty*
375, **399**; *Carlton House, Pall Mall* 375, **398**;
Conic sections 377, **401**; metal globes 383, **404**;
Pulteney Bridge, Bath 380–1, **403**; *Royal
Academy Great Room/Lecture Room north wall*
378, **402**; Raphael's *Transfiguration* lecture
diagram, 237, 376, **400**; Transparent globes 383,
405

Liber Studiorum engravings: *Basle* 299; *Blair
Athol, Near* 395, **412**; *Bridge and Cows*
(preliminary drawing) 289, **338**; *Bridge and
Cows* (etching) 289, **339**; *Bridge and Cows*
(final print) 299; *Bridge in Middle Distance*
316, **360**; *Coast of Yorkshire* 371, **396**;
Frontispiece (Europa and the Bull) 410–12, **420**;
Hedging and Ditching 304, 412; *Hind Head
hill* (preliminary drawing) 287, 303–4, **351**;
Inverary Pier 395, **414**; *Jason* 299; *Juvenile
Tricks* 371, **395**; *Martello Towers near Bexhill*
395, **413**; *Mer de Glace* 412; *Morpeth* 325,
364; *Peat Bog, Scotland* 400, 406, **417**;
Pembury Mill (etching) 317–18, **359**; *Procris
and Cephalus* 403–4, **416**; *Rivaux Abbey*
412–13; *Temple of Minerva Medica* 292; *Scene
in the Campagna* 292; *Scene on the French
Coast* 299; *Solway Moss* 286–7; *The Straw
Yard* 311; *Woman and Tambourine* (preliminary
drawing) 287, 299, **337**

Oil paintings: *Aeneas and the Sibyl, Lake
Avernus*, 1798 165–6, **202**; *Aeneas and the
Cumaean Sibyl, Lake Avernus*, 1815 448–9,
465; *Apollo and Python* 392, **409**; *Apullia in
search of Appullus* **428**, 436–9; *Army of the
Medes* 205, 207; *Avalanche in the Grisons, Fall
of an* 352, 359–62, **392**; *Beech Wood, A* 182,
230; *Ben Lomond Mountains, Scotland* 216,
225; *Bere, Forest of* 302, 304, 306, 314–15,
357, 463; *Blythe-sand, Fishing upon* 325, 354,
450, 452; *Boats carrying out anchors* 256–7,
264, **308**; *Bonneville* [B.J.46] 465; *Bonneville*
[B.J.124] 464; *Bonneville* [B.J.148] 460, 461;
Buttermere Lake 156, **189**; *Calais harbour,
Fishing boats entering* 254, 257; *Calais Pier*
238, 242–4, 254, 365, **298**; *Cliveden on Thames*
295; *Cockermouth Castle* 340, 350, 359, **391**,
463; *Colebrook Dale* 140, **170**; *Coniston Fells,
Morning amongst the* 153–4, **185**; *Conway
Castle* 460; *Country blacksmith, A* 285, 295–7,
298, 299, **344, 346**, 462; *Crossing the brook*
436, 452–4, 456; *Dee, Trout Fishing in the* 329,
339, **369**, 463; *The Deluge* 264, 365, 420–3,
423; *Dido and Aeneas* **430**, 434, 441; *Dido
building Carthage* 452, **437**, 454–6; *Discord,
The goddess of* 252, 280–1, 300, **333**, 365;
Dolbadern Castle 184, 191–3, **239**;
Dunstanborough 462; *Dutch boats in a gale* xi,
207–11, **251**, **253**; *Fifth Plague of Egypt* 193,
196, **240**; *Fish market* 357, 364, 463; *Fishermen
at sea* 127, 129, **158**, 460; *Fishermen becalmed*
462; *Fishermen coming ashore at sun
set/Mildmay seapiece* 139, 140, **169**, 403, 460;
Fishermen on the beach 461; *Fishermen upon a
lee-shore* 225, **268**; *Frosty Morning* 412, 415,
418–20, 421–3, **422**; *The Garreteer's petition*
333–4, **375**; *Goring Mill and Church* 273, **326**;
Hannibal and his army crossing the alps 229,
368, 405–9, **418**; *Harlech Castle, summer's
evening twilight* 167, **204**; *Holy family* 244,
299, 365; *Hulks Tamar* 409, 464; *Jason* 226–7,
309, **272**; *Kilgarren castle on the Twyvey* 167–8,
205; *Kingston Bank, Harvest Dinner* 274, 328,
368; *Linlithgow* 463; *London* 301, 304,
329–30, 366–8, **370**; *Lowther Castle[s]* 337,
350, 356, 463; *Margate* 278, 304, 463; *Margate
Pier* 259; *Margate, Winter sunrise* 278, **331**;
Mâcon, Festival upon the vintage of 241–2, 246,
254, 266, **297**; *Mercury and Hersé* 390–1, 394,
395, 396, **408**, 409, 464; *Moonlight, a study at
Millbank* 139, **168**; *Morning amongst the
Coniston Fells* 153–4, **185**; *Narcissus and Echo*
160, 280, 365, 425, 464; *Newark Abbey on the
Wey* 295 461; *Oxford, High Street* 351, 353,
355, 357–9, **390**, 404, 405–6; *Oxford, distant
view* 366, 402, 404–5, 405–6; *Petworth, Sussex*
357, **388**; *Plompton Rocks*, two views of
141–2; *Plymouth Harbour, view over* 424, **425**,
427–8; *Pope's Villa at Twickenham* 299–300,
301, 304, 312–13, 326, 327, 389, **354**, 401–2,
407, 463; *Purfleet from the Essex shore* 278,
304, 314, 462; *Richmond hill and bridge* 304,
365; *River Scene with Cattle* 319, 366;
Rochester Castle 81; *Rosehill* 464; *Saltash,
with the Water Ferry* 409, **419**; *Schaffhausen,
Fall of the Rhine at* 254, 257, 282, 283, 292,
334; *Self-portrait*, 1789 16, **16**, 21; *Self-Portrait*,
c.1800 197–8, **243**; *Sheerness as seen from the
Nore* 278, 304, 313–14, 315, **355**; *Sheerness and
the Isle of Sheppey* 294, 315, **343**, 462; *Ships
bearing up for anchorage* 226, 264, **270**, 461;
*Shipwreck with Boats endeavouring to save the
Crew* 264–5, 266, 283, 292, **315**, 365, 461;
Slough, Plowing up Turnips near 327–8, 365,
366, 367; *Sodom, Destruction of* 265–6, **316**,
365; *Southall Mill, Grand Junction Canal at*
340, 357, **389**; *Spithead* 304, 330–1, 365, **371**,
372; *The Straw Yard* 311, **353**; *Sun rising
through vapour*, 1807 290, 297–9, 323, 324,
366, **347**; *Sun rising through vapour*, 1809 302,
324, 329, **363**, 366; *Tabley oil sketch on paper*
318; *Tabley, Calm morning* 318, 319, 323,
331–3, 337, 340, 351, 357, 365, **374**, 403, 464,
465; *Tabley, Windy day* 318, 319, 323, 331–3,
337, 340, 351, 357, 365, **373**, 403, 464, 465;
Teignmouth 409, 464; *Tenth plague of Egypt*
225, 237, 254, **269**, 365; *Thames at Eton* 295,
304, 462; *Thames at Weybridge*, 311, 462;
Thames, Barge on the 272–3, **325**; *Thames,
House besides the* 272, **324**; *Thames Lock* 463;
Thames and Medway, confluence of the 304,
314, **356**, 463; *Thames, Trees beside the* 272,
327; *Thames near Windsor* 295, 462; *Thomson's
Æolian Harp* 320, 325–7, 333, 341, 350, **365**,
463; *Trafalgar, Battle of* 309–10, **352**, 365;
Transport ship, wreck of a 362, **393**, 463;
Tummel Bridge, Perthshire 217, **266**; *Union of*

the Thames and Isis (aka *Dorchester Mead*) 304, 365; *The Unpaid bill* 292, 316–17, 334, **358**; *Venus and Adonis* 465; *Victory in Three Positions* 282, 322, 323, 324, 366, 463; *Walton bridges*, 1806 282, 292, 461; *Walton bridges*, 1807 294–5, 462; *Watermill and Stream* 39, **46**; *Whalley Bridge* 390, 393; *Windsor Castle from the river* 269, **319**; *Windsor Castle from the Thames* 271, 311, **320**, 462; *Windsor, near the Thames Lock* 463

Sketchbooks: *Academical* 164, **198**; *Academy Auditing* 292, **342**; *Boats, Ice* 439; *Cockermouth* 346; *Finance* 292, **341**, 365, 443; *Fonthill* **216**, **217**, **218**, **219**, **236**; *Greenwich* 301, 324, 327, 348, 439; *Harvest Home* 351; *Hastings* 351; *Lowther* 415; *Spithead* **291**, 302, 303, 304; *Studies for Pictures* **214**, **232**, 420; *Studies in the Louvre* 232, 234, **287**, **289**, **291**, 237; *Swans* 160

Watercolours: *Aberdulais Mill* 117, **142**; *Abergavenny bridge*, R.A. 1799 168, **206**; *?Ash Grove, Knockholt, Kent* 220, **267**; *Avon, mouth of the* 41, **48**; *Bath Abbey from the north-east* 41, 44, **51**; *Bath Abbey, West front* 104, 126–7, **156**; *Bath, The Vale of, from Kingsdown Hill*, 1792–3 63, **76**; *Bay on a rocky coast with a man running*, 1792–3 64, 110–11, **78**; *Bolton Abbey, Yorkshire* 346, 348, 386, **384**; *Bridge seen through trees, unidentified* 258, 273, **328**; *Brighthelmstone* 133, **161**; *Brighton from the west* 133, **160**; *Bristol Cathedral from the north-west* 44, **52**; *Bristol, Hot Wells, from St. Vincent's Rock* 41, **49**; *Bristol, Stoke House* 41, **50**; *Britain at Peace* 74–6, **91**, **92**, 152, 287; '*Cader Idris, Pool on the Summit of*' 159, **196**; *Cadair Idris, Afterglow* title pages, 189, **233**; *Caernarfon Castle, sunset*, 1798 164, **198**; *Caernarvon Castle*, R.A. 1799 170–1, **209**; *Caernarvon Castle, North Wales*, R.A. 1800 196–7, **241**, 348; *Cambridge, King's College Chapel* 91, **107**; *Cannon Foundry, A* 142, 144, **175**; *Canterbury Cathedral, St Anselm's chapel* 88–9, 98, 151–2, **105**; *Canterbury, Christ Church Gate* (Cathedral Close view) 55, **64**; *Canterbury, Christ Church Gate* (street view) 56, **66**; *Canterbury, Gate of St Augustine's monastery*, 1792 59, 73, **70**; *Canterbury, Gate of St Augustine's monastery*, R.A. 1793 72–3, **88**, 98; *Canterbury, The West Gate*, 1792 55, **65**; *Canterbury, The West Gate*, 1793 80, 86–8, **103**; *Castle on Promontory* (with Girtin) 98, **118**; *Chryses* 393–5, **410**; Claude's *Landing of Aeneas*, Study of 173, **214**; *Clifton, Nuneham Courtenay, near Abingdon* 7, **8**; *Clyde, Fall of the* 226, **271**, 382; *Conway Castle, North Wales*, c.1800 200, 202, **245**; *Couple in bed* 230, **282**; *Cowes Castle, Isle of Wight* 117, 118,

145; *Dolbadarn Castle and the Llanberis Pass* 180, **228**; *Dolbadarn Castle from above the Llanberis Pass* 180, **229**; *Don Quixote and the enchanted barque* 69, **86**; *Dover*, 1794 102, **124**; *The Dover Mail* 30, 38–9, **45**; *Dover, Storm off* 81, **99**; *Dunstanborough Castle* 144, **178**; *Durham Cathedral, Interior* 144, **176**; *East Malling Abbey, Kent* 24, **27**; *Edinburgh from the East* 214, **256**; *Edinburgh, from above Duddingston* 214, **255**; *Eltham, King John's Palace* 36, **43**; *Eltham, Interior of King John's Palace* 84, **100**; *Ely Cathedral, Interior of*, 1796–7 130, 133, **162**; *Ely Minster, Trancept and Choir*, R.A. 1796 125–6, 133, **155**; *Ely Cathedral, South Trancept*, R.A.1797? 114, 137–8, **165**; *Ely, Internal of a cottage* 125, **153**, 284; *Evesham, Arch of the old abbey*, signed and dated version 77, **93**; *Evesham, Arch of the old abbey* 77, **94**; *Ewenny Priory, Trancept of* 133, 135, 152, **163**; *Flüelen* 264, 447; *Fonthill Abbey, Distant View from the East* 176, **218**; *Fonthill Abbey, South view (evening)* 190, **238**; *Fonthill Abbey, South-west view (morning)* 190, **237**; *Fonthill Bishop, View looking towards* 190, **236**; *Fonthill, North-West view of a building now erecting*, 1798 (with James Wyatt) 156, **190**; *Fonthill estate, A wooden shelter on the* 176, **219**; *Fort Rock, Battle of* 447, **433**, 452; *Fountain's Abbey, dormitory and transcept of* 155–6, **188**; *Fyne, Loch* 301, **349**; *Hampton Court, Herefordshire, The Cascades* 121, **148**; *Harewood House from the north east* 146, **182**; *Harewood House from the south east* 146, **183**; *Hereford Cathedral* 77, **95**; *Isère Valley from above La Frette* 229, **276**; *Isleworth, All Saints' Church* 28, **34**; *Kidwelly Castle* 111–12, **134**; *Kidwelly Castle*, 1835 v, 111–12, **135**; *Kirkstall Abbey, Refectory of* 150, 154–5, 254, **186**; *Lambeth Palace*, 1789 25, 28, **33**; *Lambeth Palace*, R.A. 1790 28, 34, **40**; *Landaff Cathedral* [sic] 111, **133**; *Landscape composition with a ruined castle on a cliff* 56, 66, **67**; *Landscape with a man watering his horse* 67, **85**; *Leatherhead* 145, **180**; *Lime kiln by moonlight* 117, **144**; *Lincoln, Cathedral Church at* 109, **127**; *Llangollen, North Wales* 91, **108**; *Llanstephan Castle by moonlight* 117, **143**; *Llanthony Abbey, Monmouthshire* 54, **63**; *Loch Lomond from near Tarbet* 216, **261**; *Loch Long* 216, **260**; *Loch Long, evening* 216, **260**; *London: Autumnal morning* 204, **246**; *London from Lambeth* 121, **147**; *Lucerne, Lake of* **432**, 447, 452; *Ludlow Castle, Shropshire* 202, **244**; *Malmesbury Abbey*, 1791 44, **53**; *Malmsbury Abbey*, R.A. 1792 45, 51, **55**, 63, 92–3; *Malmesbury Abbey* [Scale Practice Set 'A'] 60, **71**; *Malmesbury Abbey*, 1794 92–3, **111**;

Malvern Abbey, Porch of Great 88, **104**; *Margate, Dent de Lion* 36, 38, **44**; *Margate, St John's Church* 11, **12**; *Margate, a street in* 11, **13**; *Mer de Glace, Blair's Hut* 229, 346, **382**; *Mer de Glace and Source of the Arveron*, R.A. 1803 244–6, **301**, 322; *Mer de Glace, Switzerland*, c.1815 446, 447, **434**; *Minster Church* 11, **15**; *Minster, Isle of Thanet, Kent* 11, **14**; *Montanvert, Valley of Chamouni* 346, **383**; *Nant Peris, looking towards Snowdon* 162, 180, **226**; *Nemi, Entrance to* (with Girtin) 98, **117**; *Norbury Park, Beech Trees at* 145, **179**; *Norbury Park,* [very autumnal] *Beech Trees at* 145, **181**; *Norham Castle on the Tweed, Summer's morn*, R.A. 1798 155, **187**; *Northampton* 92, **110**; OXFORD, CITY of, 1787 7, **7**; *Oxford, Distant view from the Abingdon Road*, 1789 24, **28**; *Oxford, Christ Church, from Merton Fields*, 1789 25, **32**; *Oxford, Christ Church*, 1794 100, **122**; *Oxford, Christ Church, Tom Tower* [Scale Practice Set 'A'], 1792 60, **72**; *Oxford, Christ Church, Tom Tower* [Scale Practice Set 'B'], 1792–3 62–3, **74**; *Oxford, Corpus Christi College* 249; *Oxford, Folly Bridge and Bacon's tower* 7, **10**, 160; *Oxford, Magdalen College, The Founder's Tower*, [Scale Practice Set 'A'], 1792 60, 61, **73**; *Oxford, Magdalene College, The Founder's Tower*, 1792–3 81, **97**, 98; *Oxford, Merton College Chapel* 213; *Oxford from Oriel Lane*, 1792 [Scale Practice Set 'A'] 58, **69**, 81; *Oxford from Oriel Lane*, c.1793 81, **101**; *Oxford from 'Heddington Hill'* 249; *Oxford, from the south* 24, **29**; *Pantheon, the morning after the fire* 44, 45, **56**, 105, 122; *Pantin Bruck, Near the* (with Girtin) 98, **119**; *Pembroke castle*, 1801 204–5, **247**, 283; *Pembroke-castle*, 1806 204, 276, 283, **335**; *Petworth, St Mary's Church* 49–50, **61**; *Radley Hall, Oxfordshire, from the north-west* 24–5, **30**; *Radley Hall, Oxfordshire, from the south-east* 24–5, **31**; *Reichenbach, Fall of the*, 1804 248, 254, 255, **307**, 450; *Reichenbach, Fall of the*, c.1810 366, **394**; *River landscape with distant mountains*, 1792–3 63, **75**; *Rochester Castle possibly coloured by Turner*, 1787 6, **6**; *Rochester Castle from the River Medway*, 1792 57, **68**; *Rochester*, 1793 86, **102**; *Rochester*, 1795 117, 121, **146**; *Rocky shore, with men attempting to rescue a storm-tossed boat*, 1792–3 65, 66, **79**, 110–11; Rooker's *Battle Abbey* [turret], study of 49–50, 51, **59**; Rooker's *Battle Abbey* [foliage], study of 49–50, 51, **60**; *Sailors getting pigs on board in a gale*, 1792–3 64, 69, **77**, 208; *St David's Head from Porthsallie Bay* 110–11, **131**; *St Gotthard, Devil's Bridge* **435**, 447; *St Gothard, Passage of*

Mount 254, 255, **306**, 450; *St Huges denouncing vengeance* 244, 254, **300**; *Salisbury Cathedral, chapter-house*, R.A. 1799 168, 205, **207**; *Salisbury Cathedral, Choir of* 135–7, 160, **164**; *Salisbury Cathedral, North Porch of* 138, **166**; *Salisbury Cathedral, West front* 168, 170, **208**; *Salisbury, Chapter-house*, R.A.1801 205, **248**; *Salisbury, Close Gate*, R.A.1796 122, **150**; *Salisbury, Gateway to the Close, c.*1802 262, **313**; *Scarborough, Town and Castle* 388, 395, **411**; *Self-portrait, 1791* 17, 41, **47**; *Seringapatam* 202; *Shipwreck on a rocky coastline, 1792–3* 65, 67, 79, 110–11, **80**; *Shrewsbury, Welsh Bridge* 109, 122, **128**; *The Sick Cat: A Cottage Interior* 16, **17**; *Snowdon, View across Llyn Padarn towards* 180, **227**; *Stonyhurst College* 179–80, **222**; *Stourhead, at Sunrise* 165, **203**; *Stourton, Cross at* 165, **201**; *Swansea* 116; *Syon Ferry House, Isleworth* 260, **309**; *Syon Ferry with the Syon Park pavilion in the background* 267, **318**; *Thames with Isleworth Ferry* 260, **310**; *Timber-framed house, A* (with Girtin) **120**; *Tintern Abbey, transept of* 127, **157**; *Tintern Abbey, West Front* 81, **96**; *Tivoli, Falls of the Anio at* (with Girtin) 100, **121**; *Traeth Mawr* 180, **225**; *Valle Crucis Abbey, Ruins of* 106, **126**; *Wanstead Old Church* 19, **20**; *Warkworth Castle* 172, **210**; *Warwick Castle and Bridge* 91, **106**; *Westminster Abbey with Henry VII's Chapel* 14, 21, **23**, 24; *Westminster Abbey, St Erasmus and Bishop Islip's Chapel* 122, 140, **151**; *Weymouth, Dorsetshire* 398, **415**; *Windsor Great Park* (with Sawrey Gilpin) **393**; *W. F. Wells, The Two Eldest Daughters of* 109–10, **129**; *Worcester College* [Oxford] 250, **305**; *Woolverhampton, Staffordshire* 105, 125, **152**; *Wrotham, St George's Church* 24, **26**

Turner, Joshua (paternal uncle) 201
Turner, Mary Ann (sister) 4, 5, 16
Turner, Mary, née Marshall (mother) 2, **3**, 4, 5, 7, 24, 54, 77, 110, 125, 160, 187, 188, 192, 201, 220, 224, 225, 249, 254, 262, 305, 316, 350, 458
 AND: ancestors 1–2; physical and mental characteristics, 4; mental instability 4, 5, 100, 187, 188; death 254
Turner, Price (paternal uncle) 398
Turner, Sarah, née Marshall (maternal great grandmother) 1–2, **2**
Turner, William (father) 1, **1**, 2, 3, 4, 5, 6, 10, 15, 16, 20, 28, 40, 72, 96, 100, 117, 159, 160, 163, 183, 187, 188, 189, 192, 220, 225, 253, 254, 305, 325, 335, 337, 344, 350, 366, 379, 397, 398, 415–16, 425, 428, 431, 443, 444, 456, 458
 AND: attitude to money 4; Hair Powder Tax makes wigmaking unprofitable 225; marriage 2; physical characteristics 1

Twickenham 299, 300, 304, 326, 327, 337, **348**, **354**, 365, 366, **377**, **378**, **379**, 402, 416, 425, 431, 443, 445, 449
Tywi, river 110

Uccello, Paolo 373
Ulverston 350
Unterseen 230
Uwins, Thomas 449

Valle Crucis 91, 106, **126**
Varley, Cornelius 96, 413
Varley, John 96
Vega, Lope de 341
Velázquez, Diego 164
Velde, Adriaen van de 386
Velde, Willem van de, the elder 208
Velde, Willem van de, the younger 7, 95, 208, 297
 WORKS: *Shipping in a Storm* 5, **5**; *Ships in a Stormy Sea* 178, 190, 207, 208, 213, 225, 254, **250**
Ventnor 116
Venus de' Medici 33, 374
Vernet, Claude-Joseph 142
Veronese, Paolo
 WORKS: *Hermes, Herse and Aglauros* 384, **406**; *Wedding Feast at Cana* 384
Verrio, Antonio 385
Vesalius, Andreas (Andries van Wesel) 111
Vevey 230
Victoria, Queen 457
Victory, HMS 277, 282
Virgil 271, 344, 441, 454, 458
Voreppe 228
Vries, Jan Vredeman de 307

Wales, George, Prince of 81, 252, 316; *see also* Prince Regent
Waltham, Essex 122
Waltham Cross 91
Walton bridges 269
Wapping 1
Ward, James 252, 253, 304, 418, 441, 450
Warrell, Ian 67
Warriner, Mr 252
Warwick 91, **106**
Watchet 399
Watercolour, reactivation of 106
Watteau, Antoine 326, 386
Weathercote Cave 319, 324
Webb, Thomas 252
Weir Head 427
Weld, Thomas 179
Weldon Bridge 214

Wells, Somerset 110, 199, 399
Wells, Clarissa [Clara] Anne 109, 110, 220, 286, 287
Wells, Mary, death of 292–3
Wells, Mary Anne 109, 110
Wells, William Frederick 109, 110, 186, 220, 250, 266, 275, 281, 285–6, 287, 289, 292, 321, 412, 426
Wells family 159, 220, 426
Welshpool 159
Wenvoe 159
West, Benjamin 15, 175, 177, 198, 209, 225, 231, 240, 246, 247, 250, 251, 252, 253, 257, 264, 275, 282, 289, 295, 298, 371, 398, 402
 Hagar and Ishmael 241
Westall, Richard 197, 297, 418:
 Flora unveiled by the zephyrs 295
West Country 159, 397–9, 443–4
Westminster School 321
Weybridge 269
Weymouth 398, **415**
Wey Navigation canal 269
Wey valley 269, 295, 304
Whalley 177, 178
Whalley Abbey 177, 178, 180
Wharfedale 322, 368, 375
Wheatley, Francis 95
Whig opinions 321, 322, 340, 341, 390, 426, 429
Whitaker, Thomas Dunham 177–2, 178, 179–80, **220**
Whitby 213. 214
White, John 5
'White painters' 354, 418, 420, 421, 439
Whitehall Evening Post 155
Whitehaven 350
Whitewell 178, 350
Wilkes, John 7, 8, 198
Wilkie, David 264, 284–5, 295, 296, 299, 316, 334, 346, 354, 357, 384
 WORKS: *The Blind Fiddler* 284, 295, 299, **345**; *Village Politicians* 283–4, 285, 295, 297, **336**
Williams-Wynn, Sir Watkin 182
Willoughby, Sir Hugh 439
Wilson, Richard 95, 121, 152, 156–8, 159, 166, 167, 168, 171, 174, 186, 196, 354, 386, 448; birthplace 159
 WORKS: *Apollo and the Seasons* 157; *Celadon and Amelia* 157, **193**; *Cicero and his Friends at his Villa at Arpinum* 157; *Destruction of the Children of Niobe* 157; *Lake of Nemi, or Speculum Dianae* **191**; *Lake Nemi with Diana and Callisto* 165–6, 448, 449; *Tivoli, Temple of the Sibyl and Campagna at* **192**; drawings 145, 156, 214
Wiltshire 40, 110, 112, 165, 174, 199
Winchelsea 302
Winchester 116, **139**, 199
Windsor 5, 269, 271, 273, 300
Windsor Castle 74, 116, 247, 251, 271, 316, **319**, **320**, 328

Windsor Great Park 116, 393
Winspit 398
The Wirral 91
Witham Priory 244
Witton-le-Wear 227
Wolcot, John ('Peter Pindar') 429
Wolverhampton 91, 122, 125, **152**
Wood, John George 307
Woodforde, Samuel 183, 379
 Portrait of Sir Richard Colt Hoare **136**
Woodgate, William Francis 351, 364, 390, 392
Worcester 77
Worcester College, Oxford 249, 250, **305**
Worcestershire 77, 88
Worsley Old Hall 178
Wrexham 91
Wright, Joseph, of Derby 15, 418

Wyatt, James, architect 138, 142, 156, 160, 175, 180, 190, 220, 239, 240, 247, 250, 251, 252, 253, 275, 282, 289
 Fonthill, North-West view of a building now erecting, 1798 (with Turner) 156, **190**
Wyatt, James, art dealer and printseller 351, 353, 355, 366, 395, 402, 404, 405, 406
Wycombe, High 203
Wye valley 54, 77, 78, 110, 159
Wynnstay 180

Yarborough, Charles Anderson Pelham, 1st Baron 140, 141, 142, 160, 211, 227, 254, 241, 281, 362
Yardstick, £26 per annum workman's average income xii, 88, 426, 458
Yarmouth, Isle of Wight 116

Yenn, John 239, 240, 247, 250, 251, 252, 253
York 141, 213
Yorkshire 140, 142, 146, 174, 213, 254, 318, 321, 322, 323, 324, 340, 346, 353, 365, 366, 367, 368, 402, 413, 417, 419, 443, 447
Yorkshire, county elections 1796–1807 321–2
Yorke, Dr James 133
Young, Benjamin 335
Young, John 436, 439

Zuccarelli, Francesco 386
Zurich 230

Photograph credits

Abbot Hall Art Gallery, Lakeland Arts Trust, Kendal: 306; Aberdeen Art Gallery & Museums Collections: 162; Image courtesy of Agnew's Gallery: 353, 410; Art Gallery of South Australia, Adelaide, Gift from the collection of the late Mrs S. M. Crabtree by her children Rosalind, Robert, Richard and John assisted by the Roy and Marjory Edwards Bequest Fund and the Art Gallery of South Australia Foundation to commemorate the Gallery's 125th anniversary 2006: 411; © Ashmolean Museum, University of Oxford: 305, 390; The Bacon Collection: 53, 76; The Henry Barber Trust, The Barber Institute of Fine Arts, University of Birmingham: 363; © The Trustees of the British Museum: 5, 21, 22, 36, 42, 96, 97, 98, 114, 127, 138, 149, 151, 157, 169, 199, 223, 235, 232, 242, 285, 302, 339, 360, 364, 384, 386, 387, 395, 396, 407, 412, 413, 414, 416, 417, 420; Museum of Fine Arts, Boston, Bequest of Alice Marian Curtis and Special Picture Fund 13.2723: 334

Bridgeman Images: Private Collection / Photo © Agnew's, London / Bridgeman Images: 72, 187, 261; © Bristol Museum and Art Gallery, UK / Bridgeman Images: 48, 49; Private Collection / Photo © Christie's Images / Bridgeman Images: 246, 389; The National Library of Wales Aberystwyth / Photo © Christie's Images / Bridgeman Images: 142; By permission of Llyfrgell Genedlaethol Cymru / The National Library of Wales: 142; Museu Calouste Gulbenkian, Lisbon, Portugal / Bridgeman Images: 393; Harris Museum and Art Gallery, Preston, Lancashire, UK / Bridgeman Images: 135, 208; Museum of Fine Arts, Houston, Texas, USA / museum purchase with funds provided by the Alice Pratt Brown Museum Fund and the Brown Foundation Accessions Endowment Fund, with additional gifts from Isabel B. and Wallace S. Wilson, The Brown Foundation, Inc., and Ann Trammell / Bridgeman Images: 355; © Isabella Stewart Gardner Museum, Boston, MA, USA / Bridgeman Images: 252; Manchester Art Gallery, UK / Bridgeman Images: 146, 365; Salisbury Museum / Bridgeman Images: 164, 166; Science Museum, London, UK / Bridgeman Images: 84; Sheffield Galleries and Museums Trust, UK / Photo © Museums Sheffield / Bridgeman Images: 297; Southampton City Art Gallery, Hampshire, UK / Bridgeman Images: 83, 268; Sterling and Francine Clark Art Institute, Williamstown, Massachusetts, USA / Gift of the Manton Art Foundation in memory of Sir Edwin and Lady Manton / Bridgeman Images: 102, 425; © Tabley House Collection, University of Manchester, UK / Bridgeman Images: 317, 373; Taft Museum of Art, Cincinnati, Ohio, USA / Bequest of Charles Phelps and Anna Sinton Taft / Bridgeman Images: 369; © Victoria Art Gallery, Bath and North East Somerset Council / Bridgeman Images: 82, 156; © Manchester Museum & the Whitworth, University of Manchester / Bridgeman Images: 104, 106; © Wolverhampton Art Gallery, West Midlands, UK / Bridgeman Images: 152; Collection of the Earl of Yarborough, Lincolnshire, UK / Bridgeman Images: 173; © York Museums Trust (York Art Gallery), UK / Bridgeman Images: 188

Photograph by Christopher Chard: 410; © Chiswick and Hounslow Libraries / Photograph by Matthew Hollow: 6; © Christie's Images Limited 2016: 24, 25, 159, 180, 206, 358; Corsham Court Collection: 155; The Samuel Courtauld Trust, The Courtauld Gallery, London: 382; Reproduced by permission of Durham University Library: 274; © Fitzwilliam Museum, Cambridge: 66, 122, 295, 313, 406; Harvard Art Museums / Fogg Museum, Gift of Mr. and Mrs. William Emerson, 1930.455 / Photograph: Imaging Department © President and Fellows of Harvard College: 230; Photograph courtesy of the J. Paul Getty Museum Open Content Program: 245; Reproduced by the kind permission of the Trustees of the 7th Earl of Harewood and the Trustees of the Harewood House Trust: 171, 182, 183; Hereford Museum and Gallery, Herefordshire Museums Service: 95;

Photograph reproduced with the permission of the Herbert Art Gallery & Museum, Coventry: 144; Trustees of the Cecil Higgins Art Gallery, Bedford: 307; Indianapolis Museum of Art, Gift of Mr. and Mrs. Kurt F. Pantzer: 16; Indianapolis Museum of Art, Gift in memory of Dr. and Mrs. Hugo O. Pantzer: 40; Indianapolis Museum of Art, Gift in memory of Dr. and Mrs. Hugo O. Pantzer by their children: 63; Indianapolis Museum of Art, Bequest of Kurt F. Pantzer: 116, 123; Indianapolis Museum of Art, Gift in memory of Evan F. Lilly: 240; Photograph courtesy of the National Gallery of Ireland: 103, 137, 179, 255; By Courtesy of the Trustees of Sir John Soane's Museum: 54, 186, 300; © The Provost and Scholars of King's College, Cambridge: 107; © Manchester Museum & the Whitworth, University of Manchester: 80, 105, 108, 128, 248, 383; Photograph courtesy of the Metropolitan Museum of Art Open Access for Scholarly Content Program: 125; The Montreal Museum of Fine Arts, purchase, Horsley and Annie Townsend Bequest. Photo: The Montreal Museum of Fine Arts, Brian Merrett: 238; © The National Gallery, London: 200, 303, 304; © The National Gallery, London. Turner Bequest, 1856: 298, 347, 437; © National Portrait Gallery, London: 47, 81, 115, 167, 177, 215, 220, 221, 314, 385, 397, 424, 426; © National Trust Images/Tate Enterprises/A. Dunkley & M. Leith: 191, 194; © National Trust Images: 205, 212, 381, 427; © National Trust Images/John Hammond: 136, 211; © The Principal and Fellows of Newnham College, Cambridge: 150; Norfolk Museums Service (Norwich Castle Museum & Art Gallery): 55; Northampton Museum & Art Gallery: 110; Art Gallery of Ontario. Bequest of John Paris Bickell, Toronto, 1952: 237; Private Collection/Photograph by Matthew Hollow: 1, 2, 3, 23; Private Collection/Photograph by Jerry Hardman-Jones: 361; Private collection, courtesy of Andrew Clayton-Payne: 147; Photography by Erik Gould, courtesy of the Museum of Art, Rhode Island School of Design, Providence, Anonymous gift 69.154.60: 93; Rijksmuseum, Amsterdam: 89; Photo © RMN-Grand Palais (Musée du Louvre)/Jean-Gilles Berizzi: 283; Photo © RMN-Grand Palais (Musée du Louvre)/Stéphane Maréchalle: 286, 294; Photo © Musée du Louvre, Dist. RMN-Grand Palais/Martine Beck-Coppola: 288; Photo © RMN-Grand Palais (Musée du Louvre)/René-Gabriel Ojéda: 290; Photo © RMN-Grand Palais (Musée du Louvre)/Gérard Blot: 292; Photo © RMN-Grand Palais (Musée du Louvre)/Mathieu Rabeau: 293; © Royal Academy of Arts, London: 35, 57, 58, 184, 234, 239; City of Salford Museums and Art Gallery: 213; The Metropolitan Museum of Art/Art Resource/Scala, Florence: 419; Pinacoteca Vaticana, Rome/Scala, Florence: 284; Courtesy of the Earls of Mansfield, Scone Palace, Perth: 336; © National Galleries of Scotland: 233, 254, 273; Smith College Museum of Art, Northampton, Massachusetts: 71; © Photograph Courtesy of Sotheby's: 27, 45, 154, 354, 408; © Tate, London 2016: 7, 8, 9, 10, 11, 12, 13, 14, 17, 18, 19, 28, 30, 31, 32, 37, 38, 39, 46, 51, 52, 56, 59, 60, 61, 62, 64, 65, 67, 68, 69, 74, 75, 77, 78, 79, 91, 92, 99, 101, 109, 112, 113, 117, 118, 119, 120, 126, 131, 132, 133, 134, 139, 140, 141, 143, 145, 153, 158, 168, 174, 175, 176, 178, 185, 189, 192, 195, 196, 197, 198, 201, 202, 203, 214, 216, 217, 218, 219, 224–9, 232, 236, 241, 243, 249, 256–60, 262, 263, 264, 265, 267, 269, 270, 272, 275–82, 287, 289, 291, 299, 309, 310, 311, 312, 315, 316, 318–331, 333, 337, 338, 340, 341, 342, 344, 345, 346, 348, 350, 351, 352, 356, 357, 359, 366, 367, 368, 370, 371, 372, 374–80, 388, 391, 392, 398–405, 409, 418, 422, 423, 428, 429, 430, 431, 433, 436; The Timothy Clode Collection: 160; Toledo Museum of Art (Toledo, Ohio), Purchased with funds from the Libbey Endowment, Gift of Edward Drummond Libbey, 1977.62. Photo Credit: Photography, Incorporated, Toledo: 250; University of Toronto Art Collection 1999-006. Courtesy the Governing Council of the University of Toronto. Ontario, Canada, Gift of Mrs. Augustine FitzGerald in memory of her husband Mr. Augustine FitzGerald, and especially of her husband's father, Mr. William FitzGerald, 1932/Photograph by Toni Hafkenscheid: 247; Courtesy of Turner's House Trust: 421; © Victoria and Albert Museum, London: 148, 121, 161, 207, 210; Courtesy of the Howard de Walden Estates/Photograph by Matthew Hollow: 231; © National Museum Wales: 163, 301; © Walker Art Gallery, National Museums Liverpool: 271; National Gallery of Art Washington Open Access Program: 90, 308, 343; Yale Center for British Art: 44, 70, 88, 100, 170, 190, 204, 266, 296, 394, 415, 434, 435; © Yamanashi Prefectural Museum of Art: 349